KB085465

이 책『thisisneverthisisneverthat』은
2020년 봄여름 시즌에 thisisneverthat과 워크룸이 협업한 제품 가운데 첫 번째 결과물이다.

Prefix	Year	Season	Category	Number	Color

WR20SPT001NA

thisisneverthisisneverthat is the first output of the thisisneverthat–Workroom
collaboration for the SS20 season.

thisisneverthisisneverthat

thisisneverthat®

ɯo
rk
ro
om

일러두기

1. thisisneverthat을 제외하고 외국 인명, 브랜드명을 한글로 옮길 때
되도록 국립국어원의 외래어표기법을 따르되 통용되는 표기가 있거나
한국에 공식 진출한 브랜드에서 자체적으로 사용하는 표기가 있는 경우
그를 따랐다.
2. 단행본, 정기간행물, 앨범, 전시는 겹낫표(『』)로, 글, 논문, 기사, 노래,
작품은 홑낫표(「」)로 묶었다.
3. 목록에서 제품은 코드 순, 그 밖의 항목은 가나다순(한글),
알파벳순(로마자)으로 정렬했다.

Code	Category	Name	Material(s)	Color(s)
GS20SAC001BK	Accessory	DW-5600TNT-1DR	-	Black
NB20SAC001GN	Socks	NB TNT Socks	Cotton	Green
NB20SAC001WH	Socks	NB TNT Socks	Cotton	White
NB20SFW003BE	Shoes	ML827	-	Beige
NB20SFW003BK	Shoes	ML827	-	Black
NB20SHS001CH	Sweatshirt	NB TNT Zipup Sweat	Cotton	Charcoal
NB20SHS001GN	Sweatshirt	NB TNT Zipup Sweat	Cotton	Green
NB20SHS001OT	Sweatshirt	NB TNT Zipup Sweat	Cotton	Oatmeal
NB20SHW001BK	Hat	NB TNT Bucket Hat	Cotton	Black
NB20SHW001WH	Hat	NB TNT Bucket Hat	Cotton	White
NB20SLS001CH	Long Sleeve Tee	NB TNT Pocket L/S	Cotton	Charcoal
NB20SLS001GN	Long Sleeve Tee	NB TNT Pocket L/S	Cotton	Green
NB20SLS001OT	Long Sleeve Tee	NB TNT Pocket L/S	Cotton	Oatmeal
NB20SSO001CH	Pants	NB TNT Sweat Short	Cotton	Charcoal
NB20SSO001GN	Pants	NB TNT Sweat Short	Cotton	Green
NB20SSO001OT	Pants	NB TNT Sweat Short	Cotton	Oatmeal
NB20STS001CH	Tee	NB TNT Tee	Cotton	Charcoal
NB20STS001GN	Tee	NB TNT Tee	Cotton	Green
NB20STS001OT	Tee	NB TNT Tee	Cotton	Oatmeal
NB20STS002CH	Tee	NB TNT POCKET Tee	Cotton	Charcoal
NB20STS002GN	Tee	NB TNT Pocket Tee	Cotton	Green
NB20STS002OT	Tee	NB TNT Pocket Tee	Cotton	Oatmeal
NE20SBA001BK	Bag	Carrier Pack TNT	Nylon	Black
NE20SBA002BK	Bag	Multi Case TNT	Nylon	Black
NE20SHW001BK	Hat	5950 TNT	Wool	Black
NE20SHW002BK	Hat	Bucket01 LB TNT	Cotton	Black
NE20SHW003BK	Hat	920UNST TNT	Cotton	Black
NE20SHW003GH	Hat	920UNST TNT	Cotton	Graphite
NE20SHW004NA	Hat	920UNST TNT NEYYAN	Cotton	Navy
NE20SHW005SC	Hat	920UNST TNT BOSRED	Cotton	Scarlet
NE20SHW006BK	Hat	920UNST TNT SAFGIA	Cotton	Black
NE20STS001WH	Tee	AP TNT NEYYAN	Cotton	White
NE20STS002HR	Tee	AP TNT BOSRED	Cotton	Heather Grey
NE20STS003BK	Tee	AP TNT SAFGIA	Cotton	Black
PM20SAC001BL	Accessory	PKM Duralex® Glass	Glass	Blue
PM20SAC001GR	Accessory	PKM Duralex® Glass	Glass	Green
PM20SAC001OR	Accessory	PKM Duralex® Glass	Glass	Orange
PM20SAC002BL	Accessory	PKM Silhouette iPhone Case	TPU	Blue
PM20SAC002OR	Accessory	PKM Silhouette iPhone Case	TPU	Orange
PM20SAC003BL	Accessory	PKM Outline iPhone Case	TPU	Blue
PM20SAC003GR	Accessory	PKM Outline iPhone Case	TPU	Green
PM20SAC003OR	Accessory	PKM Outline iPhone Case	TPU	Orange
PM20SAC004BL	Accessory	PKM Outline AirPods Case	TPU	Blue
PM20SAC004GR	Accessory	PKM Outline AirPods Case	TPU	Green
PM20SAC004OR	Accessory	PKM Outline AirPods Case	TPU	Orange
PM20SAC005BL	Accessory	PKM Silhouette AirPods Case	TPU	Blue
PM20SAC005OR	Accessory	PKM Silhouette AirPods Case	TPU	Orange
PM20SAC006WH	Accessory	PKM Break Key Ring	Silicone	White
PM20SAC007YL	Accessory	PKM Pikachu Plush	Polyester	Yellow
PM20SAC008SR	Accessory	PKM Silhouette Key Ring	Brass	Silver
PM20SAC009MT	Accessory	PKM Sticker Pack	-	-
PM20SAC010BL	Accessory	PKM Silhouette AirPods Pro Case	TPU	Blue
PM20SAC010OR	Accessory	PKM Silhouette AirPods Pro Case	TPU	Orange
PM20SBA002BK	Bag	PKM Tote Bag	Cotton	Black
PM20SBA002IV	Bag	PKM Tote Bag	Cotton	Ivory

Code	Category	Name	Material(s)	Color(s)
PM20SHW001BK	Hat	PKM T-Logo Cap	Cotton	Black
PM20SHW001BL	Hat	PKM T-Logo Cap	Cotton	Blue
PM20SHW002BK	Hat	PKM Break Cap	Cotton	Black
PM20SHW002GR	Hat	PKM Break Cap	Cotton	Grey
PM20SLS001WB	Long Sleeve Tee	PKM Reflective L/SL Top	Cotton	White, Blue
PM20SLS001WG	Long Sleeve Tee	PKM Reflective L/SL Top	Cotton	White, Green
PM20SLS001WO	Long Sleeve Tee	PKM Reflective L/SL Top	Cotton	White, Orange
PM20SLS002BG	Long Sleeve Tee	PKM Reversible L/SL Top	Cotton	Black, Green
PM20SLS002BO	Long Sleeve Tee	PKM Reversible L/SL Top	Cotton	Black, Orange
PM20SLS002WB	Long Sleeve Tee	PKM Reversible L/SL Top	Cotton	White, Blue
PM20SLS002WO	Long Sleeve Tee	PKM Reversible L/SL Top	Cotton	White, Orange
PM20SLS003BK	Long Sleeve Tee	PKM Break L/SL Top	Cotton	Black
PM20SLS003WH	Long Sleeve Tee	PKM Break L/SL Top	Cotton	White
PM20STS001BG	Tee	PKM Reversible Tee	Cotton	Black, Green
PM20STS001BO	Tee	PKM Reversible Tee	Cotton	Black, Orange
PM20STS001WB	Tee	PKM Reversible Tee	Cotton	White, Blue
PM20STS001WO	Tee	PKM Reversible Tee	Cotton	White, Orange
PM20STS002BG	Tee	PKM T-Logo Tee	Cotton	Black, Green
PM20STS002WB	Tee	PKM T-Logo Tee	Cotton	White, Blue

TN20SMV005NA

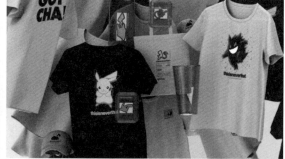

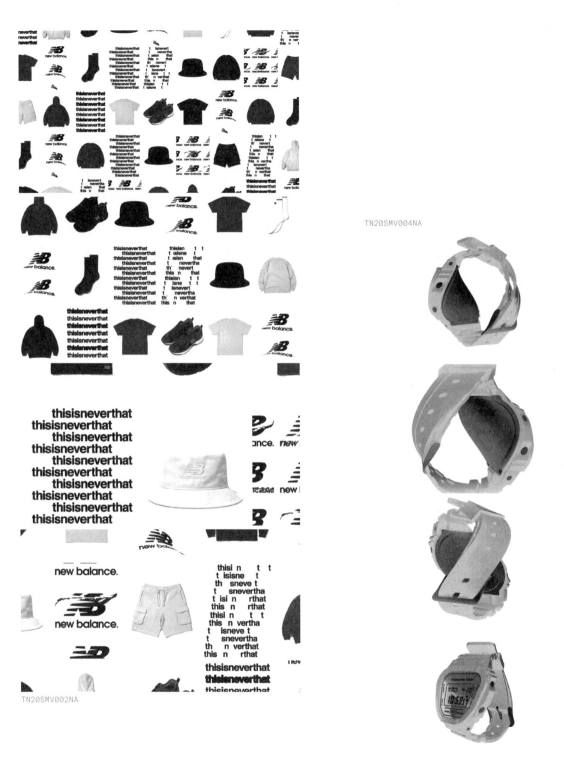

TN20SMV004NA

TN20SMV002NA

thisisneverthat®

Code	Category	Name	Material(s)	Color(s)
PM20STS002WO	Tee	PKM T-Logo Tee	Cotton	White, Orange
PM20STS003BG	Tee	PKM Information Tee	Cotton	Black, Green
PM20STS003BO	Tee	PKM Information Tee	Cotton	Black, Orange
PM20STS003WB	Tee	PKM Information Tee	Cotton	White, Blue
PM20STS003WO	Tee	PKM Information Tee	Cotton	White, Orange
PM20STS004BB	Tee	PKM Paint Tee	Cotton	Black, Blue
PM20STS004BO	Tee	PKM Paint Tee	Cotton	Black, Orange
PM20STS004WG	Tee	PKM Paint Tee	Cotton	White, Green
PM20STS005WB	Tee	PKM Reflective Tee	Cotton	White, Blue
PM20STS005WG	Tee	PKM Reflective Tee	Cotton	White, Green
PM20STS005WO	Tee	PKM Reflective Tee	Cotton	White, Orange
PM20STS006BK	Tee	PKM Jump Tee	Cotton	Black
PM20STS006WH	Tee	PKM Jump Tee	Cotton	White
PM20STS007BK	Tee	PKM GOTCHA! Tee	Cotton	Black
PM20STS007WH	Tee	PKM GOTCHA! Tee	Cotton	White
PM20STS008BK	Tee	PKM Break Tee	Cotton	Black
PM20STS008WH	Tee	PKM Break Tee	Cotton	White
TN20SAC001BK	Accessory	Leather Belt	Cow Leather, Acrylic, Polyester	Black
TN20SAC001BR	Accessory	Leather Belt	Cow Leather, Acrylic, Polyester	Brown
TN20SAC002BK	Socks	HSP-Logo Socks	Cotton, Spandex, Polyester	Black
TN20SAC002IM	Socks	HSP-Logo Socks	Cotton, Spandex, Polyester	Lime
TN20SAC002WH	Socks	HSP-Logo Socks	Cotton, Spandex, Polyester	White
TN20SAC004SR	Accessory	INTL. Logo Ring	925 Silver	Silver
TN20SAC006SR	Accessory	T-Logo Bangle	925 Silver	Silver
TN20SAC007BK	Accessory	SP-Logo Magnet Buckle Belt	Acrylic, Polyester	Black
TN20SAC009SR	Accessory	Steel Pint 16oz	Stainless Steel	Silver
TN20SAC010SR	Accessory	Steel Cup 10oz	925 Silver	Silver
TN20SAC011BK	Accessory	ARC-Logo Key Ring	Silicone	Black
TN20SAC012SR	Accessory	Earth Key Ring	Brass	Silver
TN20SAC013BK	Accessory	SQUIRT PS4	420HC Stainless Steel	Black
TN20SAC013BL	Accessory	SQUIRT PS4	420HC Stainless Steel	Blue
TN20SBA001BK	Bag	CORDURA® Satin Daypack	Nylon	Black
TN20SBA001OR	Bag	CORDURA® Satin Daypack	Nylon	Orange
TN20SBA002BK	Bag	CORDURA® 330D Nylon SP Backpack	Nylon, Polyester	Black
TN20SBA002IB	Bag	CORDURA® 330D Nylon SP Backpack	Nylon, Polyester	Ice Blue
TN20SBA002IR	Bag	CORDURA® 330D Nylon SP Backpack	Nylon, Polyester	Light Grey
TN20SBA004BK	Bag	CORDURA® Satin Record Bag	Nylon	Black
TN20SBA004OR	Bag	CORDURA® Satin Record Bag	Nylon	Orange
TN20SBA005BK	Bag	CORDURA® 330D Nylon SP Messenger Bag	Nylon, Polyester	Black
TN20SBA005IB	Bag	CORDURA® 330D Nylon SP Messenger Bag	Nylon, Polyester	Ice Blue
TN20SBA005IR	Bag	CORDURA® 330D Nylon SP Messenger Bag	Nylon, Polyester	Light Grey
TN20SBA006BK	Bag	CORDURA® Satin Shoulder Bag	Nylon	Black
TN20SBA006OR	Bag	CORDURA® Satin Shoulder Bag	Nylon	Orange
TN20SBA007BK	Bag	CORDURA® 330D Nylon SP BOP	Nylon, Polyester	Black
TN20SBA007IB	Bag	CORDURA® 330D Nylon SP BOP	Nylon, Polyester	Ice Blue
TN20SBA007IR	Bag	CORDURA® 330D Nylon SP BOP	Nylon, Polyester	Light Grey
TN20SBA008BK	Bag	CORDURA® 330D Nylon SP Packing Cube	Nylon, Polyester	Black
TN20SBA009BK	Bag	CORDURA® 330D Nylon SP Card Holder	Nylon, Polyester	Black
TN20SBA009IB	Bag	CORDURA® 330D Nylon SP Card Holder	Nylon, Polyester	Ice Blue
TN20SBA009IR	Bag	CORDURA® 330D Nylon SP Card Holder	Nylon, Polyester	Light Grey
TN20SBA010BK	Bag	CORDURA® Satin Wallet	Nylon	Black
TN20SBA010OR	Bag	CORDURA® Satin Wallet	Nylon	Orange
TN20SBA011BK	Bag	CORDURA® Satin 13" Laptop Sleeve	Nylon	Black

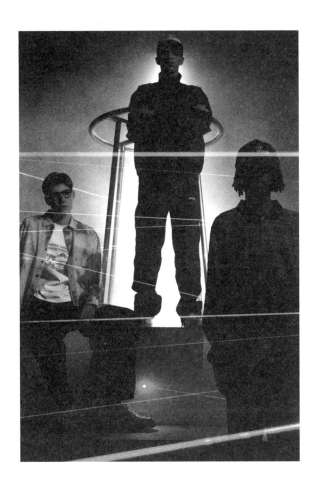

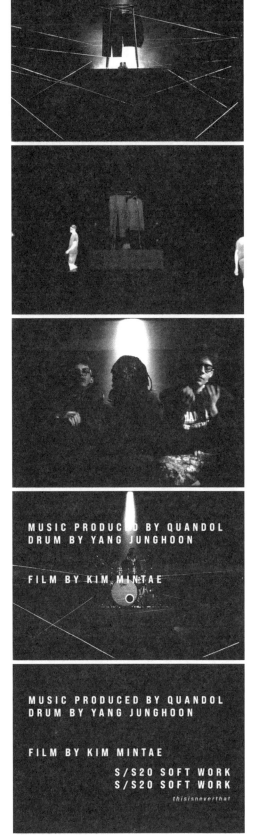

MUSIC PRODUCED BY QUANDOL
DRUM BY YANG JUNGHOON

FILM BY KIM MINTAE

MUSIC PRODUCED BY QUANDOL
DRUM BY YANG JUNGHOON

FILM BY KIM MINTAE

S/S20 SOFT WORK
S/S20 SOFT WORK

thisisneverthat

TN20SMV001NA

Code	Category	Name	Material(s)	Color(s)
TN20SBA011OR	Bag	CORDURA® Satin 13" Laptop Sleeve	Nylon	Orange
TN20SBA012BK	Bag	PERTEX® Mini Bag	Polyester	Black
TN20SBA012BL	Bag	PERTEX® Mini Bag	Polyester	Blue
TN20SBA012GR	Bag	PERTEX® Mini Bag	Polyester	Grey
TN20SBA012OV	Bag	PERTEX® Mini Bag	Polyester	Olive
TN20SBA012RD	Bag	PERTEX® Mini Bag	Polyester	Red
TN20SBA013BK	Bag	CORDURA® 330D Nylon SP Box Pouch	Nylon	Black
TN20SBA013IB	Bag	CORDURA® 330D Nylon SP Box Pouch	Nylon	Ice Blue
TN20SBA013IR	Bag	CORDURA® 330D Nylon SP Box Pouch	Nylon	Light Grey
TN20SHS001CH	Sweatshirt	DSN-Logo Zipup Sweat	Cotton	Charcoal
TN20SHS001DCL	Sweatshirt	DSN-Logo Zipup Sweat	Cotton	Deep Coral
TN20SHS001MI	Sweatshirt	DSN-Logo Zipup Sweat	Cotton	Mint
TN20SHS001YL	Sweatshirt	DSN-Logo Zipup Sweat	Cotton	Yellow
TN20SHS002BK	Sweatshirt	NEW ARC Zipup Sweat	Cotton	Black
TN20SHS002IV	Sweatshirt	NEW ARC Zipup Sweat	Cotton	Ivory
TN20SHS002RV	Sweatshirt	NEW ARC Zipup Sweat	Cotton	Dark Olive
TN20SHS003BK	Sweatshirt	FD-Logo Hooded Sweatshirt	Cotton	Black
TN20SHS003DBG	Sweatshirt	FD-Logo Hooded Sweatshirt	Cotton	Dark Bluegrey
TN20SHS003GR	Sweatshirt	FD-Logo Hooded Sweatshirt	Cotton	Grey
TN20SHS003IL	Sweatshirt	FD-Logo Hooded Sweatshirt	Cotton	Light Olive
TN20SHS004BK	Sweatshirt	S.W. ARC Hooded Sweatshirt	Cotton	Black
TN20SHS004DNY	Sweatshirt	S.W. ARC Hooded Sweatshirt	Cotton	Dark Navy
TN20SHS004LGN	Sweatshirt	S.W. ARC Hooded Sweatshirt	Cotton	Light Green
TN20SHS005BK	Sweatshirt	DESIGN Hooded Sweatshirt	Cotton	Black
TN20SHS005IR	Sweatshirt	DESIGN Hooded Sweatshirt	Cotton	Light Grey
TN20SHS005PK	Sweatshirt	DESIGN Hooded Sweatshirt	Cotton	Pink
TN20SHS006BK	Sweatshirt	N 1/4 Zip Hooded Sweatshirt	Cotton	Black
TN20SHS006DBG	Sweatshirt	N 1/4 Zip Hooded Sweatshirt	Cotton	Dark Bluegrey
TN20SHS006MD	Sweatshirt	N 1/4 Zip Hooded Sweatshirt	Cotton	Mustard
TN20SHS007BE	Sweatshirt	ISW Hooded Sweatshirt	Cotton	Beige
TN20SHS007CH	Sweatshirt	ISW Hooded Sweatshirt	Cotton	Charcoal
TN20SHS007SGN	Sweatshirt	ISW Hooded Sweatshirt	Cotton	Sage Green
TN20SHS008BK	Sweatshirt	Damaged Hooded Sweatshirt	Cotton	Black
TN20SHS008FR	Sweatshirt	Damaged Hooded Sweatshirt	Cotton	Forest
TN20SHS008PP	Sweatshirt	Damaged Hooded Sweatshirt	Cotton	Purple
TN20SHW001BE	Hat	SP-Logo Cap	Cotton	Beige
TN20SHW001BK	Hat	SP-Logo Cap	Cotton	Black
TN20SHW001NA	Hat	SP-Logo Cap	Cotton	Navy
TN20SHW001OR	Hat	SP-Logo Cap	Cotton	Orange
TN20SHW002GR	Hat	Suede Bill Cap	Cotton, Polyester, Polyurethane	Grey
TN20SHW002IV	Hat	Suede Bill Cap	Cotton, Polyester, Polyurethane	Ivory
TN20SHW003BK	Hat	Bleached E/T-Logo Cap	Cotton	Black
TN20SHW003GN	Hat	Bleached E/T-Logo Cap	Cotton	Green
TN20SHW004GR	Hat	SOFT WORK Jersey Cap	Cotton	Grey
TN20SHW004NA	Hat	SOFT WORK Jersey Cap	Cotton	Navy
TN20SHW005BK	Hat	PERMUTATIONS Mesh Trucker	Polyester, Rayon, Spandex	Black
TN20SHW005NA	Hat	PERMUTATIONS Mesh Trucker	Polyester, Rayon, Spandex	Navy
TN20SHW006BK	Hat	DSN-Logo Camp Cap	Cotton	Black
TN20SHW006BL	Hat	DSN-Logo Camp Cap	Cotton	Blue
TN20SHW006CH	Hat	DSN-Logo Camp Cap	Cotton	Charcoal
TN20SHW007BK	Hat	Reflective Folding Bill Cap	Nylon, Polyester	Black
TN20SHW007GR	Hat	Reflective Folding Bill Cap	Nylon, Polyester	Grey
TN20SHW007OR	Hat	Reflective Folding Bill Cap	Nylon, Polyester	Orange

Code	Category	Name	Material(s)	Color(s)
TN20SHW008CH	Hat	Overdyed Jungle Bucket Hat	Cotton	Charcoal
TN20SHW008GN	Hat	Overdyed Jungle Bucket Hat	Cotton	Green
TN20SHW008NA	Hat	Overdyed Jungle Bucket Hat	Cotton	Navy
TN20SHW009BG	Hat	T-Logo Beanie	Cotton	Black
TN20SHW009BK	Hat	T-Logo Beanie	Cotton	Blue Green
TN20SHW009LV	Hat	T-Logo Beanie	Cotton	Lavender
TN20SHW009YL	Hat	T-Logo Beanie	Cotton	Yellow
TN20SHW010BK	Hat	PERTEX® Reversible Bucket Hat	Polyester	Black
TN20SHW010CK	Hat	PERTEX® Reversible Bucket Hat	Polyester	Check
TN20SHW010RD	Hat	PERTEX® Reversible Bucket Hat	Polyester	Red
TN20SHW011BK	Hat	SP-Logo Short Beanie	Cotton, Acrylic	Black
TN20SHW011IY	Hat	SP-Logo Short Beanie	Cotton, Acrylic	Light Yellow
TN20SHW011PK	Hat	SP-Logo Short Beanie	Cotton, Acrylic	Pink
TN20SHW012BK	Hat	Capital N Cap	Cotton	Black
TN20SHW012OV	Hat	Capital N Cap	Cotton	Olive
TN20SHW012RD	Hat	Capital N Cap	Cotton	Red
TN20SHW013BK	Hat	Tiedye ARC-Logo Beanie	Cotton	Black
TN20SHW013GN	Hat	Tiedye ARC-Logo Beanie	Cotton	Green
TN20SHW013GR	Hat	Tiedye ARC-Logo Beanie	Cotton	Grey
TN20SHW015BK	Hat	CORDURA® DSN-Logo Cap	Nylon	Black
TN20SHW015IB	Hat	CORDURA® DSN-Logo Cap	Nylon	Ice Blue
TN20SHW015IR	Hat	CORDURA® DSN-Logo Cap	Nylon	Light Grey
TN20SHW999BK	Hat	EXHIBITION 20 Beanie	Nylon	Black
TN20SKW002BK	Top	E/T-Logo Cardigan	Cotton, Acrylic	Black
TN20SKW002MD	Top	E/T-Logo Cardigan	Cotton, Acrylic	Mustard
TN20SKW003BK	Top	DSN Striped Cardigan	Cotton, Acrylic	Black
TN20SKW003GN	Top	DSN Striped Cardigan	Cotton, Acrylic	Green
TN20SKW007BK	Top	Zip Up Polo Shirt	Cotton	Black
TN20SKW007MD	Top	Zip Up Polo Shirt	Cotton	Mustard
TN20SKW008OO	Top	Multi L/SL Jersey Polo	Cotton	#1
TN20SKW008TW	Top	Multi L/SL Jersey Polo	Cotton	#2

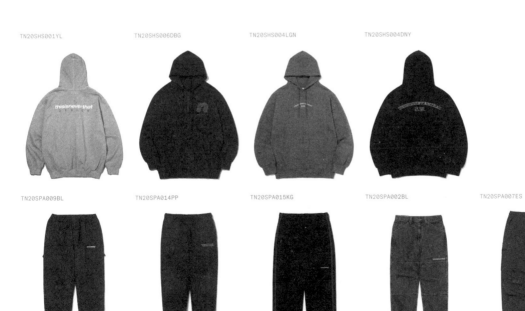

TN20SHS001YL TN20SHS006DBG TN20SHS004LGN TN20SHS004DNY

TN20SPA009BL TN20SPA014PP TN20SPA015KG TN20SPA002BL TN20SPA007ES

Code	Category	Name	Material(s)	Color(s)
TN20SKW009BK	Top	DSN S/SL Jersey Polo	Cotton	Black
TN20SKW009IL	Top	DSN S/SL Jersey Polo	Cotton	Light Olive
TN20SKW009SB	Top	DSN S/SL Jersey Polo	Cotton	Sky Blue
TN20SLS001BK	Long Sleeve Tee	ARC-Logo L/SL Top	Cotton	Black
TN20SLS001GR	Long Sleeve Tee	ARC-Logo L/SL Top	Cotton	Grey
TN20SLS001LY	Long Sleeve Tee	ARC-Logo L/SL Top	Cotton	Light Navy
TN20SLS001WH	Long Sleeve Tee	ARC-Logo L/SL Top	Cotton	White
TN20SLS002DBG	Long Sleeve Tee	SP-3 L/SL Top	Cotton	Dark Bluegrey
TN20SLS002MI	Long Sleeve Tee	SP-3 L/SL Top	Cotton	Mint
TN20SLS002WH	Long Sleeve Tee	SP-3 L/SL Top	Cotton	White
TN20SLS002YL	Long Sleeve Tee	SP-3 L/SL Top	Cotton	Yellow
TN20SLS003CH	Long Sleeve Tee	Overdyed Rocket L/SL Top	Cotton	Charcoal
TN20SLS003DBL	Long Sleeve Tee	Overdyed Rocket L/SL Top	Cotton	Dusty Blue
TN20SLS003DR	Long Sleeve Tee	Overdyed Rocket L/SL Top	Cotton	Dusty Rose
TN20SLS003MD	Long Sleeve Tee	Overdyed Rocket L/SL Top	Cotton	Mustard
TN20SLS004BK	Long Sleeve Tee	STWK L/SL Top	Cotton	Black
TN20SLS004EA	Long Sleeve Tee	STWK L/SL Top	Polyester	Neon Orange
TN20SLS004IR	Long Sleeve Tee	STWK L/SL Top	Cotton	Light Bluegrey
TN20SLS005BU	Long Sleeve Tee	Striped L/SL Top	Cotton	Burgundy
TN20SLS005LY	Long Sleeve Tee	Striped L/SL Top	Cotton	Light Navy
TN20SLS005MI	Long Sleeve Tee	Striped L/SL Top	Cotton	Mint
TN20SLS005NA	Long Sleeve Tee	Striped L/SL Top	Cotton	Navy
TN20SLS006NA	Long Sleeve Tee	Script Striped L/SL Top	Cotton	Navy
TN20SLS006OV	Long Sleeve Tee	Script Striped L/SL Top	Cotton	Olive
TN20SLS006SB	Long Sleeve Tee	Script Striped L/SL Top	Cotton	Sky Blue
TN20SLS007BK	Long Sleeve Tee	Acid Washed L/SL Top	Cotton	Black
TN20SLS007BU	Long Sleeve Tee	Acid Washed L/SL Top	Cotton	Burgundy
TN20SLS007DNY	Long Sleeve Tee	Acid Washed L/SL Top	Cotton	Dark Navy
TN20SLS007FR	Long Sleeve Tee	Acid Washed L/SL Top	Cotton	Forest
TN20SLS008BK	Long Sleeve Tee	L-Logo L/SL Top	Cotton	Black
TN20SLS008COR	Long Sleeve Tee	L-Logo L/SL Top	Cotton	Coral
TN20SLS008IL	Long Sleeve Tee	L-Logo L/SL Top	Cotton	Light Olive
TN20SLS008IR	Long Sleeve Tee	L-Logo L/SL Top	Cotton	Light Grey
TN20SLS009BK	Long Sleeve Tee	Striped Tiedye L/SL Top	Cotton	Black
TN20SLS009GN	Long Sleeve Tee	Striped Tiedye L/SL Top	Cotton	Green
TN20SLS009OR	Long Sleeve Tee	Striped Tiedye L/SL Top	Cotton	Orange
TN20SLS010DNY	Long Sleeve Tee	T-Logo Waffle L/SL Top	Cotton	Dark Navy
TN20SLS010GR	Long Sleeve Tee	T-Logo Waffle L/SL Top	Cotton	Grey
TN20SLS010WG	Long Sleeve Tee	T-Logo Waffle L/SL Top	Cotton	Warm Grey
TN20SLS011DNY	Long Sleeve Tee	N Layered L/SL Top	Cotton	Dark Navy
TN20SLS011IV	Long Sleeve Tee	N Layered L/SL Top	Cotton	Dark Olive
TN20SLS011RV	Long Sleeve Tee	N Layered L/SL Top	Cotton	Ivory
TN20SLS999NA	Long Sleeve Tee	EXHIBITION 20 L/SL	Cotton	Burgundy
TN20SMV001NA	Video	SOFT WORK	Film	-
TN20SMV002NA	Video	thisisneverthat® × New Balance® ML827	Film	-
TN20SMV003NA	Video	San Francisco, 2019	Film	-
TN20SMV004NA	Video	thisisneverthat® × G-SHOCK	Film	-
TN20SMV005NA	Video	thisisneverthat® Pokémon Collection	Film	-
TN20SOW001BK	Jacket	PCU Jacket	Cotton, Nylon	Black
TN20SOW001GR	Jacket	PCU Jacket	Cotton, Nylon	Grey
TN20SOW001OV	Jacket	PCU Jacket	Cotton, Nylon	Olive
TN20SOW002BK	Jacket	Sportsman Jacket	Cotton, Polyester	Black
TN20SOW002BL	Jacket	Sportsman Jacket	Cotton, Polyester	Blue
TN20SOW002SO	Jacket	Sportsman Jacket	Cotton, Polyester	Stone

Code	Category	Name	Material(s)	Color(s)
TN20SOW003BK	Jacket	POLARTEC® Fleece Jacket	Polyester, Nylon	Black
TN20SOW003BL	Jacket	POLARTEC® Fleece Jacket	Polyester, Nylon	Blue
TN20SOW003BU	Jacket	POLARTEC® Fleece Jacket	Polyester, Nylon	Burgundy
TN20SOW003IV	Jacket	POLARTEC® Fleece Jacket	Polyester, Nylon	Ivory
TN20SOW004BK	Jacket	POLARTEC® Field Parka	Polyester, Nylon	Black
TN20SOW004BL	Jacket	POLARTEC® Field Parka	Polyester, Nylon	Blue
TN20SOW004MD	Jacket	POLARTEC® Field Parka	Polyester, Nylon	Mustard
TN20SOW006BK	Jacket	Seer Zip Jacket	Cotton	Black
TN20SOW006GN	Jacket	Seer Zip Jacket	Cotton	Green
TN20SOW006PP	Jacket	Seer Zip Jacket	Cotton	Purple
TN20SOW007BK	Jacket	PERTEX® SP Pullover	Polyester, 3M Thinsulate	Black
TN20SOW007BL	Jacket	PERTEX® SP Pullover	Polyester, 3M Thinsulate	Blue
TN20SOW007IR	Jacket	PERTEX® SP Pullover	Polyester, 3M Thinsulate	Light Grey
TN20SOW008BK	Jacket	PERTEX® SP Vest	Polyester, 3M Thinsulate	Black
TN20SOW008OV	Jacket	PERTEX® SP Vest	Polyester, 3M Thinsulate	Olive
TN20SOW008RD	Jacket	PERTEX® SP Vest	Polyester, 3M Thinsulate	Red
TN20SOW009BE	Jacket	Overdyed Oxford Jacket	Cotton	Beige
TN20SOW009CH	Jacket	Overdyed Oxford Jacket	Cotton	Charcoal
TN20SOW009PNT	Jacket	Overdyed Oxford Jacket	Cotton	Paint
TN20SOW011CH	Jacket	Overdyed Work Vest	Cotton	Charcoal
TN20SOW011GN	Jacket	Overdyed Work Vest	Cotton	Green
TN20SOW013BK	Jacket	L-Logo Zip jacket	Cotton	Black
TN20SOW013BL	Jacket	L-Logo Zip jacket	Cotton	Blue
TN20SOW013GR	Jacket	L-Logo Zip jacket	Cotton	Grey
TN20SOW015BK	Jacket	Track Jacket	Polyester	Black
TN20SOW015KG	Jacket	Track Jacket	Polyester	Dark Green
TN20SOW015NA	Jacket	Track Jacket	Polyester	Navy
TN20SPA002BK	Jean	Paneled Jean	Cotton, Polyester	Black
TN20SPA002BL	Jean	Paneled Jean	Cotton	Blue
TN20SPA003BK	Pants	Zip Flight Pant	Cotton, Nylon	Black
TN20SPA003OV	Pants	Zip Flight Pant	Cotton, Nylon	Olive
TN20SPA003TB	Pants	Zip Flight Pant	Cotton, Nylon	Light Blue
TN20SPA004BE	Pants	Work Pant	Cotton	Beige
TN20SPA004NA	Pants	Work Pant	Cotton	Navy
TN20SPA005FL	Pants	Crazy Work Pant	Cotton	Flower
TN20SPA005PNT	Pants	Crazy Work Pant	Cotton	Paint
TN20SPA006CH	Pants	Overdyed Big Pant	Cotton	Charcoal
TN20SPA006GN	Pants	Overdyed Big Pant	Cotton	Green
TN20SPA007BK	Pants	Zip Cargo Pant	Cotton	Black
TN20SPA007ES	Pants	Zip Cargo Pant	Cotton	Sage
TN20SPA008BK	Pants	S.W. Carpenter Pant	Cotton	Black
TN20SPA008MI	Pants	S.W. Carpenter Pant	Cotton	Mint
TN20SPA008NA	Pants	S.W. Carpenter Pant	Cotton	Navy
TN20SPA009BK	Pants	Sportsman Pant	Cotton, Polyester	Black
TN20SPA009BL	Pants	Sportsman Pant	Cotton, Polyester	Blue
TN20SPA009SO	Pants	Sportsman Pant	Cotton, Polyester	Stone
TN20SPA010BK	Pants	DSN Warm Up Pant	Nylon, Polyester	Black
TN20SPA010LM	Pants	DSN Warm Up Pant	Nylon, Polyester	Lemon
TN20SPA010NA	Pants	DSN Warm Up Pant	Nylon, Polyester	Navy
TN20SPA013DNY	Pants	SP-Logo Sweatpant	Cotton	Dark Navy
TN20SPA013FR	Pants	SP-Logo Sweatpant	Cotton	Forest
TN20SPA013LBG	Pants	SP-Logo Sweatpant	Cotton	Light Bluegrey
TN20SPA014BK	Pants	Damaged Sweatpant	Cotton	Black
TN20SPA014FR	Pants	Damaged Sweatpant	Cotton	Forest

Code	Category	Name	Material(s)	Color(s)
TN20SPA014PP	Pants	Damaged Sweatpant	Cotton	Purple
TN20SPA015BK	Pants	Track Pant	Polyester	Black
TN20SPA015KG	Pants	Track Pant	Polyester	Dark Green
TN20SPA015NA	Pants	Track Pant	Polyester	Navy
TN20SPA016BW	Pants	Houndstooth Sweatpant	Cotton, Polyester	Black, White
TN20SPA017PNT	Pants	Painter Pant	Cotton	Paint
TN20SSH001GRB	Shirt	BIG Striped S/S Shirt	Cotton	Green, Brown
TN20SSH001NW	Shirt	BIG Striped S/S Shirt	Cotton	Navy, White
TN20SSH001REP	Shirt	BIG Striped S/S Shirt	Cotton	Red, Pink
TN20SSH002BL	Shirt	DSN-Logo Striped Shirt	Cotton	Blue
TN20SSH002GR	Shirt	DSN-Logo Striped Shirt	Cotton	Grey
TN20SSH002YL	Shirt	DSN-Logo Striped Shirt	Cotton	Yellow
TN20SSH003GN	Shirt	Bleach Check Shirt	Cotton	Green
TN20SSH003OR	Shirt	Bleach Check Shirt	Cotton	Orange
TN20SSH003YL	Shirt	Bleach Check Shirt	Cotton	Yellow
TN20SSH004AC	Shirt	MI-Logo Oxford S/S Shirt	Cotton	Apricot
TN20SSH004BL	Shirt	MI-Logo Oxford S/S Shirt	Cotton	Blue
TN20SSH004WH	Shirt	MI-Logo Oxford S/S Shirt	Cotton	White
TN20SSH005DGY	Shirt	E/T-Logo Ripstop S/S Shirt	Cotton	Deep Grey
TN20SSH005IR	Shirt	E/T-Logo Ripstop S/S Shirt	Cotton	Light Grey
TN20SSH005NA	Shirt	E/T-Logo Ripstop S/S Shirt	Cotton	Navy
TN20SSH006BR	Shirt	80'S CT S/S Shirt	Rayon	Brown
TN20SSH006RV	Shirt	80'S CT S/S Shirt	Rayon	Dark Olive
TN20SSH008BM	Shirt	CS Check S/S Shirt	Cotton	Brown, Green
TN20SSH008KP	Shirt	CS Check S/S Shirt	Cotton	Black, Purple
TN20SSH008YH	Shirt	CS Check S/S Shirt	Cotton	Grey, White
TN20SSO001CH	Pants	Regular Denim Short	Cotton, Rayon, Polyester	Charcoal
TN20SSO001TB	Pants	Regular Denim Short	Cotton, Rayon, Polyester	Light Blue
TN20SSO002BK	Pants	Work Short	Cotton	Black
TN20SSO002GR	Pants	Work Short	Cotton	Grey
TN20SSO002WH	Pants	Work Short	Cotton	White
TN20SSO003BK	Pants	Spaceship Nylon Short	Nylon	Black
TN20SSO003GN	Pants	Spaceship Nylon Short	Nylon	Green
TN20SSO004BK	Pants	PCU Short	Cotton, Nylon	Black
TN20SSO004GR	Pants	PCU Short	Cotton, Nylon	Grey
TN20SSO004OV	Pants	PCU Short	Cotton, Nylon	Olive
TN20SSO005BK	Pants	Zip Jogging Short	Nylon	Black
TN20SSO005BL	Pants	Zip Jogging Short	Nylon	Blue
TN20SSO005FR	Pants	Zip Jogging Short	Nylon	Forest
TN20SSO006BK	Pants	M65 Cargo Short	Cotton	Black
TN20SSO006BL	Pants	M65 Cargo Short	Cotton	Blue
TN20SSO007BE	Pants	Nylon Sport Short	Nylon	Beige
TN20SSO007BK	Pants	Nylon Sport Short	Nylon	Black
TN20SSO007IM	Pants	Nylon Sport Short	Nylon	Lime
TN20SSO007OV	Pants	Nylon Sport Short	Nylon	Olive
TN20SSO008BE	Pants	DSN Hiking Short	Nylon	Beige
TN20SSO008BK	Pants	DSN Hiking Short	Nylon	Black
TN20SSO008BL	Pants	DSN Hiking Short	Nylon	Blue
TN20SSO009BK	Pants	Seer Short	Cotton	Black
TN20SSO009GN	Pants	Seer Short	Cotton	Green
TN20SSO009PP	Pants	Seer Short	Cotton	Purple
TN20SSO010BE	Pants	Overdyed Short	Cotton	Beige
TN20SSO010CH	Pants	Overdyed Short	Cotton	Charcoal
TN20SSO010RD	Pants	Overdyed Short	Cotton	Red
TN20SSO011BK	Pants	SP-Logo Sweatshort	Cotton	Black

Code	Category	Name	Material(s)	Color(s)
TN20SSO011BU	Pants	SP-Logo Sweatshort	Cotton	Burgundy
TN20SSW001BK	Sweatshirt	ARC-Logo Crewneck	Cotton	Black
TN20SSW001BU	Sweatshirt	ARC-Logo Crewneck	Cotton	Burgundy
TN20SSW001DBG	Sweatshirt	ARC-Logo Crewneck	Cotton	Dark Bluegrey
TN20SSW001IR	Sweatshirt	ARC-Logo Crewneck	Cotton	Light Grey
TN20SSW002BK	Sweatshirt	SP Wappen Crewneck	Cotton	Black
TN20SSW002BU	Sweatshirt	SP Wappen Crewneck	Cotton	Burgundy
TN20SSW002DNY	Sweatshirt	SP Wappen Crewneck	Cotton	Dark Navy
TN20SSW004DNY	Sweatshirt	SOFT WORK Crewneck	Cotton	Dark Navy
TN20SSW004GR	Sweatshirt	SOFT WORK Crewneck	Cotton	Grey
TN20SSW004RD	Sweatshirt	SOFT WORK Crewneck	Cotton	Red
TN20SSW005CH	Sweatshirt	Pigment Script Crewneck	Cotton	Charcoal
TN20SSW005NA	Sweatshirt	Pigment Script Crewneck	Cotton	Navy
TN20SSW005SGN	Sweatshirt	Pigment Script Crewneck	Cotton	Sage Green
TN20SSW006BK	Sweatshirt	Chest Stripe Crewneck	Cotton	Black
TN20SSW006DF	Sweatshirt	Chest Stripe Crewneck	Cotton	Dark Forest
TN20SSW006MD	Sweatshirt	Chest Stripe Crewneck	Cotton	Mustard
TN20SSW007CH	Sweatshirt	NEW ARC Crewneck	Cotton	Charcoal
TN20SSW007DBL	Sweatshirt	NEW ARC Crewneck	Cotton	Dusty Blue
TN20SSW007LV	Sweatshirt	NEW ARC Crewneck	Cotton	Lavender
TN20SSW007MI	Sweatshirt	NEW ARC Crewneck	Cotton	Mint
TN20SSW008BG	Sweatshirt	Tiedye DRAGON Crewneck	Cotton	Blue, Green
TN20SSW008GP	Sweatshirt	Tiedye DRAGON Crewneck	Cotton	Purple, Green
TN20SSW009IA	Sweatshirt	Houndstooth Crewneck	Cotton, Polyurethane	Black, White
TN20STP001BK	Top	C-Logo Half Zip Pullover	Cotton	Black
TN20STP001DF	Top	C-Logo Half Zip Pullover	Cotton	Dark Forest
TN20STP001IV	Top	C-Logo Half Zip Pullover	Cotton	Ivory
TN20STP002BK	Sweatshirt	Sleeveless Sweatshirt	Cotton	Black
TN20STP002GR	Sweatshirt	Sleeveless Sweatshirt	Cotton	Grey
TN20STP003GN	Top	2tone Logo Pullover	Cotton	Green
TN20STP003LY	Top	2tone Logo Pullover	Cotton	Light Navy
TN20STP003VT	Top	2tone Logo Pullover	Cotton	Violet
TN20STP004MD	Top	Jacquard L/SL Jersey Polo	Cotton	Mustard
TN20STP004PK	Top	Jacquard L/SL Jersey Polo	Cotton	Pink
TN20STP006BKO	Top	SP Football Jersey	Polyester	Black, Orange
TN20STP006EN	Top	SP Football Jersey	Polyester	Navy, Beige
TN20STS001BK	Tee	Small T-Logo Tee	Cotton	Black
TN20STS001ER	Tee	Small T-Logo Tee	Polyester	Neon Green
TN20STS001GR	Tee	Small T-Logo Tee	Cotton	Grey
TN20STS001WH	Tee	Small T-Logo Tee	Cotton	White
TN20STS002BK	Tee	SOFT WORK Tee	Cotton	Black
TN20STS002MI	Tee	SOFT WORK Tee	Cotton	Mint
TN20STS002VT	Tee	SOFT WORK Tee	Cotton	Violet
TN20STS002WH	Tee	SOFT WORK Tee	Cotton	White
TN20STS003BK	Tee	Submarine Volcano Tee	Cotton	Black
TN20STS003IL	Tee	Submarine Volcano Tee	Cotton	Light Olive
TN20STS003LY	Tee	Submarine Volcano Tee	Cotton	Light Navy
TN20STS003WH	Tee	Submarine Volcano Tee	Cotton	White
TN20STS004BK	Tee	Palm Tree Tee	Cotton	Black
TN20STS004BL	Tee	Palm Tree Tee	Cotton	Blue
TN20STS004IV	Tee	Palm Tree Tee	Cotton	Ivory
TN20STS004MI	Tee	Palm Tree Tee	Cotton	Mint
TN20STS004WH	Tee	Palm Tree Tee	Cotton	White
TN20STS005BK	Tee	Spaceship Tee	Cotton	Black
TN20STS005EA	Tee	Spaceship Tee	Polyester	Neon Orange

Code	Category	Name	Material(s)	Color(s)

TN20STP001DF TN20SOW003BL TN20SSW001BU TN20SSW005CH TN20SSW004DNY

TN20STP006BKO TN20SLS005BU TN20SOW011GN TN20SOW008RD TN20SSH001GRB TN20SSH004WH

TN20STS018IL TN20STS021MI TN20STS020PK TN20STS016BU TN20SSH005NA

Code	Category	Name	Material(s)	Color(s)
TN20STS005WH	Tee	Spaceship Tee	Cotton	White
TN20STS006BK	Tee	Earth Tee	Cotton	Black
TN20STS006DF	Tee	Earth Tee	Cotton	Dark Forest
TN20STS006WH	Tee	Earth Tee	Cotton	White
TN20STS007BK	Tee	Dragon Tee	Cotton	Black
TN20STS007GR	Tee	Dragon Tee	Cotton	Grey
TN20STS007PP	Tee	Dragon Tee	Cotton	Purple
TN20STS007WH	Tee	Dragon Tee	Cotton	White
TN20STS008BK	Tee	3D Logo Tee	Cotton	Black
TN20STS008GN	Tee	3D Logo Tee	Cotton	Green
TN20STS008VT	Tee	3D Logo Tee	Cotton	Violet
TN20STS008WH	Tee	3D Logo Tee	Cotton	White
TN20STS009LBG	Tee	CNP-Logo Tee	Cotton	Light Bluegrey
TN20STS009LY	Tee	CNP-Logo Tee	Cotton	Light Navy
TN20STS009RV	Tee	CNP-Logo Tee	Cotton	Dark Olive
TN20STS009WH	Tee	CNP-Logo Tee	Cotton	White
TN20STS010BK	Tee	DSN-Logo Tee	Cotton	Black
TN20STS010BU	Tee	DSN-Logo Tee	Cotton	Burgundy
TN20STS010DGN	Tee	DSN-Logo Tee	Cotton	Dark Bluegreen
TN20STS010DNY	Tee	DSN-Logo Tee	Cotton	Dark Navy
TN20STS010WH	Tee	DSN-Logo Tee	Cotton	White
TN20STS011BK	Tee	DESIGN Pocket Tee	Cotton	Black
TN20STS011DNY	Tee	DESIGN Pocket Tee	Cotton	Dark Navy
TN20STS011WH	Tee	DESIGN Pocket Tee	Cotton	White
TN20STS012BL	Tee	TNT S.W. Tee	Cotton	Blue

Code	Category	Name	Material(s)	Color(s)
TN20STS012GN	Tee	TNT S.W. Tee	Cotton	Green
TN20STS012RD	Tee	TNT S.W. Tee	Cotton	Red
TN20STS013DGN	Tee	Overlapped S.W. Tee	Cotton	Dark Bluegreen
TN20STS013GR	Tee	Overlapped S.W. Tee	Cotton	Grey
TN20STS013WH	Tee	Overlapped S.W. Tee	Cotton	White
TN20STS015AR	Tee	SP-Logo Striped Tee	Cotton	Navy, Grey
TN20STS015BKO	Tee	SP-Logo Striped Tee	Cotton	Black, Orange
TN20STS015KR	Tee	SP-Logo Striped Tee	Cotton	Black, Green
TN20STS016BK	Tee	3Line Striped Tee	Cotton	Black
TN20STS016BU	Tee	3Line Striped Tee	Cotton	Burgundy
TN20STS016MD	Tee	3Line Striped Tee	Cotton	Mustard
TN20STS017BK	Tee	Logo Jacquard Tee	Cotton	Black
TN20STS017MD	Tee	Logo Jacquard Tee	Cotton	Mustard
TN20STS017NA	Tee	Logo Jacquard Tee	Cotton	Navy
TN20STS017PK	Tee	Logo Jacquard Tee	Cotton	Pink
TN20STS018BL	Tee	Overdyed INTL. Logo Tee	Cotton	Blue
TN20STS018CH	Tee	Overdyed INTL. Logo Tee	Cotton	Charcoal
TN20STS018IL	Tee	Overdyed INTL. Logo Tee	Cotton	Light Olive
TN20STS018RD	Tee	Overdyed INTL. Logo Tee	Cotton	Red
TN20STS019CH	Tee	Reverse Overdyed Tee	Cotton	Charcoal
TN20STS019NA	Tee	Reverse Overdyed Tee	Cotton	Navy
TN20STS019YL	Tee	Reverse Overdyed Tee	Cotton	Yellow
TN20STS020BK	Tee	Acid Washed Tee	Cotton	Black
TN20STS020GN	Tee	Acid Washed Tee	Cotton	Green
TN20STS020PK	Tee	Acid Washed Tee	Cotton	Pink
TN20STS020PP	Tee	Acid Washed Tee	Cotton	Purple
TN20STS021BL	Tee	Tiedye Tee	Cotton	Blue
TN20STS021MI	Tee	Tiedye Tee	Cotton	Mint
TN20STS021YL	Tee	Tiedye Tee	Cotton	Yellow
TN20STS022DNY	Tee	Cracked T-Logo Tee	Cotton	Dark Navy
TN20STS022PI	Tee	Cracked T-Logo Tee	Cotton	Pistachio
TN20STS022WH	Tee	Cracked T-Logo Tee	Cotton	White
TN20STS023BK	Tee	SP-Logo Tee	Cotton	Black
TN20STS023FR	Tee	SP-Logo Tee	Cotton	Forest
TN20STS023RD	Tee	SP-Logo Tee	Cotton	Red
TN20STS023WH	Tee	SP-Logo Tee	Cotton	White
TN20STS024BK	Tee	Pocket Tee	Cotton	Black
TN20STS024BU	Tee	Pocket Tee	Cottoo	Burgundy
TN20STS024DBG	Tee	Pocket Tee	Cotton	Dark Bluegrey
TN20STS024FR	Tee	Pocket Tee	Cotton	Forest
TN20STS025CH	Tee	Cracked T-Logo Tee	Cotton	Charcoal
TN20STS025RU	Tee	Cracked T-Logo Tee	Cotton	Dark Blue
TN20STS999BU	Tee	EXHIBITION 20 Tee	Cotton	Burgundy

TN20SSO001TB TN20SSO006BL TN20SSO007IM TN20SSO003BK TN20SSO009GN

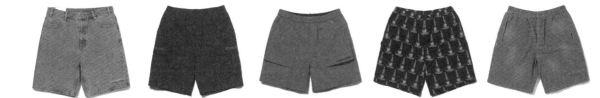

Code	Category	Name	Material(s)	Color(s)
TN20STS999NA	Tee	EXHIBITION 20 Tee	Cotton	Navy
TNCOCSW002DB	Sweatshirt	T-Logo Crewneck	Cotton	Dark Blue, Green
TNCOCTS002LBG	Tee	T-Logo Tee	Cotton	Light Blue, Grey
TNCOCTS002YL	Tee	T-Logo Tee	Cotton	Yellow
WR20SPT001NA	Printed Matter	thisisneverthisisneverthat	Paper	-
WR20SPT002NA	Website	thisisneverthisisneverthat.com	HTML, CSS, JavaScript, PHP	-
WR20SPT003NA	Text	Either/Or	Letter, Image	-
WR20SPT004NA	Text	thisisneverthisisneverthat	Letter, Image	-
WR20SPT005NA	Text	Street Fashion and Youth Culture: Clothes Depend on How People Wear Them	Letter, Image	-

WR20SPT002NA

Code	Category	Name	Material(s)	Color(s)
APCOCAC001NNE	Accessory	TNT × APFR Room Mist Spray	Water, Ethanol, Fragrance, Surfactant	White
APCOCAC002BW	Accessory	TNT × APFR Paper Tag	Paper	White, Black
NB19FAC001BE	Accessory	NB TNT PT Fleece Gloves	Polyester	Beige
NB19FAC001BK	Accessory	NB TNT PT Fleece Gloves	Polyester	Black
NB19FAC001KH	Accessory	NB TNT PT Fleece Gloves	Polyester	Khaki
NB19FAC002BK	Socks	NB TNT PT Socks	Cotton	Black
NB19FAC002GR	Socks	NB TNT PT Socks	Cotton	Grey
NB19FFW001BE	Shoes	M997TNV	Suede Mesh, Rubber	Beige
NB19FHW001BE	Hat	NB TNT PT Fleece Hat	Polyester	Beige
NB19FHW001BK	Hat	NB TNT PT Fleece Hat	Polyester	Black
NB19FHW001KH	Hat	NB TNT PT Fleece Hat	Polyester	Khaki
NB19FLS001BE	Long Sleeve Tee	NB TNT PT L/S	Cotton	Beige
NB19FLS001BK	Long Sleeve Tee	NB TNT PT L/S	Cotton	Black
NB19FLS001IR	Long Sleeve Tee	NB TNT PT L/S	Cotton	Light Grey
NB19FLS001KH	Long Sleeve Tee	NB TNT PT L/S	Cotton	Khaki
NB19FLS001WH	Long Sleeve Tee	NB TNT PT L/S	Cotton	White
NB19FOW001BE	Jacket	NB TNT PT Fleece Jacket	Polyester, Nylon	Beige
NB19FOW001BK	Jacket	NB TNT PT Fleece Jacket	Polyester, Nylon	Black
NB19FOW001KH	Jacket	NB TNT PT Fleece Jacket	Polyester, Nylon	Khaki
NB19FPA001BE	Pants	NB TNT PT Fleece Pant	Polyester, Nylon	Beige
NB19FPA001BK	Pants	NB TNT PT Fleece Pant	Polyester, Nylon	Black
NB19FPA001KH	Pants	NB TNT PT Fleece Pant	Polyester, Nylon	Khaki
NE19FBA001BK	Bag	URBAN PACK TNT	Nylon	Black
NE19FBA002BK	Bag	SACOCHE TNT	Nylon	Black
NE19FHW001BK	Hat	920UNST TNT	Cotton	Black
NE19FHW002BK	Hat	920UNST MLB × TNT NEYYAN	Cotton	Black
NE19FHW003BK	Hat	920UNST MLB × TNT LOSDOD	Cotton	Black
NE19FHW004BK	Hat	KNIT CUFF MLB × TNT NEYYAN	Cotton	Black
NE19FHW005BK	Hat	KNIT CUFF MLB × TNT LOSDOD	Cotton	Black
TA19FOW001BK	Jacket	TNT × TAION CREW NECK W-Zip DOWN VEST	Nylon, Polyester, Down, Feather	Black
TA19FOW001KH	Jacket	TNT × TAION CREW NECK W-Zip DOWN VEST	Nylon, Polyester, Down, Feather	Khaki
TN19FAC001SR	Accessory	SP-Logo Klean Kanteen®	Stainless Steel	Silver
TN19FAC002BK	Accessory	GORE-TEX® INFINIUM™ Gloves	Nylon, Spandex, Polyester, Polyurethane	Black
TN19FAC003BK	Underwear	SP-Logo Boxer Briefs	Cotton	Black
TN19FAC003GR	Underwear	SP-Logo Boxer Briefs	Cotton	Grey
TN19FAC003KH	Underwear	SP-Logo Boxer Briefs	Cotton	Khaki
TN19FAC004BK	Accessory	SP-Logo Web Belt	Nylon	Black
TN19FAC007BL	Accessory	SP-Logo Towel	Cotton, Bamboo	Blue
TN19FAC007GR	Accessory	SP-Logo Towel	Cotton, Bamboo	Grey
TN19FAC009BK	Socks	Striped Socks	Cotton	Black
TN19FAC009WH	Socks	Striped Socks	Cotton	White
TN19FAC010BK	Socks	Tiedye Socks	Cotton, Spandex, Polyester	Black
TN19FAC010MD	Socks	Tiedye Socks	Cotton, Spandex, Polyester	Mustard
TN19FAC010MI	Socks	Tiedye Socks	Cotton, Spandex, Polyester	Mint
TN19FAC010NA	Socks	Tiedye Socks	Cotton, Spandex, Polyester	Navy
TN19FAC012BK	Accessory	Klean Kanteen® Insulated Wide 16oz	Stainless Steel	Black
TN19FAC013BK	Accessory	C-Logo Document Folder (6 Pack)	Polypropylene	Black
TN19FAC014SR	Accessory	INTL. Logo Ring	925 Silver	Silver
TN19FAC015SR	Accessory	LION 2010 Necklace	925 Silver	Silver
TN19FAC016SR	Accessory	SP-Logo Necklace	925 Silver	Silver
TN19FAC017SR	Accessory	LION Necklace	925 Silver	Silver

Code	Category	Name	Material(s)	Color(s)
TN19FAC021BR	Accessory	WHO YA Bandana	Cotton	Brown
TN19FAC021NA	Accessory	WHO YA Bandana	Cotton	Navy
TN19FAC023NNE	Accessory	School Bus Patch Set	Cotton	None
TN19FAC024NNE	Accessory	Crossover Patch Set	Cotton	None
TN19FAC028BK	Accessory	T-Logo Pin	Brass	Black
TN19FAC029BK	Accessory	WHO YA Pin	Brass	Black
TN19FAC030BK	Accessory	GOING TO CLASS Pin	Brass	Black
TN19FAC031BK	Accessory	TOWN Pin	Brass	Black
TN19FAC032BK	Accessory	C-Logo Pin	Brass	Black
TN19FAC033WH	Accessory	Skater Key Tag	Silicone	White
TN19FAC034NA	Accessory	NEW SPORT Key Tag	Silicone	Navy
TN19FAC035BK	Accessory	Neponsit, NY 11695	Paper	Black
TN19FBA001BK	Bag	CORDURA® 750D Nylon Shoulder Bag	Nylon, Polyester	Black
TN19FBA001GR	Bag	CORDURA® 750D Nylon Shoulder Bag	Nylon, Polyester	Grey
TN19FBA003BK	Bag	CORDURA® 750D Nylon Messenger Bag	Nylon, Polyester	Black
TN19FBA003GR	Bag	CORDURA® 750D Nylon Messenger Bag	Nylon, Polyester	Grey
TN19FBA004BK	Bag	CORDURA® 1000D Nylon Traveler Backpack	Nylon, Polyester	Black
TN19FBA004GR	Bag	CORDURA® 1000D Nylon Traveler Backpack	Nylon, Polyester	Grey
TN19FBA005BK	Bag	CORDURA® 750D Nylon 2P Backpack	Nylon, Polyester	Black
TN19FBA005GR	Bag	CORDURA® 750D Nylon 2P Backpack	Nylon, Polyester	Grey

TN19FAC035BK

Neponsit, NY 11695
June 22nd – 25th, 2019

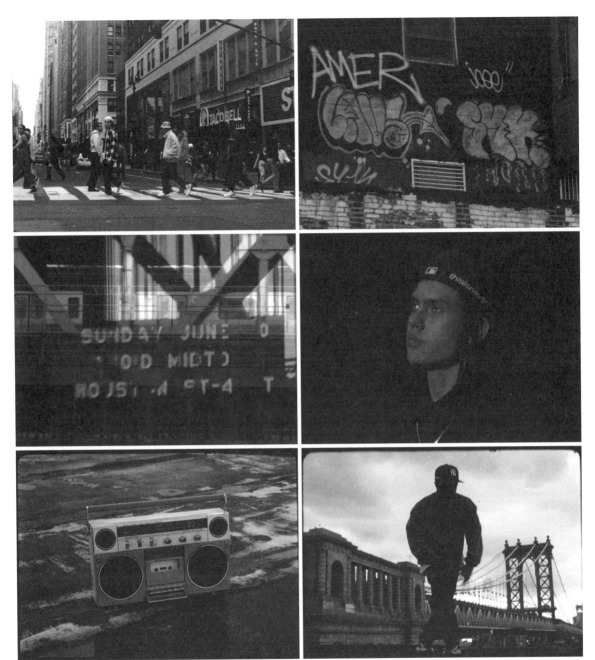

TN19FMV001NA

Code	Category	Name	Material(s)	Color(s)
TN19FBA006BK	Accessory	CORDURA® 750D Nylon Wallet	Nylon, Polyester	Black
TN19FBA006GR	Accessory	CORDURA® 750D Nylon Wallet	Nylon, Polyester	Grey
TN19FBA007BK	Bag	CORDURA® 750D&1000D Nylon BOP	Nylon, Polyester	Black
TN19FBA007GR	Bag	CORDURA® 750D&1000D Nylon BOP	Nylon, Polyester	Grey
TN19FHS001BG	Sweatshirt	POLARTEC Fleece Hoodie	Polyester	Blue Green
TN19FHS001BK	Sweatshirt	POLARTEC Fleece Hoodie	Polyester	Black
TN19FHS001BR	Sweatshirt	POLARTEC Fleece Hoodie	Polyester	Brown
TN19FHS001OV	Sweatshirt	POLARTEC Fleece Hoodie	Polyester	Olive
TN19FHS002BE	Sweatshirt	E/T-Logo Zipup Sweat	Cotton	Beige
TN19FHS002BG	Sweatshirt	E/T-Logo Zipup Sweat	Cotton	Blue Green
TN19FHS002CH	Sweatshirt	E/T-Logo Zipup Sweat	Cotton	Charcoal
TN19FHS002OV	Sweatshirt	E/T-Logo Zipup Sweat	Cotton	Olive
TN19FHS003BK	Sweatshirt	C-Logo Zipup Sweat	Cotton	Black
TN19FHS003BR	Sweatshirt	C-Logo Zipup Sweat	Cotton	Brown
TN19FHS003IR	Sweatshirt	C-Logo Zipup Sweat	Cotton	Light Grey
TN19FHS003LM	Sweatshirt	C-Logo Zipup Sweat	Cotton	Lemon
TN19FHS005BK	Sweatshirt	TOWN Hooded Sweatshirt	Cotton	Black
TN19FHS005CH	Sweatshirt	TOWN Hooded Sweatshirt	Cotton	Charcoal
TN19FHS005PP	Sweatshirt	TOWN Hooded Sweatshirt	Cotton	Purple
TN19FHS006BK	Sweatshirt	SP-3 Hooded Sweatshirt	Cotton	Black
TN19FHS006OV	Sweatshirt	SP-3 Hooded Sweatshirt	Cotton	Olive
TN19FHS006RD	Sweatshirt	SP-3 Hooded Sweatshirt	Cotton	Red
TN19FHS006RU	Sweatshirt	SP-3 Hooded Sweatshirt	Cotton	Dark Blue
TN19FHS006SB	Sweatshirt	SP-3 Hooded Sweatshirt	Cotton	Sky Blue
TN19FHS007BK	Sweatshirt	Marker Script Logo Hooded Sweatshirt	Cotton	Black
TN19FHS007NA	Sweatshirt	Marker Script Logo Hooded Sweatshirt	Cotton	Navy
TN19FHS007OV	Sweatshirt	Marker Script Logo Hooded Sweatshirt	Cotton	Olive
TN19FHS008IR	Sweatshirt	NEW SPORT Hooded Sweatshirt	Cotton	Light Grey
TN19FHS008NA	Sweatshirt	NEW SPORT Hooded Sweatshirt	Cotton	Navy
TN19FHS008RV	Sweatshirt	NEW SPORT Hooded Sweatshirt	Cotton	Dark Olive
TN19FHS009BK	Sweatshirt	INTL. Logo Hooded Sweatshirt	Cotton	Black
TN19FHS009BU	Sweatshirt	INTL. Logo Hooded Sweatshirt	Cotton	Burgundy
TN19FHS009WG	Sweatshirt	INTL. Logo Hooded Sweatshirt	Cotton	Warm Grey
TN19FHS010BE	Sweatshirt	WC Bus Hooded Sweatshirt	Cotton	Beige
TN19FHS010GR	Sweatshirt	WC Bus Hooded Sweatshirt	Cotton	Grey
TN19FHS010PP	Sweatshirt	WC Bus Hooded Sweatshirt	Cotton	Purple
TN19FHS010TB	Sweatshirt	WC Bus Hooded Sweatshirt	Cotton	Light Blue
TN19FHS011BK	Sweatshirt	Tiedye Hooded Sweatshirt	Cotton	Black
TN19FHS011GN	Sweatshirt	Tiedye Hooded Sweatshirt	Cotton	Green
TN19FHS011RD	Sweatshirt	Tiedye Hooded Sweatshirt	Cotton	Red
TN19FHS012BU	Sweatshirt	ARC-Logo Overdyed Hooded Sweatshirt	Cotton	Burgundy
TN19FHS012CH	Sweatshirt	ARC-Logo Overdyed Hooded Sweatshirt	Cotton	Charcoal
TN19FHS012IL	Sweatshirt	ARC-Logo Overdyed Hooded Sweatshirt	Cotton	Light Olive

TN19FTP001BU TN19FTP001GR TN19FOW006BK TN19FOW021RD TN19FSH008MI

 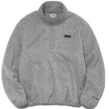 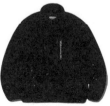 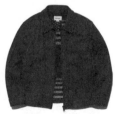 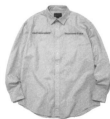

Code	Category	Name	Material(s)	Color(s)

| Code | Category | Name | Material(s) | Color(s) |

TN19FOW009IV TN19FOW005BK TN19FOW005KH TN19FOW004BK TN19FOW004BL

Code	Category	Name	Material(s)	Color(s)
TN19FHS012NA	Sweatshirt	ARC-Logo Overdyed Hooded Sweatshirt	Cotton	Navy
TN19FHW001BK	Hat	GORE-TEX® INFINIUM™ Explorer Hat	Nylon, Elastane	Black
TN19FHW002BK	Hat	SP-Logo Cap	Cotton	Black
TN19FHW002BL	Hat	SP-Logo Cap	Cotton	Blue
TN19FHW002GN	Hat	SP-Logo Cap	Cotton	Green
TN19FHW002GR	Hat	SP-Logo Cap	Cotton	Grey
TN19FHW003BR	Hat	E/T-Logo Overdyed Cap	Cotton	Brown
TN19FHW003CH	Hat	E/T-Logo Overdyed Cap	Cotton	Charcoal
TN19FHW003PK	Hat	E/T-Logo Overdyed Cap	Cotton	Pink
TN19FHW004IDG	Hat	DSN-Logo Cap	Cotton	Indigo
TN19FHW004ML	Hat	DSN-Logo Cap	Cotton	Mid Blue
TN19FHW005BK	Hat	SP-Logo Camp Cap	Cotton	Black
TN19FHW005BL	Hat	SP-Logo Camp Cap	Cotton	Blue
TN19FHW005OV	Hat	SP-Logo Camp Cap	Cotton	Olive
TN19FHW005YL	Hat	SP-Logo Camp Cap	Cotton	Yellow
TN19FHW006BG	Hat	Fleece Earflap Cap	Polyester	Blue Green
TN19FHW006BK	Hat	Fleece Earflap Cap	Polyester	Black
TN19FHW006RD	Hat	Fleece Earflap Cap	Polyester	Red
TN19FHW008BK	Hat	SP Bucket Hat	Cotton	Black
TN19FHW008EO	Hat	SP Bucket Hat	Cotton	Purple Camo
TN19FHW008TO	Hat	SP Bucket Hat	Cotton	Desert Camo
TN19FHW009BK	Hat	SP Ear Flap Beanie	Cotton	Black
TN19FHW009BU	Hat	SP Ear Flap Beanie	Cotton	Burgundy
TN19FHW009NA	Hat	SP Ear Flap Beanie	Cotton	Navy
TN19FHW010BK	Hat	Stadium Pom Beanie	Cotton	Black
TN19FHW010GN	Hat	Stadium Pom Beanie	Cotton	Green
TN19FHW010NA	Hat	Stadium Pom Beanie	Cotton	Navy
TN19FHW011BK	Hat	Beanie Visor Cap	Cotton	Black
TN19FHW011OV	Hat	Beanie Visor Cap	Cotton	Olive
TN19FHW012BK	Hat	Newsboy Hat	Cotton	Black
TN19FHW012WH	Hat	Newsboy Hat	Cotton	White
TN19FHW013BK	Hat	HSP-Logo Beanie	Cotton	Black
TN19FHW013MI	Hat	HSP-Logo Beanie	Cotton	Mint
TN19FHW013NA	Hat	HSP-Logo Beanie	Cotton	Navy
TN19FHW014BK	Hat	Rubber C-Logo Short Beanie	Cotton	Black
TN19FHW014OV	Hat	Rubber C-Logo Short Beanie	Cotton	Olive
TN19FHW014YL	Hat	Rubber C-Logo Short Beanie	Cotton	Yellow
TN19FHW015BK	Hat	GOING TO CLASS Cap	Cotton	Black
TN19FHW015KH	Hat	GOING TO CLASS Cap	Cotton	Khaki
TN19FHW015RD	Hat	GOING TO CLASS Cap	Cotton	Red
TN19FHW016GN	Hat	ARC-Logo Cap	Cotton	Green
TN19FHW016NA	Hat	ARC-Logo Cap	Cotton	Navy
TN19FHW017BK	Hat	SP Fleece Balaclava	Polyester	Black

Code	Category	Name	Material(s)	Color(s)
TN19FHW017OR	Hat	SP Fleece Balaclava	Polyester	Orange
TN19FKW001BK	Top	Argyle Shirt Cardigan	Acrylic, Polyester	Black
TN19FKW001NA	Top	Argyle Shirt Cardigan	Acrylic, Polyester	Navy
TN19FKW001OV	Top	Argyle Shirt Cardigan	Acrylic, Polyester	Olive
TN19FKW003BG	Top	Overdyed Knit Sweater	Cotton	Blue Green
TN19FKW003CH	Top	Overdyed Knit Sweater	Cotton	Charcoal
TN19FKW004BE	Top	T-Logo Knit Sweater	Cotton	Beige
TN19FKW004BK	Top	T-Logo Knit Sweater	Cotton	Black
TN19FKW004OR	Top	T-Logo Knit Sweater	Cotton	Orange
TN19FKW006BR	Top	E/T-Logo Knit Polo	Cotton	Brown
TN19FKW006GR	Top	E/T-Logo Knit Polo	Cotton	Grey
TN19FKW006NA	Top	E/T-Logo Knit Polo	Cotton	Navy
TN19FKW007BG	Top	INTL. Logo Overdyed Polo	Cotton	Blue Green
TN19FKW007CH	Top	INTL. Logo Overdyed Polo	Cotton	Charcoal
TN19FKW007RD	Top	INTL. Logo Overdyed Polo	Cotton	Red
TN19FKW008BK	Top	Jacquard Jersey Polo	Cotton	Black
TN19FKW008NA	Top	Jacquard Jersey Polo	Cotton	Navy
TN19FKW008PK	Top	Jacquard Jersey Polo	Cotton	Pink
TN19FKW009BE	Top	L-Logo Striped Jersey Polo	Cotton	Beige
TN19FKW009BU	Top	L-Logo Striped Jersey Polo	Cotton	Burgundy
TN19FKW009CH	Top	L-Logo Striped Jersey Polo	Cotton	Charcoal
TN19FLS002BK	Long Sleeve Tee	Rubber C-Logo L/SL Top	Cotton	Black
TN19FLS002BR	Long Sleeve Tee	Rubber C-Logo L/SL Top	Cotton	Brown
TN19FLS002OV	Long Sleeve Tee	Rubber C-Logo L/SL Top	Cotton	Olive
TN19FLS003BG	Long Sleeve Tee	Marker Script Logo L/SL Top	Cotton	Blue Green
TN19FLS003BK	Long Sleeve Tee	Marker Script Logo L/SL Top	Cotton	Black
TN19FLS003GR	Long Sleeve Tee	Marker Script Logo L/SL Top	Cotton	Grey
TN19FLS003NA	Long Sleeve Tee	Marker Script Logo L/SL Top	Cotton	Navy
TN19FLS003RV	Long Sleeve Tee	Marker Script Logo L/SL Top	Cotton	Dark Olive
TN19FLS004BK	Long Sleeve Tee	Skater L/SL Top	Cotton	Black
TN19FLS004IL	Long Sleeve Tee	Skater L/SL Top	Cotton	Light Olive
TN19FLS004WH	Long Sleeve Tee	Skater L/SL Top	Cotton	White
TN19FLS005BG	Long Sleeve Tee	Overdyed Pocket L/SL Top	Cotton	Blue Green
TN19FLS005CH	Long Sleeve Tee	Overdyed Pocket L/SL Top	Cotton	Charcoal
TN19FLS005MI	Long Sleeve Tee	Overdyed Pocket L/SL Top	Cotton	Mint
TN19FLS005NA	Long Sleeve Tee	Overdyed Pocket L/SL Top	Cotton	Navy
TN19FLS006CV	Long Sleeve Tee	Rubber SP Striped L/SL Top	Cotton	Black, Olive
TN19FLS006KD	Long Sleeve Tee	Rubber SP Striped L/SL Top	Cotton	Black, Red
TN19FLS006VL	Long Sleeve Tee	Rubber SP Striped L/SL Top	Cotton	Navy, Olive
TN19FLS007NA	Long Sleeve Tee	N-Tiedye L/SL Top	Cotton	Navy
TN19FLS007PP	Long Sleeve Tee	N-Tiedye L/SL Top	Cotton	Purple
TN19FLS008CH	Long Sleeve Tee	TWO BOYS Overdyed L/SL Top	Cotton	Charcoal
TN19FLS008MI	Long Sleeve Tee	TWO BOYS Overdyed L/SL Top	Cotton	Mint

TN19FHS011RD TN19FHS011GN TN19FHS011BK TN19FHS001BG TN19FHS005CH

Code	Category	Name	Material(s)	Color(s)
TN19FLS008RD	Long Sleeve Tee	TWO BOYS Overdyed L/SL Top	Cotton	Red
TN19FLS010BK	Long Sleeve Tee	NEVER L/SL Top	Cotton	Black
TN19FLS010CH	Long Sleeve Tee	NEVER L/SL Top	Cotton	Charcoal
TN19FLS010IR	Long Sleeve Tee	NEVER L/SL Top	Cotton	Light Grey
TN19FLS010WH	Long Sleeve Tee	NEVER L/SL Top	Cotton	White
TN19FLS011BK	Long Sleeve Tee	T-Logo Waffle L/SL Top	Cotton	Black
TN19FLS011GR	Long Sleeve Tee	T-Logo Waffle L/SL Top	Cotton	Grey
TN19FLS011WG	Long Sleeve Tee	T-Logo Waffle L/SL Top	Cotton	Warm Grey
TN19FMV001NA	Video	PREP-SCHOOL GANGSTERS	Film	-
TN19FMV002NA	Video	thisisneverthat® × New Balance®: PFU II	Film	-
TN19FMV003NA	Video	GORE-TEX INFINIUM™ × thisisneverthat®	Film	-
TN19FOW001BK	Jacket	SP-INTL. Sport Down Jacket	Nylon, Down, Feather	Black
TN19FOW001GN	Jacket	SP-INTL. Sport Down Jacket	Nylon, Down, Feather	Green
TN19FOW001YL	Jacket	SP-INTL. Sport Down Jacket	Nylon, Down, Feather	Yellow
TN19FOW003BK	Jacket	Explorer Down Parka	Nylon, Polyester, Down, Feather	Black
TN19FOW003OR	Jacket	Explorer Down Parka	Nylon, Polyester, Down, Feather	Orange
TN19FOW004AC	Jacket	HSP Hooded Down Jacket	Polyester, Down, Feather	Apricot
TN19FOW004BK	Jacket	HSP Hooded Down Jacket	Polyester, Down, Feather	Black
TN19FOW004BL	Jacket	HSP Hooded Down Jacket	Polyester, Down, Feather	Blue
TN19FOW005BK	Jacket	ECWCS Parka	Polyester, Nylon, 3M Thinsulate	Black
TN19FOW005KH	Jacket	ECWCS Parka	Polyester, Nylon, 3M Thinsulate	Khaki
TN19FOW005OV	Jacket	ECWCS Parka	Polyester, Nylon, 3M Thinsulate	Olive
TN19FOW006BK	Jacket	SP Boa Fleece Jacket	Polyester, Acrylic, Nylon	Black
TN19FOW006IV	Jacket	SP Boa Fleece Jacket	Polyester, Acrylic, Nylon	Ivory
TN19FOW006PP	Jacket	SP Boa Fleece Jacket	Polyester, Acrylic, Nylon	Purple
TN19FOW007BK	Jacket	POLARTEC Fleece Jacket	Polyester	Black
TN19FOW007FR	Jacket	POLARTEC Fleece Jacket	Polyester	Forest
TN19FOW007RD	Jacket	POLARTEC Fleece Jacket	Polyester	Red
TN19FOW008BE	Jacket	Oversized Fleece Jacket	Polyester	Beige
TN19FOW008BK	Jacket	Oversized Fleece Jacket	Polyester	Black
TN19FOW008RD	Jacket	Oversized Fleece Jacket	Polyester	Red
TN19FOW009BK	Jacket	Hooded Boa Fleece Jacket	Polyester, Acrylic, Nylon	Black
TN19FOW009IV	Jacket	Hooded Boa Fleece Jacket	Polyester, Acrylic, Nylon	Ivory
TN19FOW009NA	Jacket	Hooded Boa Fleece Jacket	Polyester, Acrylic, Nylon	Navy
TN19FOW010BK	Jacket	C-Logo Boa Fleece Vest	Polyester, Acrylic, Nylon	Black
TN19FOW010BL	Jacket	C-Logo Boa Fleece Vest	Polyester, Acrylic, Nylon	Blue
TN19FOW010OR	Jacket	C-Logo Boa Fleece Vest	Polyester, Acrylic, Nylon	Orange
TN19FOW011BK	Jacket	Driver Jacket	Cotton, Nylon, Polyester	Black
TN19FOW011BU	Jacket	Driver Jacket	Cotton, Nylon, Polyester	Burgundy
TN19FOW011GR	Jacket	Driver Jacket	Cotton, Nylon, Polyester	Grey
TN19FOW012BK	Jacket	Overdyed M51 Parka	Cotton, Nylon	Black
TN19FOW012OV	Jacket	Overdyed M51 Parka	Cotton, Nylon	Olive
TN19FOW013BK	Jacket	Work Jacket	Cotton, Polyester	Black
TN19FOW013FR	Jacket	Work Jacket	Cotton, Polyester	Forest
TN19FOW014BK	Jacket	Corduroy Zip Jacket	Cotton, Polyester	Black
TN19FOW014BR	Jacket	Corduroy Zip Jacket	Cotton, Polyester	Brown
TN19FOW014FR	Jacket	Corduroy Zip Jacket	Cotton, Polyester	Forest
TN19FOW015NA	Jacket	GORE-TEX® INFINIUM™ Explorer Down Parka	Polyester, Down, Feather	Navy
TN19FOW016FR	Jacket	GORE-TEX® INFINIUM™ Explorer jacket	Polyester, Nylon	Forest
TN19FOW016GR	Jacket	GORE-TEX® INFINIUM™ Explorer jacket	Polyester, Nylon	Grey

Code	Category	Name	Material(s)	Color(s)
TN19FOW017CH	Jacket	GORE-TEX® INFINIUM™ Explorer Fleece Jacket	Polyester, Acrylic, Nylon	Charcoal
TN19FOW017ES	Jacket	GORE-TEX® INFINIUM™ Explorer Fleece Jacket	Polyester, Acrylic, Nylon	Sage
TN19FOW018BK	Jacket	GORE-TEX® INFINIUM™ Explorer Vest	Nylon, Elastane	Black
TN19FOW019BK	Jacket	Wool Over Coat	Wool, Nylon, Polyester	Black
TN19FOW019NA	Jacket	Wool Over Coat	Wool, Nylon, Polyester	Navy
TN19FOW020BK	Jacket	LION 2010 Varsity Jacket	Polyester, Wool, Cow Leather	Black
TN19FOW020NA	Jacket	LION 2010 Varsity Jacket	Polyester, Wool, Cow Leather	Navy
TN19FOW021BK	Jacket	Leather Motorcycle Jacket	Cow Leather, Polyester	Black
TN19FOW021RD	Jacket	Leather Motorcycle Jacket	Cow Leather, Polyester	Red
TN19FOW022BE	Jacket	HSP Track Jacket	Polyester	Beige
TN19FOW022BK	Jacket	HSP Track Jacket	Polyester	Black
TN19FOW022OV	Jacket	HSP Track Jacket	Polyester	Olive
TN19FOW023BK	Jacket	American Flag Work Jacket	Cotton, Polyester	Black
TN19FPA001FR	Pants	GORE-TEX® INFINIUM™ Explorer Pant	Polyester, Nylon	Forest
TN19FPA001GR	Pants	GORE-TEX® INFINIUM™ Explorer Pant	Polyester, Nylon	Grey
TN19FPA002BK	Jean	Regular Jean	Cotton, Polyester	Black
TN19FPA002IDG	Jean	Regular Jean	Cotton, Rayon, Polyester	Indigo
TN19FPA002ML	Jean	Regular Jean	Cotton, Rayon, Polyester	Mid Blue
TN19FPA002TB	Jean	Regular Jean	Cotton, Rayon, Polyester	Light Blue
TN19FPA003BK	Jean	Big Jean	Cotton, Polyester	Black
TN19FPA003ML	Jean	Big Jean	Cotton, Rayon, Polyester	Mid Blue
TN19FPA003TB	Jean	Big Jean	Cotton, Rayon, Polyester	Light Blue
TN19FPA005BK	Pants	Corduroy Easy Pant	Cotton	Black
TN19FPA005BR	Pants	Corduroy Easy Pant	Cotton	Brown
TN19FPA005FR	Pants	Corduroy Easy Pant	Cotton	Forest
TN19FPA006BK	Pants	Cargo Pant	Cotton, Nylon	Black
TN19FPA006OV	Pants	Cargo Pant	Cotton, Nylon	Olive
TN19FPA007BK	Pants	Work Pant	Cotton	Black
TN19FPA007BL	Pants	Work Pant	Cotton	Blue
TN19FPA007GR	Pants	Work Pant	Cotton	Grey
TN19FPA007OV	Pants	Work Pant	Cotton	Olive
TN19FPA008BK	Pants	American Flag Work Pant	Cotton	Black
TN19FPA009BK	Pants	Carpenter Pant	Cotton	Black
TN19FPA009BL	Pants	Carpenter Pant	Cotton	Blue
TN19FPA009BR	Pants	Carpenter Pant	Cotton	Brown
TN19FPA010BK	Pants	Jungle Pant	Cotton	Black
TN19FPA010EO	Pants	Jungle Pant	Cotton	Purple Camo
TN19FPA010TO	Pants	Jungle Pant	Cotton	Desert Camo
TN19FPA011BK	Pants	Full-Zip Pant	Nylon, Polyester	Black
TN19FPA011JA	Pants	Full-Zip Pant	Nylon, Polyester	Jade
TN19FPA011NA	Pants	Full-Zip Pant	Nylon, Polyester	Navy
TN19FPA012BK	Pants	Nylon Trail Pant	Nylon, Polyester	Black
TN19FPA012BL	Pants	Nylon Trail Pant	Nylon, Polyester	Blue
TN19FPA012NA	Pants	Nylon Trail Pant	Nylon, Polyester	Navy
TN19FPA012OV	Pants	Nylon Trail Pant	Nylon, Polyester	Olive
TN19FPA013BK	Pants	Track Pant	Polyester	Black
TN19FPA013BR	Pants	Track Pant	Polyester	Brown
TN19FPA013NA	Pants	Track Pant	Polyester	Navy
TN19FPA015BG	Pants	POLARTEC Fleece Pant	Polyester	Blue Green
TN19FPA015BK	Pants	POLARTEC Fleece Pant	Polyester	Black
TN19FPA015GR	Pants	POLARTEC Fleece Pant	Polyester	Grey
TN19FPA017BK	Pants	Driver Pant	Cotton, Polyester	Black
TN19FPA017BU	Pants	Driver Pant	Cotton, Polyester	Burgundy

Code	Category	Name	Material(s)	Color(s)
TN19FPA017GR	Pants	Driver Pant	Cotton, Polyester	Grey
TN19FPA020IR	Pants	NEW SPORT Sweatpant	Cotton	Light Grey
TN19FPA020NA	Pants	NEW SPORT Sweatpant	Cotton	Navy
TN19FPA020RV	Pants	NEW SPORT Sweatpant	Cotton	Dark Olive
TN19FPA021BR	Pants	D/P-Plaid Sweatpant	Cotton	Brown
TN19FSH001BK	Shirt	ARC-Logo African Check Shirt	Cotton	Black
TN19FSH001BL	Shirt	ARC-Logo African Check Shirt	Cotton	Blue
TN19FSH001RD	Shirt	ARC-Logo African Check Shirt	Cotton	Red
TN19FSH003CH	Shirt	SP-Logo Corduroy Shirt	Cotton	Charcoal
TN19FSH003GR	Shirt	SP-Logo Corduroy Shirt	Cotton	Grey
TN19FSH004PP	Shirt	Cut-Off Check Shirt	Cotton	Purple
TN19FSH004RD	Shirt	Cut-Off Check Shirt	Cotton	Red
TN19FSH007BE	Shirt	Overdyed Twill Shirt	Cotton	Beige
TN19FSH007CH	Shirt	Overdyed Twill Shirt	Cotton	Charcoal
TN19FSH007GN	Shirt	Overdyed Twill Shirt	Cotton	Green
TN19FSH008BR	Shirt	MI-Logo Oxford Shirt	Cotton	Brown
TN19FSH008BU	Shirt	MI-Logo Oxford Shirt	Cotton	Burgundy
TN19FSH008MI	Shirt	MI-Logo Oxford Shirt	Cotton	Mint
TN19FSH009BK	Shirt	Jungle Shirt Jacket	Cotton	Black
TN19FSH009EO	Shirt	Jungle Shirt Jacket	Cotton	Purple Camo
TN19FSH009TO	Shirt	Jungle Shirt Jacket	Cotton	Desert Camo
TN19FSW002BG	Sweatshirt	SP-Logo Crewneck	Cotton	Blue Green
TN19FSW002BK	Sweatshirt	SP-Logo Crewneck	Cotton	Black
TN19FSW002IL	Sweatshirt	SP-Logo Crewneck	Cotton	Light Olive
TN19FSW002NA	Sweatshirt	SP-Logo Crewneck	Cotton	Navy
TN19FSW002RD	Sweatshirt	SP-Logo Crewneck	Cotton	Red
TN19FSW002WH	Sweatshirt	SP-Logo Crewneck	Cotton	White
TN19FSW003BK	Sweatshirt	Rubber C-Logo Crewneck	Cotton	Black
TN19FSW003GR	Sweatshirt	Rubber C-Logo Crewneck	Cotton	Grey
TN19FSW003NA	Sweatshirt	Rubber C-Logo Crewneck	Cotton	Navy
TN19FSW003RU	Sweatshirt	Rubber C-Logo Crewneck	Cotton	Dark Blue
TN19FSW003RV	Sweatshirt	Rubber C-Logo Crewneck	Cotton	Dark Olive
TN19FSW004BK	Sweatshirt	Chest Stripe Crewneck	Cotton	Black
TN19FSW004BR	Sweatshirt	Chest Stripe Crewneck	Cotton	Brown
TN19FSW004NA	Sweatshirt	Chest Stripe Crewneck	Cotton	Navy
TN19FSW005BK	Sweatshirt	School Bus Crewneck	Cotton	Black
TN19FSW005BU	Sweatshirt	School Bus Crewneck	Cotton	Burgundy
TN19FSW005IR	Sweatshirt	School Bus Crewneck	Cotton	Light Grey
TN19FSW006BK	Sweatshirt	WHO YA Crewneck	Cotton	Black
TN19FSW006GR	Sweatshirt	WHO YA Crewneck	Cotton	Light Grey
TN19FSW006WG	Sweatshirt	WHO YA Crewneck	Cotton	Warm Grey
TN19FSW007BK	Sweatshirt	Prep-School Gangsters Crewneck	Cotton	Black
TN19FSW007OR	Sweatshirt	Prep-School Gangsters Crewneck	Cotton	Orange
TN19FSW007PP	Sweatshirt	Prep-School Gangsters Crewneck	Cotton	Purple
TN19FSW007RU	Sweatshirt	Prep-School Gangsters Crewneck	Cotton	Dark Blue
TN19FSW008BK	Sweatshirt	Crossover Crewneck	Cotton	Black
TN19FSW008BR	Sweatshirt	Crossover Crewneck	Cotton	Brown
TN19FSW008IR	Sweatshirt	Crossover Crewneck	Cotton	Light Grey
TN19FSW009BR	Sweatshirt	D/P-Plaid Crewneck	Cotton	Brown
TN19FSW010BK	Sweatshirt	INTL. Striped Crewneck	Cotton	Black
TN19FSW010BU	Sweatshirt	INTL. Striped Crewneck	Cotton	Burgundy
TN19FSW010NA	Sweatshirt	INTL. Striped Crewneck	Cotton	Navy
TN19FSW011BK	Sweatshirt	3D Logo Crewneck	Cotton	Black
TN19FSW011OR	Sweatshirt	3D Logo Crewneck	Cotton	Orange
TN19FSW011SB	Sweatshirt	3D Logo Crewneck	Cotton	Sky Blue

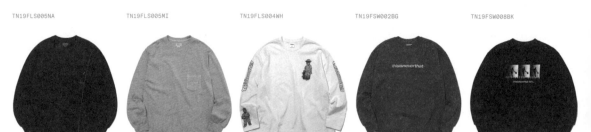

TN19FLS005NA TN19FLS005MI TN19FLS004WH TN19FSW002BG TN19FSW008BK

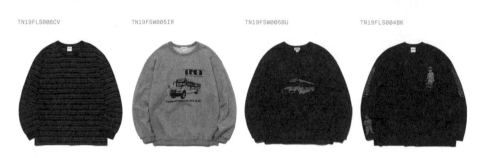

TN19FLS006CV TN19FSW005IR TN19FSW005BU TN19FLS004BK

TN19FSW011WH	Sweatshirt	3D Logo Crewneck	Cotton	White
TN19FSW012BU	Sweatshirt	Cracked Crewneck	Cotton	Burgundy
TN19FSW012CH	Sweatshirt	Cracked Crewneck	Cotton	Charcoal
TN19FSW012NA	Sweatshirt	Cracked Crewneck	Cotton	Navy
TN19FSW012PP	Sweatshirt	Cracked Crewneck	Cotton	Purple
TN19FTP001BK	Top	POLARTEC Fleece Pullover	Polyester	Black
TN19FTP001BU	Top	POLARTEC Fleece Pullover	Polyester	Burgundy
TN19FTP001GR	Top	POLARTEC Fleece Pullover	Polyester	Grey
TN19FTP001IM	Top	POLARTEC Fleece Pullover	Polyester	Lime
TN19FTP003BK	Top	GOING TO CLASS Half Zip Pullover	Cotton	Black
TN19FTP003GR	Top	GOING TO CLASS Half Zip Pullover	Cotton	Grey
TN19FTP003OR	Top	GOING TO CLASS Half Zip Pullover	Cotton	Orange
TN19FTP003SB	Top	GOING TO CLASS Half Zip Pullover	Cotton	Sky Blue
TN19FTP004BK	Top	Rubber SP Half Zip Pullover	Cotton	Black
TN19FTP004BU	Top	Rubber SP Half Zip Pullover	Cotton	Burgundy
TN19FTP004TB	Top	Rubber SP Half Zip Pullover	Cotton	Light Blue
TN19FTP006BK	Top	L-Logo Pullover	Cotton	Black
TN19FTP006PP	Top	L-Logo Pullover	Cotton	Purple
TN19FTP006WG	Top	L-Logo Pullover	Cotton	Warm Grey
TN19FTP009BK	Top	V-Zipup Shirt	Cotton	Black
TN19FTP009PP	Top	V-Zipup Shirt	Cotton	Purple
TN19FTP010GR	Top	Turtleneck L/SL Top	Cotton	Grey
TN19FTP010NA	Top	Turtleneck L/SL Top	Cotton	Navy
TN19FTP010RD	Top	Turtleneck L/SL Top	Cotton	Red
TN19FTS001BK	Tee	TOWN Tee	Cotton	Black
TN19FTS001RD	Tee	TOWN Tee	Cotton	Red
TN19FTS001WH	Tee	TOWN Tee	Cotton	White
TN19FTS003BG	Tee	NEW SPORT Striped Tee	Cotton	Blue Green
TN19FTS003DK	Tee	NEW SPORT Striped Tee	Cotton	Black
TN19FTS003NA	Tee	NEW SPORT Striped Tee	Cotton	Navy
TNCOCHS001BG	Sweatshirt	T-Logo Hooded Sweatshirt	Cotton	Blue Green
TNCOCHS001BK	Sweatshirt	T-Logo Hooded Sweatshirt	Cotton	Black
TNCOCHS001BR	Sweatshirt	T-Logo Hooded Sweatshirt	Cotton	Brown
TNCOCHS001GR	Sweatshirt	T-Logo Hooded Sweatshirt	Cotton	Grey

Code	Category	Name	Material(s)	Color(s)
TNCOCHS001IL	Sweatshirt	T-Logo Hooded Sweatshirt	Cotton	Light Olive
TNCOCHS001NA	Sweatshirt	T-Logo Hooded Sweatshirt	Cotton	Navy
TNCOCHW001BG	Hat	T-Logo Cap	Cotton	Blue Green
TNCOCHW001BU	Hat	T-Logo Cap	Cotton	Burgundy
TNCOCHW001GN	Hat	T-Logo Cap	Cotton	Green
TNCOCHW001LI	Hat	T-Logo Cap	Cotton	Lilac
TNCOCHW001NA	Hat	T-Logo Cap	Cotton	Navy
TNCOCLS001BG	Long Sleeve Tee	T-Logo L/SL Top	Cotton	Blue Green
TNCOCLS001BK	Long Sleeve Tee	T-Logo L/SL Top	Cotton	Black
TNCOCLS001BU	Long Sleeve Tee	T-Logo L/SL Top	Cotton	Burgundy
TNCOCLS001LM	Long Sleeve Tee	T-Logo L/SL Top	Cotton	Lemon
TNCOCLS001NA	Long Sleeve Tee	T-Logo L/SL Top	Cotton	Navy
TNCOCLS001RV	Long Sleeve Tee	T-Logo L/SL Top	Cotton	Dark Olive
TNCOCLS001WH	Long Sleeve Tee	T-Logo L/SL Top	Cotton	White
TNCOCSW001BE	Sweatshirt	T-Logo Crewneck	Cotton	Beige
TNCOCSW001BK	Sweatshirt	T-Logo Crewneck	Cotton	Black
TNCOCSW001BU	Sweatshirt	T-Logo Crewneck	Cotton	Burgundy
TNCOCSW001CH	Sweatshirt	T-Logo Crewneck	Cotton	Charcoal
TNCOCSW001GR	Sweatshirt	T-Logo Crewneck	Cotton	Grey
TNCOCSW001OR	Sweatshirt	T-Logo Crewneck	Cotton	Orange
TNCOCSW001OV	Sweatshirt	T-Logo Crewneck	Cotton	Olive
TNCOCSW001RU	Sweatshirt	T-Logo Crewneck	Cotton	Dark Blue

TN19FHW009NA TN19FHW014YL TN19FHW004ML TN19FHW003CH TN19FHW015BK

TN19FAC003GR TN19FAC013BK TN19FAC021NA TN19FAC007GR

TN19FAC010MD APCOCAC001NNE TN19FAC014SR TN19FAC016SR

Code	Category	Name	Material(s)	Color(s)
AP19SAC001NNE	Accessory	TINT × APFR Incense Stick	Woody Leather, Ginger, Sage, Vetiver, Amber	-
GM19SPA001BK	Pants	TINT × GRAMiCCi Sweat Pant	Cotton	Black
GM19SPA001HR	Pants	TINT × GRAMiCCi Sweat Pant	Cotton	Heather Grey
GM19SSW001BK	Sweatshirt	TINT × GRAMiCCi Talecut Sweat	Cotton	Black
GM19SSW001HR	Sweatshirt	TINT × GRAMiCCi Talecut Sweat	Cotton	Heather Grey
MP19SBA001BK	Bag	TINT Big Apple Back Pack	Nylon	Black
MP19SBA001RB	Bag	TINT Big Apple Back Pack	Nylon	Royal Blue
MP19SBA002BK	Bag	TINT Vintage Messenger Bag SM	Nylon	Black
MP19SBA002RB	Bag	TINT Vintage Messenger Bag SM	Nylon	Royal Blue
MP19SBA003RB	Accessory	TINT Coin Purse	Nylon	Royal Blue
NB19SAC001BK	Accessory	NB TNT Headband	Cotton	Black
NB19SAC001WH	Accessory	NB TNT Headband	Cotton	White
NB19SAC002BK	Accessory	NB TNT Wristband	Cotton	Black
NB19SAC002WH	Accessory	NB TNT Wristband	Cotton	White
NB19SAC003WH	Socks	NB TNT Socks	Cotton	White
NB19SFW001BK	Shoes	NB TNT Slide	Polyurethane	Black
NB19SFW001KH	Shoes	NB TNT Slide	Polyurethane	Khaki
NB19SHW001BE	Hat	NB TNT PT Cap	Cotton	Beige
NB19SHW001BK	Hat	NB TNT PT Cap	Cotton	Black
NB19SHW001KH	Hat	NB TNT PT Cap	Cotton	Khaki
NB19SOW001BE	Jacket	NB TNT Hooded Anorak Parka	Nylon	Beige
NB19SOW001BK	Jacket	NB TNT Hooded Anorak Parka	Nylon	Black
NB19SOW001KH	Jacket	NB TNT Hooded Anorak Parka	Nylon	Khaki
NB19SPA001BE	Pants	NB TNT PT Sweatpant	Cotton	Beige
NB19SPA001KH	Pants	NB TNT PT Sweatpant	Cotton	Khaki
NB19SSO001BE	Pants	NB TNT PT Short	Nylon	Beige
NB19SSO001BK	Pants	NB TNT PT Short	Nylon	Black
NB19SSO001KH	Pants	NB TNT PT Short	Nylon	Khaki
NB19SSW001BE	Sweatshirt	NB TNT PT Sweatshirt	Cotton	Beige
NB19SSW001KH	Sweatshirt	NB TNT PT Sweatshirt	Cotton	Khaki
NB19STS001BE	Tee	NB TNT PFU T-Shirt	Cotton	Beige
NB19STS001BK	Tee	NB TNT PFU T-Shirt	Cotton	Black
NB19STS001KH	Tee	NB TNT PFU T-Shirt	Cotton	Khaki
NB19STS002BK	Tee	NB TNT PT T-Shirt	Cotton	Black
NB19STS002IR	Tee	NB TNT PT T-Shirt	Cotton	Light Grey
NB19STS002WH	Tee	NB TNT PT T-Shirt	Cotton	White
NE19SHW001NA	Hat	5950 MLB × TINT NEYYAN	Polyester	Navy
NE19SHW002BL	Hat	5950 MLB × TINT LOSDOD	Polyester	Blue
NE19SHW003NA	Hat	920UNST MLB × TINT NEYYAN	Cotton	Navy
NE19SHW004BL	Hat	920UNST MLB × TINT LOSDOD	Cotton	Blue
TN19SAC001BK	Accessory	SP-Logo Webbing Belt	Nylon, Polypropylene	Black
TN19SAC001EA	Accessory	SP-Logo Webbing Belt	Nylon, Polypropylene	Neon Orange
TN19SAC002BK	Accessory	SP Regular Socks	Cotton, Spandex, Polyester	Black
TN19SAC002EA	Accessory	SP Regular Socks	Polyester, Spandex	Neon Orange
TN19SAC002WH	Accessory	SP Regular Socks	Cotton, Spandex, Polyester	White
TN19SAC004YL	Accessory	thisisneverthat Camtrays® S	Fiberglass	Yellow
TN19SAC005BK	Accessory	thisisneverthat Zippo Lighter	Brass	Black
TN19SAC006BK	Accessory	HSP Luggage Lock	Metal	Black
TN19SAC007SR	Accessory	T-Logo Ring	925 Silver	Silver
TN19SAC008SR	Accessory	C-Logo Ring	925 Silver	Silver
TN19SAC009SR	Accessory	HSP Necklace	925 Silver	Silver
TN19SAC010BK	Accessory	C-Logo Pillow	Cotton, Polyester	Black
TN19SAC011BK	Accessory	SP-Logo Lanyard	Polyester, Plastic	Black
TN19SAC013GR	Accessory	Laie Sunglasses	Acetate Frame	Grey

TN19SMV001NA

(PFU)

NB thisisneverthat

Rear Lunge

Rower

Foward Lunge

Windmill

Squat Bender

Bent-Leg Body Twist

Single-Leg Over

Bent and Reach

Overhead Arm Pull

TN19SMV004NA

Code	Category	Name	Material(s)	Color(s)
TN19SAC013YL	Accessory	Laie Sunglasses	Acetate Frame	Yellow
TN19SAC014GR	Accessory	VIK Sunglasses	Acetate Frame	Grey
TN19SAC014LE	Accessory	VIK Sunglasses	Acetate Frame	Clear
TN19SAC016BW	Accessory	T-Logo Key Tag	Acrylic	Black, White
TN19SAC017RC	Accessory	1-thisisneverthat Pin	Brass	Gold
TN19SAC017SQ	Accessory	1-thisisneverthat Pin	Brass	Gold
TN19SAC018LE	Accessory	Duralex® Glass	Glass	Clear
TN19SAC019SE	Accessory	1-thisisneverthat iPhone Case (7, 8)	TPU	Black
TN19SAC019XS	Accessory	1-thisisneverthat iPhone Case (X, Xs)	TPU	Black
TN19SAC020MI	Accessory	1-thisisneverthat iPhone Case (7, 8)	TPU	Mint
TN19SAC020PP	Accessory	1-thisisneverthat iPhone Case (7, 8)	TPU	Purple
TN19SAC020WH	Accessory	1-thisisneverthat iPhone Case (7, 8)	TPU	White
TN19SAC021MI	Accessory	1-thisisneverthat iPhone Case (X, Xs)	TPU	Mint
TN19SAC021PP	Accessory	1-thisisneverthat iPhone Case (X, Xs)	TPU	Purple
TN19SAC021WH	Accessory	1-thisisneverthat iPhone Case (X, Xs)	TPU	White
TN19SAC022BL	Accessory	thisisneverthat Camtrays® M	Fiberglass	Blue
TN19SBA001BK	Bag	Mesh Backpack	Polyester	Black
TN19SBA001IM	Bag	Mesh Backpack	Polyester	Lime
TN19SBA001IR	Bag	Mesh Backpack	Polyester	Light Grey
TN19SBA002BK	Bag	Ripstop Cordura® 210D BOP	Nylon, Polyester	Black
TN19SBA002OV	Bag	Ripstop Cordura® 210D BOP	Nylon, Polyester	Olive
TN19SBA003BK	Bag	Mesh Box Pouch	Polyester	Black

TN19SMV003NA

Code	Category	Name	Material(s)	Color(s)
TN19SBA003IM	Bag	Mesh Box Pouch	Polyester	Lime
TN19SBA003IR	Bag	Mesh Box Pouch	Polyester	Light Grey
TN19SBA004BK	Bag	Mesh Flat Pouch	Polyester	Black
TN19SBA004IM	Bag	Mesh Flat Pouch	Polyester	Lime
TN19SBA004IR	Bag	Mesh Flat Pouch	Polyester	Light Grey
TN19SBA005BK	Bag	Mesh Bottle Holder	Polyester	Black
TN19SBA005IM	Bag	Mesh Bottle Holder	Polyester	Lime
TN19SBA006BK	Bag	Ripstop Cordura® 210D Daypack	Nylon, Polyester	Black
TN19SBA006OV	Bag	Ripstop Cordura® 210D Daypack	Nylon, Polyester	Olive
TN19SBA007BK	Bag	Ripstop Cordura® 210D Mini Shoulder Bag	Nylon, Polyester	Black
TN19SBA007OV	Bag	Ripstop Cordura® 210D Mini Shoulder Bag	Nylon, Polyester	Olive
TN19SBA008BK	Bag	Ripstop Cordura® 210D Traveller Bag	Nylon, Polyester	Black
TN19SBA008OV	Bag	Ripstop Cordura® 210D Traveller Bag	Nylon, Polyester	Olive
TN19SBA009BK	Bag	Ripstop Cordura® 210D Gym Sack	Nylon, Polyester	Black
TN19SBA009OV	Bag	Ripstop Cordura® 210D Gym Sack	Nylon, Polyester	Olive
TN19SHS001BK	Sweatshirt	ARC-Logo Zipup Sweat	Cotton	Black
TN19SHS001BU	Sweatshirt	ARC-Logo Zipup Sweat	Cotton	Burgundy
TN19SHS001GR	Sweatshirt	ARC-Logo Zipup Sweat	Cotton	Grey
TN19SHS002BK	Sweatshirt	SP-INTL. Logo Zipup Sweat	Cotton	Black
TN19SHS002FR	Sweatshirt	SP-INTL. Logo Zipup Sweat	Cotton	Forest
TN19SHS002GR	Sweatshirt	SP-INTL. Logo Zipup Sweat	Cotton	Grey
TN19SHS003BG	Sweatshirt	SP-INTL. Logo Hooded Sweatshirt	Cotton	Blue Green
TN19SHS003BK	Sweatshirt	SP-INTL. Logo Hooded Sweatshirt	Cotton	Black
TN19SHS003GR	Sweatshirt	SP-INTL. Logo Hooded Sweatshirt	Cotton	Grey
TN19SHS003WH	Sweatshirt	SP-INTL. Logo Hooded Sweatshirt	Cotton	White
TN19SHS004BK	Sweatshirt	Skateboarding Hooded Sweatshirt	Cotton	Black
TN19SHS004MI	Sweatshirt	Skateboarding Hooded Sweatshirt	Cotton	Mint
TN19SHS005BK	Sweatshirt	Bulge Hooded Sweatshirt	Cotton	Black
TN19SHS005TB	Sweatshirt	Bulge Hooded Sweatshirt	Cotton	Light Blue
TN19SHS005WH	Sweatshirt	Bulge Hooded Sweatshirt	Cotton	White
TN19SHS006BK	Sweatshirt	HSP Hooded Sweatshirt	Cotton	Black
TN19SHS006NA	Sweatshirt	HSP Hooded Sweatshirt	Cotton	Navy
TN19SHS006OV	Sweatshirt	HSP Hooded Sweatshirt	Cotton	Olive
TN19SHS006TB	Sweatshirt	HSP Hooded Sweatshirt	Cotton	Light Blue
TN19SHS007BK	Sweatshirt	MV-SP Hooded Sweatshirt	Cotton	Black
TN19SHS007GR	Sweatshirt	MV-SP Hooded Sweatshirt	Cotton	Grey
TN19SHS007WH	Sweatshirt	MV-SP Hooded Sweatshirt	Cotton	White
TN19SHS008BK	Sweatshirt	CP-INTL. Hooded Sweatshirt	Cotton	Black
TN19SHS008GR	Sweatshirt	CP-INTL. Hooded Sweatshirt	Cotton	Grey
TN19SHS008YL	Sweatshirt	CP-INTL. Hooded Sweatshirt	Cotton	Yellow
TN19SHS009BG	Sweatshirt	ESP Overdyed Hooded Sweatshirt	Cotton	Blue Green
TN19SHS009CH	Sweatshirt	ESP Overdyed Hooded Sweatshirt	Charcoal	Charcoal
TN19SHS009PP	Sweatshirt	ESP Overdyed Hooded Sweatshirt	Cotton	Purple
TN19SHS010GN	Sweatshirt	Tiedye Hooded Sweatshirt	Cotton	Green
TN19SHS010LV	Sweatshirt	Tiedye Hooded Sweatshirt	Cotton	Lavender
TN19SHS012BK	Sweatshirt	1-thisisneverthat Hooded Sweatshirt	Cotton	Black
TN19SHS012GR	Sweatshirt	1-thisisneverthat Hooded Sweatshirt	Cotton	Grey
TN19SHS012OL	Sweatshirt	1-thisisneverthat Hooded Sweatshirt	Cotton	Neon Yellow
TN19SHW001BE	Hat	T-Logo Cap	Cotton	Beige
TN19SHW001RK	Hat	T-Logo Cap	Cotton	Black
TN19SHW001GN	Hat	T-Logo Cap	Cotton	Green
TN19SHW001NA	Hat	T-Logo Cap	Cotton	Navy
TN19SHW002BU	Hat	ARC-Logo Cap	Cotton	Burgundy
TN19SHW002GN	Hat	ARC-Logo Cap	Cotton	Green
TN19SHW003BK	Hat	DSN-Logo Cap	Cotton	Black

Code	Category	Name	Material(s)	Color(s)
TN19SHW003OR	Hat	DSN-Logo Cap	Cotton	Orange
TN19SHW003OV	Hat	DSN-Logo Cap	Cotton	Olive
TN19SHW003WH	Hat	DSN-Logo Cap	Cotton	White
TN19SHW004BK	Hat	SP-Logo Cap	Cotton, Nylon	Black
TN19SHW004EA	Hat	SP-Logo Cap	Cotton, Nylon	Neon Orange
TN19SHW004RB	Hat	SP-Logo Cap	Cotton, Nylon	Royal Blue
TN19SHW005BK	Hat	Athletics Mesh Cap	Polyester, Nylon, Cotton	Black
TN19SHW005NA	Hat	Athletics Mesh Cap	Polyester, Nylon, Cotton	Navy
TN19SHW006BK	Hat	Trucker Mesh Cap	Cotton, Polyester	Black
TN19SHW006TB	Hat	Trucker Mesh Cap	Cotton, Polyester	Light Blue
TN19SHW007BK	Hat	Nylon Bucket Hat	Nylon, Polyester	Black
TN19SHW007EN	Hat	Nylon Bucket Hat	Nylon, Polyester	Beige, Navy
TN19SHW007EW	Hat	Nylon Bucket Hat	Nylon, Polyester	Blue, White
TN19SHW008NA	Hat	TWOBOYS Bucket Hat	Cotton	Navy
TN19SHW008RD	Hat	TWOBOYS Bucket Hat	Cotton	Red
TN19SHW009FW	Hat	Fishing Hat	Cotton	Off White
TN19SHW009NA	Hat	Fishing Hat	Cotton	Navy
TN19SHW010BK	Hat	HSP Logo Camp Cap	Nylon	Black
TN19SHW010BU	Hat	HSP Logo Camp Cap	Nylon	Burgundy
TN19SHW010WH	Hat	HSP Logo Camp Cap	Nylon	White
TN19SHW011AT	Hat	3Line-Logo Camp Cap	Nylon	Anthracite
TN19SHW011BL	Hat	3Line-Logo Camp Cap	Nylon	Blue
TN19SHW011IN	Hat	3Line-Logo Camp Cap	Nylon	Lime Green
TN19SHW011IR	Hat	3Line-Logo Camp Cap	Nylon	Light Grey
TN19SHW014BD	Hat	HSP Short Beanie	Acrylic	Brick Red
TN19SHW014BK	Hat	HSP Short Beanie	Acrylic	Black
TN19SHW014LV	Hat	HSP Short Beanie	Acrylic	Lavender
TN19SHW014MI	Hat	HSP Short Beanie	Acrylic	Mint
TN19SHW015BD	Hat	Striped Beanie	Cotton	Brick Red
TN19SHW015BL	Hat	Striped Beanie	Cotton	Blue
TN19SHW015WH	Hat	Striped Beanie	Cotton	White
TN19SHW016BU	Hat	SD-TSN Cap	Cotton	Burgundy
TN19SHW016EC	Hat	SD-TSN Cap	Cotton	Ecru
TN19SHW016NA	Hat	SD-TSN Cap	Cotton	Navy
TN19SHW017CH	Hat	SPORTS_TSN Cap	Cotton	Charcoal
TN19SHW017MI	Hat	SPORTS_TSN Cap	Cotton	Mint
TN19SHW018BE	Hat	Fishing Bucket Hat	Cotton	Beige
TN19SHW018BK	Hat	Fishing Bucket Hat	Cotton	Black
TN19SHW019BK	Hat	1-thisisneverthat Cap	Cotton	Black
TN19SKW001BK	Top	SCRT Zip Knit Polo	Cotton	Black
TN19SKW001IV	Top	SCRT Zip Knit Polo	Cotton	Ivory
TN19SKW001SB	Top	SCRT Zip Knit Polo	Cotton	Sky Blue
TN19SKW002BK	Top	Jacquard Knit Polo	Cotton	Black

TN19SOW003KE TN19SOW002WH TN19SOW008GR TN19SOW005IV TN19SOW003BK

Code	Category	Name	Material(s)	Color(s)

TN19SHS008BK TN19SHS009BG TN19SHS003GR TN19SHS008YL TN19SHS012GR

TN19SKW001IV TN19SKW005WH TN19SSH008BL TN19SSH001MI TN19SSH004RP

TN19SKW002BR	Top	Jacquard Knit Polo	Cotton	Brown
TN19SKW002MI	Top	Jacquard Knit Polo	Cotton	Mint
TN19SKW003IV	Top	Tennis Knit Vest	Acrylic, Polyester	Ivory
TN19SKW005BK	Top	Zipup L/SL Polo	Cotton	Black
TN19SKW005WH	Top	Zipup L/SL Polo	Cotton	White
TN19SKW006BK	Top	HSP Jersey Polo	Cotton	Black
TN19SKW006BL	Top	HSP Jersey Polo	Cotton	Blue
TN19SKW006LM	Top	HSP Jersey Polo	Cotton	Lemon
TN19SKW007GY	Top	DSN Striped Jersey Polo	Cotton	Green, Navy
TN19SKW007VL	Top	DSN Striped Jersey Polo	Cotton	Navy, Olive
TN19SKW007VY	Top	DSN Striped Jersey Polo	Cotton	Olive, Grey
TN19SKW008KD	Top	Striped Rugby Shirt	Cotton	Black, Red
TN19SKW008NG	Top	Striped Rugby Shirt	Cotton	Navy, Green
TN19SKW008NW	Top	Striped Rugby Shirt	Cotton	Navy, White
TN19SLS001BK	Long Sleeve Tee	NEON BoX L/SL Top	Cotton	Black
TN19SLS001GK	Long Sleeve Tee	NEON BoX L/SL Top	Cotton	Light Pink
TN19SLS001WH	Long Sleeve Tee	NEON BoX L/SL Top	Cotton	White
TN19SLS002BK	Long Sleeve Tee	SportsTSN L/SL Top	Cotton	Black
TN19SLS002GR	Long Sleeve Tee	SportsTSN L/SL Top	Cotton	Grey
TN19SLS002WH	Long Sleeve Tee	SportsTSN L/SL Top	Cotton	White
TN19SLS003BK	Long Sleeve Tee	DIA-SP L/SL Top	Cotton	Black
TN19SLS003BL	Long Sleeve Tee	DIA-SP L/SL Top	Cotton	Blue
TN19SLS003WH	Long Sleeve Tee	DIA-SP L/SL Top	Cotton	White
TN19SLS004BK	Long Sleeve Tee	2Tone Logo L/SL Top	Cotton	Black
TN19SLS004OV	Long Sleeve Tee	2Tone Logo L/SL Top	Cotton	Olive
TN19SLS004PK	Long Sleeve Tee	2Tone Logo L/SL Top	Cotton	Pink
TN19SLS004WH	Long Sleeve Tee	2Tone Logo L/SL Top	Cotton	White
TN19SLS005BG	Long Sleeve Tee	RACING L/SL Top	Cotton	Blue Green
TN19SLS005BK	Long Sleeve Tee	RACING L/SL Top	Cotton	Black
TN19SLS005WH	Long Sleeve Tee	RACING L/SL Top	Cotton	White
TN19SLS006BK	Long Sleeve Tee	BUG BLOOD L/SL Top	Cotton	Black
TN19SLS006WH	Long Sleeve Tee	BUG BLOOD L/SL Top	Cotton	White

Code	Category	Name	Material(s)	Color(s)
TN19SLS007BK	Long Sleeve Tee	Fishing L/SL Top	Cotton	Black
TN19SLS007ER	Long Sleeve Tee	Fishing L/SL Top	Cotton	Neon Green
TN19SLS007OV	Long Sleeve Tee	Fishing L/SL Top	Cotton	Olive
TN19SLS008GP	Long Sleeve Tee	N Striped L/SL Top	Cotton	Green, Purple
TN19SLS008LR	Long Sleeve Tee	N Striped L/SL Top	Cotton	Black, Grey
TN19SLS008VB	Long Sleeve Tee	N Striped L/SL Top	Cotton	Olive, Blue
TN19SLS009BW	Long Sleeve Tee	HSP Striped L/SL Top	Cotton	Black, White
TN19SLS009UE	Long Sleeve Tee	HSP Striped L/SL Top	Cotton	Blue, Green
TN19SLS011CH	Long Sleeve Tee	T-Logo Pocket L/SL Top	Cotton	Charcoal
TN19SLS011GN	Long Sleeve Tee	T-Logo Pocket L/SL Top	Cotton	Green
TN19SLS011PP	Long Sleeve Tee	T-Logo Pocket L/SL Top	Cotton	Purple
TN19SLS012CH	Long Sleeve Tee	TN INTL. L/SL Top	Cotton	Charcoal
TN19SLS012GN	Long Sleeve Tee	TN INTL. L/SL Top	Cotton	Green
TN19SLS012PP	Long Sleeve Tee	TN INTL. L/SL Top	Cotton	Purple
TN19SMV001NA	Video	TEENAGE FISHING CLUB	Film	-
TN19SMV002NA	Video	thisisneverthat Spring 19: "Teenage Fishing Club" Exhibition	Film	-
TN19SMV003NA	Video	thisisneverthat® × NEW ERA®	Film	-
TN19SOW001BK	Jacket	GORE® WINDSTOPPER® CITY Jacket	Polyester	Black
TN19SOW001IM	Jacket	GORE® WINDSTOPPER® CITY Jacket	Polyester	Lime
TN19SOW001OV	Jacket	GORE® WINDSTOPPER® CITY Jacket	Polyester	Olive
TN19SOW002BK	Jacket	DSN Sport Parka	Cotton, Nylon, Polyester	Black
TN19SOW002KH	Jacket	DSN Sport Parka	Cotton, Nylon, Polyester	Khaki
TN19SOW002WH	Jacket	DSN Sport Parka	Cotton, Nylon, Polyester	White
TN19SOW003BK	Jacket	T-Court Track Jacket	Cotton	Black
TN19SOW003KE	Jacket	T-Court Track Jacket	Cotton	Checkerboard
TN19SOW005BK	Jacket	INTL. Fleece Jacket	Polyester, Nylon	Black
TN19SOW005GN	Jacket	INTL. Fleece Jacket	Polyester, Nylon	Green
TN19SOW005IV	Jacket	INTL. Fleece Jacket	Polyester, Nylon	Ivory
TN19SOW005NA	Jacket	INTL. Fleece Jacket	Polyester, Nylon	Navy
TN19SOW006BK	Jacket	Fisherman Jacket	Nylon, Polyester	Black
TN19SOW006IN	Jacket	Fisherman Jacket	Nylon, Polyester	Lime Green
TN19SOW006SB	Jacket	Fisherman Jacket	Nylon, Polyester	Sky Blue
TN19SOW007BK	Jacket	MI-Logo M51 Parka	Polyester	Black
TN19SOW007OV	Jacket	MI-Logo M51 Parka	Polyester	Olive
TN19SOW008BK	Jacket	Denim Trucker Jacket	Cotton, Polyester, Rayon	Black
TN19SOW008GR	Jacket	Denim Trucker Jacket	Cotton, Polyester, Rayon	Grey
TN19SPA001BK	Pants	GORE® WINDSTOPPER® CITY Pant	Polyester	Black
TN19SPA001IM	Pants	GORE® WINDSTOPPER® CITY Pant	Polyester	Lime
TN19SPA001OV	Pants	GORE® WINDSTOPPER® CITY Pant	Polyester	Olive
TN19SPA002BK	Pants	T-Court Track Pant	Cotton	Black
TN19SPA002KE	Pants	T-Court Track Pant	Cotton	Checkerboard
TN19SPA003BK	Pants	Zipped Fishing Pant	Nylon, Cotton	Black
TN19SPA003OV	Pants	Zipped Fishing Pant	Nylon, Cotton	Olive
TN19SPA005BK	Pants	Velcro Cuff Pant	Cotton	Black
TN19SPA005OV	Pants	Velcro Cuff Pant	Cotton	Olive
TN19SPA006GR	Pants	Carpenter Pant	Cotton	Grey
TN19SPA006WH	Pants	Carpenter Pant	Cotton	White
TN19SPA007BE	Pants	Multi Cargo Pant	Nylon	Beige
TN19SPA007BK	Pants	Multi Cargo Pant	Nylon	Black
TN19SPA007BU	Pants	Multi Cargo Pant	Nylon	Burgundy
TN19SPA008BK	Jean	Regular Jean	Cotton, Polyester, Rayon	Black
TN19SPA008ML	Jean	Regular Jean	Cotton, Polyester, Rayon	Mid Blue
TN19SPA008TB	Jean	Regular Jean	Cotton, Polyester, Rayon	Light Blue
TN19SPA009BK	Jean	Fatigue Jean	Cotton, Polyester, Rayon	Black

Code	Category	Name	Material(s)	Color(s)
TN19SPA009IDG	Jean	Fatigue Jean	Cotton	Indigo
TN19SPA010BK	Jean	Cropped Jean	Cotton, Polyester, Rayon	Black
TN19SPA010TB	Jean	Cropped Jean	Cotton, Polyester, Rayon	Light Blue
TN19SPA011BK	Pants	HSP Warm Up Pant	Nylon, Polyester	Black
TN19SPA011IN	Pants	HSP Warm Up Pant	Nylon, Polyester	Lime Green
TN19SPA011SB	Pants	HSP Warm Up Pant	Nylon, Polyester	Sky Blue
TN19SPA012BE	Pants	Skater Pant	Cotton	Beige
TN19SPA012OV	Pants	Skater Pant	Cotton	Olive
TN19SPA013BK	Pants	Blue Tepee Pant	Cotton	Black
TN19SPA013WH	Pants	Blue Tepee Pant	Cotton	White
TN19SPA016GN	Pants	Tiedye Sweatpant	Cotton	Green
TN19SPA016LV	Pants	Tiedye Sweatpant	Cotton	Lavender
TN19SPA018BK	Pants	DIA-SP Sweatpant	Cotton	Black
TN19SPA018FR	Pants	DIA-SP Sweatpant	Cotton	Forest
TN19SPA018GR	Pants	DIA-SP Sweatpant	Cotton	Grey
TN19SPA018NA	Pants	DIA-SP Sweatpant	Cotton	Navy
TN19SPA019GR	Pants	EMB T-Logo PT Sweatpant	Cotton	Grey
TN19SPA019NA	Pants	EMB T-Logo PT Sweatpant	Cotton	Navy
TN19SPA019SB	Pants	EMB T-Logo PT Sweatpant	Cotton	Sky Blue
TN19SSH001BK	Shirt	Sports Fishing Shirt	Cotton	Black
TN19SSH001MI	Shirt	Sports Fishing Shirt	Cotton	Mint
TN19SSH002MI	Shirt	HSP Check Shirt	Cotton	Mint
TN19SSH002NA	Shirt	HSP Check Shirt	Cotton	Navy
TN19SSH003GN	Shirt	DIA-Logo Gingham Check Shirt	Cotton	Green
TN19SSH003NA	Shirt	DIA-Logo Gingham Check Shirt	Cotton	Navy
TN19SSH004RP	Shirt	HSP Oxford S/SL Shirt	Cotton	Orange, Purple
TN19SSH004YR	Shirt	HSP Oxford S/SL Shirt	Cotton	Sky Blue, Green
TN19SSH005RD	Shirt	BUG BLOOD Hawaiian Shirt	Cotton	Red
TN19SSH005WH	Shirt	BUG BLOOD Hawaiian Shirt	Rayon	White
TN19SSH005YL	Shirt	BUG BLOOD Hawaiian Shirt	Rayon	Yellow
TN19SSH006NA	Shirt	TR Satin S/SL Shirt	Polyester, Rayon	Navy

TN19SSW008MI TN19SLS001BK TN19SLS011GN TN19SLS008LR TN19SLS012PP

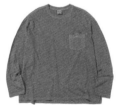
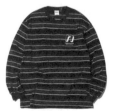
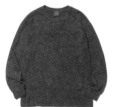

TN19SLS006WH TN19SLS005BG TN19SKW003IV

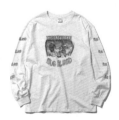
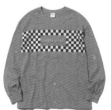
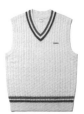

Code	Category	Name	Material(s)	Color(s)

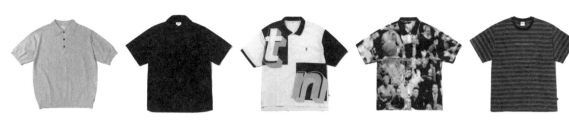

TN19SSH006PK	Shirt	TR Satin S/SL Shirt	Polyester, Rayon	Pink
TN19SSH007AC	Shirt	Velour S/SL Shirt	Cotton, Polyester	Apricot
TN19SSH007BK	Shirt	Velour S/SL Shirt	Cotton, Polyester	Black
TN19SSH007SB	Shirt	Velour S/SL Shirt	Cotton, Polyester	Sky Blue
TN19SSH008BL	Shirt	DSN-Logo Striped Shirt	Cotton	Blue
TN19SSH008GR	Shirt	DSN-Logo Striped Shirt	Cotton	Grey
TN19SSH008PK	Shirt	DSN-Logo Striped Shirt	Cotton	Pink
TN19SSH009BU	Shirt	TINT Pin Tuck Zip Up Shirt	Cotton	Burgundy
TN19SSH009IN	Shirt	TINT Pin Tuck Zip Up Shirt	Cotton	Lime Green
TN19SSH009NA	Shirt	TINT Pin Tuck Zip Up Shirt	Cotton	Navy
TN19SSH010BK	Shirt	Rayon S/SL Shirt	Rayon	Black
TN19SSH010YL	Shirt	Rayon S/SL Shirt	Rayon	Yellow
TN19SSH011BW	Shirt	Court Hawaiian Shirt	Cotton	Black, White
TN19SSO002BK	Pants	Mesh Pocket Short	Nylon	Black
TN19SSO002MT	Pants	Mesh Pocket Short	Nylon	Multi
TN19SSO002OV	Pants	Mesh Pocket Short	Nylon	Olive
TN19SSO003BE	Pants	T-Logo PT Short	Cotton	Beige
TN19SSO003BK	Pants	T-Logo PT Short	Cotton	Black
TN19SSO003GR	Pants	T-Logo PT Short	Cotton	Grey
TN19SSO004BE	Pants	T-Logo Cargo Short	Cotton	Beige
TN19SSO004BK	Pants	T-Logo Cargo Short	Cotton	Black
TN19SSO004OV	Pants	T-Logo Cargo Short	Cotton	Olive
TN19SSO005ML	Jean	Denim Skate Short	Cotton, Rayon, Polyester	Mid Blue
TN19SSO005TB	Jean	Denim Skate Short	Cotton, Rayon, Polyester	Light Blue
TN19SSO006AC	Pants	Velour Short	Cotton, Polyester	Apricot
TN19SSO006BK	Pants	Velour Short	Cotton, Polyester	Black
TN19SSO006SB	Pants	Velour Short	Cotton, Polyester	Sky Blue
TN19SSO007BK	Pants	HSP Sweatshort	Cotton	Black
TN19SSO007FR	Pants	HSP Sweatshort	Cotton	Forest
TN19SSO007LV	Pants	HSP Sweatshort	Cotton	Lavender
TN19SSO008BK	Pants	MV-SP Sweatshort	Cotton	Black
TN19SSO008GR	Pants	MV-SP Sweatshort	Cotton	Grey

Code	Category	Name	Material(s)	Color(s)
TN19SSO009BK	Jean	Carpenter Short	Cotton	Black
TN19SSO009IDG	Jean	Carpenter Short	Cotton	Indigo
TN19SSO010BK	Pants	Jogging Short	Nylon, Cotton	Black
TN19SSO010BL	Pants	Jogging Short	Nylon, Cotton	Blue
TN19SSO010RD	Pants	Jogging Short	Nylon, Cotton	Red
TN19SSW001BK	Sweatshirt	T-Logo Crewneck	Cotton	Black
TN19SSW001BU	Sweatshirt	T-Logo Crewneck	Cotton	Burgundy
TN19SSW001GR	Sweatshirt	T-Logo Crewneck	Cotton	Grey
TN19SSW001LV	Sweatshirt	T-Logo Crewneck	Cotton	Lavender
TN19SSW002BK	Sweatshirt	Striped SP Crewneck	Cotton	Black
TN19SSW002FR	Sweatshirt	Striped SP Crewneck	Cotton	Forest
TN19SSW002GK	Sweatshirt	Striped SP Crewneck	Cotton	Light Pink
TN19SSW003BK	Sweatshirt	DIA-SP Crewneck	Cotton	Black
TN19SSW003FR	Sweatshirt	DIA-SP Crewneck	Cotton	Forest
TN19SSW003GR	Sweatshirt	DIA-SP Crewneck	Cotton	Grey
TN19SSW003NA	Sweatshirt	DIA-SP Crewneck	Cotton	Navy
TN19SSW004GR	Sweatshirt	T-Logo PT Crewneck	Cotton	Grey
TN19SSW004NA	Sweatshirt	T-Logo PT Crewneck	Cotton	Navy
TN19SSW004SB	Sweatshirt	T-Logo PT Crewneck	Cotton	Sky Blue
TN19SSW005NG	Sweatshirt	L-Logo Striped Crewneck	Cotton	Navy, Green
TN19SSW005NW	Sweatshirt	L-Logo Striped Crewneck	Cotton	Navy, White
TN19SSW005RG	Sweatshirt	L-Logo Striped Crewneck	Cotton	Brown, Grey
TN19SSW006BK	Sweatshirt	Brick Striped Crewneck	Cotton	Black
TN19SSW006SB	Sweatshirt	Brick Striped Crewneck	Cotton	Sky Blue
TN19SSW007BG	Sweatshirt	ACE Logo Overdyed Crewneck	Cotton	Blue Green
TN19SSW007BL	Sweatshirt	ACE Logo Overdyed Crewneck	Cotton	Blue
TN19SSW007CH	Sweatshirt	ACE Logo Overdyed Crewneck	Cotton	Charcoal
TN19SSW008BK	Sweatshirt	HSP Crewneck	Cotton	Black
TN19SSW008MI	Sweatshirt	HSP Crewneck	Cotton	Mint
TN19SSW008WH	Sweatshirt	HSP Crewneck	Cotton	White
TN19SSW010BK	Sweatshirt	N-Cubic Crewneck	Cotton	Black
TN19SSW010GR	Sweatshirt	N-Cubic Crewneck	Cotton	Grey
TN19SSW010OV	Sweatshirt	N-Cubic Crewneck	Cotton	Olive
TN19STS001BK	Tee	INTL. Logo Tee	Cotton	Black
TN19STS001FR	Tee	INTL. Logo Tee	Cotton	Forest
TN19STS001MI	Tee	INTL. Logo Tee	Cotton	Mint
TN19STS001WH	Tee	INTL. Logo Tee	Cotton	White
TN19STS002BK	Tee	HSP Logo Tee	Cotton	Black
TN19STS002LV	Tee	HSP Logo Tee	Cotton	Lavender
TN19STS002OV	Tee	HSP Logo Tee	Cotton	Olive
TN19STS002WH	Tee	HSP Logo Tee	Cotton	White
TN19STS003BK	Tee	C-Logo Tee	Cotton	Black
TN19STS003ER	Tee	C-Logo Tee	Cotton	Neon Green
TN19STS003PK	Tee	C-Logo Tee	Cotton	Pink
TN19STS003WH	Tee	C-Logo Tee	Cotton	White
TN19STS004BK	Tee	DEEP SHADE Tee	Cotton	Black
TN19STS004BU	Tee	DEEP SHADE Tee	Cotton	Burgundy
TN19STS004FR	Tee	DEEP SHADE Tee	Cotton	Forest
TN19STS005BK	Tee	TF Bulge Tee	Cotton	Black
TN19STS005WH	Tee	TF Bulge Tee	Cotton	White
TN19STS005YL	Tee	TF Bulge Tee	Cotton	Yellow
TN19STS006BK	Tee	CNP-Logo Tee	Cotton	Black
TN19STS006GR	Tee	CNP-Logo Tee	Cotton	Grey
TN19STS006OV	Tee	CNP-Logo Tee	Cotton	Olive
TN19STS006WH	Tee	CNP-Logo Tee	Cotton	White

Code	Category	Name	Material(s)	Color(s)
TN19STS007BK	Tee	T-Logo Pocket Tee	Cotton	Black
TN19STS007ER	Tee	T-Logo Pocket Tee	Cotton	Neon Green
TN19STS007NA	Tee	T-Logo Pocket Tee	Cotton	Navy
TN19STS007WH	Tee	T-Logo Pocket Tee	Cotton	White
TN19STS008BK	Tee	TN INTL. Panel Tee	Cotton	Black
TN19STS008BL	Tee	TN INTL. Panel Tee	Cotton	Blue
TN19STS008WH	Tee	TN INTL. Panel Tee	Cotton	White
TN19STS010BK	Tee	MI-Logo Tee	Cotton	Black
TN19STS010LM	Tee	MI-Logo Tee	Cotton	Lemon
TN19STS010MI	Tee	MI-Logo Tee	Cotton	Mint
TN19STS010WH	Tee	MI-Logo Tee	Cotton	White
TN19STS011BK	Tee	T-Logo Tee	Cotton	Black
TN19STS011BU	Tee	T-Logo Tee	Cotton	Burgundy
TN19STS011GR	Tee	T-Logo Tee	Cotton	Grey
TN19STS011LM	Tee	T-Logo Tee	Cotton	Lemon
TN19STS011TB	Tee	T-Logo Tee	Cotton	Light Blue
TN19STS011WH	Tee	T-Logo Tee	Cotton	White
TN19STS012BK	Tee	SP-INTL. Logo Tee	Cotton	Black
TN19STS012LV	Tee	SP-INTL. Logo Tee	Cotton	Lavender
TN19STS012NA	Tee	SP-INTL. Logo Tee	Cotton	Navy
TN19STS012WH	Tee	SP-INTL. Logo Tee	Cotton	White
TN19STS013BG	Tee	ARC Logo Tee	Cotton	Blue Green
TN19STS013BK	Tee	ARC Logo Tee	Cotton	Black
TN19STS013BU	Tee	ARC Logo Tee	Cotton	Burgundy
TN19STS013NA	Tee	ARC Logo Tee	Cotton	Navy
TN19STS013WH	Tee	ARC Logo Tee	Cotton	White
TN19STS014BK	Tee	Tennis Player Tee	Cotton	Black
TN19STS014WH	Tee	Tennis Player Tee	Cotton	White
TN19STS015BK	Tee	CP-INTL. Tee	Cotton	Black
TN19STS015NA	Tee	CP-INTL. Tee	Cotton	Navy
TN19STS015WH	Tee	CP-INTL. Tee	Cotton	White
TN19STS016BK	Tee	BUG BLOOD Tee	Cotton	Black
TN19STS016WH	Tee	BUG BLOOD Tee	Cotton	White
TN19STS017BK	Tee	Fishing Club Tee	Cotton	Black
TN19STS017BU	Tee	Fishing Club Tee	Cotton	Burgundy
TN19STS017WH	Tee	Fishing Club Tee	Cotton	White
TN19STS018BK	Tee	3SP Striped Tee	Cotton	Black
TN19STS018RD	Tee	3SP Striped Tee	Cotton	Red
TN19STS018WH	Tee	3SP Striped Tee	Cotton	White
TN19STS019BK	Tee	3ESP Logo Striped Tee	Cotton	Black
TN19STS019IB	Tee	3ESP Logo Striped Tee	Cotton	Ice Blue
TN19STS019WH	Tee	3ESP Logo Striped Tee	Cotton	White
TN19STS020BK	Tee	Cherokee Striped Tee	Cotton	Black
TN19STS020IV	Tee	Cherokee Striped Tee	Cotton	Ivory
TN19STS020NA	Tee	Cherokee Striped Tee	Cotton	Navy
TN19STS021BL	Tee	C-UNION Pocket Tee	Cotton	Blue
TN19STS021CH	Tee	C-UNION Pocket Tee	Cotton	Charcoal
TN19STS021PP	Tee	C-UNION Pocket Tee	Cotton	Purple
TN19STS022BG	Tee	NEW SPORTS Tee	Cotton	Blue Green
TN19STS022CH	Tee	NEW SPORTS Tee	Cotton	Charcoal
TN19STS022RD	Tee	NEW SPORTS Tee	Cotton	Red
TN19STS023GN	Tee	Tiedye Tee	Cotton	Green
TN19STS023LV	Tee	Tiedye Tee	Cotton	Lavender
TN19STS025GK	Tee	Bubble SP Tee	Cotton	Light Pink
TN19STS025NA	Tee	Bubble SP Tee	Cotton	Navy

Code	Category	Name	Material(s)	Color(s)
TN19STS025WH	Tee	Bubble SP Tee	Cotton	White
TN19STS027BK	Top	TN Polo	Cotton	Black
TN19STS027WH	Top	TN Polo	Cotton	White
TN19STS028BK	Tee	ACE Logo Tank	Cotton	Black
TN19STS028GR	Tee	ACE Logo Tank	Cotton	Grey
TN19STS028NA	Tee	ACE Logo Tank	Cotton	Navy
TN19STS029BK	Tee	Teenage Fishing Club Tee	Cotton	Black
TN19STS029WH	Tee	Teenage Fishing Club Tee	Cotton	White
TN19STS029YL	Tee	Teenage Fishing Club Tee	Cotton	Yellow
TN19STS030BG	Tee	T-CUBIC Tee	Cotton	Blue Green
TN19STS030BK	Tee	T-CUBIC Tee	Cotton	Black
TN19STS030BL	Tee	T-CUBIC Tee	Cotton	Blue
TN19STS030WH	Tee	T-CUBIC Tee	Cotton	White
TN19STS031BK	Tee	EMB. HSP Tee	Cotton	Black
TN19STS031BL	Tee	EMB. HSP Tee	Cotton	Blue
TN19STS031LM	Tee	EMB. HSP Tee	Cotton	Lemon
TN19STS031WH	Tee	EMB. HSP Tee	Cotton	White
TN19STS032BK	Tee	1-thisisneverthat Tee	Cotton	Black
TN19STS032OL	Tee	1-thisisneverthat Tee	Cotton, Polyester	Neon Yellow
TN19STS032WH	Tee	1-thisisneverthat Tee	Cotton	White

TN19SSO002OV

TN19SSO008BK

TN19SPA012BE

TN19SPA006GR

TN19SPA016GN

TN19SPA005OV

TN19SPA003BK

Code	Category	Name	Material(s)	Color(s)

TN19SHW011BL TN19SHW002GN TN19SHW010WH TN19SHW017CH TN19SHW005NA

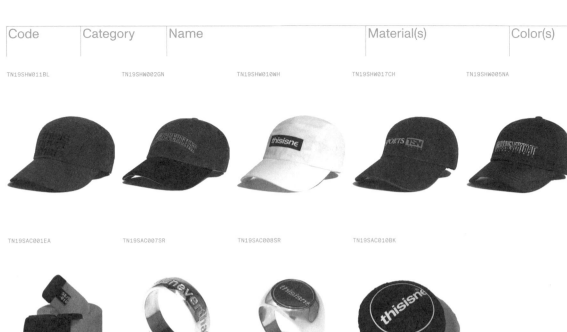

TN19SAC001EA TN19SAC007SR TN19SAC008SR TN19SAC010BK

TN19SAC004YL TN19SAC005BK TN19SAC002BK

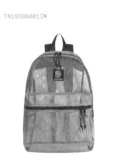 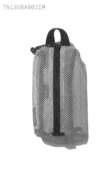 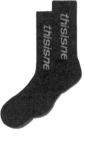

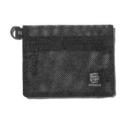

TN19SBA001IM TN19SBA003IM TN19SBA004BK TN19SBA003BK

이것이냐 저것이냐

정지돈, 소설가

늙음은 젊음의 꿈을 실현시킨다. 스위프트의 경우를 보라.
그는 젊어서 정신병원을 세웠지만, 늙어서 그 자신이 거기에 입원하였다.
—쇠렌 키르케고르(Søren Kierkegaard)

개요

2020년 1월 7일 화요일 오후 5시 16분 출판사 워크룸 프레스에서 청탁 메일을 받았다. 'thisisneverthat'이라는 패션 브랜드의 10주년을 기념하는 책과 웹사이트를 만드는 중이고, 그 책과 웹사이트에 실을 단편소설 또는 단편소설에 가까운 무엇을 써달라는 내용이었다. 다음은 책과 웹사이트의 편집자 겸 민구홍 매뉴팩처링(Min Guhong Manufacturing) 운영자 민구홍이 보낸 소설에 관한 구체적인 지침과 제반 사항이다.

- 결과물: 단편소설 또는 단편소설에 가까운 무엇
- 지침: '이것'과 '저것'이라는 대명사를 사용한다.
- 분량: 원고지 50매 이내 (최소 40매)
- 마감일: 2020년 3월 6일 금요일
- 원고료: 원고지 매당 15,000원 (최대 75만 원)
- 참고 사항: 워크룸 프레스 스타일 가이드 (한편, 원고가 영문으로 번역될 수 있습니다.)

나는 같은 날 밤 다음과 같이 질문했다.

지침에서 '이것'과 '저것'이라는 대명사만 사용한다는 게 정확히 무슨 뜻인가요? 고유명사를 사용해서는 안 되며 '이것'과 '저것'만 사용해야 한다는 뜻인지, 아니면 다른 의미가 있는지 궁금합니다.

그는 다음날 오전 다음과 같이 답변했다.

본디 고유명사까지 제한하는 방식도 생각했는데, 그러면 제약의 힘이 지나치게 세지지 않을까요? 고유명사를 제외한 대명사만 '이것'과 '저것'으로 활용해주시면 감사하겠습니다. 지침에는 다음과 같은 몇 가지 후보가 있었습니다. 지침 자체보다는 '느낌'에 집중하시고, 마음에 드시는 게 있다면 그대로 적용하시거나 기존 지침을 수정해 포함하셔도 좋습니다.

- 브랜드명에서 추출한 요소인 '이것', '결코', '저것', '아니다'를 적극적으로 활용한다.
- '이것'과 '저것'에 관해 서술한다.
- '이것'이 '결코' '저것'이 '아니게 된' 국면을 고안한다.

나는 이것이 무척 흥미로운 청탁이라고 생각했다. 글을 쓸 때 '이것'이나 '저것'을 많이 쓰는지, 그것만 써야 하는 제한이 어느 정도의 제약이 될지 의문이 들었지만 추세에는 지장이 없다고 생각했다. 그보다 10여 년 전에 지금은 사라진 극동방송국 근처의 에이랜드에서 thisisneverthat의 남색 코트를 산 기억이 났고, 꽤 오랫동안 잘 입고 다녔다는 사실이 떠올랐다. 한국예술종합학교에서 방송 영상을 전공한 친구의 졸업 영화제에 입고 갔는데, 당시 들고 다닌 잭 스페이드(Jack Spade)의 가방과 코트가 잘 어울려 사진을 여러 장 찍은 것도 기억났다. 그 이후로 꽤 많은 시간이 흘렀고 많은 게 변했다. 친구와는 연락이 끊겼고, 가방과 코트는 버렸으며, 잭 스페이드는 이제 딱히 살 이유가 없는 브랜드가 됐다.

지침에 관해

울리포(OuLiPo, Ouvroir de littérature potentielle) 같은 프랑스의 아방가르드 그룹들은 소설을 쓸 때 이것저것 제약을 뒀다. 알파벳 e가 들어가는 단어를 쓰지 않거나 e가 들어가는 단어만 쓰거나. 한편, 윌리엄 버로스(William Burroughs)나 브리온 기신(Brion Gysin)은 다른 글에서 자른 내용을 붙여 글을 완성하는 컷업(Cut-up) 기법을 활용했다. 이런 제약은 글을 흥미롭게 변형할 수 있다. 자아나 습관, 관습 밖으로 행위를 꺼낼 수 있는 가능성을 주기 때문이다. 소비에트 출신의 미학자 보리스 그로이스(Boris Groys)는 제약이야말로 작품을 완성하게 만드는 가장 중요한 요소라고 말했다. 제약, 일종의 한계가 없다면 작품은 영원히 확장되고 전진하게 될 것이다. 보리스 그로이스는 말한다. "우리의 한계가 우리를 완성시킨다."

　　그러나 이건 어디까지나 관념적인 이야기다. 실제로 글을 쓰는 입장에서는 그런 제약이나 조건 또는 수학적 규칙에 따라 글을 쓰는 시도에 큰 의미를 느낄 수 없었다. 규칙이 정해지고, 그 규칙을 위반할

수 있는 가능성이 사라지는 순간, 글을 쓰는 일은 더 이상 흥미롭지 않다. 글이 흥미로운 건 그곳에 위반의 가능성이 있으며 동시에 그런 위반이 한계를 깰 뿐 아니라 한계를 재도입하기 때문이다. 규칙은 오로지 글을 쓰는 과정 속에서 탄생하고 사라지기를 반복해야 한다. 다시 말해 규칙은 1) 명시적이어서는 안 되며 2) 변화해야 한다. 그러나 그런 걸 규칙이라고 부를 수 있을까.

프랑스의 소설가 조르주 페렉(Georges Perec)은 알파벳 e를 사용하지 않은 소설 『실종(La Disparition)』을 쓰고, 그 뒤 소설의 제목처럼 모음의 위치에 e만 사용한 소설 『돌아오는 사람들(Les Reventes)』을 썼다. 사전 지침, 즉 제약은 그에게 작품을 만드는 원동력이자 성경이었다. 따라서 제약을 위반하는 일은 그에게 작품의 균열, 나아가 붕괴를 의미했다.

보리스 그로이스는 말했다. "우리의 한계가 우리를 완성시킨다." 하지만 한계, 즉 규칙은 1) 명시적이어서는 안 되며 2) 변화해야 한다. 그러나 그런 걸 규칙이라고 부를 수 있을까.

한편, 미국의 시인 케네스 골드스미스(Kenneth Goldsmith)는 뒤섞기, 다시 사용하기, 용도 또는 맥락 바꾸기, 복사하기, 다시 쓰기, 반복하기 등 '문예 비창작적' 기법을 활용한 규칙을 통해 문예 창작을 실천한다. 그럼에도 규칙이 정해지고, 그 규칙을 위반할 수 있는 가능성이 사라지는 순간, 글을 쓰는 일은 더 이상 흥미롭지 않다. 물론 규칙이 정교하게 규칙을 위반할 수 있는 가능성까지 포섭한다면 이야기는 조금 달라진다. 규칙이 작품의 보조물을 넘어 규칙 자체가 또 다른 작품이 될 가능성이 커지므로.

전개

청탁을 받은 지 한 달 정도가 지나 작업에 착수했다. 결론부터 말하면 나는 지침을 적용하는 것과 지침을 위반하는 것 모두를 거의 포기했다. 지침 탓인지 아이디어가 떠오르지 않았다. SM 플레이에 빠진 신학도 게이의 연애담을 다룬 소설을 조금 썼지만 전혀 마음에 들지 않았다. 애초에 왜 이런 얼빠진 소재가 떠올랐는지 의문이었다. 이것이 결코 저것이 아니게 된 국면이 도래하리라는 일말의 기대가 있었던 것 같다. 쉬운 예로 이 관계가 결코 사랑이 아니게 되는 이야기라거나, 이 사랑은(this) 결코(never) 그런 사랑이(that) 아니라거나(is)… 게이 친구의 경험담이 소설 구상에 영향을 주기도 했다. 친구는 채팅 애플리케이션으로 젊고 몸이 좋은 목사 게이를 만났다. 피부가 깨끗한 교회 오빠 같은 목사는 자신을 발가벗기고 묶은 뒤 세게 한 방 갈겨달라고 부탁하는데… (후략)

친구의 이야기는 재미있었지만, 이것이 저것과 무슨 상관인지 알 수 없었고, 네이트 판에서 읽을 법한 이야기를 쓰는 것 같아 흥미가 생기지 않았다. 이야기로 들었을 때 좋은 이야기와 글로 읽었을 때 좋은 이야기는 분명히 다르다.

지인은 출판계나 문학계의 글이 점점 네이트 판 게시물처럼 변해가고 있음을 지적했다. 이것은 절대 저것이 아니라고 생각했는데, 어느새 자리가 바뀐 것이다. 마셜 매클루언(Marshall McLuhan)이 예언했듯 2차 구술 문화의 시대가 온 걸까. 문장이 말을 옮겨놓은 것처럼 가벼워지고 감정적이 되는 걸까.

지인은 말했지만 나는 이런 변화를 결코 부정적으로 생각하지 않았다. 변화의 양상이 단일하다고 보지도 않고 문학이 이것에서 저것이 되든 저것에서 이것이 되든 큰 상관이 없다. 솔직히 말하면 나는 아무것도 부정하지 않는다. 예술에 관한 것이라면 더더욱. 오직 중요한 건 원고를 마감할 수 있느냐 없느냐 뿐이다… 그러니 네이트 판이건 울리포건 쓰고 싶었지만 글은 영 진도가 나가지 않았다.

그렇게 작업이 지지부진하던 중 서울대학교 대학원에서 사회학을 공부하는 친구의 지인을 만나게 됐다. 친구는 그와 트위터로 알게 됐다고 말하며 자신이 아는 사람 중 책을 가장 많이 읽은 사람이라고 그를 소개했다. 지인의 말 때문인지 나이와 성별을 짐작할 수 없는 용모의 그/그녀는 범상치 않아 보였고, 대화를 주고받는 내내 한 번도 눈을

깜박이지 않았다. 말랐지만 손이 크고 거칠어 책만 읽는 사람처럼 보이지 않았는데, 아버지 가게 일을 돕는다고 했다.

딱히 직업은 없구요.

그/그녀가 말했다. 일을 하지 않을 때는 도서관에서 책을 읽는다고 했다. 취미도 없고 애인도 없고 돈도 없고 미래도 없다. 그런 걸 생각하지 않습니다만, 그런 걸 생각해야 하나요?

나는 할 말이 없었다. 미래가 없는 건 저도 마찬가지입니다, 라고 대답하고 싶었지만 그처럼 저돌적인 스타일은 아니기에 어색하게 웃기만 했다.

우리가 만난 곳은 망원동 앤트러사이트였다. 3층에 앉아 있었고, 평일 오전이라 그런지, 코로나19 때문인지, 사람이 거의 없었다. 우리는 이것과 저것에 관한 산만한 대화를 나누고, 나는 원고를 청탁받은 이야기를 꺼냈다. '이것'과 '저것'으로 글을 써야하는데 망했다, 뭘 써야할지 모르겠다, 마감까지 일주일도 남지 않았다.

내 이야기를 들은 그/그녀는 자신에게 글이 하나 있다고 했다. 너무 딱 맞아 말을 안 하는 게 이상할 정도라면서. 그/그녀는 한때 키르케고르에 빠졌고, 그래서 키르케고르의 책 『이것이냐 저것이냐』를 바탕으로 뭔가를 썼다고 했다.

이것이냐 저것이냐입니다.

쇠렌. 키르케고르 아시죠?

'쇠얀 키에르케고어'라고 말하기도 합니다만.

알죠.

어떻게 생각하세요?

그/그녀가 물었다.

…

솔직히 말하면 나는 키르케고르에 관해 아는 게 없었다. 내가 아는 건 그의 책 제목뿐이다. 『죽음에 이르는 병(The Sickness Unto Death)』, 『이것이냐 저것이냐(Either/Or)』, 『절망한 날엔 키르케고르(Vivre passionnément avec Kierkegaard)』…? 그러나 그렇게 말할 수는 없었다. 책을 많이 읽는 사람과의 대화에서 특정 작가에 대한 견해가 없음은 대화의 단절을 의미한다. 상대가 어떤 이름을 꺼내건 내밀 카드가 있어야 한다.

책에서 스치듯 본 키르케고르에 관한 묘사가 떠올랐다.
미남이지만 키가 너무 작았죠. 목소리도 안 좋았구요. 그/그녀가 고개를
끄덕였다. 키가 조금만 더 컸다면 볼테르가 될 수 있었을지도 모르죠.
볼테르가 키가 컸던가? 나는 우리의 대화가 조금 이상하다고 생각했지만
아무튼 고개를 끄덕였다. 비트겐슈타인도 키가 작았죠… 칸트도 작았고…

지돈 씨가 괜찮다면 제 글을 보내드려도 될까요? 마음에 드시면
자유롭게 사용하셔도 됩니다. 그/그녀는 자신의 글을 내가 청탁받은
원고에 써도 된다고 했다. 마감은 하셔야 하니까요. 단, 조건이 있습니다.
제가 누군지 절대 밝히면 안 됩니다. 그리고 원고료의 반을 제게 주세요.

그/그녀는 이틀 후 메일을 보냈다. 그/그녀의 글은 『이것이냐
저것이냐』 1부의 형식을 패러디한 일종의 사변소설이었다. 나는 신춘문예
같은 곳에 내볼 생각이 없는지 물었지만 경멸에 가까운 대답만 돌아왔다.
키르케고르/키에르케고어는 말했습니다. 모든 유형의 인간 중에서 가장
불쾌한 인간은 바로 대학 교수다. 저는 등단에는 관심이 없습니다.

나는 그의 입장을 충분히 이해하겠다고 했다. 등단을 한다고
대학 교수가 되는 건 아니지만… 다만 청탁에 '이것'과 '저것'만 써야
하는 지침이 있기 때문에 필요하면 임의로 글을 수정하겠다고 말했다.
그/그녀는 수락했다.

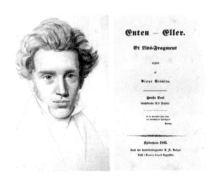

키르케고르의 초상과 1843년 2월 20일 덴마크에서 출간된 『이것이냐 저것이냐』 초판 표제지.
키르케고르는 이 책에서 가명을 사용했기 때문에 저자가 그인 사실을 아무도 몰랐다. 그렇게 그는
가명을 통해 오직 혼자서 자신의 여러 자아와 놀았다. 그의 가명 또는 이명(異名) 놀이는 1855년 11월
11일 끝났지만, 이후 페르난두 페소아는 자기식으로 놀이를 잇는다.

불안의 책

1.

구분과 선택은 인간의 가장 기본적인 활동이다. 의미를 만들어내는 건
의미가 아니라 구분과 선택이다. 옳고 그름, 선과 악은 존재하지 않는다.
구분과 선택의 관점에서는 모든 게 가능하다. 그러나 모든 게 동시에
가능한 건 아니다. 이것 아니면 저것이지 이것인 동시에 저것인 경우는
없다. 그렇다면 우리는 무엇 때문에 '아니오'라는 언어를 가지는가?

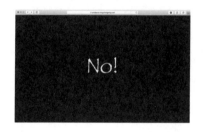

민구홍 매뉴팩처링의 제품 「오늘이 성탄절인가요?」. "매해 12월 이맘때면 문득 궁금해지곤 한다. 올해는
얼마나 다사다난했고, 이듬해는 얼마나 다사다난할지, 그리고 무엇보다 오늘이 성탄절인지. 진실, 또는
진실에 가까운 무엇은 강한 긍정과 강한 부정 둘 사이에 있다." 웹사이트의 형식을 띠는 제품은 오늘이
성탄절인지 파악해 고객에게 알려준다. 결과적으로 고객이 마주하는 문구는 대개 "아니오!(No!)"다.
그뿐이다. 이것 아니면 저것이지 이것인 동시에 저것인 경우는 없다. 오늘이 성탄절인가, 아닌가.
원고는 완성되는가, 아닌가. 제품은 중국과 베트남에 자리한 공장에서 대량생산되는가, 아닌가. https://
products.minguhongmfg.com/is-it-christmas-today

2.

1811년에 태어나 1855년에 죽은 덴마크의 철학자 쇠렌
키르케고르에게 선택은 중요한 문제였다. 그는 약혼자 레기네 올센(Regine
Olsen)과 파혼하고 코펜하겐을 떠나 베를린으로 갔다. 헤겔의 철학을
넘어섰다고 소문 난 프리드리히 빌헬름 요제프 셸링(Friedrich Wilhelm
Joseph von Schelling)의 강의를 듣기 위해서였다. 키르케고르는 강연을
듣고 난 뒤 친구 에밀 보에센(Emil Boesen)에게 다음과 같은 편지를
보냈다. "셸링은 터무니없는 횡설수설을 늘어놓고 있소. 그의 강연은
한마디로 요약할 수 있소. 참을 수 없는 헛소리! 나는 베를린을 떠나
코펜하겐으로 돌아갑니다. 『이것이냐 저것이냐』를 완성하기 위해."
　　　『이것이냐 저것이냐』에서 그는 두 가지 관점을 충돌시킨다.

심미적인 관점과 윤리적인 관점. 다시 말해 쾌락을 쫓으며 살 것인가, 의무와 책임을 다하며 살 것인가. 그러나 둘 중 어느 쪽 삶이 더 나은지 고민할 필요는 없다. 세간의 평가와 달리 중요한 건 두 관점의 내용이 아니라, 선택의 문제 그 자체다. 키르케고르는 선택이라는 문제를 정식화하고 파고든 거의 최초의 철학자다.

　　　　　선택은 불안을 야기한다. 우리는 우리의 선택이 옳은지 그른지 알 수 없기 때문이다. 그러므로 첫 번째 결론, 불안은 존재의 본질이다. 동시에 불안은 자유를 가능케 한다. 선악과를 먹지 말라는 신의 금지가 있었기에 아담에겐 선악과를 먹느냐 마느냐를 택할 수 있는 자유가 주어졌다. 의무와 책임이 있기 때문에 우리는 그것을 방기할 수 있다. 선택은 우리를 파멸로 이끌 수 있지만 우리에겐 우리를 망칠 수 있는 자유가 있다. 그러므로 두 번째 결론, 자유는 불안의 결과다. 현기증은 추락에 대한 공포로 발생하지 않는다. 우리 안의 떨어지고자 하는 충동 때문에 발생한다. 우리에게 주어진 우리를 망칠 수 있는 자유, 그것이 우리를 현기증 나게 한다. 고로 선택 → 불안 → 자유는 우로보로스(Ouroboros)의 원처럼 끝없이 맴돌며 스스로를 집어삼킨다.

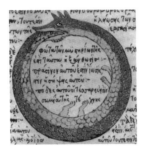

선택 → 불안 → 자유 → 선택 → 불안 (…)

3.

그러나 내겐 자유가 없다. 자유를 원하지도 않는다. 내게 필요한
건 자유보다 돈이다. 돈이 곧 자유 아닌가? 아니, 그건 헛소리다!
키르케고르의 논리 구조에 따르면 돈은 불안이 아니라 안정에 기여한다.
우리가 가진 돈이 한정돼 있으면, 우리는 둘 중 하나를 선택해야 한다.
그러므로 선택의 문제가 발생한다. 그러나 돈이 충분히 있다면 둘 다 사면
된다! 고로 돈은 선택을 제거하고 불안을 제거하고 자유를 제거한다. 돈은
본질의 반대급부다.

4.

키르케고르는 이렇게 말했다. "내 숙부는 이것이냐 저것이냐(either/or)
였고, 아버지는 이것도 저것도(both/and)였으나, 나는 이것도 저것도
아니었다(neither/ nor)."

> A. 돈이 많다. → 이것도 저것도 가능하다.
> B. 돈이 조금 있다. → 이것이냐 저것이냐.
> C. 돈이 없다. → 이것도 저것도 불가능하다.

5.

A와 C는 유사한 매커니즘으로 인간을 파멸시킨다. A의 인간은 지루함과
권태에 따른 광기, 과욕과 탐욕의 병증 속에서 타락한다. C의 인간은
무력감과 불능 때문에 쪼그라든다. 이렇게 말할 수도 있을 것이다. 돈이
적당히 있으면 되는 것 아닌가. 그러면 절반의 자유와 그 때문에 놓치는
기회비용이 발생한다. 선택의 자유가 다시 주어지는 것이다. 그러나 돈은
그 속성상 적당함을 모른다. 돈, 자본의 본질은 무한한 증가와 확장이다.
돈이 증가하기 위해서는 빈부를 오가는 운동이 필수적이다. 그러므로 돈은
누구에게도 중간 단계를 허락하지 않는다. 우리는 더 많은 돈을 원하거나
더 많은 돈을 잃는다.

조금 더 '현대적으로' 묘사한 우로보로스.

6.

나는 아무것도 하고 싶지 않다. 나는 차를 타고 싶지 않다. 왜냐하면
운전이란 지나치게 위험한 짓이니까. 나는 걷고 싶지 않다. 왜냐하면
걷는다는 건 힘든 일이니까. 나는 눕고 싶지 않다. 왜냐하면 누운 채로
있거나 결국 다시 일어나야 하는데, 나는 둘 다 하기 싫기 때문이다. 나는
돈을 벌고 싶지 않다. 왜냐하면 돈을 벌면 돈을 쓰거나 돈을 더 벌어야
하는데, 나는 둘 다 하기 싫기 때문이다. 결국 나는 아무것도 하고 싶지
않다.

7.

『이것이냐 저것이냐』는 1843년 2월 20일에 출간됐다. 책은 덴마크
코펜하겐에서 센세이션을 일으켰지만, 가명으로 출간됐기 때문에 아무도
저자가 키르케고르라는 사실을 몰랐다. 키르케고르는 사람들이 책을
전혀 이해하지 못하기 때문에 책이 잘 팔린다고 생각했다. 몇몇 눈이
빠른 사람은 책의 저자가 교회를 비판하는 유명 논객인 키르케고르라고
떠들기도 했다. 이에 키르케고르는 격분에 찬 항의문을 썼다. "그
책의 저자가 나라는 이야기가 있다. 터무니 없는 소리다. 『이것이냐
저것이냐』는 형편없는 저작이다."

　　　　키르케고르는 사람들을 속이는 데 병적인 즐거움을 느꼈고,
거의 모든 저작을 가명으로 쓴 뒤 자신의 가명을 비판하기 위해 가명을
썼고, 그 비판을 다시 비판하기 위해 가명을 썼다. 후세 사람들은
키르케고르가 왜 그렇게 피곤한 짓거리를 했는지 의문을 표했다. 그는
이후 『철학적 조각들에 대한 결론으로서의 비학문적 후서(Afsluttende
uvidenskabelig Efterskrift)』라는 책에서 그 이유를 다음과 같이 밝혔다.

"내가 가명 내지 여러 이름을 쓴 건 내 개인 속에 우연적인 이유가
있어서가 아니라… 작품 그 자체의 성격 속에 본질적인 이유가 있다."
그러나 그 본질적인 이유에 관해서는 아무런 부가적인 설명이 없다.
게다가 그의 저작은 이름만 가명일 뿐 내용은 자신에 관한 전기적인
내용으로 가득했다. 사람들은 처음에는 키르케고르가 벌이는 가명 놀이에
흥미를 표현했지만, 나중에는 아무도 관심이 없었다. 키르케고르는 오직
혼자서 자기 자신의 여러 자아와 놀았다.

8.
우리는 거의 언제나 우리 자신 밖에 살고 있으며, 인생 자체는 영원한
분산이다. 그러나 우리는 결국 우리 자신을 중심에 두고 마치 행성처럼 그
주위를 터무니없이 긴 타원을 그리며 돌고 있다.

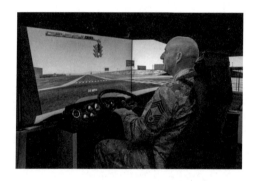

나는 차를 타고 싶지 않다. 왜냐하면 운전이란 지나치게 위험한 짓이니까. (…) 나는 돈을 벌고 싶지
않다. 왜냐하면 돈을 벌면 돈을 쓰거나 돈을 더 벌어야 하는데, 나는 둘 다 하기 싫기 때문이다. 결국 나는
아무것도 하고 싶지 않다. 그럼에도 원고는 조금씩 나아가고, 제품은 중국과 베트남에 자리한 공장에서
대량생산될 채비를 마친다.

9.
결혼을 하라. 그러면 그대는 후회할 것이다. 결혼하지 말라. 그래도 역시
그대는 후회할 것이다. 결혼을 하든 않든 간에 그대는 후회할 것이다.
세상의 어리석은 일을 보고 웃어라. 그러면 그대는 후회할 것이다. 세상의
어리석은 일을 보고 울라. 그래도 역시 그대는 후회할 것이다. 그대 자신의
목을 매달라. 그대는 후회할 것이다. 그대 자신의 목을 매달지 말라. 그래도
그대는 후회할 것이다. 그대 자신의 목을 매달든 그렇지 않든 간에 그대는
후회할 것이다. 그대는 그대 자신의 목을 매달거나 매달지 않을 테지만,

어느 쪽을 택해도 그대는 후회할 것이다. 이것이 모든 철학의 총화이자 알맹이다. 진정한 영원은 이것이냐 저것이냐의 뒤에 있는 게 아니라, 그것 앞에 있다. 내 철학은 이해하기 매우 쉽다. 내겐 단 하나의 원칙만 있을 뿐이고, 그 원칙에서 출발조차 하지 않기 때문이다. 내 원칙에서 출발하지 않는다는 건 그것에서 출발한다는 것에 대한 반대 개념으로 이해할 게 아니라, 오히려 그것에서 출발하는 것이나 그것에서 출발하지 않는 것에 꼭 같이 반대한다는 뜻으로, 즉 원칙 그 자체에 대한 소극적인 표현이다. 나는 내 원칙에서 출발하지 않는다. 나는 결코 출발하지 않기 때문에, 나는 중지하려 해도 중지할 수가 없다. 나의 영원한 출발은 곧 나의 영원한 중지다.

10.

이것이 내가 아무런 일도 구하지 않고 책을 출판하지도 않으며 독립하지도 않고 친구도 사귀지 않는 이유다. 나는 아무것도 하지 않지만 아무것도 하지 않기 때문에 모든 것을 할 수 있다. 선택에 대한 거부는 오로지 이런 방식으로 가능하다.

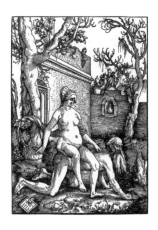

아리스토텔레스(Aristotle)의 애인 필리스(Phyllis)는 그에게 고삐를 채우고 등에 올라타 채찍을 내려친다. 여기서 던질 만한 질문은 '왜?'가 아니라 엄밀히 따지면 '무엇을 위해?'다. 본디 SM 플레이에 빠진 신학도 게이의 연애담을 다룬 소설을 조금 썼지만 전혀 마음에 들지 않았다. 애초에 왜 이런 얼빠진 소재가 떠올랐는지 의문이었다. 이것이 결코 저것이 아니게 된 국면이 도래하리라는 일말의 기대가 있었던 것 같다. 기대한 바가 이룩되리라는 기대는 대개 기대만큼 이룩되지 않는다.

마감

그/그녀의 글을 살펴본 결과 「단장 9」는 페르난두 페소아(Fernando Pessoa)의 『불안의 책(Livro do Desassossego)』에서 인용한 내용이었다. 내가 인용처를 표기해야 하는지 묻자 그/그녀는 인용한 게 아니라고 했다.

우연의 일치입니다.
한 단어도 빼지 않고 같은데요.
놀라운 일이네요.

그/그녀가 말했다. 나는 페소아의 책에서 다음과 같은 구절도 발견했다.

나는 아무것도 아니다.
아무것도 될 수 없을 것이다.
아무것도 아니고 싶을 수도 없다.
그럼으로써 나는 세상의 모든 꿈을 내 안에 품는다.

「단장 11」과 많이 유사하지 않나요?
—나, 2020년 3월 7일 토요일 23시 54분

결정적인 부분이 다르네요. 저는 아무것도 "하지" 않는다고
했지만 페소아는 아무것도 "되지" 않는다고 했습니다.
그는 존재를 부정하는 것이고, 저는 행위를 부정하면서 존재를
미결정 상태에 빠뜨리는 것이지요.
—그/그녀, 2020년 3월 8일 일요일 0시 8분

Either/Or

Jung Jidon, Writer

Old age realizes the dreams of youth: look at Dean Swift;
in his youth he built an asylum for the insane, in his old age he himself entered it.
— Søren Kierkegaard, *Either/Or* (1843)

Overview

At 5:16 p.m. on Tuesday, January 7, 2020, I received an email from Workroom Press. They were working on a book and a website to commemorate the tenth anniversary of the fashion brand "thisisneverthat" and wanted me to contribute a short story or something close to one. Min Guhong, editor and CEO of Min Guhong Manufacturing, sent me the following guidelines and other details of the commission:

- *Outcome: A short story or something similar*
- *Instructions: Use the pronouns "this" and "that"*
- *Length: Maximum 50 squared manuscript sheets (minimum 40)*
- *Deadline: Friday, March 6, 2020*
- *Fee: 15,000 KRW per sheet (maximum 750,000 KRW)*
- *Note: Please refer to the Workroom Press Style Guide. (Your text may be translated into English.)*

I replied the same night with a question:

> *What exactly does the instruction to use the pronouns "this" and "that" mean? Does it mean I can't use proper nouns and can only use "this" and "that," or does it mean something else?*

The next morning, I received the following reply:

> *We did originally think of restricting the use of proper nouns too, but we felt that would be too much of a constraint. It'd be great if you use only "this" and "that." We had shortlisted a few other instructions at first. Please don't think of them as set in stone but rather focus on the "feeling," and if you like any of them please feel free to apply them as they are or modify the existing guidelines to include them.*
> - *Utilize elements from the brand name: "this," "never," and "that."*
> - *Describe "this" and "that."*
> - *Devise a situation in which "this" can "never" be "that."*

I found this to be an intriguing proposition. I wondered if I used "this" or "that" a lot in my writing and was skeptical how much of a constraint using only them would prove to be, but I had no problem with the direction. More than that, I remembered buying a blue thisisneverthat coat from an ÅLAND

store close to the now defunct Far East Broadcasting Station building and enjoying wearing it for quite some time. I wore it to the graduation film festival of a friend who majored in broadcasting at the Korea National University of Arts and I remembered having several snaps taken because the Jack Spade bag I was carrying went well with the coat. A lot of time has passed since then and much has changed. I've lost touch with my friend, have discarded the bag and coat, and Jack Spade is now a brand I don't really have a reason to buy.

About the Guidelines

French avant-garde groups like Oulipo use different constrained writing techniques. For example, not using words that contain the letter E or only using words that have the letter E. William Burroughs and Brion Gysin used the cut-up technique to complete their text by pasting portions cut out from other texts. Such restrictions can alter the text in interesting ways because they offer the possibility to act separately from one's self, habits, and customs. Soviet aesthetician Boris Groys said that constraints were the most important factor in completing a work. Without constraints, without some sort of limitation, the work would expand and advance forever. He said, "Our limits complete us."

But all this was conceptual. As somebody who actually wrote, I didn't find much meaning in writing with such restrictions, conditions, or mathematical rules. When rules are set and the possibility of breaking them disappears, writing is no longer interesting. Writing is fun because of the possibility of breaking rules, and at the same time such rule breaking not only destroys limits but also reintroduces them. Rules should be born and disappear in the writing process. In other words, rules should (a) not be explicit and (b) should change. But could such a rule still be called a rule?

French novelist Georges Perec wrote the novel *La Disparition* using only words that did not contain the letter E and then wrote another novel *Les Revenentes* in which the only vowel he used, including in the title, was the letter E. Pre-existing guidelines, or constraints, were like the Bible for him and a driving force that helped create his work. Thus, to him violating the restrictions meant a rupture in his work and, going further, its collapse.

Boris Groys said, "Our limits complete us." However, limits, that is rules, should (a) not be explicit and (b) should change. But could such a thing still be called a rule?

Meanwhile, American poet Kenneth Goldsmith practiced creative writing by applying rules that used "noncreative writing" techniques such as shuffling, reusing, changing purpose or context, copying, rewriting, and repeating. Nevertheless, as soon as rules are established and the possibility of breaking them disappears, writing is no longer interesting. Of course, it's a different story if the rule embraces the possibility of deftly breaking it. Because it increases the likelihood that the rule goes beyond being an aid and itself turns into another work.

Discussion

I began working on the story a month after receiving the commission. In conclusion, I almost gave up on both applying the guidelines and violating them. I don't know if it was the because of the guidelines, but an idea just didn't occur to me. I started on a story about a theologian who gets into SM play but it was not at all to my liking. I don't know why such a sloppy material occurred to me in the first place. I guess I had a tinge of expectation that it would eventually arrive at a point where this would never be that. Put simply, a story about how this relationship would never turn into love, how "this" love would "never" be "that" love … The tales I heard from my gay friends also influenced my conception of the story. A friend hooked up with a young and fit gay pastor through an app. The pastor who had clean skin and a "church guy" look asked my friend to strip him bare, tie him up, and give him a sound smacking… [omitted]

The friend's anecdote was interesting but I couldn't figure out what this had to do with that and it felt like something I would find posted on Nate Pann message boards, so developing it into a story wasn't that appealing. Stories that are fun to listen to are clearly different from those that are fun to write.

An acquaintance pointed out that the writings coming out of the publishing and literary circles were also becoming more and more like Nate Pann posts. I had thought this would never be that, but the positions had interchanged at some point. Had the era of secondary orality that Marshall

McLuhan prophesied arrived? Were sentences becoming lighter and more emotional as if they were spoken words put to paper?

Unlike my acquaintance, I never thought of such changes negatively. I didn't think change had only one aspect and I thought it didn't really matter if literature became that from this or this from that. To be honest, I reject nothing. All the more so when it comes to art. The only thing that matters is whether I can finish the story … So I wanted to write no matter if it was a Nate Pann-type post or an Oulipo piece, but I made no progress whatsoever.

While the writing was proceeding at a sluggish pace, I met an acquaintance of a friend who was studying sociology at Seoul National University. The friend said they had connected over Twitter and that this person was the most well-read person he knew. Maybe because of what my friend said, his acquaintance appeared out of the ordinary. I couldn't make out the person's age or gender from their appearance and he/she never blinked once during our conversation. They were thin, but their hands were large and rough, so it didn't look like they only read books. He/she said they helped out their father at his shop.

I don't have a real job, he/she said.

They said they read books at the library when they were not working. I have no hobbies, no lover, no money, no future. I don't think about such things. Do I have to?

I had nothing to say. I wanted to reply, I have no future either, but I wasn't the reckless-type like them so I just laughed weakly.

We were at an Anthracite coffee shop in the Mangwon-dong district. We were on the third floor and since it was a weekday morning, or maybe because of COVID-19, there were very few people. We shared a discursive conversation about this and that, and I told them about the commission. I have to write using "this" and "that" but I'm screwed. I have no idea what to write, and the deadline is less than a week away.

When he/she heard this, they said they had a piece. It was so perfect it'd be weird not to share. He/she said they were once completely taken up by Søren Kierkegaard and wrote something based on his work.

It's *Either/Or*. Kierkegaard. Søren Kierkegaard. Have you heard of him? It's pronounced SORR-ən KEER-kə-gor.

I've heard of him.

What do you think of him? he/she asked.

…

To be honest, I knew nothing about Kierkegaard. All I knew were the titles of his books: *The Sickness Unto Death, Either/Or, Vivre passionnément*

avec Kierkegaard. But I couldn't tell them that. To lack knowledge of a particular writer while talking to a well-read person means a break in the conversation. No matter what name the other person brings up, you should have a card you can play.

A description of Kierkegaard that I'd skimmed through in a book came to mind. He was good looking but short. His voice wasn't good either. He/she nodded. If he were a little taller he could've been the next Voltaire. How tall was Voltaire? I thought our conversation was a bit strange but I nodded anyway. Wittgenstein was also short … Kant too …

If you don't mind, can I send you my piece? If you like it, you can use it as you please. He/she said I could use their piece for the commission. You have to send in something, right? But I have a few conditions. You can't reveal who I am. And you have to give me half of your payment.

He/she emailed me two days later. The piece was a sort of speculative fiction that parodied the format of part one of *Either/Or.* I asked them if they didn't want to submit it to a literary contest or something but I only received a disdainful reply: Kierkegaard/KEER-kə-gor said the most loathsome of all humans was the university professor. I have no interest in debuting.

I said I fully understood their position. *But debuting as a writer won't make you a professor* … I told them I could amend their text if necessary to fit the theme of "this" and "that." He/she agreed.

A portrait of Kierkegaard and the cover of his *Either/Or* published in Denmark on February 20, 1843. Kierkegaard published this book under a pseudonym so nobody knew he was the author. He played alone with his various selves using pseudonyms. His pseudonym or nickname game ended on November 11, 1855, but Fernando Pessoa continued the game in his own way.

1. Classifying and choosing are the most basic human activities. What creates meaning is not meaning but classification and choice. There is no right or wrong, or good or evil. Everything is possible in terms of classifying and choosing. But not everything is possible at the same time. If it's not this, then it's that, but this cannot be that at the same time. So why do we have the language for "no"?

Min Guhong Manufacturing's product "Is it Christmas Today?" "Around this time every December I find myself thinking how eventful this year was, how eventful the next year would be, and, above all, if today was Christmas. The truth, or something close to truth, lies between strong affirmation and strong denial." This product which is in the form of a website tells customers if today is Christmas. As a result, the word customers usually encounter is "No!" That's all. If it's not this, then it's that; it cannot be this and that at the same time. Is today Christmas or is it not? Is the manuscript ready or is it not? Is the product mass-produced in factories in China and Vietnam or is it not? https://products.minguhongmfg.com/is-it-christmas-today

2. Choice was an important issue for the Danish philosopher Søren Kierkegaard who was born in 1811 and died in 1855. He broke off his engagement with Regine Olsen and left Copenhagen for Berlin. He wanted to attend the lectures of Friedrich Wilhelm Joseph von Schelling who was rumored to have surpassed Hegel. After listening to his lecture, Kierkegaard sent the following letter to his friend Emil Boesen: *Schelling is talking utter gibberish. I can summarize his lecture thus: insufferable nonsense! I shall leave Berlin and come to Copenhagen. I intend to complete* Either/Or.

Kierkegaard collides two perspectives in *Either/Or*: the aesthetic and the ethical. In other words, will you spend your life in pursuit of pleasure or will you live while carrying out your duties and responsibilities? But you don't have to worry about which life is better. Unlike what the world tells you, what is important is not the content of the two perspectives but the choice itself. Kierkegaard was the first philosopher to formulate and delve into the issue of choice.

Choice causes anxiety. Because we can't tell if our choice is right

or wrong. Therefore, the first conclusion is that anxiety is the essence of existence. At the same time, anxiety enables freedom. Adam was given the freedom to choose between eating or not eating from the tree of the knowledge of good and evil precisely because God forbade him to eat from it. We can give up freedom because of our obligations and responsibilities. Choice can lead us to ruin but we have the freedom to head toward ruin. Thus the second conclusion is that freedom is the result of anxiety. Vertigo doesn't arise from the fear of falling. It is caused by our internal urge to fall. The freedom granted us to wreck ourselves—that is what makes us dizzy. Choice → anxiety → freedom circulate endlessly like the circle of Ouroboros that devours itself.

Choice → anxiety → freedom → choice → anxiety [...]

3. But I have no freedom. I don't want it either. More than freedom I need money. Isn't money freedom? No, that's nonsense! Going by Kierkegaard's logic, money contributes to stability, not anxiety. If our money is limited, we have to choose between the two. Therefore the question of choice arises. But if we have enough money we can buy both! So money removes choice, removes anxiety, and removes freedom. Money is the opposite of essence.

4.　　　　Kierkegaard said, "My uncle was Either/Or, my father is Both/And, and I am Neither/Nor."

> A. A lot of money → Both/And
> B. Some money → Either/Or
> C. No money → Neither/Nor

5.　　　　A and C destroy people with a similar mechanism. People in A degenerate from the diseases of insanity, avarice, covetousness arising from boredom and ennui. People in C shrivel from their helplessness and incompetence. You might say you'll be fine if you have a moderate amount of money. But that would cost you half your freedom and the resulting expense of missed opportunity. The freedom of choice is bestowed on you again. However, money by nature doesn't know moderation. The essence of money, of capital, is unlimited growth and expansion. For money to grow, movement between the rich and poor is essential. Therefore, money doesn't allow any intermediate step to anybody. We want more money or lose more money.

A more "modern" depiction of Ouroboros

6.　　　　I can't be bothered. I can't be bothered to ride, the motion is too violent; I can't be bothered to walk, it's strenuous; I can't be bothered to lie down, for either I'd have to stay lying down and that I can't be bothered with, or I'd have to get up again, and I can't be bothered with that either; I can't be bothered to make money, for either I'd have to spend it and that I can't be bothered with, or I'd have to make more, and I can't be bothered with that either. In short: I just can't be bothered.

7.　　　　*Either/Or* was published on February 20, 1843. It caused a sensation in Copenhagen, Denmark, but since it was published under a pseudonym nobody knew Kierkegaard was the author. Kierkegaard thought the book was selling well because people didn't understand it at all. Some

sharp-eyed people clamored that Kierkegaard, the famous critic of the Church, was the author. In response, Kierkegaard shot off a letter, protesting furiously, "There is talk that I'm the author of the book. That's gibberish. *Either/Or* is a terrible book."

Kierkegaard took morbid pleasure in deceiving people, and published almost all of his books under pseudonyms, then used other pseudonyms to criticize those same books. Future generations questioned why Kierkegaard pulled such tiring pranks. He explained the reason in *Afsluttende uvidenskabelig Efterskrift*: "I use pseudonyms or heteronyms not out of some incidental reason within my person … rather the fundamental reason lies in the character of the work itself." But he gave no additional explanation about the fundamental reason. Besides, while his book was written under a pseudonym, the content was full of biographical details about himself. People initially showed interest in Kierkegaard's pseudonym game but their interest soon withered. Kierkegaard was left to play with his various selves by himself.

8. We almost always live outside ourselves, and life itself is an eternal dispersion. However, we end up putting ourselves in the center and revolve around it like a planet drawing a ridiculously long ellipse.

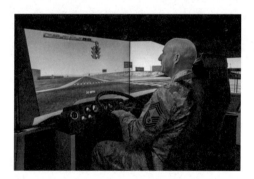

I can't be bothered to ride, the motion is too violent […] I can't be bothered to make money, for either I'd have to spend it and that I can't be bothered with, or I'd have to make more, and I can't be bothered with that either. In short: I just can't be bothered. Nevertheless, the manuscript is progressing little by little, and the products are ready for mass production at factories in China and Vietnam.

9. Marry, and you'll regret it; don't marry, you'll also regret it; marry or don't marry, you'll regret it either way. Laugh at the world's follies, you'll regret it; weep over them, you'll regret that too; laugh at the world's follies or weep over them, you'll regret both. Hang yourself, you'll regret it; don't hang yourself, and you'll regret that too; hang yourself or

don't hang yourself, you'll regret it either way; whether you hang yourself
or don't hang yourself, you'll regret both. This is the sum and substance of
all philosophy. True eternity lies not behind either/or but ahead of it. My
philosophy is easy to understand, for I have only one principle, which is not
even my starting-point. In saying that I don't start out from my principle,
the opposite of this is not a starting-out from it, but simply the negative
expression of my principle, the expression for its grasping itself as in oppo-
sition to a starting-out or a not-starting-out from it. I don't start out from my
principle. Since I never start I can't stop even if I try, for my eternal starting
is my eternal stopping.

10. This is why I don't look for work, publish books, become inde-
pendent, or make friends. I don't do anything, but because I do nothing I
can do everything. Rejection of choice is possible only in this way.

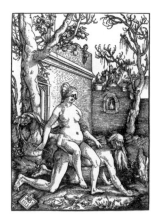

Phyllis puts a bridle on her lover, Aristotle, climbs onto his back, and cracks her whip. The ques-
tion worth asking here is not "Why?" but "For what?" I originally started with the gay love story
of a theologian who gets into SM play but it was not at all to my liking. I don't know why such
a sloppy material came to my mind in the first place. I guess I had a tinge of expectation that it
would arrive at a point where this would never be that. The expectation that your expectations will
be fulfilled is generally not fulfilled to the degree you expect.

Closing

On examining his/her piece, I realized "9" was quoted from Fernando Pessoa's *Livro do Desassossego*. When I inquired if I should clarify the source, they replied that it wasn't a quote.

> It's a coincidence.
> But it's exactly the same without a single word changed.
> That's surprising, he/she said.

I also discovered the following lines in Pessoa's book:

> *I am nothing.*
> *I'll never be anything.*
> *I couldn't want to be something.*
> *Apart from that, I have in me all the dreams in the world.*

Isn't it a lot similar to "11"?
—You sent on Saturday, March 7, 2020, 11:54 p.m.

> *The crucial part is different. I said I can't be bothered to "do" anything but Pessoa said he can't "be" anything. He is denying existence and I'm denying action and putting existence in an indeterminate state.*
> —He/she sent on Sunday, March 8, 2020, 00:08 a.m.

Translation
Agnel Joseph

SPRING/SUMMER 2020

SOFT WORK

TN20SSH003GN, Shirt, Bleach Check Shirt ◾ TN20STS001ER, Tee, Small
T-Logo Tee ◾ TN20SSO010CH, Pants, Overdyed Short

TN20SLS007FR, Long Sleeve Tee, Acid Washed L/SL Top ◾ TN20SPA005FL,
Pants, Crazy Work Pant ◾ TN19FAC017SR, Accessory, LION Necklace

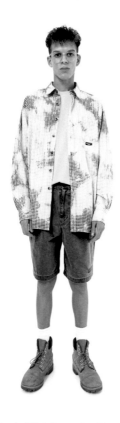

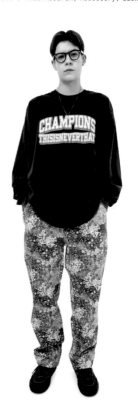

TN20SOW011GN, Top, Overdyed Work Vest ◾ TN20STS001WH, Tee, Small T-Logo
Tee ◾ TN20SPA006GN, Pants, Overdyed Big Pant ◾ TN20SHW004GR, Hat, SOFT
WORK Jersey Cap

TN20SLS009OR, Long Sleeve Tee, Striped Tiedye L/SL Top ◾ TN20SPA017PNT,
Pants, Painter Pant

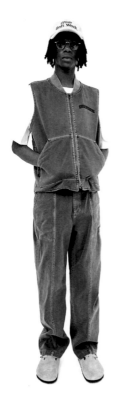

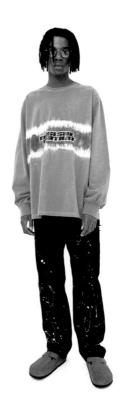

TN20SSH005DGY, Shirt, E/T-Logo Ripstop S/S Shirt ▌TN20SLS010WG, Long Sleeve Tee, T-Logo Waffle L/SL Top ▌TN19FPA002TB, Jean, Regular Jean ▌TN20SAC001BK, Accessory, Leather Belt

TN20SOW001OV, Jacket, PCU Jacket ▌TN20STS019YL, Tee, Reverse Overdyed Tee ▌TN20SSO004OV, Pants, PCU Short ▌TN19FAC010MD, Socks, Tiedye Socks

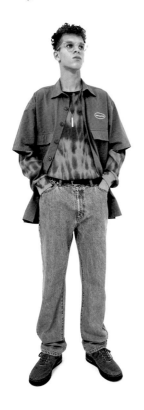

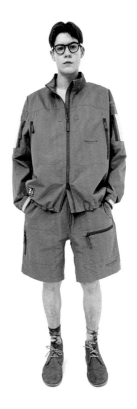

TN20SSW009IA, Sweatshirt, Houndstooth Crewneck ▌TN20SPA016BW, Pants, Houndstooth Sweatpant ▌TN20SAC002WH, Socks, HSP-Logo Socks

TN20SOW002BL, Jacket, Sportsman Jacket ▌TN20SPA009BL, Pants, Sportsman Pant ▌TN20SHW005BK, Hat, PERMUTATIONS Mesh Trucker

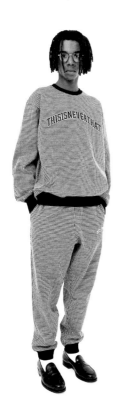

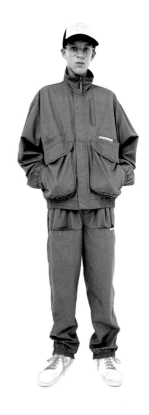

TN20SSW008GP, Sweatshirt, Tiedye DRAGON Crewneck ❚ TN20SPA007BK, Pants, Zip Cargo Pant ❚ TN20SAC004SR, Accessory, INTL. Logo Ring

TN20STS006DF, Tee, Earth Tee ❚ TN20SPA003TB, Pants, Zip Flight Pant ❚ TN20SAC001BR, Accessory, Leather Belt ❚ TN20SAC006SR, Accessory, T-Logo Bangle ❚ TN20SAC004SR, Accessory, INTL. Logo Ring

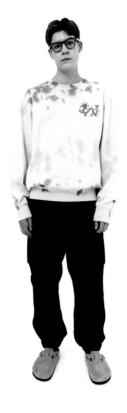

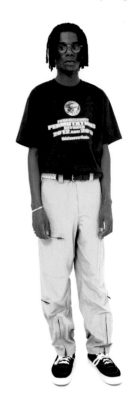

TN20SOW006BK, Jacket, Seer Zip Jacket ❚ TN20SSO009BK, Pants, Seer Short

TN20SHS008PP, Sweatshirt, Damaged Hooded Sweatshirt ❚ TN20SPA014PP, Pants, Damaged Sweatpant ❚ TN20SAC002BK, Socks, HSP-Logo Socks

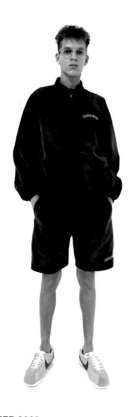

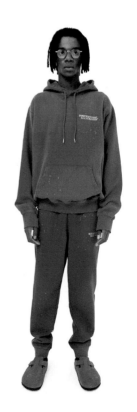

TN20SOW003BL, Jacket, POLARTEC® Fleece Jacket ▊ TN20SLS006SB, Long Sleeve Tee, Script Striped L/SL Top ▊ TN20SPA003OV, Pants, Zip Flight Pant

TN20SHS006DBG, Sweatshirt, N 1/4 Zip Hooded Sweatshirt ▊ TN20STS001WH, Tee, Small T-Logo Tee ▊ TN20SPA007ES, Pants, Zip Cargo Pant ▊ TN20SHW002IV, Hat, Suede Bill Cap

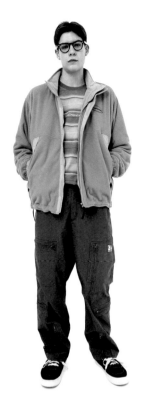

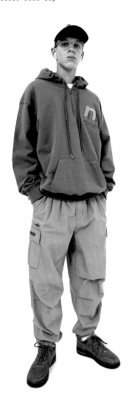

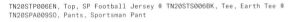

TN20STP006EN, Top, SP Football Jersey ▊ TN20STS006BK, Tee, Earth Tee ▊ TN20SPA009SO, Pants, Sportsman Pant

TN20SHS001MI, Sweatshirt, DSN-Logo Zipup Sweat ▊ TN19SSH008GR, Shirt, DSN-Logo Striped Shirt ▊ TN20SPA007ES, Pants, Zip Cargo Pant ▊ TN20SAC004SR, Accessory, INTL. Logo Ring

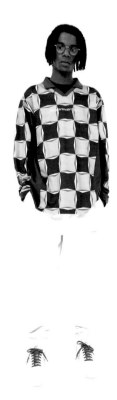

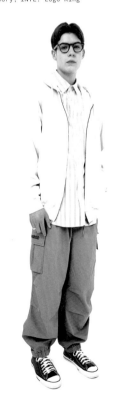

TN20STP004MD, Top, Jacquard L/SL Jersey Polo ❚ TN20SPA004NA, Pants,
Work Pant ❚ TN20SHW004NA, Hat, SOFT WORK Jersey Cap

TN20SSW006DF, Sweatshirt, Chest Stripe Crewneck ❚ TN20STS021BL,
Tee, Ticdyc Tee ❚ TN20SPA002BL, Jean, Paneled Jean ❚ TN20SAC004SR,
Accessory, INTL. Logo Ring

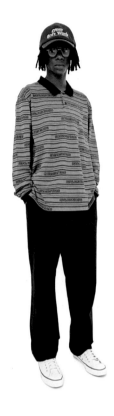

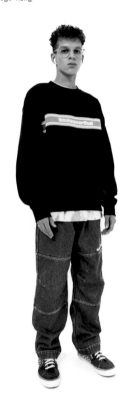

TN20SOW008OV, Jacket, PERTEX® SP Vest ❚ TN20STS011DNY, Tee, DESIGN
Pocket Tee ❚ TN20SPA002BK, Jean, Paneled Jean

TN20SOW007BL, Jacket, PERTEX® SP Pullover ❚ TN20STS012RD, Tee, TNT S.W.
Tee ❚ TN20SPA005PNT, Pants, Crazy Work Pant

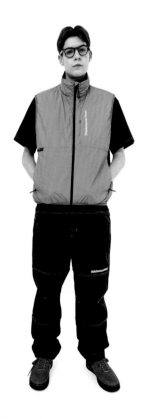

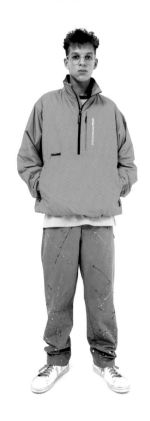

TN20SOW013BK, Jacket, L-Logo Zip Jacket ◍ TN20STS012GN, Tee, TNT S.W. Tee ◍ TN20SSO008BK, Pants, DSN Hiking Short ◍ TN20SAC002BK, Socks, HSP-Logo Socks

TN20SSH008BM, Shirt, CS Check S/S Shirt ◍ TN20SPA004BE, Pants, Work Pant

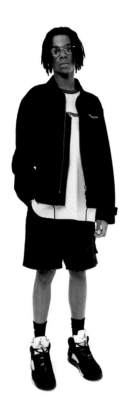

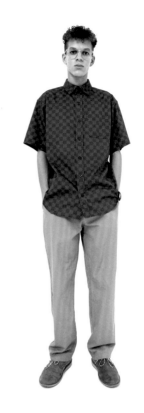

TN20SSH001GRB, Shirt, BIG Striped S/S Shirt ◍ TN20SPA004NA, Pants, Work Pant ◍ TN20SAC006SR, Accessory, T-Logo Bangle

TN20SSH006BR, Shirt, 80'S CT S/S Shirt ◍ TN20SSO002GR, Pants, Work Short ◍ NE20SHW004NA, Hat, 920UNST TNT NEYYAN ◍ TN20SAC001BK, Accessory, Leather Belt ◍ TN20SAC006SR, Accessory, T-Logo Bangle ◍ TN20SAC004SR, Accessory, INTL. Logo Ring

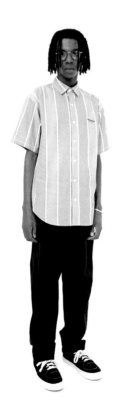

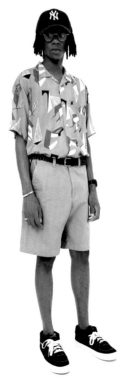

TN20SSW005NA, Sweatshirt, Pigment Script Crewneck ▮ TN20SSO010BE, Pants, Overdyed Short ▮ TN20SAC002BK, Socks, HSP-Logo Socks ▮ TN20SAC004SR, Accessory, INTL. Logo Ring

TN20SKW002MD, Top, E/T-Logo Cardigan ▮ TN20STS020PK, Tee, Acid Washed Tee ▮ TN19FPA002TB, Jean, Regular Jean ▮ TN20SAC001BK, Accessory, Leather Belt

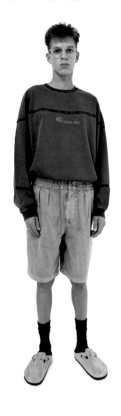

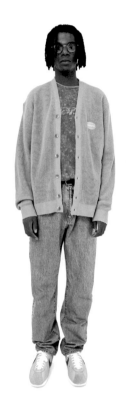

TN20SOW004BK, Jacket, POLARTEC® Field Parka ▮ TN20SLS003DR, Long Sleeve Tee, Overdyed Rocket L/SL Top ▮ TN20SPA006GN, Pants, Overdyed Big Pant

TN20SOW001BK, Jacket, PCU Jacket ▮ TN20SHS007CH, Sweatshirt, ISW Hooded Sweatshirt ▮ TN20SSO004BK, Pants, PCU Short ▮ TN20SAC006SR, Accessory, T-Logo Bangle ▮ TN19FAC010BK, Socks, Tiedye Socks

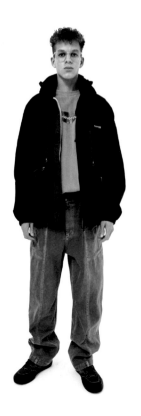

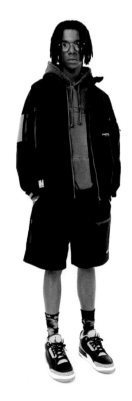

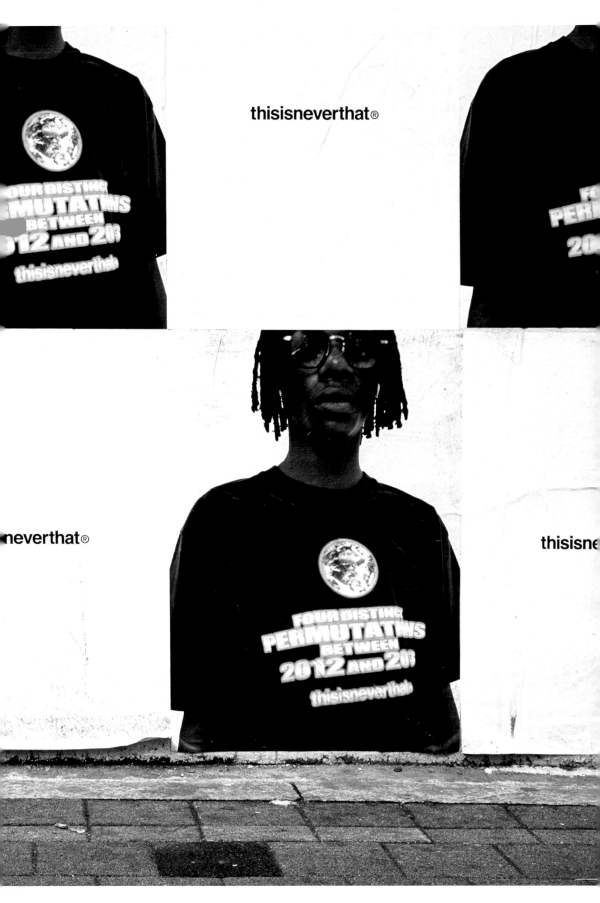

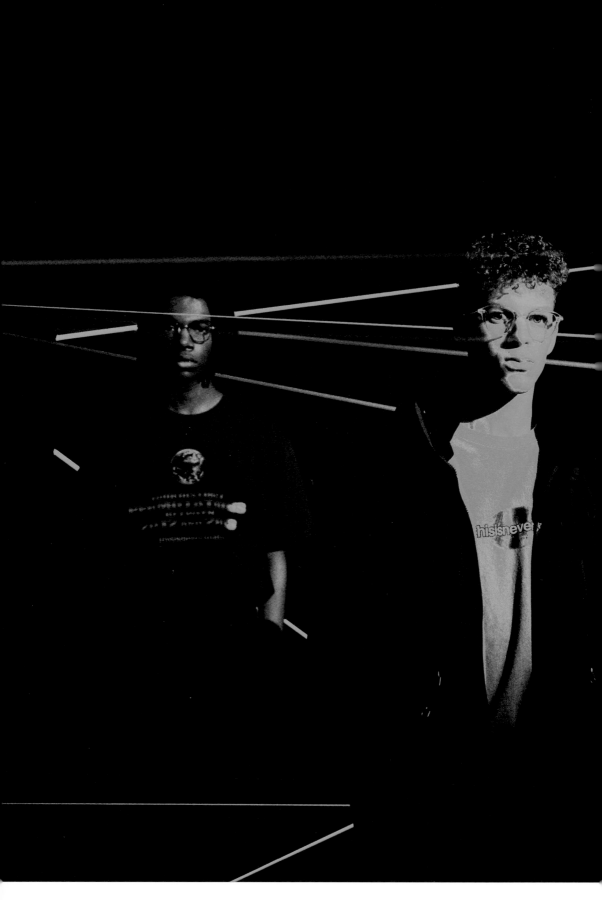

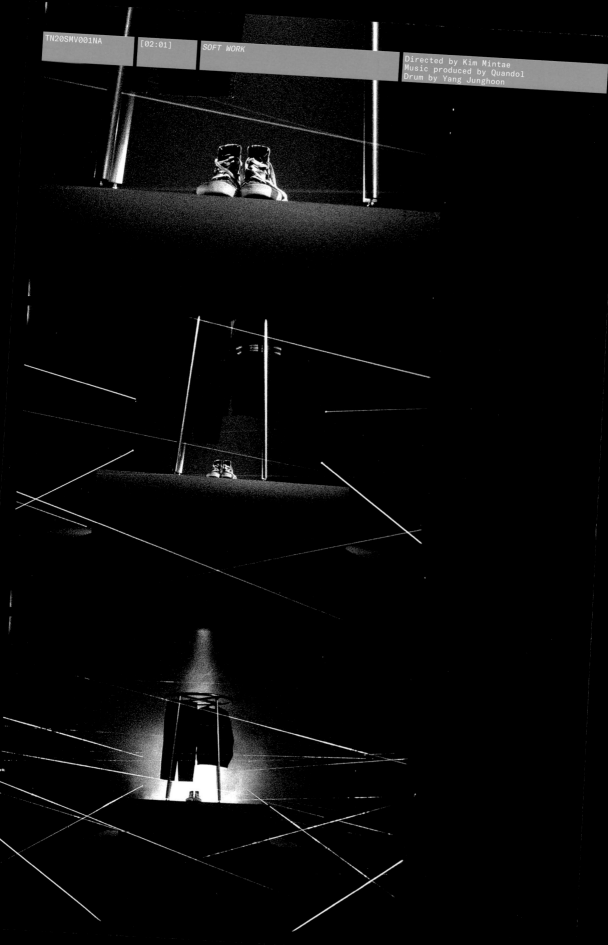

TN20SMV001NA [02:01] *SOFT WORK*

Directed by Kim Mintae
Music produced by Quandol
Drum by Yang Junghoon

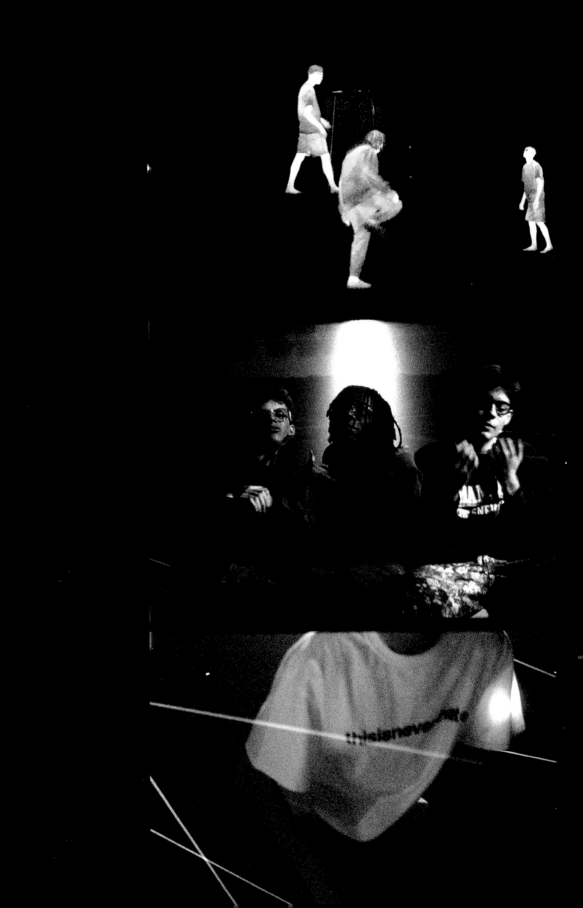

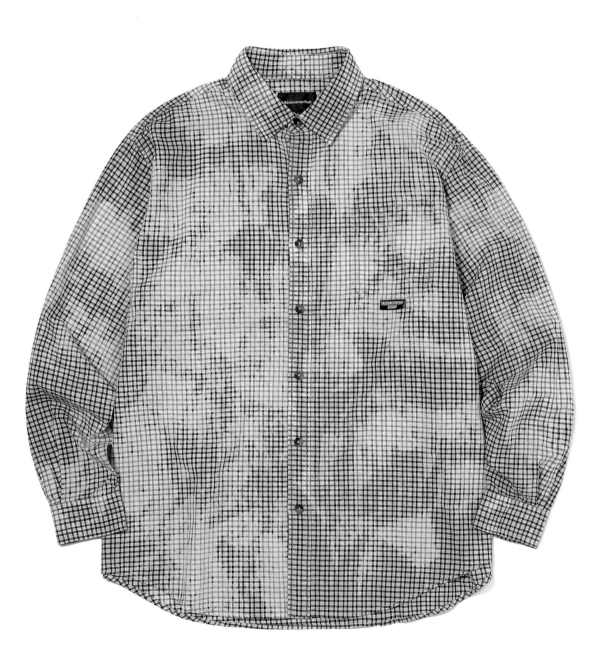

TN20SOW009BE / Jacket
Overdyed Oxford Jacket
Cotton / Beige

TN20SOW002SO / Jacket
Sportsman Jacket
Cotton, Polyester / Stone

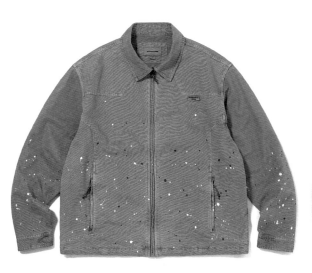

TN20SOW001OV / Jacket
PCU Jacket
Cotton, Nylon / Olive

TN20SSH002GR / Shirt
DSN-Logo Striped Shirt
Cotton / Grey

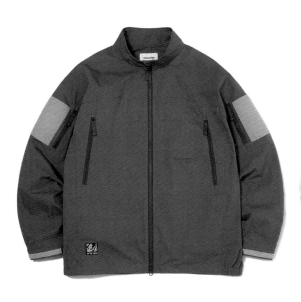

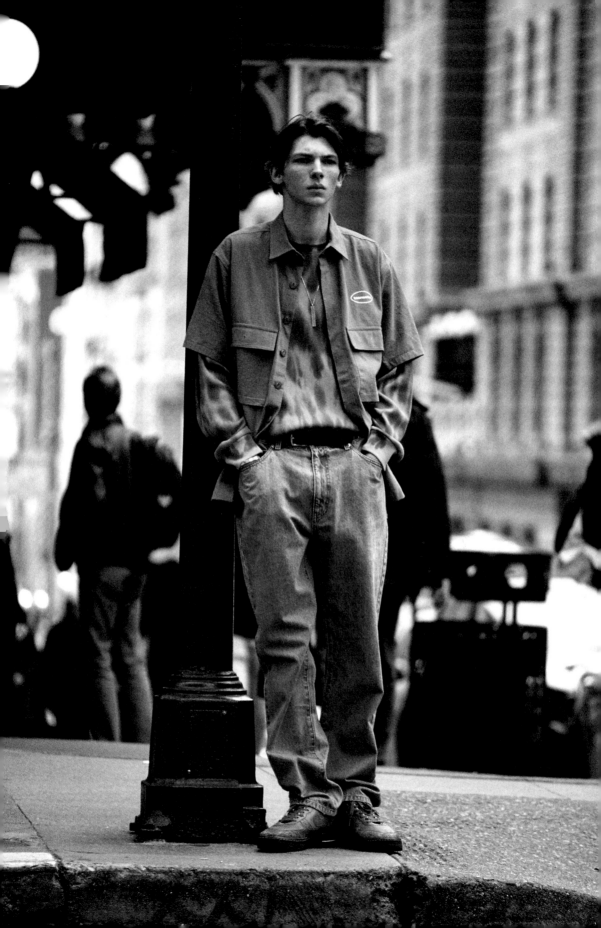

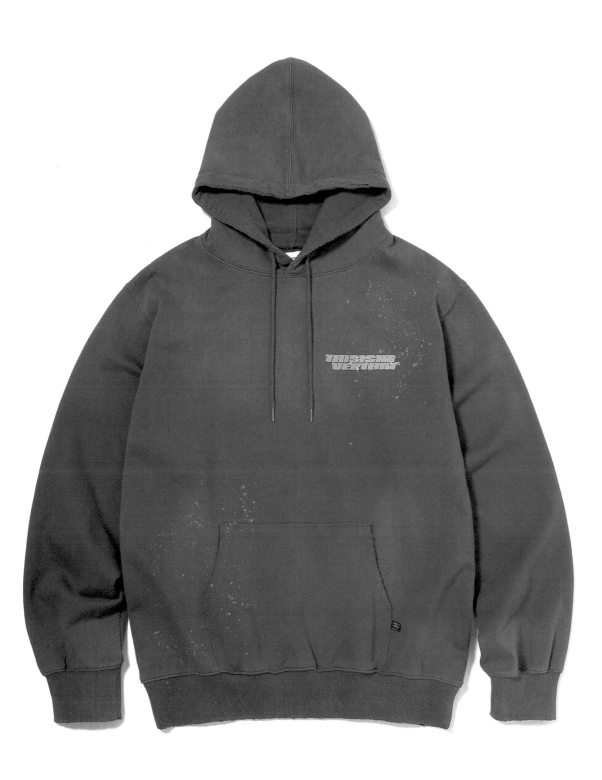

TN20SLS007BU / Long Sleeve Tee
Acid Washed L/SL Top
Cotton / Burgundy

TN20SLS003CH / Long Sleeve Tee
Overdyed Rocket L/Sl Top
Cotton / Charcoal

TN20STS002VT / Tee
SOFT WORK Tee
Cotton /Violet

TNCOCTS002LBG / Tee
T-Logo Tee
Cotton / Light Bluegrey

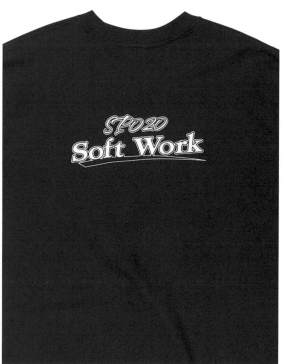

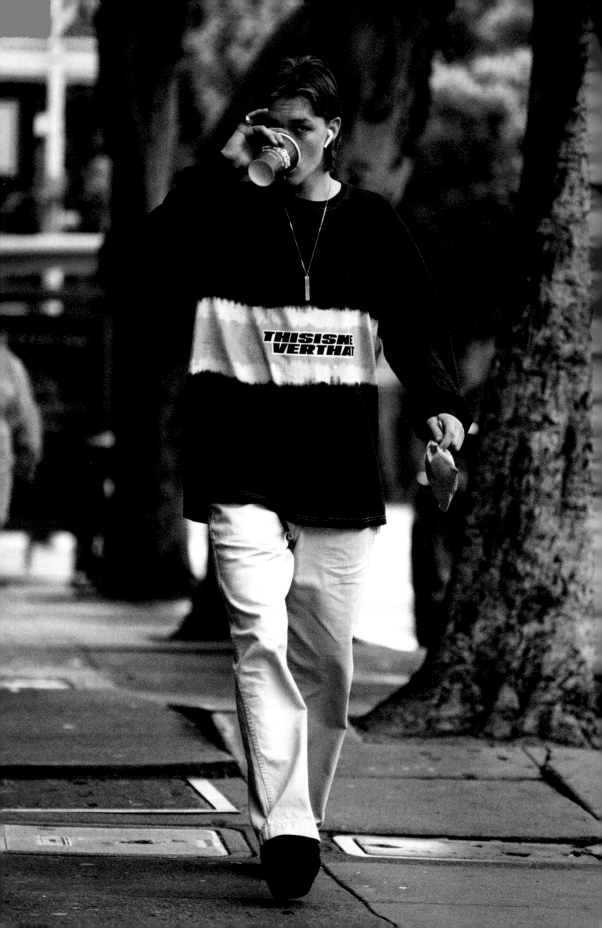

TN20STS005BK / Tee
Spaceship Tee
Cotton / Black

TN20STS009WH / Tee
CNP-Logo Tee
Cotton / White

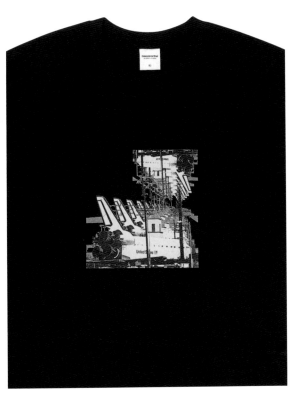

TN20STS003LY / Tee
Submarine Volcano Tee
Cotton / Light Navy

TN20STS012RD / Tee
TNT S.W. Tee
Cotton / Red

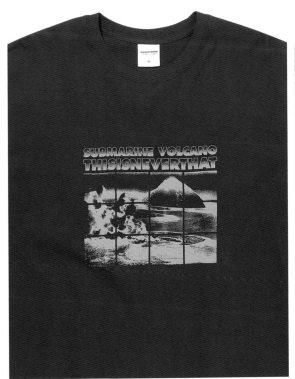

TN20SSO010CH / Pants
Overdyed Short
Cotton / Charcoal

TN20SPA005PNT / Pants
Crazy Work Pant
Cotton / Paint

TN20SPA006GN / Pants
Overdyed Big Pant
Cotton / Green

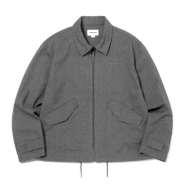

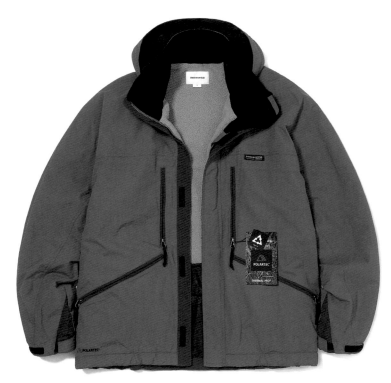

TN20SOW007BL

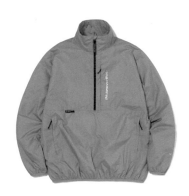

TN20SSW006DF

TN20SLS009GN

TN20SOW006GN

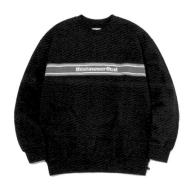

TN20SOW004BL	Jacket	POLARTEC® Field Parka	Polyester, Nylon	Blue
TN20SOW013BL	Jacket	L-Logo Zip jacket	Cotton	Blue
TN20SOW007BL	Top	PERTEX® SP Pullover	Polyester, 3M Thinsulate	Blue
TN20SSW006DF	Sweatshirt	Chest Stripe Crewneck	Cotton	Dark Forest
TN20SLS009GN	Long Sleeve Tee	Striped Tiedye L/SL Top	Cotton	Green
TN20SOW006GN	Jacket	Seer Zip Jacket	Cotton	Green

TN20SSH006BR

TN20STS017MD

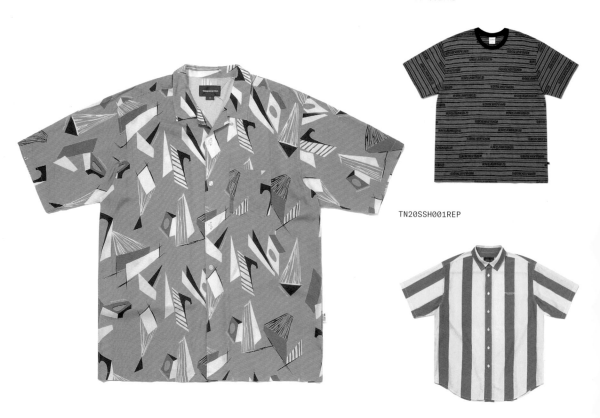

TN20SSH001REP

TN20STS004MI

TN20STS021YL

TNCOCTS002YL

TN20SSH006BR	Shirt	80'S CT S/S Shirt	Rayon	Brown
TN20STS017MD	Tee	Logo Jacquard Tee	Cotton	Mustard
TN20SSH001REP	Shirt	BIG Striped S/S Shirt	Cotton	Red, Pink
TN20STS004MI	Tee	Palm Tree Tee	Cotton	Mint
TN20STS021YL	Tee	Tiedye Tee	Cotton	Yellow
TNCOCTS002YL	Tee	T-Logo Tee	Cotton	Yellow

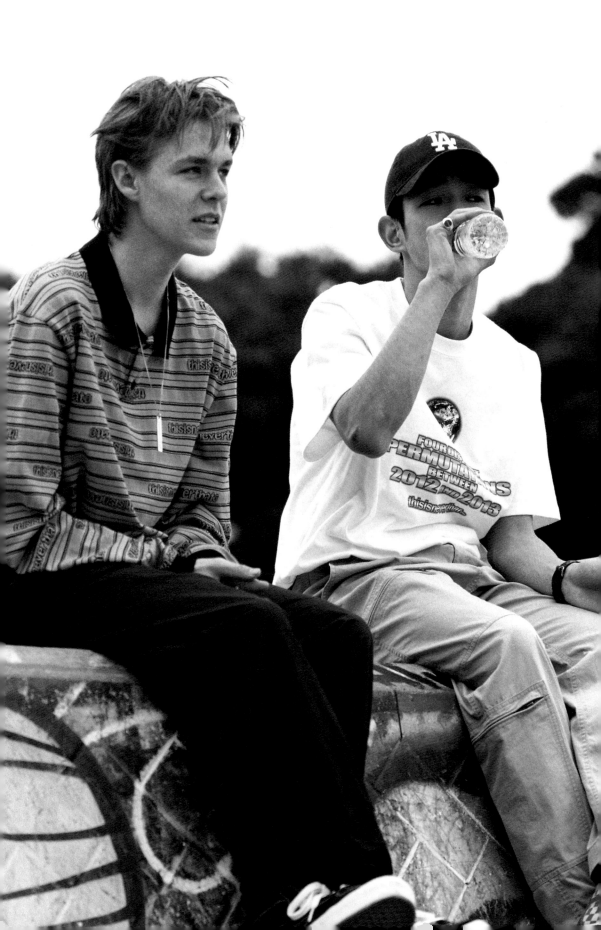

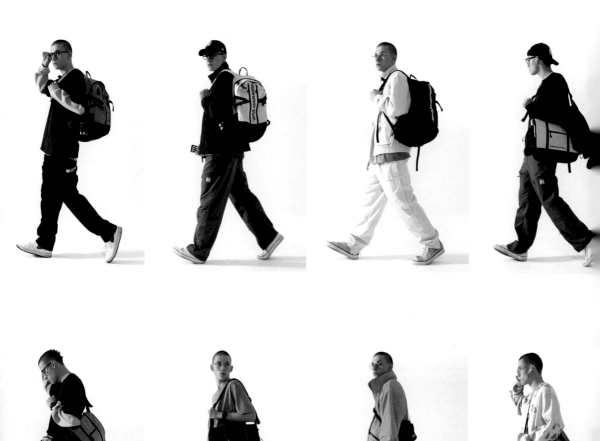
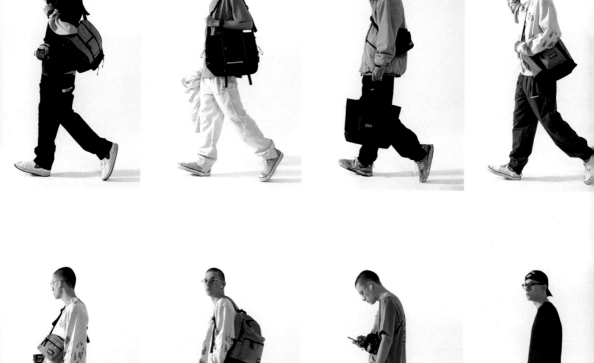

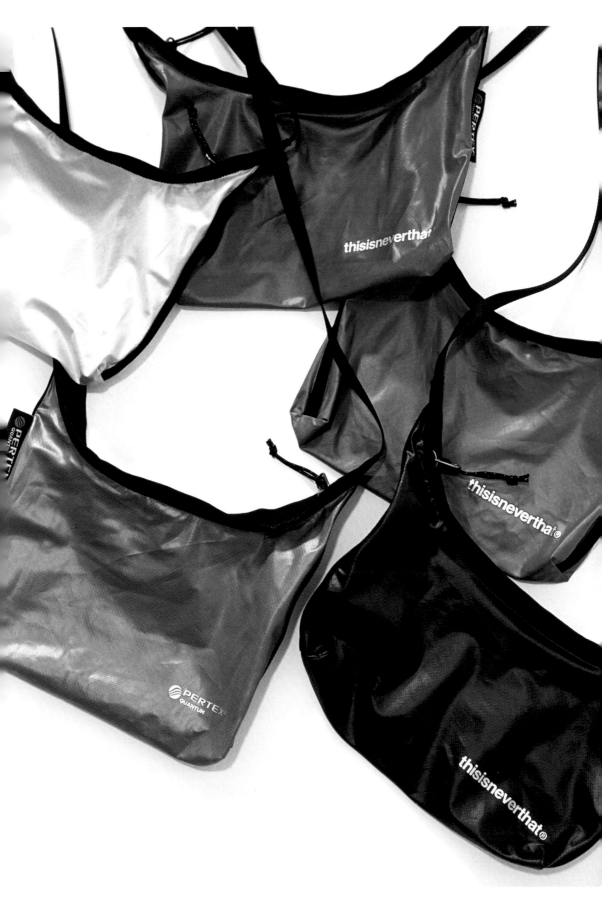

SOFT WORK

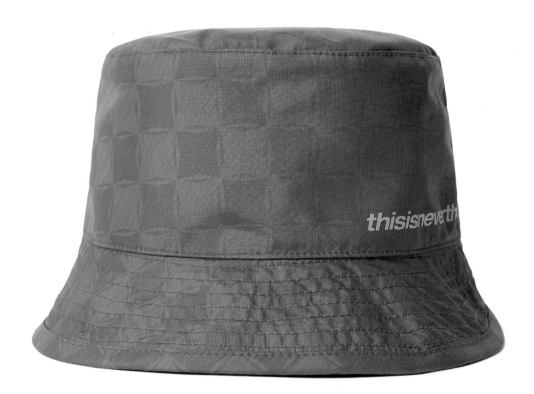

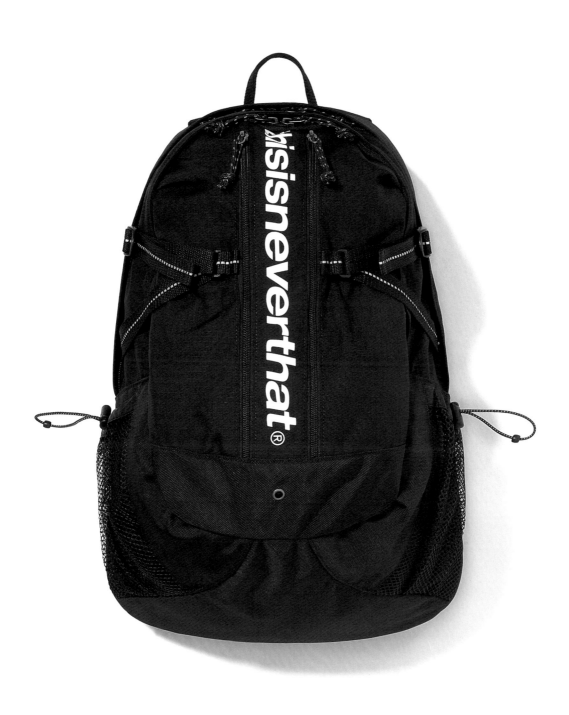

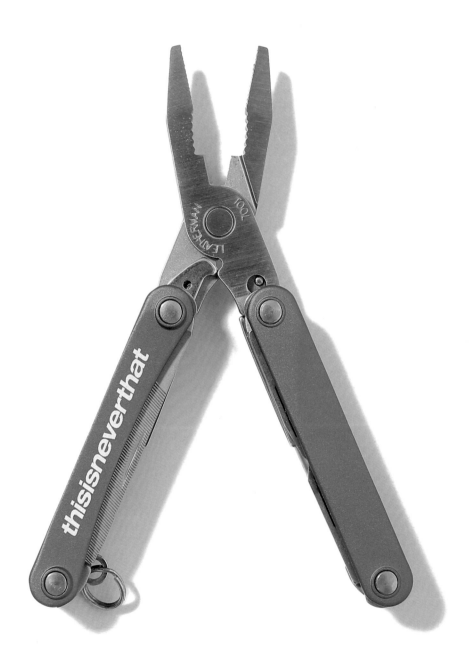

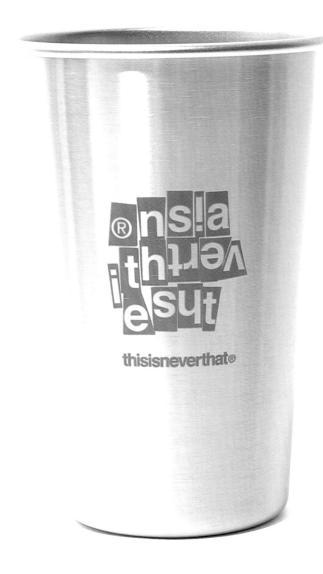

TN20SAC006SR / Accessory
T-Logo Bangle
925 Silver / Silver

TN20SAC004SR / Accessory
INTL. Logo Ring
925 Silver / Silver

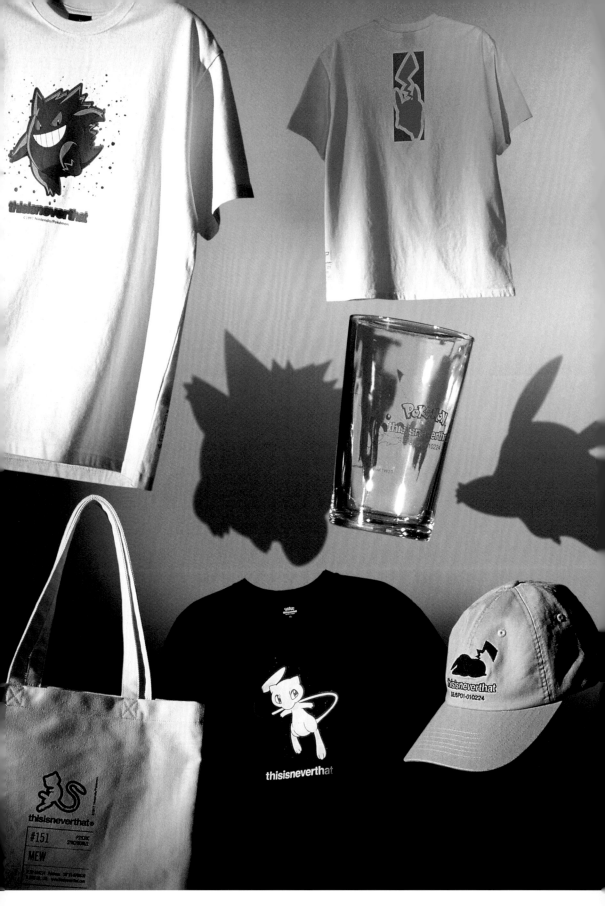

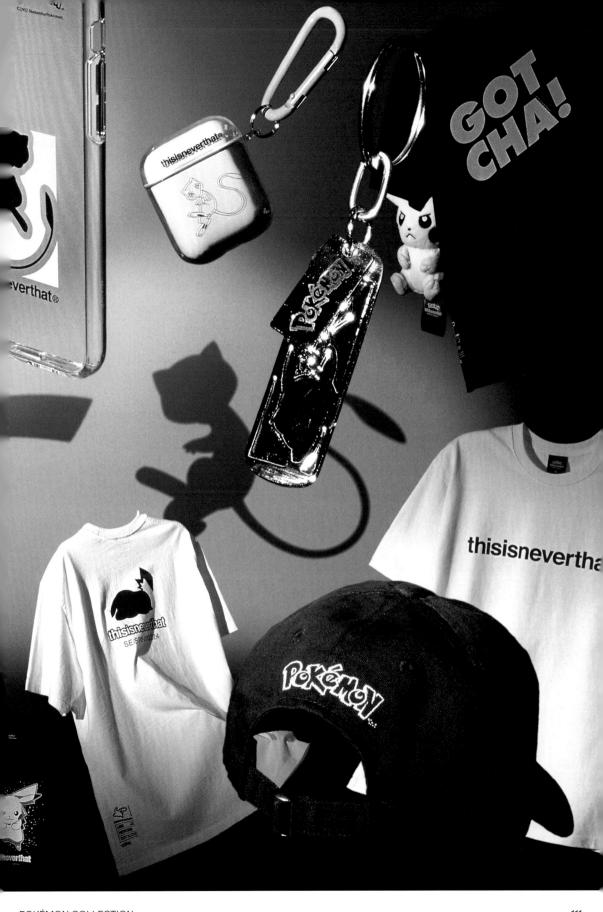

SE/SP01-010224

SE/SP01-010224

SE/SP01-010224

PM20STS004BO / Tee
PKM Paint Tee
Cotton / Black, Orange

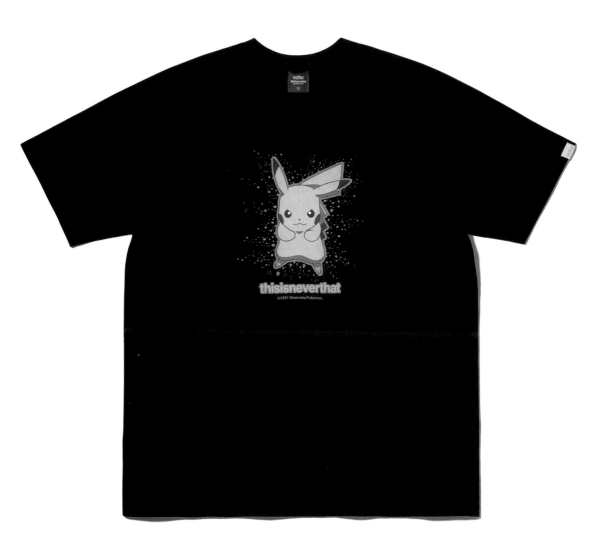

PM20SLS003BK

PM20SLS002BG

PM20STS003BO

PM20STS008WH

PM20STS004WG

PM20STS003WB

PM20SHW002GR

PM20SBA002BK

PM20SAC010BL

PM20SLS003BK	Long Sleeve Tee	PKM Break L/SL Top	Cotton	Black
PM20SLS002BG	Long Sleeve Tee	PKM Reversible L/SL Top	Cotton	Black, Green
PM20STS003BO	Tee	PKM Information Tee	Cotton	Black, Orange
PM20STS008WH	Tee	PKM Break Tee	Cotton	White
PM20STS004WG	Tee	PKM Paint Tee	Cotton	White, Green
PM20STS003WB	Tee	PKM Information Tee	Cotton	White, Blue
PM20SHW002GR	Hat	PKM Break Cap	Cotton	Grey
PM20SBA002BK	Bag	PKM Tote Bag	Cotton	Black
PM20SAC010BL	Accessory	PKM Silhouette AirPods Pro Case	TPU	Blue
PM20SAC003OR	Accessory	PKM Outline iPhone Case	TPU	Orange
PM20SAC001BL	Accessory	PKM Duralex® Glass	Glass	Blue
PM20SAC007YL	Accessory	PKM Pikachu Plush	Polyester	Yellow
PM20SAC008SR	Accessory	PKM Silhouette Key Ring	Brass	Silver
PM20SAC004BL	Accessory	PKM Outline AirPods Case	TPU	Blue

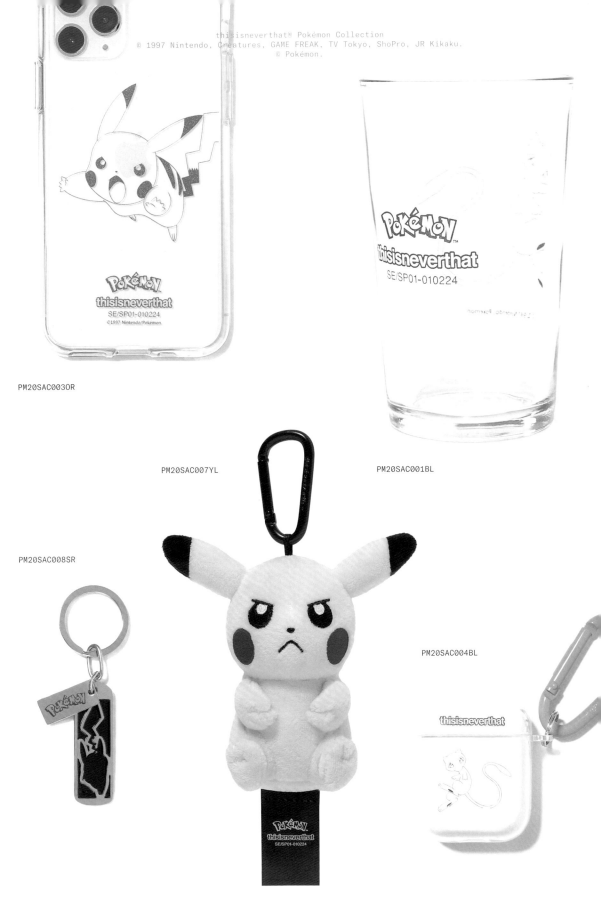

PM20SAC003OR

PM20SAC007YL

PM20SAC001BL

PM20SAC008SR

PM20SAC004BL

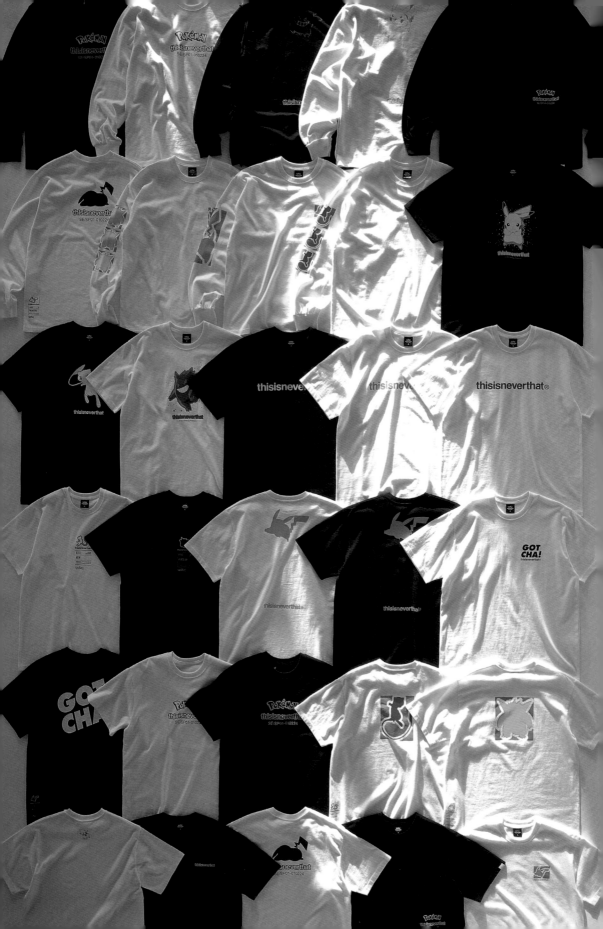

Collaborator

Release Date
Apr 3, 2020

Prefix
NB

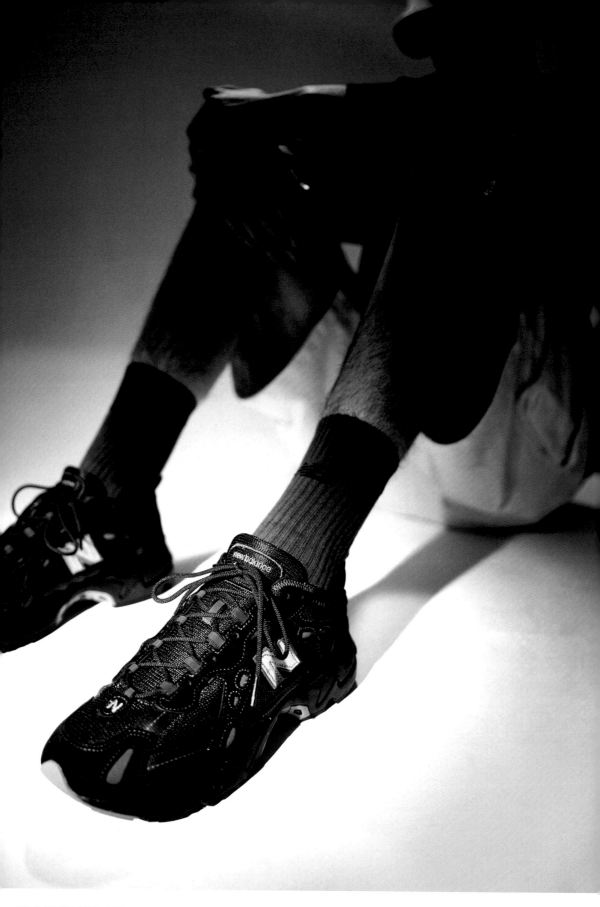

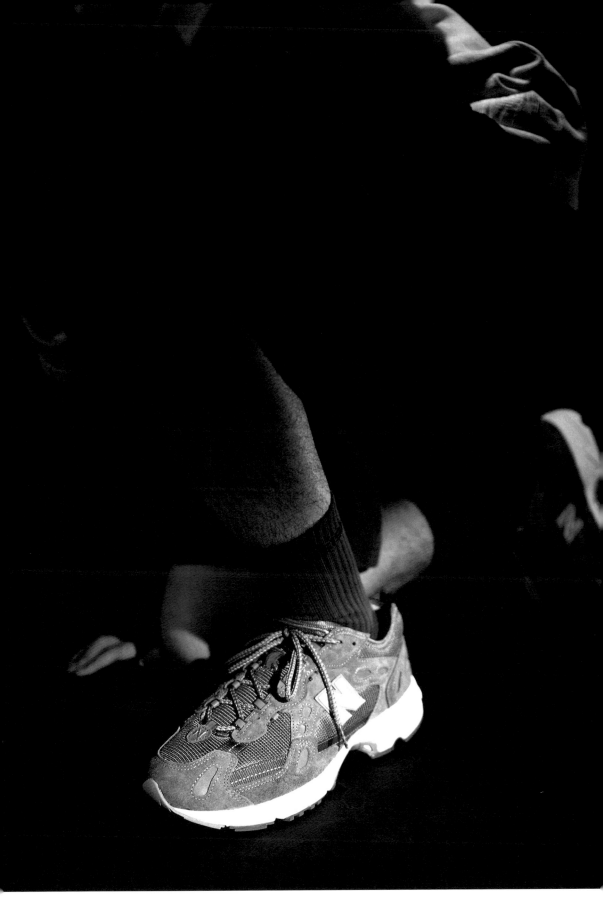

NB20SFW003BE / Shoes
ML827
Beige

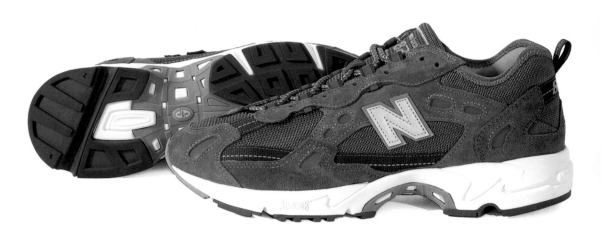

NB20SFW003BK / Shoes
ML827
Black

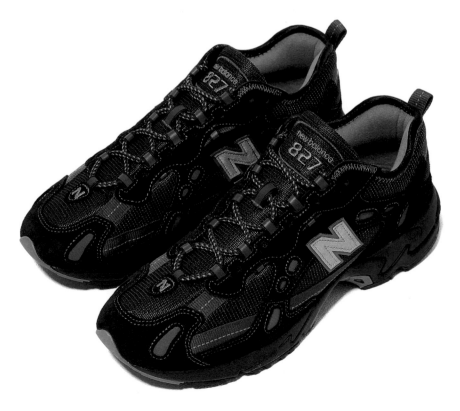

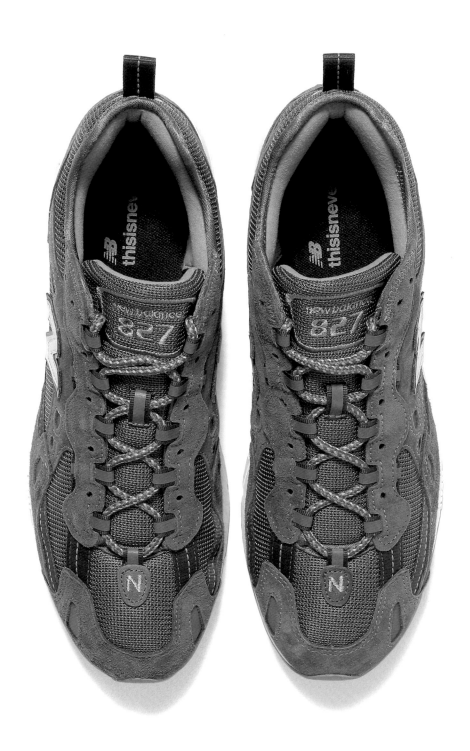

NB20SHS001OT

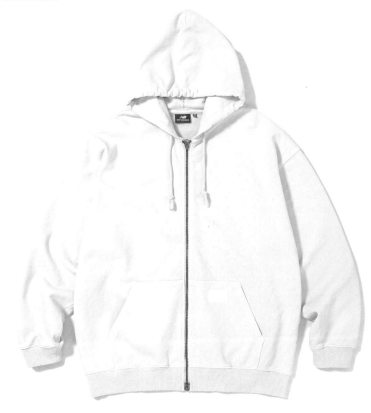

NB20SHS001CH

NB20SLS001GN

NB20STS001GN

NB20SSO001OT

NB20SAC001GN

NB20SHS001OT	Sweatshirt	NB TNT Zipup Sweat	Cotton	Oatmeal
NB20SHS001CH	Sweatshirt	NB TNT Zipup Sweat	Cotton	Charcoal
NB20SLS001GN	Long Sleeve Tee	NB TNT Pocket L/S	Cotton	Green
NB20STS001GN	Tee	NB TNT Tee	Cotton	Green
NB20SSO001OT	Pants	NB TNT Sweat Short	Cotton	Oatmeal
NB20SAC001GN	Socks	NB TNT Socks	Cotton	Green

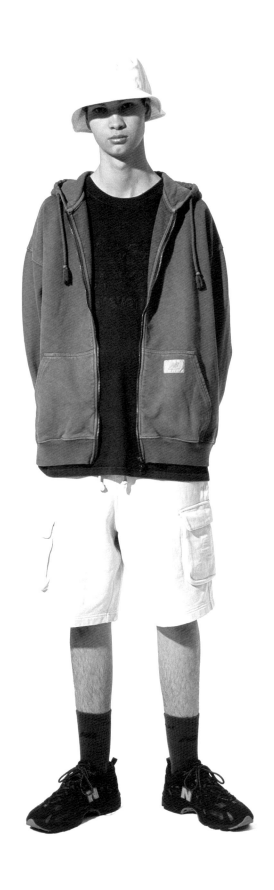

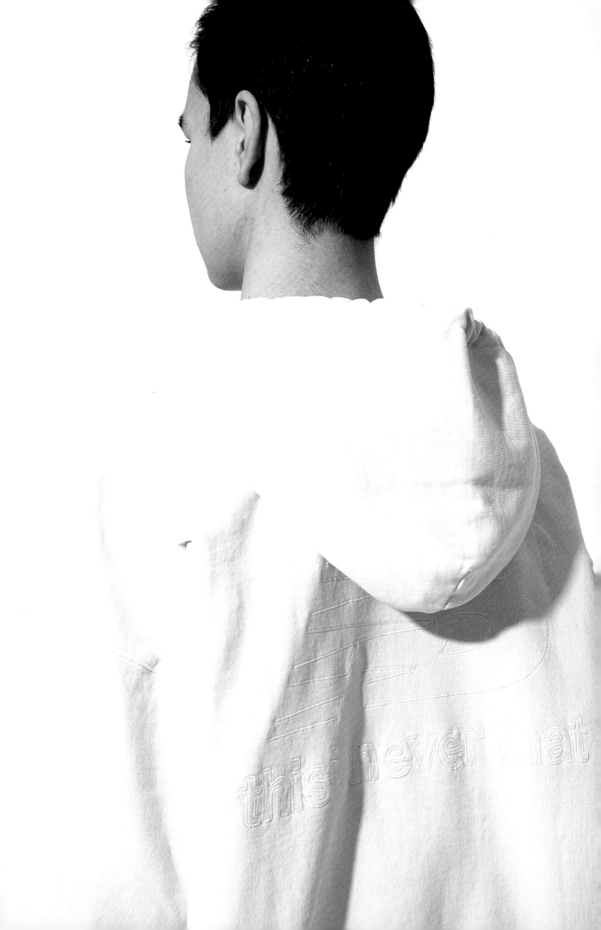

NB20SHW001WH / Hat
NB TNT Bucket Hat
Cotton / White

NB20SSO001GN / Pants
NB TNT Sweat Short
Cotton / Green

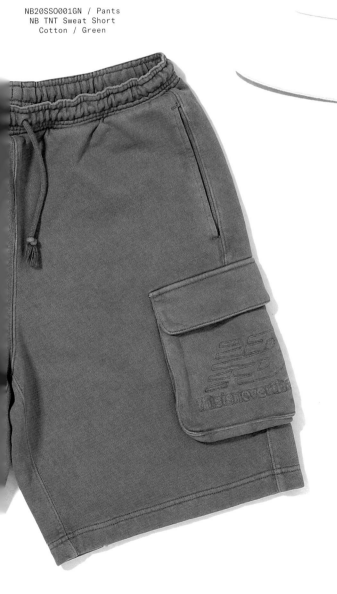

NB20SAC001WH / Socks
NB TNT Socks
Cotton / White

G-SHOCK

2020.04.20.

2020.04.20.

G-SHOCK

thisisneverthat®

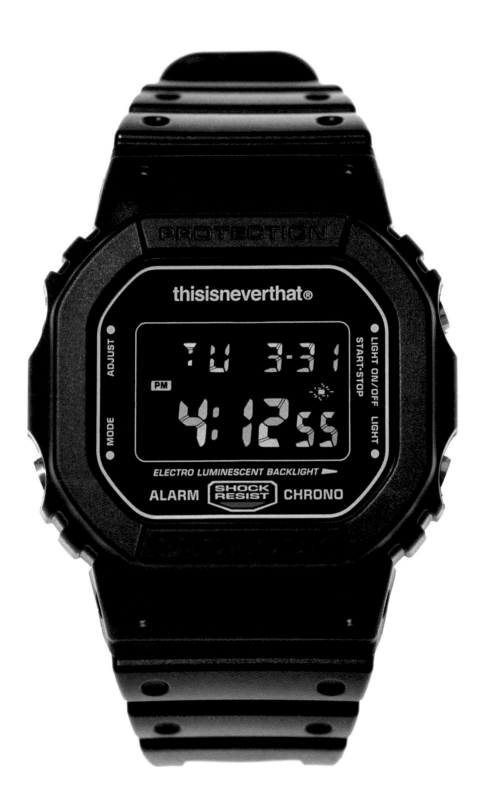

G-SHOCK × thisisneverthat

G-SHOCK × thisisneverthat

Collaborator

Release Date
Jan 31, 2020
May 22, 2020

Prefix
NE

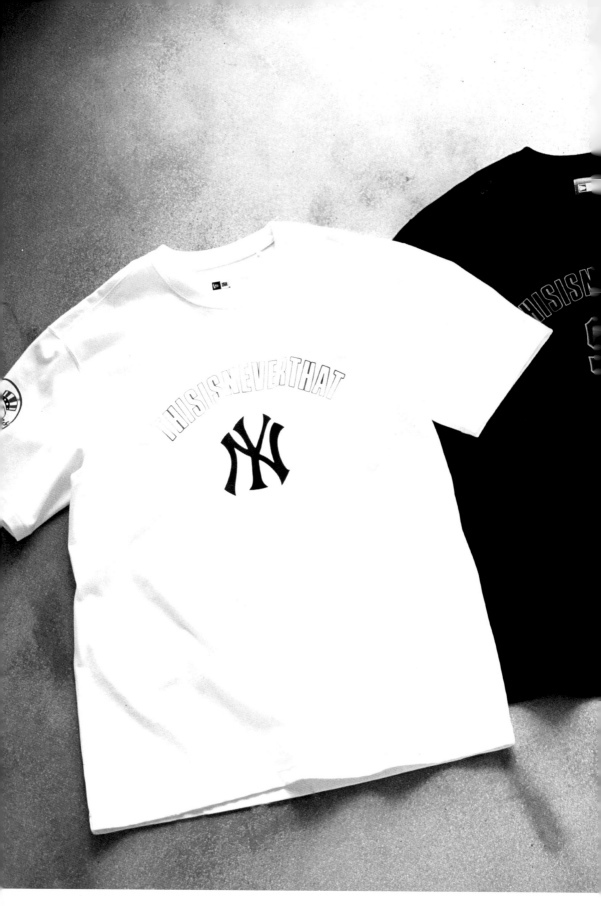

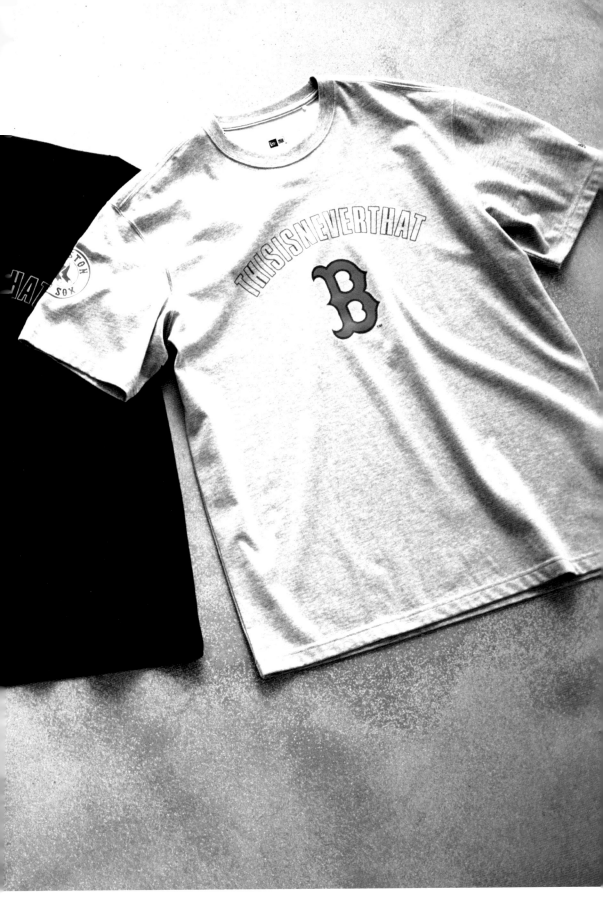

NEW ERA × thisisneverthat

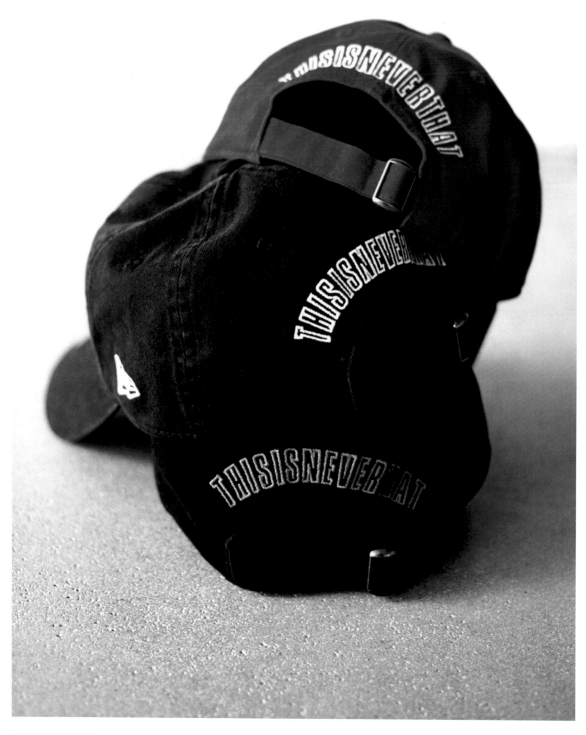

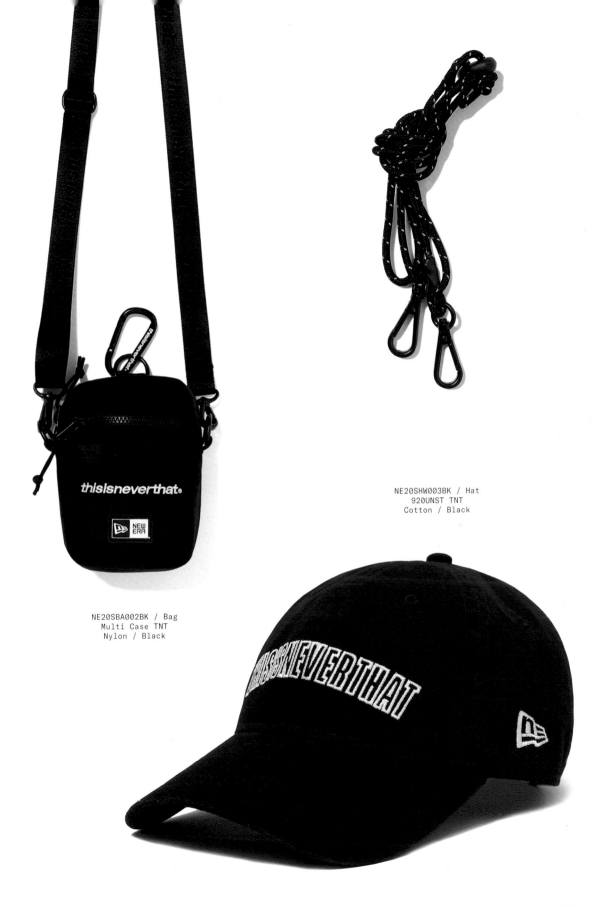

NE20SHW003BK / Hat
920UNST TNT
Cotton / Black

NE20SBA002BK / Bag
Multi Case TNT
Nylon / Black

Appearing in four distinct permutations between 2012 and 2013.

Softness, stuffedness, presents little of the freedom or terror of the formless. It is not rigid, no: it dangles, flops and piles up. It gives to the touch. It does not resist gravity. Yet it is hardly liquid either, that is, it is not in a process of flow, rhythm, transience, and striation: it remains roughly what it is.

920UNST TINT NEYYAN NAVY, '80S CT S/S Shirt Brown, Work Short Grey, Leather Belt Black, DW-5600TNT Black, T-Logo Bangle Silver, INTL. Logo Ring Silver

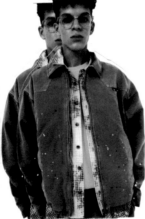

Charged as it may be, this pitched struggle is only a preliminary scenario into which a different order will impose itself: an order of liquid. Blocks of translucent urethane hold flows of color pigment, collages are slashed with nail polish, teardrop shapes are cast, and urethane is drizzled into mutant spires.

Sculptures offer up surrogate beings in space; paintings address themselves to the eye. Both embody a sort of self-sufficieny and mute containment. Sculpture produces a mass to which our bodies relate in three dimensions, without touching, while paintings invent an implied space that we cannot enter.

PERTE

Bleach Check Shirt Green, Small T-Logo Tee Neon Green, Overdyed Short Charcoal

Charged as it may be, this pitched struggle is only a preliminary scenario into which a different order will impose itself: an order of liquid. Blocks of translucent urethane hold flows of color pigment, collages are slashed with nail polish, teardrop shapes are cast, and urethane is drizzled into mutant spires.

C5 Check S/S Shirt Brown/Green, Work Pant Beige, DW-5600TNT Black

FALL/WINTER 2019

PREP-SCHOOL GANGSTERS

TN19FOW003OR, Jacket, Explorer Down Parka ❙ TN19FKW003CH, Top, Overdyed Knit Sweater ❙ TN19FPA003TB, Jean, Big Jean ❙ NE19SHW001NA, Hat, 5950 MLB × TINT NEYYAN

TN19FOW001GN, Jacket, SP-INTL. Sport Down Jacket ❙ TN19FLS007NA, Long Sleeve Tee, N-Tiedye L/SL Top ❙ IN19FPA007GR, Pants, Work Pant ❙ NE19FHW004BK, Hat, KNIT CUFF MLB × TNT NEYYAN ❙ TN19FAC017SR, Accessory, LION Necklace

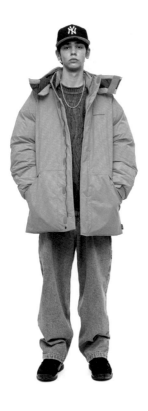

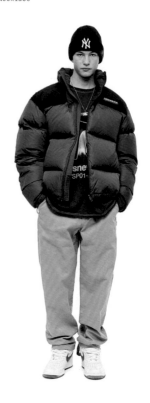

TN19FOW012BK, Jacket, Overdyed M51 Parka ❙ TN19FSW012CH, Sweatshirt, Cracked Crewneck ❙ TN19FPA007OV, Pants, Work Pant ❙ TN19FAC017SR, Accessory, LION Necklace

TN19FOW001BK, Jacket, SP-INTL. Sport Down Jacket ❙ TN19FTS003BG, Tee, NEW SPORT Striped Tee ❙ TN19FPA003BK, Jean, Big Jean ❙ TN19FAC015SR, Accessory, LION 2010 Necklace

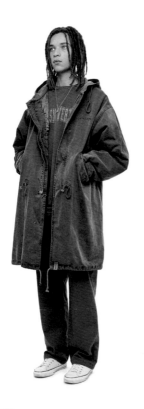

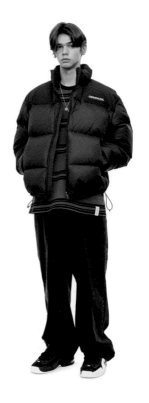

TN19FOW006PP, Jacket, SP Boa Fleece Jacket ⦿ TN19FHS012CH, Sweatshirt, ARC-Logo Overdyed Hooded Sweatshirt ⦿ TN19FPA017BK, Pants, Driver Pant

TN19FHS007NA, Sweatshirt, Marker Script Logo Hooded Sweatshirt ⦿ TN19FPA021BR, Pants, D/P-Plaid Sweatpant

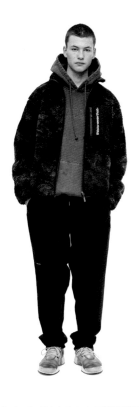

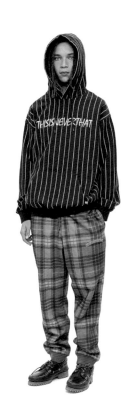

TN19FSH009TO, Shirt, Jungle Shirt Jacket ⦿ TN19FPA003TB, Jean, Big Jean ⦿ TN19FHW008TO, Hat, SP Bucket Hat

TN19FTP003SB, Top, GOING TO CLASS Half Zip Pullover ⦿ TN19FPA010EO, Pants, Jungle Pant

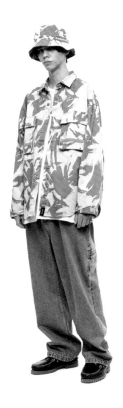

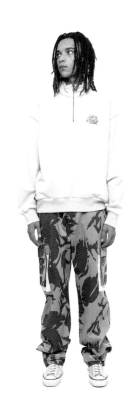

TN19FOW011BU, Jacket, Driver Jacket ◉ TN19FPA017BU, Pants, Driver Pant

TN19FSH001RD, Shirt, ARC-Logo African Check Shirt ◉ TN19FKW006NA, Top, E/T-Logo Knit Polo ◉ TN19FPA002ML, Jean, Regular Jean

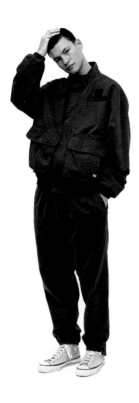

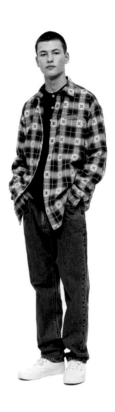

TN19FOW019NA, Jacket, Wool Over Coat ◉ TN19FLS009BW, Long Sleeve Tee, H.A.A.Y Striped L/SL Top ◉ TN19FPA005BR, Pants, Corduroy Easy Pant ◉ NE19FHW002BK, Hat, 920UNST MLB × TNT NEYYAN

TN19FSH003GR, Shirt, SP-Logo Corduroy Shirt ◉ TNCOCSW001CH, Sweatshirt, T-Logo Crewneck ◉ TN19FPA003BK, Jean, Big Jean ◉ TN19FHW015BK, Hat, GOING TO CLASS Cap

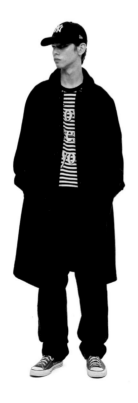

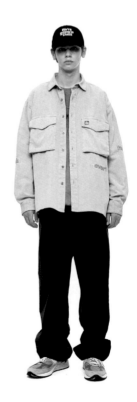

TN19FKW004OR, Top, T-Logo Knit Sweater ❚ TN19FLS003BG, Long Sleeve
Tee, Marker Script Logo L/SL Top ❚ TN19FPA012NA, Pants, Nylon Trail
Pant ❚ TN19FAC017SR, Accessory, LION Necklace

TN19FOW008RD, Jacket, Oversized Fleece Jacket ❚ TN19FLS003RV, Long
Sleeve Tee, Marker Script Logo L/SL Top ❚ TN19FPA002TB, Jean, Regular
Jean ❚ TN19FAC015SR, Accessory, LION 2010 Necklace

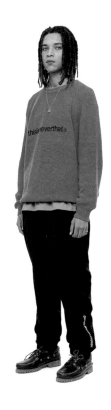

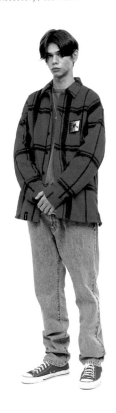

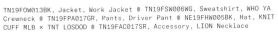

TN19FOW013BK, Jacket, Work Jacket ❚ TN19FSW006WG, Sweatshirt, WHO YA
Crewneck ❚ TN19FPA017GR, Pants, Driver Pant ❚ NE19FHW005BK, Hat, KNIT
CUFF MLB × TNT LOSDOD ❚ TN19FAC017SR, Accessory, LION Necklace

TN19FOW005KH, Jacket, ECWCS Parka ❚ TN19FTP001GR, Top, POLARTEC Fleece
Pullover ❚ TN19FPA009BR, Pants, Carpenter Pant

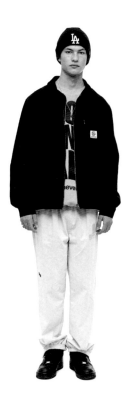

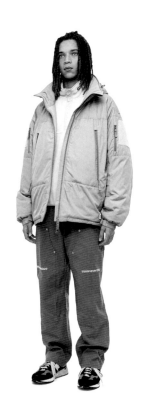

TN19FHS002OV, Sweatshirt, E/T-Logo Zipup Sweat ◊ TN19FLS006CV, Long
Sleeve Tee, Rubber SP Striped L/SL Top ◊ TN19FPA006DK, Pants, Cargo
Pant ◊ TN19FAC017SR, Accessory, LION Necklace

TN19FKW001BK, Top, Argyle Shirt Cardigan ◊ TN19FPA002BK, Jean, Regular
Jean

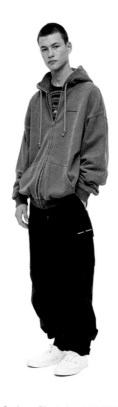
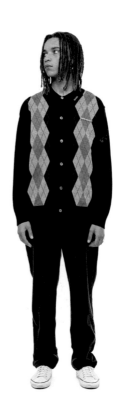

TN19FOW014BK, Jacket, Corduroy Zip Jacket ◊ TN19FPA002TB, Jean, Regular
Jean

TN19FTS001RD, Tee, TOWN Tee ◊ TN19FLS009NA, Long Sleeve Tee, H.A.A.Y
Striped L/SL Top ◊ TN19FPA003ML, Jean, Big Jean

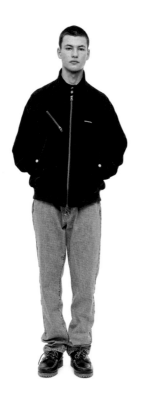
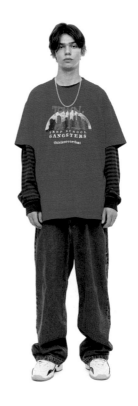

TN19FKW007BG, Top, INTL. Logo Overdyed Polo ⬙ TN19FTP010RD, Top, Turtleneck L/SL Top ⬙ TN19FPA012NA, Pants, Nylon Trail Pant

TN19FOW010BK, Jacket, C-Logo Boa Fleece Vest ⬙ TN19FLS008RD, Long Sleeve Tee, TWO BOYS Overdyed L/SL Top ⬙ TN19FPA015BK, Pants, POLARTEC Fleece Pant ⬙ TN19FAC017SR, Accessory, LION Necklace

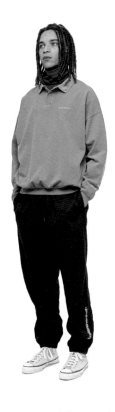

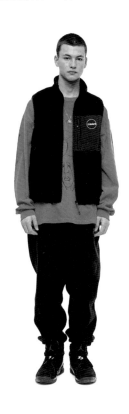

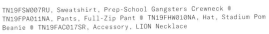

TN19FSW007RU, Sweatshirt, Prep-School Gangsters Crewneck ⬙ TN19FPA011NA, Pants, Full-Zip Pant ⬙ TN19FHW010NA, Hat, Stadium Pom Beanie ⬙ TN19FAC017SR, Accessory, LION Necklace

TN19FOW002OV, Jacket, DSN Down Puffer Jacket ⬙ TN19FLS008MI, Long Sleeve Tee, TWO BOYS Overdyed L/SL Top ⬙ TN19FPA015GR, Pants, POLARTEC Fleece Pant ⬙ TN19FAC017SR, Accessory, LION Necklace

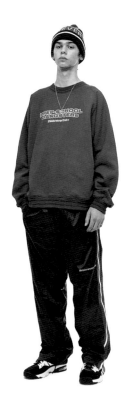

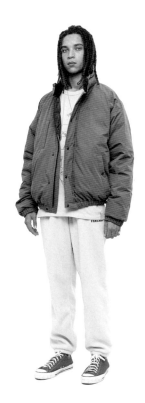

TN19FOW008BK, Jacket, Oversized Fleece Jacket ● TN19FTP010GR, Top, Turtleneck L/SL Top ● TN19FPA012BK, Pants, Nylon Trail Pant ● TN19FHW006BK, Hat, Fleece Earflap Cap

TN19FKW009BU, Top, L-Logo Striped Jersey Polo ● TN19FPA013BR, Pants, Track Pant

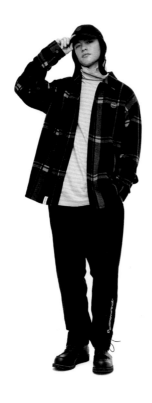

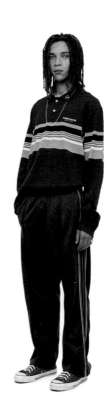

TN19FOW011GR, Jacket, Driver Jacket ● TN19FHS001BR, Sweatshirt, POLARTEC Fleece Hoodie ● TN19FPA007BL, Pants, Work Pant

TN19FOW001YL, Jacket, SP-INTL. Sport Down Jacket ● TNCOCLS001WH, Long Sleeve Tee, T-Logo L/SL Top ● TN19FPA007BK, Pants, Work Pant

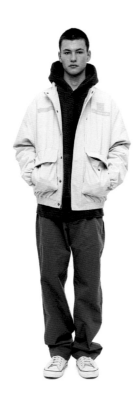

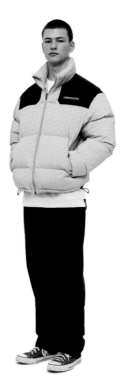

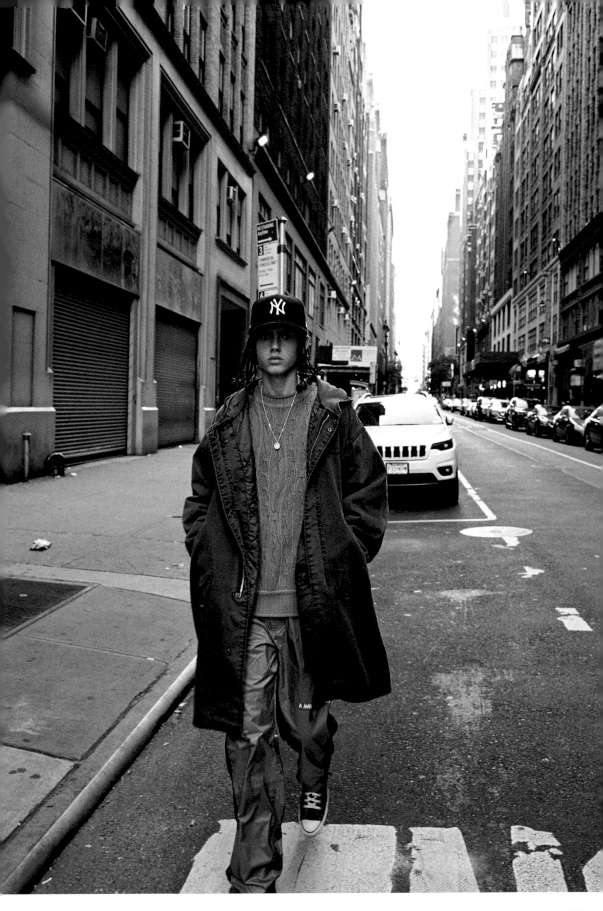

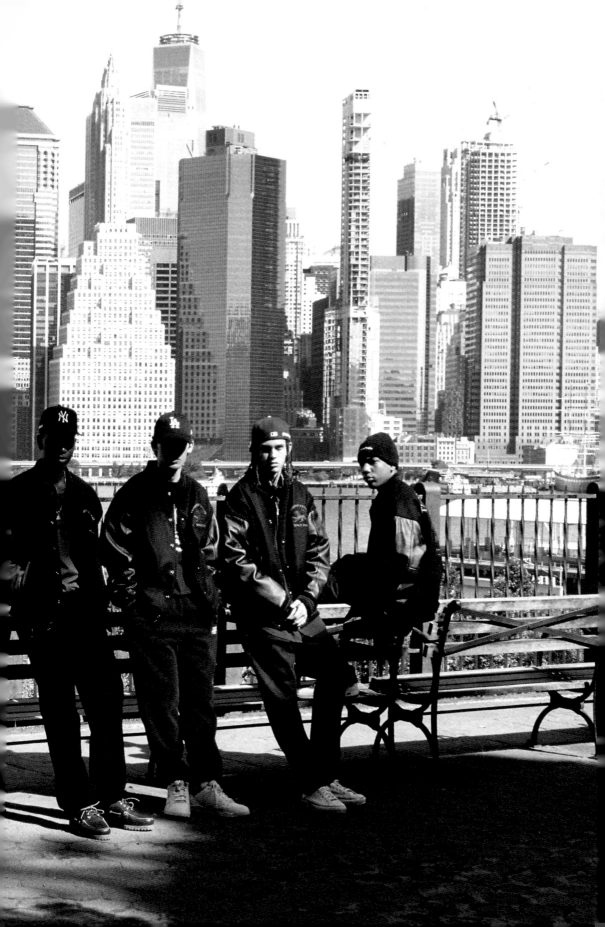

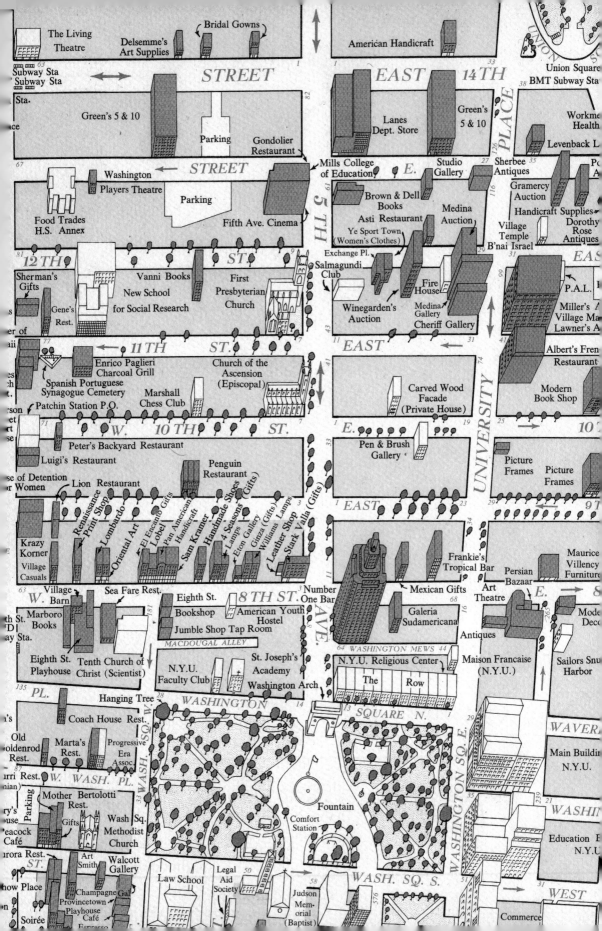

The Living Theatre

Delsemme's Art Supplies

Bridal Gowns

American Handicraft

UNION SQ.

Union Square
BMT Subway Sta

STREET · **EAST** **14TH**

Subway Sta
Subway Sta

Green's 5 & 10

Parking

Gondolier Restaurant

Lanes Dept. Store

Green's 5 & 10

PLACE

Workme
Health

Levenback L

STREET

Mills College of Education

E.

Studio Gallery

Sherbee Antiques

Gramercy Auction

Washington Players Theatre

Parking

Fifth Ave. Cinema

5TH

Brown & Dell Books

Asti Restaurant

Ye Sport Town (Women's Clothes)

Medina Auction

Handicraft Supplies

Food Trades H.S. Annex

Village Temple B'nai Israel

Dorothy Rose Antiques

EAS

12TH · **ST.**

Exchange Pl.

Salmagundi Club

Fire House

P.A.L.

Sherman's Gifts

Vanni Books

New School for Social Research

First Presbyterian Church

Winegarden's Auction

Medina Gallery

Cheriff Gallery

Miller's
Village Ma
Lawner's A

Gene's Rest.

11TH **ST.**

EAST

Albert's Fren
Restaurant

Enrico Paglieri Charcoal Grill

Church of the Ascension (Episcopal)

Carved Wood Façade (Private House)

Modern Book Shop

Spanish Portuguese Synagogue Cemetery

Patchin Station P.O.

Marshall Chess Club

W. **10TH** **ST.**

E.

10T

Peter's Backyard Restaurant

Pen & Brush Gallery

UNIVERSITY

Picture Frames

Picture Frames

Luigi's Restaurant

se of Detention
r Women

Lion Restaurant

Penguin Restaurant

EAST

9T

Renaissance Print Shop

Lombardo

Oriental Art

El Encanto Gifts

Lobel

Pan American Handicraft

Sam Kramer

Handmade Shoes

4 Seasons (Gifts)

Eton Gallery

Lamps

Ginza (Gifts)

Williams Lamps

Leather Shop

Stark Valla (Gifts)

Krazy Korner

Village Casuals

Frankie's Tropical Bar

Maurice Villency Furniture

Persian Bazaar

E.

W. **8TH ST.**

Number One Bar

Mexican Gifts

Art Theatre

8

Village Barn

Sea Fare Rest.

Eighth St.

Eighth St. Bookshop

American Youth Hostel

Galeria Sudamericana

Mode
Deco

Marboro Books

Jumble Shop Tap Room

Antiques

Sailors Snu
Harbor

MACDOUGAL ALLEY

WASHINGTON MEWS

Maison Francaise (N.Y.U.)

Eighth St. Playhouse

Tenth Church of Christ (Scientist)

St. Joseph's Academy

N.Y.U. Religious Center

N.Y.U. Faculty Club

Washington Arch

The Row

PL.

Hanging Tree

WASHINGTON **SQUARE N.**

WAVER

Coach House Rest.

WASH. SQ. W.

Main Buildin
N.Y.U.

Old
oldenrod
Rest.

Marta's Rest.

Progressive Era Assoc.

rri Rest.

W. **WASH. PL.**

Mother Bertolotti Rest.

Wash. Sq. Methodist Church

WASHI

y's
use

Gifts

Fountain

Education E
N.Y.U.

eacock Café

urora Rest.

Comfort Station

ST.

Art Smith

Walcott Gallery

Law School

Legal Aid Society

WASH. SQ. S.

WEST

how Place

Champagne Gal

Provincetown Playhouse Café Espresso

Judson Memorial (Baptist)

Commerce

Soirée

thisisneverthat FW19
"Neponsit, NY 11695"
thisisneverthat RECORDS
Music: DJ Soulscape
Film: Kim Mintae

TN19FOW006IV / Jacket
SP Boa Fleece Jacket
Polyester, Acrylic, Nylon / Ivory

TN19FOW011BU / Jacket
Driver Jacket
Cotton, Nylon, Polyester / Burgundy

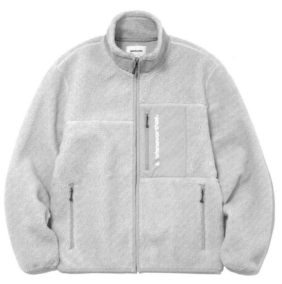
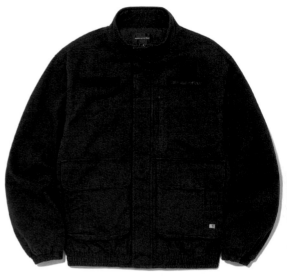

TN19FOW020NA / Jacket
LION 2010 Varsity Jacket
Polyester, Wool, Cow Leather / Navy

TN19FOW020BK / Jacket
LION 2010 Varsity Jacket
Polyester, Wool, Cow Leather / Black

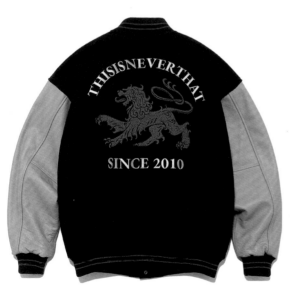
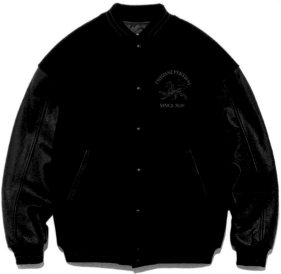

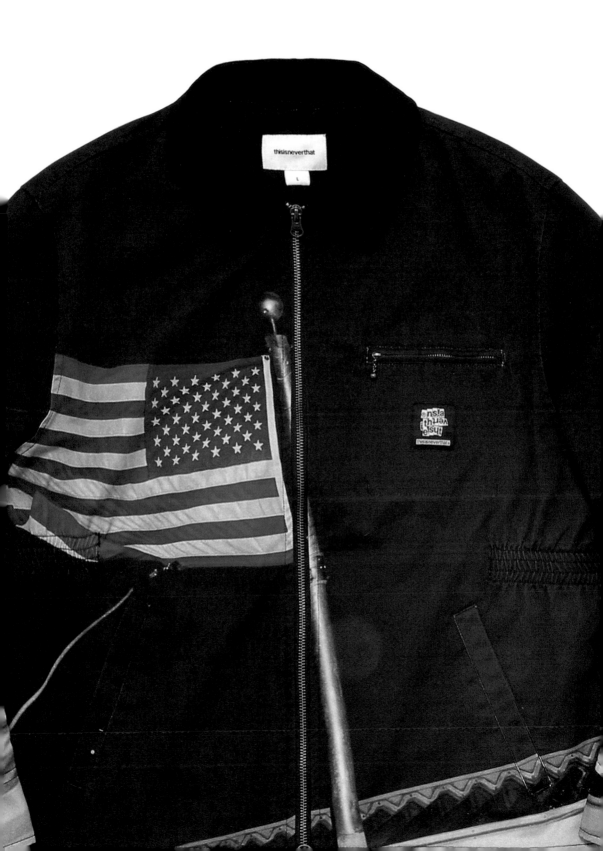

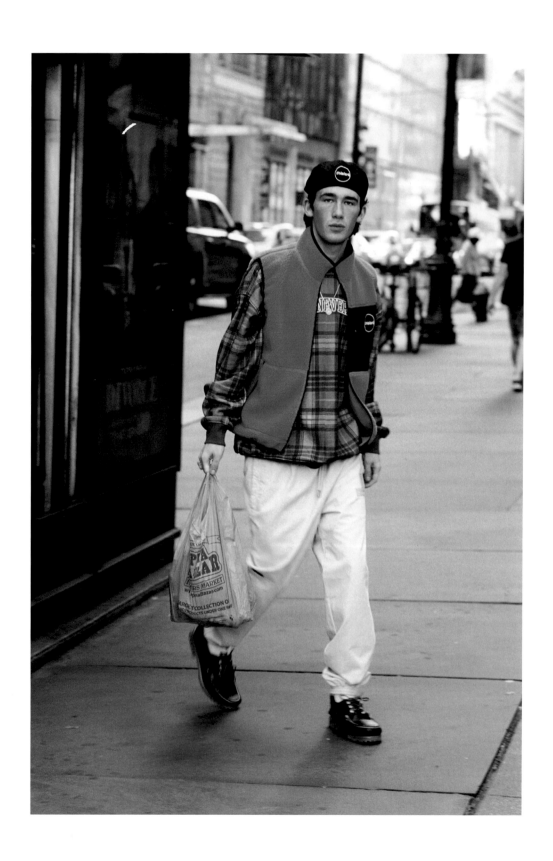

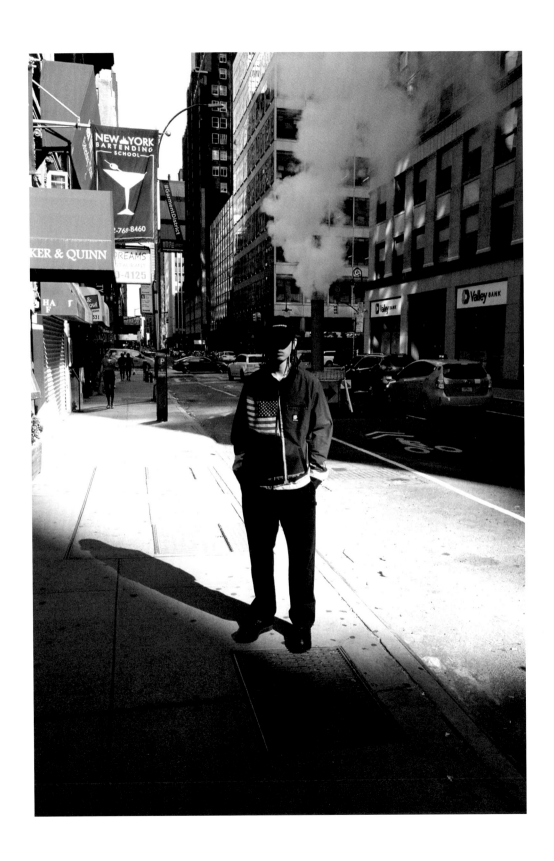

PREP-SCHOOL GANGSTERS

TN19FSH001BK / Shirt
ARC Logo African Check Shirt
Cotton / Black

TN19FOW001GN / Jacket
SP-INTL. Sport Down Jacket
Nylon, Down, Feather / Green

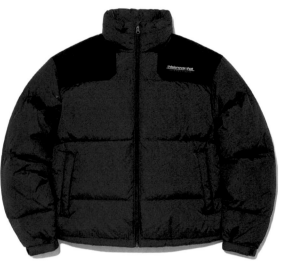

TN19FOW005OV / Jacket
ECWCS Parka
Polyester, Nylon, 3M Thinsulate / Olive

TN19FTS001RD / Tee
TOWN Tee
Cotton / Red

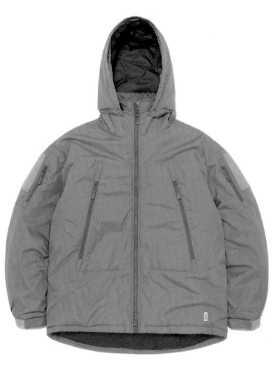

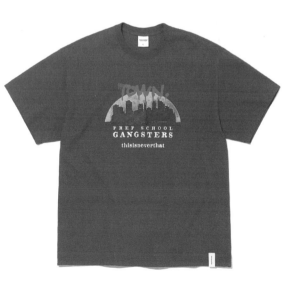

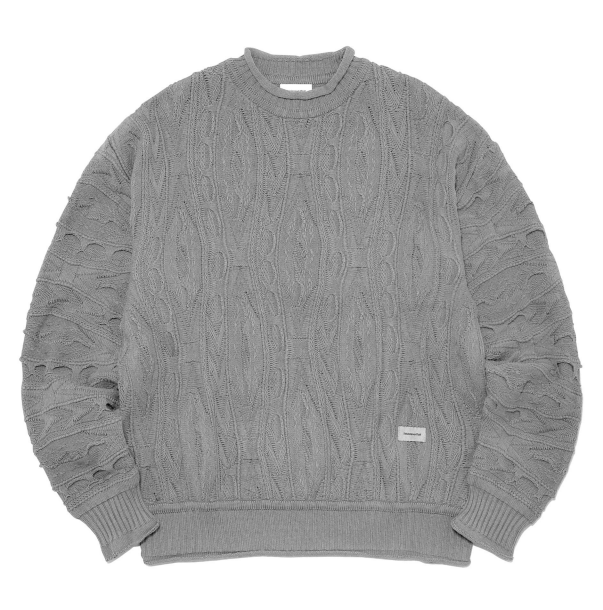

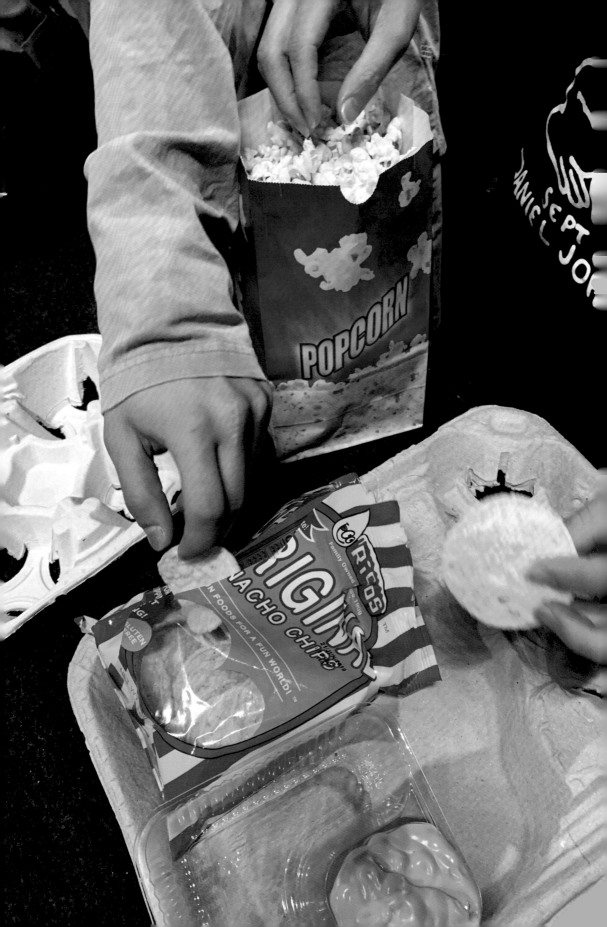

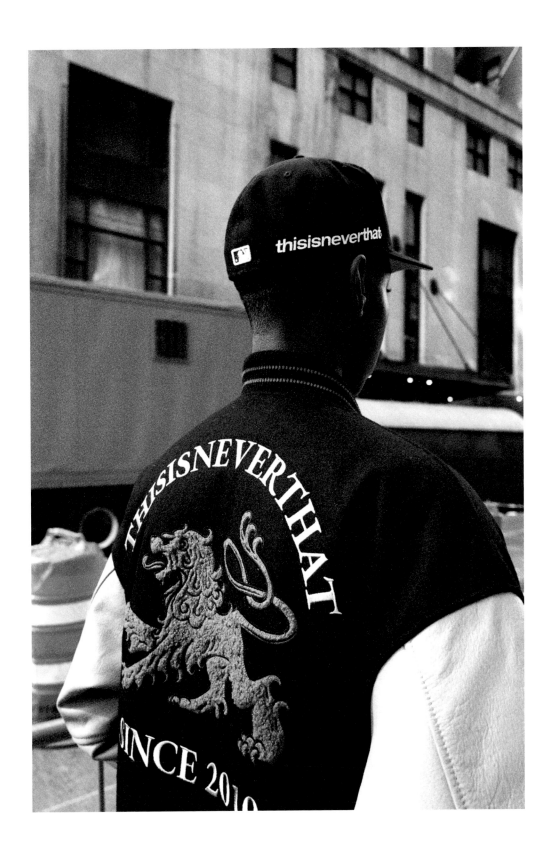

TN19FPA015BK / Pants
POLARTEC Fleece Pant
Polyester / Black

TN19FPA011NA / Pants
Full-Zip Pant
Nylon, Polyester / Navy

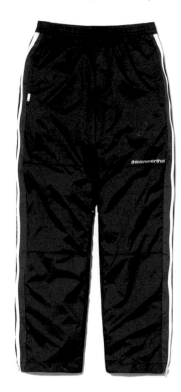

TN19FPA008BK / Pants
American Flag Work Pant
Cotton / Black

TN19FPA007GR / Pants
Work Pant
Cotton / Grey

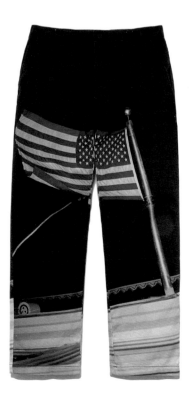

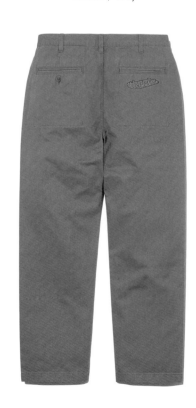

TN19FOW004AC / Jacket
HSP Hooded Down Jacket
Polyester, Down, Feather / Apricot

TN19FHS012IL / Sweatshirt
ARC-Logo Overdyed Hooded Sweatshirt
Cotton / Light Olive

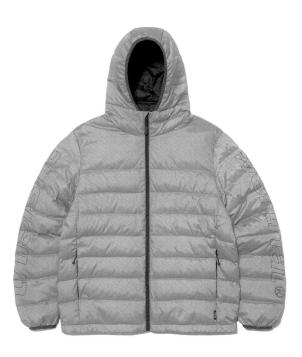

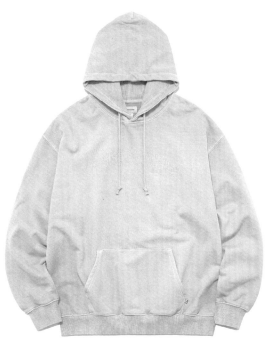

TN19FHS002BG / Sweatshirt
E/T-Logo Zipup Sweat
Cotton / Blue Green

TN19FOW009NA / Jacket
Hooded Boa Fleece Jacket
Polyester, Acrylic, Nylon / Navy

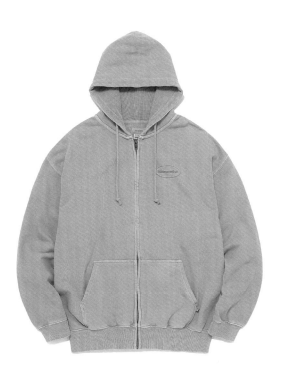

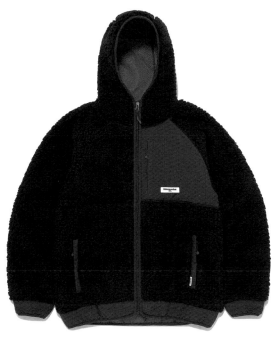

TN19FKW001NA

TN19FLS007NA

TN19FTP001IM

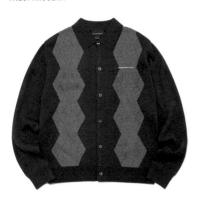

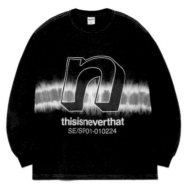

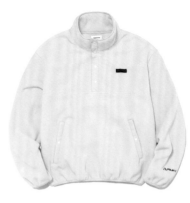

TN19FOW011GR

TN19FSW007PP

TN19FKW006NA

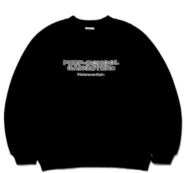

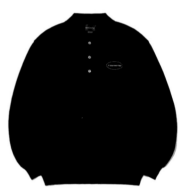

TN19FSW012PP

TA19FOW001KH

TN19FSH007BE

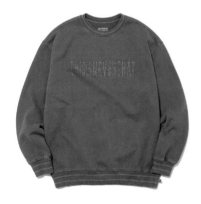

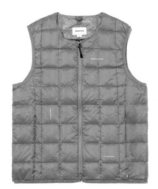

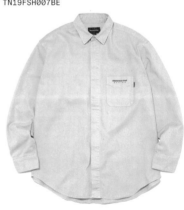

TN19FKW001NA	Top	Argyle Shirt Cardigan	Acrylic, Polyester	Navy
TN19FLS007NA	Long Sleeve Tee	N-Tiedye L/SL Top	Cotton	Navy
TN19FTP001IM	Top	POLARTEC Fleece Pullover	Polyester	Lime
TN19FOW011GR	Jacket	Driver Jacket	Cotton, Nylon	Grey
TN19FSW007PP	Sweatshirt	Prep-School Gangsters Crewneck	Cotton	Purple
TN19FKW006NA	Top	E/T-Logo Knit Polo	Cotton	Navy
TN19FSW012PP	Sweatshirt	Cracked Crewneck	Cotton	Purple
TA19FOW001KH	Jacket	TNT × TAION Crewneck W-Zip Down Vest	Nylon, Polyester, Down, Feather	Khaki
TN19FSH007BE	Shirt	Overdyed Twill Shirt	Cotton	Beige

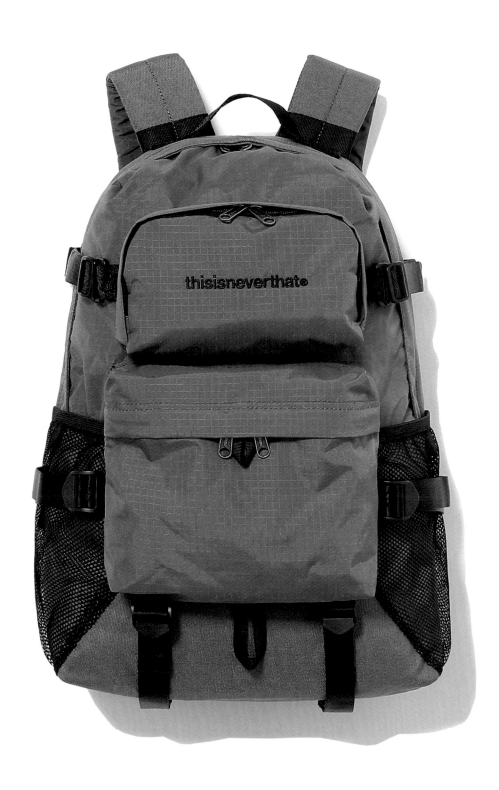

PREP-SCHOOL GANGSTERS

O PARKING

VEHICLES WILL BE **TOWED** TO THE

NEAREST LEGAL SPOT IF NOT MOVED BY:

AY & DATE: Sat 6/22/19

TIME: 10PM _____ AM PM

ATE(S): Sun 6/23/19

ANY NAME : OTR

ER & CELL #: 347-803-6910

347-803-6910

THE CITY OF NEW YORK
MAYOR'S OFFICE
OF MEDIA AND ENTERTAINMENT
Office of Film, Theatre and
Broadcasting

VEHICLE HAS BEEN RELOCATED – PLEASE CALL 311

TN19FHS005BK / Sweatshirt
TOWN Hooded Sweatshirt
Cotton / Black

TN19FHS001OV / Sweatshirt
POLARTEC Fleece Hoodie
Polyester / Olive

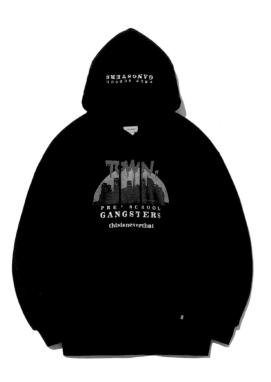

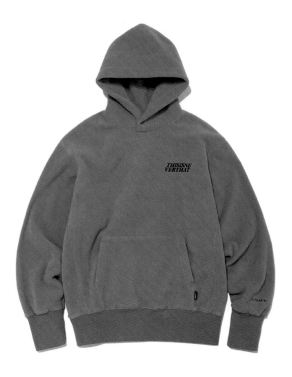

TN19FHW006RD / Hat
Fleece Earflap Cap
Polyester / Red

TN19FHW009BU / Hat
SP Earflap Beanie
Acrylic / Burgundy

TN19FAC012BK / Accessory
Klean Kanteen® Insulated Wide 16oz
Black

TN19FAC017SR / Accessory
LION Necklace
925 Silver / Silver

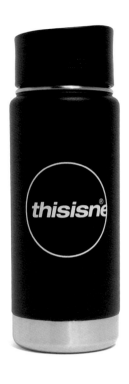

APCOCAC002BW / Accessory
TNT × APFR Paper Tag
Paper / White, Black

APCOCAC001NNE / Accessory
TNT × APFR Room Mist Spray
Water, Ethanol, Fragrance, Surfactant / White

TN19FHW016GN / Hat
ARC Logo Cap
Cotton / Green

TN19FHW012BK / Hat
Newsboy Hat
Cotton / Black

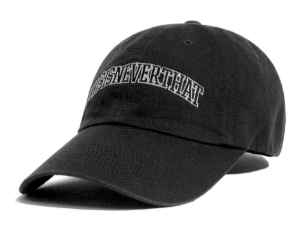

TN19FHW013NA / Hat
HSP-Logo Beanie
Acrylic / Navy

TN19FHW002GN / Hat
SP-Logo Cap
Cotton / Green

 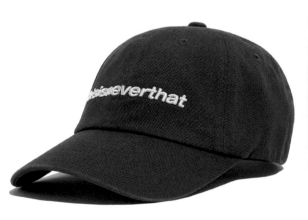

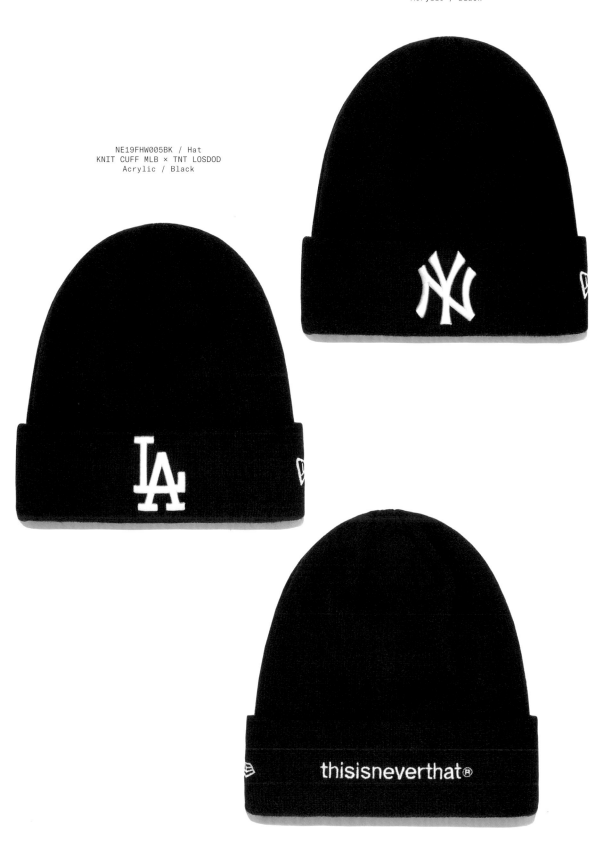

NE19FHW004BK / Hat
KNIT CUFF MLB × TNT NEYYAN
Acrylic / Black

NE19FHW005BK / Hat
KNIT CUFF MLB × TNT LOSDOD
Acrylic / Black

NE19FHW001BK / Hat
920UNST TNT
Cotton / Black

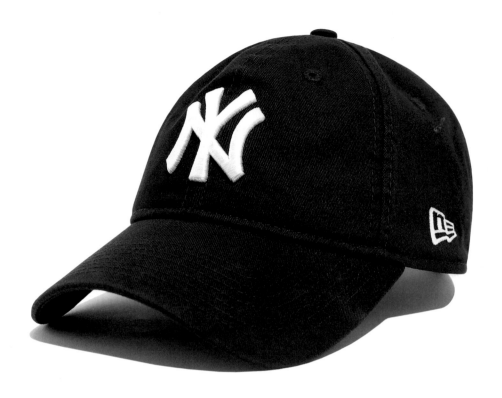

NE19FBA002BK / Bag
SACOCHE TNT
Nylon / Black

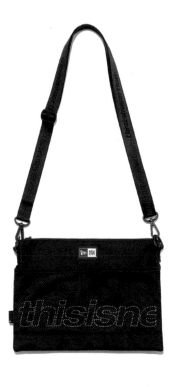

NE19FBA001BK / Bag
URBAN PACK TNT
Nylon / Black

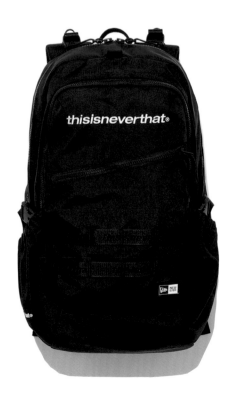

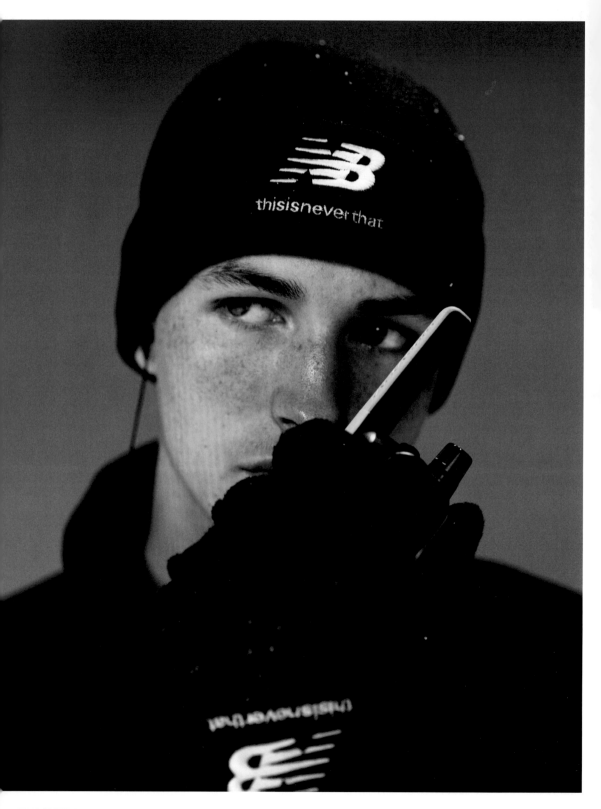

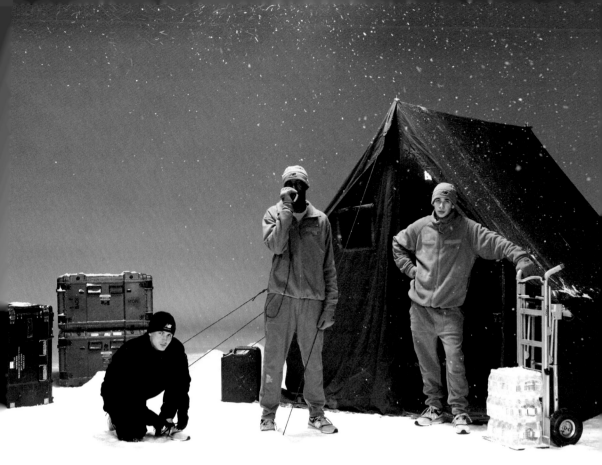

NEW BALANCE × thisisneverthat

NEW BALANCE × thisisneverthat

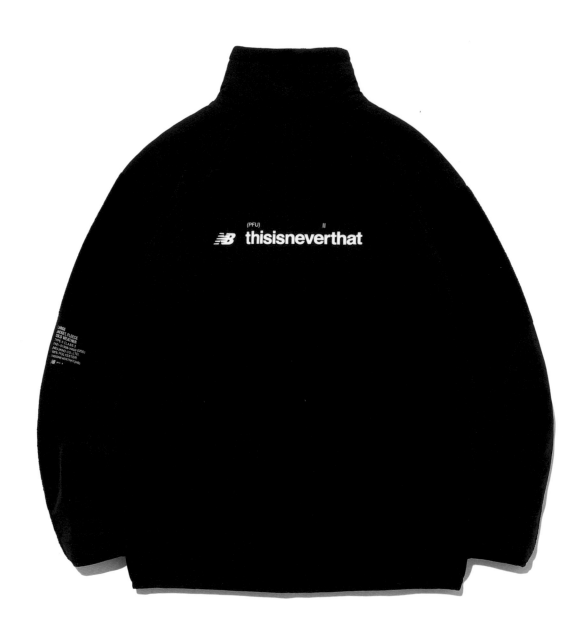

NB19FOW001BE / Jacket
NB TNT PT Fleece Jacket
Polyester, Nylon / Beige

NB19FOW001KH / Jacket
NB TNT PT Fleece Jacket
Polyester, Nylon / Khaki

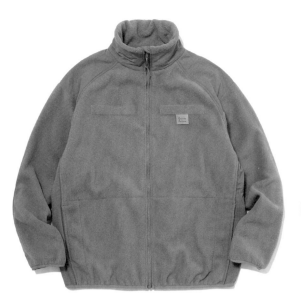
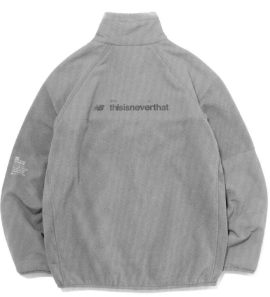

NB19FLS001BE / Long Sleeve Tee
NB TNT PT L/S
Cotton / Beige

NB19FLS001BK / Long Sleeve Tee
NB TNT PT L/S
Cotton / Black

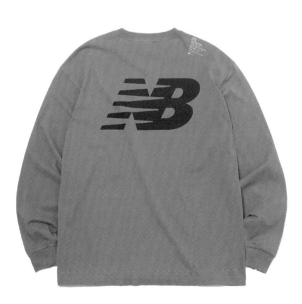
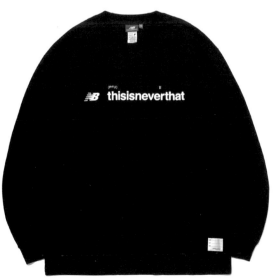

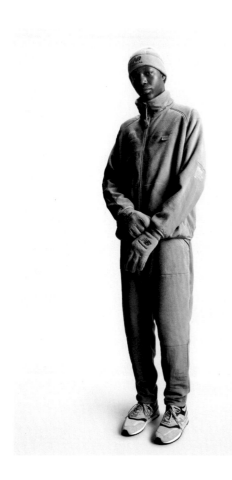

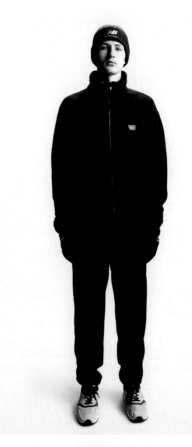

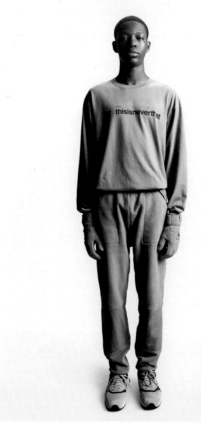

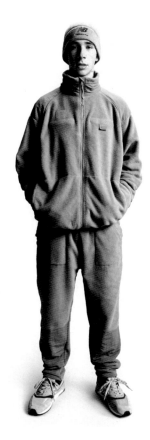

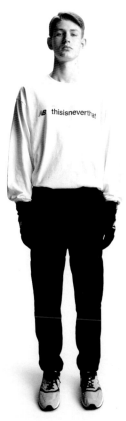

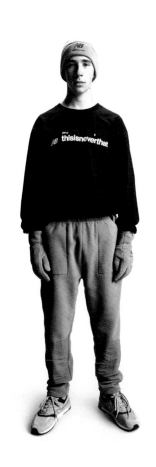

NEW BALANCE × thisisneverthat

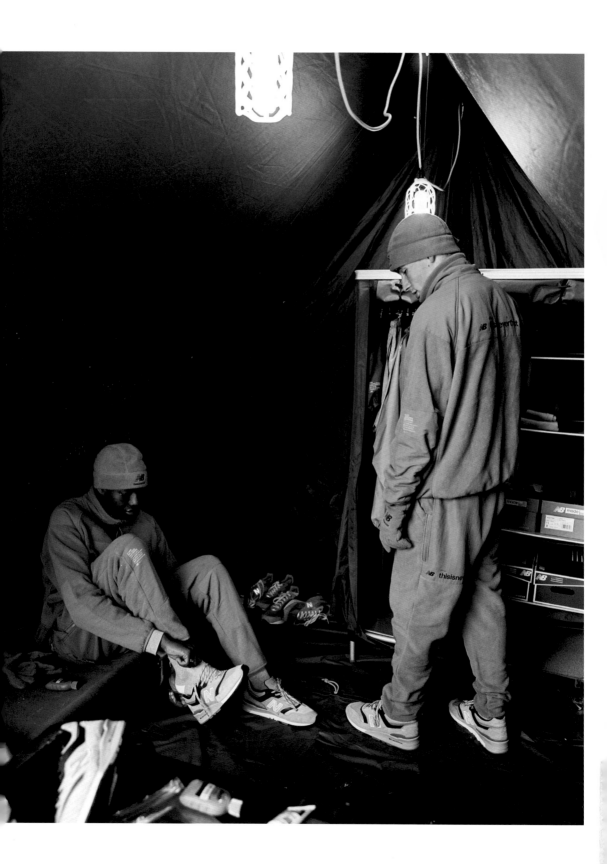

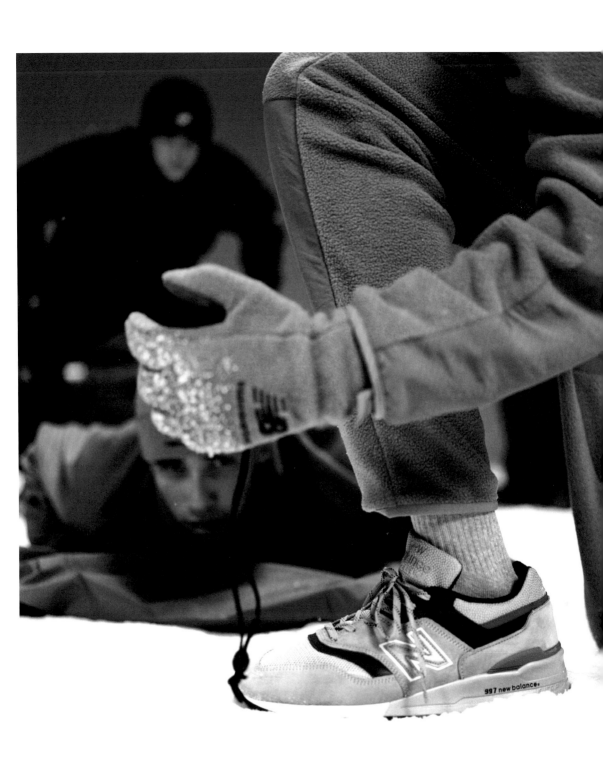

NB19FPA001BK

NB19FPA001BE

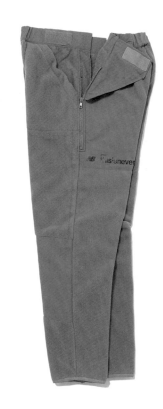

NB19FLS001BK

NB19FLS001BE

NB19FLS001KH

NB19FHW001BK

NB19FHW001BE

NB19FAC002BK

NB19FPA001KH

NB19FAC001KH

NB19FHW001KH

NB19FLS001IR

NB19FLS001WH

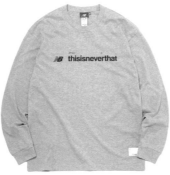

NB19FPA001BK	Pants	NB TNT PT Fleece Pant	Polyester, Nylon	Black
NB19FPA001BE	Pants	NB TNT PT Fleece Pant	Polyester, Nylon	Beige
NB19FPA001KH	Pants	NB TNT PT Fleece Pant	Polyester, Nylon	Khaki
NB19FAC001KH	Accessory	NB TNT PT Fleece Gloves	Polyester	Khaki
NB19FHW001KH	Hat	NB TNT PT Fleece Hat	Polyester	Khaki
NB19FLS001BK	Long Sleeve Tee	NB TNT PT L/S	Cotton	Black
NB19FLS001BE	Long Sleeve Tee	NB TNT PT L/S	Cotton	Beige
NB19FLS001KH	Long Sleeve Tee	NB TNT PT L/S	Cotton	Khaki
NB19FLS001IR	Long Sleeve Tee	NB TNT PT L/S	Cotton	Light Grey
NB19FLS001WH	Long Sleeve Tee	NB TNT PT L/S	Cotton	White
NB19FHW001BK	Hat	NB TNT PT Fleece Hat	Polyester	Black
NB19FHW001BE	Hat	NB TNT PT Fleece Hat	Polyester	Beige
NB19FAC002BK	Socks	NB TNT PT Socks	Cotton	Black

NEW BALANCE × thisisneverthat

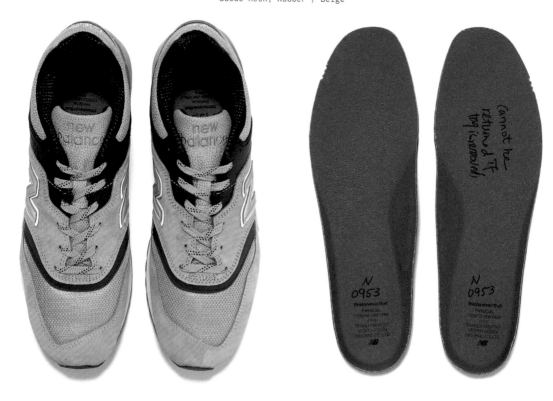

NB19FAC001KH / Accessory
NB TNT PT Fleece Gloves
Polyester / Khaki

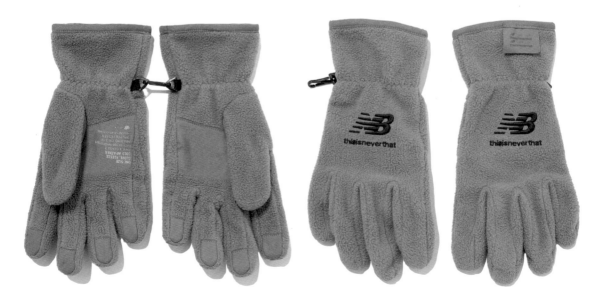

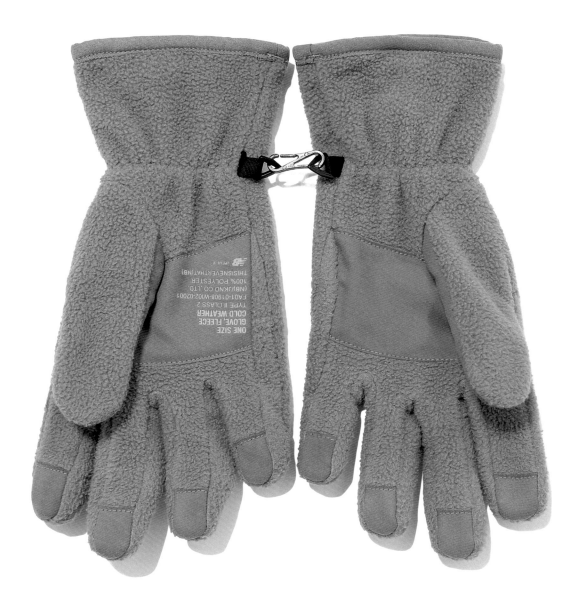

Collaborator

Release Date
Oct 18, 2019

Prefix
GT

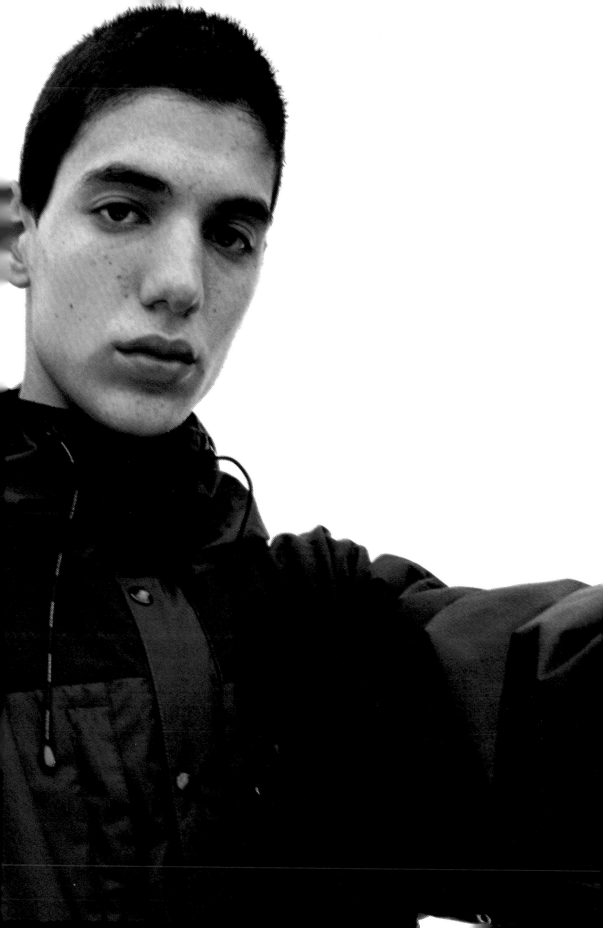

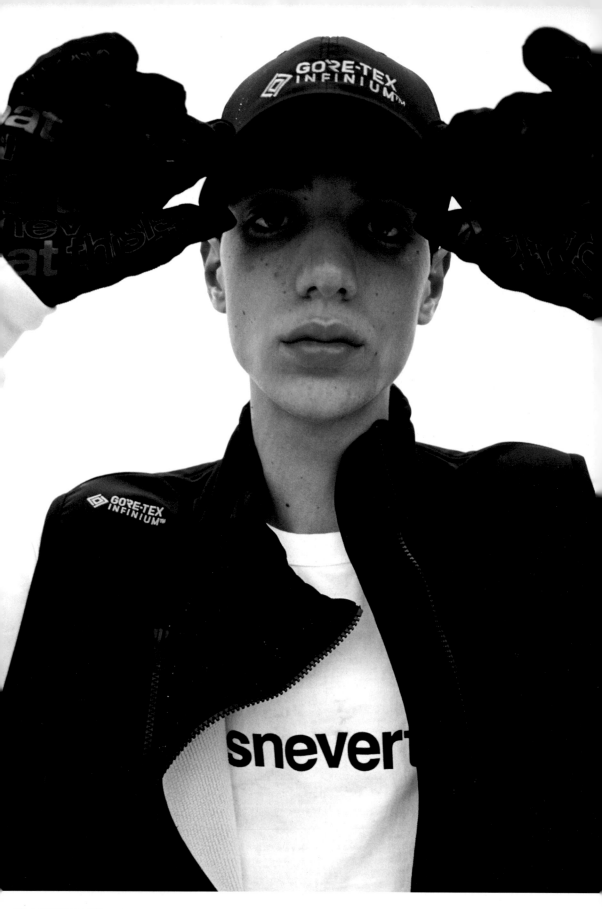

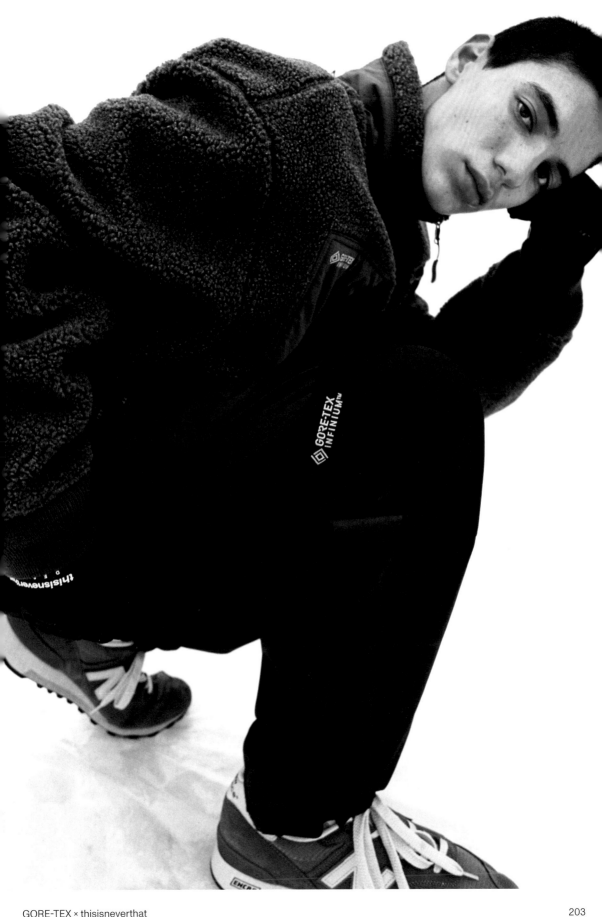

GORE-TEX × thisisneverthat

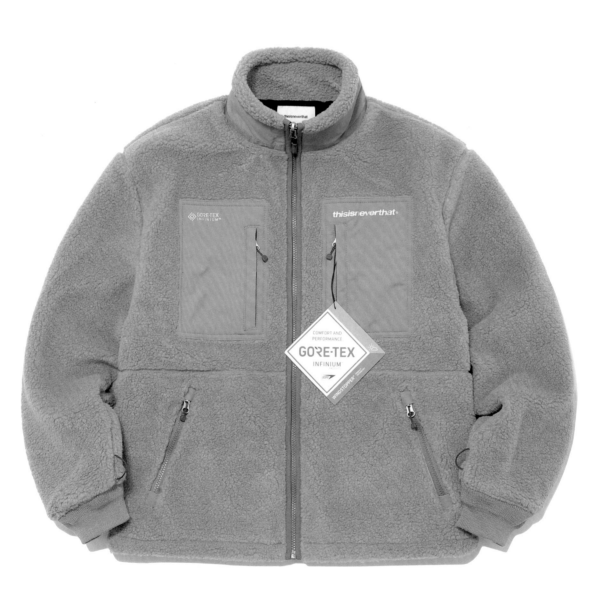

TN19FOW016GR

TN19FPA001GR

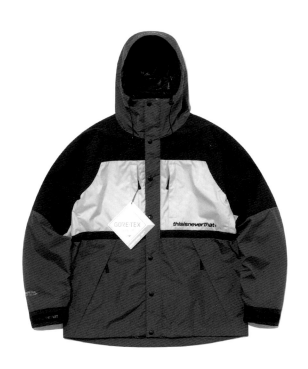

TN19FOW016FR

TN19FPA001FR

TN19FOW017CH

TN19FOW016GR	Jacket	GORE-TEX® INFINIUM™ Explorer Jacket	Polyester, Nylon	Grey
TN19FPA001GR	Pants	GORE-TEX® INFINIUM™ Explorer Pant	Polyester, Nylon	Grey
TN19FOW016FR	Jacket	GORE-TEX® INFINIUM™ Explorer Jacket	Polyester, Nylon	Forest
TN19FPA001FR	Pants	GORE-TEX® INFINIUM™ Explorer Pant	Polyester, Nylon	Forest
TN19FOW017CH	Jacket	GORE-TEX® INFINIUM™ Explorer Fleece Jacket	Polyester, Acrylic, Nylon	Charcoal

GORE-TEX × thisisneverthat

TN19FOW018BK / Jacket
GORE-TEX® INFINIUM™ Explorer Vest
Nylon, Elastane / Black

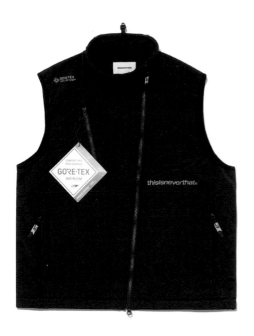 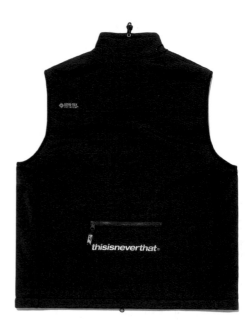

TN19FAC002BK / Accessory
GORE-TEX® INFINIUM™ Gloves
Nylon, Span, Polyester, Polyurethane / Black

TN19FHW001BK / Hat
GORE-TEX® INFINIUM™ Explorer Hat
Nylon, Elastane / Black

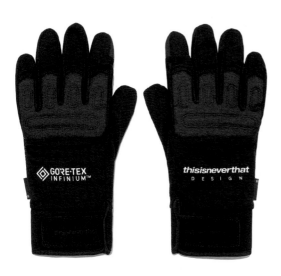 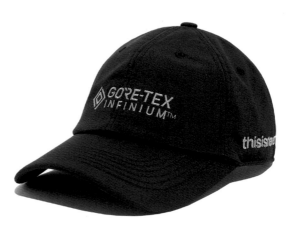

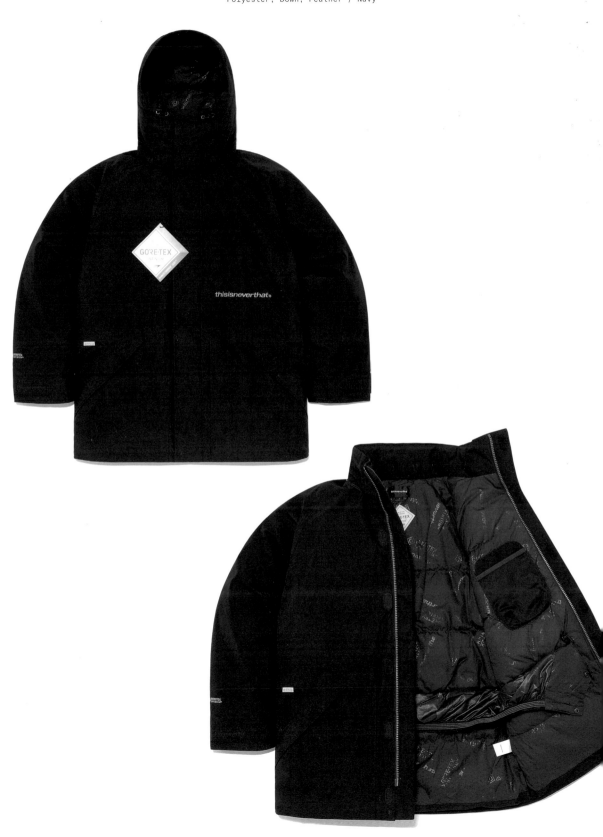

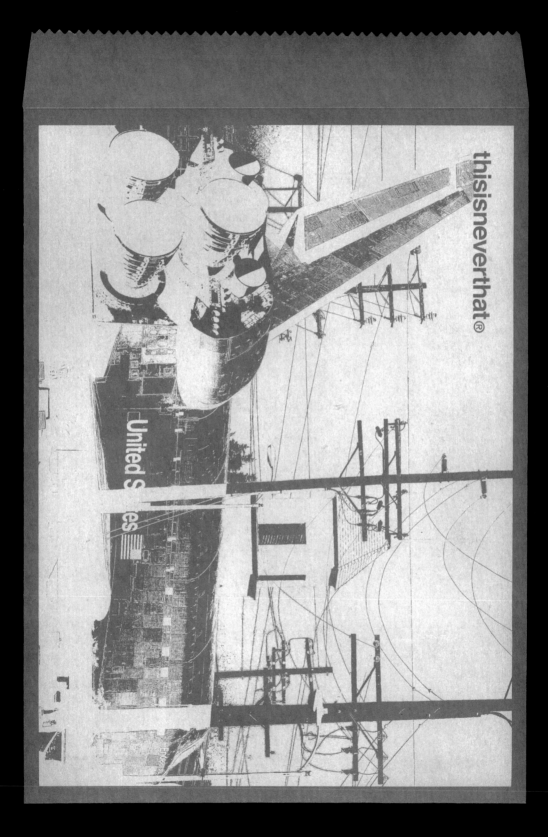

SPRING/SUMMER 2019

TEENAGE FISHING CLUB

TN19SKW003IV, Top, Tennis Knit Vest ▌ TN19STS029WH, Tee, Teenage Fishing Club Tee ▌ TN19SPA007BE, Pants, Multi Cargo Pant ▌ TN19SHW018BE, Hat, Fishing Bucket Hat ▌ TN19SBA008OV, Bag, Ripstop Cordura® 210D Traveller Bag

TN19SSH001MI, Shirt, Sports Fishing Shirt ▌ TN19STS017BK, Tee, Fishing Club Tee ▌ TN19SSO0040V, Pants, T-Logo Cargo Short ▌ TN19SBA0070V, Bag, Ripstop Cordura® 210D Mini Shoulder Bag ▌ TN19SBA0080V, Bag, Ripstop Cordura® 210D Traveller Bag

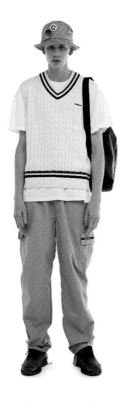

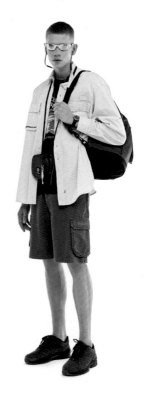

TN19SSH010YL, Shirt, Rayon S/SL Shirt ▌ TN19SPA011SB, Pants, HSP Warm Up Pant ▌ TN19SHW008RD, Hat, TWOBOYS Bucket Hat ▌ TN19SAC009SR, Accessory, HSP Necklace ▌ TN19SAC008SR, Accessory, C-Logo Ring

TN19STS022RD, Tee, NEW SPORTS Tee ▌ TN19SPA003OV, Pants, Fishing Pant ▌ TN19SPA002BK, Pants, T-Court Track Pant ▌ TN19SBA009BK, Bag, Ripstop Cordura® 210D Gym Sack ▌ TN19SAC001BK, Accessory, SP-Logo Webbing Belt

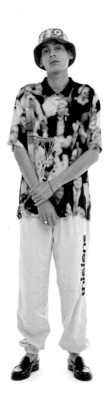

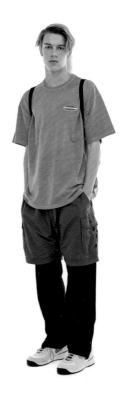

TN19SHS001BU, Sweatshirt, ARC-Logo Zipup Sweat ● TN19SLS008GP, Long
Sleeve Tee, N Striped L/SL Top ● TN19SPA006GR, Pants, Carpenter Pant
● TN19SHW002GN, Hat, ARC-Logo Cap ● TN19SAC001BK, Accessory, SP-Logo
Webbing Belt

TN19SHS009PP, Sweatshirt, ESP Overdyed Hooded Sweatshirt ●
TN19SPA013BK, Pants, Blue Tepee Pant ● TN19SAC001BK, Accessory, SP-Logo
Webbing Belt ● TN19SAC008SR, Accessory, C-Logo Ring

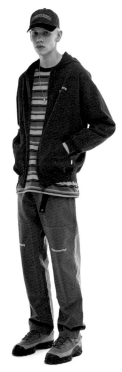
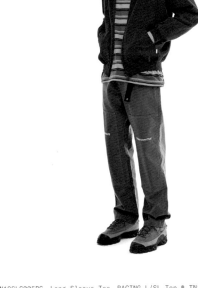

TN19SLS005BG, Long Sleeve Tee, RACING L/SL Top ● TN19SPA007BU, Pants,
Multi Cargo Pant ● TN19SBA006BK, Bag, Ripstop Cordura® 210D Daypack

TN19SOW003KE, Jacket, T-Court Track Jacket ● TN19STS027WH, Top, TN Polo
● TN19SPA010TB, Jean, Cropped Jean ● TN19SHW003WH, Hat, DSN-Logo Cap ●
TN19SAC009SR, Accessory, HSP Necklace

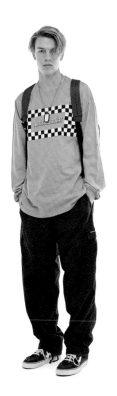
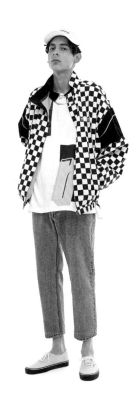

TN19SSH009IN, Shirt, TINT Pin Tuck Zip Up Shirt ● TN19SLS011PP, Long Sleeve Tee, T-Logo Pocket L/SL Top ● TN19SPA009BK, Jean, Fatigue Jean

TN19SSH008BL, Shirt, DSN-Logo Striped Shirt ● TN19STS010WH, Tee, MI-Logo Tee ● TN19SPA011IN, Pants, HSP Warm Up Pant ● TN19SAC009SR, Accessory, HSP Necklace ● TN18SAC003WH, Accessory, Skogar Sunglasses

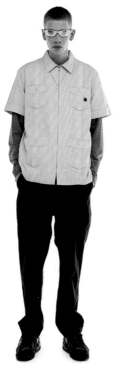

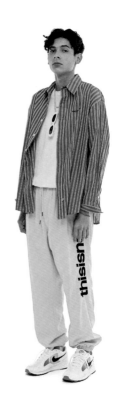

TN19SOW006IN, Jacket, Fisherman Jacket ● TN19SSH010BK, Shirt, Rayon S/SL Shirt ● TN19SSO004BK, Pants, T-Logo Cargo Pant

TN19SSH007SB, Shirt, Velour S/SL Shirt ● TN19SLS011PP, Long Sleeve Tee, T-Logo Pocket L/SL Top ● TN19SPA016LV, Pants, Tiedye Sweatpant

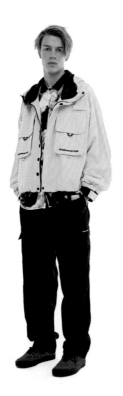

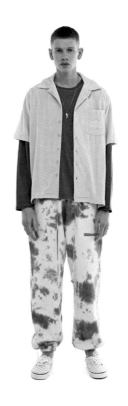

TN19SOW005NA, Jacket, INTL. Fleece Jacket ❚ TN19STS023LV, Tee, Tiedye Tee ❚ TN19SS0005TB, Jean, Denim Skate Short ❚ TN19SAC009SR, Accessory, HSP Necklace ❚ TN19SAC008SR, Accessory, C-Logo Ring

TN19STS014BK, Tee, Tennis Player Tee ❚ TN19SLS007ER, Long Sleeve Tee, Fishing L/SL Top ❚ TN19SPA018FR, Pants, DIA-SP Sweatpant ❚ TN19SHW017MI, Hat, SPORTS_TSN Cap ❚ TN19SAC009SR, Accessory, HSP Necklace

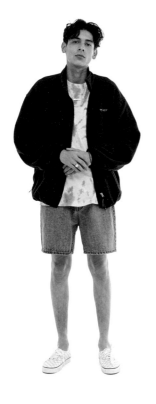

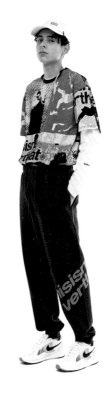

TN19SHS010GN, Sweatshirt, Tiedye Hooded Sweatshirt ❚ TN19SPA003OV, Pants, Zipped Fishing Pant ❚ TN19SPA002KE, Pants, T-Court Track Pant

TN19SKW001BK, Top, SCRT Zip Knit Polo ❚ TN19SPA002KE, Pants, T-Court Track Pant ❚ TN19SAC009SR, Accessory, HSP Necklace ❚ TN19SAC008SR, Accessory, C-Logo Ring ❚ TN18SAC003WH, Accessory, Skogar Sunglasses

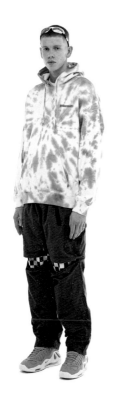

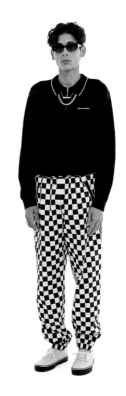

TN19SOW008GR, Jacket, Denim Trucker Jacket ⬙ TN19STS019BK, Tee, 3ESP Logo Striped Tee ⬙ TN19SPA008BK, Jean, Regular Jean

TN19SLS006BK, Long Sleeve Tee, BUG BLOOD L/SL Top ⬙ TN19SPA0050V, Pants, Velcro Cuff Pant ⬙ TN19SBA001BK, Bag, Mesh Backpack

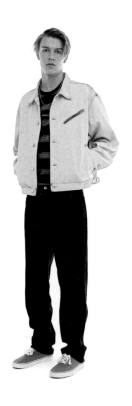

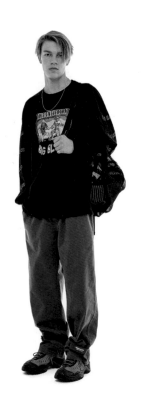

TN19SSH005RD, Shirt, BUG BLOOD Hawaiian Shirt ⬙ TN19SPA010BK, Jean, Cropped Jean

TN19SHS008YL, Sweatshirt, CP-INTL. Hooded Sweatshirt ⬙ TN19STS030BG, Tee, T-CUBIC Tee ⬙ TN19SPA002BK, Pants, T-Court Track Pant

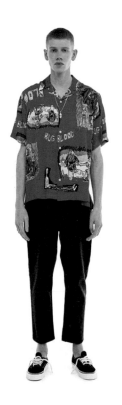

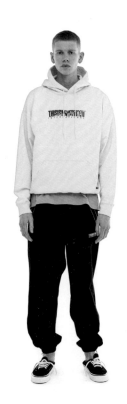

TN19SSH009BU, Shirt, TINT Pin Tuck Zip Up Shirt ◊ TN19SLS007OV, Long Sleeve Tee, Fishing L/SL Top ◊ TN19SPA006WH, Pants, Carpenter Pant ◊ TN19SAC009SR, Accessory, HSP Necklace

TN19SKW002BR, Top, Jacquard Knit Polo ◊ TN19SPA008ML, Jean, Regular Jean ◊ TN19SAC009SR, Accessory, HSP Necklace ◊ TN18SAC003WH, Accessory, Skogar Sunglasses

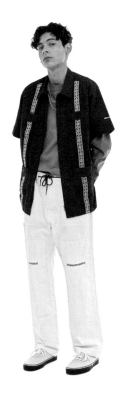

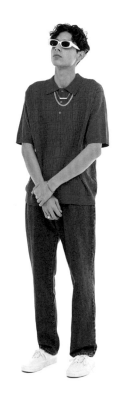

TN19SSH011BW, Shirt, Court Hawaiian Shirt ◊ TN19SPA011BK, Pants, HSP Warm Up Pant ◊ TN19SBA007BK, Bag, Ripstop Cordura® 210D Mini Shoulder Bag ◊ TN19SAC008SR, Accessory, C-Logo Ring

TN19SKW005BK, Top, Zipup L/SL Polo ◊ TN19SSO010BK, Pants, Jogging Short ◊ TN19SBA002BK, Bag, Ripstop Cordura® 210D BOP ◊ TN19SAC009SR, Accessory, HSP Necklace ◊ TN19SAC008SR, Accessory, C-Logo Ring

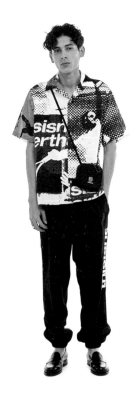

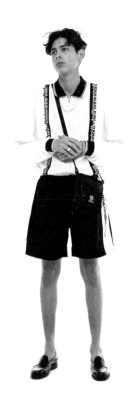

TN19SOW007BK, Jacket, MI-Logo M51 Parka ⬤ TN19STS018BK, Tee, 3SP Striped Tee ⬤ TN19SSO004BE, Pants, T-Logo Cargo Short

TN19SOW002KH, Jacket, DSN Sport Parka ⬤ TN19SSH002MI, Shirt, HSP Check Shirt ⬤ TN19SSO004BK, Pants, T-Logo Cargo Short ⬤ TN19SHW009NA, Hat, Fishing Hat

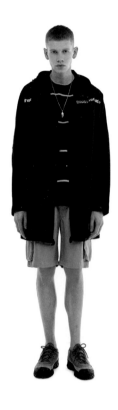

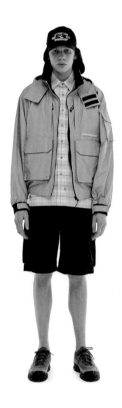

TN19SKW007VY, Top, DSN Striped Jersey Polo ⬤ TN19SPA012BE, Pants, Skater Pant ⬤ TN19SHW003OV, Hat, DSN-Logo Cap ⬤ TN19SBA001BK, Bag, Mesh Backpack ⬤ TN19SAC001BK, Accessory, SP-Logo Webbing Belt

TN19SHS004MI, Sweatshirt, Skateboarding Hooded Sweatshirt ⬤ TN19SSO008BK, Pants, MV-SP Sweatshort

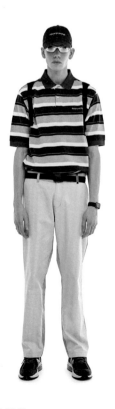

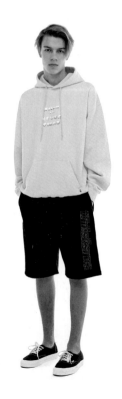

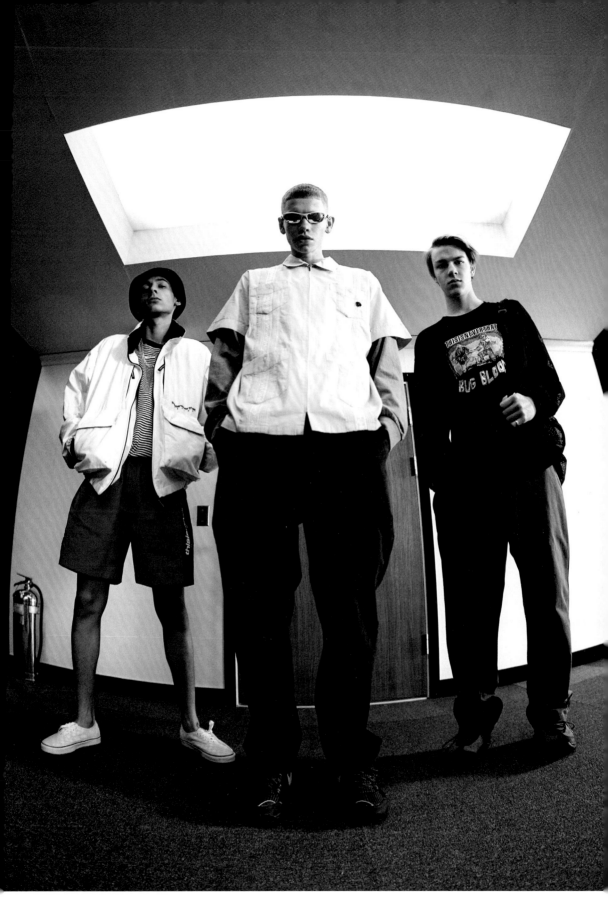

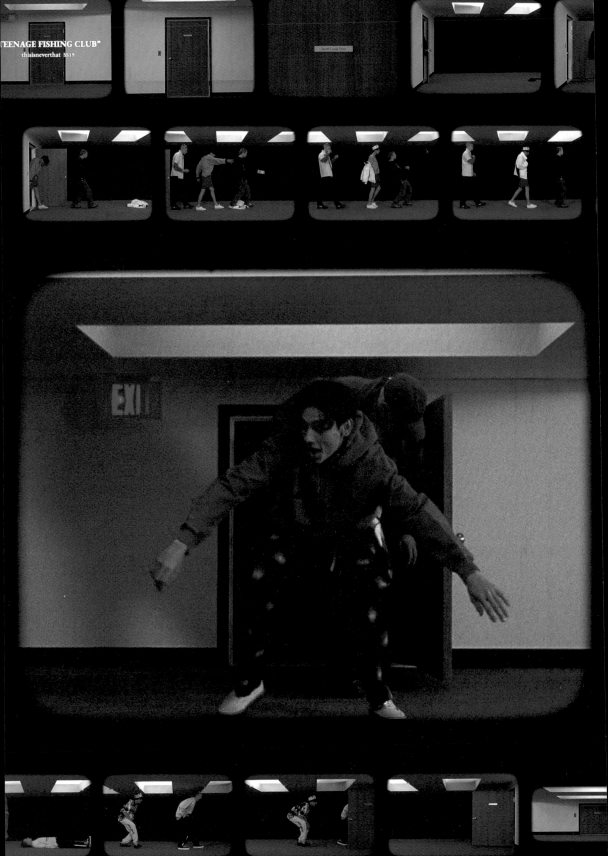

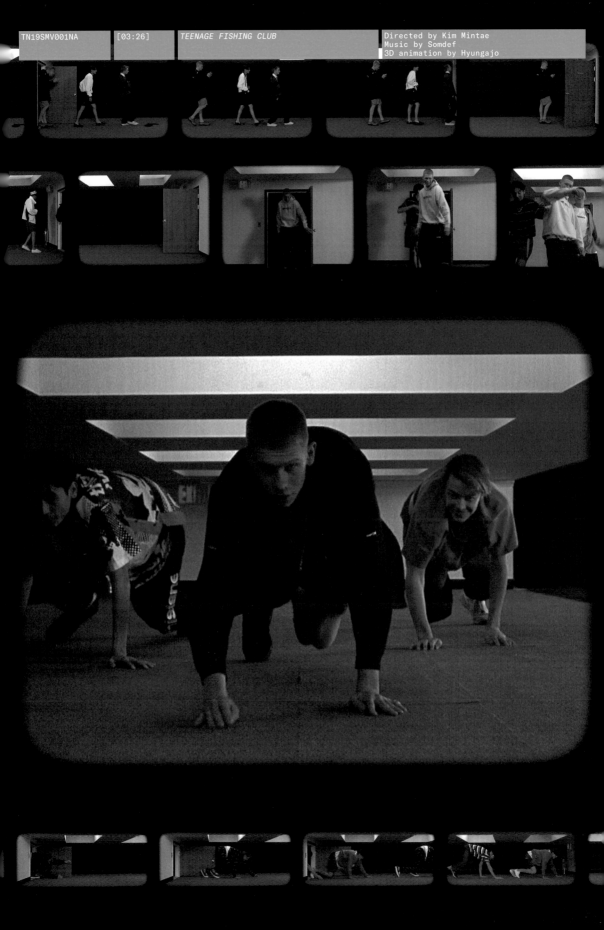

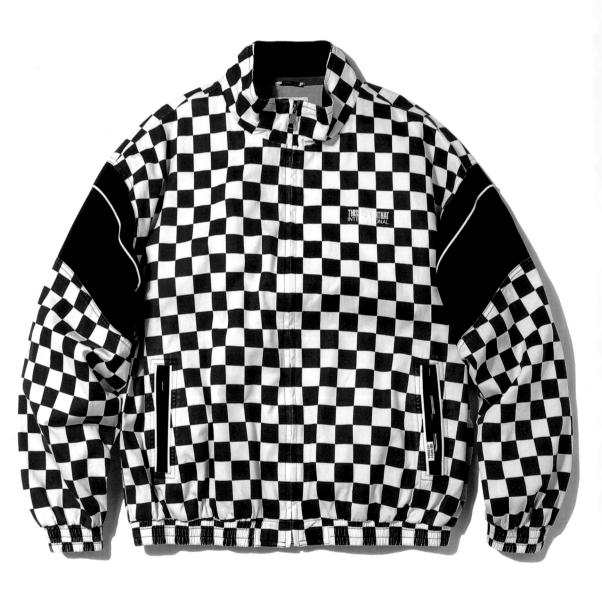

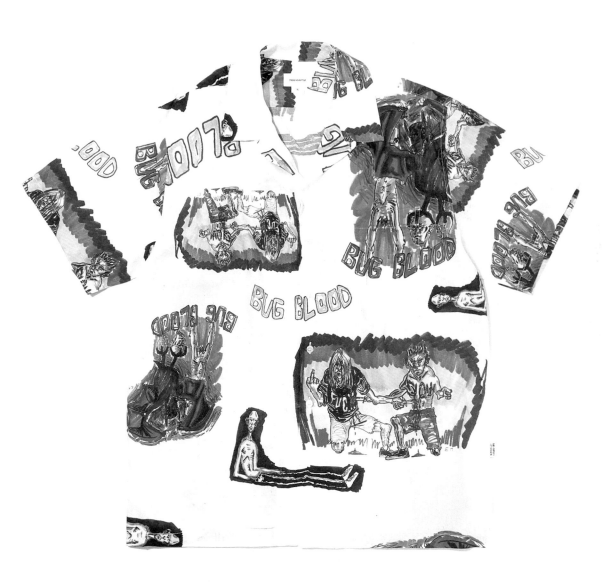

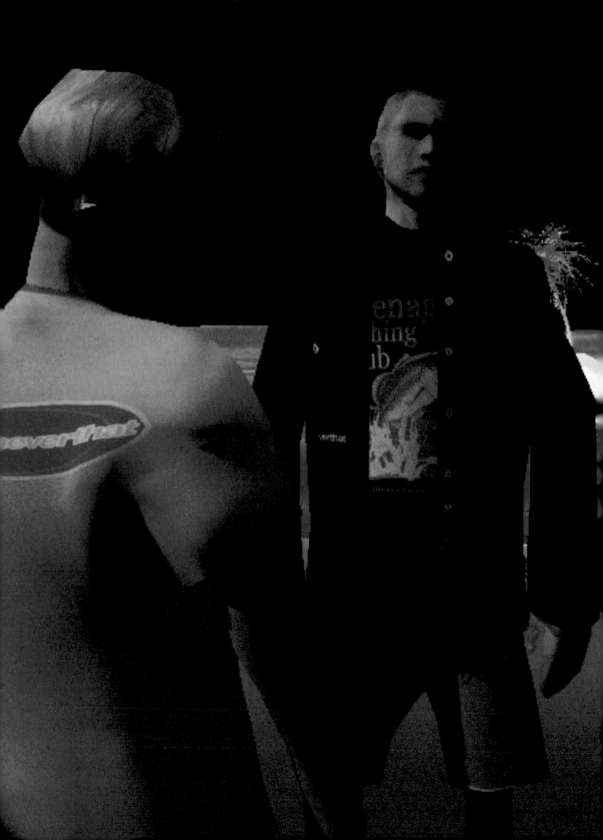

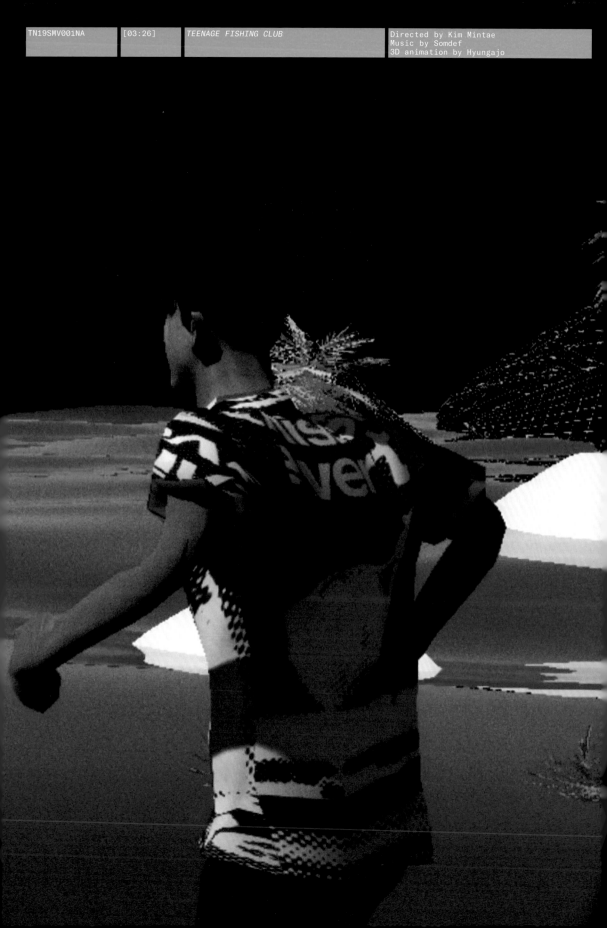

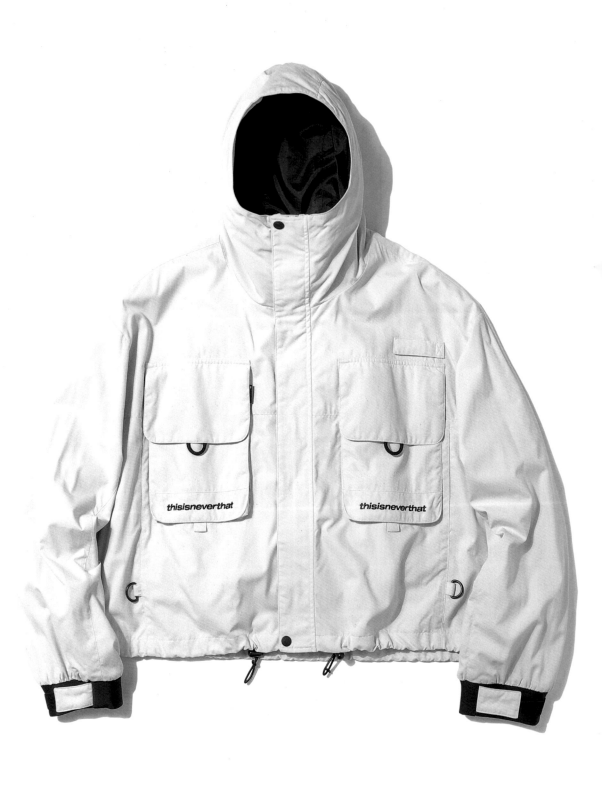

TN19SOW005NA / Jacket
INTL. Fleece Jacket
Polyester, Nylon / Navy

TN19SOW006IN / Jacket
Fisherman Jacket
Nylon, Polyester / Lime Green

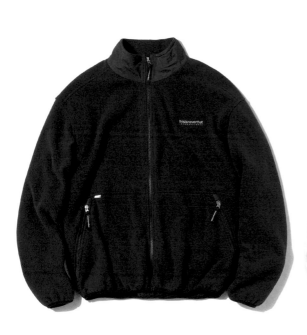

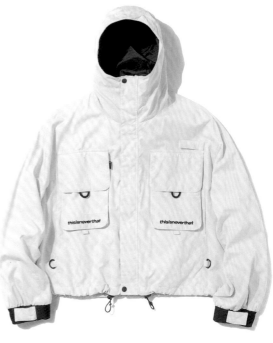

TN19SOW002BK / Jacket
DSN Sport Parka
Cotton, Nylon, Polyester / Black

TN19SOW002KH / Jacket
DSN Sport Parka
Cotton, Nylon, Polyester / Khaki

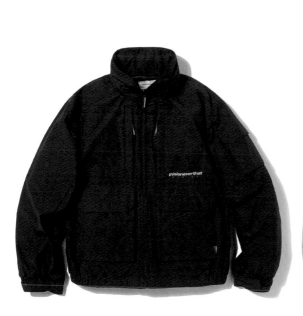

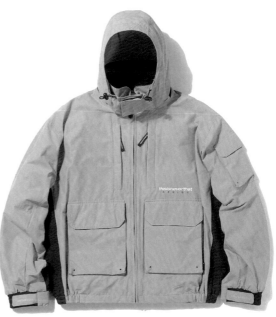

TN19SOW008IN / Jacket
Fisherman Jacket
Nylon, Polyester / Lime Green

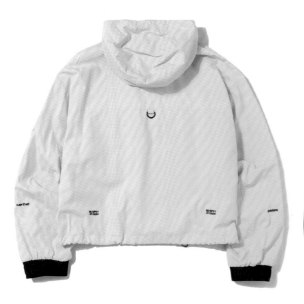

TN19SOW005NA / Jacket
INTL. Fleece Jacket
Polyester, Nylon / Navy

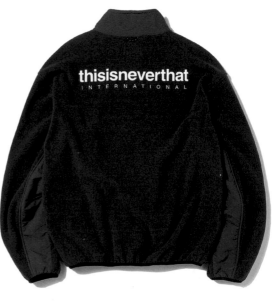

TN19SOW002KH / Jacket
DSN Sport Parka
Cotton, Nylon, Polyester / Khaki

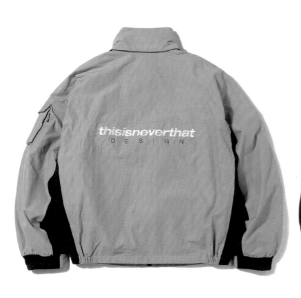

TN19SOW002BK / Jacket
DSN Sport Parka
Cotton, Nylon, Polyester / Black

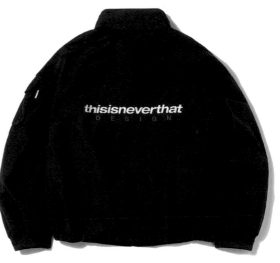

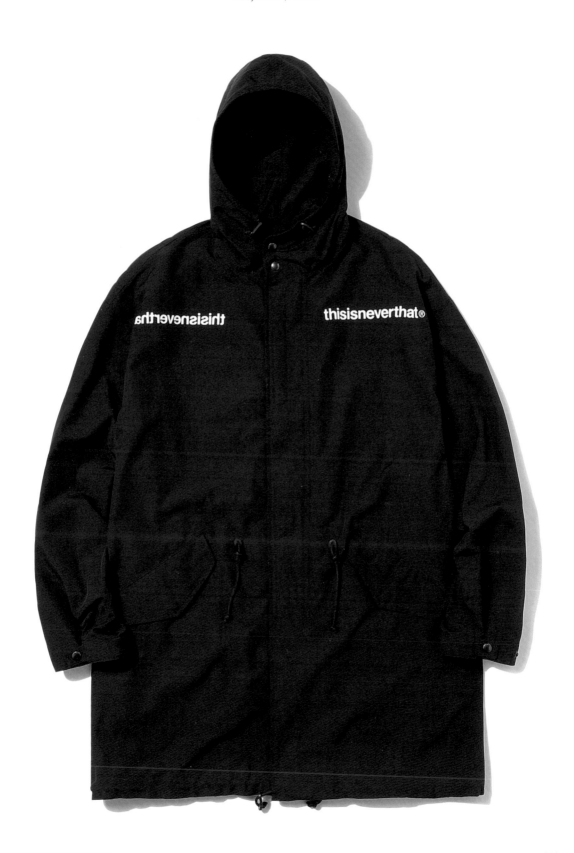

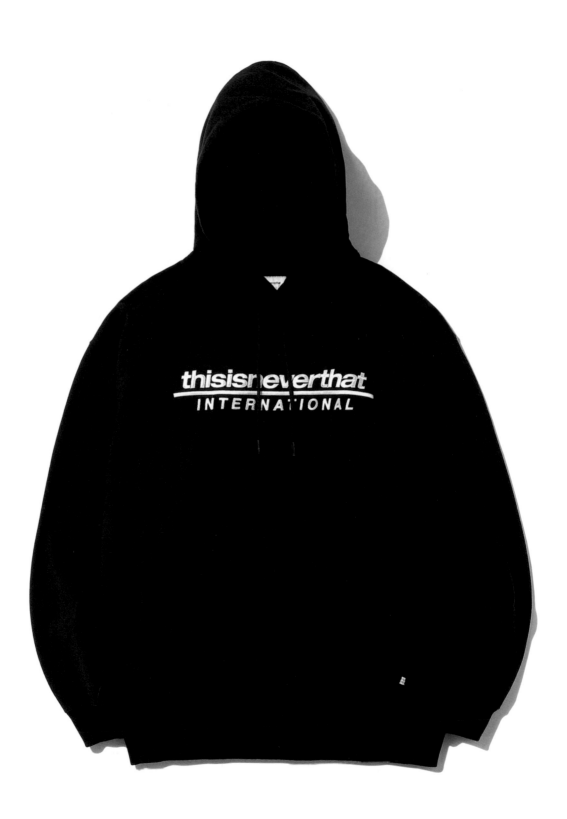

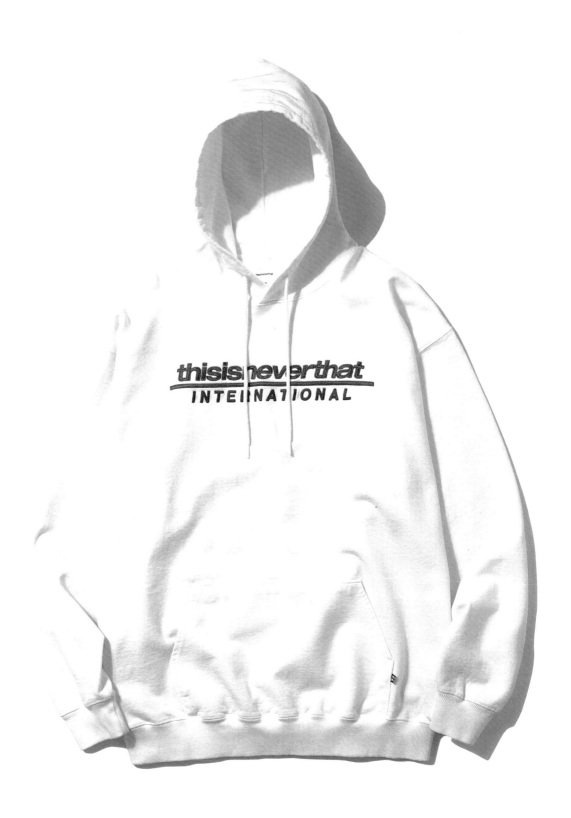

TN19SHS002BK TN19SHS002FR

TN19SHS006NA TN19SHS009PP

TN19SHS002BK	Sweatshirt	SP-INTL. Logo Zipup Sweat	Cotton	Black
TN19SHS002FR	Sweatshirt	SP-INTL. Logo Zipup Sweat	Cotton	Forest
TN19SHS006NA	Sweatshirt	HSP Hooded Sweatshirt	Cotton	Navy
TN19SHS009PP	Sweatshirt	ESP Overdyed Hooded Sweatshirt	Cotton	Purple

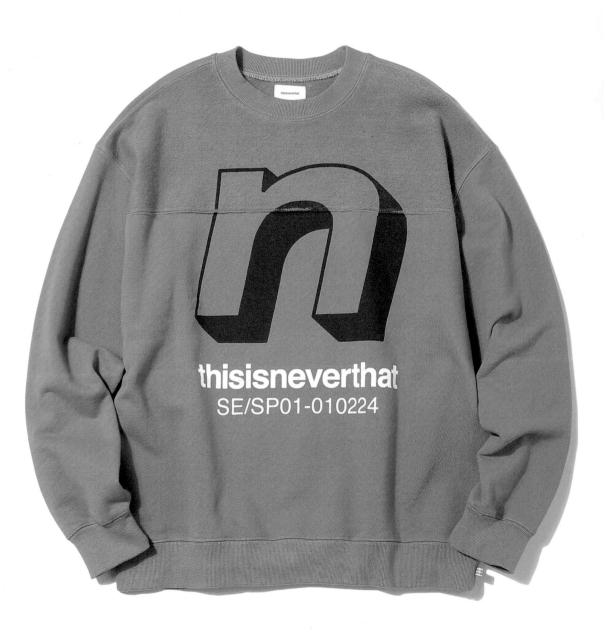

TN19SSW010BK

TN19SSW002FR

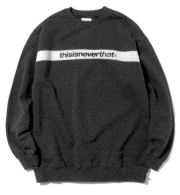

TN19SSW003NA

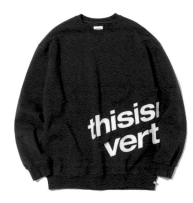

TN19SSW005RG

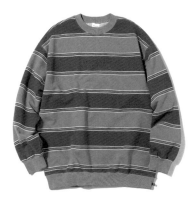

TN19SLS008VB

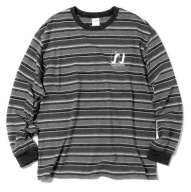

TN19SLS008GP

TN19STS032BK

TN19STS016BK

TN19SSH010BK

TN19SSW010BK	Sweatshirt	N-Cubic Crewneck	Cotton	Black
TN19SSW002FR	Sweatshirt	Striped SP Crewneck	Cotton	Forest
TN19SSW003NA	Sweatshirt	DIA-SP Crewneck	—	Navy
TN19SSW005RG	Sweatshirt	L-Logo Striped Crewneck	Cotton	Brown, Grey
TN19SLS008VB	Long Sleeve Tee	N Striped L/SL Top	Cotton	Olive, Blue
TN19SLS008GP	Long Sleeve Tee	N Striped L/SL Top	Cotton	Green, Purple
TN19STS032BK	Tee	1-thisisneverthat Tee	Cotton	Black
TN19STS016BK	Tee	BUG BLOOD Tee	Cotton	Black
TN19SSH010BK	Shirt	Rayon S/SL Shirt	Rayon	Black

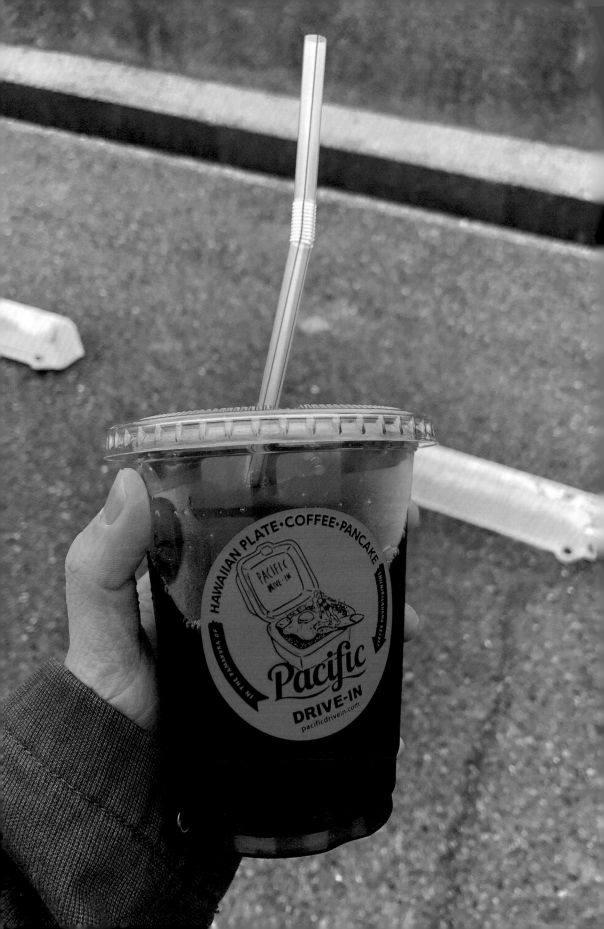

TN19SPA010BK / Jean
Cropped Jean
Cotton, Polyester, Rayon / Black

TN19SPA008TB / Jean
Regular Jean
Cotton, Polyester, Rayon / Light Blue

TN19SPA013BK / Pants
Blue Tepee Pant
Cotton / Black

TN19SPA013WH / Pants
Blue Tepee Pant
Cotton / White

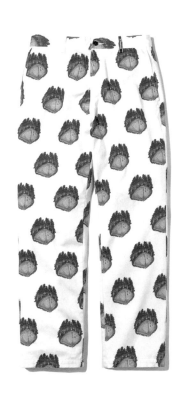

TN19SBA006OV / Bag
Ripstop Cordura® 210D Daypack
Nylon, Polyester / Olive

TN19SBA002OV / Bag
Ripstop Cordura® 210D BOP
Nylon, Polyester / Olive

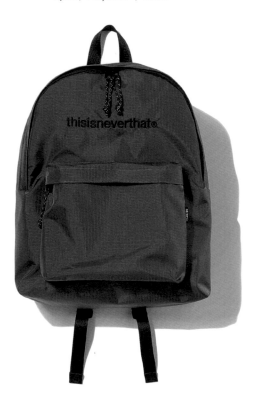

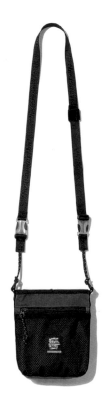

TN19SBA009OV / Bag
Ripstop Cordura® 210D Gym Sack
Nylon, Polyester / Olive

TN19SBA008BK / Bag
Ripstop Cordura® 210D Traveller Bag
Nylon, Polyester / Black

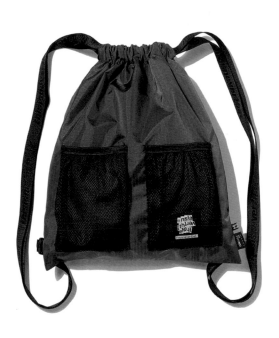

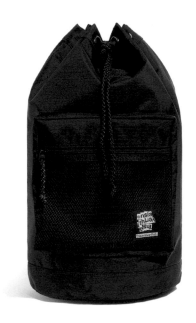

AP19SAC001NNE / Accessory
TINT × APFR Incense Stick
Woody Leather, Ginger, Sage, Vetiver, Amber / None

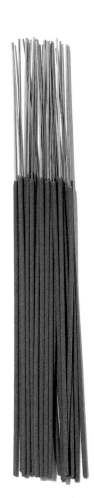

TN19FAC001SR / Accessory
SP-Logo Klean Kanteen®
Stainless Steel / Silver

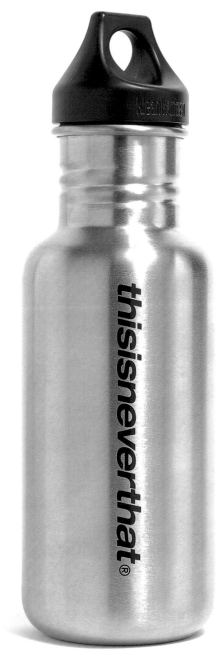

Collaborator

Release Date
Mar 16, 2019

Prefix
GT

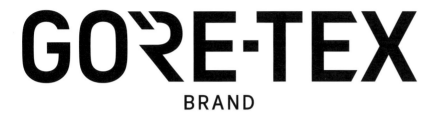

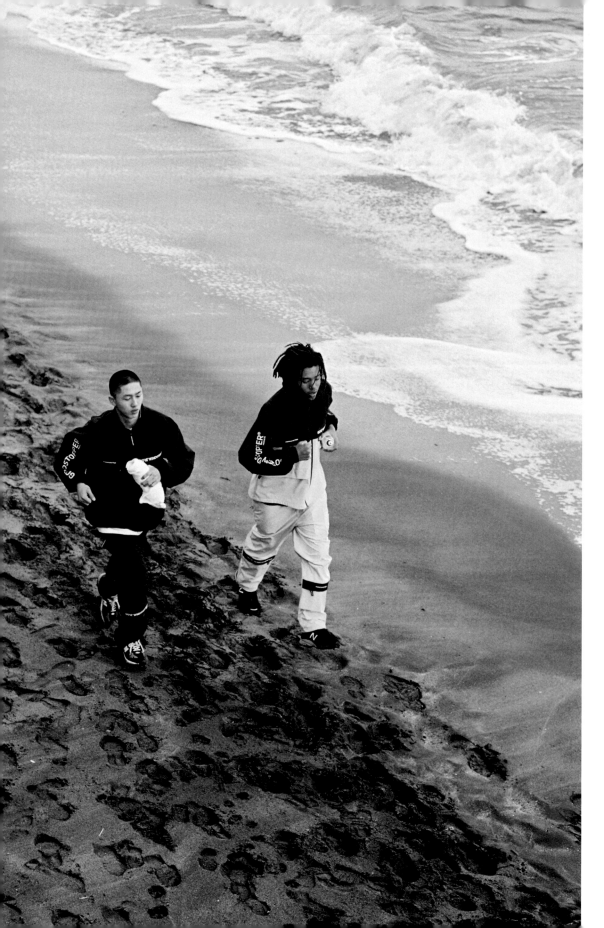

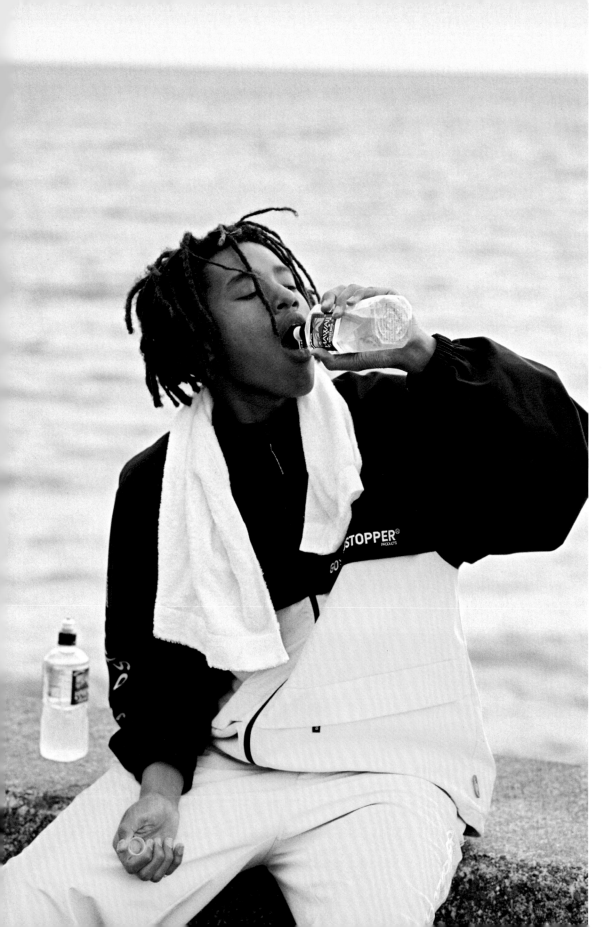

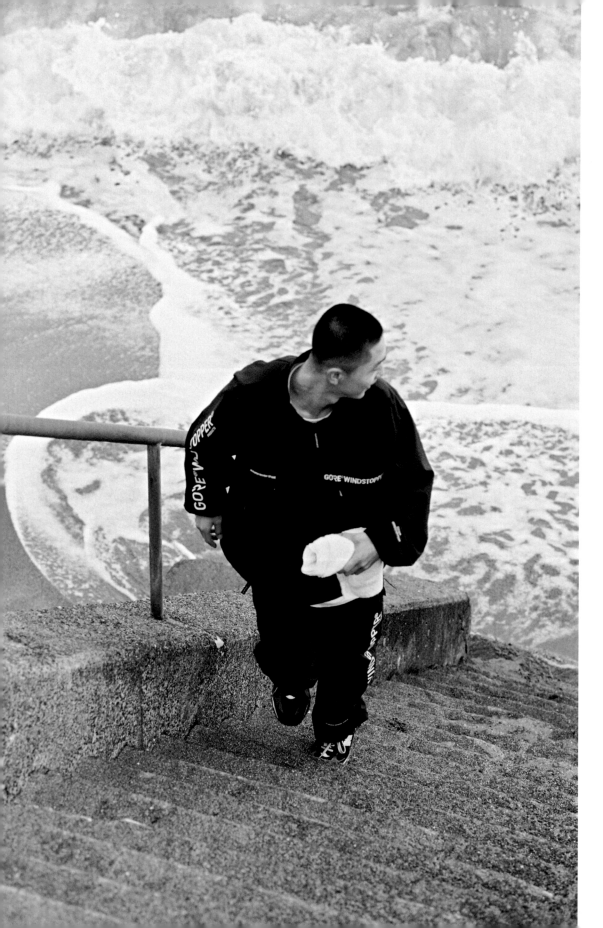

TN19SOW001OV

TN19SOW001IM

TN19SOW001BK

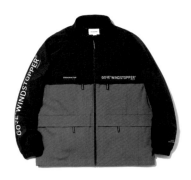
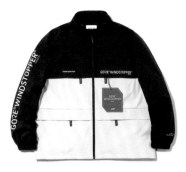
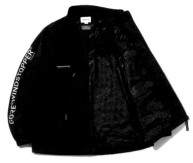

TN19SPA001OV

TN19SPA001IM

TN19SPA001BK

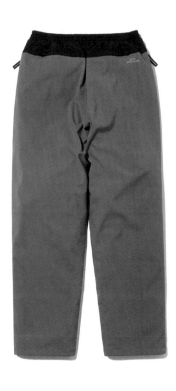
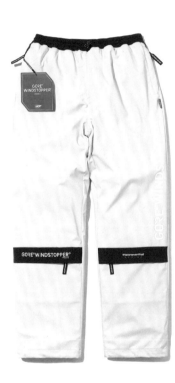
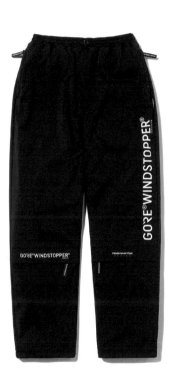

TN19SOW001OV	Jacket	GORE® WINDSTOPPER® CITY Jacket	Polyester	Olive
TN19SOW001IM	Jacket	GORE® WINDSTOPPER® CITY Jacket	Polyester	Lime
TN19SOW001BK	Jacket	GORE® WINDSTOPPER® CITY Jacket	Polyester	Black
TN19SPA001OV	Pants	GORE® WINDSTOPPER® CITY Pant	Polyester	Olive
TN19SPA001IM	Pants	GORE® WINDSTOPPER® CITY Pant	Polyester	Lime
TN19SPA001BK	Pants	GORE® WINDSTOPPER® CITY Pant	Polyester	Black

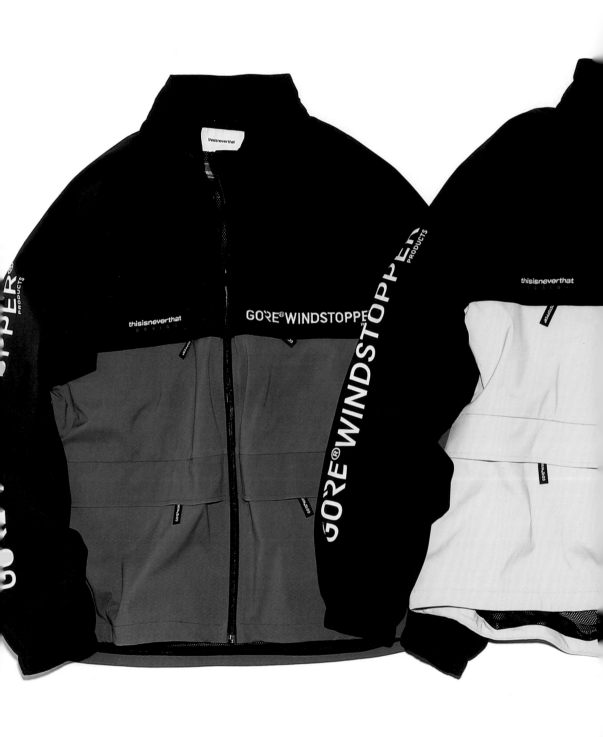

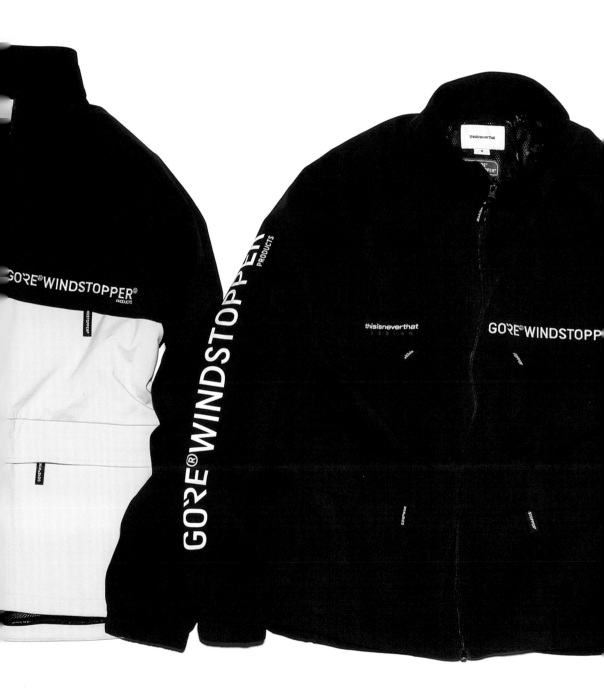

GORE-TEX × thisisneverthat

Collaborator

Release Date
Mar 23, 2019

Prefix
GM

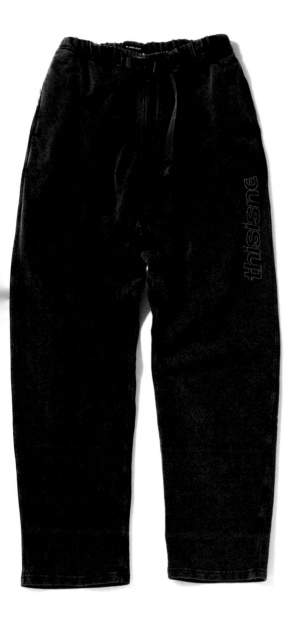
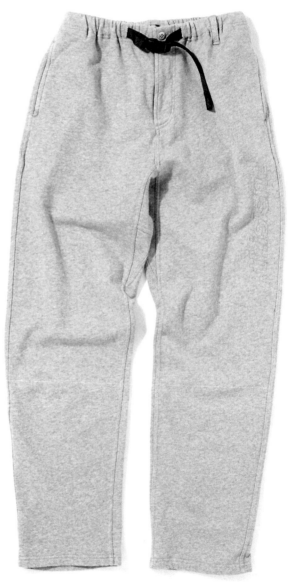

GRAMICCI × thisisneverthat

GM19SSW001BK / Sweatshirt
TINT × GRAMiCCi Talecut Sweat
Cotton / Black

GM19SSW001HR / Sweatshirt
TINT × GRAMiCCi Talecut Sweat
Cotton / Heather Grey

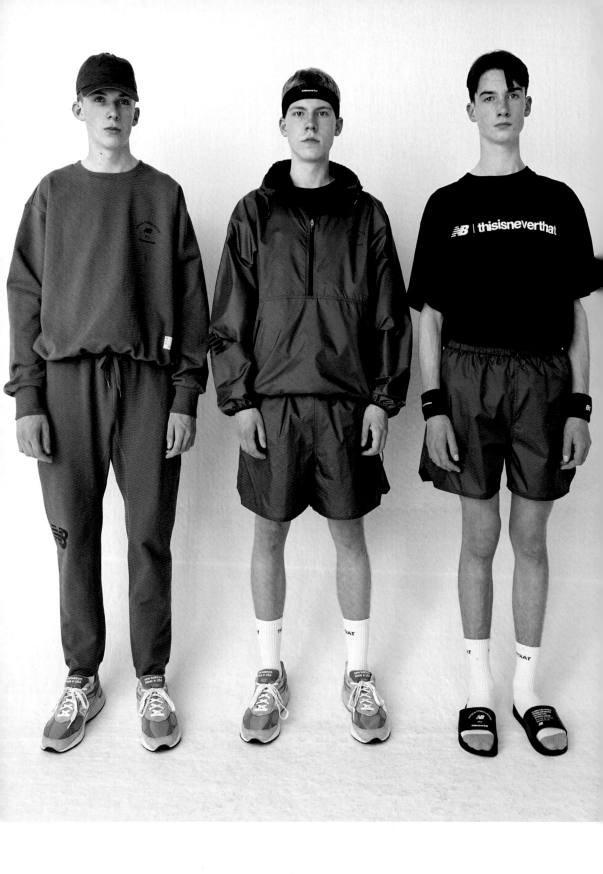

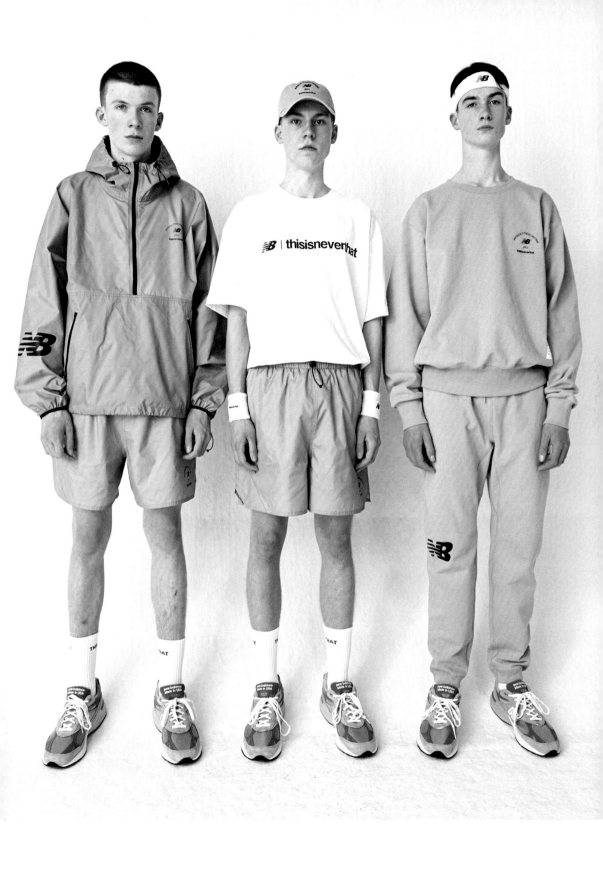

NB19SOW001KH

NB19SOW001BE

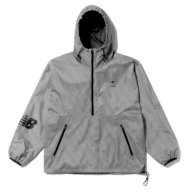

NB19STS001KH

NB19SSW001KH

NB19STS001BE

NB19SSO001KH

NB19SSO001BE

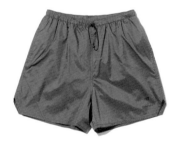
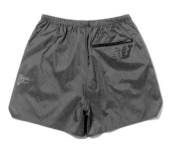
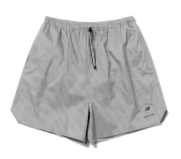

NB19SPA001KH

NB19SPA001BE

ND19SOW001DK

 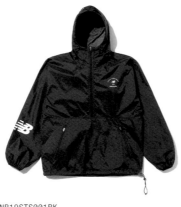

NB19SSW001BE NB19STS001BK

NB19SSO001BK

 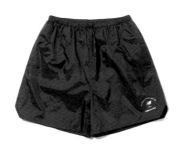 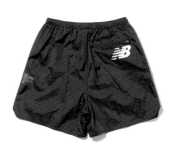

NB19SOW001KH	Jacket	NB TNT Hooded Anorak Parka	Nylon	Khaki
NB19SOW001BE	Jacket	NB TNT Hooded Anorak Parka	Nylon	Beige
NB19SOW001BK	Jacket	NB TNT Hooded Anorak Parka	Nylon	Black
NB19STS001KH	Tee	NB TNT PFU T-Shirt	Cotton	Khaki
NB19SSW001KH	Sweatshirt	NB TNT PT Sweatshirt	Cotton	Khaki
NB19STS001BE	Tee	NB TNT PFU T-Shirt	Cotton	Beige
NB19SSW001BE	Sweatshirt	NB TNT PT Sweatshirt	Cotton	Beige
NB19STS001BK	Tee	NB TNT PFU T-Shirt	Cotton	Black
NB19SSO001KH	Pants	NB TNT PT Short	Nylon	Khaki
NB19SSO001BE	Pants	NB TNT PT Short	Nylon	Beige
NB19SSO001BK	Pants	NB TNT PT Short	Nylon	Black
NB19SPA001KH	Pants	NB TNT PT Sweatpant	Cotton	Khaki
NB19SPA001BE	Pants	NB TNT PT Sweatpant	Cotton	Beige

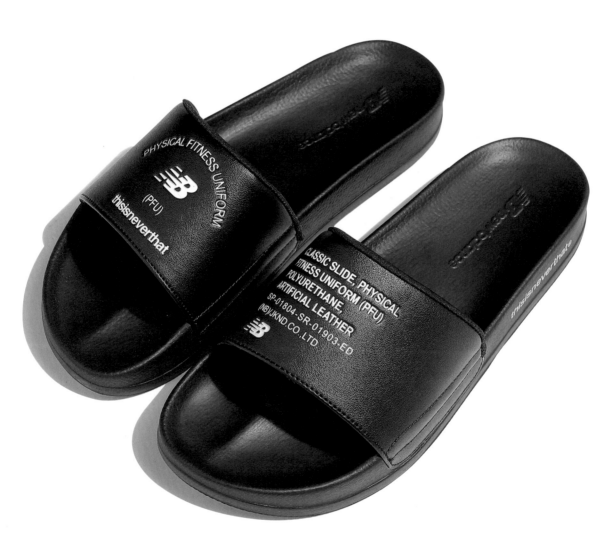

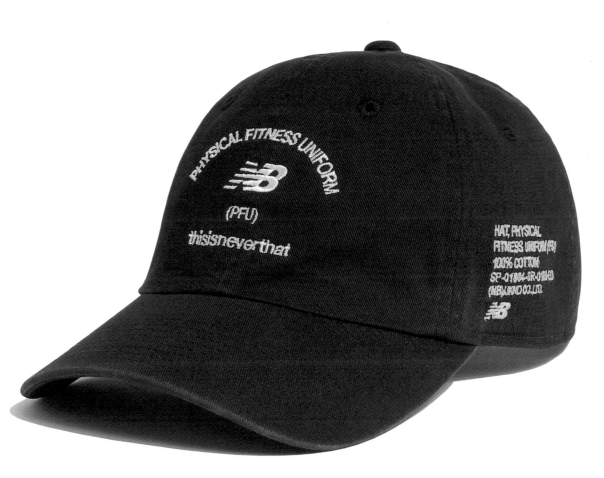

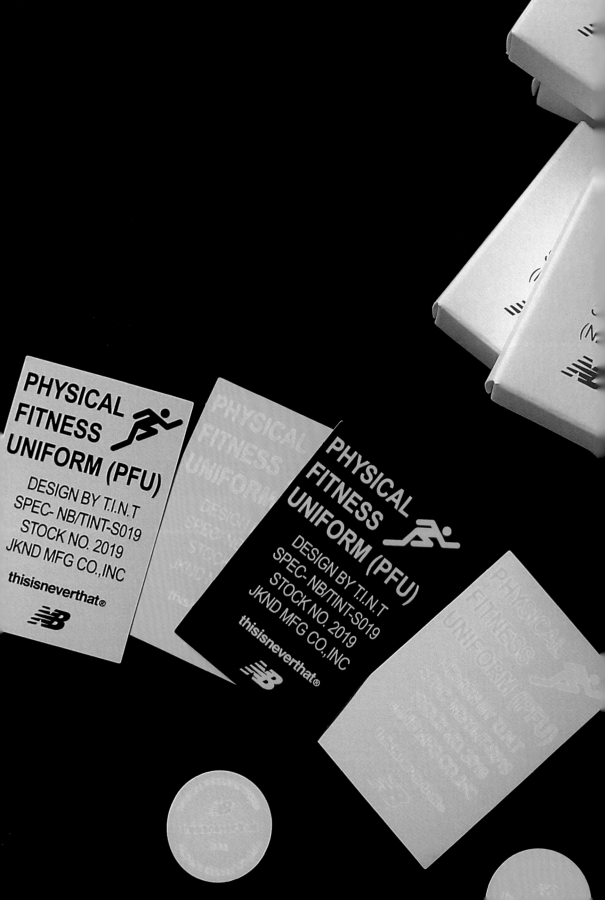

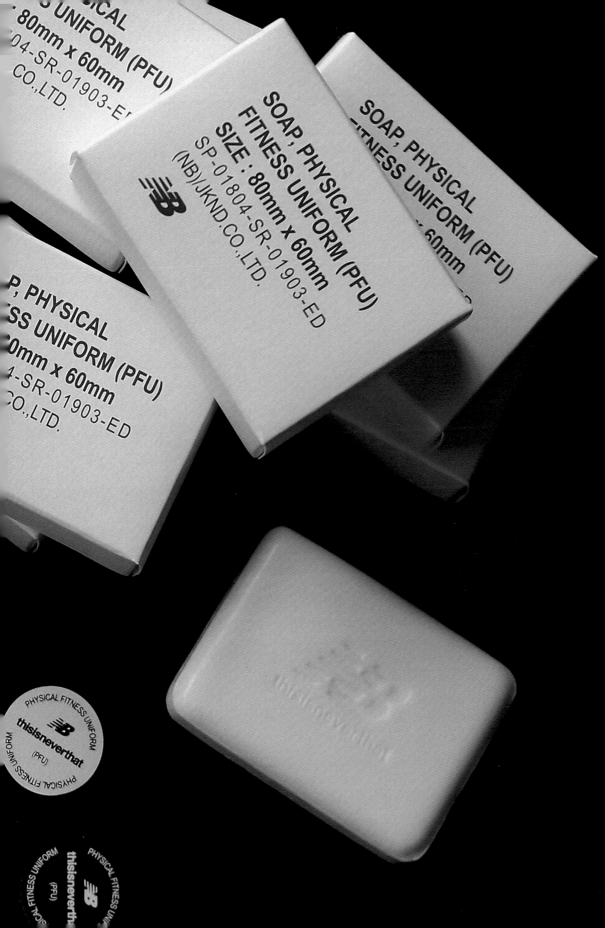

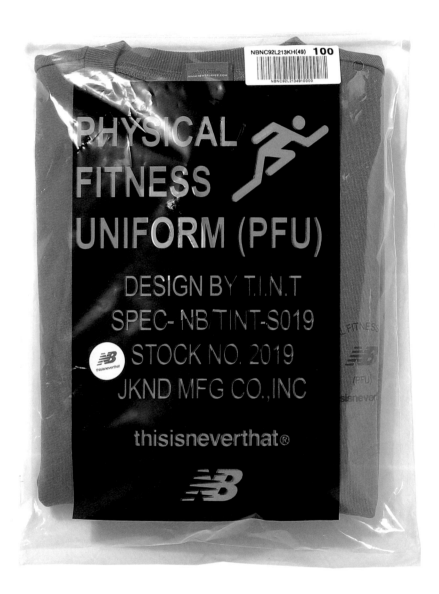

NB19SAC001WH	Accessory	NB TNT Headband	Cotton	White
NB19SAC001BK	Accessory	NB TNT Headband	Cotton	Black
NB19SAC002WH	Accessory	NB TNT Wristband	Cotton	White
NB19SAC002BK	Accessory	NB TNT Wristband	Cotton	Black
NB19SFW001BK	Shoes	NB TNT Slide	Polyurethane	Black
NB19SFW001KH	Shoes	NB TNT Slide	Polyurethane	Khaki
NB19SAC003WH	Socks	NB TNT Socks	Cotton	White

NB19SAC001WH

NB19SAC001BK

NB19SAC002WH

NB19SAC002BK

NB19SFW001BK

NB19SAC003WH

NB19SFW001KH

NEW BALANCE × thisisneverthat

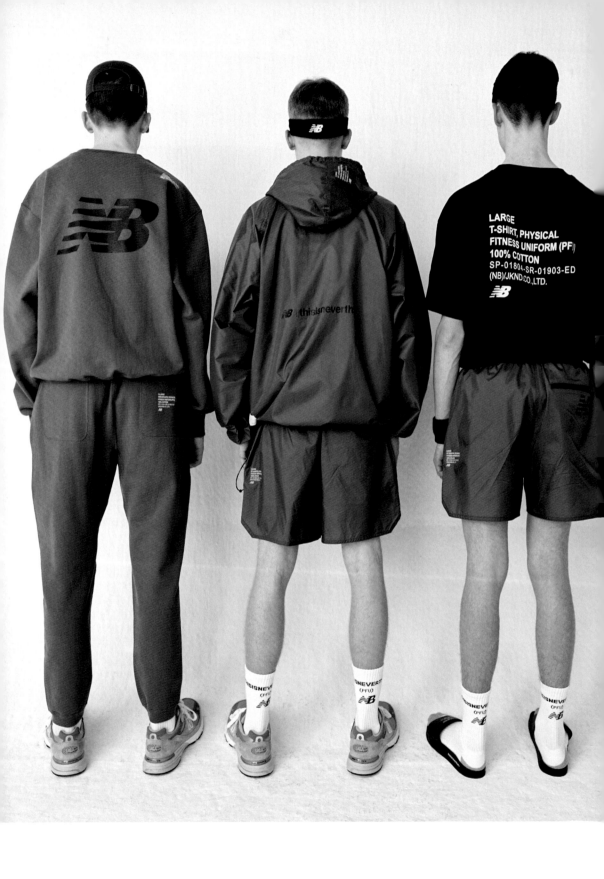

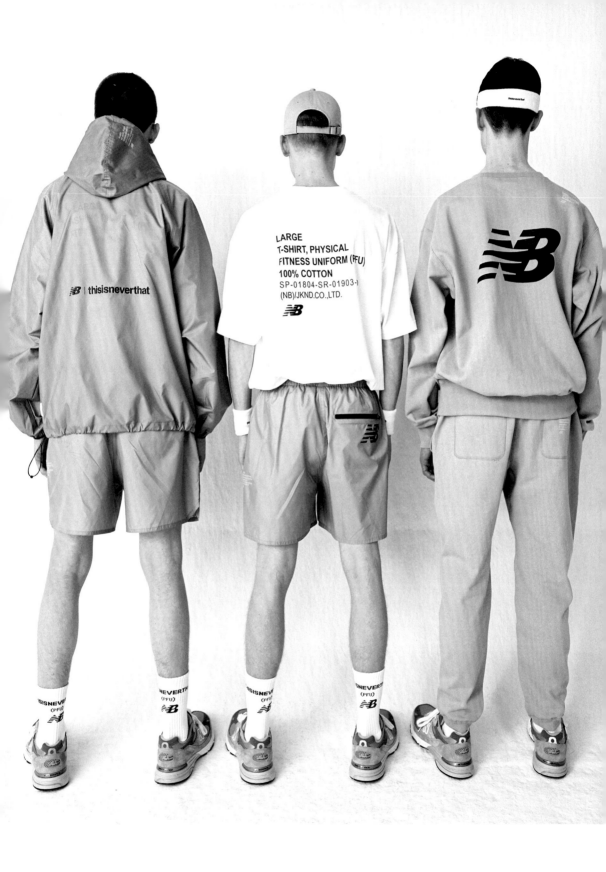

The text visible within the image:

LARGE
T-SHIRT, PHYSICAL
FITNESS UNIFORM (PFU)
100% COTTON
SP-01804-SR-01903-)
(NB)/JKND.CO.,LTD.

Collaborator

Release Date
Jan 28, 2019

Prefix
MP

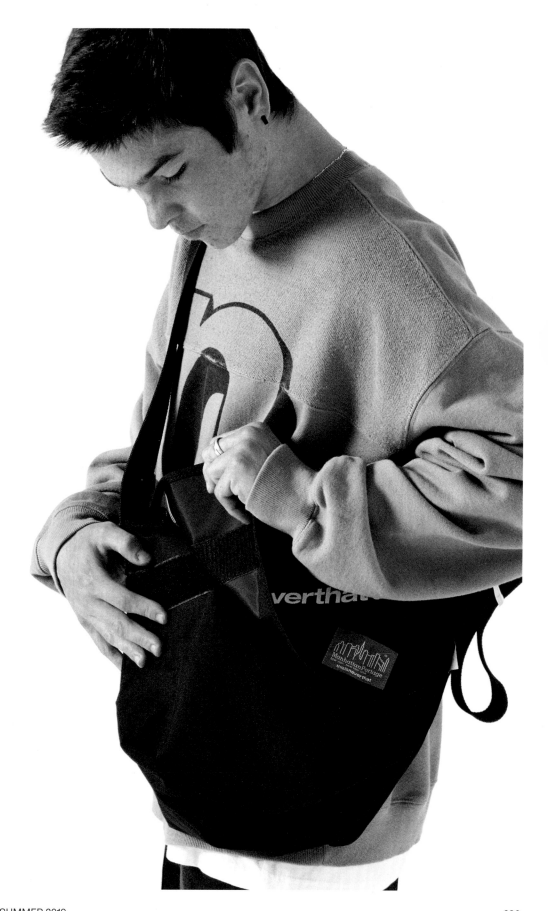

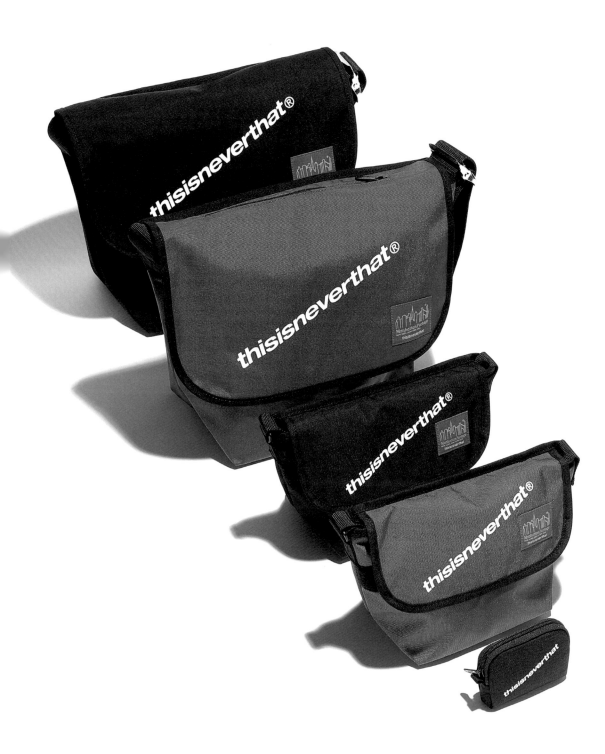

MANHATTAN PORTAGE × thisisneverthat

MP19SBA001RB / Bag
TINT Big Apple Backpack
Nylon / Royal Blue

MP19SBA001BK / Bag
TINT Big Apple Backpack
Nylon / Black

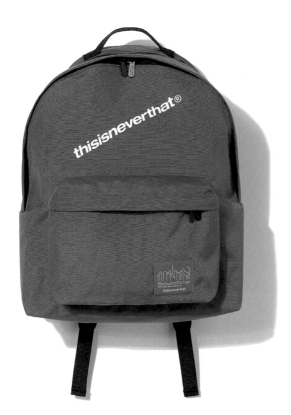

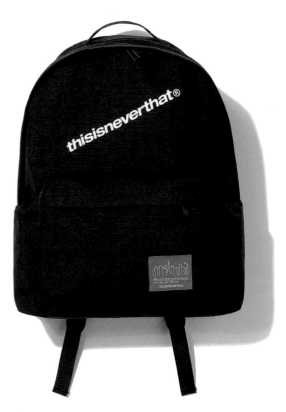

MP19SBA003RB / Accessory
TINT Coin Purse
Nylon / Royal Blue

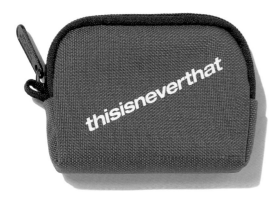

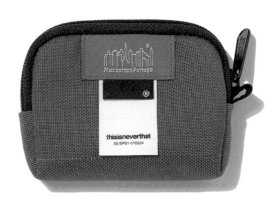

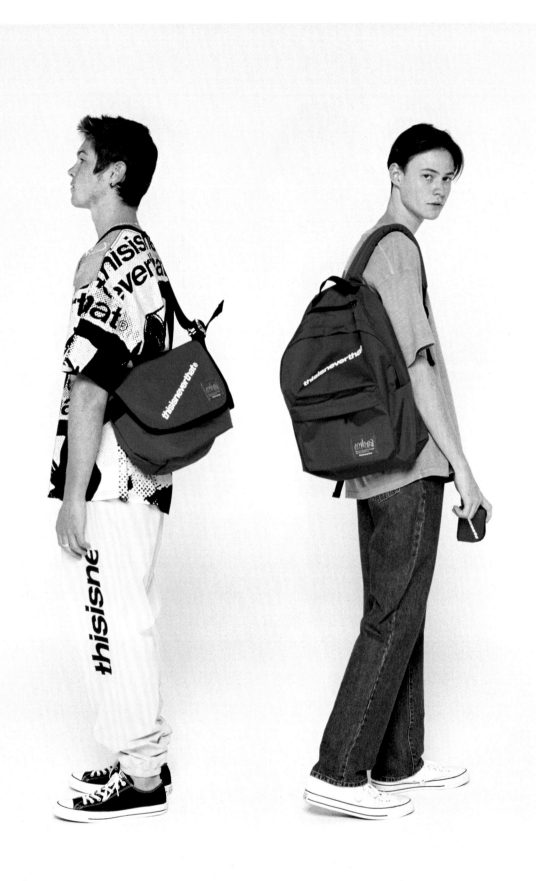

MANHATTAN PORTAGE × thisisneverthat

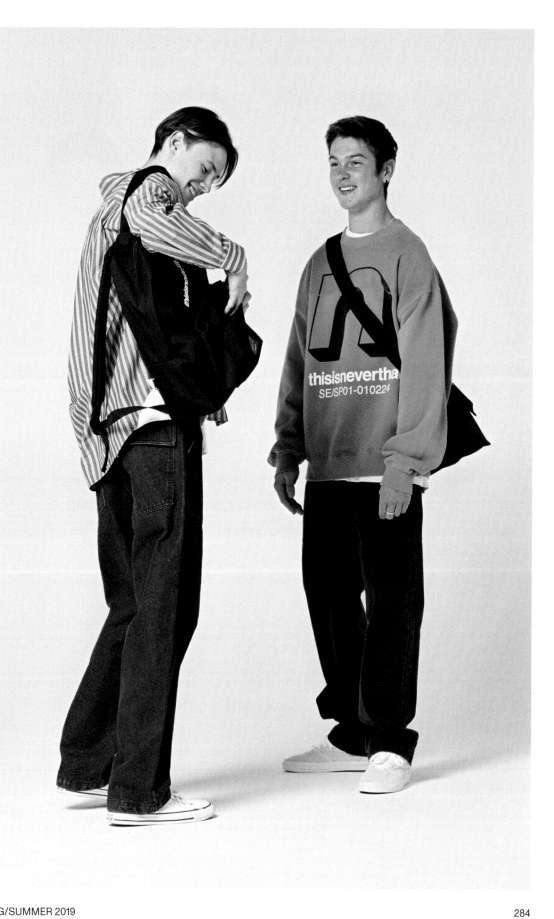

MP18FBA002BK / Bag
TINT Vintage Messenger Bag MD
Nylon / Black

MP19SBA002BK / Bag
TINT Vintage Messenger Bag SM
Nylon / Black

MP18FBA003BK / Bag
TINT Coin Purse
Nylon / Black

 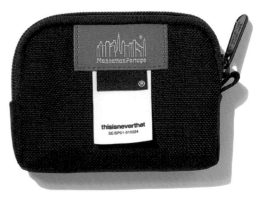

MANHATTAN PORTAGE × thisisneverthat

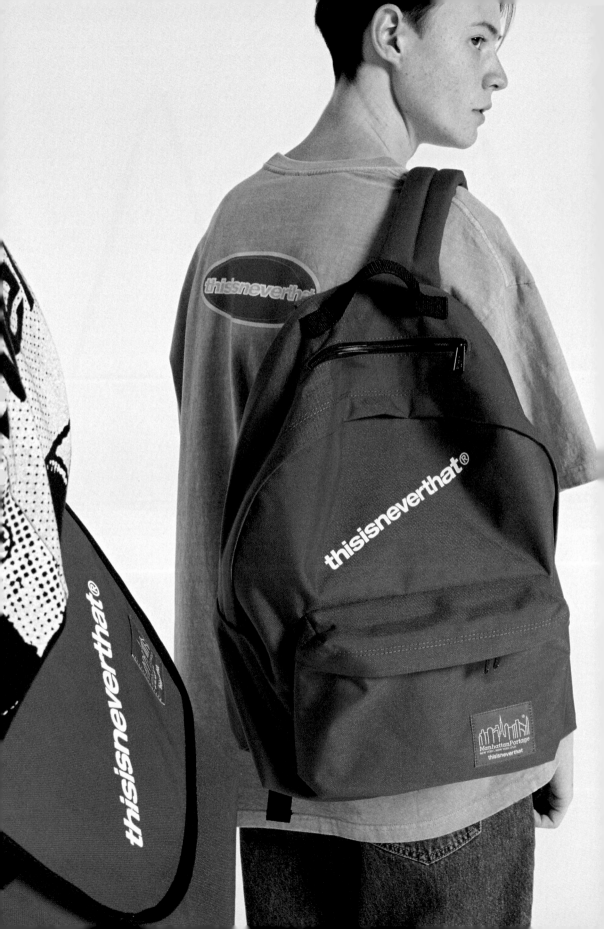

Collaborator

Release Date
Apr 27, 2019

Prefix
NE

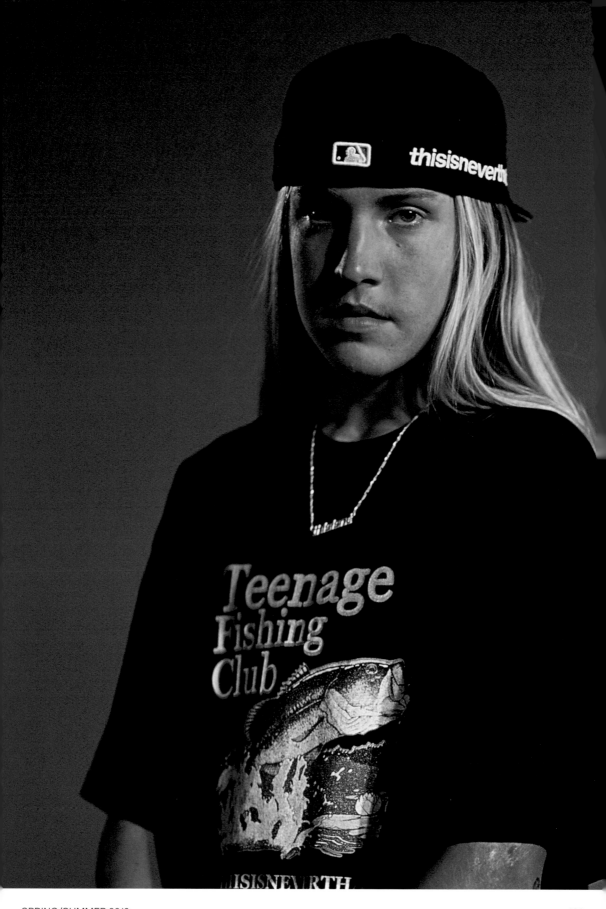

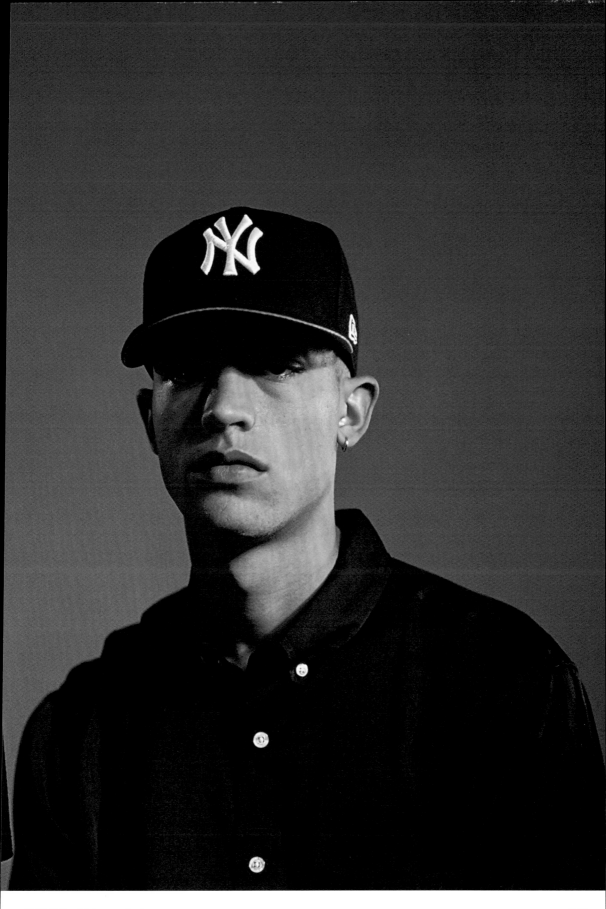

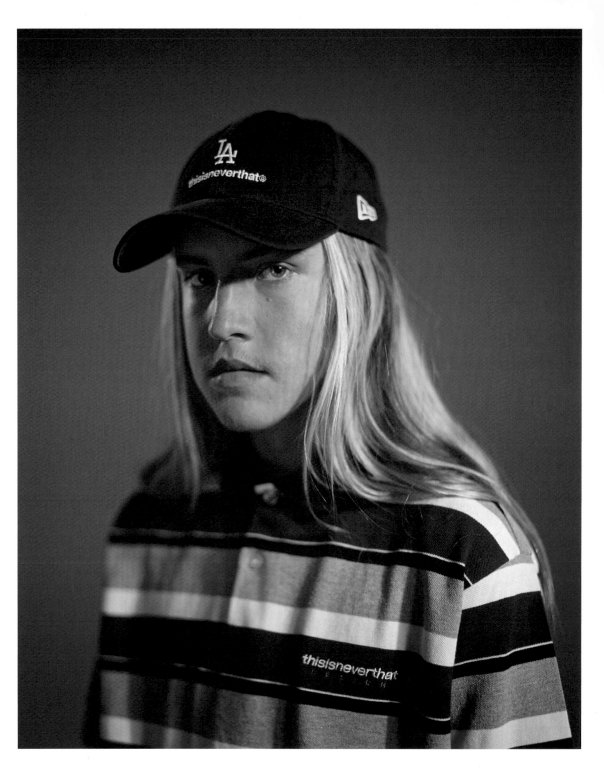

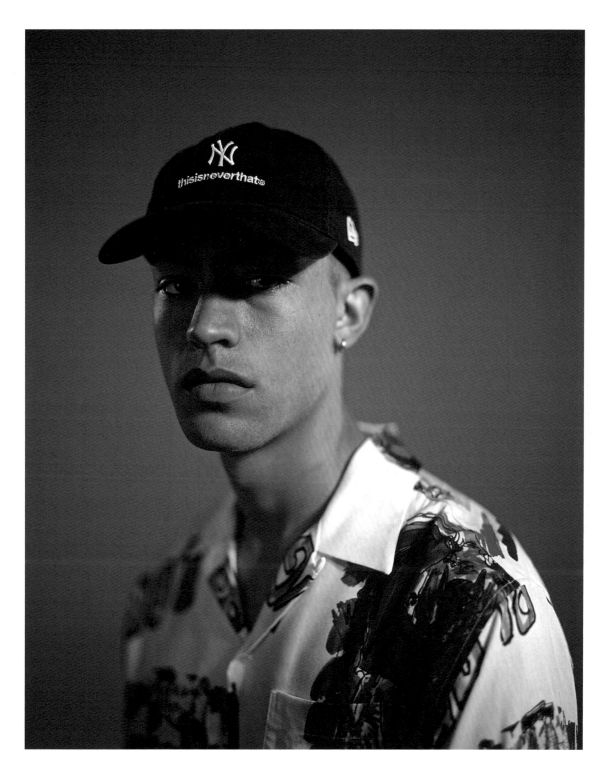

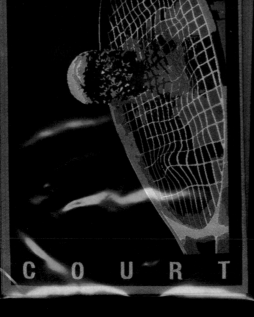
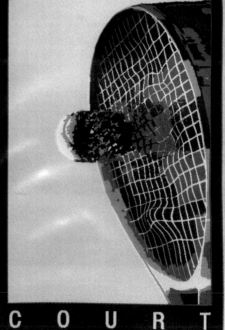

STORE & OFFICE

Location
32, Jandari-ro, Mapo-gu, Seoul,
Republic of Korea

Space and Furniture Design
COM

Completion Date
Jan 25, 2019

Flagship Store

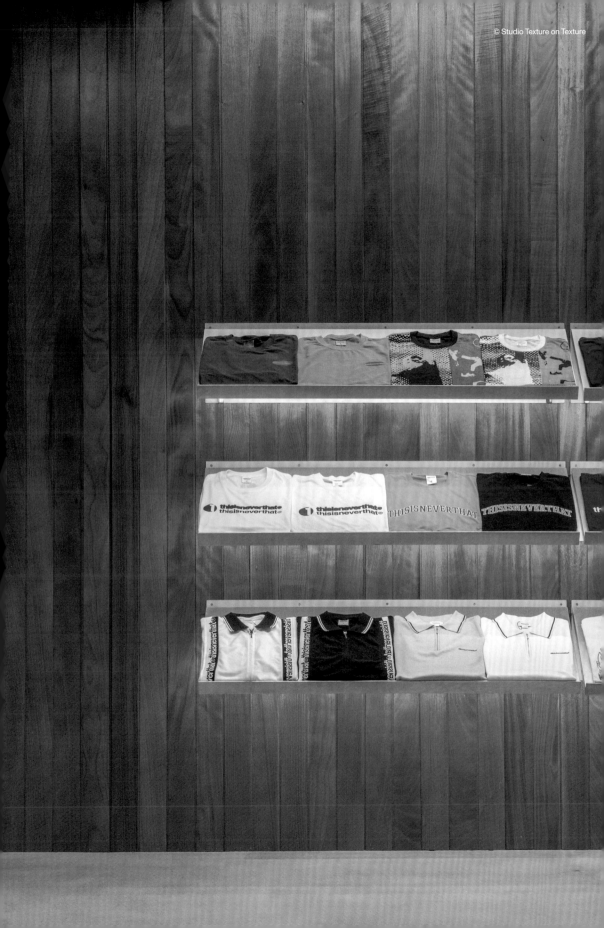

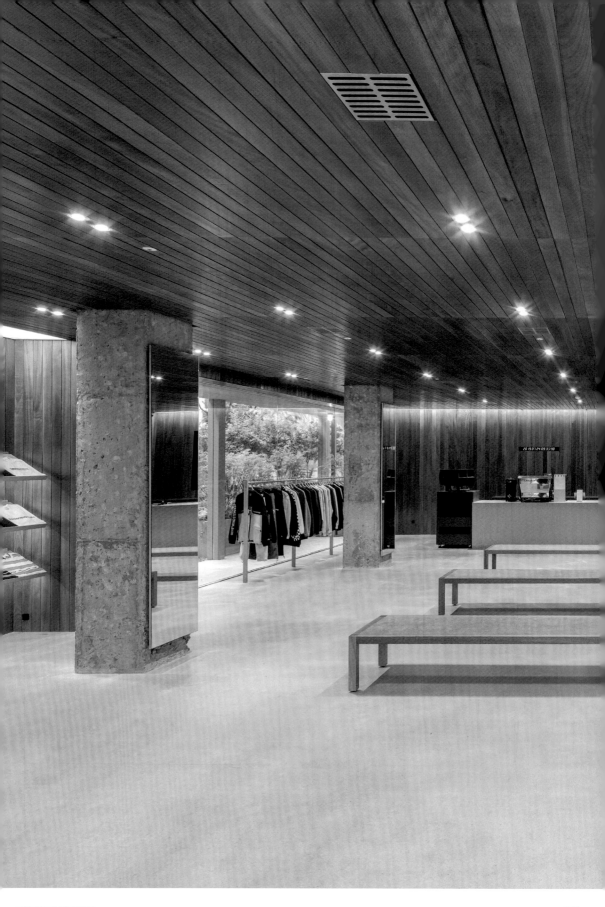

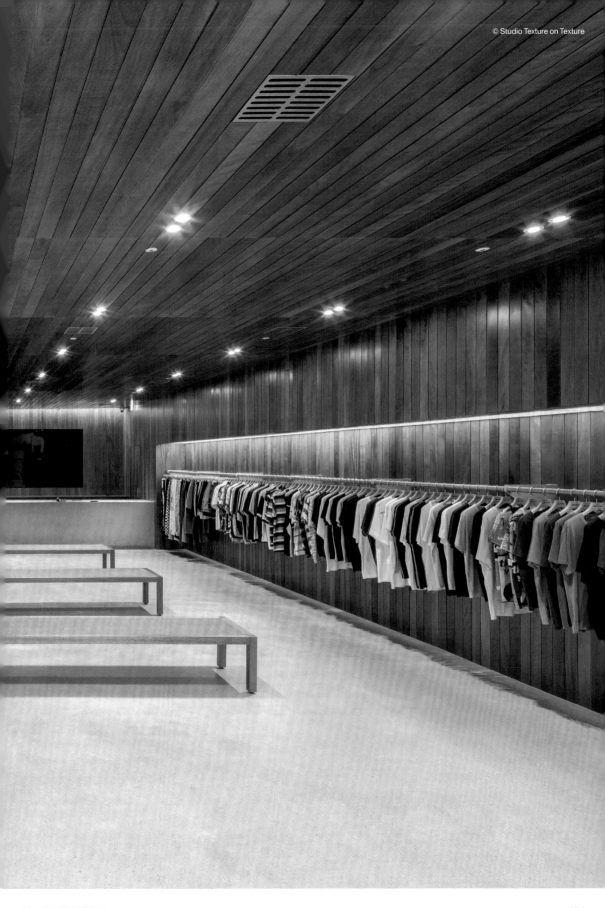

© Studio Texture on Texture

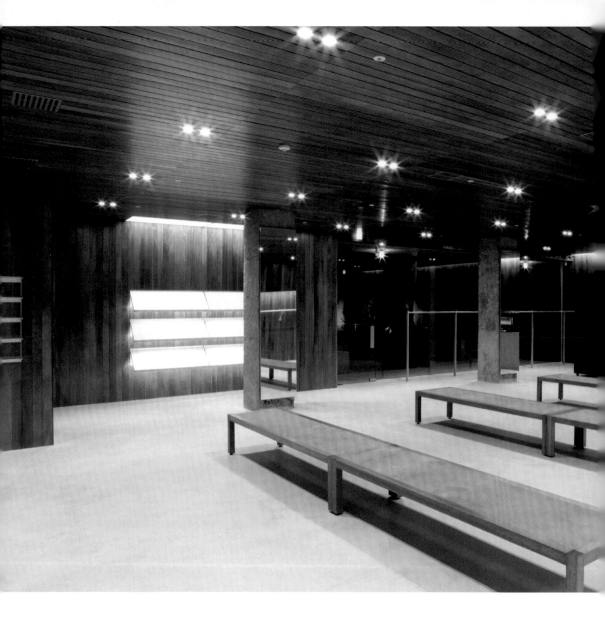

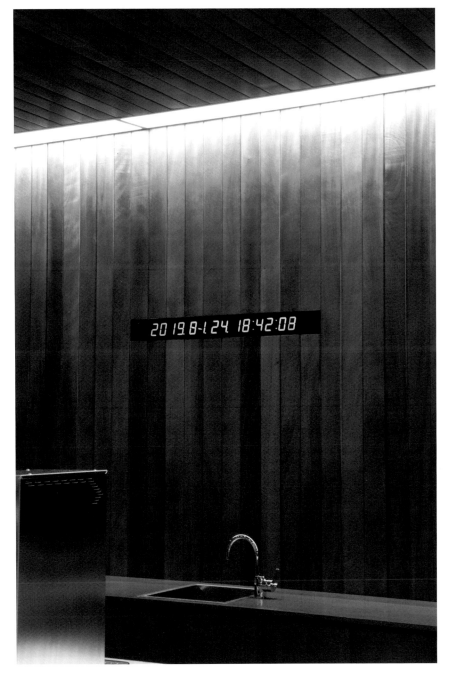

W 600 D 50 H 150

W 745 D 80 H 75

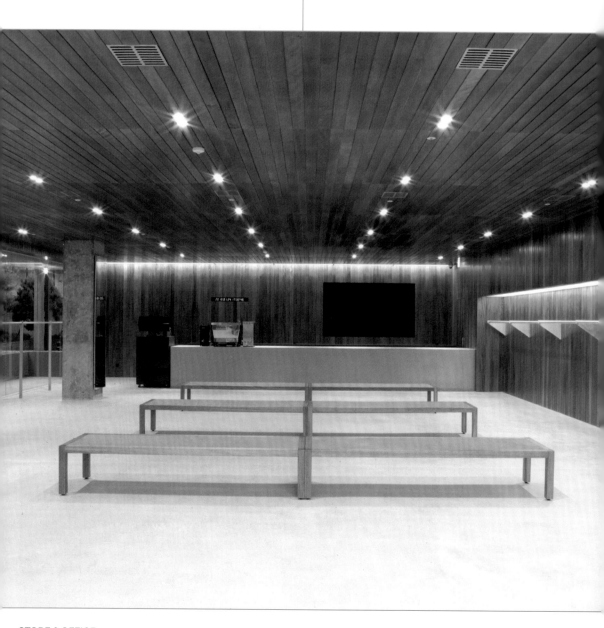

W 1600 D 240 H 935

W 2700 D 390 H 1285

W 7000 D 550 H 920

W 2200 D 650 H 430

W 5690 D 50 H 1475

W 7000 D 900 H 920

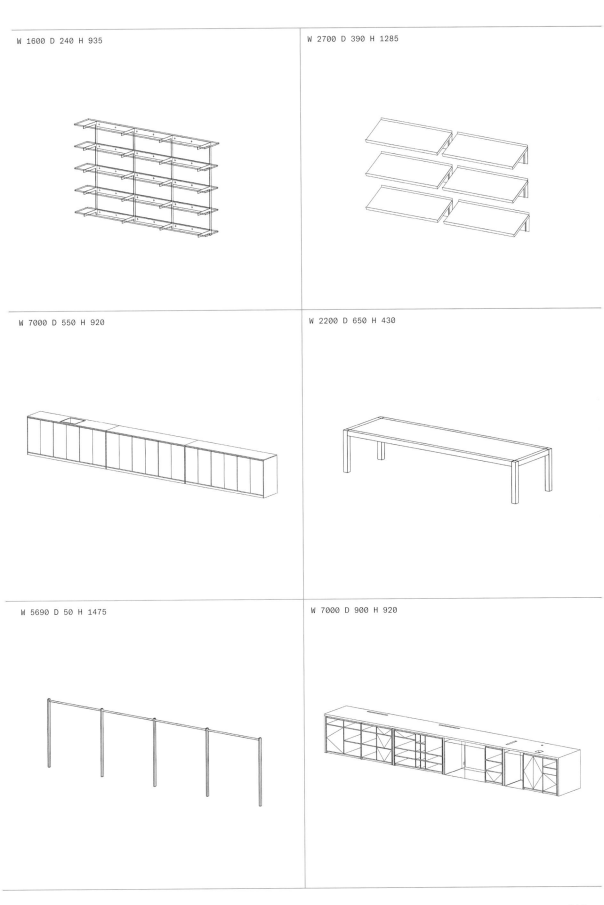

Location
10-2, Yeonhui-ro 11ra-gil,
Seodaemun-gu, Seoul,
Republic of Korea

Furniture Design
COM

Completion Date
Sep 1, 2019

(Khakis)

Concept Store

© Studio Texture on Texture

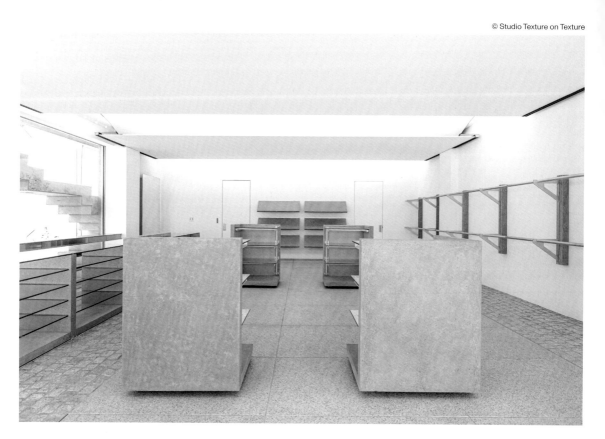

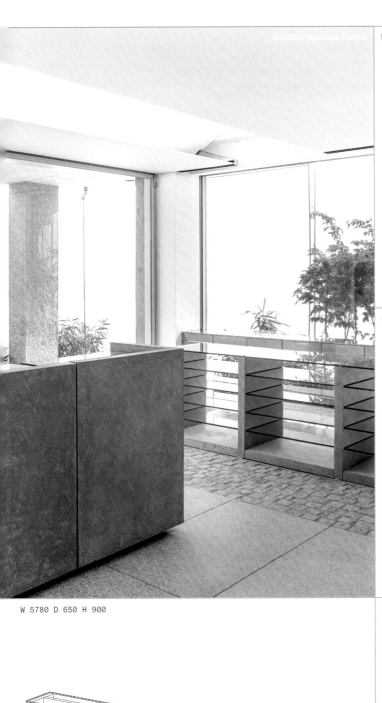

W 900 D 600 H 1100

W 1300 D 375 H 280

W 5780 D 650 H 900

Location
10-2, Yeonhui-ro 11ra-gil,
Seodaemun-gu, Seoul,
Republic of Korea

Space Design
FHHH Friends

Furniture Design
COM

Completion Date
April 22, 2019

Office Building

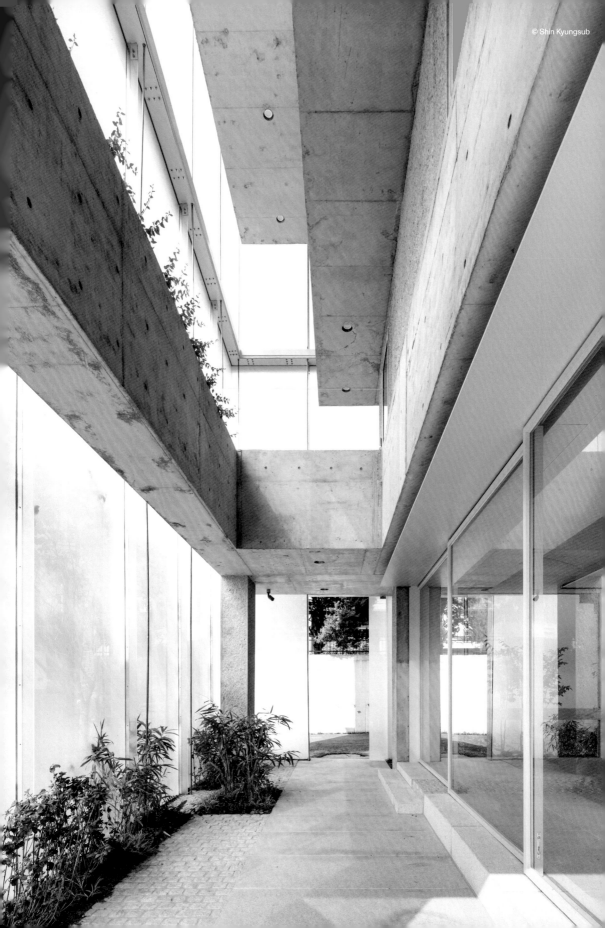

© Shin Kyungsub

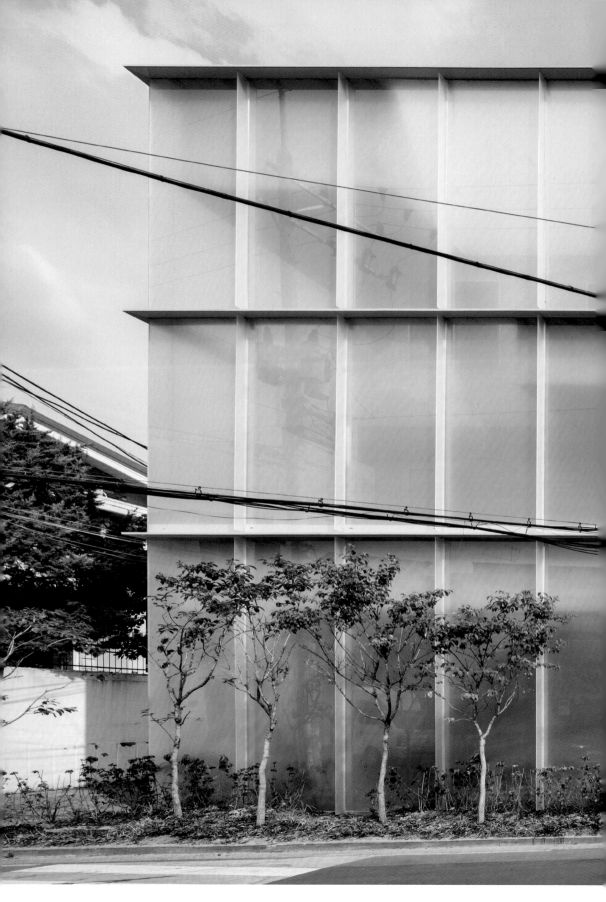

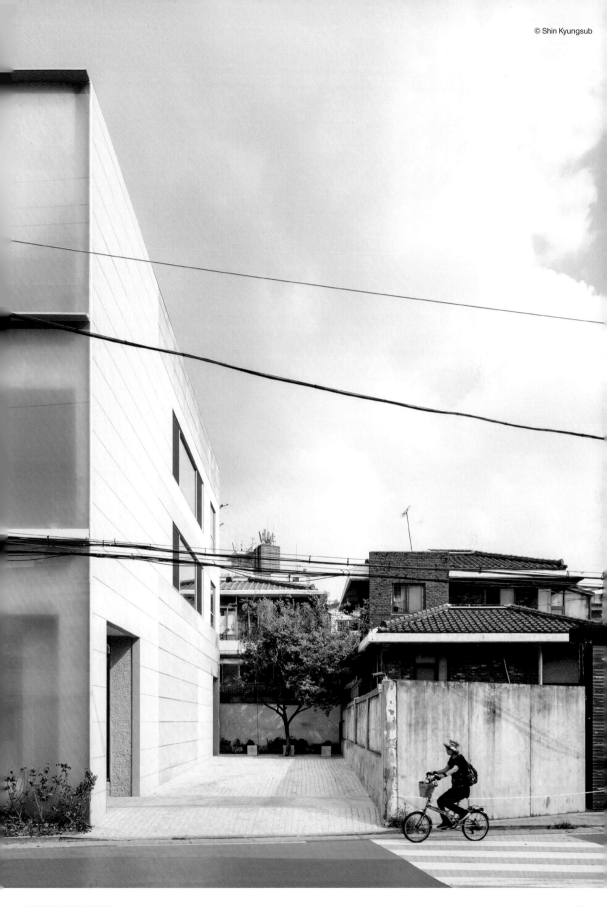

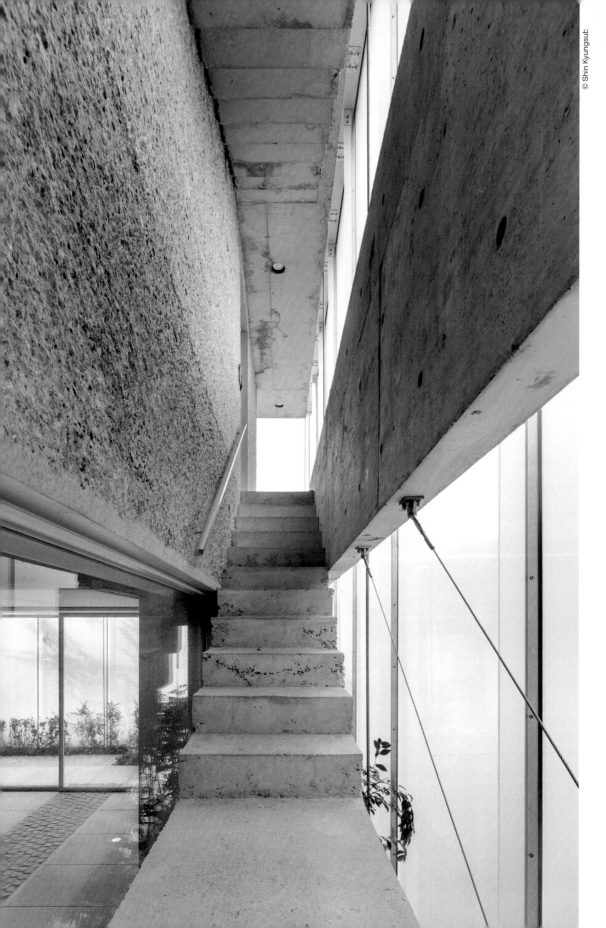

© Shin Kyungsub

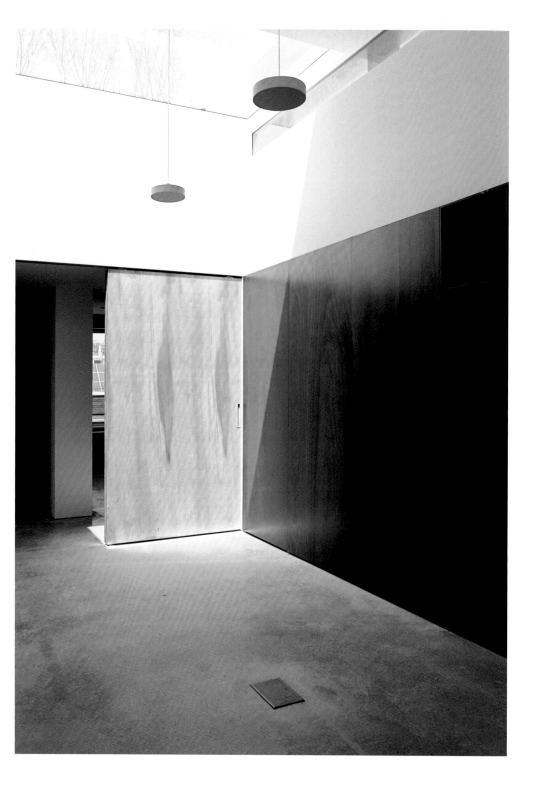

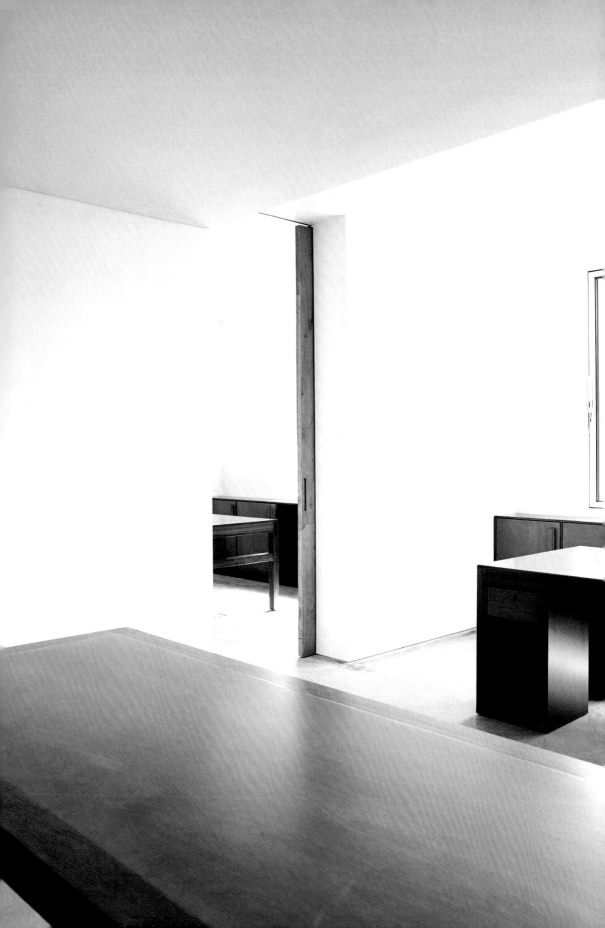

W 2300 D 1100 H 720

W 1150 D 1100 H 720

W 1100 D 840 H 720

W 1400 D 310 H 775

W 4200 D 272 H 1155

W 1580 D 310 H 775

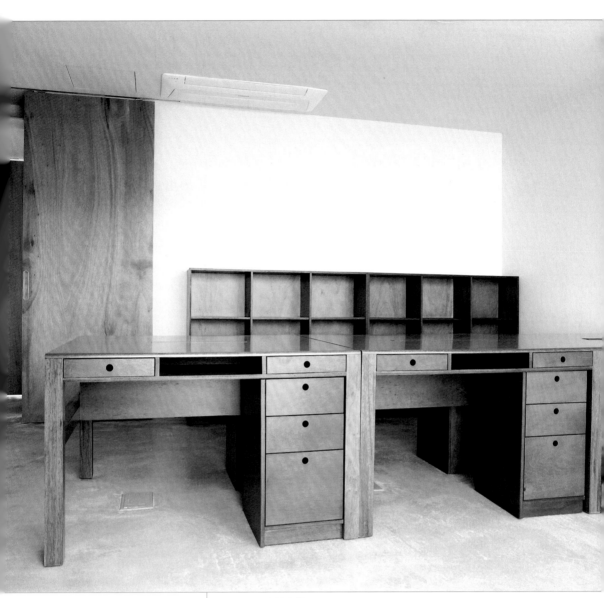

W 440 D 315 H 2175 W 5185 D 110 H 2185

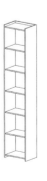

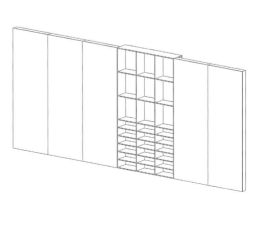

OFFICE BUILDING

Location
31, Yeonhuimat-ro,
Seodaemun-gu, Seoul,
Republic of Korea

Space and Furniture Design
COM

Completion Date
May 1, 2020

Digital Team Office

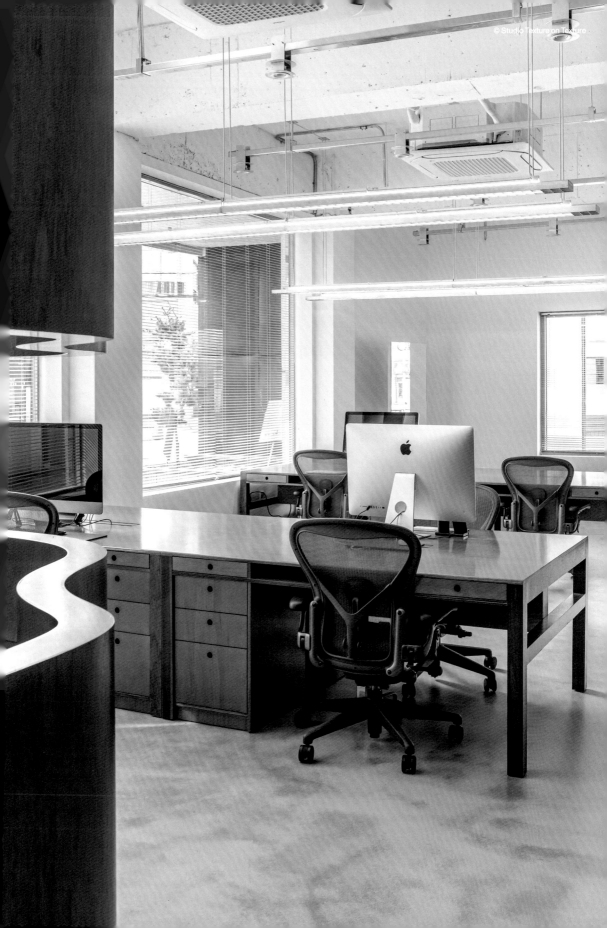

W 2380 D 5540 H 2200

W 2300 D 3150 H 2200

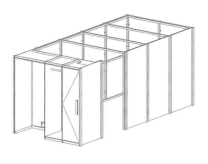

W 3150 D 2200 H 2200

W 1600 D 1230 H 2200

W 3200 D 108 H 1445

W 1170 D 480 H 350

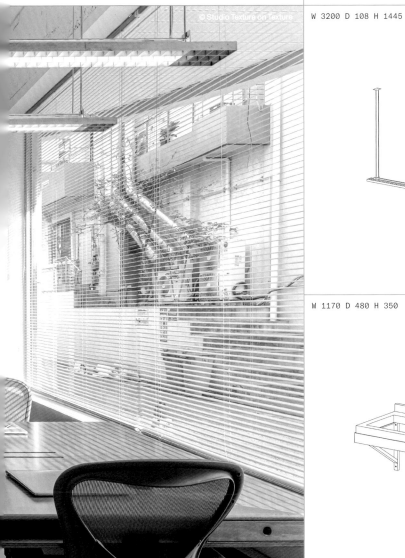

DIGITAL TEAM OFFICE

Code	Category	Name	Material(s)	Color(s)
GT18FOW001GR	Jacket	thisisneverthat × GORE-TEX City Peak Jacket	Polyester	Grey
GT18FOW001NA	Jacket	thisisneverthat × GORE-TEX City Peak Jacket	Polyester	Navy
GT18FPA001GR	Pants	thisisneverthat × GORE-TEX City Peak Pant	Polyester	Grey
GT18FPA001NA	Pants	thisisneverthat × GORE-TEX City Peak Pant	Polyester	Navy
GT18FPA002BK	Pants	thisisneverthat × GORE® WINDSTOPPER® Fleece Pant	Polyester	Black
GT18FPA002BL	Pants	thisisneverthat × GORE® WINDSTOPPER® Fleece Pant	Polyester	Blue
GT18FSW001BK	Top	thisisneverthat × GORE® WINDSTOPPER® Fleece Top	Polyester	Black
GT18FSW001BL	Top	thisisneverthat × GORE® WINDSTOPPER® Fleece Top	Polyester	Blue
MP18FBA001BK	Bag	TINT MINI NY MESSENGER BAG	Nylon	Black
MP18FBA001RB	Bag	TINT MINI NY MESSENGER BAG	Nylon	Royal Blue
MP18FBA002BK	Bag	TINT VINTAGE MESSENGER BAG MD	Nylon	Black
MP18FBA002RB	Bag	TINT VINTAGE MESSENGER BAG MD	Nylon	Royal Blue
MP18FBA003BK	Bag	TINT COIN PURSE	Nylon	Black
PB19FFW001DS	Shoes	thisisneverthat × Paraboot-MICHAEL	Suede, Rubber	Desert
TN18FAC001BK	Accessory	DIA-HSP Gloves	Leather, Polyester, Nylon	Black
TN18FAC001BL	Accessory	DIA-HSP Gloves	Leather, Polyester, Nylon	Blue
TN18FAC002BE	Accessory	HSP Fleece Muffler	Polyester	Beige
TN18FAC002BK	Accessory	HSP Fleece Muffler	Polyester	Black
TN18FAC002NA	Accessory	HSP Fleece Muffler	Polyester	Navy
TN18FAC002RD	Accessory	HSP Fleece Muffler	Polyester	Red
TN18FAC002YL	Accessory	HSP Fleece Muffler	Polyester	Yellow
TN18FAC003BK	Accessory	CP WEB Belt	Polyester	Black
TN18FAC003OV	Accessory	CP WEB Belt	Polyester	Olive
TN18FAC004BK	Accessory	HSP Mug	Ceramic	Black
TN18FAC005BK	Accessory	C-Logo Coaster	Rubber	Black
TN18FAC006BK	Accessory	HSP Zippo®	-	Black
TN18FAC007BK	Accessory	SP-Logo Carabiner	Stainless Steel	Black
TN18FAC007SR	Accessory	SP-Logo Carabiner	Stainless Steel	Silver
TN18FAC008LE	Accessory	GLOBE Paperweight	Crystal	Clear
TN18FAC009WH	Accessory	DIA-HSP Ashtray	Ceramic	White
TN18FBA001BK	Bag	CORDURA® 750D Nylon Waist Bag	Nylon	Black
TN18FBA001NA	Bag	CORDURA® 750D Nylon Waist Bag	Nylon	Navy
TN18FBA001PP	Bag	CORDURA® 750D Nylon Waist Bag	Nylon	Purple
TN18FBA002BE	Bag	Nylon Shoulder Bag	Nylon	Beige
TN18FBA002BK	Bag	Nylon Shoulder Bag	Nylon	Black
TN18FBA002LV	Bag	Nylon Shoulder Bag	Nylon	Lavender
TN18FBA003BK	Bag	CORDURA® 750D Nylon SP Backpack	Nylon	Black
TN18FBA003NA	Bag	CORDURA® 750D Nylon SP Backpack	Nylon	Navy
TN18FBA004BK	Bag	CORDURA® 750D Nylon CP-INTL. Logo BOP	Nylon	Black
TN18FBA004NA	Bag	CORDURA® 750D Nylon CP-INTL. Logo BOP	Nylon	Navy
TN18FBA004PP	Bag	CORDURA® 750D Nylon CP-INTL. Logo BOP	Nylon	Purple
TN18FBA005BK	Bag	CORDURA® 750D Nylon Messenger Bag	Nylon	Black
TN18FBA005NA	Bag	CORDURA® 750D Nylon Messenger Bag	Nylon	Navy
TN18FBA005PP	Bag	CORDURA® 750D Nylon Messenger Bag	Nylon	Purple
TN18FHS001BK	Sweatshirt	L-Logo Zipup Sweat	Cotton	Black
TN18FHS001IR	Sweatshirt	L-Logo Zipup Sweat	Cotton	Light Grey
TN18FHS001SB	Sweatshirt	L-Logo Zipup Sweat	Cotton	Sky Blue

Code	Category	Name	Material(s)	Color(s)
TN18FHS001YT	Sweatshirt	L-Logo Zipup Sweat	Cotton	Coyote
TN18FHS002BK	Sweatshirt	MI-Logo Hooded Sweatshirt	Cotton	Black
TN18FHS002IL	Sweatshirt	MI-Logo Hooded Sweatshirt	Cotton	Light Olive
TN18FHS003BK	Sweatshirt	NEW SPORT SP Hooded Sweatshirt	Cotton	Black
TN18FHS003BU	Sweatshirt	NEW SPORT SP Hooded Sweatshirt	Cotton	Burgundy
TN18FHS003IR	Sweatshirt	NEW SPORT SP Hooded Sweatshirt	Cotton	Light Grey
TN18FHS004BK	Sweatshirt	Ellipse Hooded Sweatshirt	Cotton	Black
TN18FHS004IR	Sweatshirt	Ellipse Hooded Sweatshirt	Cotton	Light Grey
TN18FHS004NA	Sweatshirt	Ellipse Hooded Sweatshirt	Cotton	Navy
TN18FHS005BK	Sweatshirt	BB TINT Hooded Sweatshirt	Cotton	Black
TN18FHS005FR	Sweatshirt	BB TINT Hooded Sweatshirt	Cotton	Forest
TN18FHS005IR	Sweatshirt	BB TINT Hooded Sweatshirt	Cotton	Light Grey
TN18FHS006BK	Sweatshirt	DSN Logo Hooded Sweatshirt	Cotton	Black
TN18FHS006GR	Sweatshirt	DSN Logo Hooded Sweatshirt	Cotton	Grey
TN18FHS006RD	Sweatshirt	DSN Logo Hooded Sweatshirt	Cotton	Red
TN18FHS006TG	Sweatshirt	DSN Logo Hooded Sweatshirt	Cotton	Light Beige
TN18FHS007BK	Sweatshirt	HSP Hooded Sweatshirt	Cotton	Black
TN18FHS007GN	Sweatshirt	HSP Hooded Sweatshirt	Cotton	Green
TN18FHS007OV	Sweatshirt	HSP Hooded Sweatshirt	Cotton	Olive
TN18FHS008BK	Sweatshirt	GLOBE Hooded Sweatshirt	Cotton	Black
TN18FHS008GN	Sweatshirt	GLOBE Hooded Sweatshirt	Cotton	Green
TN18FHS008IR	Sweatshirt	GLOBE Hooded Sweatshirt	Cotton	Light Grey
TN18FHS009BK	Sweatshirt	SP-INTL. Logo Hooded Sweatshirt	Cotton	Black
TN18FHS009FR	Sweatshirt	SP-INTL. Logo Hooded Sweatshirt	Cotton	Forest
TN18FHS009GR	Sweatshirt	SP-INTL. Logo Hooded Sweatshirt	Cotton	Grey
TN18FHS009WH	Sweatshirt	SP-INTL. Logo Hooded Sweatshirt	Cotton	White
TN18FHS010BK	Sweatshirt	SP-Logo Fleece Hooded Sweatshirt	Polyester	Black
TN18FHS010LD	Sweatshirt	SP-Logo Fleece Hooded Sweatshirt	Polyester	Leopard
TN18FHS010RD	Sweatshirt	SP-Logo Fleece Hooded Sweatshirt	Polyester	Red
TN18FHS010YL	Sweatshirt	SP-Logo Fleece Hooded Sweatshirt	Polyester	Yellow
TN18FHW001BK	Hat	DIA-HSP Logo Beanie	Acrylic	Black
TN18FHW001BL	Hat	DIA-HSP Logo Beanie	Acrylic	Blue
TN18FHW001OR	Hat	DIA-HSP Logo Beanie	Acrylic	Orange
TN18FHW002BK	Hat	HSP Ear Flat Hat	Polyester	Black
TN18FHW002NA	Hat	HSP Ear Flat Hat	Polyester	Navy
TN18FHW003BK	Hat	POMPOM Beanie	Acrylic	Black
TN18FHW003NA	Hat	POMPOM Beanie	Acrylic	Navy
TN18FHW003OV	Hat	POMPOM Beanie	Acrylic	Olive
TN18FHW004BK	Hat	T-Logo Short Beanie	Acrylic	Black
TN18FHW004BL	Hat	T-Logo Short Beanie	Acrylic	Blue
TN18FHW004PK	Hat	T-Logo Short Beanie	Acrylic	Pink
TN18FHW004YL	Hat	T-Logo Short Beanie	Acrylic	Yellow
TN18FHW005BK	Hat	SP Mountain Cap	Polyester	Black
TN18FHW005BR	Hat	SP Mountain Cap	Polyester	Brown
TN18FHW005NA	Hat	SP Mountain Cap	Polyester	Navy
TN18FHW006BK	Hat	SP-Logo Cap	Cotton, Nylon	Black
TN18FHW006BL	Hat	SP-Logo Cap	Cotton, Nylon	Blue
TN18FHW006OV	Hat	SP-Logo Cap	Cotton, Nylon	Olive
TN18FHW007BE	Hat	L-Logo Fleece Camp Cap	Polyester	Beige
TN18FHW007BK	Hat	L-Logo Fleece Camp Cap	Polyester	Black
TN18FHW007YL	Hat	L-Logo Fleece Camp Cap	Polyester	Yellow
TN18FHW008NA	Hat	ADVENTURER II Cap	Cotton, Nylon	Navy
TN18FHW008WH	Hat	ADVENTURER II Cap	Cotton, Nylon	White
TN18FHW009BE	Hat	MOHUM Cap	Cotton	Beige
TN18FHW009BK	Hat	MOHUM Cap	Cotton	Black

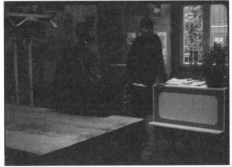

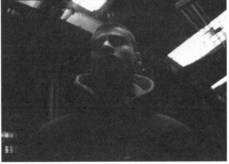

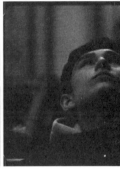

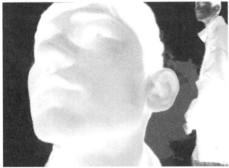

TN18FMV001NA

Code	Category	Name	Material(s)	Color(s)
TN18FHW009CH	Hat	MOHUM Cap	Cotton	Charcoal
TN18FHW010IV	Hat	Fishing Hiking Hat	Polyester	Ivory
TN18FKW001BK	Top	Striped Oversized Knit Sweater	Cotton	Black
TN18FKW001PP	Top	Striped Oversized Knit Sweater	Cotton	Purple
TN18FMV001NA	Video	der sauberkeit	Film	-
TN18FMV002NA	Video	NIKE AIR MAX 270 with thisisneverthat FW2018	Film	-
TN18FOW001BK	Jacket	INTL. Logo CITY Down Parka	Nylon, Polyester, Down, Feather	Black
TN18FOW001WH	Jacket	INTL. Logo CITY Down Parka	Nylon, Polyester, Down, Feather	White
TN18FOW002BK	Jacket	DSN-Logo Oversized Down Parka	Polyester, Down, Feather	Black
TN18FOW002OV	Jacket	DSN-Logo Oversized Down Parka	Polyester, Down, Feather	Olive
TN18FOW003BK	Jacket	L-Logo Padded Bench Parka	Nylon, 3M Thinsulate	Black
TN18FOW003CH	Jacket	L-Logo Padded Bench Parka	Nylon, 3M Thinsulate	Charcoal
TN18FOW003NA		L-Logo Padded Bench Parka	Nylon, 3M Thinsulate	Navy
TN18FOW004BK	Jacket	DIA-SP Sport Down Vest	Polyester, Down, Feather, 3M Thinsulate	Black
TN18FOW004BL	Jacket	DIA-SP Sport Down Vest	Polyester, Down, Feather, 3M Thinsulate	Blue
TN18FOW005BK	Jacket	T-Logo Puffer Down Vest	Nylon, Down, Feather	Black
TN18FOW005RD	Jacket	T-Logo Puffer Down Vest	Nylon, Down, Feather	Red
TN18FOW006BK	Jacket	SP Sport Down Jacket	Polyester, Down, Feather	Black
TN18FOW006BL	Jacket	SP Sport Down Jacket	Polyester, Down, Feather	Blue

TN18FMV002NA

Code	Category	Name	Material(s)	Color(s)
TN18FOW006GN	Jacket	SP Sport Down Jacket	Polyester, Down, Feather	Green
TN18FOW007BK	Jacket	T-Logo ECW Parka	Polyester, Nylon, 3M Thinsulate	Black
TN18FOW007OV	Jacket	T-Logo ECW Parka	Polyester, Nylon, 3M Thinsulate	Olive
TN18FOW008BK	Jacket	Hooded Fleece Jacket	Polyester, Nylon	Black
TN18FOW008IV	Jacket	Hooded Fleece Jacket	Polyester, Nylon	Ivory
TN18FOW009BK	Jacket	SP Boa Fleece Jacket	Polyester, Acrylic, Nylon	Black
TN18FOW009IV	Jacket	SP Boa Fleece Jacket	Polyester, Acrylic, Nylon	Ivory
TN18FOW009OV	Jacket	SP Boa Fleece Jacket	Polyester, Acrylic, Nylon	Olive
TN18FOW010BK	Jacket	Reversible International Jacket	Nylon, Polyester	Black
TN18FOW010OV	Jacket	Reversible International Jacket	Nylon, Polyester	Olive
TN18FOW011BK	Jacket	T-Logo Paneled Windbreaker	Polyester	Black
TN18FOW011GN	Jacket	T-Logo Paneled Windbreaker	Polyester	Green
TN18FOW011GR	Jacket	T-Logo Paneled Windbreaker	Polyester	Grey
TN18FOW012BK	Jacket	M-51 Field Parka	Cotton, Polyester, 3M Thinsulate	Black
TN18FOW012OV	Jacket	M-51 Field Parka	Cotton, Polyester, 3M Thinsulate	Olive
TN18FOW013NA	Jacket	ADVENTURER Varsity Jacket	Nylon, Polyester	Navy
TN18FOW013YL	Jacket	ADVENTURER Varsity Jacket	Nylon, Polyester	Yellow
TN18FOW014BK	Jacket	Hooded Denim Shop Coat	Cotton	Black
TN18FOW015GN	Jacket	Wool Zip Jacket	Wool, Nylon	Green
TN18FOW015GR	Jacket	Wool Zip Jacket	Wool, Nylon	Grey
TN18FOW016BK	Jacket	Zip Jacket	Cotton	Black
TN18FOW016CH	Jacket	Zip Jacket	Cotton	Charcoal
TN18FOW016NA	Jacket	Zip Jacket	Cotton	Navy
TN18FOW017CH	Jacket	Puffy Half Zip Parka Jacket	Polyester	Charcoal
TN18FOW018BK	Jacket	Multi Leather Jacket	Polyurethane, Rayon, Polyester	Black
TN18FOW018NA	Jacket	Multi Leather Jacket	Polyurethane, Rayon, Polyester	Navy
TN18FOW018WH	Jacket	Multi Leather Jacket	Polyurethane, Rayon, Polyester	White
TN18FOW019IV	Jacket	Leather Coach Jacket	Genuine Leather, Polyester	Ivory
TN18FOW020BK	Jacket	Leather Motorcycle Jacket	Genuine Leather, Cotton	Black
TN18FOW020BL	Jacket	Leather Motorcycle Jacket	Genuine Leather, Cotton	Blue
TN18FOW021BK	Jacket	Oversized Cord Shirt Jacket	Cotton	Black
TN18FOW021GR	Jacket	Oversized Cord Shirt Jacket	Cotton	Grey
TN18FOW021OV	Jacket	Oversized Cord Shirt Jacket	Cotton	Olive
TN18FOW022BK	Jacket	T-BOX Jacket	Polyester, Wool	Black
TN18FOW022SP	Jacket	T-BOX Jacket	Polyester, Wool	Stripe
TN18FOW023BK	Jacket	thisisneverthat × Alpha Sherpa MA-1	Nylon, Polyester	Black
TN18FOW023GM	Jacket	thisisneverthat × Alpha Sherpa MA-1	Nylon, Polyester	Gun Metal
TN18FPA001DP	Jean	Regular Jean	Cotton	Deep Blue
TN18FPA001TB	Jean	Regular Jean	Cotton	Light Blue
TN18FPA002OO	Jean	Crazy Jean	Cotton	#1
TN18FPA002TW	Jean	Crazy Jean	Cotton	#2
TN18FPA003BK	Jean	Big Jean	Cotton	Black
TN18FPA003DP	Jean	Big Jean	Cotton	Deep Blue
TN18FPA004BK	Pants	T-Logo ECW Pant	Polyester, Nylon, 3M Thinsulate	Black
TN18FPA004OV	Pants	T-Logo ECW Pant	Polyester, Nylon, 3M Thinsulate	Olive
TN18FPA005BK	Pants	Fleece Pant	Polyester	Black

Code	Category	Name	Material(s)	Color(s)

TN18FOW001BK TN18FOW022BK TN18FOW006GN TN18FOW004BK TN18FOW005RD

TN18FOW010BK TN18FSW015BK TN18FOW016BK TN18FOW013YL TN18FOW018WH

Code	Category	Name	Material(s)	Color(s)
TN18FPA005IV	Pants	Fleece Pant	Polyester	Ivory
TN18FPA006BK	Pants	T-Logo Paneled Warm Up Pant	Polyester	Black
TN18FPA006GN	Pants	T-Logo Paneled Warm Up Pant	Polyester	Green
TN18FPA006GR	Pants	T-Logo Paneled Warm Up Pant	Polyester	Grey
TN18FPA007DP	Jean	Weekend Wide Jean	Cotton	Deep Blue
TN18FPA007IDG	Jean	Weekend Wide Jean	Cotton	Indigo
TN18FPA008BK	Pants	Cargo Pant	Cotton	Black
TN18FPA008BL	Pants	Cargo Pant	Cotton	Blue
TN18FPA008OV	Pants	Cargo Pant	Cotton	Olive
TN18FPA009BK	Pants	Corduroy Pant	Cotton	Black
TN18FPA009GR	Pants	Corduroy Pant	Cotton	Grey
TN18FPA009OV	Pants	Corduroy Pant	Cotton	Olive
TN18FPA010CH	Pants	Velcro Track Pant	Nylon, Polyester	Charcoal
TN18FPA010GR	Pants	Velcro Track Pant	Nylon, Polyester	Grey
TN18FPA010IM	Pants	Velcro Track Pant	Nylon, Polyester	Lime
TN18FPA011BE	Pants	Classic Wide Pant	Cotton	Beige
TN18FPA011BK	Pants	Classic Wide Pant	Cotton	Black
TN18FPA012BK	Pants	Carpenter Pant	Cotton	Black
TN18FPA012GR	Pants	Carpenter Pant	Cotton	Grey
TN18FPA012NA	Pants	Carpenter Pant	Cotton	Navy
TN18FPA013BK	Pants	Work Pant	Cotton	Black
TN18FPA013GR	Pants	Work Pant	Cotton	Grey
TN18FPA013MT	Pants	Work Pant	Cotton	Multi
TN18FPA013OY	Pants	Work Pant	Cotton	Cool Grey
TN18FPA014BK	Pants	MI-Logo Sweatpant	Cotton	Black
TN18FPA014GN	Pants	MI-Logo Sweatpant	Cotton	Green
TN18FPA014TG	Pants	MI-Logo Sweatpant	Cotton	Light Beige
TN18FPA015OV	Pants	Basic Sweatpant	Cotton	Olive
TN18FPA015RD	Pants	Basic Sweatpant	Cotton	Red
TN18FPA016BK	Pants	F-Column Sweatpant	Cotton	Black
TN18FPA016IR	Pants	F-Column Sweatpant	Cotton	Light Grey
TN18FPA017NA	Pants	Tiedye Sweatpant	Cotton	Navy

Code	Category	Name	Material(s)	Color(s)
TN18FPA017PP	Pants	Tiedye Sweatpant	Cotton	Purple
TN18FPA018BK	Pants	Leather Pant	Genuine Leather, Polyester	Black
TN18FPA018IV	Pants	Leather Pant	Genuine Leather, Polyester	Ivory
TN18FPA019BK	Pants	Wool Trouser	Polyester, Wool	Black
TN18FPA019SP	Pants	Wool Trouser	Polyester, Wool	Stripe
TN18FSH001BR	Shirt	MI-Logo Oversized Check Shirt	Cotton	Brown
TN18FSH001GN	Shirt	MI-Logo Oversized Check Shirt	Cotton	Green
TN18FSH002GR	Shirt	L-Logo Oversized Check Shirt	Cotton	Grey
TN18FSH002RD	Shirt	L-Logo Oversized Check Shirt	Cotton	Red
TN18FSH003BL	Shirt	SP-Logo Sherpa Shirt	Cotton	Blue
TN18FSH003GN	Shirt	SP-Logo Sherpa Shirt	Cotton	Green
TN18FSH004BK	Shirt	HSP Sport Shirt	Cotton	Black
TN18FSH004YL	Shirt	HSP Sport Shirt	Cotton	Yellow
TN18FSH005LV	Shirt	MI-Logo Oxford Shirt	Cotton	Lavender
TN18FSH005SB	Shirt	MI-Logo Oxford Shirt	Cotton	Sky Blue
TN18FSH006BL	Shirt	SP-INTL. Logo Denim Shirt	Cotton	Blue
TN18FSH006TB	Shirt	SP-INTL. Logo Denim Shirt	Cotton	Light Blue
TN18FSH007BE	Top	SP L/SL Jersey Polo	Cotton	Beige
TN18FSH007BK	Top	SP L/SL Jersey Polo	Cotton	Black
TN18FSH007LV	Top	SP L/SL Jersey Polo	Cotton	Lavender
TN18FSH007WH	Top	SP L/SL Jersey Polo	Cotton	White
TN18FSW001BU	Sweatshirt	SCRT-Logo Paneled Crewneck	Cotton	Burgundy
TN18FSW001IR	Sweatshirt	SCRT-Logo Paneled Crewneck	Cotton	Light Grey
TN18FSW001NA	Sweatshirt	SCRT-Logo Paneled Crewneck	Cotton	Navy
TN18FSW002BK	Sweatshirt	ADVENTURER II Crewneck	Cotton	Black
TN18FSW002IL	Sweatshirt	ADVENTURER II Crewneck	Cotton	Light Olive
TN18FSW003BK	Sweatshirt	Nightscape Crewneck	Cotton	Black
TN18FSW003SB	Sweatshirt	Nightscape Crewneck	Cotton	Sky Blue
TN18FSW003SO	Sweatshirt	Nightscape Crewneck	Cotton	Stone
TN18FSW004BK	Sweatshirt	INTL. Logo Crewneck	Cotton	Black
TN18FSW004WH	Sweatshirt	INTL. Logo Crewneck	Cotton	White
TN18FSW005BK	Sweatshirt	HSP Crewneck	Cotton	Black

TN18FHS001YT TN18FHS006TG TN18FHS006BK

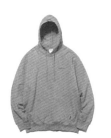
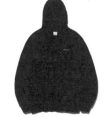

TN18FHS010RD TN18FHS010BK TN18FHS007BK TN18FHS005BK TN18FHS009GR

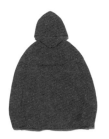
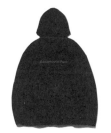
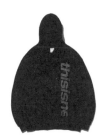

Code	Category	Name	Material(s)	Color(s)

TN18FSH001GN TN18FSH006TB TN18FSH003BL

TN18FSW002IL TN18FSW013NA TN18FSW014IV TN18FSW012NA TN18FKW001PP

 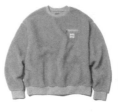 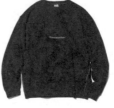 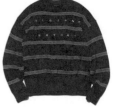

TN18FSW005BK TN18FSW001IR TN18FTS002OV TN18FTS006TW

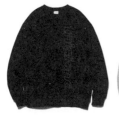 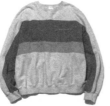 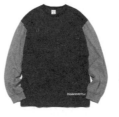 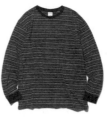

TN18FSW007IR TN18FSW007NA TN18FTS003IR

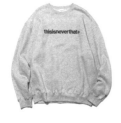 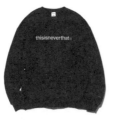 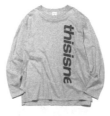

Code	Category	Name	Material(s)	Color(s)
TN18FSW005IR	Sweatshirt	HSP Crewneck	Cotton	Light Grey
TN18FSW006BK	Sweatshirt	Silver College Crewneck	Cotton	Black
TN18FSW006IR	Sweatshirt	Silver College Crewneck	Cotton	Light Grey
TN18FSW007BK	Sweatshirt	T-Logo Crewneck	Cotton	Black
TN18FSW007FR	Sweatshirt	T-Logo Crewneck	Cotton	Forest
TN18FSW007IR	Sweatshirt	T-Logo Crewneck	Cotton	Light Grey
TN18FSW007NA	Sweatshirt	T-Logo Crewneck	Cotton	Navy
TN18FSW007SB	Sweatshirt	T-Logo Crewneck	Cotton	Sky Blue
TN18FSW008BK	Sweatshirt	NEW SPORT SP Crewneck	Cotton	Black
TN18FSW008GN	Sweatshirt	NEW SPORT SP Crewneck	Cotton	Green
TN18FSW008NA	Sweatshirt	NEW SPORT SP Crewneck	Cotton	Navy
TN18FSW009BK	Sweatshirt	Bubble SP Crewneck	Cotton	Black
TN18FSW009LY	Sweatshirt	Bubble SP Crewneck	Cotton	Light Navy
TN18FSW009SO	Sweatshirt	Bubble SP Crewneck	Cotton	Stone

Code	Category	Name	Material(s)	Color(s)
TN18FSW010UM	Sweatshirt	Multi Striped Crewneck	Cotton	Burgundy, Cream
TN18FSW010VP	Sweatshirt	Multi Striped Crewneck	Cotton	Navy, Purple
TN18FSW010VR	Sweatshirt	Multi Striped Crewneck	Cotton	Navy, Brown
TN18FSW011BK	Sweatshirt	ARC-Logo S-Collar Sweatshirt	Cotton	Black
TN18FSW011BU	Sweatshirt	ARC-Logo S-Collar Sweatshirt	Cotton	Burgundy
TN18FSW011IR	Sweatshirt	ARC-Logo S-Collar Sweatshirt	Cotton	Light Grey
TN18FSW012NA	Sweatshirt	Tiedye Crewneck	Cotton	Navy
TN18FSW012PP	Sweatshirt	Tiedye Crewneck	Cotton	Purple
TN18FSW013BK	Top	Side Zip Track Top	Polyester	Black
TN18FSW013NA	Top	Side Zip Track Top	Polyester	Navy
TN18FSW014BK	Sweatshirt	Boa Fleece Crewneck	Polyester, Acrylic	Black
TN18FSW014IV	Sweatshirt	Boa Fleece Crewneck	Polyester, Acrylic	Ivory
TN18FSW014OV	Sweatshirt	Boa Fleece Crewneck	Polyester, Acrylic	Olive
TN18FSW015BK	Top	CP-INTL. Logo Half Zip Pullover	Cotton	Black
TN18FSW015SO	Top	CP-INTL. Logo Haif Zip Pullover	Cotton	Stone
TN18FSW015WH	Top	CP-INTL. Logo Haif Zip Pullover	Cotton	White
TN18FSW016BE	Top	DSN Fleece Half Zipup	Polyester	Beige
TN18FSW016BK	Top	DSN Fleece Half Zipup	Polyester	Black
TN18FSW016IV	Top	DSN Fleece Half Zipup	Polyester	Ivory
TN18FSW016NA	Top	DSN Fleece Half Zipup	Polyester	Navy
TN18FTS001BK	Long Sleeve Tee	ADVENTURER L/SL Top	Cotton	Black
TN18FTS001CH	Long Sleeve Tee	ADVENTURER L/SL Top	Cotton	Charcoal
TN18FTS001FR	Long Sleeve Tee	ADVENTURER L/SL Top	Cotton	Forest
TN18FTS002BK	Long Sleeve Tee	Multi Color L/SL Top	Cotton	Black
TN18FTS002CH	Long Sleeve Tee	Multi Color L/SL Top	Cotton	Charcoal
TN18FTS002OV	Long Sleeve Tee	Multi Color L/SL Top	Cotton	Olive
TN18FTS003BK	Long Sleeve Tee	HSP L/SL Top	Cotton	Black
TN18FTS003IR	Long Sleeve Tee	HSP L/SL Top	Cotton	Light Grey
TN18FTS003OR	Long Sleeve Tee	HSP L/SL Top	Cotton	Orange
TN18FTS003WH	Long Sleeve Tee	HSP L/SL Top	Cotton	White
TN18FTS004BK	Long Sleeve Tee	C-Logo Pocket L/SL Top	Cotton	Black
TN18FTS004LY	Long Sleeve Tee	C-Logo Pocket L/SL Top	Cotton	Light Navy
TN18FTS004PK	Long Sleeve Tee	C-Logo Pocket L/SL Top	Cotton	Pink
TN18FTS004WH	Long Sleeve Tee	C-Logo Pocket L/SL Top	Cotton	White
TN18FTS005KR	Long Sleeve Tee	Small L-Logo Stripe L/SL Top	Cotton	Black, Green
TN18FTS005PW	Long Sleeve Tee	Small L-Logo Stripe L/SL Top	Cotton	Purple, Yellow
TN18FTS005RN	Long Sleeve Tee	Small L-Logo Stripe L/SL Top	Cotton	Red, Navy
TN18FTS006OO	Long Sleeve Tee	EMB. L-Logo Stripe L/SL Top	Cotton	#1
TN18FTS006TW	Long Sleeve Tee	EMB. L-Logo Stripe L/SL Top	Cotton	#2
TN18FTS007BE	Long Sleeve Tee	L-Logo Turtle Neck L/S	Cotton	Beige
TN18FTS007BK	Long Sleeve Tee	L-Logo Turtle Neck L/S	Cotton	Black
TN18FTS007WH	Long Sleeve Tee	L-Logo Turtle Neck L/S	Cotton	White
TW18FHS001BK	Sweatshirt	Multi-T-Logo Zip Hood	Cotton	Black
TW18FHS001WH	Sweatshirt	Multi-T-Logo Zip Hood	Cotton	White
TW18FHS002BK	Sweatshirt	M-Logo Hood	Cotton	Black
TW18FHS002IL	Sweatshirt	M-Logo Hood	Cotton	Light Olive
TW18FHS002TG	Sweatshirt	M-Logo Hood	Cotton	Light Beige
TW18FKW001BK	Top	Cropped Angora Cardigan	Wool, Angora, Nylon	Black
TW18FKW001RD	Top	Cropped Angora Cardigan	Wool, Angora, Nylon	Red
TW18FOW001BK	Jacket	Womens SP-Logo Down Jacket	Nylon, Down, Feather	Black
TW18FOW001GN	Jacket	Womens SP-Logo Down Jacket	Nylon, Down, Feather	Green
TW18FOW002GR	Jacket	Padded Vest	Polyester	Grey
TW18FOW002NA	Jacket	Padded Vest	Polyester	Navy

Code	Category	Name	Material(s)	Color(s)
TW18FOW003BK	Jacket	Leather Coat	Genuine Leather, Polyester	Black
TW18FOW003GN	Jacket	Leather Coat	Genuine Leather, Polyester	Green
TW18FOW004CH	Jacket	Wool M51	Wool, Nylon, Cotton	Charcoal
TW18FOW005SG	Jacket	Chest Pocket Flight Jacket	Nylon, Polyester	Steel Grey
TW18FOW006BK	Jacket	Corduroy Jacket	Cotton	Black
TW18FOW006BR	Jacket	Corduroy Jacket	Cotton	Brown
TW18FOW007BE	Jacket	Faux Fur Jacket	Polyester, Nylon	Beige
TW18FOW007NA	Jacket	Faux Fur Jacket	Polyester, Nylon	Navy
TW18FOW007YL	Jacket	Faux Fur Jacket	Polyester, Nylon	Yellow
TW18FOW008BK	Jacket	Short Mustang Jacket	Genuine Leather	Black
TW18FOW009BL	Jacket	Multi Pocket Zipped Jacket	Nylon	Blue
TW18FOW009CH	Jacket	Multi Pocket Zipped Jacket	Nylon	Charcoal
TW18FPA001BK	Jean	Wide Denim Pant	Cotton	Black
TW18FPA001TB	Jean	Wide Denim Pant	Cotton	Light Blue
TW18FPA002TB	Jean	Bell Bottom Denim Pant	Cotton	Light Blue
TW18FPA003BK	Pants	Work Pant	Cotton	Black
TW18FPA003WH	Pants	Work Pant	Cotton	White
TW18FPA004NA	Pants	Herringbone Patterned Pant	Cotton	Navy
TW18FPA004OV	Pants	Herringbone Patterned Pant	Cotton	Olive
TW18FPA005BK	Pants	Wide Cargo Pant	Cotton	Black
TW18FPA005BR	Pants	Wide Cargo Pant	Cotton	Brown
TW18FPA006BK	Pants	M-Logo Sweat Pant	Cotton	Black
TW18FPA006OV	Pants	M-Logo Sweat Pant	Cotton	Olive
TW18FPA007BK	Pants	Velour Track Pant	Cotton, Polyester	Black
TW18FPA007BU	Pants	Velour Track Pant	Cotton, Polyester	Burgundy
TW18FSH001BL	Shirt	T-Logo Flannel Shirt	Cotton	Blue
TW18FSH001OR	Shirt	T-Logo Flannel Shirt	Cotton	Orange
TW18FSH002BU	Top	Striped Rugby Shirt	Cotton	Burgundy
TW18FSH002SB	Top	Striped Rugby Shirt	Cotton	Sky Blue
TW18FSH003BK	Shirt	Shirt Dress	Cotton	Black
TW18FSH003RD	Shirt	Shirt Dress	Cotton	Red
TW18FSK001BL	Skirt	T-Logo Check Skirt	Cotton	Blue
TW18FSK001OR	Skirt	T-Logo Check Skirt	Cotton	Orange
TW18FSK002BK	Skirt	T-Logo Long Denim Skirt	Cotton	Black
TW18FSK002TB	Skirt	T-Logo Long Denim Skirt	Cotton	Light Blue
TW18FSK003CH	Skirt	Chino Skirt	Cotton	Charcoal
TW18FSK003OV	Skirt	Chino Skirt	Cotton	Olive
TW18FSK004BK	Skirt	Sweat Skirt	Cotton	Black
TW18FSK004IR	Skirt	Sweat Skirt	Cotton	Light Grey
TW18FSK005BK	Skirt	Velour Skirt	Cotton, Polyester	Black
TW18FSK005BU	Skirt	Velour Skirt	Cotton, Polyester	Burgundy
TW18FSW001BE	Sweatshirt	SD-Logo Flock Crew	Cotton	Beige
TW18FSW001BK	Sweatshirt	SD-Logo Flock Crew	Cotton	Black
TW18FSW001IR	Sweatshirt	SD-Logo Flock Crew	Cotton	Light Grey
TW18FSW001SB	Sweatshirt	SD-Logo Flock Crew	Cotton	Sky Blue
TW18FSW002BK	Sweatshirt	W-Logo Crew	Cotton	Black
TW18FSW002BU	Sweatshirt	W-Logo Crew	Cotton	Burgundy
TW18FSW002NA	Sweatshirt	W-Logo Crew	Cotton	Navy
TW18FSW003BK	Top	Collar Sweat Shirt	Cotton	Black
TW18FSW003IR	Top	Collar Sweat Shirt	Cotton	Light Grey
TW18FSW004BK	Sweatshirt	Fleece Crew	Polyester	Black
TW18FSW004RD	Sweatshirt	Fleece Crew	Polyester	Red
TW18FSW005BK	Sweatshirt	Velour Crew	Cotton, Polyester	Black
TW18FSW005BU	Sweatshirt	Velour Crew	Cotton, Polyester	Burgundy
TW18FTS001BK	Long Sleeve Tee	Small DIA-HSP Logo L/S Tee	Cotton	Black

Code	Category	Name	Material(s)	Color(s)
TW18FTS001IR	Long Sleeve Tee	Small DIA-HSP Logo L/S Tee	Cotton	Light Grey
TW18FTS001OR	Long Sleeve Tee	Small DIA-HSP Logo L/S Tee	Cotton	Orange
TW18FTS001WH	Long Sleeve Tee	Small DIA-HSP Logo L/S Tee	Cotton	White
TW18FTS002BK	Long Sleeve Tee	Striped L/S Tee	Cotton	Black
TW18FTS002GN	Long Sleeve Tee	Striped L/S Tee	Cotton	Green
TW18FTS002PP	Long Sleeve Tee	Striped L/S Tee	Cotton	Purple
TW18FTS003BK	Long Sleeve Tee	Button L/S Tee	Cotton	Black
TW18FTS003GR	Long Sleeve Tee	Button L/S Tee	Cotton	Grey

TN18FPA007IDG

TN18FPA019BK

TN18FPA003DP

TN18FPA008BL

TN18FPA009GR

TN18FPA010IM

TN18FPA014GN

TN18FPA012BK

TN18FHW006BL

TN18FHW007BK

TN18FHW001OR

TN18FAC009WH

TN18FAC003BK

TN18FAC005BK

TN18FAC004BK

TN19FAC001SR

Code	Category	Name	Material(s)	Color(s)
GM18SPA001DK	Pants	Track Pant	Nylon	Dark
GM18SPA001WD	Pants	Track Pant	Nylon	Wood
GM18SSO001BK	Pants	Very Short	Cotton	Black
GM18SSO001OC	Pants	Very Short	Cotton	Ocean
GM18SSO002BK	Pants	G-Short	Cotton	Black
GM18SSO002NT	Pants	G-Short	Cotton	Natural
TN18SAC001BK	Accessory	Taped Belt	Polyester	Black
TN18SAC001OV	Accessory	Taped Belt	Polyester	Olive
TN18SAC002BK	Accessory	VIK Sunglasses	Acetate	Black
TN18SAC002GN	Accessory	VIK Sunglasses	Acetate	Green
TN18SAC003BK	Accessory	Skogar Sunglasses	Acetate	Black
TN18SAC003WH	Accessory	Skogar Sunglasses	Acetate	White
TN18SAC004BK	Socks	HSP Regular Socks	Cotton, Spandex, Polyester	Black
TN18SAC004LD	Socks	HSP Regular Socks	Cotton, Spandex, Polyester	Leopard
TN18SAC004WH	Socks	HSP Regular Socks	Cotton, Spandex, Polyester	White
TN18SAC005BK	Socks	HSP Ankle Socks	Cotton, Spandex, Polyester	Black
TN18SAC005WH	Socks	HSP Ankle Socks	Cotton, Spandex, Polyester	White
TN18SAC006NA	Accessory	Bottle Lanyard	Polyester Strap, Plastic Buckle	Navy
TN18SAC007GPD	Underwear	Woven Boxer	Cotton	Green Plaid
TN18SAC007RD	Underwear	Woven Boxer	Cotton	Red
TN18SAC007RPD	Underwear	Woven Boxer	Cotton	Red Plaid
TN18SAC007SB	Underwear	Woven Boxer	Cotton	Sky Blue
TN18SAC008BK	Accessory	Sharpie® Pen	Plastic	Black
TN18SAC009NNE	Accessory	Post-it® Set	Paper	None
TN18SAC010SR	Accessory	C-logo Necklace	925 Silver	Silver
TN18SAC011GR	Accessory	Nalgene Tritan Bottle 0.5L	Tritan	Grey
TN18SAC012BK	Accessory	Beer Glass	Glass	Black
TN18SAC013WH	Accessory	Duralex® Glass	Glass	White
TN18SAC014BK	Shoes	Beach Sandal	Rubber	Black
TN18SAC014NA	Shoes	Beach Sandal	Rubber	Navy
TN18SAC015BK	Accessory	BIC® Ballpen	Plastic	Black
TN18SBA001BE	Bag	CORDURA® 750D Nylon Backpack 34L	Nylon	Beige
TN18SBA001BK	Bag	CORDURA® 750D Nylon Backpack 34L	Nylon	Black
TN18SBA001GN	Bag	CORDURA® 750D Nylon Backpack 34L	Nylon	Green
TN18SBA002BK	Bag	CORDURA® 750D Nylon BOP	Nylon	Black
TN18SBA002GN	Bag	CORDURA® 750D Nylon BOP	Nylon	Green
TN18SBA003EA	Bag	BOP	Polyester	Neon Orange
TN18SBA004BK	Bag	Leather Sling Bag	Genuine Leather, Polyester	Black
TN18SBA004GN	Bag	Leather Sling Bag	Genuine Leather, Polyester	Green
TN18SBA004SD	Bag	Leather Sling Bag	Genuine Leather, Polyester	Suede
TN18SBA005BK	Accessory	CORDURA® 750D Nylon Wallet	Nylon	Black
TN18SBA005GN	Accessory	CORDURA® 750D Nylon Wallet	Nylon	Green
TN18SBA006EA	Accessory	Wallet	Polyester	Neon Orange
TN18SBA007BK	Bag	CORDURA® 750D Nylon Flat Pouch	Nylon	Black
TN18SBA007GN	Bag	CORDURA® 750D Nylon Flat Pouch	Nylon	Green
TN18SBA008BK	Bag	CORDURA® 750D Nylon Box Pouch	Nylon	Black
TN18SBA008GN	Bag	CORDURA® 750D Nylon Box Pouch	Nylon	Green
TN18SBA009BE	Bag	CORDURA® 750D Nylon Messenger Bag	Nylon	Beige
TN18SBA009BK	Bag	CORDURA® 750D Nylon Messenger Bag	Nylon	Black
TN18SBA009GN	Bag	CORDURA® 750D Nylon Messenger Bag	Nylon	Green
TN18SBA010BK	Bag	CORDURA® 750D Nylon 13" Laptop Case	Nylon	Black
TN18SHS001BK	Sweatshirt	L-Logo Hooded Sweatshirt	Cotton	Black
TN18SHS001IM	Sweatshirt	L-Logo Hooded Sweatshirt	Cotton	Lime
TN18SHS001IR	Sweatshirt	L-Logo Hooded Sweatshirt	Cotton	Light Grey

Code	Category	Name	Material(s)	Color(s)
TN18SHS001YT	Sweatshirt	L-Logo Hooded Sweatshirt	Cotton	Coyote
TN18SHS002BK	Sweatshirt	NNN EMB. Hooded Sweatshirt	Cotton	Black
TN18SHS002IR	Sweatshirt	NNN EMB. Hooded Sweatshirt	Cotton	Light Grey
TN18SHS003BK	Sweatshirt	ARC Lower Hooded Sweatshirt	Cotton	Black
TN18SHS003LV	Sweatshirt	ARC Lower Hooded Sweatshirt	Cotton	Lavender
TN18SHS003MD	Sweatshirt	ARC Lower Hooded Sweatshirt	Cotton	Mustard
TN18SHS004CM	Sweatshirt	Mosaic Logo Hooded Sweatshirt	Cotton	Cream
TN18SHS004EA	Sweatshirt	Mosaic Logo Hooded Sweatshirt	Polyester, Cotton	Neon Orange
TN18SHS004IR	Sweatshirt	Mosaic Logo Hooded Sweatshirt	Cotton	Light Grey
TN18SHS005BK	Sweatshirt	S/L HSP Hooded Sweatshirt	Cotton	Black
TN18SHS005CM	Sweatshirt	S/L HSP Hooded Sweatshirt	Cotton	Cream
TN18SHS005GR	Sweatshirt	S/L HSP Hooded Sweatshirt	Cotton	Grey
TN18SHS006BK	Sweatshirt	C-Logo Zipup Sweat	Cotton	Black
TN18SHS006GR	Sweatshirt	C-Logo Zipup Sweat	Cotton	Grey
TN18SHS006LV	Sweatshirt	C-Logo Zipup Sweat	Cotton	Lavender
TN18SHS007BK	Sweatshirt	ARC EMB. Hooded Sweatshirt	Cotton	Black
TN18SHS007YT	Sweatshirt	ARC EMB. Hooded Sweatshirt	Cotton	Coyote
TN18SHS008RW	Sweatshirt	NSP Tiedye Hooded Sweatshirt	Cotton	Rainbow
TN18SHS009IR	Sweatshirt	NEVER Hooded Sweatshirt	Cotton	Light Grey
TN18SHS009NA	Sweatshirt	NEVER Hooded Sweatshirt	Cotton	Navy
TN18SHS010BK	Sweatshirt	CP INTL. Hooded Sweatshirt	Cotton	Black
TN18SHS010GR	Sweatshirt	CP INTL. Hooded Sweatshirt	Cotton	Grey
TN18SHS011NA	Sweatshirt	Multi Colored Hooded Sweatshirt	Cotton	Navy
TN18SHS011YT	Sweatshirt	Multi Colored Hooded Sweatshirt	Cotton	Coyote
TN18SHS012BE	Sweatshirt	HSP APP Hooded Sweatshirt	Cotton	Beige
TN18SHS012BK	Sweatshirt	HSP APP Hooded Sweatshirt	Cotton	Black
TN18SHS012EA	Sweatshirt	HSP APP Hooded Sweatshirt	Cotton, Polyester	Neon Orange
TN18SHW001BK	Hat	L-Logo bucket	Cotton	Black
TN18SHW001YL	Hat	L-Logo bucket	Cotton	Yellow
TN18SHW002BK	Hat	L-Logo Cap	Cotton	Black
TN18SHW002BL	Hat	L-Logo Cap	Cotton	Blue
TN18SHW002WH	Hat	L-Logo Cap	Cotton	White
TN18SHW003BK	Hat	DSN-Logo Camp Cap	Cotton, Nylon	Blcak
TN18SHW003GN	Hat	DSN-Logo Camp Cap	Cotton, Nylon	Green
TN18SHW003WH	Hat	DSN-Logo Camp Cap	Cotton, Nylon	White
TN18SHW004BK	Hat	DSN-Logo Short Beanie	Acrylic	Black
TN18SHW004OR	Hat	DSN-Logo Short Beanie	Acrylic	Orange
TN18SHW005BE	Hat	INTL. Logo Baseball Cap	Cotton	Beige
TN18SHW005BK	Hat	INTL. Logo Baseball Cap	Cotton	Black
TN18SHW005BL	Hat	INTL. Logo Baseball Cap	Cotton	Blue
TN18SHW005OR	Hat	INTL. Logo Baseball Cap	Cotton	Orange
TN18SHW005YT	Hat	INTL. Logo Baseball Cap	Cotton	Coyote
TN18SHW006BK	Hat	N-Baseball Cap	Cotton	Black

TN18SOW005LD TN18SOW006CM TN18SOW002BK TN18SOW001GN TN18SOW003CM

Code	Category	Name	Material(s)	Color(s)
TN18SHW006WH	Hat	N-Baseball Cap	Cotton	White
TN18SHW007BE	Hat	TINT Design Cap	Cotton, Nylon	Beige
TN18SHW007BK	Hat	TINT Design Cap	Cotton, Nylon	Black
TN18SHW007ER	Hat	TINT Design Cap	Cotton, Nylon	Neon
TN18SHW008NA	Hat	NEVER EMB. Long Bill Cap	Cotton	Navy
TN18SHW008RD	Hat	NEVER EMB. Long Bill Cap	Cotton	Red
TN18SHW008WH	Hat	NEVER EMB. Long Bill Cap	Cotton	White
TN18SHW009BE	Hat	Fishing Hiking Hat	Polyester	Beige
TN18SHW009NA	Hat	Fishing Hiking Hat	Polyester	Navy
TN18SHW010CK	Hat	Check Bucket Hat	Cotton	Check
TN18SHW011BK	Hat	Adventurer Hat	Cotton	Black
TN18SHW011OV	Hat	Adventurer Hat	Cotton	Olive
TN18SHW012BK	Hat	Front Pocket Cap	Cotton, Nylon	Black
TN18SHW012GE	Hat	Front Pocket Cap	Cotton, Nylon	Green, Olive
TN18SHW012RY	Hat	Front Pocket Cap	Cotton, Nylon	Red, Yellow
TN18SMV001NA	Video	ADVENTURER	Film	-
TN18SOW001BK	Jacket	Leather Coach Jacket	Genuine Leather, Polyester	Black
TN18SOW001GN	Jacket	Leather Coach Jacket	Genuine Leather, Polyester	Green
TN18SOW002BE	Jacket	Harrington Jacket	Cotton, Polyester	Beige
TN18SOW002BK	Jacket	Harrington Jacket	Cotton, Polyester	Black
TN18SOW002MT	Jacket	Harrington Jacket	Cotton, Polyester	Multi
TN18SOW003CM	Jacket	NEVER EMB. Denim Jacket	Cotton	Cream
TN18SOW003IDG	Jacket	NEVER EMB. Denim Jacket	Cotton	Indigo
TN18SOW004BL	Jacket	C&P Work Jacket	Cotton	Blue
TN18SOW004TB	Jacket	C&P Work Jacket	Cotton	Light Blue
TN18SOW005BK	Jacket	Fleece Jacket	Polyester	Black
TN18SOW005CM	Jacket	Fleece Jacket	Polyester	Cream
TN18SOW005LD	Jacket	Fleece Jacket	Polyester	Leopard
TN18SOW005LV	Jacket	Fleece Jacket	Polyester	Lavender
TN18SOW006BK	Jacket	Reversible Fleece Vest	Polyester	Black
TN18SOW006CM	Jacket	Reversible Fleece Vest	Polyester	Cream

TN18SMV001NA

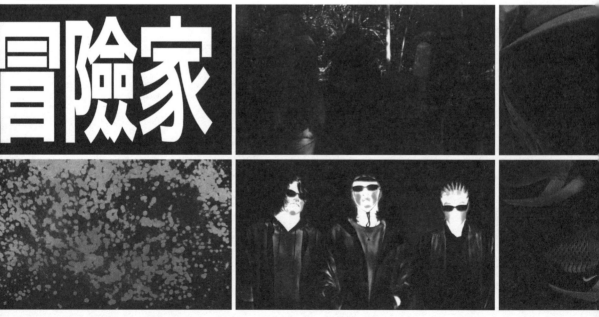

Code	Category	Name	Material(s)	Color(s)
TN18SOW006LD	Jacket	Reversible Fleece Vest	Polyester	Leopard
TN18SOW007BK	Jacket	HSP Sport Jacket	Cotton, Polyester, Nylon	Black
TN18SOW007KL	Jacket	HSP Sport Jacket	Cotton, Polyester, Nylon	Black, Gold
TN18SOW007KR	Jacket	HSP Sport Jacket	Cotton, Polyester, Nylon	Black, Green
TN18SOW008BK	Jacket	3SP-Taped Seam Jacket	Nylon	Black
TN18SOW008MT	Jacket	3SP-Taped Seam Jacket	Nylon	Multi
TN18SOW008YT	Jacket	3SP-Taped Seam Jacket	Nylon	Coyote
TN18SOW009BK	Jacket	CAMPER R/S Nylon Coat	Nylon, Polyester	Black
TN18SOW009GD	Jacket	CAMPER R/S Nylon Coat	Nylon, Polyester	Gold
TN18SOW009GN	Jacket	CAMPER R/S Nylon Coat	Nylon, Polyester	Green
TN18SPA001BK	Pants	R/S Cargo Pant	Cotton	Black
TN18SPA001OV	Pants	R/S Cargo Pant	Cotton	Olive
TN18SPA001PK	Pants	R/S Cargo Pant	Cotton	Pink
TN18SPA002BK	Jean	Washed Regular Jean	Cotton	Black
TN18SPA002CM	Jean	Washed Regular Jean	Cotton	Cream
TN18SPA002NA	Jean	Washed Regular Jean	Cotton	Navy
TN18SPA002RD	Jean	Washed Regular Jean	Cotton	Red
TN18SPA002TB	Jean	Washed Regular Jean	Cotton	Light Blue
TN18SPA003CM	Jean	Washed BIG Jean	Cotton	Cream
TN18SPA003TB	Jean	Washed BIG Jean	Cotton	Light Blue
TN18SPA004ME	Jean	T-Logo Crazy Jean	Cotton	Cream
TN18SPA004TE	Jean	T-Logo Crazy Jean	Cotton	Light Blue, Blue
TN18SPA005CK	Pants	Relaxed Pant	Cotton	Check
TN18SPA006BU	Pants	Basketball Training Pant	Nylon	Burgundy
TN18SPA006GN	Pants	Basketball Training Pant	Nylon	Green
TN18SPA007BE	Pants	Work Pant	Cotton	Beige
TN18SPA007BK	Pants	Work Pant	Cotton	Black
TN18SPA007MT	Pants	Work Pant	Cotton	Multi
TN18SPA007NT	Pants	Work Pant	Cotton	Natural
TN18SPA007YT	Pants	Work Pant	Cotton	Coyote

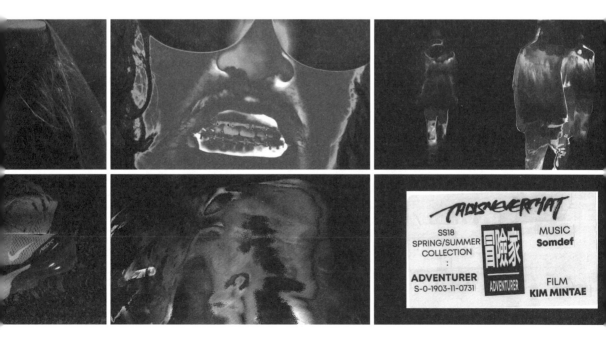

Code	Category	Name	Material(s)	Color(s)
TN18SPA008BK	Pants	HSP Warm Up Pant	Nylon	Black
TN18SPA008NT	Pants	HSP Warm Up Pant	Nylon	Natural
TN18SPA009BK	Pants	1Tuck Chino Pant	Cotton	Black
TN18SPA009NT	Pants	1Tuck Chino Pant	Cotton	Natural
TN18SPA009OV	Pants	1Tuck Chino Pant	Cotton	Olive
TN18SPA010BK	Pants	T-Logo Sweatpant	Cotton	Black
TN18SPA010LV	Pants	T-Logo Sweatpant	Cotton	Lavender
TN18SPA010MD	Pants	T-Logo Sweatpant	Cotton	Mustard
TN18SPA011GR	Pants	SP-Basic Sweatpant	Cotton	Grey
TN18SPA011IM	Pants	SP Basic Sweatpant	Cotton	Lime
TN18SPA011YT	Pants	SP Basic Sweatpant	Cotton	Coyote
TN18SPA012BL	Pants	RFLT-Logo Tiedye Sweatpant	Cotton	Blue
TN18SSH001BL	Shirt	Oversized Check Shirt	Cotton	Blue
TN18SSH001OR	Shirt	Oversized Check Shirt	Cotton	Orange
TN18SSH001RD	Shirt	Oversized Check Shirt	Cotton	Red
TN18SSH002BL	Shirt	Micro Check Shirt	Cotton	Blue
TN18SSH002BR	Shirt	Micro Check Shirt	Cotton	Brown
TN18SSH003BL	Shirt	Oversized Denim Shirt	Cotton	Blue
TN18SSH003TB	Shirt	Oversized Denim Shirt	Cotton	Light Blue
TN18SSH004BK	Shirt	SP Terry Shirt	Cotton	Black
TN18SSH004NA	Shirt	SP Terry Shirt	Cotton	Navy
TN18SSH004YL	Shirt	SP Terry Shirt	Cotton	Yellow
TN18SSH005BK	Shirt	HSP Sport Shirt	Cotton	Black
TN18SSH005BL	Shirt	HSP Sport Shirt	Cotton	Blue
TN18SSH006BK	Shirt	Nightscape ALOHA Shirt	Cotton	Black
TN18SSH006WH	Shirt	Nightscape ALOHA Shirt	Cotton	White
TN18SSH007GN	Shirt	Micro Check S/SL Shirt	Cotton	Green
TN18SSH008TB	Shirt	L-Logo Denim S/SL Shirt	Cotton	Light Blue
TN18SSH009BK	Top	DSN-Logo S/SL Jersey Polo	Cotton	Black
TN18SSH009CM	Top	DSN-Logo S/SL Jersey Polo	Cotton	Cream
TN18SSH009GN	Top	DSN-Logo S/SL Jersey Polo	Cotton	Green
TN18SSH010NA	Top	SP L/SL Jersey Polo	Cotton	Navy
TN18SSH010YT	Top	SP L/SL Jersey Polo	Cotton	Coyote
TN18SSH011BK	Top	Zipup L/SL Polo	Cotton	Black
TN18SSH011GN	Top	Zipup L/SL Polo	Cotton	Green
TN18SSO001BK	Pants	HSP Jogging Short	Nylon, Cotton	Black
TN18SSO001NA	Pants	HSP Jogging Short	Nylon, Cotton	Navy
TN18SSO001OV	Pants	HSP Jogging Short	Nylon, Cotton	Olive
TN18SSO002BE	Pants	N-2tuck Short	Cotton	Beige
TN18SSO002BK	Pants	N-2tuck Short	Cotton	Black
TN18SSO002OV	Pants	N-2tuck Short	Cotton	Olive
TN18SSO003BE	Pants	R/S Cargo Short	Cotton	Beige
TN18SSO003BK	Pants	R/S Cargo Short	Cotton	Black

TN18SSH002BL TN18SSH003TB TN18SSH008TB

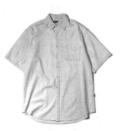

Code	Category	Name	Material(s)	Color(s)
TN18SSO004KH	Pants	Hiking Short	Cotton	Khaki
TN18SSO004MT	Pants	Hiking Short	Cotton	Multi
TN18SSO004NA	Pants	Hiking Short	Cotton	Navy
TN18SSO005BK	Pants	SP Sport Short	Cotton	Black
TN18SSO005NT	Pants	SP Sport Short	Cotton	Natural
TN18SSO005OV	Pants	SP Sport Short	Cotton	Olive
TN18SSO006BK	Pants	HSP Sweatshort	Cotton	Black
TN18SSO006CM	Pants	HSP Sweatshort	Cotton	Cream
TN18SSO006IM	Pants	HSP Sweatshort	Cotton	Lime
TN18SSO007BE	Pants	L-logo Sweatshort	Cotton	Beige
TN18SSO007NA	Pants	L-logo Sweatshort	Cotton	Navy
TN18SSO007OR	Pants	L-logo Sweatshort	Polyester, Cotton	Neon Orange
TN18SSO008RW	Pants	N Tiedye Sweatshort	Cotton	Rainbow
TN18SSW001BK	Sweatshirt	2T-Logo Crewneck	Cotton	Black
TN18SSW001GR	Sweatshirt	2T-Logo Crewneck	Cotton	Grey
TN18SSW001MD	Sweatshirt	2T-Logo Crewneck	Cotton	Mustard
TN18SSW001NA	Sweatshirt	2T-Logo Crewneck	Cotton	Navy
TN18SSW002BK	Sweatshirt	DSN-Logo Crewneck	Cotton	Black
TN18SSW002CM	Sweatshirt	DSN-Logo Crewneck	Cotton	Cream
TN18SSW002EA	Sweatshirt	DSN-Logo Crewneck	Polyester, Cotton	Neon Orange
TN18SSW002GR	Sweatshirt	DSN-Logo Crewneck	Cotton	Grey
TN18SSW003BK	Sweatshirt	CP-Logo Crewneck	Cotton	Black
TN18SSW003EI	Sweatshirt	CP-Logo Crewneck	Cotton	Lime
TN18SSW003IR	Sweatshirt	CP-Logo Crewneck	Cotton	Light grey
TN18SSW004BK	Sweatshirt	Rubber Logo Crewneck	Cotton	Black
TN18SSW004IR	Sweatshirt	Rubber Logo Crewneck	Cotton	Light grey
TN18SSW004OR	Sweatshirt	Rubber Logo Crewneck	Cotton	Orange
TN18SSW005BE	Sweatshirt	L-Logo Paneled Crewneck	Cotton	Beige
TN18SSW005NA	Sweatshirt	L-Logo Paneled Crewneck	Cotton	Navy
TN18SSW005YT	Sweatshirt	L-Logo Paneled Crewneck	Cotton	Coyote
TN18SSW006BK	Sweatshirt	RIB Logo Crewneck	Cotton	Black
TN18SSW006LV	Sweatshirt	RIB Logo Crewneck	Cotton	Lavender
TN18SSW006MD	Sweatshirt	RIB Logo Crewneck	Cotton	Mustard
TN18SSW007AE	Sweatshirt	Rose EMB. Crewneck	Cotton	Cream, Red
TN18SSW007MB	Sweatshirt	Rose EMB. Crewneck	Cotton	Mustard, Black
TN18SSW008BK	Sweatshirt	RFLT-Logo Tiedye Crewneck	Cotton	Black
TN18SSW008BL	Sweatshirt	RFLT-Logo Tiedye Crewneck	Cotton	Blue
TN18STS001BE	Long Sleeve Tee	SD-Logo L/SL Top	Cotton	Beige
TN18STS001BK	Long Sleeve Tee	SD-Logo L/SL Top	Cotton	Black
TN18STS001WH	Long Sleeve Tee	SD-Logo L/SL Top	Cotton	White
TN18STS002BK	Long Sleeve Tee	CA-Logo L/SL Top	Cotton	Black
TN18STS002EA	Long Sleeve Tee	CA-Logo L/SL Top	Polyester, Cotton	Neon Orange

TN18SHS008RW TN18SHS009IR TN18SHS002BK TN18SHS003MD TN18SHS006BK

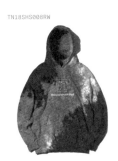 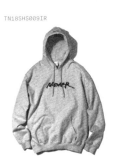 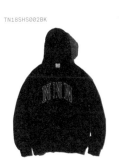

Code	Category	Name	Material(s)	Color(s)
TN18STS002IR	Long Sleeve Tee	CA-Logo L/SL Top	Cotton	Light Grey
TN18STS003BK	Long Sleeve Tee	WAVE-T L/SL Top	Cotton	Black
TN18STS003NA	Long Sleeve Tee	WAVE-T L/SL Top	Cotton	Navy
TN18STS003YT	Long Sleeve Tee	WAVE-T L/SL Top	Cotton	Coyote
TN18STS004BE	Long Sleeve Tee	CP INTL. L/SL Top	Cotton	Beige
TN18STS004BK	Long Sleeve Tee	CP INTL. L/SL Top	Cotton	Black
TN18STS004IR	Long Sleeve Tee	CP INTL. L/SL Top	Cotton	Light Grey
TN18STS004WH	Long Sleeve Tee	CP INTL. L/SL Top	Cotton	White
TN18STS005BK	Long Sleeve Tee	G-Building L/SL Top	Cotton	Black
TN18STS005LV	Long Sleeve Tee	G-Building L/SL Top	Cotton	Lavender
TN18STS005MD	Long Sleeve Tee	G-Building L/SL Top	Cotton	Mustard
TN18STS006BK	Long Sleeve Tee	HSP L/SL Top	Cotton	Black
TN18STS006IM	Long Sleeve Tee	HSP L/SL Top	Cotton	Lime
TN18STS006PK	Long Sleeve Tee	HSP L/SL Top	Cotton	Pink
TN18STS006WH	Long Sleeve Tee	HSP L/SL Top	Cotton	White
TN18STS007BK	Long Sleeve Tee	C-Logo L/SL Top	Cotton	Black
TN18STS007LV	Long Sleeve Tee	C-Logo L/SL Top	Cotton	Lavender
TN18STS007WH	Long Sleeve Tee	C-Logo L/SL Top	Cotton	White
TN18STS008BL	Long Sleeve Tee	Small DSN Logo Stripe L/SL Top	Cotton	Blue
TN18STS008BU	Long Sleeve Tee	Small DSN Logo Stripe L/SL Top	Cotton	Burgundy
TN18STS008GN	Long Sleeve Tee	Small DSN Logo Stripe L/SL Top	Cotton	Green
TN18STS009BL	Long Sleeve Tee	L-Logo Stripe L/SL Top	Cotton	Blue
TN18STS009LV	Long Sleeve Tee	L-Logo Stripe L/SL Top	Cotton	Lavender
TN18STS009NA	Long Sleeve Tee	L-Logo Stripe L/SL Top	Cotton	Navy
TN18STS010BK	Long Sleeve Tee	RFLT-Logo Tiedye L/SL Top	Cotton	Black
TN18STS010BL	Long Sleeve Tee	RFLT-Logo Tiedye L/SL Top	Cotton	Blue
TN18STS010LV	Long Sleeve Tee	RFLT-Logo Tiedye L/SL Top	Cotton	Lavender
TN18STS011RW	Long Sleeve Tee	NSP Tiedye L/SL Top	Cotton	Rainbow
TN18STS012LGB	Top	Motorcycle Hooded L/LS Top	Cotton	Light Grey, Black
TN18STS012LR	Top	Motorcycle Hooded L/LS Top	Cotton	Black, Grey
TN18STS013BK	Tee	Cracked T-Logo Tee	Cotton	Black
TN18STS013EA	Tee	Cracked T-Logo Tee	Polyester, Cotton	Neon Orange
TN18STS013IR	Tee	Cracked T-Logo Tee	Cotton	Light Grey
TN18STS013NA	Tee	Cracked T-Logo Tee	Cotton	Navy
TN18STS013WH	Tee	Cracked T-Logo Tee	Cotton	White
TN18STS014BK	Tee	Small T-Logo Tee	Cotton	Black
TN18STS014GN	Tee	Small T-Logo Tee	Cotton	Green
TN18STS014IR	Tee	Small T-Logo Tee	Cotton	Light Grey
TN18STS014MD	Tee	Small T-Logo Tee	Cotton	Mustard
TN18STS014WH	Tee	Small T-Logo Tee	Cotton	White
TN18STS015BE	Tee	L-Logo Tee	Cotton	Beige
TN18STS015BK	Tee	L-Logo Tee	Cotton	Black

TN18STS001BK TN18STS009NA TN18SSH011GN TN18SSW006LV TN18SSW002CM

Code	Category	Name	Material(s)	Color(s)

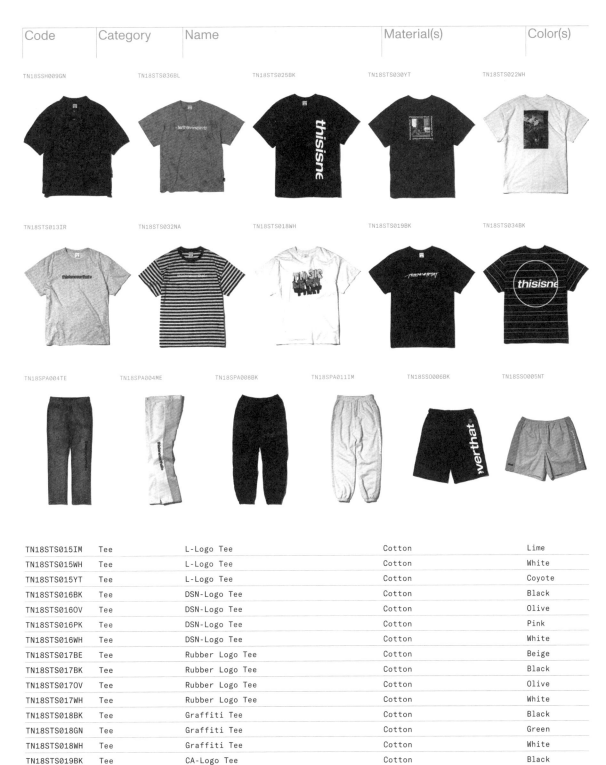

TN18SSH009GN TN18STS036BL TN18STS025BK TN18STS030YT TN18STS022WH

TN18STS013IR TN18STS032NA TN18STS018WH TN18STS019BK TN18STS034BK

TN18SPA004TE TN18SPA004ME TN18SPA008BK TN18SPA011IM TN18SSO006BK TN18SSO005NT

Code	Category	Name	Material(s)	Color(s)
TN18STS015IM	Tee	L-Logo Tee	Cotton	Lime
TN18STS015WH	Tee	L-Logo Tee	Cotton	White
TN18STS015YT	Tee	L-Logo Tee	Cotton	Coyote
TN18STS016BK	Tee	DSN-Logo Tee	Cotton	Black
TN18STS016OV	Tee	DSN-Logo Tee	Cotton	Olive
TN18STS016PK	Tee	DSN-Logo Tee	Cotton	Pink
TN18STS016WH	Tee	DSN-Logo Tee	Cotton	White
TN18STS017BE	Tee	Rubber Logo Tee	Cotton	Beige
TN18STS017BK	Tee	Rubber Logo Tee	Cotton	Black
TN18STS017OV	Tee	Rubber Logo Tee	Cotton	Olive
TN18STS017WH	Tee	Rubber Logo Tee	Cotton	White
TN18STS018BK	Tee	Graffiti Tee	Cotton	Black
TN18STS018GN	Tee	Graffiti Tee	Cotton	Green
TN18STS018WH	Tee	Graffiti Tee	Cotton	White
TN18STS019BK	Tee	CA-Logo Tee	Cotton	Black
TN18STS019FG	Tee	CA-Logo Tee	Cotton	Forest Green
TN18STS019WH	Tee	CA-Logo Tee	Cotton	White
TN18STS020BK	Tee	CP-Logo Tee	Cotton	Black
TN18STS020EA	Tee	CP-Logo Tee	Polyester, Cotton	Neon Orange
TN18STS020LV	Tee	CP-Logo Tee	Cotton	Lavender
TN18STS020WH	Tee	CP-Logo Tee	Cotton	White
TN18STS021BK	Tee	NEVER EMB. Tee	Cotton	Black
TN18STS021LV	Tee	NEVER EMB. Tee	Cotton	Lavender

Code	Category	Name	Material(s)	Color(s)
TN18STS021MD	Tee	NEVER EMB. Tee	Cotton	Mustard
TN18STS022BE	Tee	Flower Tee	Cotton	Beige
TN18STS022WH	Tee	Flower Tee	Cotton	White
TN18STS023IR	Tee	NSTAVH® Tee	Cotton	Light Grey
TN18STS023NA	Tee	NSTAVH® Tee	Cotton	Navy
TN18STS023WH	Tee	NSTAVH® Tee	Cotton	White
TN18STS024CM	Tee	Mosaic Logo Tee	Cotton	Cream
TN18STS024EA	Tee	Mosaic Logo Tee	Polyester, Cotton	Neon Orange
TN18STS024IM	Tee	Mosaic Logo Tee	Cotton	Lime
TN18STS025BK	Tee	HSP Tee	Cotton	Black
TN18STS025FG	Tee	HSP Tee	Cotton	Forest Green
TN18STS025WH	Tee	HSP Tee	Cotton	White
TN18STS025YT	Tee	HSP Tee	Cotton	Coyote
TN18STS026BK	Tee	DIA-SP Tee	Cotton	Black
TN18STS026LV	Tee	DIA-SP Tee	Cotton	Lavender
TN18STS026MD	Tee	DIA-SP Tee	Cotton	Mustard
TN18STS026OR	Tee	DIA-SP Tee	Polyester, Cotton	Neon Orange
TN18STS026WH	Tee	DIA-SP Tee	Cotton	White
TN18STS027BE	Tee	CP INTL. Tee	Cotton	Beige
TN18STS027BK	Tee	CP INTL. Tee	Cotton	Black
TN18STS027GN	Tee	CP INTL. Tee	Cotton	Green
TN18STS027WH	Tee	CP INTL. Tee	Cotton	White
TN18STS028BK	Tee	Motorcycle Tee	Cotton	Black
TN18STS028WH	Tee	Motorcycle Tee	Cotton	White
TN18STS029BK	Tee	Rose EMB. Tee	Cotton	Black
TN18STS029FG	Tee	Rose EMB. Tee	Cotton	Forest Green
TN18STS029LV	Tee	Rose EMB. Tee	Cotton	Lavender
TN18STS029WH	Tee	Rose EMB. Tee	Cotton	White
TN18STS030BK	Tee	Burning Car Tee	Cotton	Black
TN18STS030WH	Tee	Burning Car Tee	Cotton	White
TN18STS030YT	Tee	Burning Car Tee	Cotton	Coyote
TN18STS031BK	Tee	Small T-logo SPORT Tee	Cotton, Polyester	Black
TN18STS031LV	Tee	Small T-Logo SPORT Tee	Cotton, Polyester	Lavender
TN18STS031OV	Tee	Small T-Logo SPORT Tee	Cotton, Polyester	Olive
TN18STS031WH	Tee	Small T-logo SPORT Tee	Cotton, Polyester	White
TN18STS032BE	Tee	T-Logo Stripe Tee	Cotton	Beige
TN18STS032BK	Tee	T-Logo Stripe Tee	Cotton	Black
TN18STS032NA	Tee	T-Logo Stripe Tee	Cotton	Navy
TN18STS033BV	Tee	Small DSN-Logo Stripe Tee	Cotton	Blue, Navy
TN18STS033KR	Tee	Small DSN-Logo Stripe Tee	Cotton	Black, Green
TN18STS033VD	Tee	Small DSN-Logo Stripe Tee	Cotton	Navy, Burgundy
TN18STS034BK	Tee	C-Logo Stripe Tee	Cotton	Black
TN18STS034BL	Tee	C-Logo Stripe Tee	Cotton	Blue
TN18STS034GN	Tee	C-Logo Stripe Tee	Cotton	Green
TN18STS035LV	Tee	Rubber Logo Stripe Tee	Cotton	Lavender
TN18STS035OR	Tee	Rubber Logo Stripe Tee	Cotton	Orange
TN18STS036BK	Tee	RFLT-Logo Tiedye Tee	Cotton	Black
TN18STS036BL	Tee	RFLT-Logo Tiedye Tee	Cotton	Blue
TN183TS037GN	Tee	HSP Tiedye Tee	Cotton	Green
TN18STS037NA	Tee	HSP Tiedye Tee	Cotton	Navy
TN18STS038BK	Tee	Painting CP-Logo BIG Tee	Cotton	Black
TN18STS038EA	Tee	Painting CP-Logo BIG Tee	Polyester, Cotton	Neon Orange
TN18STS038IR	Tee	Painting CP-Logo BIG Tee	Cotton	Light Grey
TN18STS038MD	Tee	Painting CP-Logo BIG Tee	Cotton	Mustartd

Code	Category	Name	Material(s)	Color(s)

TW18SOW003BK TW18SOW002BK TW18SOW001GR TW18SSH001NA

TW18SHS002NA TW18SSH003BL TW18SHS003GN TW18SHS001IR TW18SDR004BB

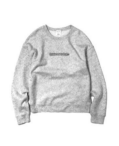 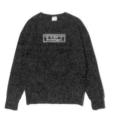 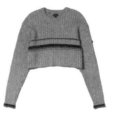 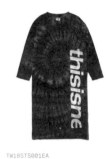

TW18SSW002IR TW18SSW001YT TW18SKW003LV TW18STS002BK TW18STS001EA

TW18SPA004IR TW18SPA003OV TW18SPA005GN TW18SPA006TB TW18SPA004BK

TW18SSK003IDG TW18SSK001BL TW18SSK004YT TW18SSK002BK TW18SSO002GN

Code	Category	Name	Material(s)	Color(s)
TN18STS038YT	Tee	Painting CP-Logo BIG Tee	Cotton	Coyote
TW18SDR001BK	Tee	Sleeveless Dress	Polyester, Spandex	Black
TW18SDR001BR	Tee	Sleeveless Dress	Polyester, Spandex	Brown
TW18SDR002BK	Tee	HSP-Logo L/S Dress	Cotton	Black
TW18SDR003BK	Tee	RIB Logo Dress	Cotton	Black
TW18SDR003CM	Tee	RIB Logo Dress	Cotton	Cream
TW18SDR004BB	Tee	HSP-Logo L/S Dress	Cotton	Blue, Black
TW18SDR004PY	Tee	HSP-Logo L/S Dress	Cotton	Pink, Yellow
TW18SHS001BK	Sweatshirt	PT-Logo Zip Hood	Cotton	Black
TW18SHS001CM	Sweatshirt	PT-Logo Zip Hood	Cotton	Cream
TW18SHS001IR	Sweatshirt	PT-Logo Zip Hood	Cotton	Light Grey
TW18SHS002BE	Sweatshirt	SD-Logo Flock Hood	Cotton	Beige
TW18SHS002NA	Sweatshirt	SD-Logo Flock Hood	Cotton	Navy
TW18SHS003BR	Sweatshirt	Velour Hood	Cotton, Polyester	Brown
TW18SHS003GN	Sweatshirt	Velour Hood	Cotton, Polyester	Green
TW18SHS003NA	Sweatshirt	Velour Hood	Cotton, Polyester	Navy
TW18SKW001BK	Top	Multi Color Striped Cardigan	Cotton	Black
TW18SKW001BL	Top	Multi Color Striped Cardigan	Cotton	Blue
TW18SKW002BL	Top	Oversized Striped Cardigan	Cotton	Blue
TW18SKW002IV	Top	Oversized Striped Cardigan	Cotton	Ivory
TW18SKW003BK	Top	Cropped Sweater	Cotton	Black

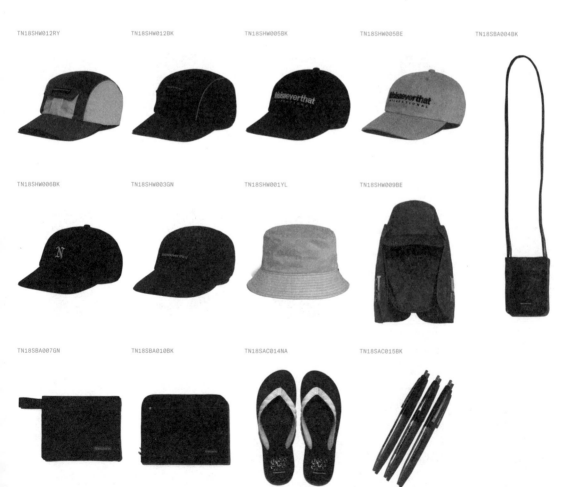

TN18SHW012RY TN18SHW012BK TN18SHW005BK TN18SHW005BE TN18SBA004BK

TN18SHW006BK TN18SHW003GN TN18SHW001YL TN18SHW009BE

TN18SBA007GN TN18SBA010BK TN18SAC014NA TN18SAC015BK

Code	Category	Name	Material(s)	Color(s)
TW18SKW003LV	Top	Cropped Sweater	Cotton	Lavender
TW18SOW001BK	Jacket	Oversized CT Jacket	Cotton	Black
TW18SOW001GR	Jacket	Oversized CT Jacket	Cotton	Grey
TW18SOW002BK	Jacket	Denim Trucker Jacket	Cotton	Black
TW18SOW002CM	Jacket	Denim Trucker Jacket	Cotton	Cream
TW18SOW002RD	Jacket	Denim Trucker Jacket	Cotton	Red
TW18SOW003BK	Jacket	Leather Jacket	Genuine Leather, Polyester	Black
TW18SPA001BK	Pants	Work Pant	Cotton	Black
TW18SPA001IV	Pants	Work Pant	Cotton	Ivory
TW18SPA002BK	Pants	Wide Chino Pant	Cotton	Black
TW18SPA002NT	Pants	Wide Chino Pant	Cotton	Natural
TW18SPA003NA	Pants	Check Pant	Cotton	Navy
TW18SPA003OV	Pants	Check Pant	Cotton	Olive
TW18SPA004BK	Pants	PT-Logo Lounge Pant	Cotton	Black
TW18SPA004CM	Pants	PT-Logo Lounge Pant	Cotton	Cream
TW18SPA004IR	Pants	PT-Logo Lounge Pant	Cotton	Light Grey
TW18SPA005BR	Pants	Velour Track Pant	Cotton, Polyester	Brown
TW18SPA005GN	Pants	Velour Track Pant	Cotton, Polyester	Green
TW18SPA005NA	Pants	Velour Track Pant	Cotton, Polyester	Navy
TW18SPA006BK	Jean	Classic Denim Pant	Cotton	Black
TW18SPA006TB	Jean	Classic Denim Pant	Cotton	Light Blue
TW18SSH001NA	Shirt	Flannel Shirt	Cotton	Navy
TW18SSH001OV	Shirt	Flannel Shirt	Cotton	Olive
TW18SSH002TB	Shirt	Denim Hooded Shirt	Cotton	Light Blue
TW18SSH003BL	Shirt	Check Hooded Shirt	Cotton	Blue
TW18SSH004GN	Top	Striped Rugby Shirt	Cotton	Green
TW18SSH004LV	Top	Striped Rugby Shirt	Cotton	Lavender
TW18SSK001BL	Skirt	Hooked Skirt	Polyester, Rayon, Polyurethane	Blue
TW18SSK001RD	Skirt	Hooked Skirt	Polyester, Rayon, Polyurethane	Red
TW18SSK002BK	Skirt	Leather Skirt	Polyester, Polyurethane	Black
TW18SSK002MD	Skirt	Leather Skirt	Polyester, Polyurethane	Mustard
TW18SSK003BK	Skirt	Long Denim Skirt	Cotton, Spandex	Black
TW18SSK003IDG	Skirt	Long Denim Skirt	Cotton, Spandex	Indigo
TW18SSK004BK	Skirt	Chino Skirt	Cotton	Black
TW18SSK004YT	Skirt	Chino Skirt	Cotton	Coyote
TW18SSO001BK	Jean	C-Denim Short	Cotton	Black
TW18SSO001CM	Jean	C-Denim Short	Cotton	Cream
TW18SSO001RD	Jean	C-Denim Short	Cotton	Red
TW18SSO002GN	Pants	Banded Short	Nylon	Green
TW18SSO002MD	Pants	Banded Short	Nylon	Mustard
TW18SSO002NA	Pants	Banded Short	Nylon	Navy
TW18SSW001BK	Sweatshirt	TINT Design Crew	Cotton	Black
TW18SSW001LV	Sweatshirt	TINT Design Crew	Cotton	Lavender
TW18SSW001YT	Sweatshirt	TINT Design Crew	Cotton	Coyote
TW18SSW002IM	Sweatshirt	BASIC T-Logo Crew	Cotton	Lime
TW18SSW002IR	Sweatshirt	BASIC T-Logo Crew	Cotton	Light Grey
TW18SSW002NA	Sweatshirt	BASIC T-Logo Crew	Cotton	Navy
TW18STS001BK	Long Sleeve Tee	CP-Logo L/S	Cotton	Black
TW18STS001EA	Long Sleeve Tee	CP-Logo L/S	Cotton, Polyester	Neon Orange
TW18STS001IR	Long Sleeve Tee	CP-Logo L/S	Cotton	Light Grey
TW18STS001MD	Long Sleeve Tee	CP-Logo L/S	Cotton	Mustard
TW18STS002BK	Long Sleeve Tee	Multi INTL.-Logo L/S	Cotton	Black
TW18STS002LV	Long Sleeve Tee	Multi INTL.-Logo L/S	Cotton	Lavender

Code	Category	Name	Material(s)	Color(s)
TW18STS002WH	Long Sleeve Tee	Multi INTL.-Logo L/S	Cotton	White
TW18STS003MD	Tee	Button Tee	Cotton	Mustard
TW18STS003NA	Tee	Button Tee	Cotton	Navy
TW18STS004BU	Tee	Striped Tee	Cotton	Burgundy
TW18STS004LV	Tee	Striped Tee	Cotton	Lavender
TW18STS004NA	Tee	Striped Tee	Cotton	Navy
TW18STS006BK	Tee	SL/SP-Logo Tee	Cotton	Black
TW18STS006GN	Tee	SL/SP-Logo Tee	Cotton	Green
TW18STS006RD	Tee	SL/SP-Logo Tee	Cotton	Red
TW18STS006WH	Tee	SL/SP-Logo Tee	Cotton	White
TW18STS007BK	Tee	C&P Tee	Cotton	Black
TW18STS007IR	Tee	C&P Tee	Cotton	Light Grey
TW18STS007LV	Tee	C&P Tee	Cotton	Lavender
TW18STS007WH	Tee	C&P Tee	Cotton	White
TW18STS008BK	Tee	SP-Logo S/L	Cotton	Black
TW18STS008CM	Tee	SP-Logo S/L	Cotton	Cream
TW18STS008MD	Tee	SP-Logo S/L	Cotton	Mustard
TW18STS009LV	Tee	Small T-Logo Tee	Cotton	Lavender
TW18STS009NA	Tee	Small T-Logo Tee	Cotton	Navy
TW18STS009WH	Tee	Small T-Logo Tee	Cotton	White

Code	Category	Name	Material(s)	Color(s)
RB17FAC001BK	Hat	CL THISNV Cap	Polyester	Black
RB17FAC002GR	Shoes	CL Leather This	Suede, Rubber	Grey
RB17FBT001KH	Pants	FL Track Pant	Polyester	Khaki
RB17FBT001NA	Pants	FL Track Pant	Polyester	Navy
RB17FOW001KH	Jacket	FL Track HD JKT	Polyester	Khaki
RB17FOW001NA	Jacket	FL Track HD JKT	Polyester	Navy
RB17FTO001BK	Tee	CL LS Tee	Cotton	Black
RB17FTO001WH	Tee	CL LS Tee	Cotton	White
TN17FAC001BK	Hat	T-Logo Camp Cap	Cotton	Black
TN17FAC001CA	Hat	T-Logo Camp Cap	Cotton	Camo
TN17FAC002BK	Hat	SP-Logo Camp Cap	Nylon	Black
TN17FAC002BL	Hat	SP-Logo Camp Cap	Nylon	Blue
TN17FAC002GN	Hat	SP-Logo Camp Cap	Nylon	Green
TN17FAC003BK	Hat	H-SP Logo Mesh Cap	Nylon, Polyester	Black
TN17FAC003KH	Hat	H-SP Logo Mesh Cap	Nylon, Polyester	Khaki
TN17FAC003NA	Hat	H-SP Logo Mesh Cap	Nylon, Polyester	Navy
TN17FAC003OR	Hat	H-SP Logo Mesh Cap	Nylon, Polyester	Orange
TN17FAC003PP	Hat	H-SP Logo Mesh Cap	Nylon, Polyester	Purple
TN17FAC004BK	Hat	Script TN Fleece Cap	Polyester	Black
TN17FAC004BL	Hat	Script TN Fleece Cap	Polyester	Blue
TN17FAC005BE	Hat	T-Logo 6P Cap	Cotton	Beige
TN17FAC005BK	Hat	T-Logo 6P Cap	Cotton	Black
TN17FAC006BE	Hat	C-Logo Baseball Cap	Cotton	Beige
TN17FAC006BK	Hat	C-Logo Baseball Cap	Cotton	Black
TN17FAC006OV	Hat	C-Logo Baseball Cap	Cotton	Olive
TN17FAC007BK	Hat	RA-P Logo Cap	Polyester	Black
TN17FAC007KH	Hat	RA-P Logo Cap	Polyester	Khaki
TN17FAC008BK	Hat	ARC-Logo Bucket Hat	Cotton	Black
TN17FAC008CH	Hat	ARC-Logo Bucket Hat	Cotton	Charcoal
TN17FAC008RD	Hat	ARC-Logo Bucket Hat	Cotton	Red
TN17FAC009BK	Hat	T-Logo Bucket Hat	Cotton	Black
TN17FAC010BK	Hat	Fleece Bucket Hat	Cotton	Black
TN17FAC011BK	Hat	Traveller Hat	Cotton	Black
TN17FAC012BK	Accessory	Fleece Headband	Polyester	Black
TN17FAC012BL	Accessory	Fleece Headband	Polyester	Blue
TN17FAC013BK	Hat	BOX-Logo Beanie	Acrylic	Black
TN17FAC013PP	Hat	BOX-Logo Beanie	Acrylic	Purple
TN17FAC014BW	Hat	ARC-Logo Beanie	Acrylic	Black, White
TN17FAC014DB	Hat	ARC-Logo Beanie	Acrylic	Black
TN17FAC014OR	Hat	ARC-Logo Beanie	Acrylic	Orange
TN17FAC015BK	Hat	SP-Logo Beanie	Acrylic	Black
TN17FAC015GN	Hat	SP-Logo Beanie	Acrylic	Green
TN17FAC015WS	Hat	SP-Logo Beanie	Acrylic	White Stripe
TN17FAC015YS	Hat	SP-Logo Beanie	Acrylic	Yellow Stripe
TN17FAC016BK	Hat	C-Logo Beanie	Acrylic	Black
TN17FAC016OR	Hat	C-Logo Beanie	Acrylic	Orange
TN17FAC016WH	Hat	C-Logo Beanie	Acrylic	White
TN17FAC017BK	Hat	Small SP-Logo Beanie	Cotton, Acrylic	Black
TN17FAC017GN	Hat	Small SP-Logo Beanie	Cotton, Acrylic	Green
TN17FAC018BE	Bag	Shoulder Bag	Nylon	Beige
TN17FAC018BK	Bag	Shoulder Bag	Nylon	Black
TN17FAC019BE	Bag	Small HIP Bag	Nylon	Beige
TN17FAC019BK	Bag	Small HIP Bag	Nylon	Black
TN17FAC020BE	Bag	BOP	Nylon	Beige
TN17FAC020BK	Bag	BOP	Nylon	Black

Code	Category	Name	Material(s)	Color(s)
TN17FAC021BE	Accessory	Wallet	Nylon	Beige
TN17FAC021BK	Accessory	Wallet	Nylon	Black
TN17FAC022BE	Accessory	Card Case	Nylon	Beige
TN17FAC022BK	Accessory	Card Case	Nylon	Black
TN17FAC023CA	Accessory	Army Pouch	Cotton	Camo
TN17FAC024BK	Accessory	Fleece Neck Warmer	Polyester	Black
TN17FAC024BL	Accessory	Fleece Neck Warmer	Polyester	Blue
TN17FAC025BK	Accessory	Fleece Scarf	Polyester	Black
TN17FAC025BL	Accessory	Fleece Scarf	Polyester	Blue
TN17FAC025CK	Accessory	Fleece Scarf	Polyester	Check
TN17FAC025NN	Accessory	Fleece Scarf	Polyester	Neon
TN17FAC026BK	Socks	Regular Socks	Cotton, Spandex, Polyester	Black
TN17FAC026BL	Socks	Regular Socks	Cotton, Spandex, Polyester	Blue
TN17FAC026WH	Socks	Regular Socks	Cotton, Spandex, Polyester	White
TN17FAC027BK	Socks	Ankle Socks	Cotton, Spandex, Polyester	Black
TN17FAC027BL	Socks	Ankle Socks	Cotton, Spandex, Polyester	Blue
TN17FAC027WH	Socks	Ankle Socks	Cotton, Spandex, Polyester	White
TN17FAC028BK	Accessory	Belt	Nylon	Black
TN17FAC028WH	Accessory	Belt	Nylon	White
TN17FAC029BK	Underwear	Boxer Briefs	Cotton	Black
TN17FAC029NN	Underwear	Boxer Briefs	Cotton	Neon
TN17FAC029OV	Underwear	Boxer Briefs	Cotton	Olive
TN17FAC030GR	Accessory	thisisneverthat® Wireless Earbuds by SUDIO®	-	Grey
TN17FAC031BK	Hat	NEVER-Logo Beanie	Acrylic	Black
TN17FAC031NN	Hat	NEVER-Logo Beanie	Acrylic	Neon
TN17FBT001BK	Pants	Work Pant	Cotton	Black
TN17FBT001CH	Pants	Work Pant	Cotton	Charcoal
TN17FBT001MT	Pants	Work Pant	Cotton	Multi
TN17FBT001OV	Pants	Work Pant	Cotton	Olive
TN17FBT002BK	Pants	TN Fleece Pant	Polyester	Black
TN17FBT002BL	Pants	TN Fleece Pant	Polyester	Blue
TN17FBT002CK	Pants	TN Fleece Pant	Polyester	Check
TN17FBT002NN	Pants	TN Fleece Pant	Polyester	Neon
TN17FBT003BK	Pants	INTL. Logo Sweatpant	Cotton	Black
TN17FBT003GR	Pants	INTL. Logo Sweatpant	Cotton	Grey
TN17FBT003IR	Pants	INTL. Logo Sweatpant	Cotton	Light Grey
TN17FBT004BG	Pants	T-Logo Tape Sweatpant	Cotton	Blue Green
TN17FBT004BK	Pants	T-Logo Tape Sweatpant	Cotton	Black
TN17FBT004GR	Pants	T-Logo Tape Sweatpant	Cotton	Grey
TN17FBT005BK	Pants	Stripe SP-Logo Sweatpant	Cotton	Black
TN17FBT005CH	Pants	Stripe SP-Logo Sweatpant	Cotton, Polyester	Charcoal
TN17FBT005PK	Pants	Stripe SP-Logo Sweatpant	Cotton	Pink
TN17FBT006BK	Jean	Denim Jean	Cotton	Black
TN17FBT006CZ	Jean	Denim Jean	Cotton	Crazy
TN17FBT006GR	Jean	Denim Jean	Cotton	Grey
TN17FBT006TB	Jean	Denim Jean	Cotton	Light Blue
TN17FBT007BK	Pants	Training Jogger Pant	Polyester	Black
TN17FBT007BL	Pants	Training Jogger Pant	Polyester	Blue
TN17FBT008BK	Pants	C-Logo Relaxed Pant	Cotton	Black
TN17FBT008NA	Pants	C-Logo Relaxed Pant	Cotton	Navy
TN17FBT009OV	Pants	ECILOP-P Pant	Cotton	Olive
TN17FBT009WH	Pants	ECILOP-P Pant	Cotton	White
TN17FBT010BK	Pants	Rep-Logo Training Pant	Nylon, Polyester	Black
TN17FBT010WH	Pants	Rep-Logo Training Pant	Nylon, Polyester	White

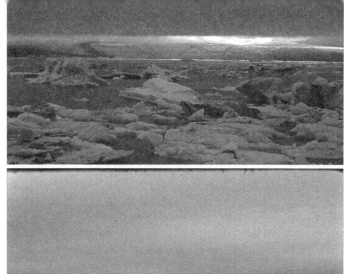

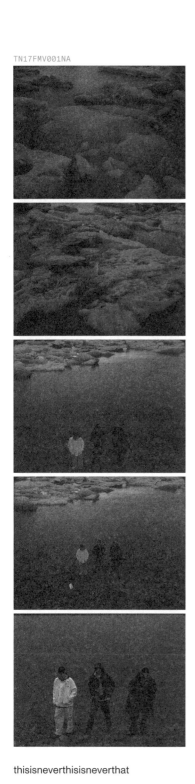

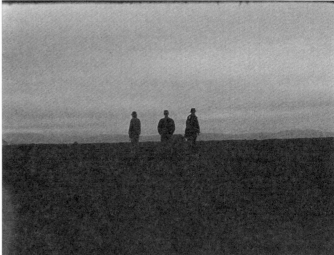

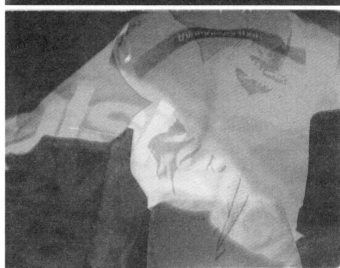

FALL / WINTER 2017 COLLECTION Special Guest

thisisneverthat®

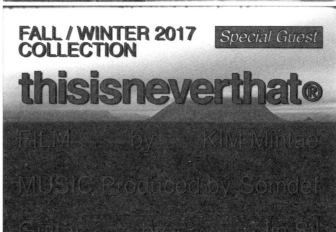

FILM by KIM Mintae

MUSIC Produced by Somdef

thisisneverthisisneverthat

Code	Category	Name	Material(s)	Color(s)
TN17FBT011BK	Pants	Zip Track Pant	Cotton, Nylon	Black
TN17FBT011NA	Pants	Zip Track Pant	Cotton, Nylon	Navy
TN17FBT011OV	Pants	Zip Track Pant	Cotton, Nylon	Olive
TN17FBT012GR	Skirt	Zip Skirt	Cotton	Grey
TN17FBT012TB	Skirt	Zip Skirt	Cotton	Light Blue
TN17FBT013CH	Skirt	Banded Skirt	Cotton	Charcoal
TN17FBT013NA	Skirt	Banded Skirt	Cotton	Navy
TN17FBT014BK	Skirt	Wrapped Mini Skirt	Wool, Nylon	Black
TN17FBT014CK	Skirt	Wrapped Mini Skirt	Cotton	Check
TN17FBT015BK	Skirt	STRETCH Cotton Skirt	Cotton, Spandex	Black
TN17FBT015WH	Skirt	STRETCH Cotton Skirt	Cotton, Spandex	White
TN17FBT016BK	Skirt	Corduroy Skirt	Cotton	Black
TN17FBT016RD	Skirt	Corduroy Skirt	Cotton	Red
TN17FBT017BK	Pants	High-Waist Work Pant	Cotton	Black
TN17FBT017WH	Pants	High-Waist Work Pant	Cotton	White
TN17FBT018TB	Jean	Wide Denim Pant	Cotton	Light Blue
TN17FMV001NA	Video	Reebok CLASSIC × thisisneverthat Vector COLLECTION	Film	-
TN17FMV002NA	Video	SPECIAL GUEST	Film	-
TN17FOW001BK	Jacket	SP-Logo Puffy Down Jacket	Nylon, Polyester, Down, Feather	Black
TN17FOW001GN	Jacket	SP-Logo Puffy Down Jacket	Nylon, Polyester, Down, Feather	Green
TN17FOW001SB	Jacket	SP-Logo Puffy Down Jacket	Nylon, Polyester, Down, Feather	Sky Blue
TN17FOW002BK	Jacket	Hooded Puffy Down Jacket	Polyester, Down, Feather	Black
TN17FOW002SB	Jacket	Hooded Puffy Down Jacket	Polyester, Down, Feather	Sky Blue
TN17FOW002YL	Jacket	Hooded Puffy Down Jacket	Polyester, Down, Feather	Yellow
TN17FOW003BK	Jacket	SP-Logo CITY Down Parka	Nylon, Polyester, Down, Feather	Black

TN17FOW006CH TN17FOW004CH TN17FOW014BK

TN17FOW017BK TN17FOW011BL TN17FOW011CK TN17FOW012BL

Code	Category	Name	Material(s)	Color(s)

TN17FTO022GR TN17FTO022CH TN17FTO022BG TN17FTO026BK TN17FTO026GR

TN17FTO026OV TN17FTO026GN TN17FTO031BK TN17FTO031GR TN17FTO032GN

Code	Category	Name	Material(s)	Color(s)
TN17FOW003SR	Jacket	SP-Logo CITY Down Parka	Nylon, Polyester, Down, Feather	Silver
TN17FOW004BK	Jacket	INTL. Logo Oversized Down Parka	Polyester, Nylon, Down, Feather	Black
TN17FOW004CH	Jacket	INTL. Logo Oversized Down Parka	Polyester, Nylon, Down, Feather	Charcoal
TN17FOW005BK	Jacket	S-Light Padded Jacket	Polyester, 3M Thinsulate	Black
TN17FOW005SB	Jacket	S-Light Padded Jacket	Polyester, 3M Thinsulate	Sky Blue
TN17FOW006BK	Jacket	Mountain Down Parka	Polyester, Nylon, Down, Feather, Raccoon Fur	Black
TN17FOW006CH	Jacket	Mountain Down Parka	Polyester, Nylon, Down, Feather, Raccoon Fur	Charcoal
TN17FOW006OV	Jacket	Mountain Down Parka	Polyester, Nylon, Down, Feather, Raccoon Fur	Olive
TN17FOW007BK	Jacket	MA-1 Jacket	Nylon, 3M Thinsulate	Black
TN17FOW007OV	Jacket	MA-1 Jacket	Nylon, 3M Thinsulate	Olive
TN17FOW008BK	Jacket	M-51 Field Parka	Cotton, Polyester, 3M Thinsulate	Black
TN17FOW008OV	Jacket	M-51 Field Parka	Cotton, Polyester, 3M Thinsulate	Olive
TN17FOW009BK	Jacket	Taped Seam Jacket	Nylon	Black
TN17FOW009BL	Jacket	Taped Seam Jacket	Nylon	Blue
TN17FOW009GN	Jacket	Taped Seam Jacket	Nylon	Green
TN17FOW010BK	Jacket	R-Logo Fleece Reversible Jacket	Polyester	Black
TN17FOW010BR	Jacket	R-Logo Fleece Reversible Jacket	Polyester	Brown
TN17FOW010IV	Jacket	R-Logo Fleece Reversible Jacket	Polyester	Ivory
TN17FOW011BK	Jacket	Fleece Zip Jacket	Polyester	Black
TN17FOW011BL	Jacket	Fleece Zip Jacket	Polyester	Blue
TN17FOW011CK	Jacket	Fleece Zip Jacket	Polyester	Check
TN17FOW011NN	Jacket	Fleece Zip Jacket	Polyester	Neon
TN17FOW012BK	Jacket	Windbreaker Jacket	Polyester	Black
TN17FOW012BL	Jacket	Windbreaker Jacket	Polyester	Blue

Code	Category	Name	Material(s)	Color(s)

TN17FTO010BL	TN17FTO010GN	TN17FTO007PP	TN17FTO007YL	TN17FTO014EI

 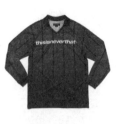 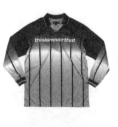 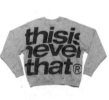

TN17FTO012BK	TN17FTO001NA	TN17FTO005EP	TN17FTO017YB	TN17FTO015BK

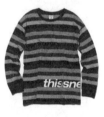 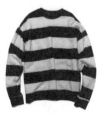 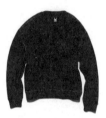

TN17FOW013BK	Jacket	Shop Coat	Cotton	Black
TN17FOW013CA	Jacket	Shop Coat	Cotton	Camo
TN17FOW014BK	Jacket	Wool Overcoat	Wool, Nylon	Black
TN17FOW015BL	Shirt	Flannel Sherpa Shirt	Cotton	Blue
TN17FOW015NN	Shirt	Flannel Sherpa Shirt	Cotton	Neon
TN17FOW016BK	Jacket	C-Logo Trucker Jacket	Cotton	Black
TN17FOW016NA	Jacket	C-Logo Trucker Jacket	Cotton	Navy
TN17FOW017BK	Jacket	Leather MA-1 (Solid)	Genuine Leather, Polyester	Black
TN17FOW018BK	Jacket	Leather MA-1 (Suede)	Genuine Leather, Polyester	Black
TN17FOW019NA	Jacket	TINT Quilted Parka	Nylon, Cotton, Polyester	Navy
TN17FOW019OV	Jacket	TINT Quilted Parka	Nylon, Cotton, Polyester	Olive
TN17FOW020BK	Jacket	Oversized Fleece Coat	Polyester, Acrylic	Black
TN17FOW020IV	Jacket	Oversized Fleece Coat	Polyester, Acrylic	Ivory
TN17FOW021BK	Jacket	Oversized Twill Jacket	Cotton	Black
TN17FOW021OV	Jacket	Oversized Twill Jacket	Cotton	Olive
TN17FOW022GR	Jacket	Denim Zip-up Jacket	Cotton	Grey
TN17FOW022TB	Jacket	Denim Zip-up Jacket	Cotton	Light Blue
TN17FOW023BK	Jacket	TSN Coach Jacket	Nylon	Black
TN17FOW023OV	Jacket	TSN Coach Jacket	Nylon	Olive
TN17FOW024BK	Jacket	Button-up Jacket dress	Cotton	Black
TN17FOW024CA	Jacket	Button-up Jacket dress	Cotton	Camo
TN17FTO001NA	Tee	TVES L/S Tee	Cotton	Navy
TN17FTO001OV	Tee	TVES L/S Tee	Cotton	Olive
TN17FTO002BK	Long Sleeve Tee	Stripe SP-Logo L/S Tee	Cotton	Black
TN17FTO002MI	Long Sleeve Tee	Stripe SP-Logo L/S Tee	Cotton	Mint
TN17FTO002NN	Long Sleeve Tee	Stripe SP-Logo L/S Tee	Cotton	Neon
TN17FTO002WH	Long Sleeve Tee	Stripe SP-Logo L/S Tee	Cotton	White
TN17FTO003BK	Long Sleeve Tee	C-Logo L/S Tee	Cotton	Black
TN17FTO003OV	Long Sleeve Tee	C-Logo L/S Tee	Cotton	Olive
TN17FTO003PK	Long Sleeve Tee	C-Logo L/S Tee	Cotton	Pink
TN17FTO003WH	Long Sleeve Tee	C-Logo L/S Tee	Cotton	White
TN17FTO004LN	Long Sleeve Tee	Multi Stripe HT-Logo L/S Tee	Cotton	Lime, Navy
TN17FTO004RE	Long Sleeve Tee	Multi Stripe HT-Logo L/S Tee	Cotton	Green, Yellow

Code	Category	Name	Material(s)	Color(s)
TN17FT0004RN	Long Sleeve Tee	Multi Stripe HT-Logo L/S Tee	Cotton	Red, Navy
TN17FT0005EP	Long Sleeve Tee	Multi Stripe H-SP-Logo L/S Tee	Cotton	Lime, Purple
TN17FT0005PG	Long Sleeve Tee	Multi Stripe H-SP-Logo L/S Tee	Cotton	Pink, Green
TN17FT0006BK	Long Sleeve Tee	Layered L/S Tee	Cotton	Black
TN17FT0006NN	Long Sleeve Tee	Layered L/S Tee	Cotton	Neon
TN17FT0007PP	Top	FB Team Shirt	Polyester	Purple
TN17FT0007YL	Top	FB Team Shirt	Polyester	Yellow
TN17FT0008PP	Long Sleeve Tee	FB Team L/S Tee	Polyester	Purple
TN17FT0008YL	Long Sleeve Tee	FB Team L/S Tee	Polyester	Yellow
TN17FT0009BK	Top	SP-Logo Polo Shirt	Cotton	Black
TN17FT0009GN	Top	SP-Logo Polo Shirt	Cotton	Green
TN17FT0010BL	Shirt	Hombre Check Shirt	Cotton	Blue
TN17FT0010GN	Shirt	Hombre Check Shirt	Cotton	Green
TN17FT0011BL	Shirt	Oversized Tartan Shirt	Cotton	Blue
TN17FT0011OR	Shirt	Oversized Tartan Shirt	Cotton	Orange
TN17FT0012BK	Sweatshirt	Stripe SP-Logo Crewneck	Cotton	Black
TN17FT0012CH	Sweatshirt	Stripe SP-Logo Crewneck	Cotton, Polyester	Charcoal
TN17FT0012PK	Sweatshirt	Stripe SP-Logo Crewneck	Cotton	Pink
TN17FT0013BK	Sweatshirt	ARC-Logo Crewneck	Cotton	Black
TN17FT0013CH	Sweatshirt	ARC-Logo Crewneck	Cotton, Polyester	Charcoal
TN17FT0013RD	Sweatshirt	ARC-Logo Crewneck	Cotton	Red
TN17FT0014BK	Sweatshirt	3 LINES Logo Crewneck	Cotton	Black
TN17FT0014CA	Sweatshirt	3 LINES Logo Crewneck	Cotton	Camo
TN17FT0014EI	Sweatshirt	3 LINES Logo Crewneck	Cotton	Neon Lime
TN17FT0014GR	Sweatshirt	3 LINES Logo Crewneck	Cotton	Grey
TN17FT0015BK	Sweatshirt	T-Logo Tape Crewneck	Cotton	Black
TN17FT0015BL	Sweatshirt	T-Logo Tape Crewneck	Cotton	Blue
TN17FT0015OV	Sweatshirt	T-Logo Tape Crewneck	Cotton	Olive
TN17FT0016BK	Sweatshirt	INTL. Logo Crewneck	Cotton	Black
TN17FT0016CH	Sweatshirt	INTL. Logo Crewneck	Cotton, Polyester	Charcoal
TN17FT0016WH	Sweatshirt	INTL. Logo Crewneck	Cotton	White
TN17FT0017BB	Sweatshirt	Striped Crewneck	Cotton	Blue, Black

TN17FBT002BL

TN17FBT002NN

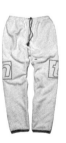

TN17FBT005CH

TN17FBT003IR

TN17FBT007BL

TN17FBT009OV

TN17FBT011BK

TN17FBT001MT

TN17FBT008BK

TN17FBT006CZ

Code	Category	Name	Material(s)	Color(s)
TN17FTO0017NG	Sweatshirt	Striped Crewneck	Cotton	Navy, Green
TN17FTO0017YB	Sweatshirt	Striped Crewneck	Cotton	Yellow, Black
TN17FTO0018BG	Sweatshirt	NEVER EMB. Crewneck	Cotton	Blue Green
TN17FTO0018BK	Sweatshirt	NEVER EMB. Crewneck	Cotton	Black
TN17FTO0018GR	Sweatshirt	NEVER EMB. Crewneck	Cotton	Grey
TN17FTO0019BK	Sweatshirt	T-Logo S-Collar Sweatshirt	Cotton	Black
TN17FTO0019CH	Sweatshirt	T-Logo S-Collar Sweatshirt	Cotton	Charcoal
TN17FTO0019NN	Sweatshirt	T-Logo S-Collar Sweatshirt	Cotton	Neon
TN17FTO0020BK	Sweatshirt	Embroidery BOX Logo Hooded Sweatshirt	Cotton	Black
TN17FTO0020GR	Sweatshirt	Embroidery BOX Logo Hooded Sweatshirt	Cotton	Grey
TN17FTO0021BK	Sweatshirt	Reflective Partition Logo Hooded Sweatshirt	Cotton	Black
TN17FTO0021GR	Sweatshirt	Reflective Partition Logo Hooded Sweatshirt	Cotton	Grey
TN17FTO0021NN	Sweatshirt	Reflective Partition Logo Hooded Sweatshirt	Cotton	Neon
TN17FTO0022BG	Sweatshirt	Hood Logo Hooded Sweatshirt	Cotton	Blue Green
TN17FTO0022BK	Sweatshirt	Hood Logo Hooded Sweatshirt	Cotton	Black
TN17FTO0022CH	Sweatshirt	Hood Logo Hooded Sweatshirt	Cotton	Charcoal
TN17FTO0022GR	Sweatshirt	Hood Logo Hooded Sweatshirt	Cotton	Grey
TN17FTO0023BK	Sweatshirt	Mosaic 250 Hooded Sweatshirt	Cotton	Black
TN17FTO0023BL	Sweatshirt	Mosaic 250 Hooded Sweatshirt	Cotton	Blue
TN17FTO0024BK	Sweatshirt	Square SP Logo Hooded Sweatshirt	Cotton	Black
TN17FTO0024GR	Sweatshirt	Square SP Logo Hooded Sweatshirt	Cotton	Grey
TN17FTO0024OV	Sweatshirt	Square SP Logo Hooded Sweatshirt	Cotton	Olive
TN17FTO0025BK	Sweatshirt	sfdf C-Logo Hooded Sweatshirt	Cotton	Black
TN17FTO0025GR	Sweatshirt	sfdf C-Logo Hooded Sweatshirt	Cotton	Grey
TN17FTO0026BK	Sweatshirt	Stripe SP-Logo Hooded Sweatshirt	Cotton	Black
TN17FTO0026GN	Sweatshirt	Stripe SP-Logo Hooded Sweatshirt	Cotton	Green
TN17FTO0026GR	Sweatshirt	Stripe SP-Logo Hooded Sweatshirt	Cotton	Grey
TN17FTO0026OV	Sweatshirt	Stripe SP-Logo Hooded Sweatshirt	Cotton	Olive
TN17FTO0027BK	Sweatshirt	Reflective BOX Logo Hooded Sweatshirt	Cotton	Black
TN17FTO0027CH	Sweatshirt	Reflective BOX Logo Hooded Sweatshirt	Cotton	Charcoal
TN17FTO0028BK	Sweatshirt	RA-P Logo Hooded Sweatshirt	Cotton	Black
TN17FTO0028OV	Sweatshirt	RA-P Logo Hooded Sweatshirt	Cotton	Olive
TN17FTO0028PK	Sweatshirt	RA-P Logo Hooded Sweatshirt	Cotton	Pink
TN17FTO0029BK	Sweatshirt	HT-Logo Hooded Sweatshirt	Cotton	Black
TN17FTO0029CA	Sweatshirt	HT-Logo Hooded Sweatshirt	Cotton	Camo
TN17FTO0029CH	Sweatshirt	HT-Logo Hooded Sweatshirt	Cotton	Charcoal
TN17FTO0029EI	Sweatshirt	HT-Logo Hooded Sweatshirt	Cotton	Neon Lime
TN17FTO0029GR	Sweatshirt	HT-Logo Hooded Sweatshirt	Cotton	Grey
TN17FTO0030GR	Sweatshirt	ECILOP-P Hooded Sweatshirt	Cotton	Grey
TN17FTO0030OV	Sweatshirt	ECILOP-P Hooded Sweatshirt	Cotton	Olive
TN17FTO0031BG	Sweatshirt	INTL. Logo Zip-up Sweat	Cotton	Blue Green
TN17FTO0031BK	Sweatshirt	INTL. Logo Zip-up Sweat	Cotton	Black
TN17FTO0031GR	Sweatshirt	INTL. Logo Zip-up Sweat	Cotton	Grey
TN17FTO0032BK	Sweatshirt	REV-T-Logo Hooded Sweatshirt	Cotton	Black
TN17FTO0032GN	Sweatshirt	REV-T-Logo Hooded Sweatshirt	Cotton	Green
TN17FTO0032GR	Sweatshirt	REV-T-Logo Hooded Sweatshirt	Cotton	Grey
TN17FTO0033BK	Sweatshirt	H-SP-Logo Hooded Sweatshirt	Cotton	Black
TN17FTO0033GR	Sweatshirt	H-SP-Logo Hooded Sweatshirt	Cotton	Grey
TN17FTO0034BK	Sweatshirt	Facet T-Logo Hooded Sweatshirt	Cotton	Black
TN17FTO0034CH	Sweatshirt	Facet T-Logo Hooded Sweatshirt	Cotton	Charcoal
TN17FTO0035BK	Sweatshirt	Script TN Crewneck	Cotton	Black
TN17FTO0035CH	Sweatshirt	Script TN Crewneck	Cotton, Polyester	Charcoal

Code	Category	Name	Material(s)	Color(s)

TN17FOW020IV TN17FOW024CA TN17FOW021BK TN17FAC024BL TN17FAC024BK

TN17FTO036BL TN17FTO038EI TN17FTO041CK TN17FOW019NA TN17FTO035BK

TN17FBT018TB TN17FBT014BK TN17FBT014CK TN17FBT013NA TN17FBT016RD

Code	Category	Name	Material(s)	Color(s)
TN17FTO035RD	Sweatshirt	Script TN Crewneck	Cotton	Red
TN17FTO036BK	Sweatshirt	H-SP-Logo Cropped Hoodie	Cotton	Black
TN17FTO036BL	Sweatshirt	H-SP-Logo Cropped Hoodie	Cotton	Blue
TN17FTO036GR	Sweatshirt	H-SP-Logo Cropped Hoodie	Cotton	Grey
TN17FTO037BK	Sweatshirt	INTL. Logo Hoodie	Cotton	Black
TN17FTO037GN	Sweatshirt	INTL. Logo Hoodie	Cotton	Green
TN17FTO037GR	Sweatshirt	INTL. Logo Hoodie	Cotton	Grey
TN17FTO038EI	Sweatshirt	tnashe® Hoodie	Cotton	Neon Lime
TN17FTO038GR	Sweatshirt	tnashe® Hoodie	Cotton	Grey
TN17FTO038OV	Sweatshirt	tnashe® Hoodie	Cotton	Olive
TN17FTO039BK	Long Sleeve Tee	T-Logo Cropped L/S Tee	Cotton	Black
TN17FTO039CH	Long Sleeve Tee	T-Logo Cropped L/S Tee	Cotton	Charcoal
TN17FTO039PK	Long Sleeve Tee	T-Logo Cropped L/S Tee	Cotton	Pink
TN17FTO039WH	Long Sleeve Tee	T-Logo Cropped L/S Tee	Cotton	White
TN17FTO040BK	Long Sleeve Tee	Turtleneck Cropped L/S Tee	Cotton, Spandex	Black
TN17FTO040WH	Long Sleeve Tee	Turtleneck Cropped L/S Tee	Cotton, Spandex	White
TN17FTO041BK	Shirt	Flannel Shirt	Wool, Nylon	Black
TN17FTO041CK	Shirt	Flannel Shirt	Cotton	Check
TN17FTO042BK	Long Sleeve Tee	INTL. Logo Turtleneck L/S Dress	Cotton, Spandex	Black
TN17FTO042CH	Long Sleeve Tee	INTL. Logo Turtleneck L/S Dress	Cotton, Spandex	Charcoal
TN17FTO042WH	Long Sleeve Tee	INTL. Logo Turtleneck L/S Dress	Cotton, Spandex	White

Code	Category	Name	Material(s)	Color(s)
TN17FTO044BG	Sweatshirt	Embroidery BOX Logo Crewneck	Cotton	Blue Green
TN17FTO044BK	Sweatshirt	Embroidery BOX Logo Crewneck	Cotton	Black
TN17FTO044GR	Sweatshirt	Embroidery BOX Logo Crewneck	Cotton	Grey

TN17FAC001BK

TN17FAC002BL

TN17FAC006BK

TN17FAC007BK

TN17FAC008BK

TN17FAC016OR

TN17FAC015BK

TN17FAC016BK

TN17FAC030GR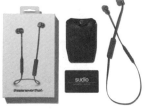

TN17FAC021BE

TN17FAC022BK

TN17FAC019BE

TN17FAC029BK

TN17FAC027BK

TN17FAC026WH

Code	Category	Name	Material(s)	Color(s)
JS17SAC001BK	Bag	thisisneverthat® × JANSPORT Right Pack	Polyester, Suede	Black
SP17SAC001BE	Shoes	thisisneverthat® × SUPERGA® 2750	Suede, Rubber	Beige
SP17SAC001NA	Shoes	thisisneverthat® × SUPERGA® 2750	Suede, Rubber	Navy
ST17SAC001BK	Hat	TINT® × STARTER® Ball Cap	Cotton	Black
ST17SAC002BK	Hat	TINT® × STARTER® 5P Cap	Acrylic, Wool	Black
ST17SAC002PP	Hat	TINT® × STARTER® 5P Cap	Acrylic, Wool	Purple
ST17SBT001BK	Pants	TINT® × STARTER® Track Pant	Nylon, Polyester	Black
ST17SOW001BK	Jacket	TINT® × STARTER® Training JK	Nylon, Polyester	Black
ST17STO001BK	Sweatshirt	TINT® × STARTER® Hooded Sweatshirt	Cotton	Black
ST17STO001GR	Sweatshirt	TINT® × STARTER® Hooded Sweatshirt	Cotton	Grey
ST17STO002BK	Tee	TINT® × STARTER® NEVER Tee	Cotton	Black
ST17STO002PP	Tee	TINT® × STARTER® NEVER Tee	Cotton	Purple
ST17STO002WH	Tee	TINT® × STARTER® NEVER Tee	Cotton	White
TM17SAC001BK	Accessory	TINT® × TIMEX® Original CAMPER	Acrylic, Nylon	Black
TM17SAC001OV	Accessory	TINT® × TIMEX® Original CAMPER	Acrylic, Nylon	Olive
TN17SAC001BK	Bag	RS-Flat Pouch	Nylon	Black
TN17SAC001BL	Bag	RS-Flat Pouch	Nylon	Blue
TN17SAC001OR	Bag	RS-Flat Pouch	Nylon	Orange
TN17SAC002BK	Bag	RS-Box Pouch	Nylon	Black
TN17SAC002BL	Bag	RS-Box Pouch	Nylon	Blue
TN17SAC002OR	Bag	RS-Box Pouch	Nylon	Orange
TN17SAC003BK	Bag	RS-Shoulder Bag	Nylon	Black
TN17SAC003BL	Bag	RS-Shoulder Bag	Nylon	Blue
TN17SAC003OR	Bag	RS-Shoulder Bag	Nylon	Orange
TN17SAC004BK	Bag	RS-Daypack	Nylon	Black
TN17SAC004BL	Bag	RS-Daypack	Nylon	Blue
TN17SAC004OR	Bag	RS-Daypack	Nylon	Orange
TN17SAC005BK	Bag	RS-Card Case	Nylon	Black
TN17SAC005BL	Bag	RS-Card Case	Nylon	Blue
TN17SAC005OR	Bag	RS-Card Case	Nylon	Orange
TN17SAC006BK	Bag	RS-BOP	Nylon	Black
TN17SAC006BL	Bag	RS-BOP	Nylon	Blue
TN17SAC006OR	Bag	RS-BOP	Nylon	Orange
TN17SAC007BE	Hat	T-Logo Camp Cap	Cotton, Nylon	Beige
TN17SAC007BK	Hat	T-Logo Camp Cap	Cotton, Nylon	Black
TN17SAC007NA	Hat	T-Logo Camp Cap	Cotton, Nylon	Navy
TN17SAC007RD	Hat	T-Logo Camp Cap	Cotton, Nylon	Red
TN17SAC007WH	Hat	T-Logo Camp Cap	Cotton, Nylon	White
TN17SAC008BK	Hat	Rubber Logo Camp Cap	Nylon	Black
TN17SAC008GR	Hat	Rubber Logo Camp Cap	Nylon	Grey
TN17SAC008NA	Hat	Rubber Logo Camp Cap	Nylon	Navy
TN17SAC008PP	Hat	Rubber Logo Camp Cap	Nylon	Purple
TN17SAC008YL	Hat	Rubber Logo Camp Cap	Nylon	Yellow
TN17SAC009BL	Hat	RS Camp Cap	Nylon	Blue
TN17SAC009GR	Hat	RS Camp Cap	Nylon	Grey
TN17SAC009NA	Hat	RS Camp Cap	Nylon	Navy
TN17SAC009WH	Hat	RS Camp Cap	Nylon	White
TN17SAC010BE	Hat	T-Logo 6P Cap	Cotton	Beige
TN17SAC010BK	Hat	T-Logo 6P Cap	Cotton	Black
TN17SAC010BL	Hat	T-Logo 6P Cap	Cotton	Blue
TN17SAC010NA	Hat	T-Logo 6P Cap	Cotton	Navy
TN17SAC010PK	Hat	T-Logo 6P Cap	Cotton	Pink
TN17SAC010SB	Hat	T-Logo 6P Cap	Cotton	Sky Blue
TN17SAC011IA	Hat	Checkerboard 6P Cap	Cotton	White, Black
TN17SAC011IU	Hat	Checkerboard 6P Cap	Cotton	White, Blue

Code	Category	Name	Material(s)	Color(s)
TN17SAC012BE	Hat	SP-Logo Cap	Polyester	Beige
TN17SAC012BK	Hat	SP-Logo Cap	Polyester	Black
TN17SAC012CA	Hat	SP-Logo Cap	Polyester	Camo
TN17SAC013BK	Hat	SP-Logo Bucket Hat	Polyester	Black
TN17SAC013CA	Hat	SP-Logo Bucket Hat	Polyester	Camo
TN17SAC014BK	Hat	Rep-Logo Bucket Hat	Cotton	Black
TN17SAC014WH	Hat	Rep-Logo Bucket Hat	Cotton	White
TN17SAC015IA	Hat	Checkerboard Bucket hat	Cotton	White, Black
TN17SAC015IU	Hat	Checkerboard Bucket hat	Cotton	White, Blue
TN17SAC016BK	Hat	T.I.N.T Trucker Cap	Polyester, Nylon	Black
TN17SAC016SB	Hat	T.I.N.T Trucker Cap	Polyester, Nylon	Sky Blue
TN17SAC016WH	Hat	T.I.N.T Trucker Cap	Polyester, Nylon	White
TN17SAC017BK	Hat	Rubber Logo Beanie	Cotton	Black
TN17SAC017NN	Hat	Rubber Logo Beanie	Cotton	Neon
TN17SAC017PK	Hat	Rubber Logo Beanie	Cotton	Pink
TN17SAC017SB	Hat	Rubber Logo Beanie	Cotton	Sky Blue
TN17SAC018GN	Hat	Small Logo Beanie	Cotton, Rayon, Linen	Green
TN17SAC018PP	Hat	Small Logo Beanie	Cotton, Rayon, Linen	Purple
TN17SAC019BK	Bag	Card Holder	Leather	Black
TN17SAC019BL	Bag	Card Holder	Leather	Blue
TN17SAC019GN	Bag	Card Holder	Leather	Green
TN17SAC019NN	Bag	Card Holder	Leather	Neon
TN17SAC019PK	Bag	Card Holder	Leather	Pink
TN17SAC019WH	Bag	Card Holder	Leather	White
TN17SAC020BK	Socks	Regular Socks	Cotton, Spandex	Black
TN17SAC020NN	Socks	Regular Socks	Polyester, Spandex	Neon
TN17SAC020WH	Socks	Regular Socks	Cotton, Spandex	White
TN17SAC021BK	Socks	Ankle Socks	Cotton, Spandex	Black
TN17SAC021NN	Socks	Ankle Socks	Polyester, Spandex	Neon
TN17SAC021WH	Socks	Ankle Socks	Cotton, Spandex	White
TN17SAC022BK	Socks	Slip on Socks	Cotton, Spandex	Black
TN17SAC022WH	Socks	Slip on Socks	Cotton, Spandex	White
TN17SAC023EV	Accessory	SP-Logo iPhone Case	TPU	For 7
TN17SAC023SX	Accessory	SP-Logo iPhone Case	TPU	For 6
TN17SAC024EV	Accessory	Cheese Burger iPhone Case	TPU	For 7
TN17SAC024SX	Accessory	Cheese Burger iPhone Case	TPU	For 6
TN17SAC025EV	Accessory	T.I.N.T iPhone Case	TPU	For 7
TN17SAC025SX	Accessory	T.I.N.T iPhone Case	TPU	For 6
TN17SAC026EV	Accessory	P-1 Logo iPhone Case	TPU	For 7
TN17SAC026SX	Accessory	P-1 Logo iPhone Case	TPU	For 6
TN17SAC027BL	Accessory	Hotel Key Tag	Plastic	Blue
TN17SAC027GN	Accessory	Hotel Key Tag	Plastic	Green
TN17SAC027OR	Accessory	Hotel Key Tag	Plastic	Orange

TN17STO026BK TN17STO023PP TN17STO023SB TN17STO025NA TN17STO003GR

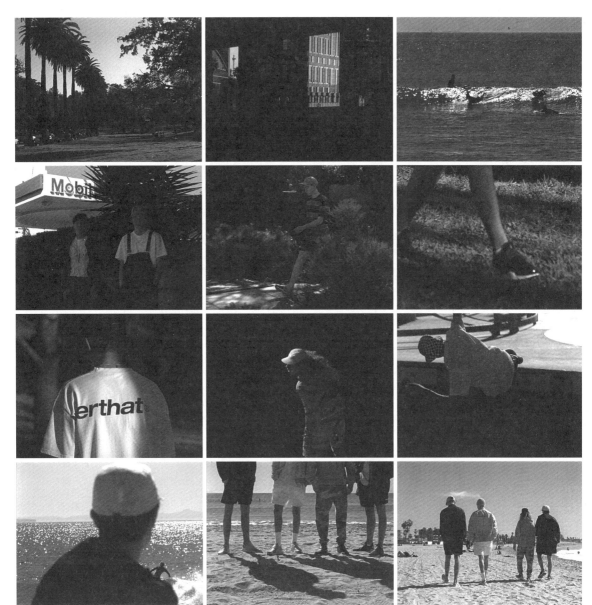

TN17SMV001NA

Code	Category	Name	Material(s)	Color(s)
TN17SAC027PK	Accessory	Hotel Key Tag	Plastic	Pink
TN17SAC027RD	Accessory	Hotel Key Tag	Plastic	Red
TN17SAC027YL	Accessory	Hotel Key Tag	Plastic	Yellow
TN17SAC028SR	Accessory	SP-Logo Pin	Brass	Silver
TN17SAC029GD	Accessory	TINT ARC Pin	Brass	Gold
TN17SAC030BK	Accessory	P-1 Logo Pin	Brass	Black
TN17SAC031WH	Accessory	DIA-Logo Pin	Brass	White
TN17SAC032CA	Accessory	Air Bed	Polyester	Camo
TN17SAC032NA	Accessory	Air Bed	Polyester	Navy
TN17SAC034PP	Accessory	BIC® Ballpen	Plastic	Purple
TN17SAC035SR	Accessory	Necklace	Silver	Silver
TN17SBT001BE	Pants	Work Pant	Cotton	Beige
TN17SBT001BK	Pants	Work Pant	Cotton	Black
TN17SBT001BU	Pants	Work Pant	Cotton	Burgundy
TN17SBT002BE	Pants	Work Short	Cotton	Beige
TN17SBT002BK	Pants	Work Short	Cotton	Black
TN17SBT002BU	Pants	Work Short	Cotton	Burgundy
TN17SBT002NA	Pants	Work Short	Cotton	Navy
TN17SBT003BL	Jean	Washed Regular Jean	Cotton	Blue
TN17SBT003TB	Jean	Washed Regular Jean	Cotton	Light Blue
TN17SBT004BK	Pants	Rep-Logo Relaxed Pant	Cotton	Black
TN17SBT004BL	Pants	Rep-Logo Relaxed Pant	Cotton	Blue
TN17SBT004BR	Pants	Rep-Logo Relaxed Pant	Cotton	Brown
TN17SBT005BK	Pants	Track Pant	Nylon, Cotton	Black
TN17SBT006BK	Jean	Washed Denim Short	Cotton	Black
TN17SBT006BL	Jean	Washed Denim Short	Cotton	Blue
TN17SBT007BK	Pants	Surfing Short	Nylon, Polyester	Black
TN17SBT007NN	Pants	Surfing Short	Nylon, Polyester	Neon
TN17SBT007OR	Pants	Surfing Short	Nylon, Polyester	Orange
TN17SBT008BK	Pants	SP Fleece Pant	Polyester, Nylon	Black
TN17SBT008RD	Pants	SP Fleece Pant	Polyester, Nylon	Red
TN17SBT008WH	Pants	SP Fleece Pant	Polyester, Nylon	White

TN17STO017SB TN17STO016GR TN17SOW006GN TN17STO014BK TN17STO014GR

TN17STO019IU TN17STO018SB TN17STO006BK TN17STO006GR

Code	Category	Name	Material(s)	Color(s)
TN17SBT009BK	Pants	SP Training Jogger	Polyester	Black
TN17SBT009CA	Pants	SP Training Jogger	Polyester	Camo
TN17SBT009WH	Pants	SP Training Jogger	Polyester	White
TN17SBT010BK	Pants	SP-Logo Sweat Pant	Cotton	Black
TN17SBT010CA	Pants	SP-Logo Sweat Pant	Cotton	Camo
TN17SBT010OR	Pants	SP-Logo Sweat Pant	Cotton	Orange
TN17SBT011GR	Pants	Basic Sweat Pant	Cotton	Grey
TN17SBT011NA	Pants	Basic Sweat Pant	Cotton	Navy
TN17SBT011SB	Pants	Basic Sweat Pant	Cotton	Sky Blue
TN17SBT012BK	Pants	Fleece Short	Polyester	Black
TN17SBT013AU	Pants	Sweat Short	Cotton	Black, Blue
TN17SBT013BK	Pants	Sweat Short	Cotton	Black
TN17SBT013GR	Pants	Sweat Short	Cotton	Grey
TN17SBT013IU	Pants	Sweat Short	Cotton	White, Blue
TN17SBT013WH	Pants	Sweat Short	Cotton	White
TN17SBT014BE	Pants	Jogging Short	Cotton	Beige
TN17SBT014NA	Pants	Jogging Short	Cotton	Navy
TN17SBT015BE	Pants	Fatigue Short	Polyester, Nylon	Beige
TN17SBT015BK	Pants	Fatigue Short	Polyester, Nylon	Black
TN17SBT015SB	Pants	Fatigue Short	Polyester, Nylon	Sky Blue
TN17SBT015YL	Pants	Fatigue Short	Polyester, Nylon	Yellow
TN17SBT016BL	Jean	W Denim Pant	Cotton	Blue
TN17SBT016TB	Jean	W Denim Pant	Cotton	Light Blue
TN17SBT017BK	Pants	W Cropped Pant	Cotton	Black
TN17SBT018BL	Pants	W Wide Pant	Cotton, Spandex	Blue
TN17SBT018TB	Pants	W Wide Pant	Cotton, Spandex	Light Blue
TN17SBT020WH	Skirt	W Button Up Skirt	Cotton	White
TN17SBT022BL	Jean	W Denim Short	Cotton	Blue
TN17SBT022TB	Jean	W Denim Short	Cotton	Light Blue
TN17SBT023BK	Pants	W Corduroy Short	Cotton	Black
TN17SBT023BL	Pants	W Corduroy Short	Cotton	Blue
TN17SBT023IV	Pants	W Corduroy Short	Cotton	Ivory
TN17SMV001NA	Video	LAST FESTIVAL	Film	-
TN17SMV002NA	Video	thisisneverthat 17 SUMMER	Film	-
TN17SOW001NA	Jacket	M3500 Trucker Jacket	Cotton	Navy
TN17SOW001WH	Jacket	M3500 Trucker Jacket	Cotton	White
TN17SOW002BK	Jacket	SP Zip Jacket	Cotton	Black
TN17SOW002BL	Jacket	SP Zip Jacket	Cotton	Blue
TN17SOW002LM	Jacket	SP Zip Jacket	Cotton	Lemon
TN17SOW003BK	Jacket	Stadium Jacket	Polyester	Black
TN17SOW003WH	Jacket	Stadium Jacket	Polyester	White
TN17SOW004BK	Jacket	Shop Coat	Cotton	Black
TN17SOW004PK	Jacket	Shop Coat	Cotton	Pink
TN17SOW005BK	Jacket	Fishing Vest	Cotton, Nylon, Polyester	Black
TN17SOW005WH	Jacket	Fishing Vest	Cotton, Nylon, Polyester	White
TN17SOW006BK	Jacket	Mohair Cardigan	Wool, Nylon	Black
TN17SOW006GN	Jacket	Mohair Cardigan	Wool, Nylon	Green
TN17SOW007IV	Jacket	W Coach Jacket	Nylon	Ivory
TN17SOW007NA	Jacket	W Coach Jacket	Nylon	Navy
TN17SOW008BK	Jacket	MCR Flight Jacket	Nylon, Polyester	Black
TN17SOW008PP	Jacket	MCR Flight Jacket	Nylon, Polyester	Purple
TN17SOW008SR	Jacket	MCR Flight Jacket	Nylon, Polyester	Silver
TN17SOW009BK	Jacket	Anorak Jacket	Nylon, Polyester	Black
TN17SOW009BL	Jacket	Anorak Jacket	Nylon, Polyester	Blue
TN17SOW009OR	Jacket	Anorak Jacket	Nylon, Polyester	Orange

Code	Category	Name	Material(s)	Color(s)

TN17STO002BK TN17STO002GN TN17STO001RD TN17STO0028BY

TN17STO034YC TN17STO021WU TN17STO030ER

 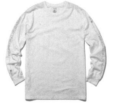

Code	Category	Name	Material(s)	Color(s)
TN17SOW010BK	Jacket	Rain Coat	Polyester	Black
TN17SOW010CH	Jacket	Rain Coat	Polyester	Charcoal
TN17SOW010WH	Jacket	Rain Coat	Polyester	White
TN17SOW011BK	Jacket	SP Fleece Jacket	Polyester, Nylon	Black
TN17SOW011RD	Jacket	SP Fleece Jacket	Polyester, Nylon	Red
TN17SOW011WH	Jacket	SP Fleece Jacket	Polyester, Nylon	White
TN17SOW012BK	Jacket	SP Half Zip Windbreaker	Polyester	Black
TN17SOW012CA	Jacket	SP Half Zip Windbreaker	Polyester	Camo
TN17SOW012WH	Jacket	SP Half Zip Windbreaker	Polyester	White
TN17SOW013BL	Jacket	W Trucker Jacket	Cotton	Blue
TN17SOW013TB	Jacket	W Trucker Jacket	Cotton	Light Blue
TN17SOW013WH	Jacket	W Trucker Jacket	Cotton	White
TN17STO001BL	Shirt	Buffalo Plaid Flannel Shirt	Cotton	Blue
TN17STO001RD	Shirt	Buffalo Plaid Flannel Shirt	Cotton	Red
TN17STO002BK	Shirt	Oversized Shirt	Cotton	Black
TN17STO002BL	Shirt	Oversized Shirt	Cotton	Blue
TN17STO002GN	Shirt	Oversized Shirt	Cotton	Green
TN17STO003GR	Shirt	Hooded Plaid Zip Shirt	Cotton	Grey
TN17STO004BK	Pants	Overalls	Cotton	Black
TN17STO004WH	Pants	Overalls	Cotton	White
TN17STO005BK	Sweatshirt	G-Logo Hooded Sweatshirt	Cotton	Black
TN17STO005OR	Sweatshirt	G-Logo Hooded Sweatshirt	Cotton	Orange
TN17STO005PP	Sweatshirt	G-Logo Hooded Sweatshirt	Cotton	Purple
TN17STO006BK	Sweatshirt	H-SP-Logo Hooded Sweatshirt	Cotton	Black
TN17STO006GR	Sweatshirt	H-SP-Logo Hooded Sweatshirt	Cotton	Grey
TN17STO006NA	Sweatshirt	H-SP-Logo Hooded Sweatshirt	Cotton	Navy
TN17STO007BL	Shirt	W Long Sleeves Shirt Dress	Cotton	Blue
TN17STO007CK	Shirt	W Long Sleeves Shirt Dress	Cotton	Check
TN17STO008CK	Shirt	W Short Sleeves Shirt Dress	Cotton	Check
TN17STO009BK	Shirt	Bandana Shirt	Cotton	Black
TN17STO009GN	Shirt	Bandana Shirt	Cotton	Green
TN17STO009PK	Shirt	Bandana Shirt	Cotton	Pink

Code	Category	Name	Material(s)	Color(s)
TN17ST0011PK	Shirt	Guayabera Shirt	Cotton	Pink
TN17ST0011WH	Shirt	Guayabera Shirt	Cotton	White
TN17ST0012NA	Sweatshirt	BMX Hooded Sweatshirt	Cotton	Navy
TN17ST0012WH	Sweatshirt	BMX Hooded Sweatshirt	Cotton	White
TN17ST0013BK	Sweatshirt	Tennis Player Hooded Sweatshirt	Cotton	Black
TN17ST0013GR	Sweatshirt	Tennis Player Hooded Sweatshirt	Cotton	Grey
TN17ST0013NA	Sweatshirt	Tennis Player Hooded Sweatshirt	Cotton	Navy
TN17ST0014BK	Sweatshirt	EMB. T-Logo Crewneck	Cotton	Black
TN17ST0014GR	Sweatshirt	EMB. T-Logo Crewneck	Cotton	Grey
TN17ST0015BK	Sweatshirt	Rubber Logo Crewneck	Cotton	Black
TN17ST0015GR	Sweatshirt	Rubber Logo Crewneck	Cotton	Grey
TN17ST0015NA	Sweatshirt	Rubber Logo Crewneck	Cotton	Navy
TN17ST0015OR	Sweatshirt	Rubber Logo Crewneck	Cotton	Orange
TN17ST0015SB	Sweatshirt	Rubber Logo Crewneck	Cotton	Sky Blue
TN17ST0016CA	Sweatshirt	ARC Logo Crewneck	Cotton	Camo
TN17ST0016GR	Sweatshirt	ARC Logo Crewneck	Cotton	Grey
TN17ST0016NA	Sweatshirt	ARC Logo Crewneck	Cotton	Navy
TN17ST0017BK	Sweatshirt	TINT.INTL. Crewneck	Cotton	Black
TN17ST0017GR	Sweatshirt	TINT.INTL. Crewneck	Cotton	Grey
TN17ST0017SB	Sweatshirt	TINT.INTL. Crewneck	Cotton	Sky Blue
TN17ST0018NA	Sweatshirt	Nylon Crewneck	Nylon, Polyester	Navy
TN17ST0018SB	Sweatshirt	Nylon Crewneck	Nylon, Polyester	Sky Blue
TN17ST0019IU	Sweatshirt	P-1 Logo Crewneck	Cotton	White, Blue
TN17ST0019WH	Sweatshirt	P-1 Logo Crewneck	Cotton	White
TN17ST0020BK	Sweatshirt	P-1 Logo Crewneck #2	Cotton	Black
TN17ST0020CA	Sweatshirt	P-1 Logo Crewneck #2	Cotton	Camo
TN17ST0021GP	Sweatshirt	Striped Crewneck	Cotton	Green, Purple
TN17ST0021UC	Sweatshirt	Striped Crewneck	Cotton	Blue, Black
TN17ST0021WU	Sweatshirt	Striped Crewneck	Cotton	Brown, Blue
TN17ST0022BK	Sweatshirt	SP-Logo Hood Zip Up	Cotton	Black
TN17ST0022GR	Sweatshirt	SP-Logo Hood Zip Up	Cotton	Grey
TN17ST0022NA	Sweatshirt	SP-Logo Hood Zip Up	Cotton	Navy
TN17ST0022PP	Sweatshirt	SP-Logo Hood Zip Up	Cotton	Purple
TN17ST0022SB	Sweatshirt	SP-Logo Hood Zip Up	Cotton	Sky Blue
TN17ST0023BK	Sweatshirt	T-Logo Hooded Sweatshirt	Cotton	Black
TN17ST0023GR	Sweatshirt	T-Logo Hooded Sweatshirt	Cotton	Grey
TN17ST0023IU	Sweatshirt	T-Logo Hooded Sweatshirt	Cotton	White, Blue
TN17ST0023NA	Sweatshirt	T-Logo Hooded Sweatshirt	Cotton	Navy
TN17ST0023PP	Sweatshirt	T-Logo Hooded Sweatshirt	Cotton	Purple
TN17ST0023SB	Sweatshirt	T-Logo Hooded Sweatshirt	Cotton	Sky Blue
TN17ST0023WH	Sweatshirt	T-Logo Hooded Sweatshirt	Cotton	White
TN17ST0024BK	Sweatshirt	Reflective DIA-Logo Hooded Sweatshirt	Cotton	Black
TN17ST0024GR	Sweatshirt	Reflective DIA-Logo Hooded Sweatshirt	Cotton	Grey
TN17ST0024NA	Sweatshirt	Reflective DIA-Logo Hooded Sweatshirt	Cotton	Navy
TN17ST0024PP	Sweatshirt	Reflective DIA-Logo Hooded Sweatshirt	Cotton	Purple
TN17ST0025BK	Sweatshirt	T.I.N.T Hooded Sweatshirt	Cotton	Black
TN17ST0025GR	Sweatshirt	T.I.N.T Hooded Sweatshirt	Cotton	Grey
TN17ST0025NA	Sweatshirt	T.I.N.T Hooded Sweatshirt	Cotton	Navy
TN17ST0026BK	Sweatshirt	TINT ARC Logo Hooded Sweatshirt	Cotton	Black
TN17ST0026CA	Sweatshirt	TINT ARC Logo Hooded Sweatshirt	Cotton	Camo
TN17ST0026GR	Sweatshirt	TINT ARC Logo Hooded Sweatshirt	Cotton	Grey
TN17ST0026WH	Sweatshirt	TINT ARC Logo Hooded Sweatshirt	Cotton	White
TN17ST0027GR	Sweatshirt	Emblem Hooded SweatShirt	Cotton	Grey
TN17ST0027NA	Sweatshirt	Emblem Hooded SweatShirt	Cotton	Navy
TN17ST0027PP	Sweatshirt	Emblem Hooded SweatShirt	Cotton	Purple

Code	Category	Name	Material(s)	Color(s)
TN17STO028BY	Top	Multi Striped Half Zip	Cotton	Blue, Yellow
TN17STO028OE	Top	Multi Striped Half Zip	Cotton	Brown, Red
TN17STO029BK	Long Sleeve Tee	Reflective SP-logo L/S	Cotton	Black
TN17STO029GN	Long Sleeve Tee	Reflective SP-logo L/S	Cotton	Green
TN17STO029OR	Long Sleeve Tee	Reflective SP-logo L/S	Cotton	Orange
TN17STO029PK	Long Sleeve Tee	Reflective SP-logo L/S	Cotton	Pink
TN17STO029PP	Long Sleeve Tee	Reflective SP-logo L/S	Cotton	Purple
TN17STO029WH	Long Sleeve Tee	Reflective SP-logo L/S	Cotton	White
TN17STO030BK	Long Sleeve Tee	Partition SP-Logo L/S	Cotton	Black
TN17STO030ER	Long Sleeve Tee	Partition SP-Logo L/S	Cotton	Neon Green
TN17STO030GR	Long Sleeve Tee	Partition SP-Logo L/S	Cotton	Grey
TN17STO030PP	Long Sleeve Tee	Partition SP-Logo L/S	Cotton	Purple
TN17STO030WH	Long Sleeve Tee	Partition SP-Logo L/S	Cotton	White
TN17STO031BK	Long Sleeve Tee	Palm Tree L/S	Cotton	Black
TN17STO031GR	Long Sleeve Tee	Palm Tree L/S	Cotton	Grey
TN17STO031PK	Long Sleeve Tee	Palm Tree L/S	Cotton	Pink
TN17STO031SB	Long Sleeve Tee	Palm Tree L/S	Cotton	Sky Blue
TN17STO032BK	Long Sleeve Tee	DIA-Logo L/S	Cotton	Black
TN17STO032BL	Long Sleeve Tee	DIA-Logo L/S	Cotton	Blue
TN17STO032WH	Long Sleeve Tee	DIA-Logo L/S	Cotton	White
TN17STO033BK	Long Sleeve Tee	T-Logo L/S	Cotton	Black
TN17STO033GN	Long Sleeve Tee	T-Logo L/S	Cotton	Green
TN17STO033NA	Long Sleeve Tee	T-Logo L/S	Cotton	Navy
TN17STO033PK	Long Sleeve Tee	T-Logo L/S	Cotton	Pink

TN17STO046WH

TN17STO047NA

TN17STO042WH

TN17STO041NN

TN17STO046NA

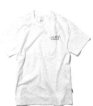

TN17STO050RP

TN17STO039OR

TN17STO048PP

TN17STO039BL

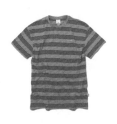

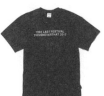

TN17STO040BL

TN17STO040WH

TN17STO036BK

TN17STO050YU

TN17STO043GN

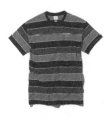

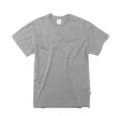

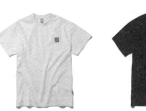

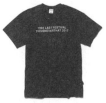

Code	Category	Name	Material(s)	Color(s)
TN17STO033SB	Long Sleeve Tee	T-Logo L/S	Cotton	Sky Blue
TN17STO033WH	Long Sleeve Tee	T-Logo L/S	Cotton	White
TN17STO034GO	Long Sleeve Tee	Multi Striped L/S	Cotton	Grey, Orange
TN17STO034GP	Long Sleeve Tee	Multi Striped L/S	Cotton	Green, Purple
TN17STO034YC	Long Sleeve Tee	Multi Striped L/S	Cotton	Grey, Black
TN17STO035BK	Tee	Rubber Logo Tee	Cotton	Black
TN17STO035NA	Tee	Rubber Logo Tee	Cotton	Navy
TN17STO035PK	Tee	Rubber Logo Tee	Cotton	Pink
TN17STO035SB	Tee	Rubber Logo Tee	Cotton	Sky Blue
TN17STO035WH	Tee	Rubber Logo Tee	Cotton	White
TN17STO036BK	Tee	ARC Logo Tee	Cotton	Black
TN17STO036BL	Tee	ARC Logo Tee	Cotton	Blue
TN17STO036NA	Tee	ARC Logo Tee	Cotton	Navy
TN17STO036PP	Tee	ARC Logo Tee	Cotton	Purple
TN17STO036WH	Tee	ARC Logo Tee	Cotton	White
TN17STO037BK	Tee	TINT.INTL. Tee	Cotton	Black
TN17STO037GN	Tee	TINT.INTL. Tee	Cotton	Green
TN17STO037OR	Tee	TINT.INTL. Tee	Cotton	Orange
TN17STO038BK	Tee	P-1 Logo Tee	Cotton	Black
TN17STO038NA	Tee	P-1 Logo Tee	Cotton	Navy
TN17STO038WH	Tee	P-1 Logo Tee	Cotton	White
TN17STO039BK	Tee	T-Logo Tee	Cotton	Black
TN17STO039BL	Tee	T-Logo Tee	Cotton	Blue
TN17STO039GR	Tee	T-Logo Tee	Cotton	Grey
TN17STO039NA	Tee	T-Logo Tee	Cotton	Navy
TN17STO039NN	Tee	T-Logo Tee	Cotton	Neon
TN17STO039OR	Tee	T-Logo Tee	Cotton	Orange
TN17STO039WH	Tee	T-Logo Tee	Cotton	White
TN17STO040BK	Tee	H-SP-Logo Tee	Cotton	Black
TN17STO040BL	Tee	H-SP-Logo Tee	Cotton	Blue
TN17STO040NA	Tee	H-SP-Logo Tee	Cotton	Navy
TN17STO040NN	Tee	H-SP-Logo Tee	Cotton	Neon
TN17STO040SB	Tee	H-SP-Logo Tee	Cotton	Sky Blue
TN17STO040WH	Tee	H-SP-Logo Tee	Cotton	White
TN17STO041BK	Tee	Reflective DIA-Logo Tee	Cotton	Black
TN17STO041NA	Tee	Reflective DIA-Logo Tee	Cotton	Navy
TN17STO041NN	Tee	Reflective DIA-Logo Tee	Cotton	Neon
TN17STO041OR	Tee	Reflective DIA-Logo Tee	Cotton	Orange
TN17STO041PP	Tee	Reflective DIA-Logo Tee	Cotton	Purple
TN17STO041WH	Tee	Reflective DIA-Logo Tee	Cotton	White
TN17STO042BK	Tee	T.I.N.T Tee	Cotton	Black
TN17STO042NA	Tee	T.I.N.T Tee	Cotton	Navy
TN17STO042OR	Tee	T.I.N.T Tee	Cotton	Orange
TN17STO042WH	Tee	T.I.N.T Tee	Cotton	White
TN17STO043BK	Tee	Reflective SP-Logo Tee	Cotton	Black
TN17STO043GN	Tee	Reflective SP-Logo Tee	Cotton	Green
TN17STO043OR	Tee	Reflective SP-Logo Tee	Cotton	Orange
TN17STO043PK	Tee	Reflective SP-Logo Tee	Cotton	Pink
TN17STO043PP	Tee	Reflective SP-Logo Tee	Cotton	Purple
TN17STO043WH	Tee	Reflective SP-Logo Tee	Cotton	White
TN17STO044BK	Tee	Palm Tree Tee	Cotton	Black
TN17STO044OR	Tee	Palm Tree Tee	Cotton	Orange
TN17STO044SB	Tee	Palm Tree Tee	Cotton	Sky Blue
TN17STO044WH	Tee	Palm Tree Tee	Cotton	White
TN17STO045GR	Tee	TINT ARC Logo Tee	Cotton	Grey

Code	Category	Name	Material(s)	Color(s)
TN17STO045NA	Tee	TINT ARC Logo Tee	Cotton	Navy
TN17STO045WH	Tee	TINT ARC Logo Tee	Cotton	White
TN17STO046NA	Tee	BMX Tee	Cotton	Navy
TN17STO046WH	Tee	BMX Tee	Cotton	White
TN17STO047NA	Tee	Tennis Player Tee	Cotton	Navy
TN17STO047SB	Tee	Tennis Player Tee	Cotton	Sky Blue
TN17STO047WH	Tee	Tennis Player Tee	Cotton	White
TN17STO048OR	Tee	9317 Tee	Cotton	Orange
TN17STO048PP	Tee	9317 Tee	Cotton	Purple
TN17STO048WH	Tee	9317 Tee	Cotton	White
TN17STO049WH	Tee	Cheese Burger Tee	Cotton	White
TN17STO050CW	Tee	Multi Striped Tee	Cotton	Black, Yellow
TN17STO050NB	Tee	Multi Striped Tee	Cotton	Navy, Blue
TN17STO050RP	Tee	Multi Striped Tee	Cotton	Orange, Purple
TN17STO050RR	Tee	Multi Striped Tee	Cotton	Purple, Charcoal
TN17STO050YU	Tee	Multi Striped Tee	Cotton	Grey, Sky Blue
TN17STO051BK	Tee	Rep-Logo Tee	Cotton	Black
TN17STO051NA	Tee	Rep-Logo Tee	Cotton	Navy
TN17STO051SB	Tee	Rep-Logo Tee	Cotton	Sky Blue
TN17STO051WH	Tee	Rep-Logo Tee	Cotton	White
TN17STO052BK	Tee	thisisneverthat Sports Tee	Cotton, Polyester	Black
TN17STO052NA	Tee	thisisneverthat Sports Tee	Cotton, Polyester	Navy
TN17STO052WH	Tee	thisisneverthat Sports Tee	Cotton, Polyester	White
TN17STO053BK	Tee	OG Pocket Tee	Cotton	Black
TN17STO053GN	Tee	OG Pocket Tee	Cotton	Green
TN17STO053PK	Tee	OG Pocket Tee	Cotton	Pink
TN17STO053PP	Tee	OG Pocket Tee	Cotton	Purple
TN17STO053SB	Tee	OG Pocket Tee	Cotton	Sky Blue
TN17STO053WH	Tee	OG Pocket Tee	Cotton	White
TN17STO054GR	Sweatshirt	W Half Zip Hooded Sweatshirt	Cotton	Grey
TN17STO054NA	Sweatshirt	W Half Zip Hooded Sweatshirt	Cotton	Navy
TN17STO054PK	Sweatshirt	W Half Zip Hooded Sweatshirt	Cotton	Pink
TN17STO055GR	Tee	W Palm Tree Tee	Cotton	Grey

TN17SAC020WH TN17SAC020NN TN17SAC021BK TN17SAC021NN TN17SAC004BK TN17SAC001OR

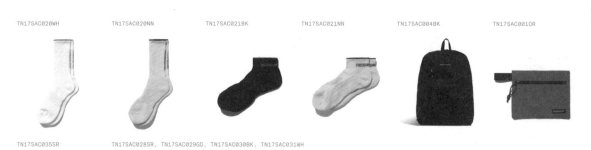

TN17SAC035SR TN17SAC028SR, TN17SAC029GD, TN17SAC030BK, TN17SAC031WH

Code	Category	Name	Material(s)	Color(s)
TN17STO055IU	Tee	W Palm Tree Tee	Cotton	White, Blue
TN17STO055NA	Tee	W Palm Tree Tee	Cotton	Navy
TN17STO055WR	Tee	W Palm Tree Tee	Cotton	White, Red
TN17STO056BL	Tee	W Pocket Tee	Cotton	Blue
TN17STO056GN	Tee	W Pocket Tee	Cotton	Green
TN17STO056RD	Tee	W Pocket Tee	Cotton	Red
TN17STO057NA	Tee	W T-Logo Tee	Cotton	Navy
TN17STO057PK	Tee	W T-Logo Tee	Cotton	Pink
TN17STO057WH	Tee	W T-Logo Tee	Cotton	White
TN17STO058BV	Tee	W Baseball Tee	Cotton	Blue, Navy
TN17STO058TR	Tee	W Baseball Tee	Cotton	White, Purple
TN17STO058WH	Tee	W Baseball Tee	Cotton	White
TN17STO061BK	Tee	thisisneverthat × Casestudy Tee	Cotton	Black

TN17SBT001BK TN17SBT003BL TN17SBT011SB TN17SBT004BL

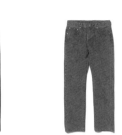 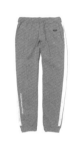 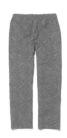

TN17SBT002BK TN17SBT007OR TN17SBT007NN TN17SBT015SB TN17SBT013IU

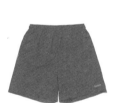 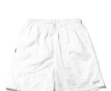 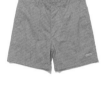 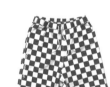

TN17SAC018GN TN17SAC017NN TN17SAC009NA TN17SAC007RD TN17SAC012BE

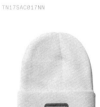

TN17SAC010BL TN17SAC010SB TN17SAC010NA TN17SAC011IU

이것은 이것이 결코
저것이 아닌 것이 결코 아니다

2020년 4월 24일
TN(thisisneverthat): 김민태, 박인욱, 조나단, 최종규
WR(워크룸): 민구홍, 황석원

WR　thisisneverthat을 시작한 해가 2010년이었다. 오늘은 그보다 조금 더 앞에서 시작해보자. thisisneverthat은 어떤 사람들이 만들었나.

TN　유년 시절부터 친구인 조나단과 최종규는 한마디로 원조 '등골 브레이커'였다. 고등학교 때부터 압구정동의 캠프(Camp)나 오일(Oil)을 들락거리고, PC 통신 천리안의 '패사모' 같은 게시판에서 활동하며 구찌(Gucci), 루이 비통(Louis Vuitton), 프라다(Prada), 엠포리오 아르마니(Emporio Armani), 돌체 & 가바나(Dolce & Gabbana) 같은 명품 브랜드를 입고 다녔다. 멋있다는 옷이 있으면 반드시 사서 입어봐야 했다. 학교도 달랐고, 함께 브랜드를 만들자고 이야기한 적도 없었지만, 둘 다 패션 디자인을 공부하게 되면서 어느 순간부터 함께 옷을 만들고 있었다. 오전 9시부터 저녁 9시까지 열두 시간 동안 옷만 만들었다. 지금 돌아보면 수행의 시간이었다. 문화적으로는 서태지와 아이들이나 『터치』, 『H2』 같은 아다치 미츠루(あだち充)의 만화를 좋아했다.

> 금요일로 시작하는 평년. 1월 1일 여성가족부와 법무부가 인터넷을 통해 아동 성범죄자의 신상 정보를 공개했으며, 4일에는 기상 관측 이래 가장 많은 눈이 서울에 내렸다. 2월 25일 헌법재판소가 사형 제도에 대해 합헌 결정을 내렸고, 26일 동계 올림픽 피겨 스케이팅 여자 싱글에서 김연아가 역대 최고 점수로 금메달을 획득했다. 3월 26일에는 백령도 인근 해상에서 해군 2함대 소속 초계함인 천안함이 침몰했고, 6월 10일에는 나로호가 두 번째로 발사됐으나 고도 70킬로미터 상공에서 폭발을 일으켜 추락했다. 11월 23일 북한이 연평도에 포격을 가했으며, 12월 6일에는 서울대공원 동물원에서 곰이 탈출해 9일 만에 청계산에서 잡혔다.
> —김형진·최성민, 「2010년」, 『그래픽 디자인, 2005-2015, 서울: 299개 어휘』

WR　2008년에는 각각 뉴욕(조나단)과 도쿄(최종규)에서 1년 반 동안 지냈다.

TN　대학교 3학년 때였다. 졸업을 1년 앞두고 서로 좋아하는 것을 직접 경험해보기 위해 각각 뉴욕과 도쿄로 떠나 1년 반 동안 지냈다. 사회에 나가기 전에 달콤한 학생 신분을 조금 더 유예하고픈 마음도 있었다. 담배를 살 돈이 떨어지면 길거리에 버려진 꽁초를 주워 피우는 게 궁색하지 않을 만큼 즐겁고 가난한 시절이었다. 조나단과 최종규는 매일 화상 채팅을 하며 오늘 입어본 옷, 가본 매장, 거리나 사람들의 분위기 등에 관해 이야기했다. 무엇보다 중요한 것은 도쿄에서 또 다른 창립 멤버인 박인욱을 만났다는 점이다. 흔히 '나이나'로 불리기도 하는 박인욱은 조나단의 대학교 동기로, 늘 아이디어가 번뜩이는 천재형 인간이다. 게다가 모든 분야에서 오타쿠인 터라 조나단과 최종규가 모르는 모든 걸 안다. 흔한 표현이지만 thisisneverthat의 '정신적 지주'로, 지금까지 늘 귀감이 된다.

2000년대 말은 지금처럼 인터넷이 발달한 시대가 아니었다. 아이폰이 등장한 게 2007년이었다. 지금도 크게 다르지 않지만 특히 일본은 더욱 심했다. 패션 잡지 뒤에 소개된 매장 목록을 가이드 삼아 가보고 싶은 매장을 찾아다니곤 했다. 일본은 한국과 달리 브랜드가 아무리 크더라도 간판을 눈에 띄게 걸거나 중심가를 고집하지 않는다. 어딘가에 숨어 있어서 찾아내야 한다. 그러다 보니 엉뚱한 곳에 들어가거나 허탕을 치는 날도 많았다.

그때의 경험 덕에 지금은 가장 실용적인 동선으로 일본을 여행할 수 있다.

일본은 '오타쿠의 나라'답게 잡지 문화가 대단하다. 깊은 수준의 취향을 매달 새로운 주제로 살펴볼 수 있다는 점은 축복이었다. 『뽀빠이(POPEYE)』, 『멘즈 논노(MEN's NON-NO)』, 『휴즈(Huge)』, 『스트리트(STREET)』, 『튠(TUNE)』, 『프리 & 이지(Free & Easy)』, 『브루투스(Brutus)』, 『아이스크림 (eyescream)』 같은 패션 잡지뿐 아니라 모든 분야의 잡지를 성경처럼 열심히 읽고 봤다. 떠나는 날 박인욱의 침대 밑에서 끊임없이 잡지가 나왔다. 귀국하고 학교를 졸업하자마자 thisisneverthat을 시작했다. 1년 반 동안 서로 떨어져 있었지만 결국 브랜드 론칭에 관해 긴 회의를 한 셈이다.

박인욱이 소장한 잡지들. 패션 잡지뿐 아니라 모든 분야의 잡지가 성경이었다.

WR　브랜드명은 어떤 뜻인가? '이것'은 무엇이고, '저것'은 무엇인가? 그리고 '이것'은 왜 결코 '저것'이 아닌가?

TN　대학교 수업 시간에 들은 말로, 처음 떠올린 이미지와 여러 과정을 거친 실제 제품은 전혀 다르다는 뜻이다. 어떤 이미지를 종이에 스케치하고, 그것을 바탕으로 뭔가 만들었을 때 결과물은 처음 떠올린 이미지와 전혀 다르거나 오히려 더 좋을 수 있다. 즉, this는 처음 떠올린 이미지, that은 결과물이다. 몇 가지 버전을 거쳐 2013년부터 지금까지 사용하는 로고는 띄어쓰기 없이 헬베티카(Helvetica) 소문자만으로 이뤄져 있다. 그런 점에서 브랜드명과 함께 기본을 중시하겠다는 태도로 읽는 사람도 있지만, 단순히 이상적인 형태를 찾은 결과다.

thisisneverthat®

abcdefghijklmn opqrstuvwxyz () & ? ! 0123456789

로고 글자체로는 헬베티카가 사용됐다.

WR 이름은 신발 같은 것이다. 처음에는 불편하고 어딘가 어색하지만, 신다 보면 익숙해지기 마련이다. 10년 전으로 돌아가 다시 브랜드명을 정할 기회를 준다면?

TN 사실 thisisneverthat은 브랜드명이 아니라 디자인에 관한 우리의 철학 같은 것이었다. 그런데 오랫동안 이렇다 할 브랜드명을 정하지 못했고, 결국 thisisneverthat이 브랜드명이 됐다. 다른 후보로는 최종규와 조나단의 이름을 줄인 JKND가 있었는데, 지금은 thisisneverthat의 법인명으로 사용된다. 다시 브랜드명을 정할 기회가 오더라도, 우리가 변하지 않는 이상 이보다 나은 것을 정할 자신이 없다.

WR 브랜드명 자체가 슬로건인 셈이다. 이밖에 좋아하는 슬로건이 있는가?

TN 음마투전(飮馬投錢). 말에게 물을 먹일 때 먼저 돈을 물속에 던져 물 값을 낸다는 뜻이다. 중국의 고서 『삼보결록(三輔決錄)』에 전해오는 사자성어인데, 쉽게 말해 세상에 공짜는 없다는 뜻이다. 크든 작든 누군가에게 신세 지는 일을 싫어한다. 브랜드를 시작할 때부터 공짜만큼 비싼 게 없다는 사실을 몸으로 느껴왔다. 이제껏 thisisneverthat이 독립성을 유지할 수 있는 까닭이기도 하다. 지금은 사용하지 않지만, 고어텍스(Gore-tex)에서 로고에 내세우던 "베스트 디펜스 (Best defense)"라는 슬로건도 좋아한다. 슬로건이 아무리 단순하더라도 브랜드의 실천과 맞아떨어지면 어떤 아우라가 생긴다.

WR 오늘날 한국에는 thisisneverthat과 타깃층이 겹치는 브랜드가 무수히 많다. 그들과 어떤 차별점이 있는가?

TN 사람들이 생각하는 스트리트 브랜드의 대표적인 이미지는 그래픽 티셔츠일 것이다. 하지만 thisisneverthat은 옷의 패턴과 구조, 원단에 대한 이해에서부터 디자인을 시작하는 패션 전문가 집단이다. 언제나 '질 좋은 편한 옷'이라는 기본에서 모든 디자인을 시작하려 노력한다. thisisneverthat은 디자인뿐 아니라 스타일링, 사진 촬영, 영상 제작 및 편집에 이르기까지 패션을 둘러싼 거의 모든 작업이 내부에서 이뤄진다. 전공이나 전문성과 무관하게 좋은 아이디어와 열정만 있다면 모든 직원이 이 작업에 참여할 수 있다. 미약하게나마 어떤 옷을 디자인할지 떠올리면서 촬영까지 염두에 둔 디자인이 가능해진다. 작은 것 하나하나 스스로 해결해야 하는 독립 레이블로 시작했기 때문인데 지금은 그런 부분이 강점이 된 듯하다.
 2009년부터 2015년까지는 완성된 제품을 본사로 납품받아 하나하나 직접 검품하고, 가격표를 붙이고, 포장을 한 뒤에야 거래처에 출고했다. 적은 인원으로는 쉽지 않은 과정이다. 하지만 실물을 직접 만져보고 적재하는 과정을 통해 우리의 규모를 몸으로 알 수 있었다. 그 연장으로 지금까지 물류 창고를 위탁이 아니라 직접 운영한다. 모든 과정은 물류 팀이 맡는다. 제품의 재고를 직접 관리하는 일은 많은 시간과 인력이 필요하지만, 우리뿐 아니라 소비자에게도 그 이상의 가치가 있는 일이다. 앞으로도 변함없이 고수해야 할 작업이라고 생각한다.

WR 초기에는 thisisneverthat을 미국산 브랜드로 인식하는 사람들이 있었다.

TN 의도적으로 브랜드나 제품에 관해 세세하게 설명하지 않았다. 신비주의 전략이라기보다는 평범한 제품을 지나치게 과장하거나 부자연스러운 스토리텔링을 덧입히는 태도와 차별을 두고 싶었다. 사실 오늘날 옷은 아주 엉망이 아니라면 품질 면에서는 브랜드의 우위를 가리기 어렵다. 쉽게 말하면 담백해지려다 보니 오히려 말수가 적어진 셈이다. 우리가 좋아하는 일본과 미국의 브랜드의 성격과 태도에 영향을 받은 것도 그렇게 보인 원인이다. 지금 생각해보면 나쁘지 않은 오해였다고 생각하지만, 한편으로는 우리가 놓치고 있는 무엇이 있지 않을지 자문하게 된다.

WR thisisneverthat이 왜 인기를 얻는다고 생각하는가?

TN thisisneverthat이 대중적으로 알려지는 데는 생각보다 오랜 시간이 걸렸다. 결과적으로는 우리가 하는 일을 의심하지 않고 꾸준함을 유지한 게 인기를 얻은 큰 이유인 듯하다. 2012년부터 2월과 8월, 1년에 두 번씩 사진과 영상으로 컬렉션을 발표했는데, 매번 전시회를 통해 모든 옷을 프레스와 바이어를 비롯한 모든 사람에게 공개했다. 당시만 해도 판매가 이뤄지지 않는 옷과 관련한 이벤트는 국내 정서에 조금 생소했던 것 같다. 오랫동안 기다려 전시장에 들어가도 '미리 보기' 외에 할 수 있는 일은 없으니 말이다. 이렇듯 정석적인 마케팅 방법을 전혀 알지 못한 탓에 우리에게 집중해 우리만의 방식으로 이야기를 전하려 노력했고, 그러다 보니 몇 년 뒤부터 시선을 끌기 시작했다.

전시장 입구. 오랫동안 기다려 전시장에 들어가도 '미리 보기' 외에 할 수 있는 일은 없다.

WR thisisneverthat의 약점은?

TN 한국의 모든 스트리트 브랜드가 그렇듯 문화적인 뿌리가 튼튼하지 않다. 일제강점기나 한국전쟁 같은 국가적인 재난 때문이기도 하지만, 스케이트보드나 서핑 같은 배경이 부족하다. 한국에는 스투시(Stussy)같이 40여 년 넘게 유지된 브랜드가 없다. 결국 우리가 보고 영향받은 많은 게 미국과

일본의 그것이다. 하지만 일본이 패션에서 제2차 세계대전 시기에 미국과 유럽을 모방하고 편집하며 자신만의 영토를 개척했고, 오늘날 다시 미국과 유럽에 영향을 미치듯 이제는 한국에서도 모방과 편집의 시기가 지나 새로운 게 생기고 있다. 물론 thisisneverthat도 그 일부다.

> 일본은 70여년 동안 아메리칸 스타일을 모방하며 미국 역사에서 거의 모든 아이디어를 흡수했다. 아메토라(아메리칸 트래디셔널)의 가타는 미국이 시작이었겠지만, 오늘날 일본에 아무 문제 없이 안착했다. 세상은 소멸 직전에 놓인 미국의 오리지널보다 여전히 건강한 일본의 사례를 따를 것이다. 학생으로 오랜 시간을 보낸 덕에 일본은 이제 선생이 될 기회를 얻었다. ─W. 데이비드 막스, 『아메토라: 일본은 어떻게 아메리칸 스타일을 구원했는가』

WR　　thisisneverthat의 주 소비자층은 10대와 20대다. 30대 이상으로 확대할 생각은 없는가?

TN　　브랜드를 시작한 20대 후반부터 우리의 기준은 늘 '우리가 입고 싶은', 조금 더 구체적으로 말하면 '질 좋고 편한' 옷이었다. 지금은 모두 30대 후반의 나이가 됐고, 브랜드 또한 함께 나이가 들었다. 하지만 함께 일하는 동료 대부분은 20대다. 처음부터 타깃을 설정하고 콘셉트에 따라 디자인을 하기보다 '바로 지금'에 가장 충실한 디자인을 하려고 노력한다. 여전히 이 원칙에 따라 옷을 디자인한다. 그 점이 thisisneverthat을 좋아하는 분들의 마음을 움직이는 것 같다. 한편, thisisneverthat의 옷은 남성복에 가깝지만 여성 고객 비율이 높은 편이다. 한때 정식으로 여성복 라인을 전개했으나 오히려 여성이 남성복을 구입하는 비율이 높아 지금은 중단한 상태다. 여성복 라인은 조금 더 체계적으로 준비한 뒤 새롭게 선보일 예정이다. 인재를 기다리고 있다.

WR　　thisisneverthat의 서브 브랜드로 삼고 싶을 만큼 탐나는 한국 브랜드가 있는가?

TN　　없다.

thisisneverthat의 시작이 된 ÅLAND 시절.

WR　　트렌드에 관한 생각은? thisisneverthat이 트렌드를 설정하는 데 일조한다고 생각하는가?

TN　　어려운 질문이다. 하지만 트렌드라는 건 분명히 있다고 생각한다. 단, 그것을 의식하거나 심각하게 연구해 우리

것으로 만들려 한 적은 한 번도 없다. 여기저기 노출된 이미지에 어느 정도 영향을 받고 있겠지만, 의식적으로는 주류에서 계속 벗어나려 했고, 지금도 마찬가지다. 학교에서 패션 디자인을 정식으로 공부했지만, 디자인을 하거나 브랜드를 운영할 때는 배운 것에 반하는 결정을 주로 했다. 컬러 차트는 한 번도 만들어본 적이 없고, 시장 조사 같은 것도 해보지 않았다. 어느 정도 무모한 자신감이 있었다. 그냥 우리의 경험과 눈을 믿었다.

우리는 시장이 급격하게 변화하는 꼭짓점에서 브랜드를 시작했다. thisisneverthat 외에도 여러 독립 브랜드가 생겨나 오프라인에서 온라인이라는 새로운 시장으로 이동하기 시작한 시기였다. 룩북, 전시, 영상, 음악 등 우리가 브랜드를 보여주는 방식은 제법 많은 브랜드에 영향을 미쳤고, 실제로 비슷한 경향이 생겨났다. 이제는 그들과 달리 보여야 하는지, 아니면 그들을 의식하지 말아야 하는지 고민하고 있다.

WR　　제품을 선보이기까지 구체적인 순서는?

TN　　다른 브랜드와 다르지 않을 것 같다. 크게 1) 기획과 디자인, 2) 생산, 3) 판매 순으로 이뤄진다. 대표 셋은 패션 전문 회사에서 일해본 경험이 없기 때문에 일련의 과정이 빈약하거나 비효율적일 수는 있다. 단순히 옷을 만들어 팔아보자는 생각에서 출발해 지금까지 세부적인 과정이 추가됐다. 조금 더 구체적으로 이야기하면, 처음에는 아우터, 셔츠, 팬츠, 가방, 모자 등 만들고 싶은 제품을 나열해본다. 그중에서 'thisisneverthat 같은' 제품을 선별해 구체적인 디자인을 시작해 생산 팀과 소재, 디테일, 생산처, 생산 일정 등 세부적인 부분을 맞춰나간다. 그 뒤에는 MD 팀에서 생산량을 정한다. 샘플이 만들어지면 사진, 영상 촬영이 이뤄진다. 이후 수주회, 해외 쇼룸 참가 등 일정을 소화하고 발매를 시작한다.

WR　　사무실에서는 어떻게 일하나? 회의를 하기도 하는가?

TN　　매주 월요일 오전에 팀장 회의가 열린다. 대표 셋과 디자인, MD, 생산, 물류, CS 팀장이 지난 주에 있었던 일과 돌아오는 주의 팀별 계획에 관해 편하게 이야기한다. 회의 시간은 20~30분 정도로 길지 않다. 회의는 중요하지만, 아무리 재미있는 주제라도 길어지면 공허해지고 아무것도 하기 싫어지기 마련이다. 공식적인 회의는 이뿐이고, 협력이 필요한 직원끼리 편하게 소통하면서 크고 작고 길고 짧은 회의가 열린다.

WR　　시즌 콘셉트는 어떻게 정하는가?

TN　　특정한 규칙 없이 편하게 정한다. 시작 단계에 명확한 콘셉트명이 없는 경우도 있다. 컬렉션을 디자인하기 전에 정해지는 경우도 있고, 디자인을 하다가 갑자기 정해질 때도 있다. 모든 것은 대개 직원들에게 어떤 옷차림을 설명하면서 시작된다. 예컨대 이렇다. "10대 후반의 긴 머리카락을 가진 외국인 친구가 피그먼트다잉된 면 트윌 하프 팬츠를 입고, 상의는 크랙 효과가 들어간 그래픽 티셔츠를 입고 있다. 아주 낡은 8홀짜리 팀버랜드 워커를 신고, 뿔테 안경을 끼고 심플한 반지나 목걸이도 하고 있다." 이를 바탕으로 어울릴 만한 원단과 워싱, 효과 등을 덧붙인다. 느슨하게 시작하지만 사소한 디테일에서부터

분위기를 반영하려 노력한다. 일상 생활에서 보고 느끼는 것 중 일부가 자연스럽게 콘셉트로 이어진다. 일과 생활이 분리되지 않고, 브랜드와 자신을 동일시할 때가 종종 있다. 그 과정에서 자연스럽게 도출된 게 시즌 콘셉트가 된다. 앞뒤가 맞지 않은 것 같지만 해당 시즌의 콘셉트는 일과 생활이 어우러진 부산물 같은 것이다. 디자인을 하고, 제품을 만들고 판매하고, 생활하는 도중에 나오는 어떤 이야기에 가깝다.

WR 예를 든다면?
TN SS15 시즌의 콘셉트는 'Lake on Fire'였다. 지금은 잘 기억이 나지 않는 어떤 전시회에서 호수에 불이 붙은 사진을 본 적이 있다. 여기서 어떤 이야기를 상상하고, 다섯 문장으로 압축했다.

At the break of dawn, I stumbled upon the lake on fire. We drove back home with a boat on fire. Each one of us took a bike and went into the woods. We rode down the path at full speed. When looked back, there we saw the lake on fire.

이 문장 자체가 옷에 들어갈 그래픽 디자인의 일부가 되기도 하고, 이야기 속 등장인물의 옷차림을 상상해 옷을 디자인하기도 했다. 그것을 토대로 영상의 방향과 분위기가 정해지고, 그에 맞는 음악도 만들어진다. 다른 시즌도 비슷하거나 때로는 더 단순한 과정을 통해 정리된다. 해외 촬영지 또한 비슷하게 정해진다. 디자인이 완성돼가면서 도시, 거리, 숲 같이 그에 어울리는 환경 또는 배경에 관해 이야기한다. 물론 처음부터 해외 촬영지가 정해진 시즌도 있지만, 대부분 샘플의 분위기로 촬영지를 정한다.

WR 시즌마다 음악이 등장한다.
TN 음악은 프로듀서 겸 DJ인 섬데프(Somdef)를 시작으로, 한국의 언더그라운드 뮤지션, DJ 등과 작업한다. 시즌에 관한 이미지가 대략적으로 도출되면 '여기서는 사람의 소리가 아닌 소리가 나오면 좋겠다.' 같이 지나칠 정도로 디테일한 부분까지 이야기한다.

WR 일하는 동안 음악을 듣기도 하는가?
TN MD 팀과 CS 팀이 일하는 3층은 비교적 조용하지만, 디자인 팀이 일하는 2층은 소리가 크든 작든 항상 음악이

흘러나온다. 음악을 담당하는 직원은 따로 없다. 스피커는 누군가의 스마트폰과 블루투스로 연결돼 있을 뿐이다. 빅뱅, 퍼렐 윌리엄스(Pharrell Williams), 프랭크 오션(Frank Ocean), 저스틴 비버(Justin Bieber)를 좋아한다. 특히 모두 태양의 팬이다. 지금 사용하는 스피커를 마련했을 때 태양의 앨범을 가장 먼저 재생했다. 정말 마음에 들지 않는 음악이 나오더라도 그냥 듣는 편이다. 3분 정도는 견딜 수 있다.

WR 영상 스타일에 영향받은 것은?
TN 미국의 영화감독 겸 각본가인 스파이크 존즈(Spike Jonze)가 만든 파사이드(The Pharcyde)의 「드롭(Drop)」 뮤직비디오나 「존 말코비치 되기(Being John Malkovich)」를 특히 좋아한다. 작업에 직접적으로 영향을 받기도 했다. 우리 중 사진이나 영상을 전공한 사람은 없다. 조나단의 집에 테이프를 넣는 구형 비디오 카메라가 있어서 자주 가지고 놀았는데, 그때부터 필름 느낌이 좋아서 지금까지 적극적으로 사용해왔다. 하지만 한국에는 우리의 의도에 맞게 필름을 현상할 수 있는 곳이 없어서 미국 로스엔젤레스에 있는 현상소에 테이프를 보낸다. 비디오 카메라로 영상을 만드는 건 어떻게 보면 비효율의 정점에 있고, 그래서 매력적이다.

조나단의 구형 비디오 카메라.

해상도와 선예도로 가치를 평가받는 이미지의 위계질서 속에서 버림받은 이미지들, 즉 이리저리 복사되고, 편집되며, 끊임없이 순환하는, 그러는 와중에 흐릿해진 이미지들은 어디로 가는가? 그들은 공식적인 스크린에서 추방당해 디지털 세계의 황무지를 떠돈다. —히토 슈타이얼, 「빈곤한 이미지를 옹호하며」, 『스크린의 추방자들』

WR 스튜디오 사진과 야외 사진을 촬영할 때 중요하게 생각하는 것은?
TN 컬렉션은 스튜디오에서 촬영하는 사진과 영상으로 완성된다. 사진의 스타일링과 순서는 많은 고민을 통해 정해진다. 서른 장 남짓한 사진에서 오랫동안 준비한 모든 것을 압축해 보여주는 셈이다. 룩북에서 가장 중요하게 생각하는 부분이다. 몇 년 전부터는 룩북의 스타일에 지나친 변화는 피하려 한다. 예컨대 스튜디오 사진은 FW17 시즌을 기점으로 지금까지 한 가지 스타일을 유지한다. 룩북에서는 시즌의 분위기를 전달하는 일도 중요하지만, 한편으로는 옷과 스타일링에 온전히 집중할 수 있는 체계가 필요했다. 비슷한 구도에서 시즌마다 달리 보이게끔 연출하는 일이 물론 쉽지 않지만, 반복되는 체계가 만들어내는 어떤 힘이 있다고 생각한다. 해외 촬영은 시즌마다 시도하는 커다란 실험의 일부다. 여기서는 장소의 한계 때문에

스튜디오에서 보여줄 수 없거나 보여주지 못한 부분을 드러내는 데 중점을 둔다. 해외 촬영은 짧게는 보름에서 길게는 한 달이 걸린다. 해외 촬영은 늘 즐겁지만, 가장 힘들었다는 점에서 아이슬란드에서 촬영한 FW17 시즌이 기억에 남는다. 촬영 장소와 숙소까지 5시간 정도를 계속 오갔다.

WR 모델은 어떻게 선정하는가? 인종을 고려하는가?

TN 시즌마다 적합한 모델을 선정하는 건 늘 어려운 일이다. 국적을 떠나 디자인과 가장 어울릴 만한 사람과 분위기를 찾다 보니 자연스럽게 주로 외국인과 작업한 것 같다. 이국적이거나 무국적인 분위기를 의도한 적은 없지만, 지금 생각해보면 자연스럽게 그렇게 해온 것 같다. 한편, 우리와 작업한 모델과 다시 함께하기는 쉽지 않다. 우리와 작업한 뒤에 다른 브랜드에서 연락이 많이 온다고 한다.

WR 책은 옷처럼 소비자가 필요한 제품이라는 점을 잊곤 한다. 제품이라면 만드는 것뿐 아니라 소비자에게 어떻게 전달할지, 즉, 유통이 중요하다. 비즈니스의 성패는 유통에서 갈린다.

TN 국내 유통은 지금 수준으로 충분하다. 우리와 색깔이 맞는 곳도 드물고, 보여주는 방식이 엇비슷하기 때문에 정말 마음에 드는 곳이 아니라면 확장할 생각은 아직 없다. 온라인, 오프라인 모두 마찬가지다. 오프라인 매장은 현재 홍익대학교 앞에 한 곳만 운영하고 있다. 홍익대학교 앞은 누구나 알다시피 문화적으로 상징성을 지녔다. 동시에 브랜드에는 일종의 험지다. 여기서 자리를 잡으면 강남이나 지방으로 확장하는 건 어렵지 않은 일이라고 생각한다. 오프라인 매장은 서울에 한두 곳 정도를 더 마련할 생각이다.

WR 제품을 유통하는 가장 효율적인 방식은?

TN 수익만 따지면 당연히 수수료가 없으니 우리 웹사이트나 매장에서 판매되는 게 가장 효율적이다. 하지만 유통처는 브랜드의 성격을 드러내기도 한다. 따라서 어떤 유통처에 입점하는 게 브랜드에 효과적이라고 판단한다면 비효율적인 일을 할 때도 있다.

WR 물류 창고는 어디에 있는가?

TN 파주. 상주하는 직원이 있지만, 시즌 초반 등 일손이 부족한 시기에는 지금도 조나단과 최종규까지 나서서 제품을 검수하고, 포장하고, 발송한다. 제품이 소비자에게 도달하는 과정의 마지막 단계라는 점에서 어쩌면 패션 산업에서 가장 중요한 순간일 수 있다.

파주의 물류 창고. 한 시즌의 결과물이 소비자에게 도달하기 직전에 반드시 거쳐야 할 공간이다.

WR 폭발적으로 인기를 얻은 제품은?

TN SS13 시즌의 앞판과 소매에 스트라이프를 프린트한 풋볼 티셔츠. 다음 시즌에 많은 브랜드에서 같은 디자인이 출시됐다. 이유는 잘 모르겠다. 오버핏이란 게 생소하던, 또는 잊혀진 상황에서 다시 새롭게 보였기 때문 아닐까. 지금까지 가장 인기 있었던 시즌은 SS15인데, 거의 모든 제품이 발매와 함께 품절됐다. 매출은 전해에 비해 400퍼센트 가까이 상승했다. 특히, 'Lake on Fire' 볼 캡은 2만여 장이 판매됐다. 너도 나도 트러커 매시 캡과 스냅백을 쓰던 시기였는데, 그 이후로 분위기가 제법 전환되기도 했다.

키도가 제작한 피규어. 풋볼 티셔츠를 입고 있다.

WR 자신을 '사업가'라 칭한 미국의 예술가 앤디 워홀(Andy Warhol)이 자신의 실크스크린 작품에 캠벨 수프 캔과 코카 콜라 병을 등장시킨 이래 예술과 산업의 협업은 자연스러운 일이 됐다. 협업은 대개 어떤 식으로 시작되는가?

TN 모두 먼저 제안해왔다. 그 밖에도 일일이 밝힐 수 없을 만큼 많지만 성사되는 것은 극소수다. 제안을 받는 이유는 크게 두 가지 아닐까. thisisneverthat이 주된 소비층인 젊은 세대에게 어필하는 점과 우리가 이미지를 만들어내는 능력.

WR 적극적인 협업은 어느 선까지 이뤄지는가?

TN 모든 협업에서 thisisneverthat은 디자인을 전담해왔다. 다른 브랜드와 협업하는 가장 큰 이유는 브랜드의 고유성을 유지하며 시도해보지 못한 방식을 실험해보고픈 욕망

때문이다. 그리고 신발, 시계 등 자체적으로 만들기 어려운 제품을 협업하는 브랜드의 기술력을 통해 만드는 데 있다. 그 과정에서 우리가 고민하지 못하던 지점을 배우기도 하고. 따라서 보통 제품 생산은 협업하는 브랜드가 맡고, 마케팅과 유통은 의견을 조율해 정한다.

2020년 봄여름, 2019년 가을겨울 시즌에 뉴발란스와 협업해 출시한 신발.

WR 협업 기간은?

TN 협업하는 브랜드마다 다르지만 평균적으로 1년에서 1년 반. 누군가는 패션에서의 협업을 단순히 '다른 브랜드의 제품에 다른 브랜드의 로고를 추가하는 일'로 생각하지만, 그 단순한 일을 위해 앞뒤에서 준비하고 따져야 할 일이 적지 않다.

WR 성공적인 협업이란?

TN 오늘날 패션에서 협업은 마치 반드시 해야 하는 일처럼 됐다. 협업에서는 전혀 다른 뭔가가 만나 누구나 감탄할 수 있는 의외성이 도출돼야 한다. 결과론이지만 판매까지 좋아야 결국 성공적인 협업이라 말할 수 있다.

WR 리미티드 에디션의 수량은? 가장 빨리 품절된 제품은?

TN 리미티드 에디션은 보통 1,000개 정도. 물론 어떤 제품은 이보다 훨씬 적은 등 제품마다 차이가 있다. 지샥(G-SHOCK)과 협업한 시계는 거의 1분 만에 품절됐다. 우리 중 아무도 예상하지 못한 결과였다. 리미티드 에디션에 임직원을 위한 특혜는 전혀 없는 터라 나중에 느긋하게 구입하려던 직원들이 안타까워했다.

2020년 봄여름 시즌에 지샥과 협업해 출시한 시계는 공개 1분 만에 품절됐다.

WR 2019년 봄 홍익대학교 앞에 오프라인 매장을 열었다. 전통적이기는 하지만 패션 브랜드로서는 제법 큰 목표를 달성한 셈이다. 오프라인 매장에서는 제품 자체를 넘어 브랜드의 고유한 취향이 소비자에게 직접적으로 전달된다. 소비자가 오프라인 매장에서 어떤 경험을 하기를 원하는가?

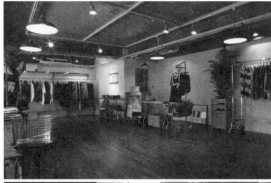

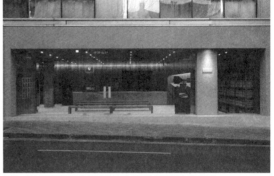

10년 사이 홍익대학교 앞 골목에 있던 매장은 번화가로 이전했다.

TN 엄밀히 따지면 확장 이전이다. 골목에 있던 매장을 중심가로 옮겼다. 새로운 오프라인 매장은 thisisneverthat의 제품을 우리 방식대로 보여줄 수 있기를 바랐다. 제품을 편하게 착용해볼 수 있는 분위기.

WR 오프라인 매장 디자인은 공간 디자인 스튜디오 COM에서 맡았다. 과정은 어땠나?

TN 이제껏 우리가 브랜드를 드러내는 방식 때문인지 사람들은 항상 thisisneverthat에는 강렬한 뭔가가 있어야 한다고 생각하는 것 같다. 하지만 제품을 판매하는 공간은 깔끔하게 정돈되고 깨끗하면서 고급스러웠으면 좋겠다고 생각했다. COM은 우리의 생각을 공간으로 완성했다. 함께 일하는 동안 편하고 즐거웠고, 결과물도 당연히 만족스러웠다. 매장 작업 이후 연희동 사옥과 내부 가구 디자인을 맡았다. 현재는 새로운 스튜디오 디자인도 의뢰해서 진행 중이다.

WR 오프라인 매장에서 가장 마음에 드는 부분은?

TN 매장의 중앙을 완전히 비웠다. 옷보다 사람과 그들의 활동이 공간의 중심이 되기를 바랐다. 요즘에는 브랜드의 콘셉트에 맞춰 매장의 최소 면적을 기준으로 세우고, 그 기준에 따라 인테리어 비용, 직원의 숫자, 평당 매출 등을 따진다. 즉, 매장의 크기가 절대적인 영향력을 끼친다. 그런 점에서 우리의 시도가 지나치게 과감하다는 평가를 받기도 하지만, 이제껏 경험한 바에 따르면 비효율적인 게 항상 더 멋있는 것 같다.

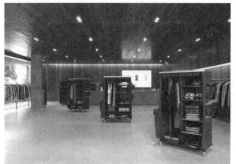

오프라인 매장의 중앙은 대개 비어 있다. 여기서는 옷보다 사람과 그들의 활동이 중심이 된다.

WR 비슷한 시기에 연희동에 지금의 사옥을 지었다. 내부 디자인은 COM에서, 외관은 푸하하하 프렌즈에서 맡았다.

TN 모든 협업에서 그렇듯 우리가 잘 모르고, 잘 할 자신이 없는 일은 협업자의 의견을 최대한 존중한다. 이는 자율성을 담보하지만 동시에 책임감을 부여한다. 게다가 전문성에서는 단순히 느낌만으로는 우리가 도달할 수 없는 영역이 있다. 예컨대 우리는 사옥의 외관을 투명한 유리로 마감하고 싶었고, 푸하하하 프렌즈에서는 끝까지 불투명한 유리를 고집했다. 반드시 그래야 한다고. 결국 푸하하하 프렌즈의 의견을 따랐고, 사옥에서 지내볼수록 그들의 선택이 적절했음을 알겠다.

> 새것에 가깝게 기존 건물을 다시 고쳐 쓰게 됐다. 주택의 평면을 조금만 고치고 입면을 조금만 변화시켜 덜어내는 방식으로 평면을 계획했다. 박스의 일부분을 덜어내 나무가 올라올 자리와 햇빛이 들어올 자리를 마련했다. 입면의 콘크리트 패널을 덜어내고 유리 패널로 마감했다. 청량한 분위기를 조성하고 싶었다.
> —푸하하하 프렌즈, 『오픈하우스서울 2019』

사옥의 외관은 결국 불투명한 유리로 마감했다.

WR 공간은 목적에 따라 달라지기 마련이다. 오프라인 매장은 제품을 판매하는 곳이고, 사무실은 일을 하는 곳이다. 사무실을 설계할 때 특별히 고려한 부분이 있다면?

TN 하나하나 구체적으로 주문하지는 않았다. 초창기에 반지하에서 궁벽하게 일하던 경험 때문인지 무엇보다 빛이 잘 들고, 직원들이 편하고 행복하게 일할 수 있는 공간을 바랐다. 특히 허먼 밀러(Herman Miller)의 에어론 체어 같이 직원들이 매일 직접 사용할 집기를 세심하게 마련하기도 했다.

허먼 밀러의 에어론 체어. 사옥은 무엇보다 직원들이 행복하게 일할 수 있는 공간이 돼야 한다.

WR 10주년을 기념하는 책과 웹사이트를 만든 워크룸과의 협업에서는 오히려 thisisneverthat에서 연락했다.

TN 일찍이 워크룸의 그래픽 디자인 작업과 워크룸 프레스의 책을 눈여겨보고 있었다. 그러던 중 반갑게도 패션 칼럼니스트 박세진 씨의 『패션 vs. 패션』을 시작으로 2016년부터 패션에 관해 읽을 만한 책이 출간되기 시작했다. '실용 총서' 중 한 권인 고바야시 야스히코(小林泰彦)의 『헤비듀티(ヘビーデューティーの本)』뿐 아니라 박세진 씨의 『일상복 탐구』를 재미있게 읽었다. 사이먼 레이놀즈(Simon Reynolds)의 『레트로 마니아: 과거에 중독된 대중문화 (Retromania: Pop Culture's Addiction to Its Own Past)』, 히토 슈타이얼(Hito Steyerl)의 『스크린의 추방자들(The Wretched of the Screen)』도 좋았다. 워크룸이라면 책에 관해서는 걱정 없이 부탁할 수 있겠다고 생각했다.

WR 모든 제품에 코드를 부여하고 목록화한 것 또한 워크룸의 제안이었다. 브랜드로서는 섣불리 할 수 없는 시도다.

TN 10년 동안 어려움이 적지 않았지만, 큰 고민 없이 닥치는 일을 하나하나 해왔다고 생각했는데, 제품을 목록화하며 하나하나 돌아보니 실로 적지 않았다. 늘 눈으로 확인해야 하고 손으로 만져야 하는 일이어서 힘이 들 때도 있지만 단언컨대 이제껏 한번도 지겨운 적이 없었다. 운 좋게 평생 하기 좋은 일을 택했다 싶다. 처음에는 많은 브랜드가 그렇듯 단순히 시장에서 살아남는 게 목표였다. 이는 언제나 현재진행형이다. 이제는 지금과 같은 태도와 방식으로 20년까지 일단 해보자는 새로운 목표도 생겼다.

WR 정말이지 하기 싫은 일은?

TN 인터뷰. 브랜드에 관해 하나하나 설명하거나 한두

사람이 브랜드를 대변하는 일을 피하려 하는데, 인터뷰 자리에서는 피하려 하는 두 가지 일을 동시에, 그것도 잘 해야 한다. 대부분 정중하게 거절하는 편이다. 팀으로서의 작업을 중요하게 생각하는 만큼 반드시 필요한 경우가 아니라면 특정한 개인이 아니라 오직 thisisneverthat으로 소개되고 싶다. 이런 태도는 룩북의 판권면에서도 드러난다. 모델, 사진가, 음악가 등 특정인을 제외하고는 모두 thisisneverthat으로 표기한다.

WR　　반대로 인터뷰하고 싶은 대상이 있는가?

TN　　지금은 유니클로(Uniqlo)로 자리를 옮겼지만, 오랫동안 『뽀빠이』 편집장이었던 기노시타 다카히로(木下孝浩). 『뽀빠이』를 수집할 만큼 재미있게 읽기도 하지만, 기획과 편집과 디자인, 그리고 그들을 어우러지게 하는 태도에 관한 부분이 궁금하다. 얼마 전에 지인이 일본에서 인터뷰한 적이 있는데, thisisneverthat을 알고 있다고 해서 놀랐다.

WR　　분야를 떠나 가장 좋아하는 브랜드와 그 이유는?

TN　　나이키(Nike)와 꼼 데 가르송(Comme des Garçons). 이유는 잘 모르겠다. 뭔가를 좋아하는 데 이유가 너무 많다면 이유를 모르거나 이유가 없는 것처럼 느껴지곤 한다.

WR　　브랜드의 규모가 커질수록 새로운 사람이 필요해진다. 직원을 채용할 때 무엇을 중요하게 생각하는가? 예컨대 워크룸에서는 지원자에게 분야를 떠나 좋아하는 브랜드를 묻곤 한다. 브랜드 하나에서 취향을 비롯한 관심 분야 등이 드러난다.

TN　　실력과 인성뿐 아니라 스타일을 중요하게 생각한다. 면접 복장을 한 가지 색으로 통일한다면 아무래도 좋은 소식을 듣기 어려울 것이다. 직원이라면 누구나 제품을 기획하는 데 의견을 제시할 수 있는 만큼 취향과 thisisneverthat에 관한 자신만의 생각도 중요하다. thisisneverthat과 기꺼이 동행할 수 있다면 즐겁게 오랫동안 함께할 수 있다. 시즌마다 제품을 선보이는 것 이상으로 공동체를 중요하게 생각한다.

WR　　직원은 총 몇 명인가?

TN　　2020년 현재 쉰두 명. 남성복을 주로 다루다 보니 어쩔 수 없이 남성이 절대적으로 많다.

WR　　직원은 모두 thisisneverthat의 제품을 입어야 하는가?

TN　　물론 의무는 아니다. 직원들이 thisisneverthat의 소비층이다. 절대적으로 비교하기는 어렵지만 다른 브랜드의 직원들보다 자신이 일하는 브랜드에 애정이 있는 것 같다. 실제로 직원들이 좋아할 만한 제품을 만드는 경우도 있고, 사내 자체 통계가 제품을 기획하는 데 반영되기도 한다. 이는 모두 우리가 채용한 직원들의 취향에 대한 믿음에서 비롯한다.

WR　　사람이 모여 적지 않은 시간 동안 함께하다 보면 자연스럽게 문화가 만들어지기 마련이다. thisisneverthat만의 사내 문화가 있는가?

TN　　서로 다른 직원의 추하게 찍힌 얼굴을 소셜 미디어의 프로필 이미지로 사용하곤 한다. 어지간히 친하지 않으면 할 수 없는 일이다. 우리를 비롯한 창립 멤버 중에는 같은 학교 출신 선후배가 제법 많다. 그러다 보니 당연히 자연스럽게 직장에서 만난 관계 이상으로 편하게 지냈고, 그 뒤에 입사한 직원들이 이런 분위기에 영향을 많이 받았다. 직원들이 서로 나이가 비슷하고 관심사가 겹치다 보니 격의 없이 지낸다. 축구, 수영, 테니스 같은 운동을 함께 하거나 술자리를 마련하기도 한다. PC방에 자주 가기도 했는데, 신종 코로나바이러스가 유행한 뒤에는 안전을 위해 사옥 한쪽에 '간이 PC방'을 차렸다.

간이 PC방. 포스트 코로나 시대에는 고객뿐 아니라 직원들의 안전 또한 중요하다.

WR　　누구에게나 크고 작은 롤모델이 있다. 롤모델은 삶의 방향을 비롯해 습관, 어조, 가족이나 친구에게 건네는 사소한 유머에까지 영향을 미친다. 그리고 분명히 그것은 브랜드의 철학과 제품 디자인에도 다다른다.

TN　　thisisneverthat 구성원 서로가 서로의 롤모델이다. 롤모델이란 건 멀리 있지 않다.

WR　　디자인에 관한 아이디어는 어디서 얻는가?

TN　　아이디어를 얻기 위한 활동은 따로 하지 않는다. 하지만 항상 동시대의 다른 디자이너들의 작업을 주시하며 1990년대와 2000년대의 스트리트 스타일에서 영감을 얻는다.

WR　　소셜 미디어를 어떤 방식으로 활용하는가? 예컨대 인스타그램에 이미지를 게시할 때 어떤 과정을 거치는가? '좋아요'를 위한 특별한 전략이 있는가?

TN　　소셜 미디어는 오늘날 무엇보다 힘이 세고 파급력이 큰 매체가 됐다. 소셜 미디어를 통해 모두 연결된 현실이 전혀 이상하지 않은 일이 됐다. 사소해 보이지만 게시 주기와 시각, 다른 게시물과의 조화 등이 모두 계산돼 있다. 하지만 드러내는 정보는 제품 이미지 외에 제품명과 발매 시기 정도로 제한한다. 게시물에 달린 댓글이나 메시지는 모두 읽는다. 질문에는 처음에 하나하나 답변했지만, 이제는 아쉽게도 그럴 수 없는 상황이다.

2005년 미국의 시인이자 아방가르드 작품을 아카이빙해 소개하는 「우부웹(UbuWeb, http://ubu.com)」의 운영자 케네스 골드스미스(Kenneth Goldsmith)는 말했다. "무엇이 인터넷상에 없다면, 그것은 존재하지 않는 것과 마찬가지입니다." 이 말은 끔찍하게 진실이다. 인터넷과 거의 동의어가 된 웹이 현실에 조금 더 가까워지거나 또 다른 차원에서 현실을 대체할 예정인 '포스트 코로나 시대'에는 더더욱. 오늘날 정보는 헤아리는 일 자체가 무용할 만큼 무수하고, 디지털화하지 않은 정보는 어지간히 여유롭거나 부지런하지 않은 이상 수용자에게 도달하지 않는다." —민구홍, 「목록으로 만들어진 웅덩이에서 헤엄치기」, 『릿터』

@thisisneverthat

TN　thisisneverthat에는 마케팅이나 홍보를 전담하는 부서가 따로 없다. 사실 그럴 필요가 없다. 우리의 크고 작은 활동 자체가 마케팅이자 홍보라는 생각에서다. 물론 가깝게 지내는 유명인에게 협찬을 하기도 하지만 아주 제한적이다. 즉, 일회성이 아니라 정말 thisisneverthat을 좋아하는지 따진다. 방송 등에서 유명인과 함께 노출되는 thisisneverthat은 대개 우리와 무관하게 스타일리스트가 선택한 결과다.

WR　브랜드를 떠나 옷에서 가장 중요한 것은?

TN　옷을 대하는 마음. 삶은 옷을 입는 대로 정해진다고 생각한다. '입는 대로 산다'고 할까? 옷에 대한 취향이 없는 것 또한 그 자체로 취향이다. 수많은 선택 사이에서 옷차림이 정해지고, 시간은 그 옷과 함께 흐른다. 처음에는 원단과 부자재, 패턴과 실루엣, 나중에는 세탁과 낡아가는 방식도 중요해진다. 옷이 없는 인생은 없을 것 같다.

WR　가장 자주 들르는 쇼핑 스폿은?

TN　요즘에는 오프라인보다 온라인 쇼핑을 즐긴다. 관심이 가는 옷과 브랜드는 취향의 변화에 따라 자주 바뀐다. 바뀐다기보다 꾸준히 새로운 것을 찾는다. 그것도 일처럼 한다. 요즘은 예전에 한번 손을 거쳐간 브랜드나 옷에서 새로움을 찾는 경우도 있다. 기본적으로 옷을 좋아한다. 입는 것과 보는 것 모두 좋아한다. 일과 무관한 일이 일처럼 바뀔 때도 있고. 한편, 특히 모든 브랜드가 제품을 쏟아내는 시즌의 한가운데 있으면 어느 순간에는 옷이 의미 없는 것처럼 느껴지기도 한다.

WR　2020년 초 생각지 않던 재앙이 전 세계를 덮쳤다. 모두 여전히 당황스럽고, 분야를 막론하고 예정된 모든 게 취소되거나 연기됐다. 크롬하츠(Chrome Hearts)는 이례적으로 안면 마스크를 제작하기도 했는데, '포스트 코로나 시대'를 위한 대비책은?

거듭 말하지만, '코로나19' 발생 이전의 세상은 이제 다시 오지 않는다. 이제는 완전히 다른 세상이다. 생활 속에서 감염병 위험을 차단하고 예방하는 방역 활동이 우리의 일상이 된다." —권준욱 (중앙방역대책본부 부본부장), 2019년 11월 정례 브리핑

TN　국제적인 브랜드들처럼 사회적인 역할을 맡기에는 역량이 부족하다. 이런 상황에서는 일단 조금 더 우리에게 집중해야 한다. 무엇보다 중요한 것은 직원들이 안심하고 일할 수 있는 환경을 조성하는 일이다. 소비자와 대면하는 매장 직원들에게도 늘 조심해달라고 당부한다. 한편, 이제껏 자연스럽고 그래서 당연하게 여겨온, 사람이 모이는 일 자체가 부자연스러워지다 보니 아무래도 오프라인보다는 온라인에 조금 더 치중할 수밖에 없다.

WR　2020년 이후에 생길 변화는?

TN　지금은 사옥 1층이 비어 있는데, 이곳에 편집숍을 준비하고 있다. thisisneverthat뿐 아니라 다른 브랜드를 소개할 예정이다. 아직 이름이 정해지지 않은 이곳에서 우리가 추구하는 '편집의 묘'를 나른 방식으로 발휘해보려 한다. 한편,

WR　제품은 한 시즌에 주별로 10개 내외로 소개한다.

TN　시즌 시작과 함께 한꺼번에 모든 제품을 소개하면 소비자는 쉽게 흥미를 잃는다. 다른 브랜드의 소비자로서 우리 또한 다르지 않았기 때문이다. 이런 방식을 처음 시도한 슈프림(Supreme)을 벤치마킹했지만, 여러 시도 끝에 thisisneverthat만의 방식을 정착시켰다. 그렇게 주마다 10개 내외의 새로운 제품을 발매하고 12~13주에 걸쳐 한 시즌 동안 총 150여 종의 제품을 선보인다.

WR　「쇼 미 더 머니」 등에서는 스윙스, 기리보이 같은 힙합 뮤지션들이 thisisneverthat의 옷을 입고 등장했다. 마케팅 진략이 궁금하다.

이제껏 진행해온 수많은 협업에서 축적된 경험을 바탕으로 thisisneverthat과는 콘셉트가 다른 브랜드를 올해 안에 선보일 예정이다. 당장 밝힐 수는 없지만, 몇 가지 새로운 협업을 동시에 진행하고 있으며 2020년 가을부터 2021년 봄까지 천천히 공개할 예정이다. 이렇듯 앞으로 thisisneverthat을 둘러싸고 제법 많은 일이 일어나겠지만, thisisneverthat은 지금과 같은 태도와 방식을 유지하려 한다.

카키스(Khakis)가 들어올 사옥 1층.

WR 앞으로도 수많은 브랜드가 끊임없이 등장하고 사라질
 것이다. 그중 누군가는 thisisneverthat의 바로 지금을
 바라보기도 할 테고. 브랜드를 시작할 때 가장 필요한
 것은?

TN 초창기에는 매일 혼자서는 할 수 없는 일과 부닥치고, 생각지 못한 일이 일어났다. 그럴 때마다 크게 고민하지 않고 늘 옆에 있는 사람과 함께 일했다. 브랜드를 시작할 때 가장 필요한 것은 함께할 수 있는 동료. 브랜드가 알려진 뒤 계속 유지할 수 있는 매출을 이끌어내기 위해서는 시간이 필요하다는 점에서 인내심도 필요하다.

WR 티셔츠는 납작하다. 책 또한 납작하다. 티셔츠란
 무엇이라고 생각하는가?

TN 티셔츠는 납작한 평면처럼 보이지만, 두께가 다소 얇을 뿐 앞판과 뒤판 패턴이 다른 입체다. 게다가 사람의 몸에 걸쳐진 뒤에는 입체가 더욱 두드러진다. 책도 비슷하지 않은가. 책을 펴는 순간 책은 입체가 되고, 글, 도판 등도 모두 입체적으로 구조화돼 있다. 모두 납작해 보이지만 무궁무진한 입체를 품고 있다.

옷의 패턴은 납작하지만 결국 입체가 된다.

WR 지금 옷장에 있는 옷 중 가장 오래된 것은?

TN A.P.C.의 프랑스군 M-65 재킷. 2007년 대학생 시절에 구매한 빈티지다. 기능적이고 편해서 생각 없이 입게 된다. 오랫동안 입지 않는 옷은 대개 처분하는 편이다. 옷을 입지 않고 옷장에 고이 모셔둔다면 옷이라 할 수 없다. thisisneverthat의 옷 또한 마땅히 그렇게 취급해야 한다.

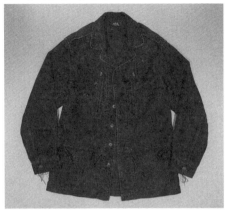

박인욱이 소장한 M-65 재킷.

© Studio Texture on Texture

thisisneverthisisneverthat

April 24, 2020
TN (thisisneverthat): Choi Jongkyu, Jo Nadan, Park Inwook, Kim Mintae
WR(Workroom): Hwang Seogwon, Min Guhong

WR Thisisneverthat was born in 2010. Let's start a little earlier. Who created the brand?

TN Childhood friends Cho Nadan and Choi Jongkyu were, in a word, the original "backbreakers" [a term used for people who figuratively break their parents' backs to keep up with expensive trends]. We frequented stores like Camp and Oil in the affluent Apgujeong District, were active on online bulletin boards like PC Communication Chollian's Paesamo, and wore luxury brands like Gucci, Louis Vuitton, Prada, Emporio Armani, and Dolce & Gabbana. If we saw a nice dress, we had to buy and wear it. We went to different schools and never discussed about co-creating a brand, but we both ended up studying fashion design and found ourselves making clothes together at some point. From 9 a.m. to 9 p.m., we worked only on clothes for twelve hours straight. Looking back now, it was a time of ascetic practice. Culturally speaking, we were fans of the rock band Seo Taiji and Boys, and manga like *Touch* and *H2* by Mitsuru Adachi.

It was a normal year that started on a Friday. On January 1, the Ministry of Gender Equality and Family and the Ministry of Justice released the personal information of child sex offenders on the internet, and on January 4, the heaviest snowfall in recorded history fell. On February 25, the Constitutional Court ruled capital punishment constitutional, and on February 26, Kim Yuna won the gold medal with the highest score ever in figure skating women's singles at the Winter Olympics. On March 26, the Cheonan, a patrol ship belonging to the Navy's Second Fleet, sank close to Baengnyeong Island, and on June 10, the Naro-1 space rocket exploded at an altitude of seventy kilometers during its second launch. On November 23, North Korea opened fire on Yeonpyeong Island in South Korea, and on December 6, a bear escaped from the Seoul Grand Park Zoo and was captured on Mount Cheonggye after nine days. — Kim Hyungjin and Choi Sungmin, "2010," *Graphic Design 2005–2015*, Seoul: 299 Vocabulary.

WR In 2008, the two of you left South Korea to spend a year and half abroad: Cho Nadan in New York and Choi Jongkyu in Tokyo.

TN We were in our third year of college. With a year left until graduation, we decided to experience firsthand the things we liked and spent a year and half in New York and Tokyo respectively. We also wanted to hang on to our precious student status for a little longer. It was a time of fun and poverty when we didn't mind picking up and smoking discarded cigarette butts when we ran out of money to buy cigarettes. We video chatted daily and talked about what we'd worn that day, the stores we'd visited, the atmosphere of the streets and the people. Most importantly, we met Park Inwook, our third founding member, in Tokyo. Park, commonly referred to as "Naina," was Cho Nadan's college mate and was a genius-type who was always brimming with ideas. Moreover, he was an otaku in all fields and knew everything we didn't know. It's a clichéd expression, but he's the "emotional anchor" of thisisneverthat and has always been a role model.

The internet was not as developed in the late 2000s as it is now. The iPhone appeared only in 2007. It's not much different now, but the situation was especially difficult in Japan back then. We used to look up stores listed on the back of magazines. Unlike Korea, in Japan, no matter how big the brands may be, they didn't put up conspicuous signs or stick to main street locations. They were hidden in a corner and you had to go out of the way to look for them. As a result, there were many days when we ended up in the wrong place or made a fool of ourselves. Thanks to the experience of that time, we can now figure out the most practical route to travel to anywhere in Japan.

As befits the "land of otaku," Japan had a thriving magazine culture. It was a blessing to study a new subject in depth every month. Not just fashion magazines like *Popeye*, *Men's No-No*, *Huge*, *Street*, *Tune*, *Free & Easy*, *Brutus*, and *Eyescream*, we studied magazines related to all fields like the Bible. On the last day when we were leaving, we kept finding magazines under Park's bed. We graduated upon returning home and immediately set up thisisneverthat. We'd been apart for a year and a half, but it turned out to be a long preparation for the brand launch.

Magazines collected by Park Inwook. Not just fashion magazines, all magazines are like the Bible to him.

WR What does the brand name mean? What is "this," and what is "that"? And why can't "this" be ever "that"?

TN It's a phrase we heard at university, and it means that the image you first think of and the actual product you end up with after going through various processes are completely different. When an image is sketched on paper and something is made based on it, the result may be completely different or rather even better than the first image. In other words, "this" is the first image that comes to mind, and "that" is the result. We tried out a few versions before finally settling on the current logo made up of only unspaced lowercase letters in Helvetica font in 2013. In this regard, some people read an attitude of valuing the basics into the brand name, but it's simply the result of finding an ideal form.

thisisneverthat®

abcdefghijklmn opqrstuvwxyz () & ? ! 0123456789

Helvetica was used for the logo font.

WR Names are like shoes. At first, they're uncomfortable and awkward, but once you start wearing them, you get used to them. What if you were given a chance to go back ten years in time and decide the brand name again?

TN Actually, thisisneverthat isn't a brand name but our philosophy about design. We couldn't decide on a name for a long time and eventually thisisneverthat became our name. One option we thought of was JKND, a short form of Choi Jongkyu and Cho Nadan, and we're using it now as our corporate name. Even if we get a second chance to pick a brand name, I don't think we'll be able to come up with a better one.

WR So your brand name itself is a slogan of sorts. Are there any other slogans that you like?
TN *Eum-ma-tu-jeon.* Literally, it means to first pay by throwing a coin into the river before allowing your horse to drink from it. It's a four-character idiom from the ancient Chinese treatise *Sam-bo-gyeol-log*, and in simple terms, it means that there's no free lunch. Big or small, we hate being in anybody's debt. When we started the brand, we quickly realized there's nothing more expensive than "free." And that's why thisisneverthat has always remained independent. Though no longer in use, we also like the slogan "Best Defense" that Gore-tex used to include in its logo. No matter how simple, a slogan has an aura to it if it matches the brand's practices.

WR Numerous brands today have a target consumer base that overlaps with that of thisisneverthat. What sets you apart from them?
When people think of street brands, the image they'll most likely see is the graphic T-shirt. But thisisneverthat is a group of fashion professionals who design with an understanding of clothing patterns, structures, and fabrics. We always try to base our designs on the concept of "good-quality comfortable clothes." Not just design, we do almost everything related to fashion in house, from styling to photography, video production, and editing. All employees can participate irrespective of their major or expertise, provided they have good ideas and passion. This makes it possible for us to keep the photoshoot in mind while planning the kind of clothes to design. We started as an independent label that had to solve every little thing on its own and that experience has now become our strength.
From 2009 to 2015, we'd have the finished products delivered to our headquarters and we'd inspect each item, attach price tags, do the packing, and ship them to our customers. It wasn't easy to do with only a handful of people. But we were able to get a sense of our size by directly touching and loading the product. Even today, we handle warehousing ourselves through our logistics team instead of outsourcing it. Direct product stock management entails a lot of time and labor investment but the value return is many times more for us and for the consumer. We'll stick to this method in the future too.

WR In the early days, many people thought thisisneverthat was an American Brand.
TN We intentionally didn't elaborate on our brand or products. It wasn't a cryptic marketing strategy, but rather we wanted to stand out from the crowd that exaggerated or superimposed artificial storytelling on ordinary products. The truth is that as long as the product isn't a complete mess, it's hard for brands to achieve dominance in terms of product quality today. Put simply, in trying to be simple we ended up being discreet. It is also the reason we appear to be influenced by the characteristics and attitude of Japanese and American brands. Now that we think about it,

it doesn't seem to be a harmful misunderstanding, but on the other hand, we also ask ourselves if there's something we haven't thought of something.

WR Why do you think thisisneverthat is popular?
TN It took us longer than expected to become popular. In the end, not doubting what we were doing and maintaining consistency seem to be the key reasons for our popularity. From 2012, we launched collections twice a year in February and August, and each time we unveiled our clothes to the press, buyers, and everyone else. At the time, a clothing event where sales didn't take place was almost unheard of in the South Korean fashion scene. Even after waiting a long time, all you got on entering our exhibition hall was a "preview." We were clueless of the standard marketing methods, so we tried to concentrate on ourselves and tell our story in our own way, and after a few years of doing this, we began to attract attention.

The entrance to the exhibition hall. Even after waiting for a long time, all you got on entering the exhibition hall was a "preview."

WR What is the weakness of thisisneverthat?
TN As is the case with all Korean street brands, we don't have deep roots, culturally speaking. National disasters like the Japanese colonization and the Korean War are a factor, but we also lack the background of skateboarding and surfing in South Korea. We don't have a Korean Stüssy that's been in the business for over forty years. After all, much of what we see and are influenced by is from the US or Japan. Japan pioneered its own domain by imitating and editing fashion from the US and Europe during World War II and is now influencing those very markets. South Korea is transitioning out of the period of imitating and editing and is creating something new now. Of course, thisisneverthat is part of that transition.

After seventy years of borrowing style ideas from the United States, the Japanese have absorbed all possible ideas from American history. The kata for Ametora may have started in the United States, but now it has settled comfortably in Japan. Going forward, the world will likely imitate the healthy Japanese example rather than the moribund American original. After so many years of being the pupil, Japan has an opportunity to be the teacher. — W. David Marx, *Ametora: How Japan Saved American Style*

WR People in their teens and twenties are your main consumer base. Do you have any plans to expand your consumer base to people in their thirties?

TN Ever since we started the brand in our late twenties, our standard has always been to create "what we want to wear," or more specifically, "good quality and comfortable" clothes. We're all now in our late thirties, and the brand, too, has grown older along with us. But most of the people who work with us are in their twenties. Rather than setting a target from the onset and designing according to a preset concept, we try to create a design that's the most faithful to "right now." We still design according to this principle. And that seems to move the hearts of those who like thisisneverthat. Meanwhile, our clothes are closer to menswear but we have a high proportion of women among our customers. We officially launched a women's line at one point of time but we suspended it because of the high ratio of women purchasing menswear. We plan to prepare more systematically and introduce a new women's line. We're waiting for the right talent.

WR Is there any Korean brand you wish you to assimilate as a sub-brand of thisisneverthat?

TN No.

WR What are your thoughts on trends? Do you think thisisneverthat helps to set trends?

TN It's a difficult question. Trends definitely exist. Only, we've never been overly conscious of them or seriously studied them and tried to make them ours. We may be influenced to some extent by images we're exposed to here and there, but we've always consciously tried to stay out of the mainstream, and it's the same even now. We studied fashion design formally, but when we design or manage the brand most of our decisions run against what we learned at school. We never made color charts or did any market research. To some extent, we were recklessly confident. We simply trusted our experience and our eyes.

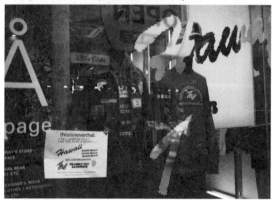

ÅLAND Days. thisisneverthat is based on this period.

We started the brand at a tipping point when the market was rapidly changing. It was a time when many indie brands were shifting from the offline market to the new market of the internet. The way we showcased our brand through lookbooks, exhibitions, videos, and music, influenced quite a few brands and in fact gave rise to a trend. Now we're thinking if we should stand out from them or not be conscious of them.

WR What exactly is your process leading up to introducing a product?

TN It's not much different from other brands. Broadly, we work in the order of planning and design, production, and sales. Since us three have zero experience of working in a fashion company, our process can be rather spare or inefficient. We started with the simple idea of making and selling clothes and added detailed processes along the way. To answer your question, we first list the products we want to create, like outerwear, shirts, pants, bags, caps, and so on. From among them, we pick products that are "like thisisneverthat," then we start work on the exact designs while synchronizing things like materials, detailing, production sites, and production schedules. After that, the Merchandiser Team sets the production volume. Once samples are ready, stills and videos are shot. Sales start after we're done with all of our scheduled trade shows and overseas exhibitions.

WR How do you work at the office? Do you have meetings?

TN We hold meetings with team leaders every Monday morning. The three of us and the leaders of the Design, Merchandiser, Production, Logistics, and Customer Satisfaction teams discuss the details of the previous week and plans for the coming week. Our meetings aren't long, maybe around twenty to thirty minutes. Meetings are important, but no matter how much fun a topic might be, if the meeting runs long, you're bound to end up feeling empty and too drained to do anything. This is our only official meeting, and the staff holds big or small, long or short meetings whenever they need to communicate.

WR How do you decide on the season concept?

TN We don't have a specific rule. At times, we don't even have a clear name for the concept when we start. Sometimes we decide on the concept before designing a collection, and at other times, it suddenly gets decided as we're designing. Everything usually starts with us explaining a certain brief to our employees. For example, "A long-haired foreigner in his late teens is wearing pigment-dyed cotton twill shorts, a crack-print graphic T-shirt, a very old pair of eight-hole Timberland boots, horn-rimmed glasses, and a simple ring or necklace." Based on this description, we add things like matching fabric, washing, and effect. We start in a relaxed manner but try to reflect the overall atmosphere in even trivial details. Some of what we see and feel in our daily lives naturally leads to a concept. There are often times when we don't separate work and life and equate ourselves with the brand. The things we deduce from that process naturally become the season concept. It might seem illogical, but the season concept is like a byproduct when work and life mingle. It's close to a story that comes out in the middle of designing, creating, selling, and living.

WR For example?

TN The concept of the SS15 season was "Lake on Fire." I saw a picture of a fire burning on a lake at an exhibition once, though I don't remember exactly which one, and I imagined a story and compressed it into five sentences:

At the break of dawn, I stumbled upon the lake on fire. We drove back home with a boat on fire. Each one of us took a bike and went into the woods. We rode down the path at full speed. When we looked back, there we saw the lake on fire.

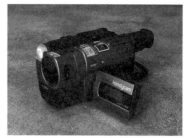

Cho Nadan's old-style video camera.

This passage itself became part of the graphics on the clothes, and we designed the clothes by imagining what the characters in the story were wearing. Based on that, the direction and atmosphere of the video was decided and suitable music was produced. Other season concepts also are arranged through a similar, or sometimes even simpler, process. Overseas shoot locations also get decided similarly. As the design is being completed, we talk about the setting or background that suits it, such as cities, streets, forests. Of course, there are seasons for which the overseas shoot locations are decided from the beginning, but most times, we decide on the location based on the atmosphere of the sample.

WR Music appears in all of your seasons.
TN For the music, we work with the underground musicians and DJs of South Korea, starting with producer and DJ Somdef. Once we arrive at a broad image of the season, we discuss the music down to the smallest detail, such as "We'd like to have non-human sound here."

WR Do you listen to music while working?
TN The third floor where the Merchandiser and Customer Satisfaction teams sit is relatively quiet, but the second floor where the Design team works always has music whether loud or faint. Nobody is in charge of the music. People connect to the speakers on their smartphones via Bluetooth. They like Big Bang, Pharrell Williams, Frank Ocean, and Justin Bieber. Everybody's especially fond of Taeyang. When we got the speakers we're using now, we played his album first. Even if we don't like the song that's playing, we just listen to it. We can stand it for about three minutes.

WR Does your video style have any influences?
TN We especially like the music video for "Drop" by The Pharcyde made by American director and screenwriter Spike Jonze, and the movie *Being John Malkovich*. They've had a direct influence on our work too. None of us three has majored in photography or videography. Cho Nadan had an old-style film camera at home that we used to play around with and we found we liked the feel of film so we actively use film even now. But there's no place in South Korea that can process the film the way we like it, so we send the tape to a lab in LA. Making videos with a film camera is in a way the height of inefficiency so we find it appealing.

Where do images that have been discarded in the hierarchical order of images based on resolution and sharpness, that is images that are copied, edited, constantly circulated, and thus become blurry, go? They are expelled from the official screen and wander in a digital no-man's land. — Hito Steyerl, "In Defense of the Poor Image," *The Wretched of the Screen*

WR What do you consider crucial in studio shoots and in outdoors shoots?
TN A collection is completed with photos and videos shot in a studio. The styling and order of pictures are determined after considerable thought. Everything we've prepared over a long time is compressed into around thirty photos. This is the most important part of the lookbook for us. Since a few years ago, we have tried to avoid excessive change to the style of our lookbooks. For example, our studio photos have maintained the same style from the FW17 season. Conveying the season's feel is important, but on the other hand, a system needs to be in place so that we can fully focus on clothes and styling. Of course, it's not easy to create images that look different from season to season despite the similar composition, but we think there is a certain power generated in a repetitive system. Overseas shoots are part of a big experiment that we try every season. The focus here is on revealing things that the studio shoot didn't or couldn't bring out because of the limitations of the venue. Overseas shoots can take anywhere between fifteen days to a month. They're always fun, but I remember we had it the hardest during the shoot for the FW17 season in Iceland. We had to travel five hours back and forth from the filming location to our accommodation.

WR How do you select your models? Is race a consideration?
TN It's always difficult to pick the right model for each season. Regardless of nationality, we look for people and vibes that best suit the design, which naturally seems to lead us to work with non-Koreans mostly. We've never intentionally sought an exotic or non-nation-specific vibe, but now that I think about it, we've been doing it naturally. Meanwhile, it's not easy to work again with a model we've worked with before. After working with us, they apparently get many calls from other brands.

WR We often forget that books are products that consumers need, just like clothes. When it comes to products, not just making them but also how they're delivered to customers, that is, distribution, is important. The success or failure of a business depends on distribution.
TN We feel that our domestic distribution is sufficient at its current level. Not many places can match our color and they all have similar styles of showing it, so, unless we

really like the place, we have no intention of expanding. It's true for both online and offline distribution. We currently operate only one offline store in front of Hongik University. As everybody knows, the area in front of Hongik University has a cultural symbolism. At the same time, it's a litmus test for a brand. If you manage to gain a foothold here, then it's not difficult to expand to the Gangnam district or to another province.

WR What is the most efficient way of distribution?
TN If we consider only profit, then selling through our website or store is clearly the most efficient way because there are no fees involved. But the distributor a brand uses also reveals its character. So if on the one hand we decide that working with a certain distributor is effective for the brand, then there are also times when we do things inefficiently.

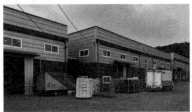

The warehouse in Paju. All the output of a season has to pass through here before it can reach the consumers.

WR Where is your warehouse located?
TN It's in Paju. Some of our employees live in Paju, but during times when we're short-handed, like in the early days of the season, Cho Nadan and Choi Jongkyu go there themselves to help with product inspection, packaging, and shipping. This may be the most important moment in the fashion industry given that it is the final step in the process of reaching the consumer.

WR What are your most popular items?
TN Our football T-shirt of the SS13 season with printed stripes on the front and sleeves. The same design was released by many brands next season. I don't know why. Maybe it's because the "overfit" design, which was unfamiliar or had been forgotten, looked fresh. Our most popular season to date is SS15 in which almost all of our products were sold out with the start of sales. Sales rose nearly 400 per cent from the previous year. In particular, we sold over twenty thousand pieces of our "Lake on Fire" ball caps. Everybody back then wore trucker mesh caps and snapbacks, but the atmosphere changed considerably after that season.

WR The collaboration of art and business has become natural since Andy Warhol, the self-styled American business-artist, introduced Campbell's soup cans and Coca-Cola bottles in his silkscreen prints. How do your collaborations start?
TN All our collaborations happened because of offers that came to us. We've got so many that we won't be able to talk about them all, but very few of them materialized. I think there are two main reasons that we get offers to collaborate: the advantage of appealing to the younger generation that's our main consumer base and our ability to create images.

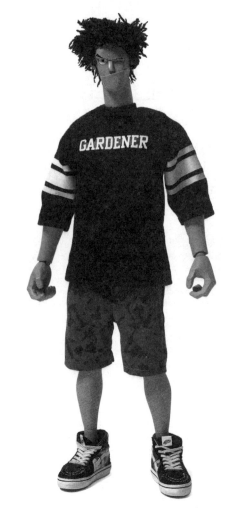

A figurine by artist Kido wearing a football T-shirt.

WR To what extent does active collaboration take place?
TN In all our collaborations, thisisneverthat has exclusive control of design. The biggest reason we collaborate with other brands is our desire to experiment with approaches we've never tried before while still maintaining our uniqueness. We also work on products that we can't make on our own, such as shoes and watches, by using the technology of the brands we collaborate with. In the process, we learn things we haven't given thought to. The partner brand handles the manufacturing while we coordinate the marketing and distribution mutually.

WR How long do your collaborations run for?
TN It varies from brand to brand, but on an average, they last from one year to a year and a half. Some people think of fashion collaboration as simply "adding one brand's logo to another brand's product," but there is much to prepare for and many details to be ironed out before and after for that simple task.

WR What is a successful collaboration?

TN Collaboration has almost become a necessity in today's fashion. We feel that we need to meet something completely different in our collaborations and derive something unexpected that anyone can admire. A collaboration can be said to be successful only if it leads to good sales.

WR How much of your limited editions do you produce? And which item sold out the fastest?

TN Our limited editions usually run up to a thousand pieces. Of course, some items are produced in much fewer numbers, so it varies. The watch we collaborated on with G-SHOCK sold out in almost a minute. None of us expected that. Our executives get no preferential treatment, so those who were planning to buy one for themselves were left disappointed.

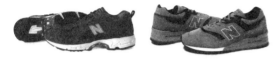

The shoes released in collaboration with New Balance in the SS20 and FW19 seasons.

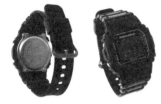

The watch released in collaboration with G-SHOCK in the SS20 season sold out in just one minute after sales were opened.

WR You opened an offline store in front of Hongik University in the spring of 2019. It's a traditional approach, but as a fashion brand, it signaled that you had achieved a major milestone. An offline store goes beyond the product to convey the brand's unique taste directly to consumers. What kind of experience do you want the consumer to have at your store?

TN Technically, it was an expansion. We moved our store that was in the alley to the main street. We hoped that the new offline store would allow us to show our products in our own way. An atmosphere where the consumer could try on our products comfortably.

WR The space design studio COM designed your offline store. How did you find the process?

TN Maybe it's because of the way we've showcased our brand so far, but people seem to expect something intense from thisisneverthat. But we thought that the space where we sold our clothes should be neat, tidy, and luxurious. COM gave shape to our thoughts. We found working with them comfortable and enjoyable and we were naturally happy with the results too. After finishing the store, they also handled the interior design of our office in the Yeonhui-dong district. We've also commissioned the design of our new studio to them.

In ten years' time, the store located in an alley near Hongik University moved to the main street.

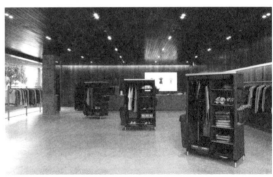

The middle of the offline store is usually kept empty. People and their activities take center stage here over clothes.

WR What is your favorite part of the store?

TN We kept the middle of the store completely empty. We wanted people and their activities to be the center of the space rather than the clothes. These days, the minimum floor size of the store is set according to the brand's concept, and based on that standard, the interior cost, number of employees, and sales per square meter is calculated. In other words, the size of the store has an absolute influence. In this regard, our attempt is considered too bold, but in our experience, an inefficient approach is always cooler.

WR You built your current office building in the Yeonhui-dong district around the same time. COM was in charge of the interior design while FHHH Friends did the exterior.

TN As in all collaborations, we respect the opinion of our collaborators as much as possible in areas we don't know much about or are not confident about doing well. This guarantees autonomy but at the same time assigns responsibility. In addition, there are areas of expertise we can't reach simply by feeling. For example, we wanted the exterior of our office to have a transparent glass finish, but FHHH Friends insisted on opaque glass to the end. They said we had to do it that way. In the end, we accepted their opinion, and the more time we spend at the office now, the more we realize their decision was the right one.

We rebuilt the existing building into an almost new one. We slightly modified the building's floor plans and changed the exterior a little. A part of the box was removed to allow space for trees and sunlight. The concrete panels on the exterior were replaced with glass panels. We wanted to create a refreshing atmosphere. — FHHH Friends, *Openhouse Seoul 2019*

The exterior of the office building was eventually finished in opaque glass.

WR It's natural for a space to differ depending on the purpose. A store is a place to sell products and an office is a place for work. Did you have any special considerations while designing your office?

TN We didn't have detailed instructions for everything. Perhaps because of the experience of working in a semi-basement in our early days, we wanted a space that was filled with light where the employees would be comfortable and happy to work. We were particular about things our employees would use on a daily basis, like the Herman Miller Aeron chairs.

The Herman Miller Aeron chairs. The office should be a place where employees can work happily.

WR For the book and website commemorating your tenth anniversary, you approached Workroom Press first.

TN We've been paying attention to the graphic design work and books of Workroom Press since early on. Fortunately, they began to publish books about fashion starting with *Fashion vs. Fashion* by fashion columnist Park Saejin in 2016. Books like Yasuhiko Kobayashi's *Heavy Duty Book* and Park Saejin's *A Study of Daily Wear* in their "practical book series" were fun to read. *Retromania: Pop Culture's Addiction to Its Own Past* by Simon Reynolds and *The Wretched of the Screen* by Hito Steyerl were also good. When it came to the book, we thought we could entrust it to Workroom Press without any worries.

WR Workroom Press suggested adding codes to all your products and cataloguing them. It must not have been an easy decision as a brand.

TN We've had our share of difficulties in the ten years we've been in business and we thought we'd dealt with things as they cropped up, but as we looked back on our designs while cataloging them we realized we had done quite a few. It's an exhausting job at times, since you have to see and touch everything with your eyes and hands, but we can confidently say we've never once been bored. We were lucky in that we chose work we'll like all our lives. Initially, our goal, like any other brand, was to survive in the market. That is still in progress. Now we have a new goal to keep working with the same attitude and manner till our twentieth year.

WR What is it that you really hate doing?

TN Interviews. When it comes to the brand, we try to avoid explaining every little thing or have one or two people represent the brand, but in an interview, we have to do both things that we try to avoid and do a good job while we're at it. We tend to politely turn down most interview requests. As much as we value our work as a team, unless necessary, we want to be introduced as thisisneverthat and not as specific individuals. This attitude is also reflected in the copyright section of our lookbooks. Except for the models, photographers, and musicians, everybody is credited as thisisneverthat.

WR Conversely, is there anybody you would like to interview?

TN Takahiro Kinoshita, who has moved on to Uniqlo now, but was the editor-in-chief of *Popeye* magazine for a long time. We enjoyed reading *Popeye* so much we'd collect the issues, but we're also curious about the planning, editing, and design, and the attitude that brought them all together. An acquaintance interviewed him recently and we were shocked to hear that he knew about thisisneverthat.

WR What is your favorite brand, irrespective of the industry, and why?

TN Nike and Comme des Garcons. We don't really know why. If you have too many reasons to like something, then you feel like you don't know the reason or feel that there's no reason.

WR As the brand grows, you require new people. What do you consider as important when you hire people? For example, at Workroom Press, we tend to ask applicants what their favorite brands are, irre-

spective of the industry. You can tell the person's tastes and interests from the brands they like.

TN Apart from skill and personality, we value style as well. If your outfit for the interview is all the same color, then, unfortunately, it's highly unlikely you'll hear good news from us. If you're our employee, then it's important that you have your own taste and your own thoughts about the brand so that you can offer your opinions as we plan a product. If you go with us readily then we can work together happily for a long time. We consider our community as more important than showcasing products every season.

WR How many people do you employ in total?
TN As of 2020, we have fifty-two people working for us. Since we deal in menswear, the proportion of men is inevitably higher.

WR Do they all have to wear thisisneverthat clothes?
TN It's not mandatory, of course. Our employees fall into the consumer base of thisisneverthat. It's hard to compare, but they seem to have more affection for the brand they work for than employees of other brands do. There are times when we make clothes that our employees will like, and our in-house statistics are reflected in our product planning. This all stems from our belief in the tastes of the people we employ.

WR When people spend considerable time together, it's natural for a culture to form. What is thisisneverthat's office culture like?
TN The employees often use one another's bad photos as their profile pictures on social media. You can't do that unless you're close. Including us three, a considerable number of people among the founding members come from the same school. As a result, we naturally share a relationship that's much more comfortable than a work relationship. The people who joined the company later were greatly influenced by this atmosphere. The employees are about the same age and their interests overlap, so they get along without reservations. They play sports like soccer, swimming, and tennis, or go for drinks together. We also frequent PC bangs, but after the COVID-19 pandemic, we've set up a simple PC Bang in one corner of the office.

The office PC bang. In the post-Corona era, the safety of not only customers but also employees is important.

WR Everyone has a role model, whether big or small. Role models affect not only one's direction of life but also habits, tone, and even trivial jokes shared with family or friends. And obviously they can affect the brand philosophy and product design too.

TN The members of thisisneverthat are one another's role models. A role model is never far away.

WR Where do you get the ideas for your designs?
TN We have no separate activity for getting ideas. But we always keep an eye out for the work of other contemporary designers and derive inspiration from the street fashion of the 1990s to 2000s.

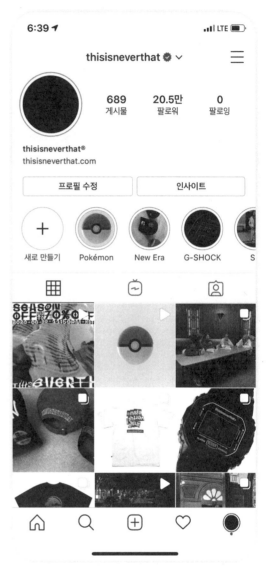

@thisisneverthat

WR How do you use social media? For example, what process do you go through when you post images on Instagram? Do you have any special strategies to get likes?
TN Social media has become the most powerful and influential media today. There's nothing strange about the reality today of everybody being connected through social

media. It looks trivial, but the frequency and timing of our posts and the harmony with our other posts are all calculated. But we limit the information we reveal to product image, name, and sale timing. We read all the comments or messages on the posts. We answered all questions in the beginning, but unfortunately, we can't do that anymore.

Kenneth Goldsmith, the American poet and operator of UbuWeb (http://ubu.com), the site that archives avant-garde material, said at a conference at the University of Pennsylvania in 2005, "If it doesn't exist on the internet, it doesn't exist." This is a terrible truth. Even more so in the "post-Corona era" as the web, which is now almost synonymous with the internet, has become closer to reality or is about to replace reality on another level. Information today is innumerable to the point of making the task of sorting it is pointless, and information that is not digitized does not reach the audience unless they have enough time or are diligent. —Min Guhong, "Swimming in a Puddle Made of Lists," *Littor*

WR You introduce around ten products per week in a season.

TN Consumers easily lose interest if we introduce our products all at once at the start of the season. We ourselves were no different as consumers of other brands. We benchmarked Supreme who attempted this method first, but after several attempts, we settled on our own approach. We release about ten products per week over twelve to thirteen weeks for a total of 150 products in a season.

WR Hip-hop musicians like Swings and Giriboy have appeared in thisisneverthat's clothes on the rap battle TV show "Show Me the Money." What's your marketing strategy?

TN We don't have a separate department dedicated to marketing or PR. Actually, there's no need for one. This is because we think our actions themselves, whether big or small, are both marketing and promotion. Of course, we sponsor the clothes of celebrities who're close to us but only on rare occasions. What I mean is that we don't treat it like a one-time thing but consider whether they really like our brand. The celebrities' stylists usually pick the thisisneverthat clothes they wear on shows and we have no say in it.

WR What is the most important thing in clothes, irrespective of brand?

TN How you deal with clothes. We think that your life is decided by what you wear. Shall we say, "You live like you wear"? Sticking to one or two styles or having no taste for clothes is also a taste in itself. Your outfit is decided among numerous choices and time passes along with that outfit. At first, the fabric, subsidiary materials, patterns, silhouettes, and later washing and aging methods become important. There's no life without clothes.

WR What is your favorite shopping spot?

TN Nowadays, we enjoy shopping online rather than offline. The clothes and brands we're interested in frequently change with changes in our tastes. Or rather, we're always on the lookout for new things. We treat that like work too. These days, we sometimes look for something new in brands or clothes we tried a long time ago. Basically, we like clothes. We like both wearing and seeing clothes. Sometimes things unrelated to work become our work. On the other hand, clothes start feeling meaningless at some point, especially when it's the mid-season when all brands are pouring out their designs.

WR In early 2020, the world was hit by an unexpected disaster. Everybody Is still reeling from it with all schedules cancelled or postponed. Chrome Hearts has even come out with facemasks. What is your contingency plan for the "post-Corona era"?

TN We don't have the capacity to assume a social role as international brands do. In times like these, we need to focus on ourselves a little more. More important than anything else is to create an environment where our employees can work with confidence. We always ask our employees who interact with customers to be careful at all times. Meanwhile, the gathering of people, once considered natural and taken for granted, has become unnatural, so we inevitably have to focus more on online than offline.

I'll say this again, but the world before Covid-19 won't come back. It's a completely different world now. Quarantine measures to block and prevent the risk of infectious diseases in daily life will become an everyday routine. — Kwon Joonwook, Deputy Director, Central Disease Control Headquarters, Regular Briefing, April 11, 2020

WR What changes are you planning after 2020?

TN The first floor of our office building is empty right now and we're preparing a "select store" there. We'll showcase thisisneverthat along with other brands. We haven't decided the name yet, but we intend to demonstrate our selection in a different way. On the other hand, based on the experience we've accumulated over our numerous collaborations so far, we plan to introduce a new brand with a concept different from thisisneverthat within this year. We can't reveal them right away, but we're also working on new collaborations and we'll slowly unveil them from fall 2020 to spring 2021. Much will happen at thisisneverthat in the future, but we intend to maintain our current attitude and style.

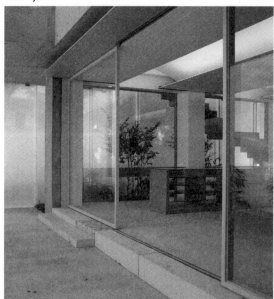

The first floor of the office building where Khakis will open.

WR Numerous brands will continue to appear and disappear in the future. Some of them will look at thisisneverthat right now. What do you need most when starting a brand?

TN In the early days, we'd run into things every day that we couldn't handle by ourselves and things we'd never even thought of. Whenever that happened, we didn't worry too much and always worked with the people beside us. In that sense, what you need most when you start a brand is a colleague who'll be with you. You also need patience because it takes time to generate sales after the brand becomes known.

Translation
Agnel Joseph

WR T-shirts are flat. Books are flat too. What do you think is a T-shirt?

TN A T-shirt might look flat but that's only because it's thin but it's actually a three-dimensional structure with different patterns on the front and back. Its three-dimensional structure becomes more pronounced after it's worn over the body. Isn't that the case with books too? The moment you open a book, it becomes a three-dimensional structure, and the writing and illustrations are all structured in three-dimensions. They all look flat, but they hold infinite three-dimensionality within them.

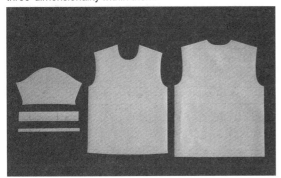

A cloth pattern maybe flat but in the end it becomes three-dimensional.

WR What's the oldest piece of clothing in your closet?

TN An A.P.C. French M-65 jacket. It's a vintage jacket that I bought in 2007 when I was in college. It's functional and comfortable so I wear it without a second thought. I tend to dispose of clothes that I haven't worn in a long time. You can't call it a cloth if you keep it in your closet without wearing it. Thisisneverthat's clothes should also be treated in the same way.

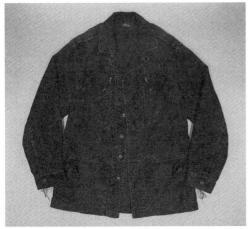

The M-65 jacket owned by Park Inwook.

FALL/WINTER 2018

ADVENTURER II

TN18FKW001BK, Top, Striped Oversized Knit Sweater ◍ TN18FHS008IR, Sweatshirt, GLOBE Hooded Sweatshirt ◍ TN18FPA017NA, Pants, Tiedye Sweatpant

TN18FOW010OV, Jacket, Reversible International Jacket ◍ TN18FHS005IR, Sweatshirt, BB TINT Hooded Sweatshirt ◍ TN18FPA003DP, Jean, Big Jean ◍ IN18FHW003NA, Hat, POMPOM Beanie

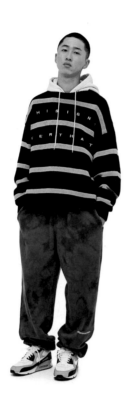

TN18FSH004YL, Shirt, HSP Sport Shirt ◍ TN18FPA007IDG, Jean, Weekend Wide Jean ◍ TN18FHW006BL, Hat, SP-Logo Cap

TN18FHS001IR, Sweatshirt, L-Logo Zipup Sweat ◍ TN18FTS006OO, Long Sleeve Tee, EMB. L-Logo Stripe L/SL Top ◍ TN18FPA007DP, Jean, Weekend Wide Jean

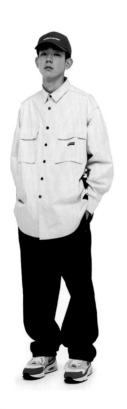

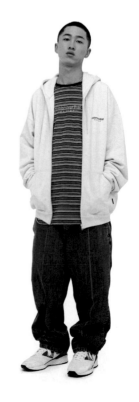

TN18FOW007OV, Jacket, T-Logo ECW Parka ‖ TN18FSW006IR, Sweatshirt,
Silver College Crewneck ‖ TN18FPA009BK, Pants, Corduroy Pant ‖
TN18FHW007BE, Hat, L-Logo Fleece Camp Cap

TN18FSW013NA, Top, Side Zip Track TOP ‖ TN18FTS007WH, Long Sleeve Tee,
L-Logo Turtle Neck L/S ‖ TN18FPA003DP, Jean, Big Jean

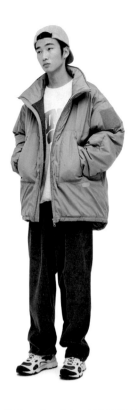

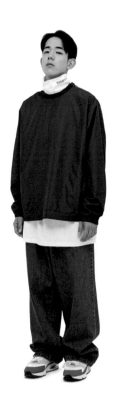

TN18FOW006GN, Jacket, SP Sport Down Jacket ‖ TN18FSH001GN, Shirt, MI-
Logo Oversized Check Shirt ‖ TN18FPA015RD, Pants, Basic Sweatpant

TN18FHS005FR, Sweatshirt, BB TINT Hooded Sweatshirt ‖ TN18FPA003BK,
Jean, Big Jean ‖ TN18FHW004PK, Hat, T-Logo Short Beanie ‖ TN18FBA001NA,
Bag, CORDURA® 750D Nylon Waist Bag

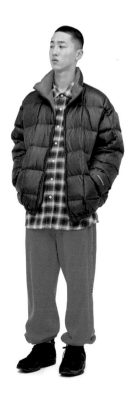

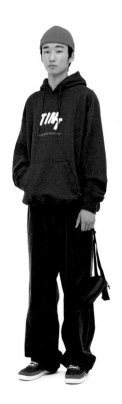

TN18FOW013NA, Jacket, ADVENTURER Varsity Jacket ◍ TN18FHS003IR, Sweatshirt, NEW SPORT SP Hooded Sweatshirt ◍ TN18FPA002TW, Jean, Crazy Jean

TN18FSW007SB, Sweatshirt, T-Logo Crewneck ◍ TN18FPA012BK, Pants, Carpenter Pant ◍ TN18FHW0010R, Hat, DIA-HSP Logo Beanie

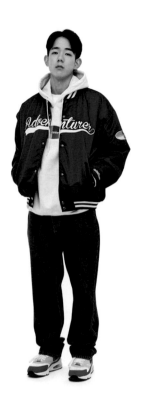

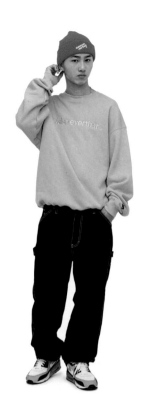

TN18FOW017CH, Jacket, Puffy Half Zip Parka Jacket ◍ TN18FPA018IV, Pants, Leather Pant ◍ TN18FHW007BE, Hat, L-Logo Fleece Camp Cap

TN18FSW014BK, Sweatshirt, Boa Fleece Crewneck ◍ TN18FPA002, Jean, Crazy Jean ◍ TN18FHW001BK, Hat, DIA-HSP Logo Beanie

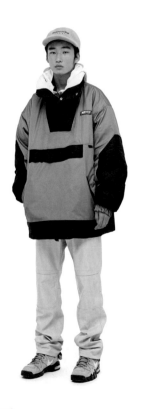

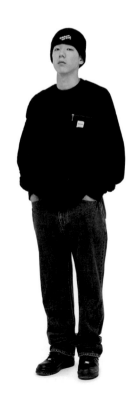

TN18FSW001BU, Sweatshirt, SCRT-Logo Paneled Crewneck ▪ TN18FPA010GR, Pants, Velcro Track Pant ▪ TN18FPA006GN, Pants, T-Logo Paneled Warm Up Pant

TN18FOW018BK, Jacket, Multi Leather Jacket ▪ TN18FPA006GN, Pants, T-Logo Paneled Warm Up Pant ▪ TN18SAC002BK, Accessory, VIK Sunglasses

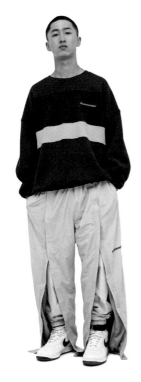

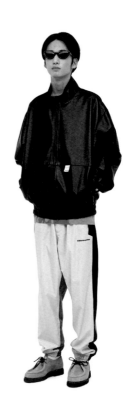

TN18FOW006BK, Jacket, SP Sport Down Jacket ▪ TN18FSW007BK, Sweatshirt, T-Logo Crewneck ▪ TN18FPA012BK, Pants, Carpenter Pant

TN18FOW009IV, Jacket, SP Boa Fleece Jacket ▪ TN18FHS007GN, Sweatshirt, HSP Hooded Sweatshirt ▪ TN18FPA014GN, Pants, MI-Logo Sweatpant

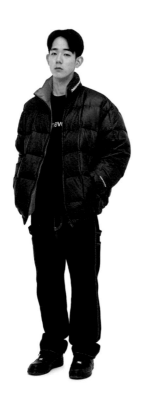

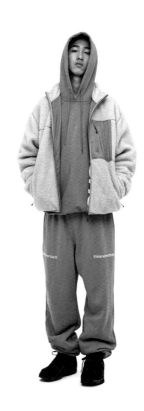

TN18FOW018WH, Jacket, Multi Leather Jacket ◍ TN18FTS007BE, Long
Sleeve Tee, L-Logo Turtle Neck L/S ◍ TN18FPA003BK, Jean, Big Jean ◍
TN18SAC002BK, Accessory, VIK Sunglasses ◍ TN18FBA002BE, Bag, Nylon
Shoulder Bag

TN18FOW007BK, Jacket, T-Logo ECW Parka ◍ TN18FSW002IL, Sweatshirt,
ADVENTURER II Crewneck ◍ TN18FPA009GR, Pants, Corduroy Pant ◍
TN18FHW009BK, Hat, MOHUM Cap

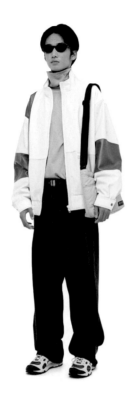

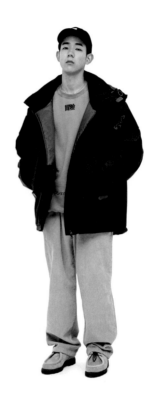

TN18FOW020BK, Jacket, Leather Motorcycle Jacket ◍ TN18FTS005PW, Long
Sleeve Tee, Small L-Logo Stripe L/SL Top ◍ TN18FPA017PP, Pants, Tiedye
Sweatpant

TN18FOW012OV, Jacket, M-51 Field Parka ◍ TN18FOW011GR, Jacket, T-Logo
Paneled Windbreaker ◍ TN18FPA016IR, Pants, F-Column Sweatpant ◍
TN18FHW010IV, Hat, Fishing Hiking Hat

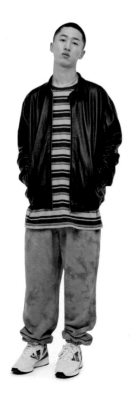

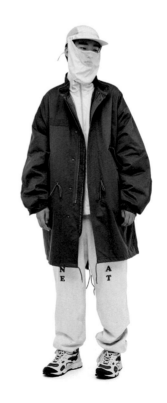

TN18FOW015GN, Jacket, Wool Zip Jacket ❚ TN18FSW003SO, Sweatshirt, Nightscape Crewneck ❚ TN18FPA011BK, Pants, Classic Wide Pant ❚ TN18SAC002BK, Accessory, VIK Sunglasses

TN18FSW004BK, Sweatshirt, INTL. Logo Crewneck ❚ TN18FPA012GR, Pants, Carpenter Pant ❚ TN18SAC002BK, Accessory, VIK Sunglasses

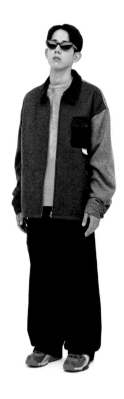 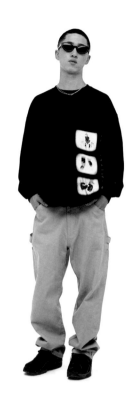

TN18FOW003NA, Jacket, L-Logo Padded Bench Parka ❚ TN18FSH007BE, Top, SP L/SL Jersey Polo ❚ TN18FPA006GN, Pants, T-Logo Paneled Warm Up Pant ❚ TN18SAC002BK, Accessory, VIK Sunglasses ❚ TN18FAC001BL, Accessory, DIA-HSP Gloves

TN18FOW016NA, Jacket, Zip Jacket ❚ TN18FTS002OV, Long Sleeve Tee, Multi Color L/SL Top ❚ TN18FPA010IM, Pants, Velcro Track Pant

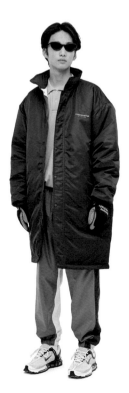 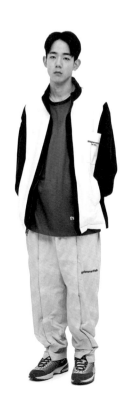

ADVENTURER II

TN18FOW005RD, Jacket, T-Logo Puffer Down Vest ◉ TN18FSH007LV, Top,
SP L/SL Jersey Polo ◉ TN18FPA011BE, Pants, Classic Wide Pant ◉
TN18SAC003BK, Accessory, Skogar Sunglasses

TN18FOW002BK, Jacket, DSN-Logo Oversized Down Parka ◉ TN18FOW008IV,
Jacket, Hooded Fleece Jacket ◉ TN18FPA005IV, Pants, Fleece Pant ◉
TN18FHW006BK, Hat, SP-Logo Cap

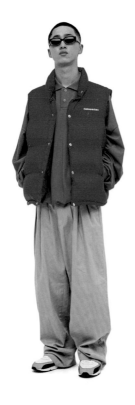

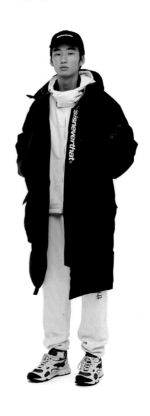

TN18FOW004BL, Jacket, DIA-SP Sport Down Vest ◉ TN18FSW016BE, Top,
DSN Fleece Half Zipup ◉ TN18FPA010CH, Pants, Velcro Track Pant ◉
TN18FHW001OR, Hat, DIA-HSP Logo Beanie

TN18FOW019IV, Jacket, Leather Coach Jacket ◉ TN18FTS005KR, Long Sleeve
Tee, Small L-Logo Stripe L/SL Top ◉ TN18FPA009OV, Pants, Corduroy Pant
◉ TN18FHW009BK, Hat, MOHUM Cap ◉ TN18FBA001BK, Bag, CORDURA® 750D Nylon
Waist Bag

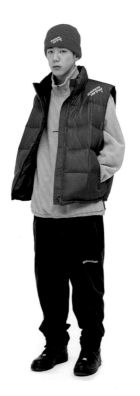

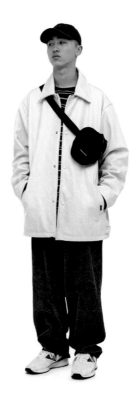

TN18FOW023BK, Jacket, thisisneverthat × Alpha Sherpa MA-1 ◍
TN18FHS008IR, Sweatshirt, GLOBE Hooded Sweatshirt ◍ TN18FPA014TG,
Pants, MI-Logo Sweatpant

TN18FSH002GR, Shirt, L-Logo Oversized Check Shirt ◍ TN18FPA001DP,
Jean, Regular Jean ◍ TN18FHW006BK, Hat, SP-Logo Cap ◍ TN18FBA005NA,
Bag, CORDURA® 750D Nylon Messenger Bag

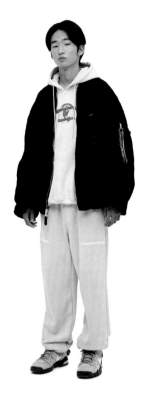

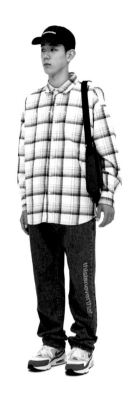

TN18FHS010YL, Sweatshirt, SP-Logo Fleece Hooded Sweatshirt ◍
TN18FSW011BU, Sweatshirt, ARC-Logo S-Collar Sweatshirt ◍ TN18FPA019BK,
Pants, Wool Trouser ◍ TN18FHW003BK, Hat, POMPOM Beanie

TN18FSW003SB, Sweatshirt, Nightscape Crewneck ◍ TN18FPA009GR, Pants,
Corduroy Pant ◍ TN18FHW006BL, Hat, SP-Logo Cap

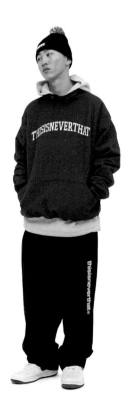

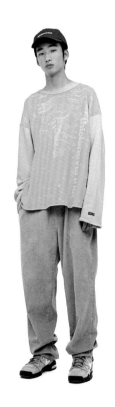

TN18FHS004IR, Sweatshirt, Ellipse Hooded Sweatshirt ❙ TN18FPA008BL, Pants, Cargo Pant

TN18FOW001WH, Jacket, INTL. Logo CITY Down Parka ❙ TN18FSH005SB, Shirt, MI-Logo Oxford Shirt ❙ TN18FPA019BK, Pants, Wool Trouser ❙ TN18FBA005BK, Bag, CORDURA® 750D Nylon Messenger Bag

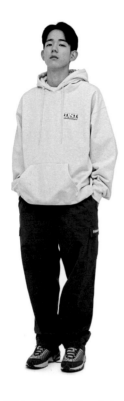

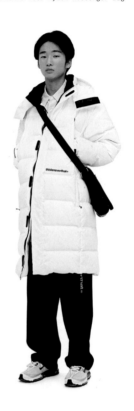

TN18FOW0020V, Jacket, DSN-Logo Oversized Down Parka ❙ TN18FOW011BK, Jacket, T-Logo Paneled Windbreaker ❙ TN18FPA006BK, Pants, T-Logo Paneled Warm Up Pant

TN18FSW008NA, Sweatshirt, NEW SPORT SP Crewneck ❙ TN18FPA001TB, Jean, Regular Jean ❙ TN18FAC001BL, Accessory, DIA-HSP Gloves ❙ TN18SAC003BK, Accessory, Skogar Sunglasses

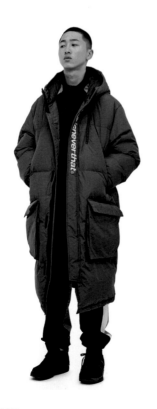

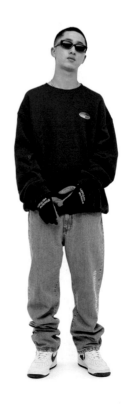

TN18FSH003BL, Shirt, SP-Logo Sherpa Shirt ◊ TN18FHS004NA, Sweatshirt, Ellipse Hooded Sweatshirt ◊ TN18FPA007DP, Jean, Weekend Wide Jean

TN18FSW010VR, Sweatshirt, Multi Striped Crewneck ◊ TN18FPA007DP, Jean, Weekend Wide Jean ◊ TN18FHW007BK, Hat, L-Logo Fleece Camp Cap ◊ TN18FBA003BK, Bag, CORDURA® 750D Nylon SP Backpack

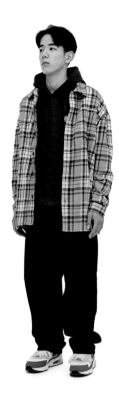

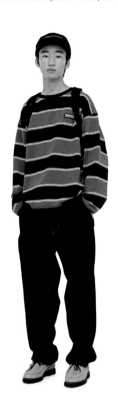

TN18FOW021GR, Shirt, Oversized Cord Shirt Jacket ◊ TN18FHS010BK, Sweatshirt, SP-Logo Fleece Hooded Sweatshirt ◊ TN18FPA009BK, Pants, Corduroy Pant

TN18FOW010BK, Jacket, Reversible International Jacket ◊ TN18FTS003IR, Long Sleeve Tee, HSP L/SL Top ◊ TN18FPA004BK, Pants, T-Logo ECW Pant ◊ TN18FHW001BL, Hat, DIA-SP Logo Beanie

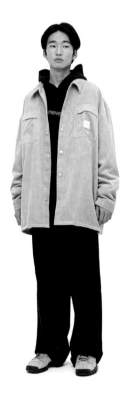

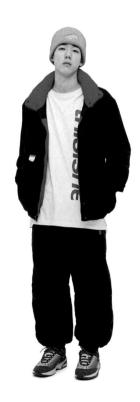

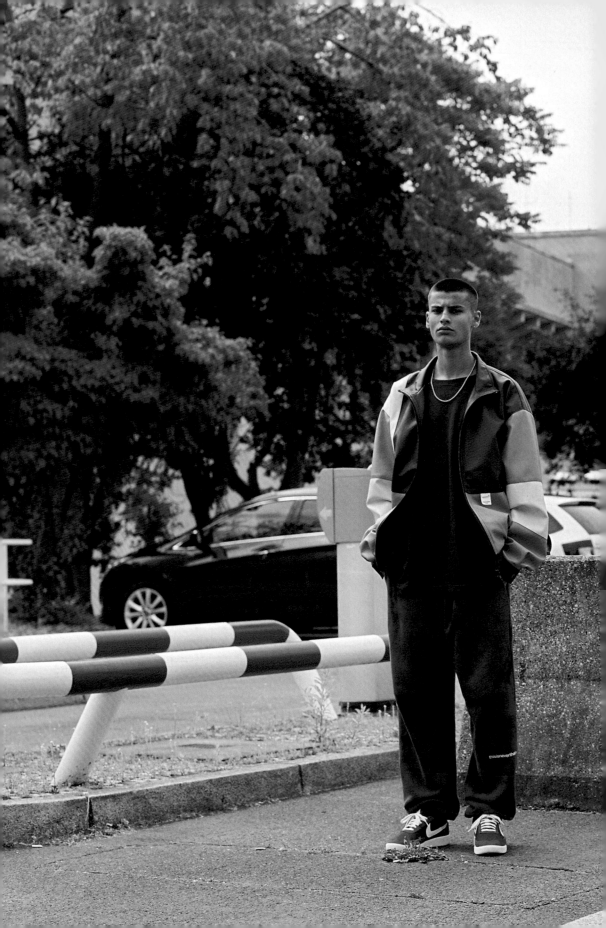

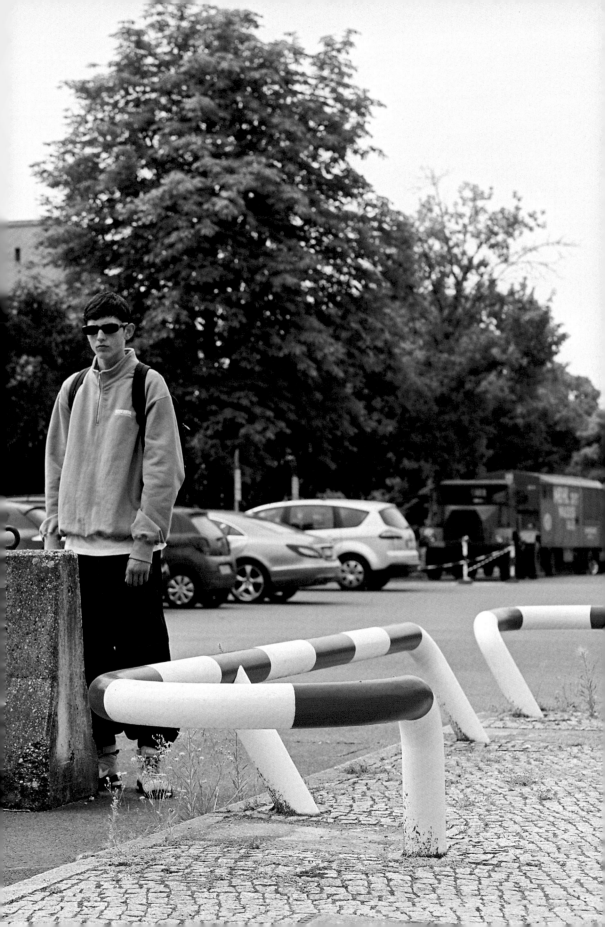

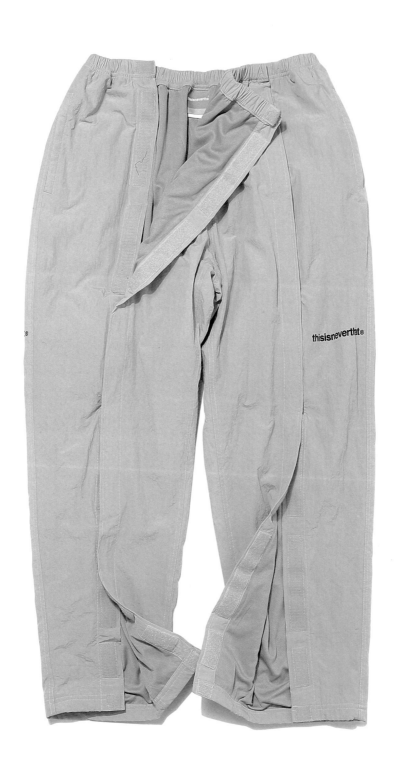

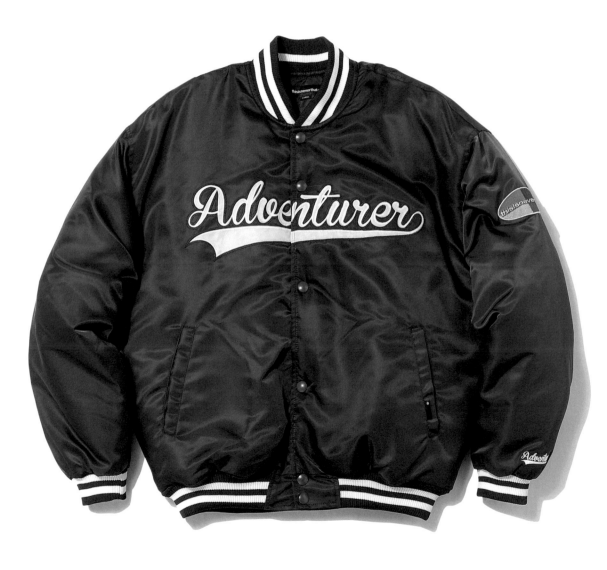

ADVENTURER II

TN18FOW011BK / Jacket
T-Logo Paneled Windbreaker
Polyester / Black

TN18FOW008IV / Jacket
Hooded Fleece Jacket
Polyester, Nylon / Ivory

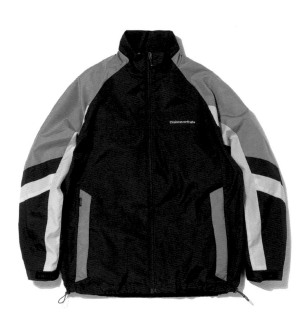

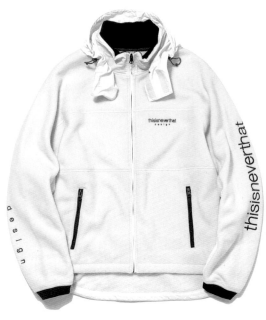

TN18FOW010OV / Jacket
Reversible International Jacket
Nylon, Polyester / Olive

TN18FOW007BK / Jacket
T-Logo ECW Parka
Polyester, Nylon, 3M Thinsulate / Black

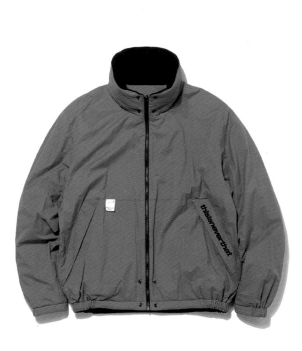

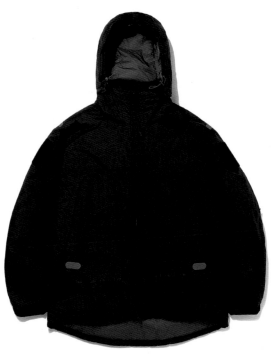

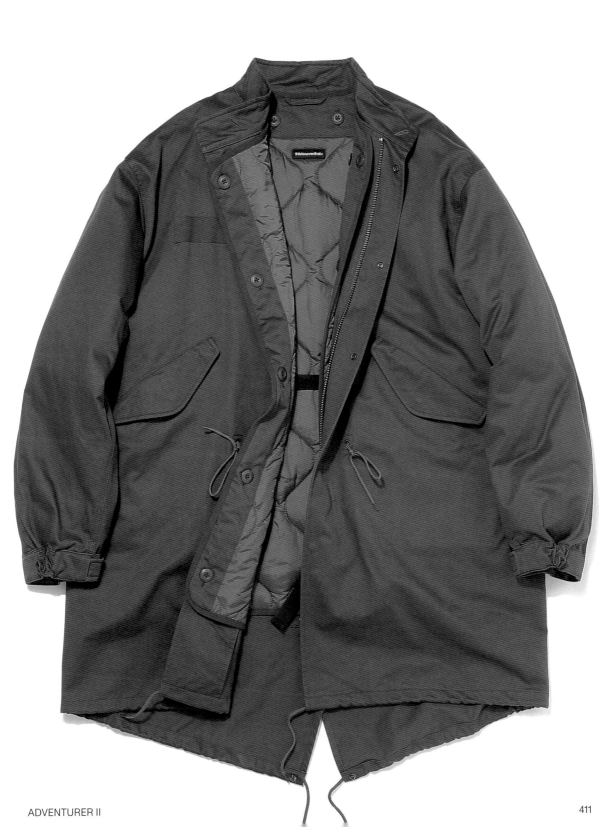

ADVENTURER II

Directed by Kim Mintae
Music by Somdef

TN18FOW009OV / Jacket
SP Boa Fleece Jacket
Polyester, Acrylic, Nylon / Olive

TN18FSW016NA / Top
DSN Fleece Half Zipup
Polyester / Navy

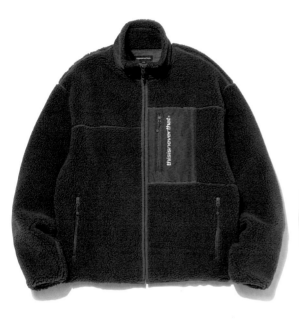

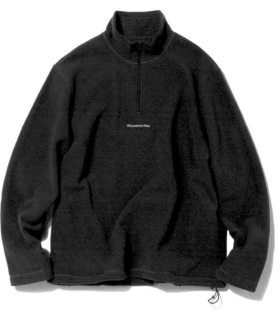

TN18FOW015GR / Jacket
Wool Zip Jacket
Wool, Nylon / Grey

TN18FOW023GM / Jacket
thisisneverthat × Alpha Sherpa MA-1
Nylon, Polyester / Gun Metal

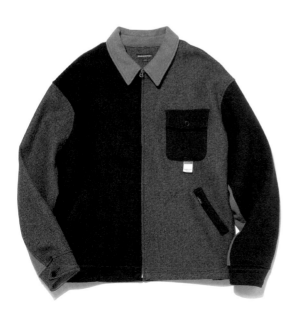

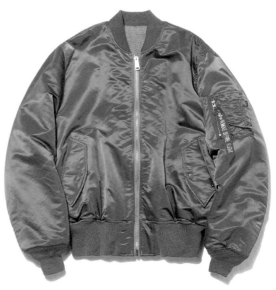

TN18FOW002BK

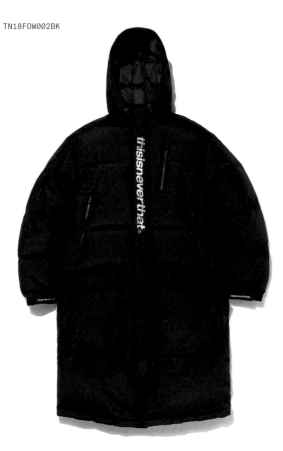

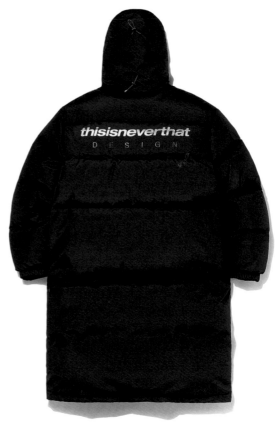

TN18FOW002OV

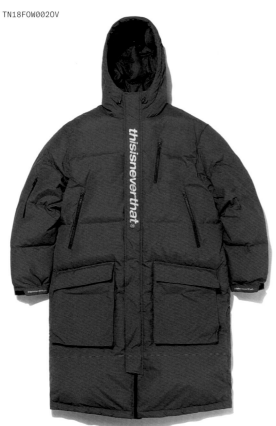

TN18FOW001WH

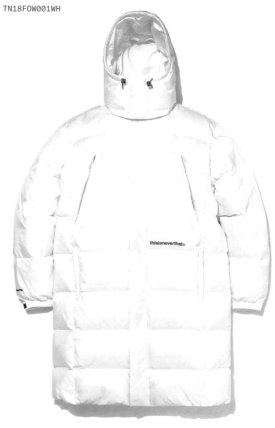

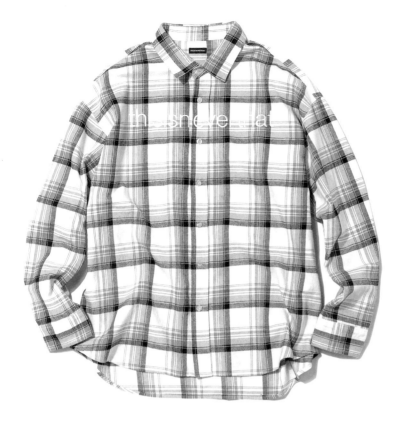

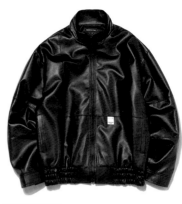

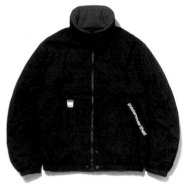

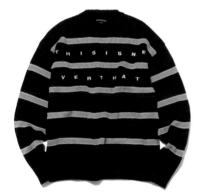

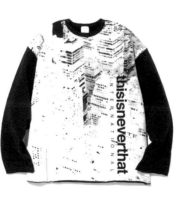

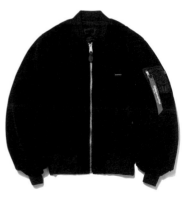

TN18FOW002BK	Jacket	DSN-Logo Oversized Down Parka	Polyester, Down, Feather	Black
TN18FOW002OV	Jacket	DSN-Logo Oversized Down Parka	Polyester, Down, Feather	Olive
TN18FOW001WH	Jacket	INTL. Logo CITY Down Parka	Nylon, Polyester, Down, Feather	White
TN18FSH002GR	Shirt	L-Logo Oversized Check Shirt	Cotton	Grey
TN18FOW018BK	Jacket	Multi Leather Jacket	Polyurethane, Rayon, Polyester	Black
TN18FOW010BK	Jacket	Reversible International Jacket	Nylon, Polyester	Black
TN18FKW001BK	Top	Striped Oversized Knit Sweater	Cotton	Black
TN18FSW003BK	Sweatshirt	Nightscape Crewneck	Cotton	Black
TN18FOW023BK	Jacket	thisisneverthat × Alpha Sherpa MA-1	Nylon, Polyester	Black

THISNE
INTERNA

FA

Haubenmeise ♂ ♀

TN18FPA006GR

TN18FPA005BK

TN18FPA018BK

TN18FPA013MT

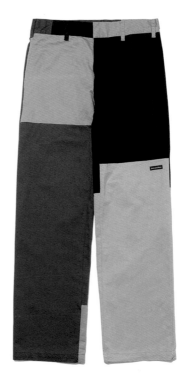

TN18FPA002TW

TN18FPA001TB

426

TN18FPA017PP

TN18FPA015RD

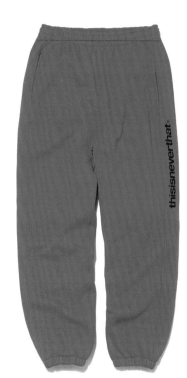

TN18FPA016IR

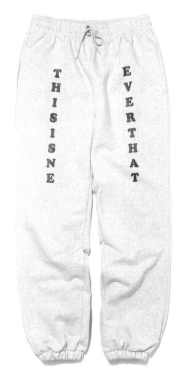

TN18FPA018BK	Pants	Leather Pant	Genuine Leather, Polyester	Black
TN18FPA005BK	Pants	Fleece Pant	Polyester	Black
TN18FPA006GR	Pants	T-Logo Paneled Warm Up Pant	Polyester	Grey
TN18FPA016IR	Pants	F-Column Sweatpant	Cotton	Light Grey
TN18FPA015RD	Pants	Basic Sweatpant	Cotton	Red
TN18FPA017PP	Pants	Tiedye Sweatpant	Cotton	Purple
TN18FPA001TB	Jean	Regular Jean	Cotton	Light Blue
TN18FPA002TW	Jean	Crazy Jean	Cotton	#2
TN18FPA013MT	Pants	Work Pant	Cotton	Multi

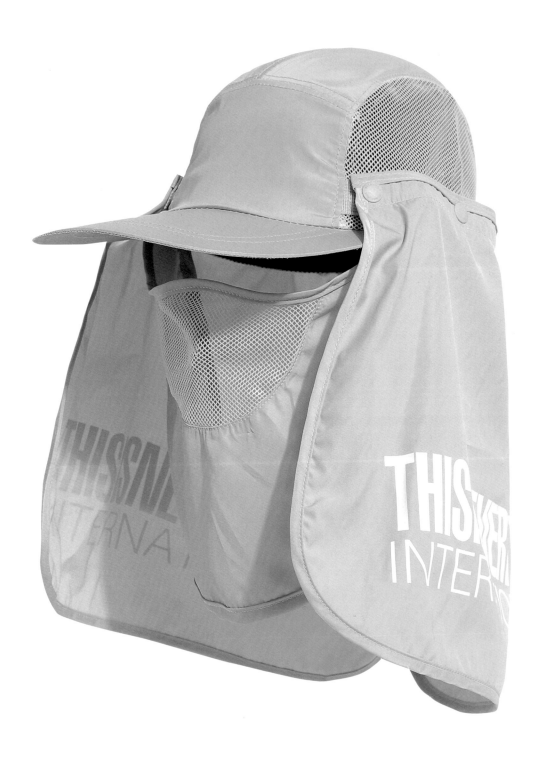

TN18FBA004NA / Bag
CORDURA® 750D Nylon CP-INTL. Logo BOP
Nylon / Navy

TN18FHW008NA / Hat
ADVENTURER II Cap
Cotton, Nylon / Navy

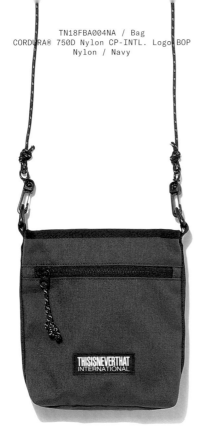

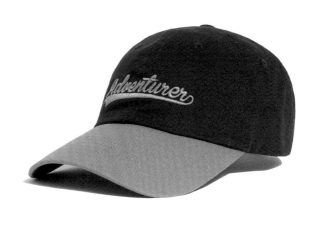

TN18FAC006BK / Accessory
HSP Zippo®
Black

TN18FHW002BK / Hat
HSP Ear Flat Hat
Polyester / Black

ADVENTURER II

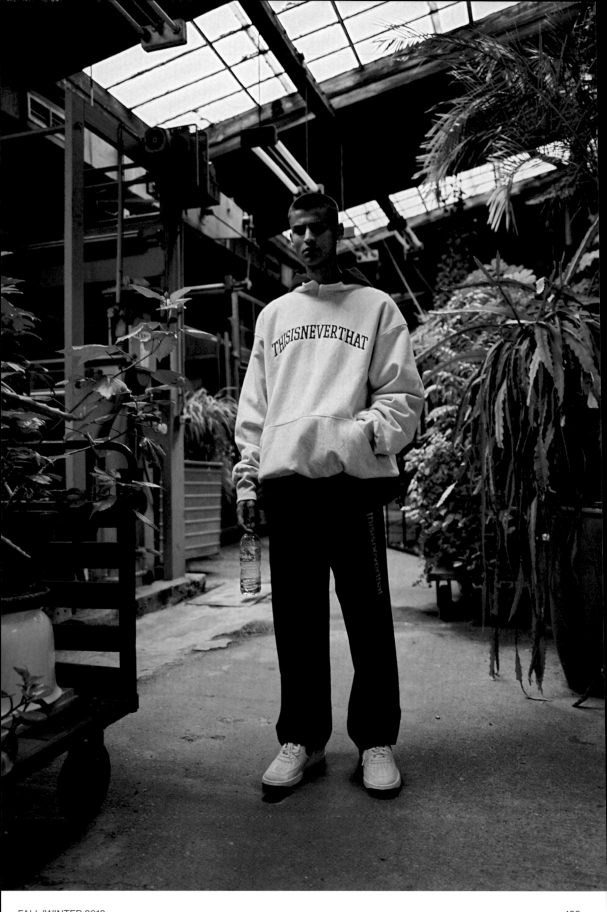

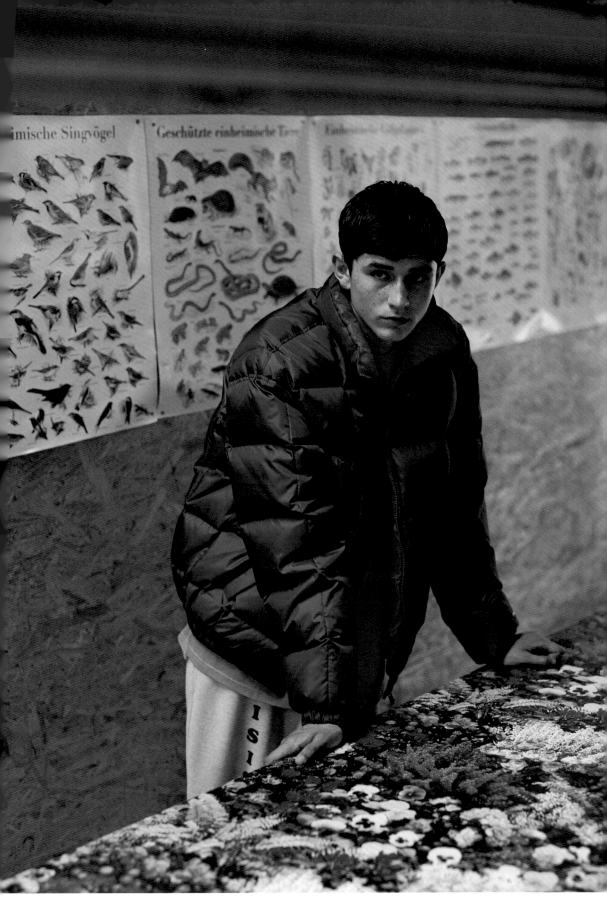

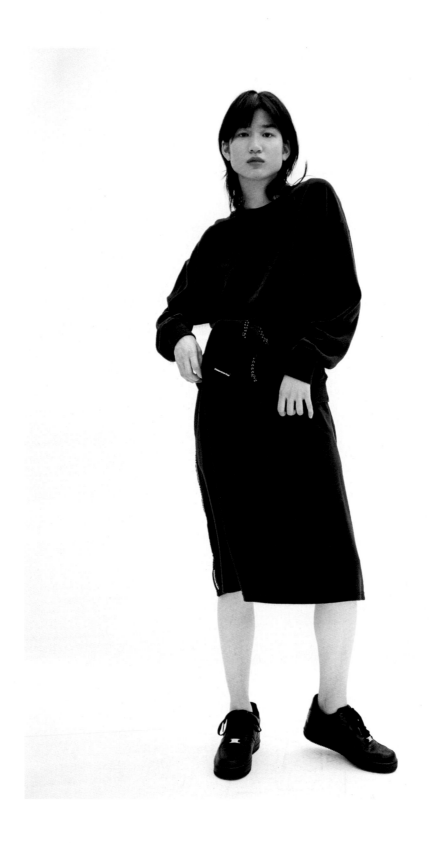

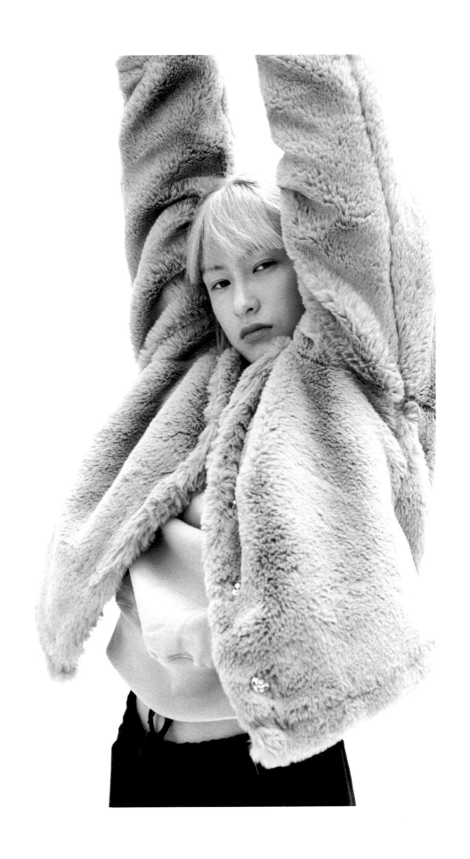

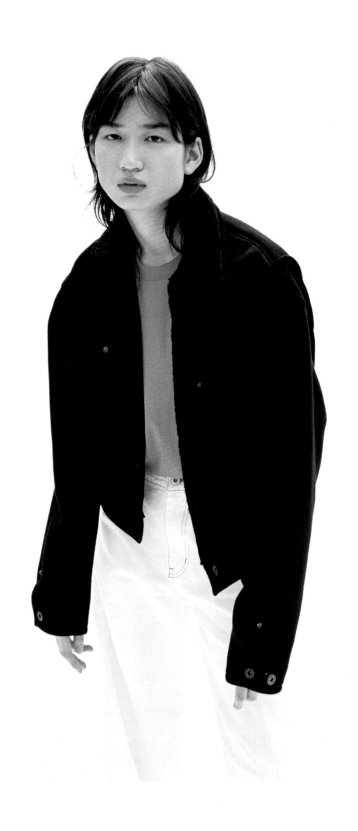

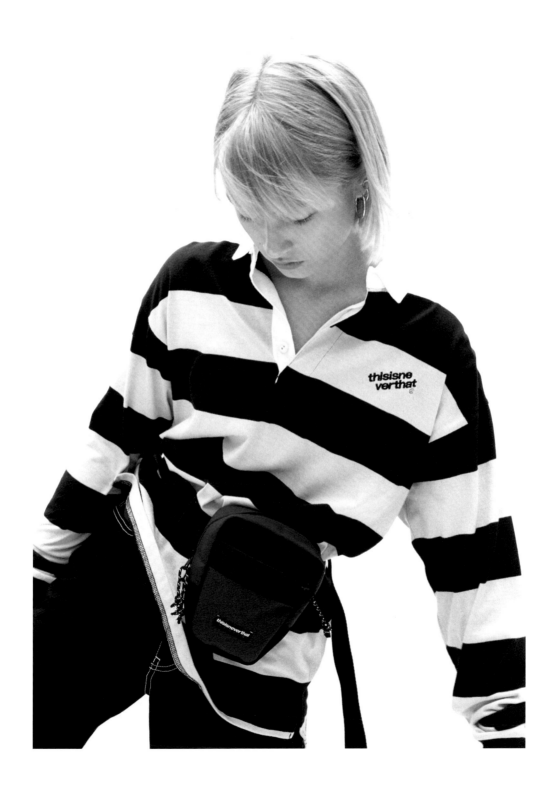

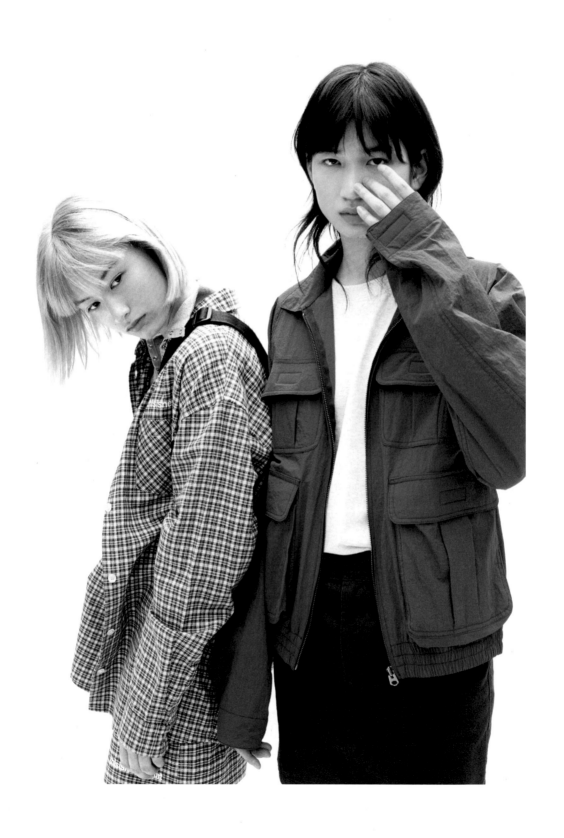

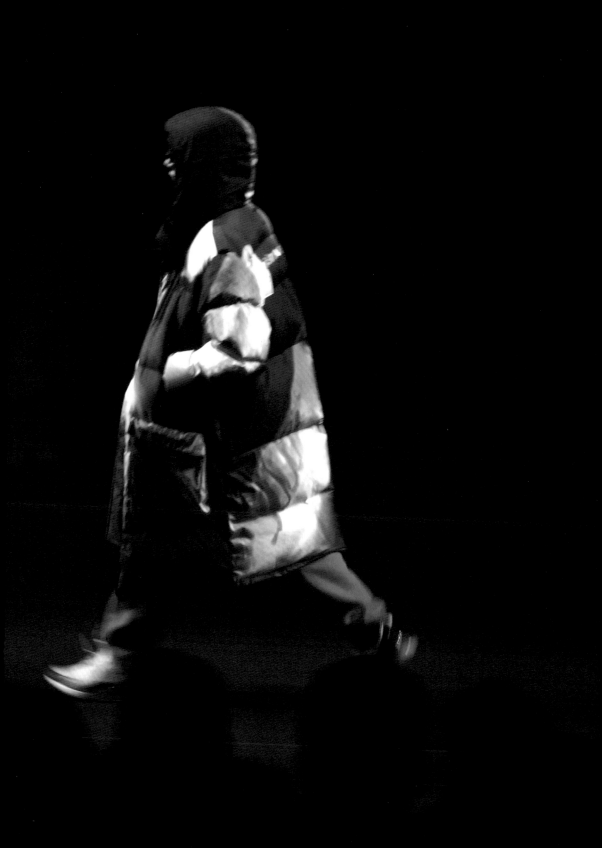

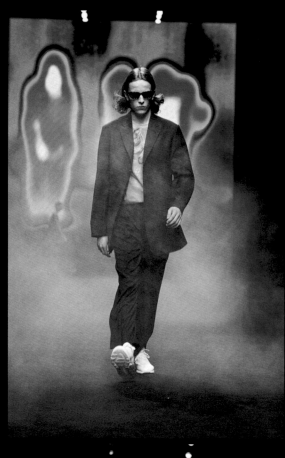
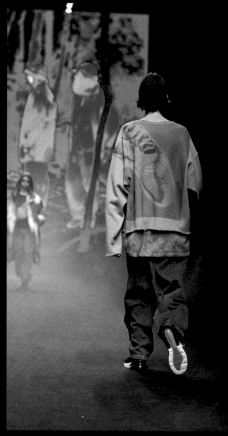
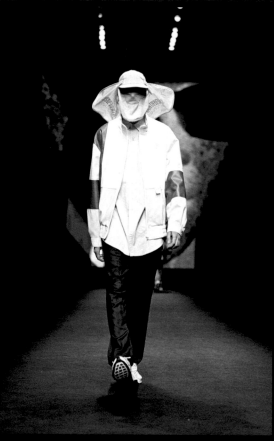
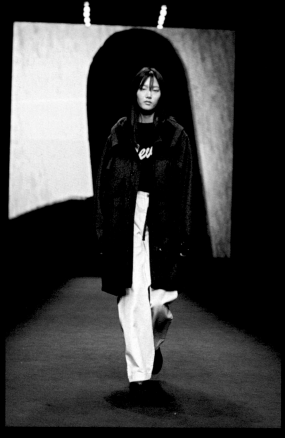

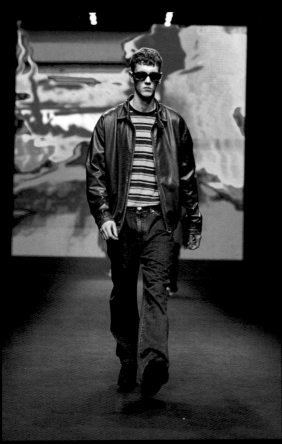
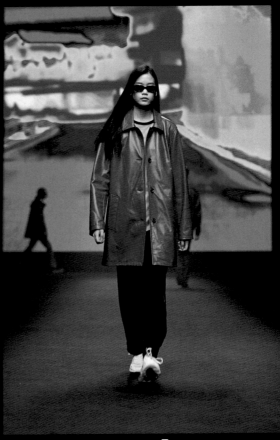
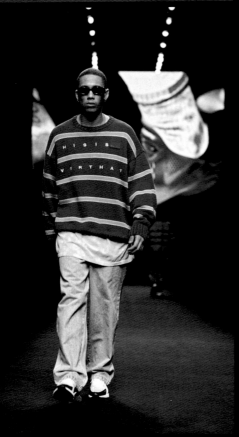
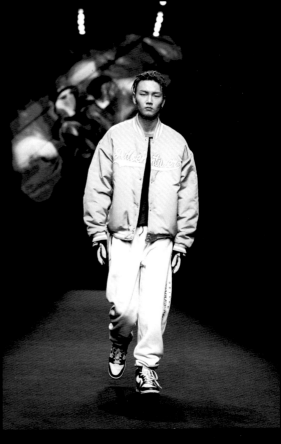

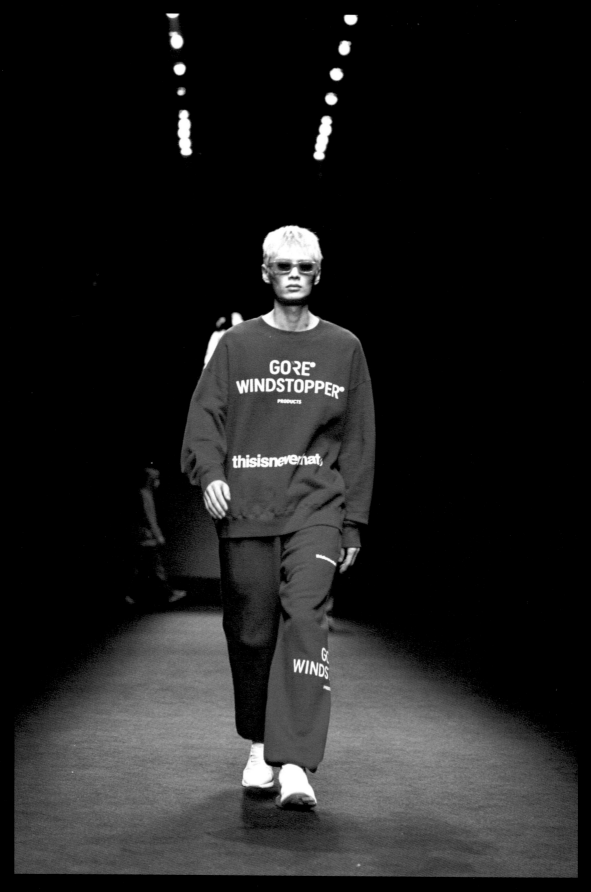

Collaborator

Release Date
Oct 29, 2018

Prefix
GT

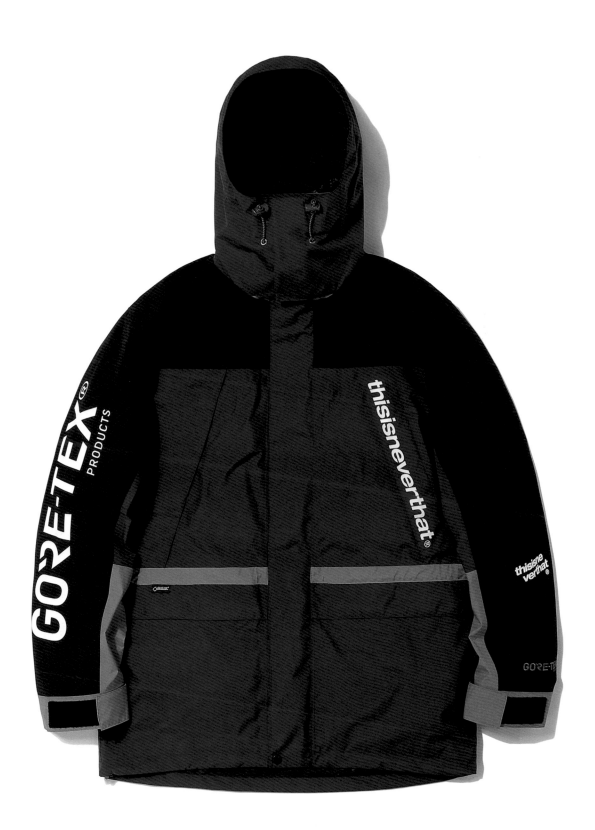

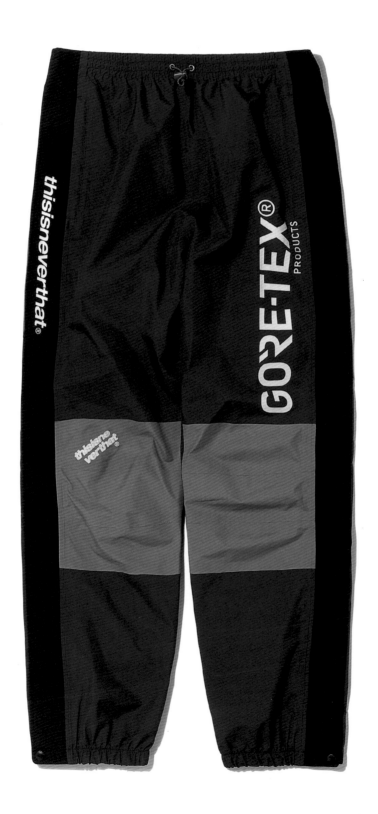

GT18FOW001NA

GT18FOW001GR / Jacket
thisisneverthat × GORE-TEX City Peak Jacket
Polyester / Grey

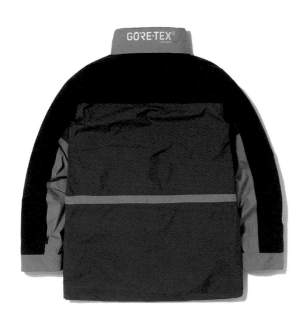
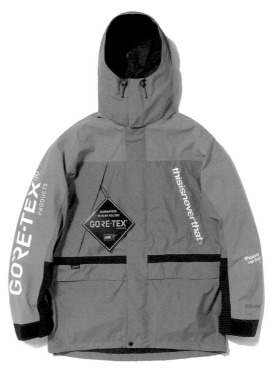

GT18FPA001NA

GT18FPA001GR / Pants
thisisneverthat × GORE-TEX City Peak Pant
Polyester / Grey

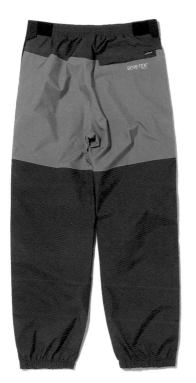
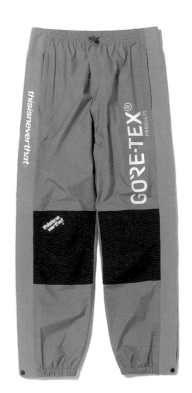

GORE-TEX × thisisneverthat

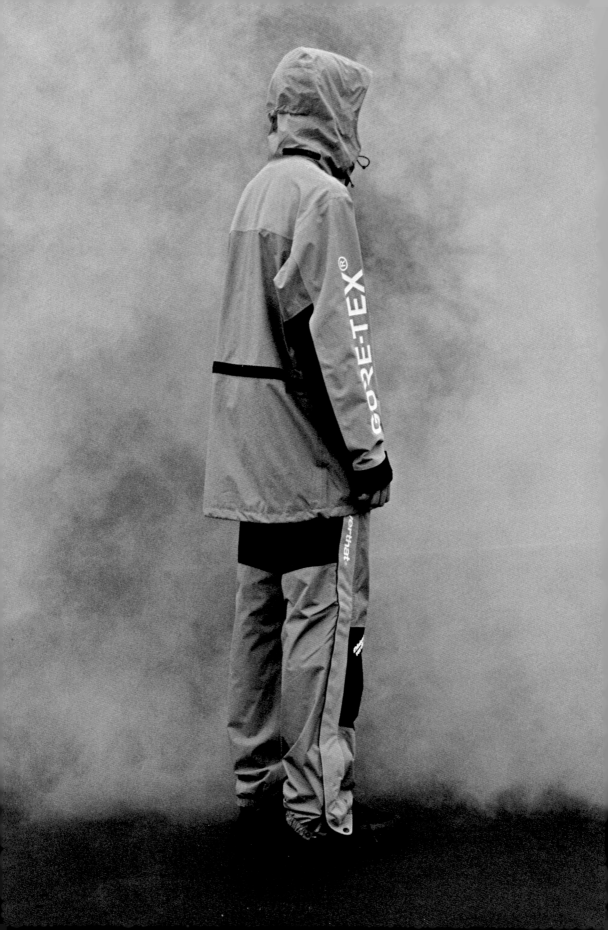

GT18FSW001BL / Top
thisisneverthat × GORE® WINDSTOPPER® Fleece Top
Polyester / Blue

GT18FSW001BK / Top
thisisneverthat × GORE® WINDSTOPPER® Fleece Top
Polyester / Black

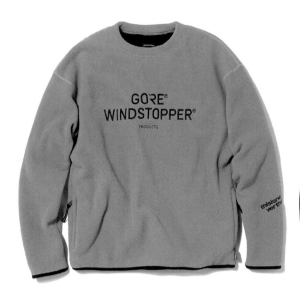

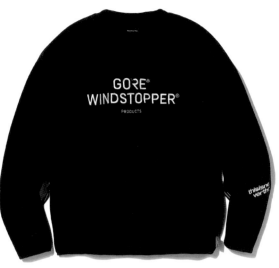

GT18FPA002BL / Pants
thisisneverthat × GORE® WINDSTOPPER® Fleece Pant
Polyester / Blue

GT18FPA002BK / Pants
thisisneverthat × GORE® WINDSTOPPER® Fleece Pant
Polyester / Black

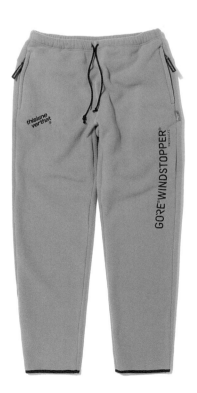

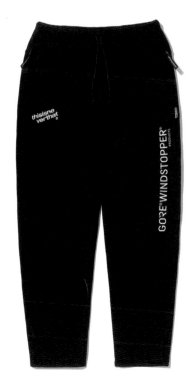

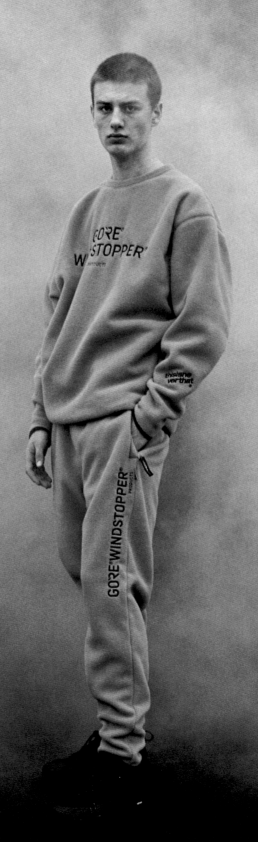

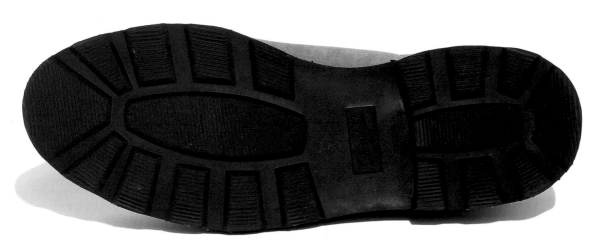

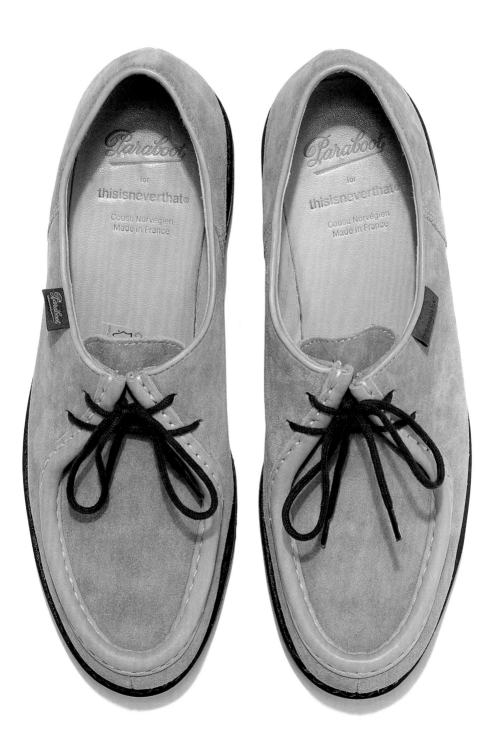

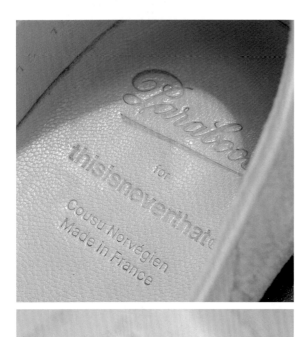

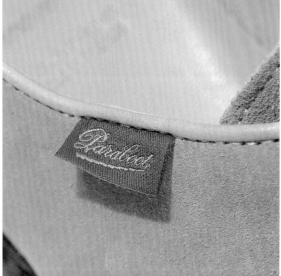

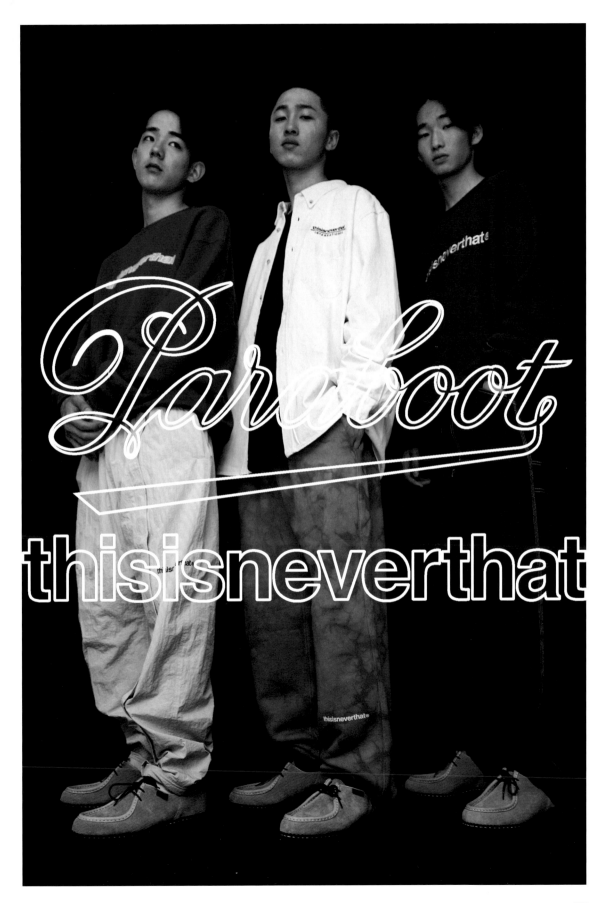

PARABOOT × thisisneverthat

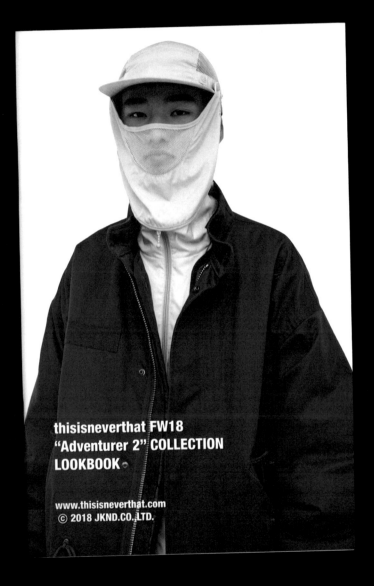

thisisneverthat FW18
"Adventurer 2" COLLECTION
LOOKBOOK

www.thisisneverthat.com
© 2018 JKND.CO.,LTD.

SPRING/SUMMER 2018

ADVENTURER

TN18SSH005BL, Shirt, HSP Sport Shirt ◍ TN18STS015BK, Tee, L-Logo Tee ◍
TN18SPA003CM, Jean, Washed BIG Jean ◍ TN18SBA001BK, Bag, CORDURA® 750D
Nylon Backpack 34l ◍ TN18SAC010SR, Accessory, C-Logo Necklace

TN18SOW005LD, Jacket, Fleece Jacket ◍ TN18STS011RW, Long Sleeve
Tee, NSP Tiedye L/SL Top ◍ TN18SPA010LV, Pants, T-Logo Sweatpant ◍
TN18SAC010SR, Accessory, C-Logo Necklace

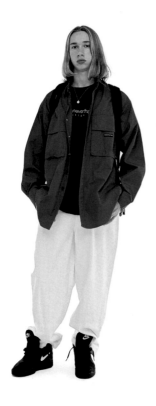

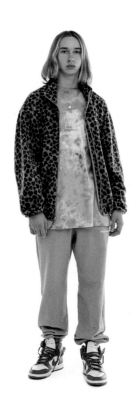

TN18SOW005CM, Jacket, Fleece Jacket ◍ TN18STS008GN, Long Sleeve Tee,
Small DSN Logo Stripe L/SL Top ◍ TN18SS00010V, Pants, HSP Jogging
Short ◍ TN18SAC003WH, Accessory, Skogar Sunglasses ◍ TN18SAC010SR,
Accessory, C-Logo Necklace

TN18SOW001BK, Jacket, Leather Coach Jacket ◍ TN18STS010LV, Long Sleeve
Tee, RFLT-Logo Tiedye L/SL Top ◍ TN18SPA002RD, Jean, Washed Regular
Jean ◍ TN18SAC002BK, Accessory, VIK Sunglasses

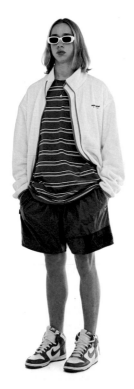

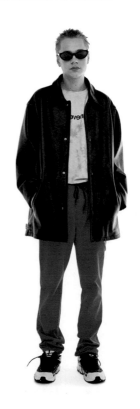

TN18SSH008TB, Shirt, L-Logo Denim S/SL Shirt ◉ TN18SHS012EA, Sweatshirt, HSP APP. Hooded Sweatshirt ◉ TN18SPA001OV, Pants, R/S Cargo Pant

TN18STS009NA, Long Sleeve Tee, L-Logo Stripe L/SL Top ◉ TN18SPA006GN, Pants, Basketball Training Pant ◉ TN18SAC002BK, Accessory, VIK Sunglasses

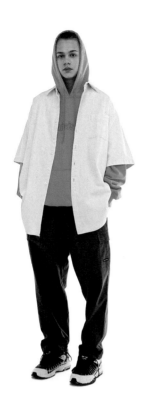

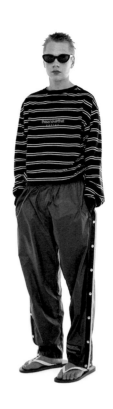

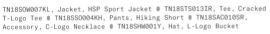

TN18SOW007KL, Jacket, HSP Sport Jacket ◉ TN18STS013IR, Tee, Cracked T-Logo Tee ◉ TN18SSO004KH, Pants, Hiking Short ◉ TN18SAC010SR, Accessory, C-Logo Necklace ◉ TN18SHW001Y, Hat, L-Logo Bucket

TN18SOW009BK, Jacket, CAMPER R/S Nylon Coat ◉ TN18SSH002BR, Shirt, Micro Check Shirt ◉ TN18SPA002TB, Jean, Washed Regular Jean ◉ TN18SAC003BK, Accessory, Skogar Sunglasses ◉ TN18SAC010SR, Accessory, C-Logo Necklace

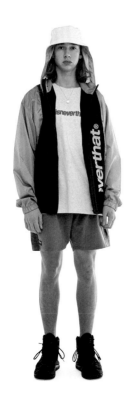

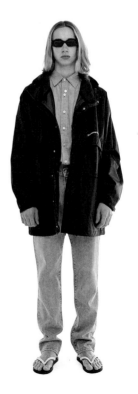

TN18SOW008BK, Jacket, 3SP-Taped Seam Jacket ● TN18SSH010YT, Top, SP L/ SL Jersey Polo ● TN18SPA012BL, Pants, RFLT-Logo Tiedye Sweatpant ● TN18SAC010SR, Accessory, C-Logo Necklace

TN18SSH001BL, Shirt, Oversized Check Shirt ● TN18STS012LGB, Top, Motorcycle Hooded L/SL Top ● TN18SSO0020V, Pants, N-2tuck Short ● TN18SHW002BL, Hat, L-Logo Cap

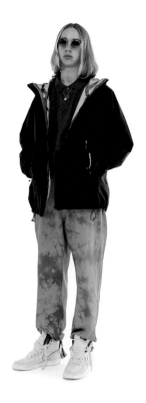

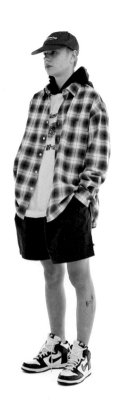

TN18SSW007MB, Sweatshirt, Rose EMB. Crewneck ● TN18SPA008NT, Pants, HSP Warm Up Pant ● TN18SHW007ER, Hat, TINT Design Cap ● TN18SAC002BK, Accessory, VIK Sunglasses

TN18SOW003IDG, Jacket, NEVER EMB. Denim Jacket ● TN18STS017WH, Tee, Rubber Logo Tee ● TN18SSO003BK, Pants, R/S Cargo Short

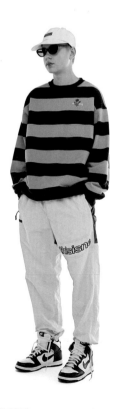

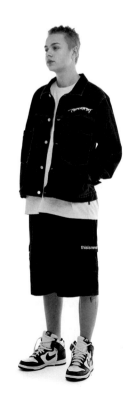

TN18SOW002BE, Jacket, Harrington Jacket ▮ TN18STS034GN, Tee, C-Logo Stripe Tee ▮ TN18SPA012BL, Jean, Washed Regular Jean ▮ TN18SAC003BK, Accessory, Skogar Sunglasses ▮ TN18SAC010SR, Accessory, C-Logo Necklace

TN18SSH001RD, Shirt, Oversized Check Shirt ▮ TN18STS038YT, Tee, Painting CP-Logo BIG Tee ▮ TN18SPA003TB, Jean, Washed BIG Jean ▮ TN18SAC010SR, Accessory, C-Logo Necklace

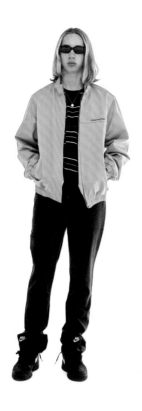

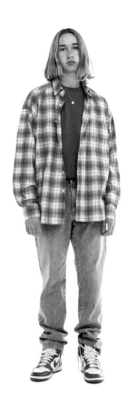

TN18SSW005NA, Sweatshirt, L-Logo Paneled Crewneck ▮ TN18SPA001OV, Pants, R/S Cargo Pant ▮ TN18SAC010SR, Accessory, C-Logo Necklace

TN18SOW003CM, Jacket, NEVER EMB. Denim Jacket ▮ TN18STS032BK, Tee, T-Logo Stripe Tee ▮ TN18SPA001PK, Pants, R/S Cargo Pant ▮ TN18SHW004BK, Hat, DSN-Logo Short Beanie

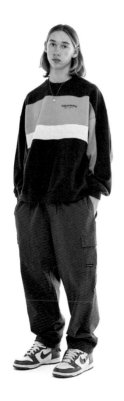

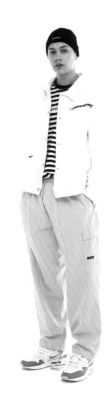

TN18STS038MD, Tee, Painting CP-Logo BIG Tee ▮ TN18SHW008WH, Hat, NEVER EMB. Long Bill Cap ▮ TN18SPA003TB, Jean, Washed BIG Jean ▮ TN18SBA009BE, Bag, CORDURA® 750D Nylon Messenger Bag ▮ TN18SBA001GN, Bag, CORDURA® 750D Nylon Backpack 34L

TN18SSH006WH, Shirt, Nightscape ALOHA Shirt ▮ TN18STS020EA, Tee, CP-Logo Tee ▮ TN18SPA004ME, Jean, T-Logo Crazy Jean ▮ TN18SAC002BK, Accessory, VIK Sunglasses

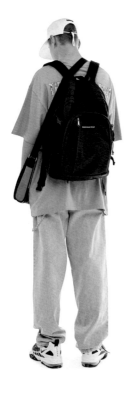

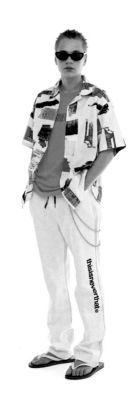

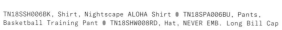

TN18SSH006BK, Shirt, Nightscape ALOHA Shirt ▮ TN18SPA006BU, Pants, Basketball Training Pant ▮ TN18SHW008RD, Hat, NEVER EMB. Long Bill Cap

TN18SOW006CM, Jacket, Reversible Fleece Vest ▮ TN18STS034BL, Tee, C-Logo Stripe Tee ▮ TN18SPA004ME, Jean, T-Logo Crazy Jean ▮ TN18SAC003BK, Accessory, Skogar Sunglasses

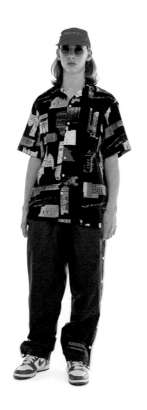

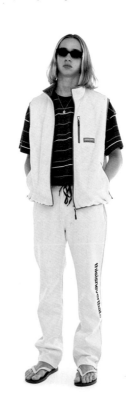

TN18SSH004YL, Shirt, SP Terry Shirt ⊘ TN18STS014WH, Tee, Small T-Logo Tee ⊘ TN18SPA007YT, Pants, Work Pant ⊘ TN18SAC003WH, Accessory, Skogar Sunglasses

TN18SOW009GN, Jacket, CAMPER R/S Nylon Coat ⊘ TN18STS014MD, Tee, Small T-Logo Tee ⊘ TN18SSO003BE, Pants, R/S Cargo Short ⊘ TN18SHW009BE, Hat, Fishing Hiking Hat ⊘ TN18SAC004LD, Accessory, HSP Regular Socks

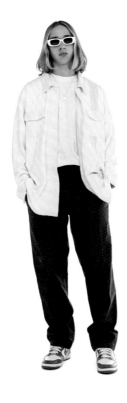

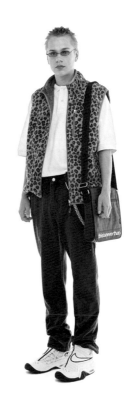

TN18SHS008RW, Sweatshirt, NSP Tiedye Hooded Sweatshirt ⊘ TN18SSO003BK, Pants, R/S Cargo Short

TN18SOW006LD, Jacket, Reversible Fleece Vest ⊘ TN18SSH009CM, Top, DSN-Logo S/SL Jersey Polo ⊘ TN18SPA002NA, Jean, Washed Regular Jean ⊘ TN18SBA009GN, Bag, CORDURA® 750D Nylon Messenger Bag

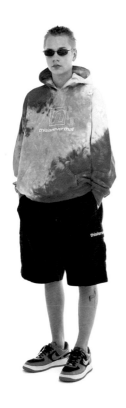

TN18SOW006CM, Jacket, Reversible Fleece Vest ▯ TN18SSH002BL, Shirt, Micro Check Shirt ▯ TN18SPA007NT, Pants, Work Pant ▯ TN18SHW009NA, Hat, Fishing Hiking Hat ▯ TN18SAC010SR, Accessory, C-Logo Necklace

TN18SOW007KR, Jacket, HSP Sport Jacket ▯ TN18SSH009CM, Top, DSN-Logo S/SL Jersey Polo ▯ TN18SPA002CM, Jean, Washed Regular Jean

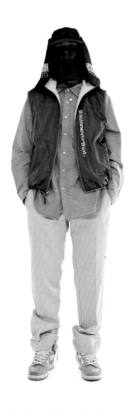

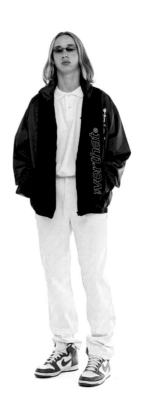

TN18SSH003TB, Shirt, Oversized Denim Shirt ▯ TN18SPA007BK, Pants, Work Pant ▯ TN18SAC002BK, Accessory, VIK Sunglasses ▯ TN18SBA001BK, Bag, CORDURA® 750D Nylon Backpack 34L

TN18SOW008YT, Jacket, 3SP-Taped Seam Jacket ▯ TN18SSW003BK, Sweatshirt, CP-Logo Crewneck ▯ TN18SPA009NT, Pants, 1Tuck Chino Pant ▯ TN18SAC002BK, Accessory, VIK Sunglasses

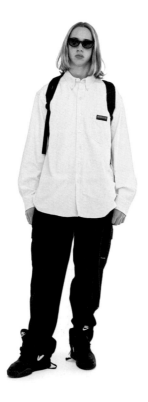

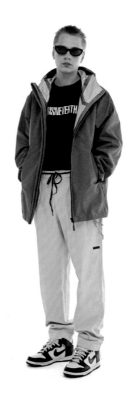

TN18SOW004TB, Jacket, C&P Work Jacket ▮ TN18STS032BE, Tee, T-Logo
Stripe Tee ▮ TN18SPA009OV, Pants, 1Tuck Chino Pant ▮ TN18SHW004OR,
Hat, DSN-Logo Short Beanie

TN18SHS006LV, Sweatshirt, C-Logo Zipup Sweat ▮ TN18STS015YT, Tee,
L-Logo Tee ▮ TN18SPA005CK, Pants, Relaxed Pant ▮ TN18SHW001YL, Hat,
L-Logo Bucket

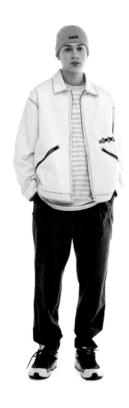

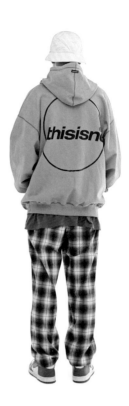

TN18SSH004NA, Shirt, SP Terry Shirt ▮ TN18STS016PK, Tee, DSN-Logo Tee
▮ TN18SSO006IM, Pants, HSP Sweatshort ▮ TN18SAC002GN, Accessory, VIK
Sunglasses ▮ TN18SAC010SR, Accessory, C-Logo Necklace

TN18SSH003BL, Shirt, Oversized Denim Shirt ▮ TN18STS012LR, Top,
Motorcycle Hooded L/SL Top ▮ TN18SPA011IM, Pants, SP Basic Sweatpant

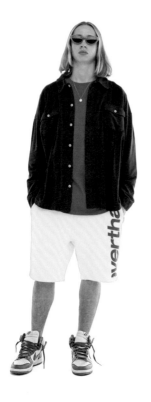

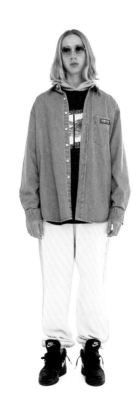

TN18SSH011GN, Top, Zipup L/SL Polo ▓ TN18SSO0007OR, Pants, L-Logo
Sweatshort ▓ TN18SAC003BK, Accessory, Skogar Sunglasses

TN18STS003YT, Long Sleeve Tee, WAVE-T L/SL Top ▓ TN18SSO0007BE, Pants,
L-Logo Sweatshort ▓ TN18SAC002GN, Accessory, VIK Sunglasses

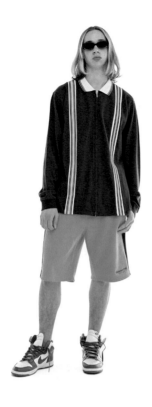

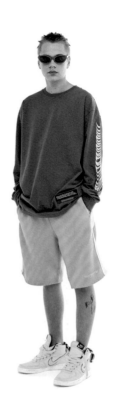

TN18SHS003LV, Sweatshirt, ARC Lower Hooded Sweatshirt ▓ TN18SSO005NT,
Pants, SP Sport Short ▓ TN18SHW012RY, Hat, Front Pocket Cap ▓
TN18SAC004LD, Socks, HSP Regular Socks

TN18SHS009NA, Sweatshirt, NEVER Hooded Sweatshirt ▓ TN18STS020LV, Tee,
CP-Logo Tee ▓ TN18SPA003TB, Jean, Washed BIG Jean ▓ TN18SHW001BK, Hat,
L-Logo Bucket ▓ TN18SAC003BK, Accessory, Skogar Sunglasses

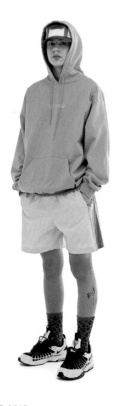

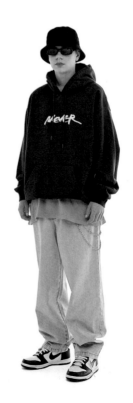

TN18SHS005CM, Sweatshirt, S/L HSP Hooded Sweatshirt ▮ TN18STS027BK, Tee, CP INTL. Tee ▮ TN18SPA009OV, Pants, 1Tuck Chino Pant ▮ TN18SHW002BK, Hat, L-Logo Cap

TN18SHS012BE, Sweatshirt, HSP APP. Hooded Sweatshirt ▮ TN18SSO001OV, Pants, HSP Jogging Short ▮ TN18SAC002BK, Accessory, VIK Sunglasses

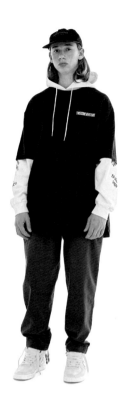

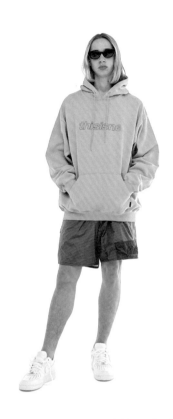

TN18SHS002IR, Sweatshirt, NNN EMB. Hooded Sweatshirt ▮ TN18SSO004MT, Pants, Hiking Short

TN18SSH004BK, Shirt, SP Terry Shirt ▮ TN18STS037NA, Tee, HSP Tiedye Tee ▮ TN18SSO005OV, Pants, SP Sport Short ▮ TN18SAC010SR, Accessory, C-Logo Necklace

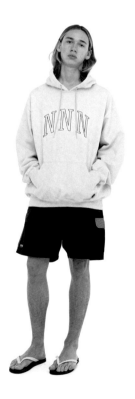

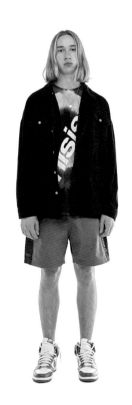

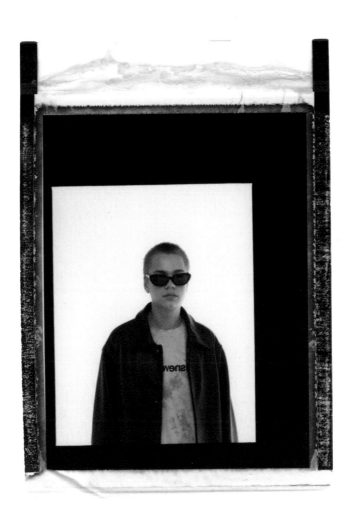

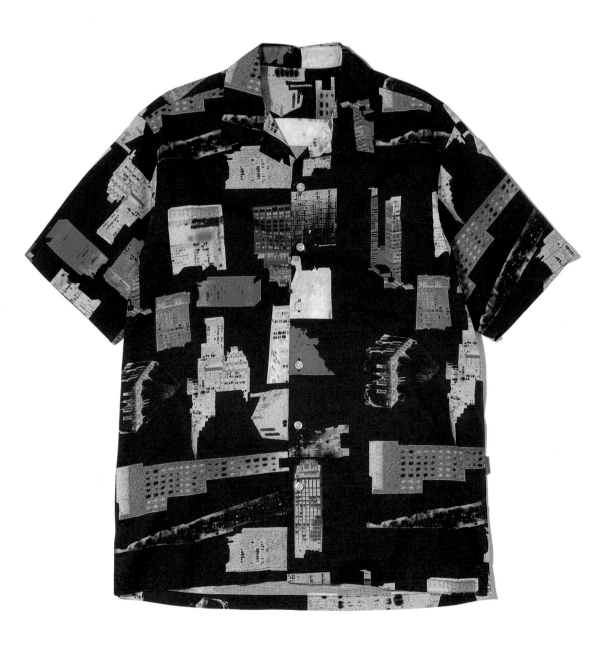

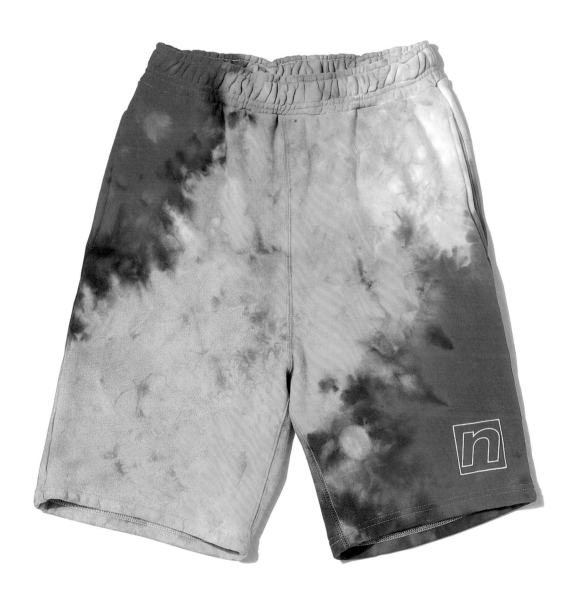

THISNEVERTHAT

SS18
SPRING/SUMMER
COLLECTION
:

ADVENTURER
S-0-1903-11-0731

ADVENTURER

MUSIC
Somdef

FILM
KIM MINTAE

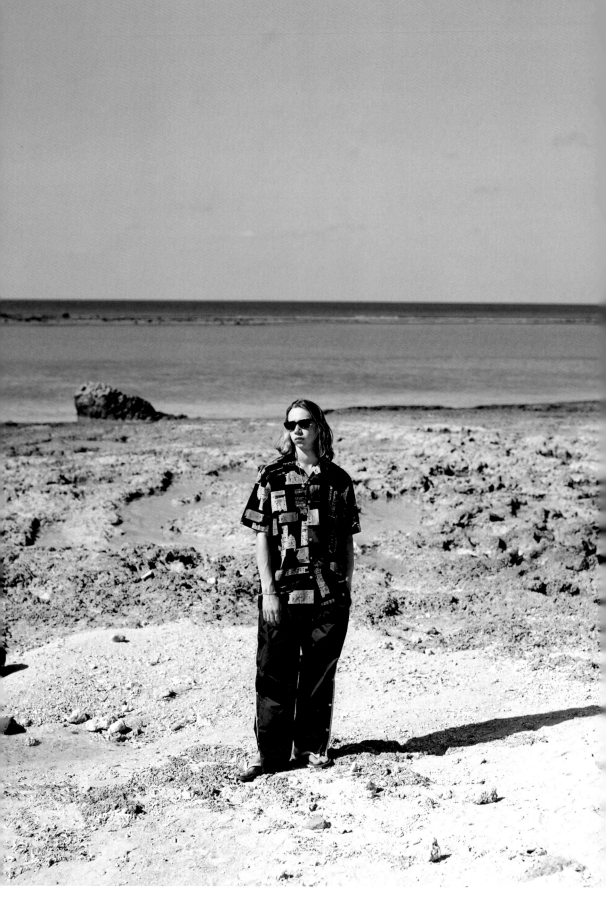

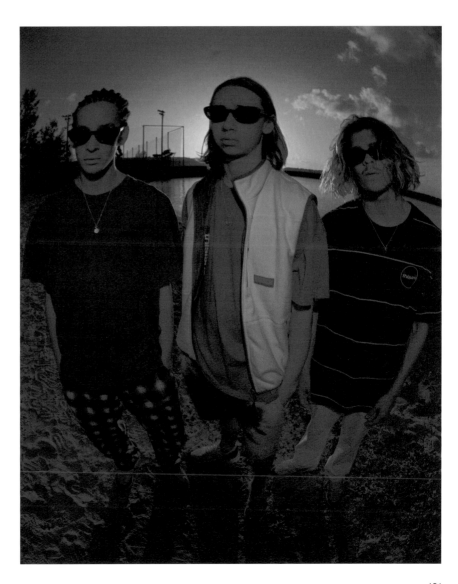

TN18SOW008YT / Jacket
3SP-Taped Seam Jacket
Nylon / Coyote

TN18SHS009NA / Sweatshirt
NEVER Hooded Sweatshirt
Cotton / Navy

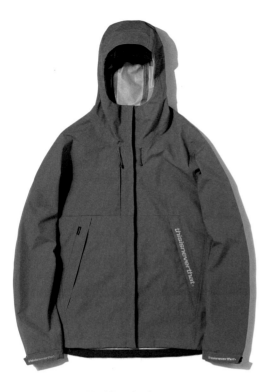

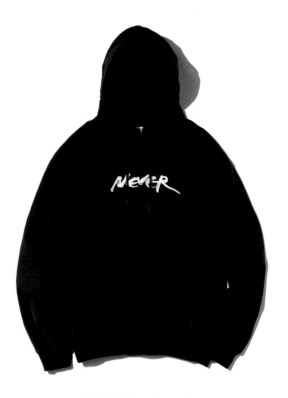

TN18SOW009GN / Jacket
CAMPER R/S Nylon Coat
Polyester, Nylon / Green

TN18SHS002IR / Sweatshirt
NNN EMB. Hooded Sweatshirt
Cotton / Light Grey

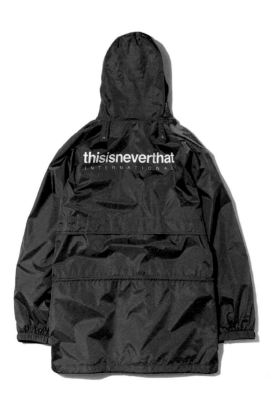

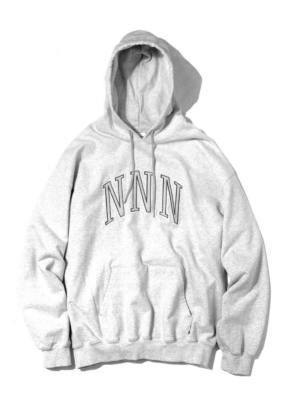

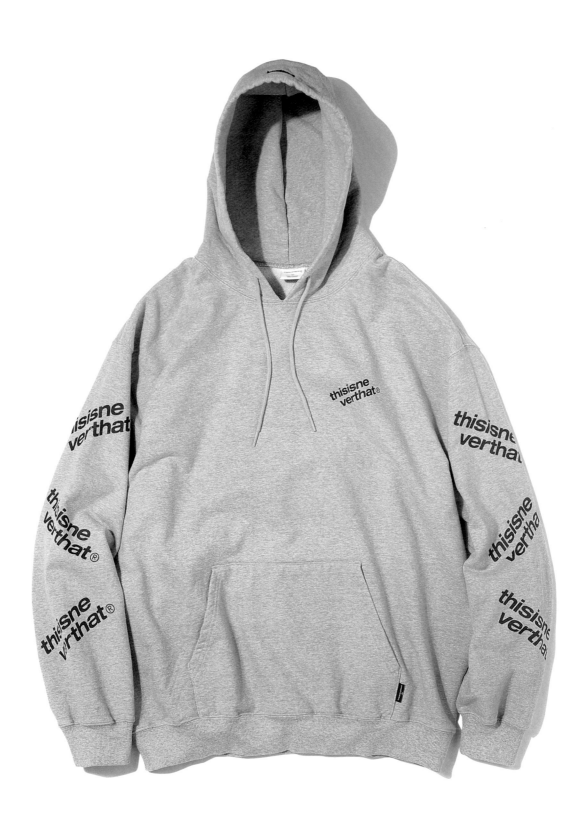

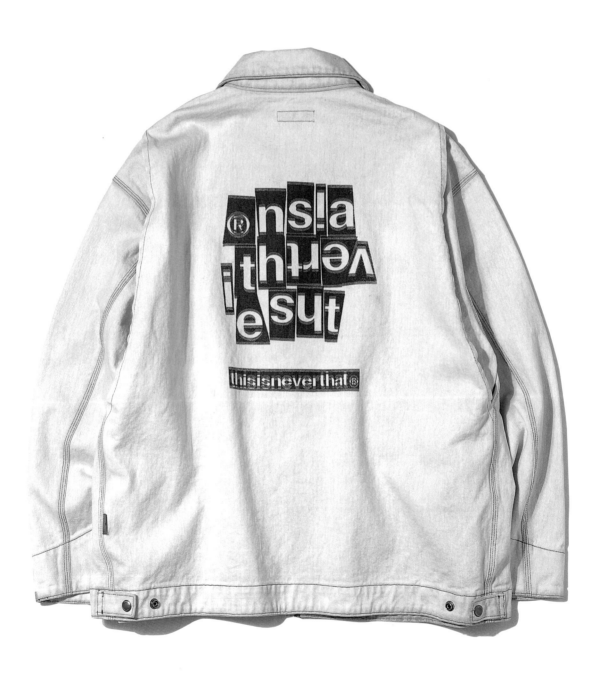

TN18SOW005LV / Jacket
Fleece Jacket
Polyester / Lavender

TN18STS003NA / Long Sleeve Tee
WAVE-T L/SL Top
Cotton / Navy

TN18SHS001YT / Sweatshirt
L-Logo Hooded Sweatshirt
Cotton / Coyote

TN18SHS011NA / Sweatshirt
Multi Colored Hooded Sweatshirt
Cotton / Navy

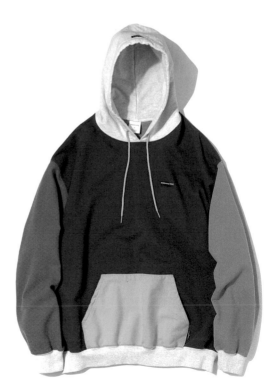

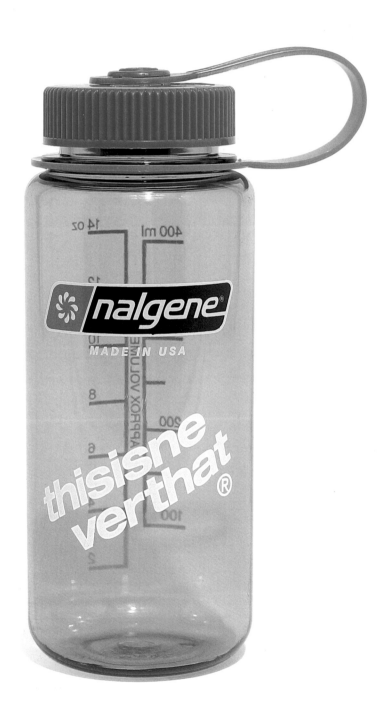

TN18SOW003IDG / Jacket
NEVER EMB. Denim Jacket
Cotton / Indigo

TN18SSH003BL / Shirt
Oversized Denim Shirt
Cotton / Blue

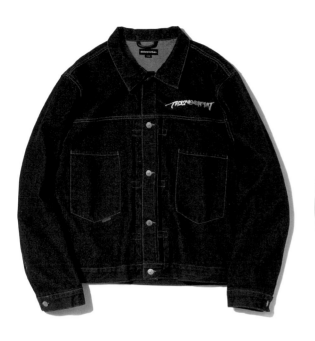

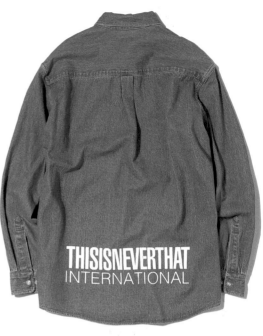

TN18STS024CM / Tee
Mosaic Logo Tee
Cotton / Cream

TN18STS037NA / Tee
HSP Tiedye Tee
Cotton / Navy

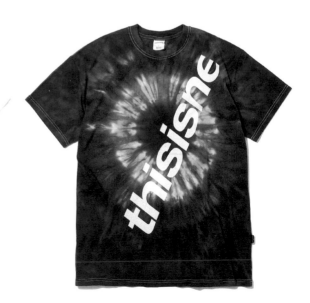

TN18SOW002MT / Jacket
Harrington Jacket
Cotton, Polyester / Multi

TN18SOW005BK / Jacket
Fleece Jacket
Polyester / Black

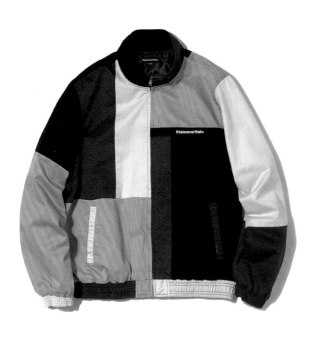

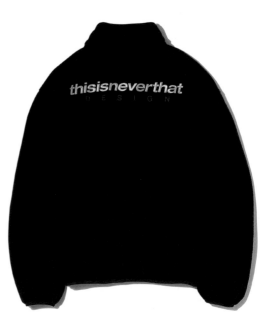

TN18SOW006LD / Jacket
Reversible Fleece Vest
Polyester / Leopard

TN18STS012LGB / Top
Motorcycle Hooded L/LS Top
Cotton / Light Grey, Black

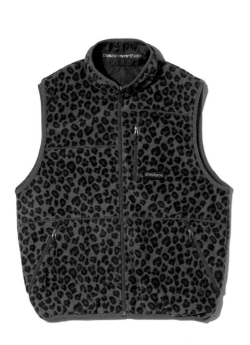

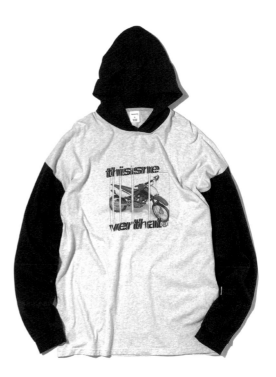

ADVENTURER

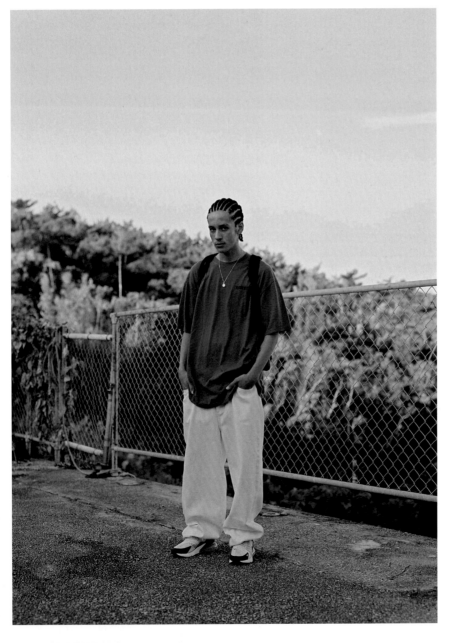

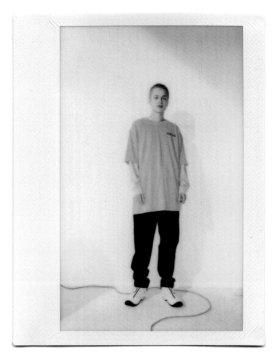
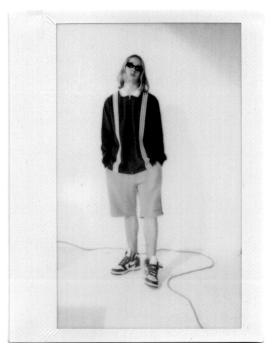
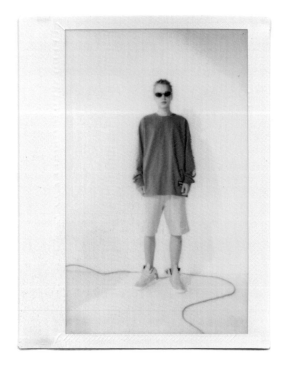
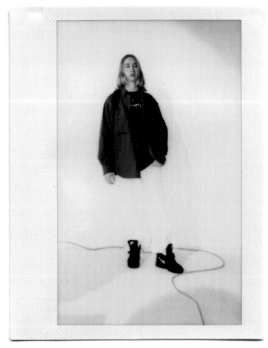

TN18SHW012GE

TN18SHW005BE

TN18SHW007ER

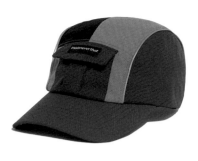 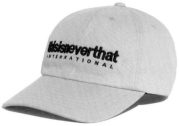

TN18SHW002BK

TN18SHW011OV

TN18SHW005YT

TN18SHW012GE	Hat	Front Pocket Cap	Cotton, Nylon	Green, Olive
TN18SHW005BE	Hat	INTL. Logo Baseball Cap	Cotton	Beige
TN18SHW007ER	Hat	TINT Design Cap	Cotton, Nylon	Neon
TN18SHW002BK	Hat	L-Logo Cap	Cotton	Black
TN18SHW011OV	Hat	Adventurer Hat	Cotton	Olive
TN18SHW005YT	Hat	INTL. Logo Baseball Cap	Cotton	Coyote

ADVENTURER

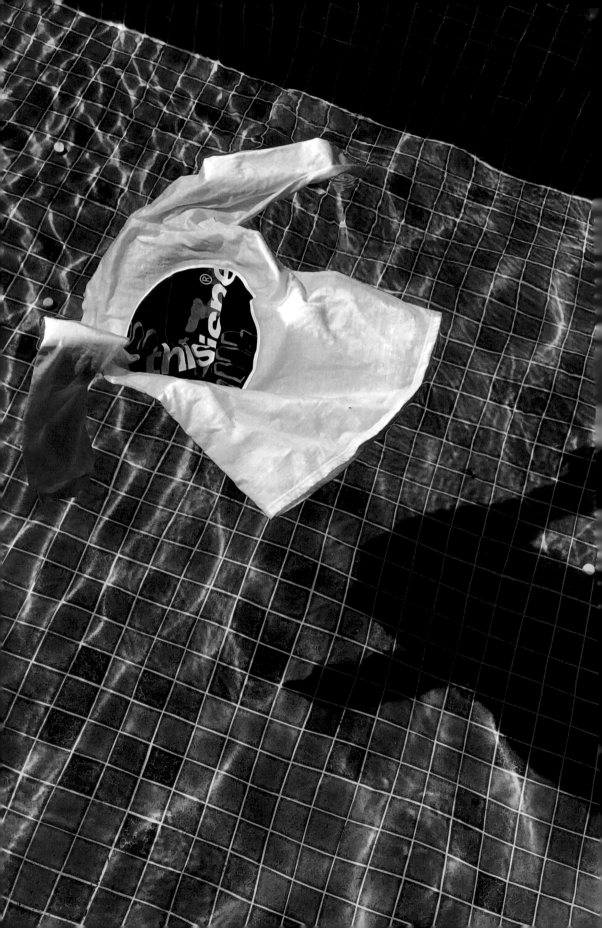

TN18SSO001NA

TN18SSO004MT

TN18SAC007RPD

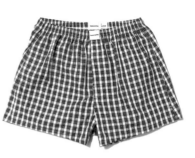

TN18SAC002BK

TN18SAC002GN

TN18SAC010SR

TN18SAC003WH

TN18SAC003BK

TN18SBA005GN

TN18SAC001OV

TN18SAC005WH

TN18SSO001NA	Pants	HSP Jogging Short	Nylon, Cotton	Navy
TN18SSO004MT	Pants	Hiking Short	Cotton	Multi
TN18SAC007RPD	Underwear	Woven Boxer	Cotton	Red Plaid
TN18SAC002BK	Accessory	VIK Sunglasses	Acetate	Black
TN18SAC002GN	Accessory	VIK Sunglasses	Acetate	Green
TN18SAC010SR	Accessory	C-logo Necklace	925 Silver	Silver
TN18SAC003WH	Accessory	Skogar Sunglasses	Acetate	White
TN18SAC003BK	Accessory	Skogar Sunglasses	Acetate	Black
TN18SBA005GN	Accessory	CORDURA® 750D Nylon Wallet	Nylon	Green
TN18SAC001OV	Accessory	Taped Belt	Polyester	Olive
TN18SAC005WH	Socks	HSP Ankle Socks	Cotton, Spandex, Polyester	White
TN18SAC009NNE	Accessory	Post-it® Set	Paper	None
TN18SAC008BK	Accessory	Sharpie® Pen	Plastic	Black

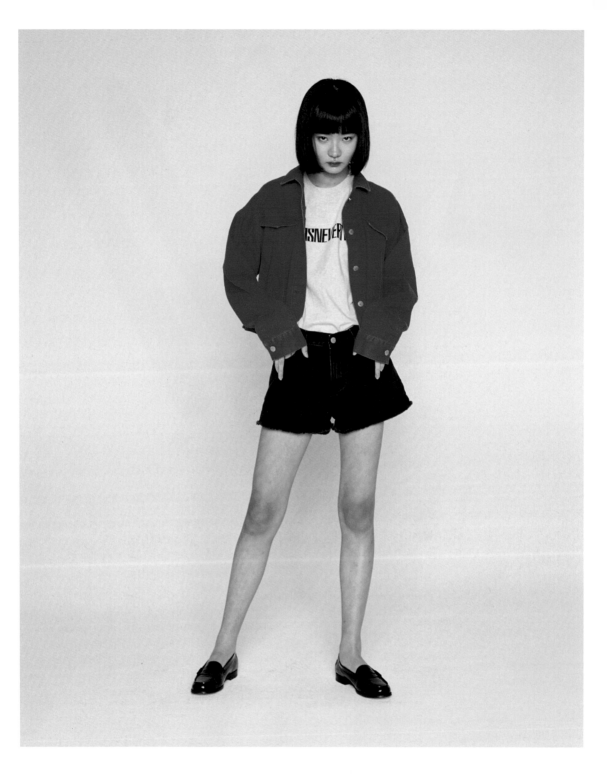

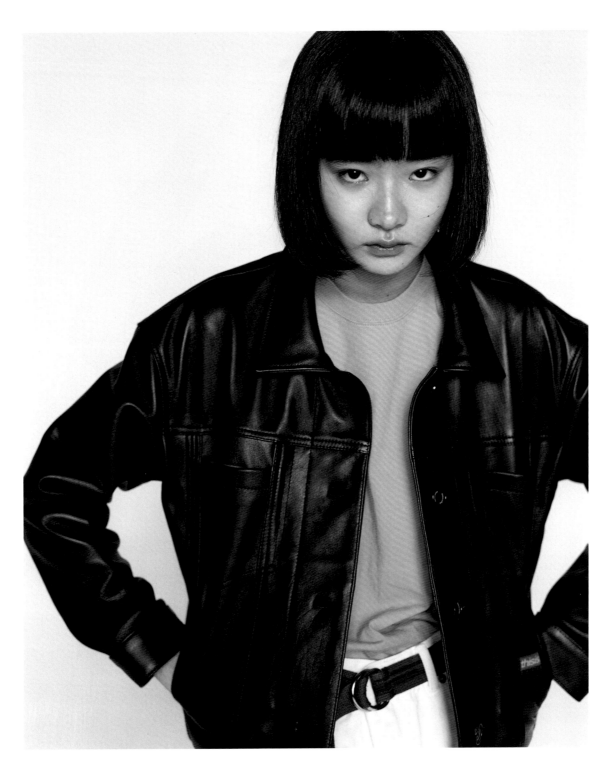

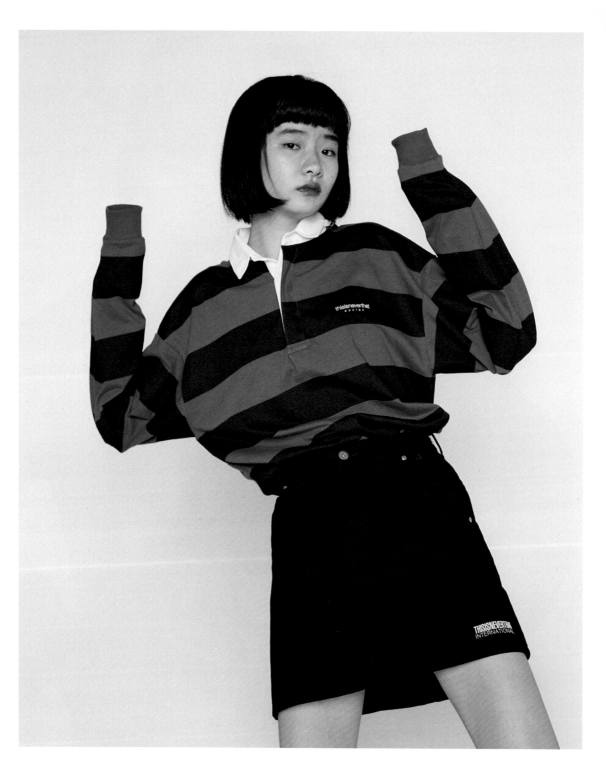

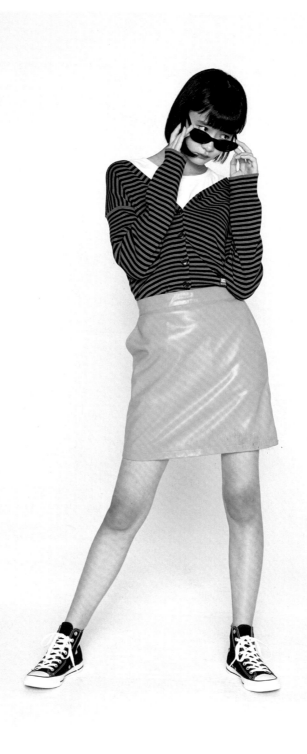

GRAMiCCi

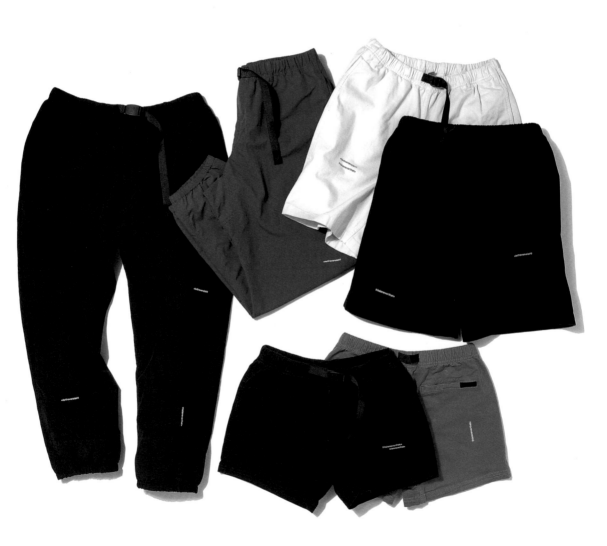

GM18SPA001WD	Pants	Track Pant	Nylon	Wood
GM18SPA001DK	Pants	Track Pant	Nylon	Dark
GM18SSO002NT	Pants	G-Short	Cotton	Natural
GM18SSO002BK	Pants	G-Short	Cotton	Black
GM18SSO001OC	Pants	Very Short	Cotton	Ocean
GM18SSO001BK	Pants	Very Short	Cotton	Black

GM18SPA001WD

GM18SPA001DK

GM18SSO002NT

GM18SSO002BK

GM18SSO001OC

GM18SSO001BK

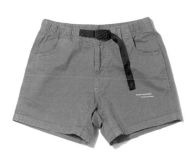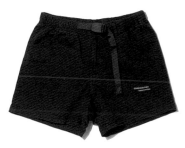

GRAMICCI x thisisneverthat

thisisneverthat ®

JKND CO.,LTD.
9-7, Wausan-ro 35-gil, Mapo-gu, Seoul, KOREA
TEL: +82(0)70-4015-0014
FAX: +82(0)70-4850-8077

www.thisisneverthat.com

FALL/WINTER 2017

SPECIAL GUEST

TN17FOW011CK, Jacket, Fleece Zip Jacket ❚ TN17FTO007YL, Top, FB Team Shirt ❚ TN17FBT0110V, Pants, Zip Track Pant ❚ TN18SAC002BK, Accessory, VIK Sunglasses ❚ TN17FAC017BK, Hat, Small SP-Logo Beanie

TN17FOW011RL, Jacket, Fleece Zip Jacket ❚ TN17FTO014EI, Sweatshirt, 3 LINES Logo Crewneck ❚ TN17FBT005CH, Pants, Stripe SP-Logo Sweatpant ❚ TN18SAC002BK, Accessory, VIK Sunglasses

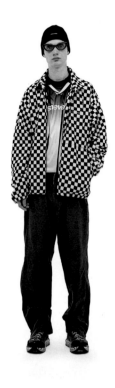

TN17FOW002SB, Jacket, Hooded Puffy Down Jacket ❚ TN17FTO012BK, Sweatshirt, Stripe SP-Logo Crewneck ❚ TN17FBT003GR, Pants, INTL. Logo Sweatpant ❚ TN18SAC002BK, Accessory, VIK Sunglasses

TN17FOW002YL, Jacket, Hooded Puffy Down Jacket ❚ TN17FTO008YL, Long Sleeve Tee, FB Team L/S Tee ❚ TN17FBT006BK, Jean, Denim Jean ❚ TN17FAC007KH, Hat, RA-P Logo Cap

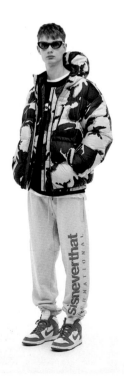

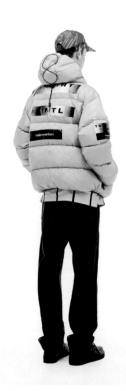

TN17FOW001GN, Jacket, SP-Logo Puffy Down Jacket ⬮ TN17FOW012BK, Jacket, Windbreaker Jacket ⬮ TN17FTO003PK, Long Sleeve Tee, C-Logo L/S Tee ⬮ TN17FBT006CZ, Jean, Denim Jean ⬮ TN17FAC001CA, Hat, T-Logo Camp Cap ⬮ TN17FAC028BK, Accessory, Belt

TN17FOW001BK, Jacket, SP-Logo Puffy Down Jacket ⬮ TN17FTO029EI, Sweatshirt, HT-Logo Hooded Sweatshirt ⬮ TN17FBT009WH, Pants, ECILOP-P Pant ⬮ TN18SAC002GN, Accessory, VIK Sunglasses ⬮ TN17FAC028WH, Accessory, Belt

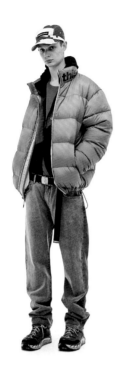

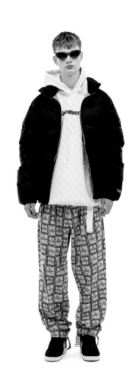

TN17FOW003SR, Jacket, SP-Logo CITY Down Parka ⬮ TN17FTO008PP, Long Sleeve Tee, FB Team L/S Tee ⬮ TN17FBT007BK, Pants, Training Jogger Pant ⬮ TN18SAC002BK, Accessory, VIK Sunglasses ⬮ TN17FAC003PP, Hat, H-SP Logo Mesh Cap

TN17FOW003BK, Jacket, SP-Logo CITY Down Parka ⬮ TN17FBT006BK, Jean, Denim Jean ⬮ TN17FAC003BK, Hat, H-SP Logo Mesh Cap ⬮ TN17FAC012BK, Accessory, Fleece Headband

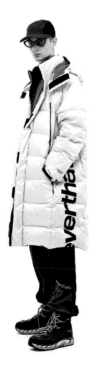

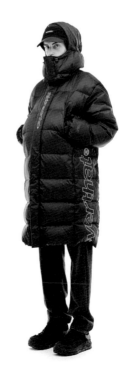

TN17FAC012BK, Jacket, M-51 Field Parka ⬢ TN17FTO0015OV, Sweatshirt, T-Logo Tape Crewneck ⬢ TN17FBT000NA, Pants, C-Logo Relaxed Pant ⬢ TN18SAC003BK, Accessory, Skogar Sunglasses ⬢ TN17FAC009BK, Hat, T-Logo Bucket Hat

TN17FOW008OV, Jacket, M-51 Field Parka ⬢ TN17FTO0029EI, Sweatshirt, HT-Logo Hooded Sweatshirt ⬢ TN17FBT002BK, Pants, TN Fleece Pant ⬢ TN18SAC002GN, Accessory, VIK Sunglasses ⬢ TN17FAC024BK, Accessory, Fleece Neck Warmer ⬢ TN17FAC019BK, Bag, Small HIP Bag

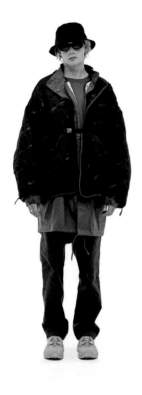

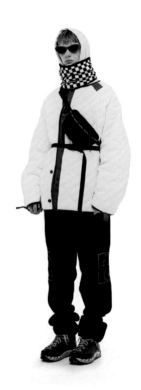

TN17FOW006CH, Jacket, Mountain Down Parka ⬢ TN17FTO0028OV, Sweatshirt, RA-P Logo Hooded Sweatshirt ⬢ TN17FBT011BK, Pants, Zip Track Pant ⬢ TN18SAC002GN, Accessory, VIK Sunglasses

TN17FOW006OV, Jacket, Mountain Down Parka ⬢ TN17FTO0014BK, Sweatshirt, 3 LINES Logo Crewneck ⬢ TN17FBT001MT, Pants, Work Pant ⬢ TN18SAC003WH, Accessory, Skogar Sunglasses

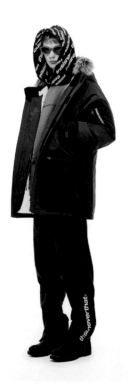

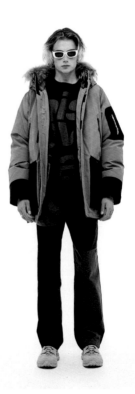

TN17FOW007OV, Jacket, MA-1 Jacket ◍ TN17FTO011OR, Shirt, Oversized Tartan Shirt ◍ TN17FTO003OV, Long Sleeve Tee, C-Logo L/S Tee ◍ TN17FBT006BK, Jean, Denim Jean ◍ TN18SAC002BK, Accessory, VIK Sunglasses ◍ TN17FAC006OV, Hat, C-Logo Baseball Cap ◍ TN17FAC028BK, Accessory, Belt

TN17FOW007BK, Jacket, MA-1 Jacket ◍ TN17FTO004LN, Long Sleeve Tee, Multi Stripe HT-Logo L/S Tee ◍ TN17FBT006GR, Jean, Denim Jean ◍ TN18SAC003BK, Accessory, Skogar Sunglasses ◍ TN17FAC028BK, Accessory, Belt

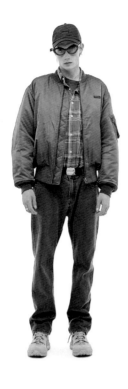

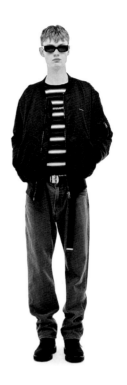

TN17FOW009GN, Jacket, Taped Seam Jacket ◍ TN17FTO019CH, Sweatshirt, T-Logo S-Collar Sweatshirt ◍ TN17FBT010WH, Pants, Rep-Logo Training Pant ◍ TN17FAC006BK, Hat, C-Logo Baseball Cap

TN17FOW009BL, Jacket, Taped Seam Jacket ◍ TN17FTO019CH, Sweatshirt, T-Logo S-Collar Sweatshirt ◍ TN17FTO011BL, Shirt, Oversized Tartan Shirt ◍ TN17FBT006TB, Jean, Denim Jean ◍ TN17FAC002BL, Hat, SP-Logo Camp Cap ◍ TN17FAC028BK, Accessory, Belt

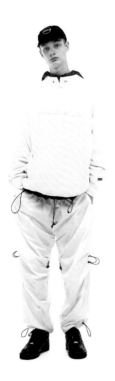

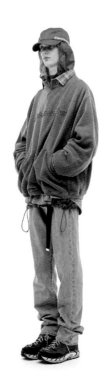

SPECIAL GUEST

TN17FOW010BR, Jacket, R-Logo Fleece Reversible Jacket ◍ TN17FTO018BG, Sweatshirt, NEVER EMB. Crewneck ◍ TN17FBT001CH, Pants, Work Pant ◍ TN18SAC003WH, Accessory, Skogar Sunglasses ◍ TN17FAC031NN, Hat, NEVER-Logo Beanie

TN17FTO031DK, Sweatshirt, INTL. Logo Zip-up Sweat ◍ TN17FTO031BG, Sweatshirt, INTL. Logo Zip-up Sweat ◍ TN17FTO004RE, Long Sleeve Tee, Multi Stripe HT-Logo L/S Tee ◍ TN17FBT006BK, Jean, Denim Jean ◍ TN17FBT011NA, Pants, Zip Track Pant ◍ TN18SAC002GN, Accessory, VIK Sunglasses

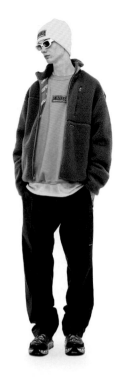

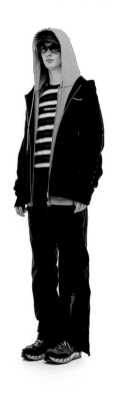

TN17FOW009BK, Jacket, Taped Seam Jacket ◍ TN17FOW015BL, Shirt, Flannel Sherpa Shirt ◍ TN17FBT002CK, Pants, TN Fleece Pant ◍ TN18SAC002GN, Accessory, VIK Suglasses ◍ TN17FAC009BK, Hat, T-Logo Bucket Hat

TN17FOW015NN, Shirt, Flannel Sherpa Shirt ◍ TN17FTO022BG, Sweatshirt, Hood Logo Hooded Sweatshirt ◍ TN17FBT006TB, Jean, Denim Jean ◍ TN18SAC002GN, Accessory, VIK Sunglasses ◍ TN17FAC019BE, Bag, Small HIP Bag ◍ TN17FAC028BK, Accessory, Belt

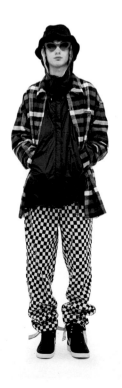

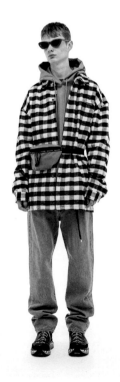

TN17FOW017BK, Jacket, Leather MA-1 (Solid) ▮ TN17FTO0110R, Shirt, Oversized Tartan Shirt ▮ TN17FTO008PP, Long Sleeve Tee, FB Team L/S Tee ▮ TN17FBT004BG, Pants, T-Logo Tape Sweatpant ▮ TN18SAC003BK, Accessory, Skogar Sunglasses

TN17FOW004BK, Jacket, INTL. Logo Oversized Down Parka ▮ TN17FTO0004RN, Long Sleeve Tee, Multi Stripe HT-Logo L/S Tee ▮ TN17FBT001CH, Pants, Work Pant ▮ TN18SAC003WH, Accessory, Skogar Sunglasses ▮ TN17FAC029BK, Accessory, Belt

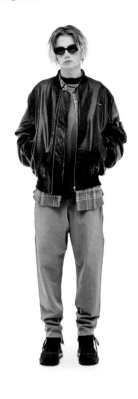

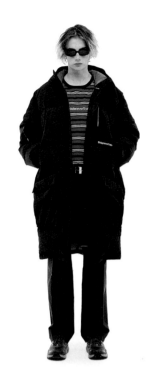

TN17FOW013BK, Jacket, Shop Coat ▮ TN17FTO030GR, Sweatshirt, ECILOP-P Hooded Sweatshirt ▮ TN17FBT001BK, Pants, Work Pant ▮ TN17FAC012BK, Accessory, Fleece Headband ▮ TN17FAC009BK, Hat, T-Logo Bucket Hat

TN17FTO034CH, Sweatshirt, Facet T-Logo Hooded Sweatshirt ▮ TN17FBT009OV, Pants, ECILOP-P Pant ▮ TN18SAC003WH, Accessory, Skogar Sunglasses ▮ TN17FAC020BK, Bag, BOP

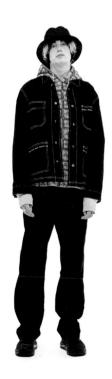

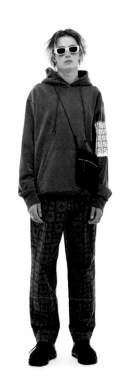

TN17FTO012PK, Sweatshirt, Stripe SP-Logo Crewneck ⏺ TN17FBT005PK,
Pants, Stripe SP-Logo Sweatpant ⏺ TN18SAC003BK, Accessory, Skogar
Sunglasses ⏺ TN17FAC025CK, Accessory, Fleece Scarf ⏺ TN17FAC019BK,
Bag, Small HIP Bag

TN17FTO012BK, Sweatshirt, Stripe SP-Logo Crewneck ⏺ TN17FBT006CZ,
Jean, Denim Jean ⏺ TN18SAC003BK, Accessory, Skogar Sunglasses

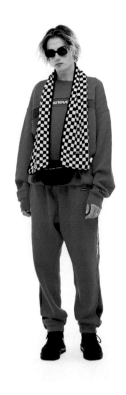

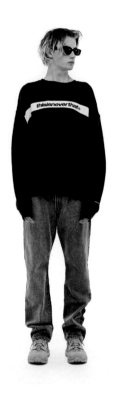

TN17FTO019BK, Sweatshirt, T-Logo S-Collar Sweatshirt ⏺ TN17FTO022BG,
Sweatshirt, Hood Logo Hooded Sweatshirt ⏺ TN17FBT002BL, Pants, TN
Fleece Pant ⏺ TN17FAC004BK, Hat, Script TN Fleece Cap

TN17FOW012BL, Jacket, Windbreaker Jacket ⏺ TN17FTO016WH, Sweatshirt,
INTL. Logo Crewneck ⏺ TN17FBT010BK, Pants, Rep-Logo Training Pant

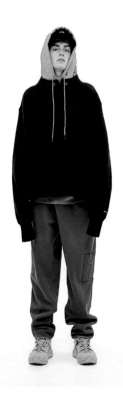

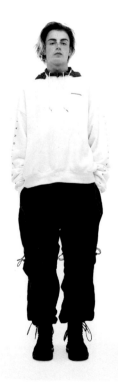

TN17FTO032GN, Sweatshirt, REV-T-Logo Hooded Sweatshirt ▮ TN17FBT008NA, Pants, C-Logo Relaxed Pant ▮ TN17FAC004BL, Hat, Script TN Fleece Cap ▮ TN17FAC018BK, Bag, Shoulder Bag

TN17FTO023BL, Sweatshirt, Mosaic 250 Hooded Sweatshirt ▮ TN17FBT002CK, Pants, TN Fleece Pant ▮ TN17FAC004BK, Hat, Script TN Fleece Cap ▮ TN17FAC025BL, Accessory, Fleece Scarf

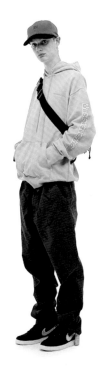
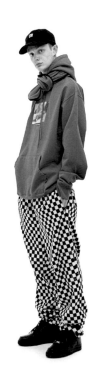

TN17FOW009BL, Jacket, Taped Seam Jacket ▮ TN17FTO002WH, Long Sleeve Tee, Stripe SP-Logo L/S Tee ▮ TN17FBT006TB, Jean, Denim Jean ▮ TN18SAC002BK, Accessory, VIK Sunglasses ▮ TN17FAC003KH, Hat, H-SP Logo Mesh Cap ▮ TN17FAC028BK, Accessory, Belt

TN17FTO002BK, Long Sleeve Tee, Stripe SP-Logo L/S Tee ▮ TN17FBT004GR, Pants, T-Logo Tape Sweatpant ▮ TN17FAC015BK, Hat, SP-Logo Beanie ▮ TN17FAC024BK, Accessory, Fleece Neck Warmer ▮ TN17FAC018BE, Bag, Shoulder Bag

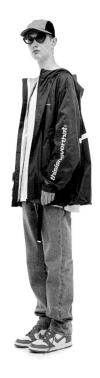
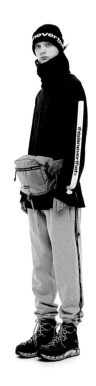

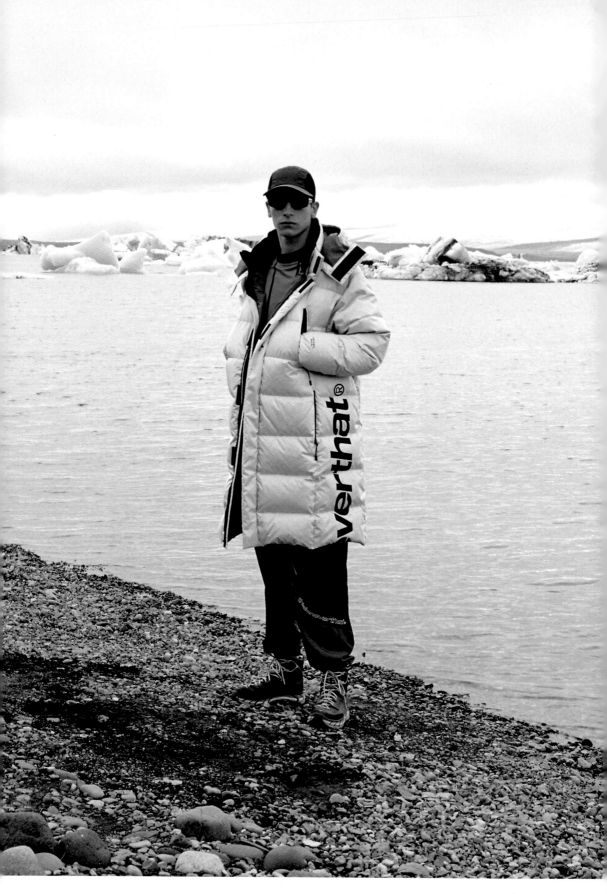

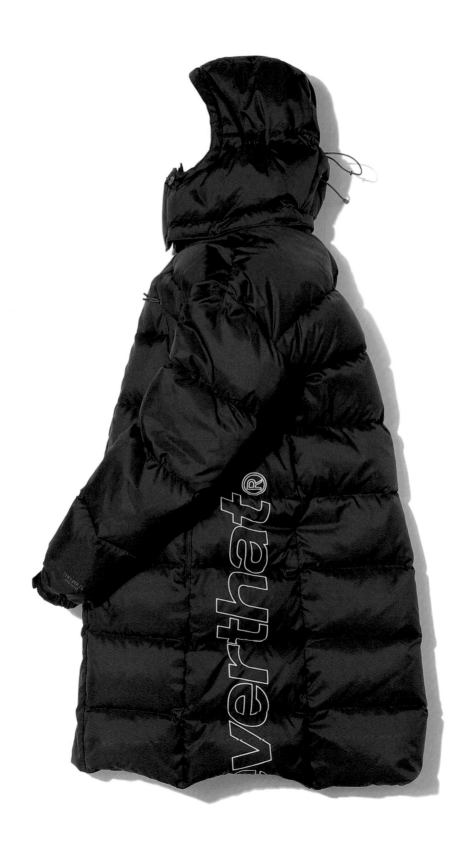

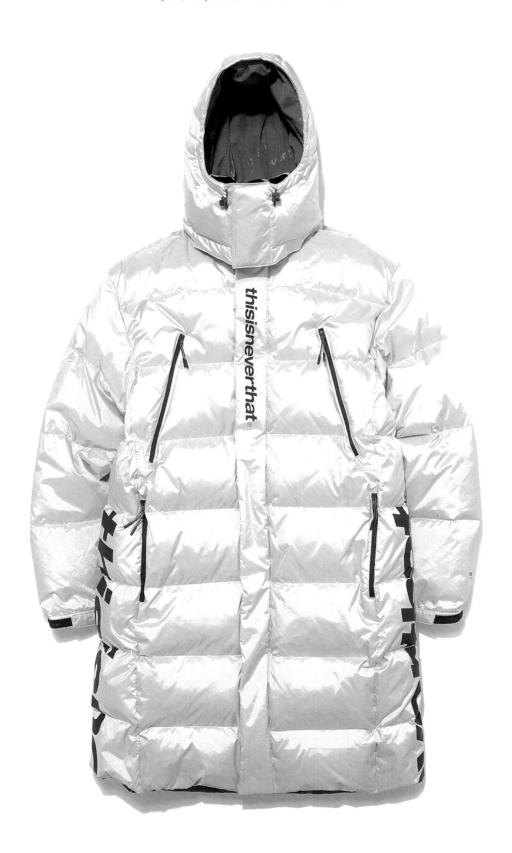

TN17FOW001SB / Jacket
SP-Logo Puffy Down Jacket
Nylon, Polyester, Down, Feather / Sky Blue

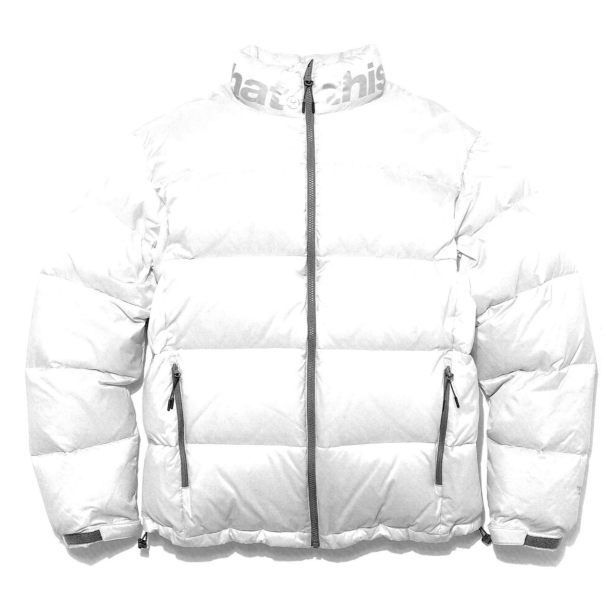

TN17FOW002YL / Jacket
Hooded Puffy Down Jacket
Polyester, Down, Feather / Yellow

TN17FOW009GN / Jacket
Taped Seam Jacket
Nylon / Green

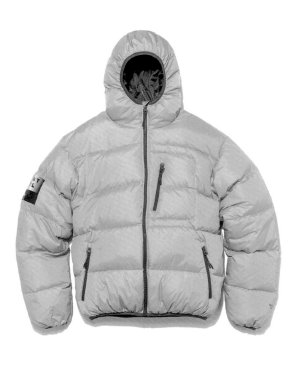

TN17FOW008OV / Jacket
M-51 Field Parka
Cotton, Polyester, 3M Thinsulate / Olive

TN17FOW006OV / Jacket
Mountain Down Parka
Polyester, Nylon, Down, Feather, Raccoon Fur / Olive

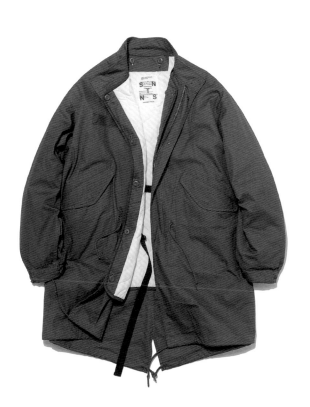

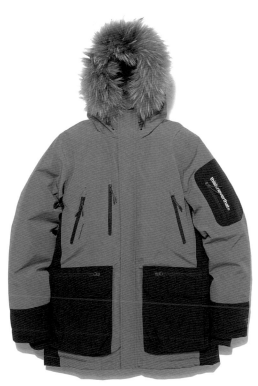

TN17FOW00GN / Jacket
Taped Seam Jacket
Nylon / Green

TN17FOW002YL / Jacket
Hooded Puffy Down Jacket
Polyester, Down, Feather / Yellow

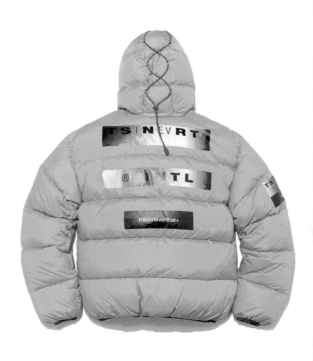

TN17FOW0060V / Jacket
Mountain Down Parka
Polyester, Nylon, Feather, Down, Raccoon Fur / Olive

TN17FOW0080V / Jacket
M-51 Field Parka
Cotton, Polyester, 3M Thinsulate / Olive

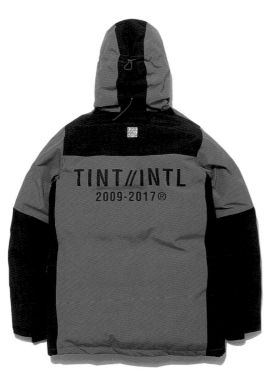

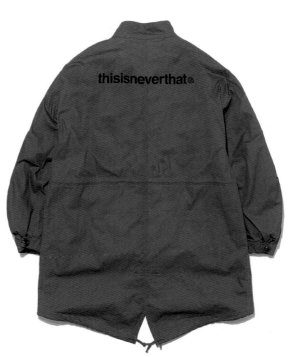

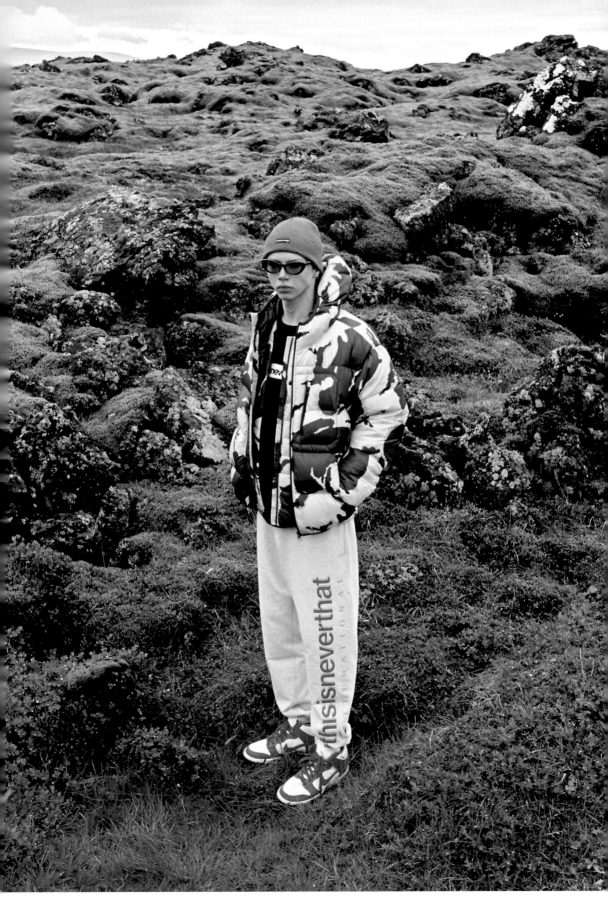

TN17FOW010BR / Jacket
R-Logo Fleece Reversible Jacket
Polyester / Brown

TN17FOW011NN / Jacket
Fleece Zip Jacket
Polyester / Neon

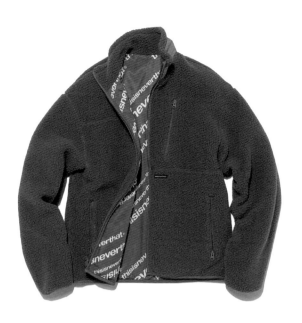

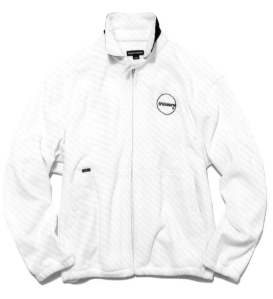

TN17FOW012BK / Jacket
Windbreaker Jacket
Polyester / Black

TN17FOW016NA / Jacket
C-Logo Trucker Jacket
Cotton / Navy

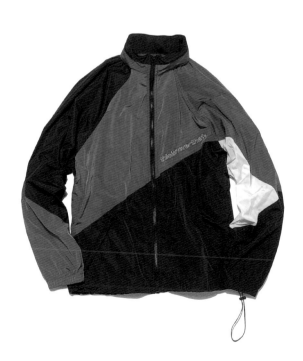

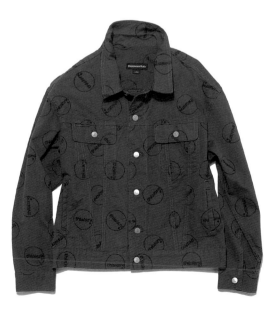

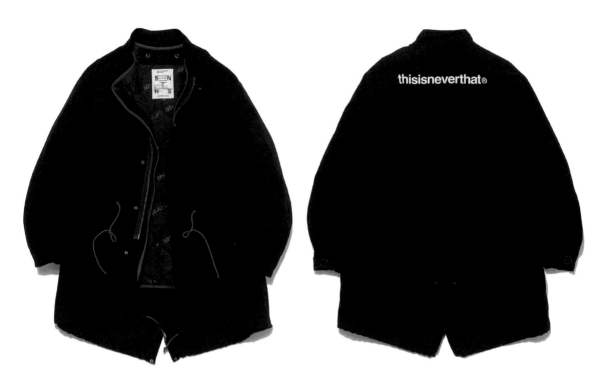

TN17FOW001BK TN17FOW001GN TN17FOW002BK

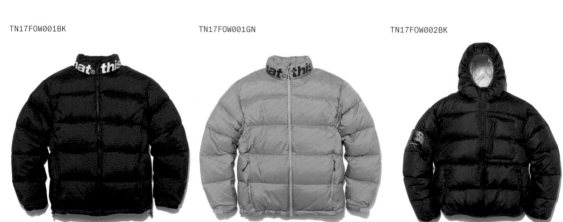

TN17FOW008BK	Jacket	M-51 Field Parka	Cotton, Polyester, 3M Thinsulate	Black
TN17FOW001BK	Jacket	SP-Logo Puffy Down Jacket	Nylon, Polyester, Down, Feather	Black
TN17FOW001GN	Jacket	SP-Logo Puffy Down Jacket	Nylon, Polyester, Down, Feather	Green
TN17FOW002BK	Jacket	Hooded Puffy Down Jacket	Polyester, Down, Feather	Black

TN17FOW015BL

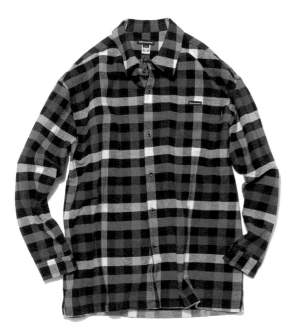 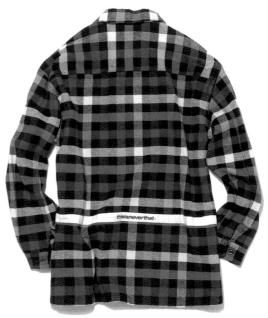

TN17FOW005SB TN17FOW007OV TN17FOW007BK

TN17FOW015BL	Shirt	Flannel Sherpa Shirt	Cotton	Blue
TN17FOW005SB	Jacket	S-Light Padded Jacket	Polyester, 3M Thinsulate	Sky Blue
TN17FOW007OV	Jacket	MA-1 Jacket	Nylon, 3M Thinsulate	Olive
TN17FOW007BK	Jacket	MA-1 Jacket	Nylon, 3M Thinsulate	Black

TN17FTO016BK / Sweatshirt
INTL. Logo Crewneck
Cotton / Black

TN17FTO019CH / Sweatshirt
T-Logo S-Collar Sweatshirt
Cotton / Charcoal

TN17FTO028BK / Sweatshirt
RA-P Logo Hooded Sweatshirt
Cotton / Black

TN17FTO030GR / Sweatshirt
ECILOP-P Hooded Sweatshirt
Cotton / Grey

TN17FTO023BK / Sweatshirt
Mosaic 250 Hooded Sweatshirt
Cotton / Black

TN17FTO024GR / Sweatshirt
Square SP Logo Hooded Sweatshirt
Cotton / Grey

TN17FTO025BK / Sweatshirt
sfdf C-Logo Hooded Sweatshirt
Cotton / Black

TN17FTO034BK / Sweatshirt
Facet T-Logo Hooded Sweatshirt
Cotton / Black

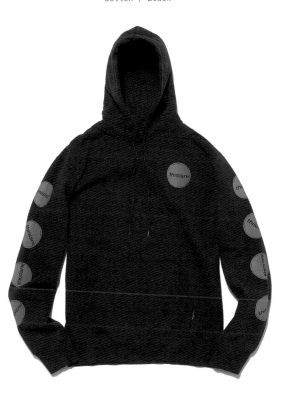

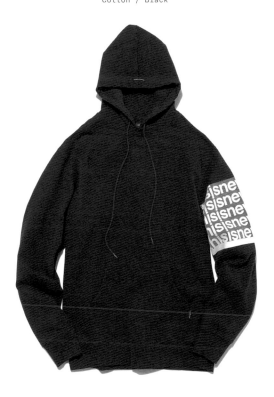

TN17FAC001CA / Hat
T-Logo Camp Cap
Cotton / Camo

TN17FOW013CA / Jacket
Shop Coat
Cotton / Camo

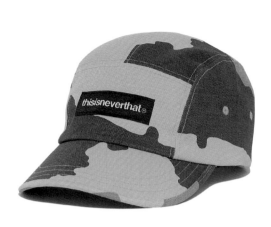

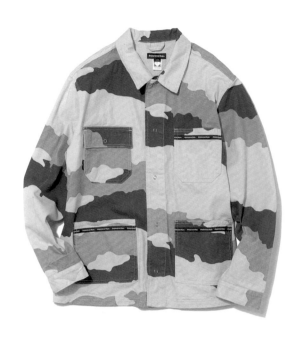

TN17FTO029CA / Sweatshirt
HT-Logo Hooded Sweatshirt
Cotton / Camo

TN17FTO014CA / Sweatshirt
3 LINES Logo Crewneck
Cotton / Camo

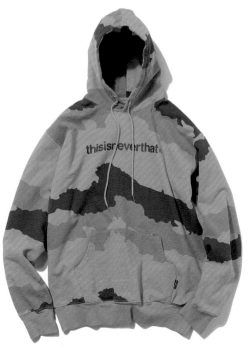

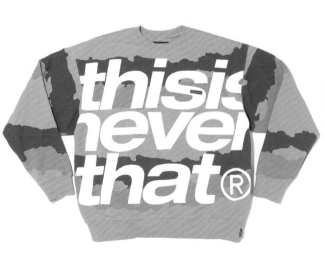

Directed by Kim Mintae
Music produced by Somdef
Guitar by Jin Sil

TN17FTO003BK

TN17FTO002MI

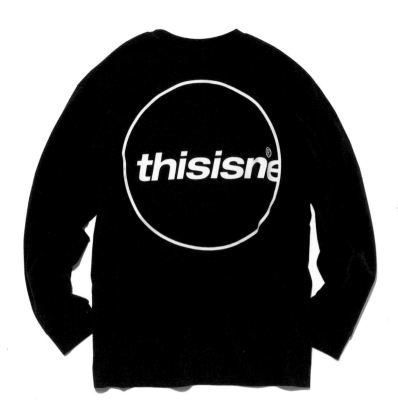

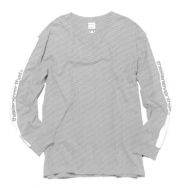

TN17FTO006NN

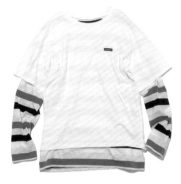

TN17FTO012CH

TN17FTO013RD

TN17FTO018BG

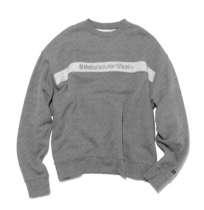

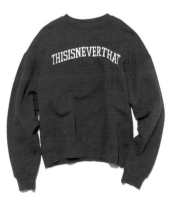

TN17FTO003BK	Long Sleeve Tee	C-Logo L/S Tee	Cotton	Black
TN17FTO002MI	Long Sleeve Tee	Stripe SP-Logo L/S Tee	Cotton	Mint
TN17FTO006NN	Long Sleeve Tee	Layered L/S Tee	Cotton	Neon
TN17FTO012CH	Sweatshirt	Stripe SP-Logo Crewneck	Cotton, Polyester	Charcoal
TN17FTO013RD	Sweatshirt	ARC-Logo Crewneck	Cotton	Red
TN17FTO018BG	Sweatshirt	NEVER EMB. Crewneck	Cotton	Blue Green

TN17FBT009WH

TN17FBT010BK

TN17FAC003KH

TN17FAC004BK

TN17FAC031BK

TN17FBT009WH	Pants	ECILOP-P Pant	Cotton	White
TN17FBT010BK	Pants	Rep-Logo Training Pant	Nylon, Polyester	Black
TN17FAC003KH	Hat	H-SP Logo Mesh Cap	Nylon, Polyester	Khaki
TN17FAC004BK	Hat	Script TN Fleece Cap	Polyester	Black
TN17FAC031BK	Hat	NEVER-Logo Beanie	Acrylic	Black

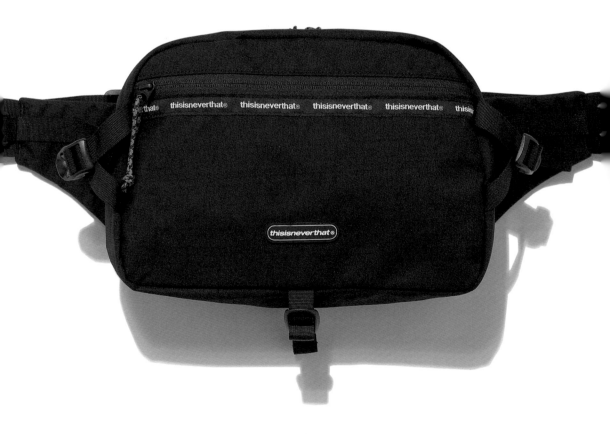

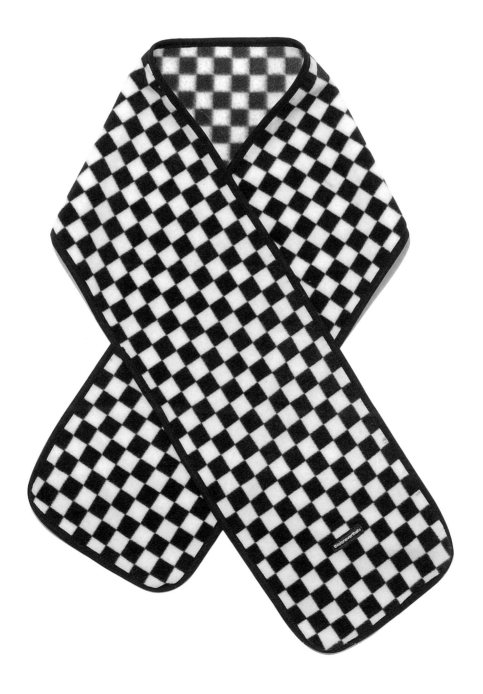

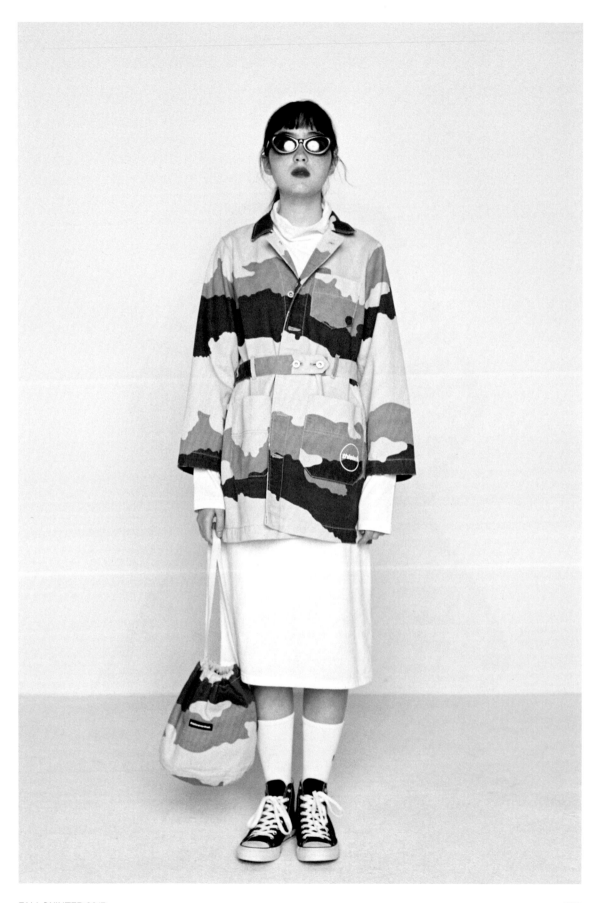

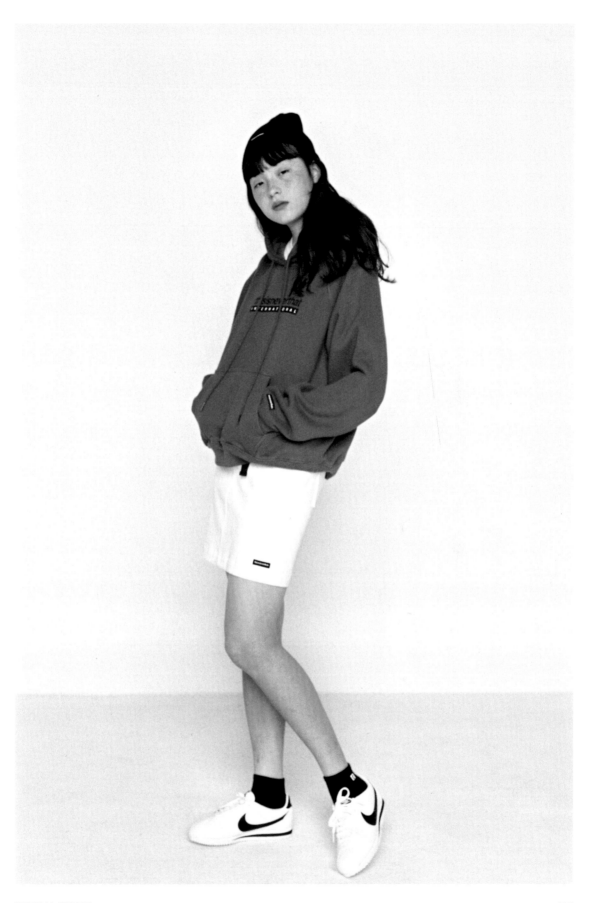

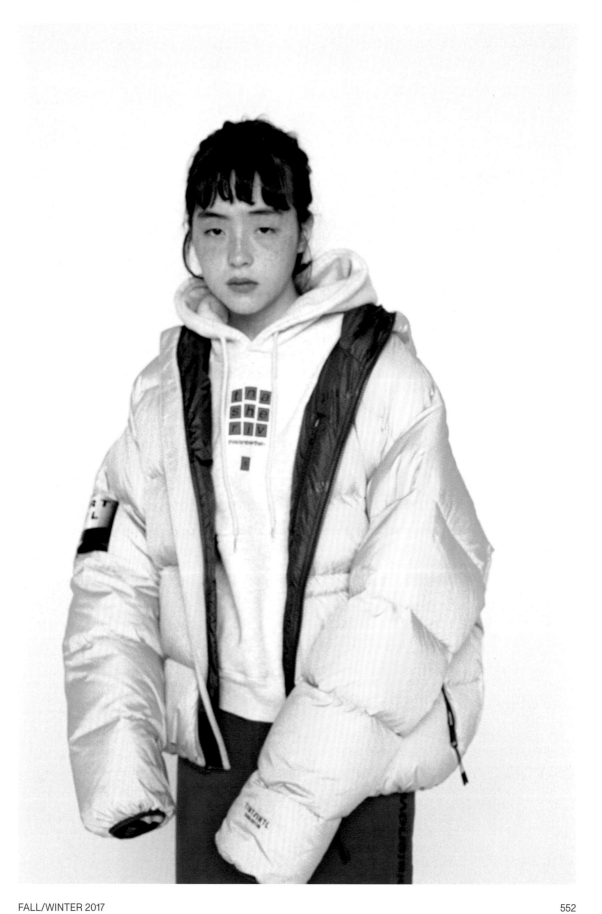

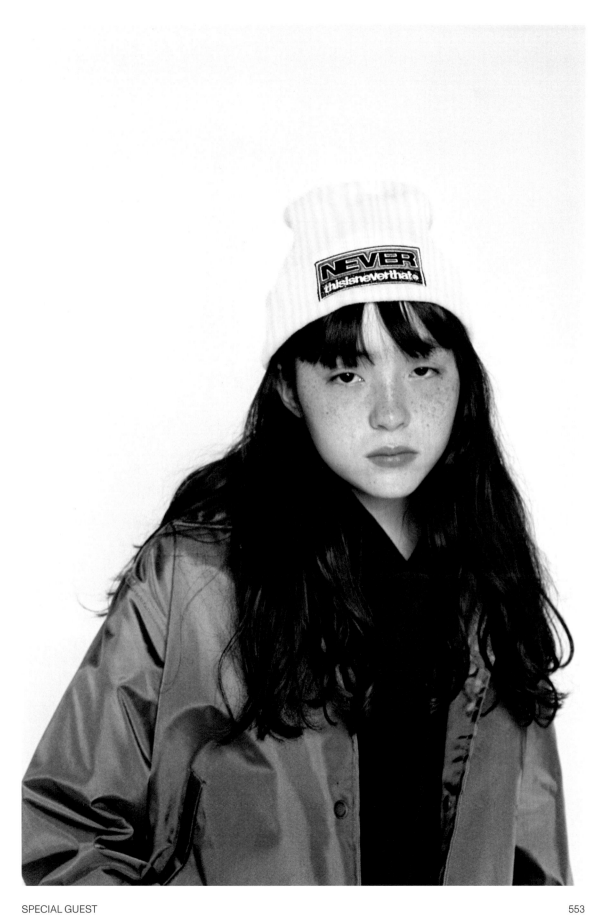

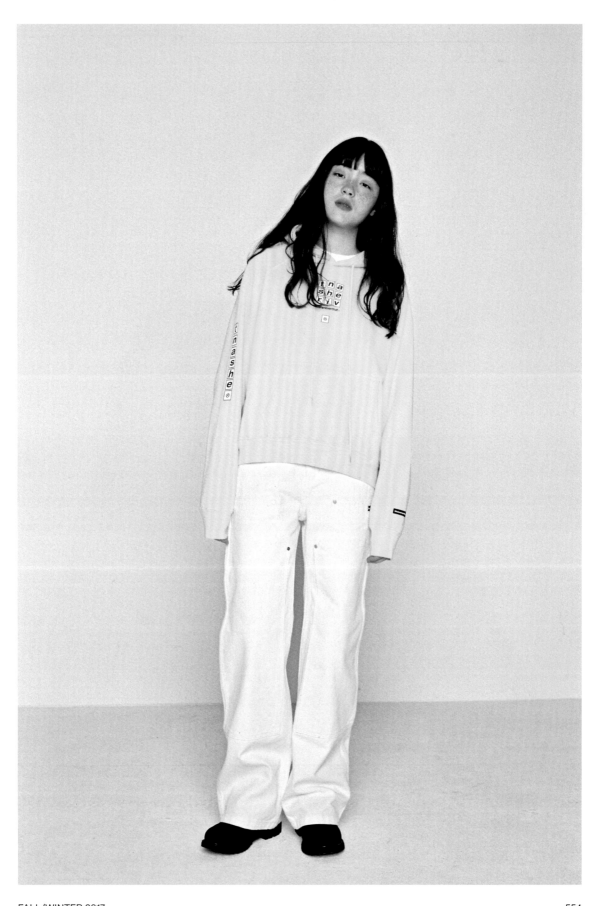

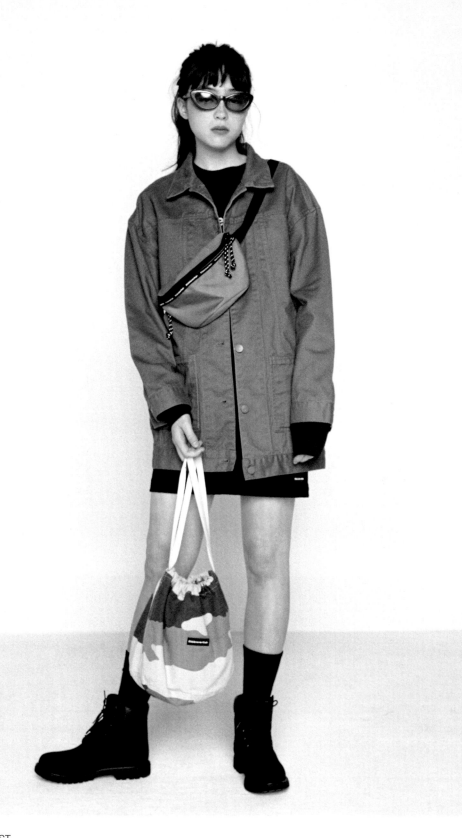

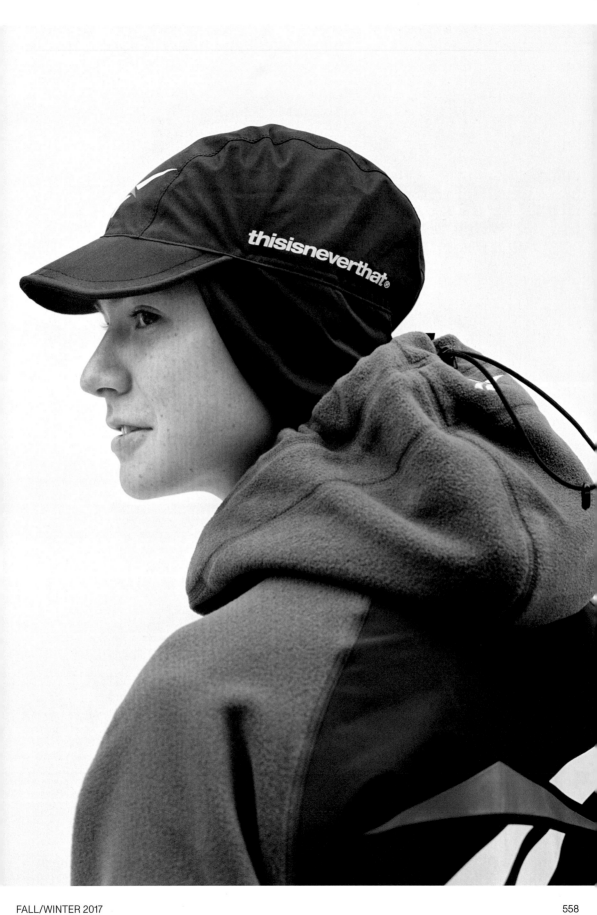

RB17FOW001NA / Jacket
FL Track HD JKT
Polyester / Navy

RB17FOW001KH / Jacket
FL Track HD JKT
Polyester / Khaki

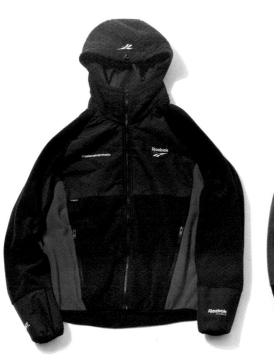 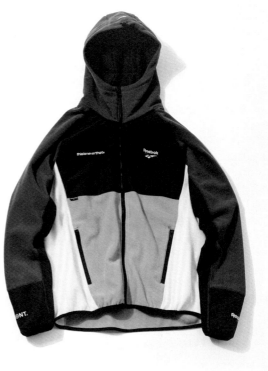

RB17FTO001WH / Tee
CL LS Tee
Cotton / White

RB17FTO001BK / Tee
CL LS Tee
Cotton / Black

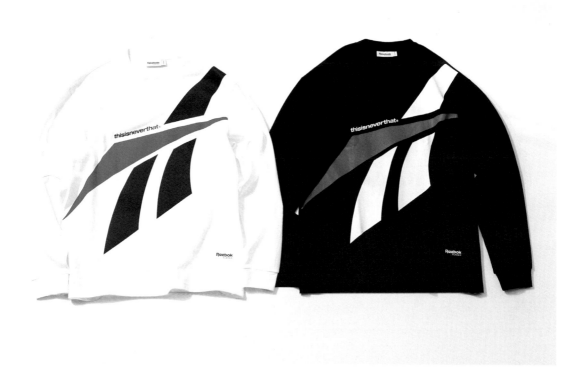

RB17FBT001NA / Pants
FL Track Pant
Polyester / Navy

RB17FBT001KH / Pants
FL Track Pant
Polyester / Khaki

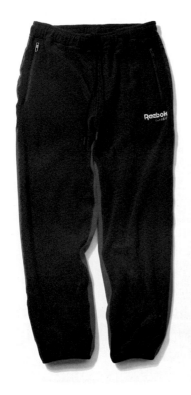 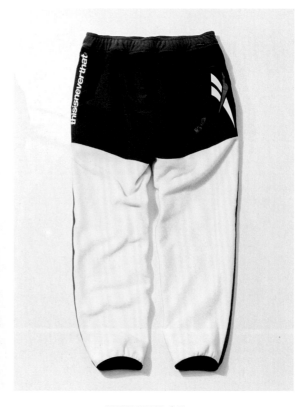

RB17FAC001BK / Hat
CL THISNV Cap
Polyester / Black

RB17FAC002GR / Shoes
CL Leather This
Suede, Rubber / Grey

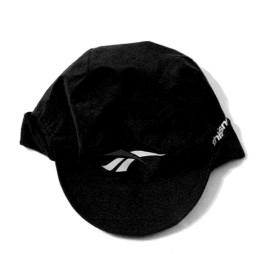 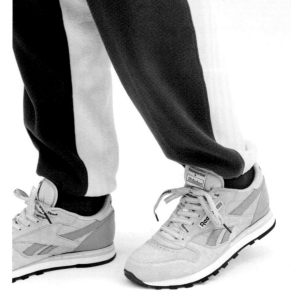

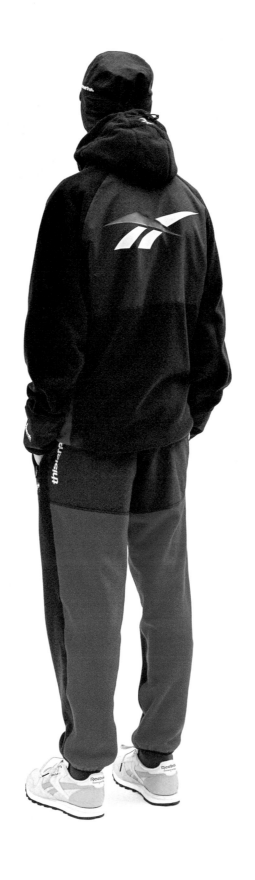

REEBOK × thisisneverthat

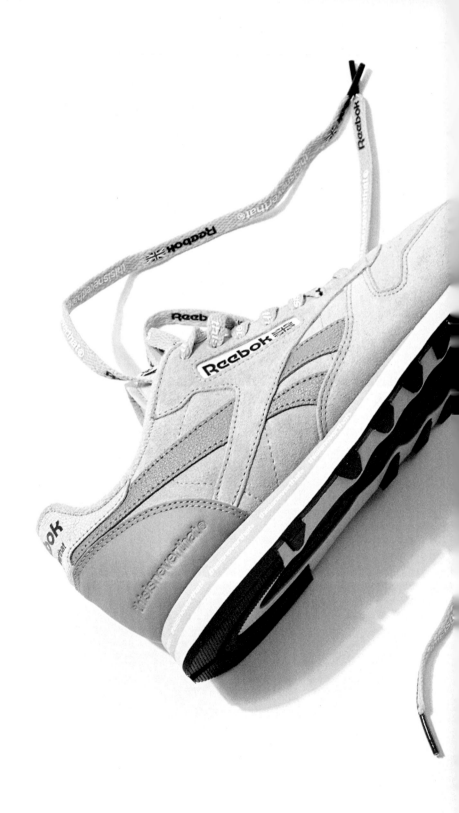

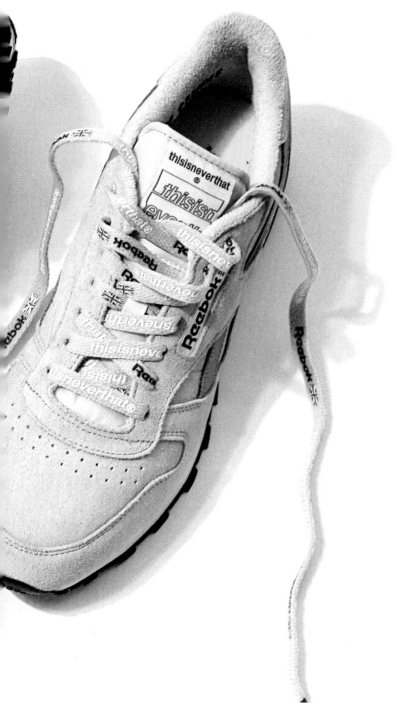

REEBOK × thisisneverthat

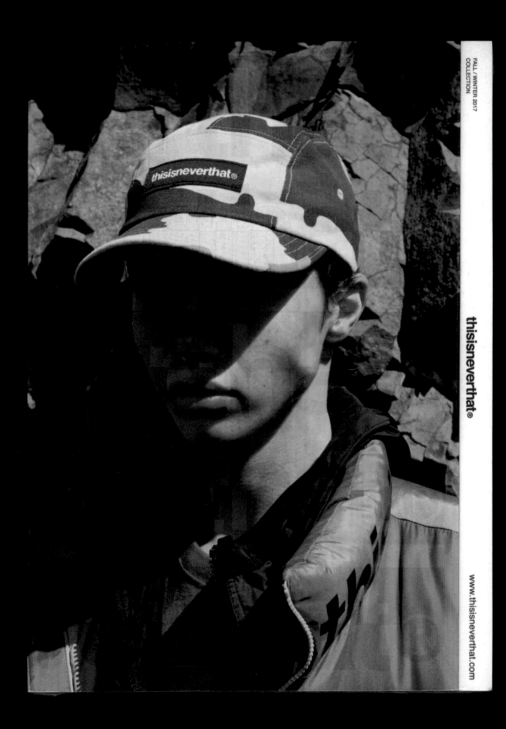

FALL / WINTER 2017
COLLECTION

thisisneverthat®

www.thisisneverthat.com

SPRING/SUMMER 2017

LAST FESTIVAL

TN17SOW005BK, Jacket, Fishing Vest ◗ TN17STO030BK, Long Sleeve
Tee, Partition SP-Logo L/S ◗ TN17SBT008BK, Pants, SP Fleece Pant ◗
TN17SAC008BK, Hat, Rubber Logo Camp Cap

TN17STO023IU, Sweatshirt, T-Logo Hooded Sweatshirt ◗ TN17SBT013IU,
Pants, Sweat Short ◗ TN17SAC015IU, Hat, Checkerboard Bucket Hat ◗
TN17SAC020NN, Socks, Regular Socks

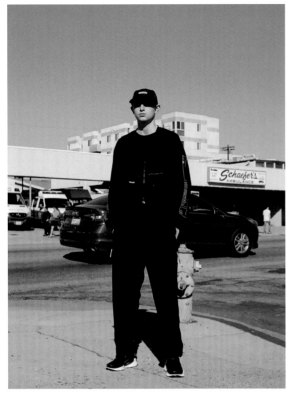

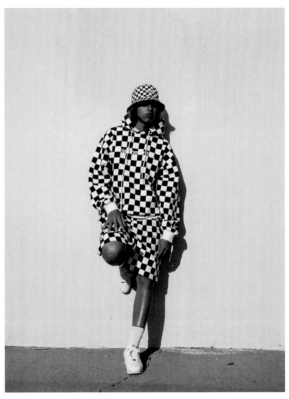

TN17STO002BK, Shirt, Oversized Shirt ◗ TN17STO045WH, Tee, TINT ARC Logo
Tee ◗ TN17SBT011SB, Pants, Basic Sweat Pant ◗ TN17SAC010BK, Hat, T-Logo
6P Cap ◗ TN17SAC003BK, Bag, RS-Shoulder Bag

TN17STO026GR, Sweatshirt, TINT ARC Logo Hooded Sweatshirt ◗
TN17SBT010CA, Pants, SP-Logo Sweat Pant ◗ TN17SAC003BK, Hat, SP-Logo
Bucket Hat

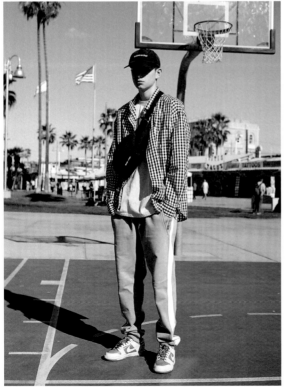

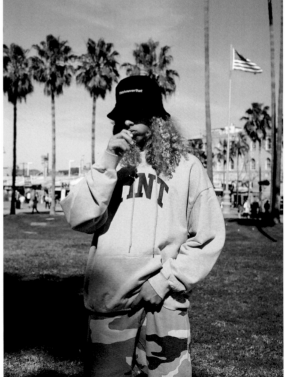

TN17STO031SB, Long Sleeve Tee, Palm Tree L/S ⬤ TN17STO004WH, Pants, Overalls ⬤ TN17SAC014WH, Hat, Rep-Logo Bucket Hat ⬤ TN17SAC035SR, Accessory, Necklace

TN17STO011PK, Shirt, Guayabera Shirt ⬤ TN17STO033NA, Long Sleeve Tee, T-Logo L/S ⬤ TN17SBT011NA, Pants, Basic Sweat Pant ⬤ TN17SAC035SR, Accessory, Necklace

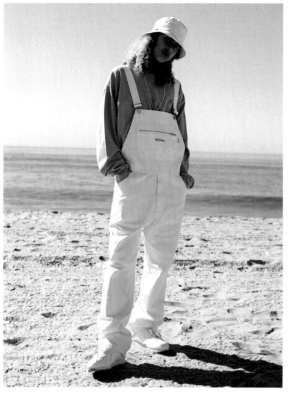

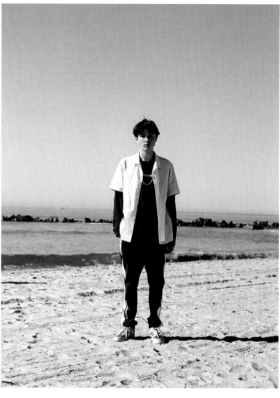

TN17SOW001WH, Jacket, M3500 Trucker Jacket ⬤ TN17STO041PP, Tee, Reflective DIA-Logo Tee ⬤ TN17SBT003BL, Jean, Washed Regular Jean

TN17STO047NA, Tee, Tennis Player Tee ⬤ TN17SBT015SB, Pants, Fatigue Short ⬤ TN17SAC008YL, Hat, Rubber Logo Camp Cap ⬤ TN17SAC003BK, Bag, RS-Shoulder Bag

TN17STO018SB, Sweatshirt, Nylon Crewneck ◖ TN17SAC014BK, Hat, Rep-Logo Bucket Hat

TN17SOW006GN, Jacket, Mohair Cardigan ◖ TN17STO042NA, Tee, T.I.N.T Tee ◖ TN17SBT003TB, Jean, Washed Regular Jean ◖ TN17SAC035SR, Accessory, Necklace

TN17STO002GN, Shirt, Oversized Shirt ◖ TN17SBT001BU, Pants, Work Pant ◖ TN17SAC014WH, Hat, Rep-Logo Bucket Hat ◖ TN17SAC035SR, Accessory, Necklace

TN17STO033GR, Long Sleeve Tee, T-Logo L/S ◖ TN17SBT001BE, Pants, Work Pant ◖ TN17SAC017SB, Hat, Rubber Logo Beanie

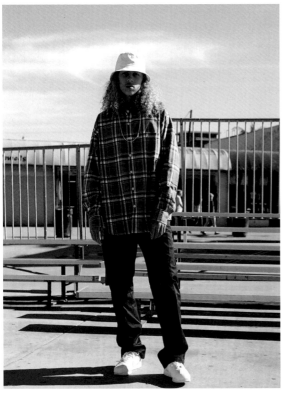

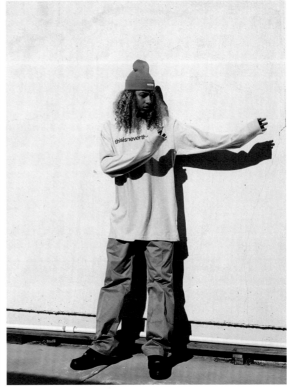

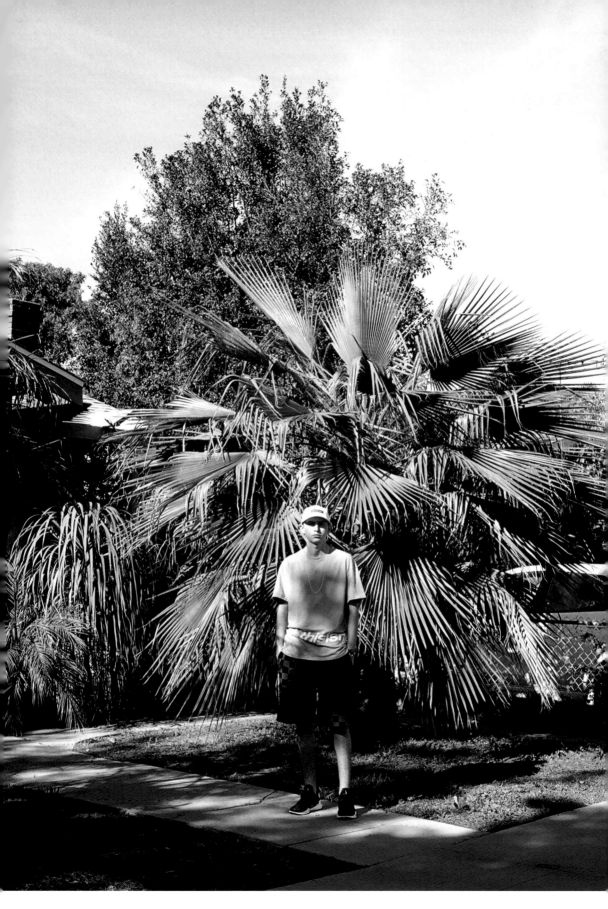

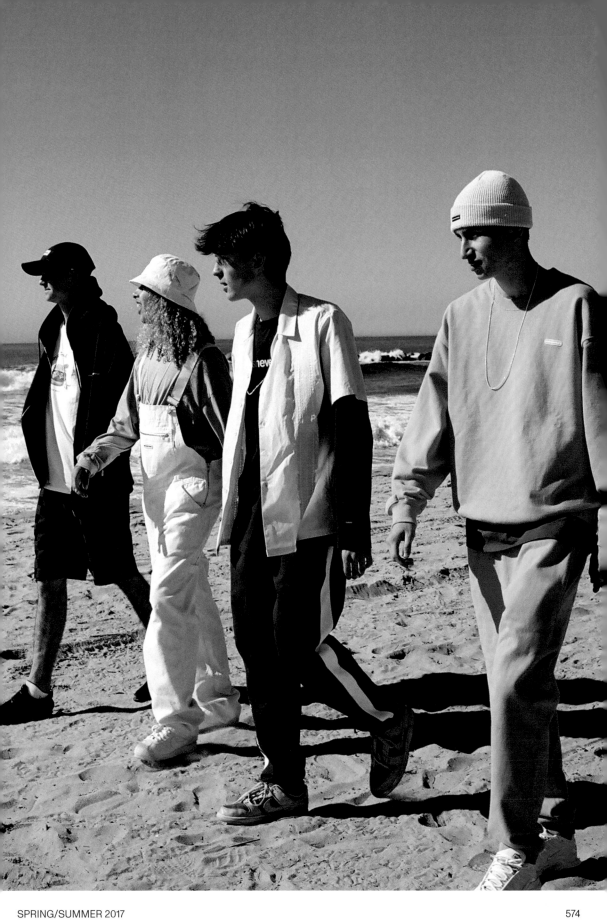

TN17STO003GR, Shirt, Hooded Plaid Zip Shirt ◊ TN17STO038BK, Tee, P-1 Logo Tee ◊ TN17SBT010BK, Pants, SP-Logo Sweat Pant ◊ TN17SAC012BK, Hat, SP-Logo Cap ◊ TN17SAC006BK, Bag, RS-BOP

TN17SOW010WH, Jacket, Rain Coat ◊ TN17STO032BK, Long Sleeve Tee, DIA-Logo L/S ◊ TN17SBT008BK, Pants, SP Fleece Pant

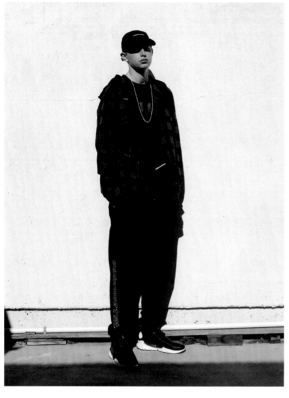

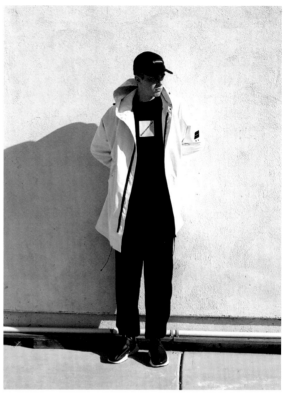

TN17SOW008PP, Jacket, MCR Flight Jacket ◊ TN17STO050NB, Tee, Multi Striped Tee ◊ TN17SBT001BK, Pants, Work Pant

TN17STO017SB, Sweatshirt, TINT.INTL. Crewneck ◊ TN17SBT004BK, Pants, Rep-Logo Relaxed Pant

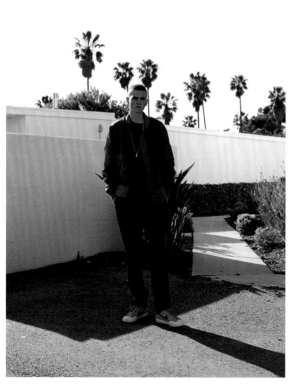

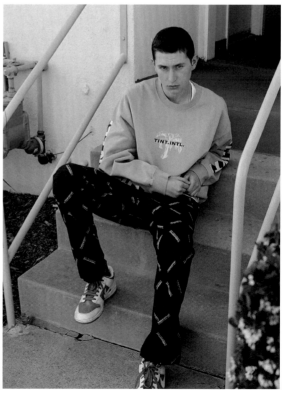

TN17STO005PP, Sweatshirt, G-Logo Hooded Sweatshirt ⬤ TN17SBT009WH, Pants, SP Training Jogger ⬤ TN17SAC018PP, Hat, Small Logo Beanie

TN17STO038NA, Tee, P-1 Logo Tee ⬤ TN17SBT007OR, Pants, Surfing Short ⬤ TN17SAC008BK, Hat, Rubber Logo Camp Cap

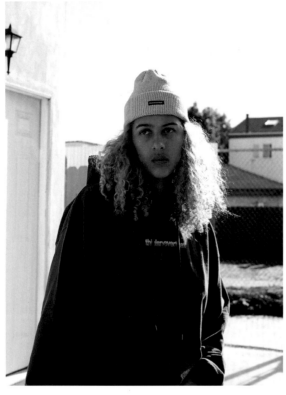

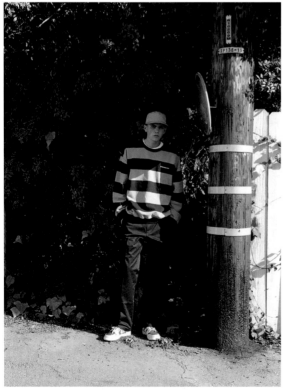

TN17STO021UC, Sweatshirt, Striped Crewneck ⬤ TN17SBT001BK, Pants, Work Pant ⬤ TN17SAC009BL, Hat, RS Camp Cap

TN17SOW004BK, Jacket, Shop Coat ⬤ TN17STO057WH, Tee, T-Logo Tee ⬤ TN17SBT013GR, Pants, Sweat Short

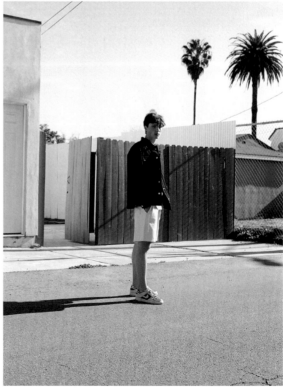

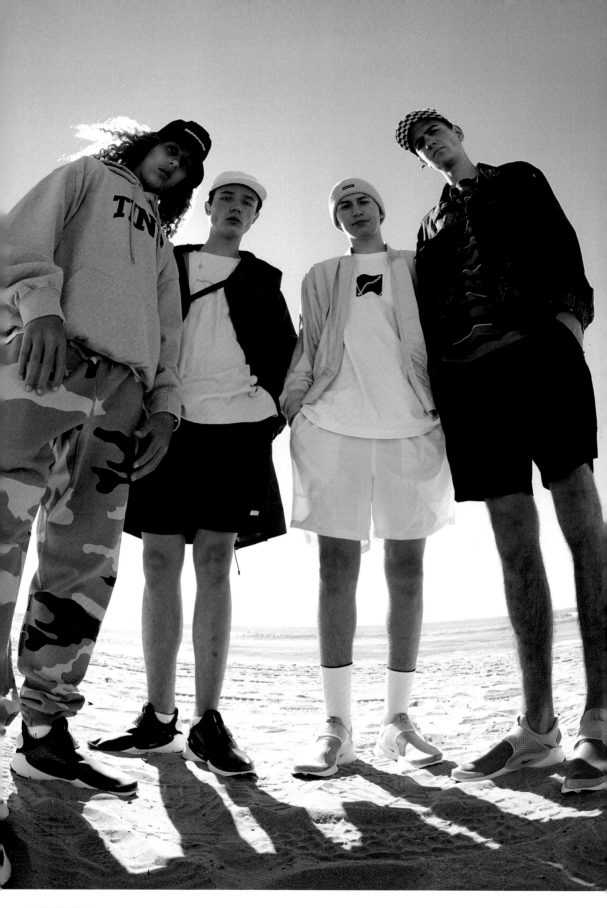

TN17STO049WH / Tee
Cheese Burger Tee
Cotton / White

TN17STO044WH / Tee
Palm Tree Tee
Cotton / White

TN17SBT013AU / Pants
Sweat Short
Cotton / Black, Blue

TN17SBT002BU / Pants
Work Short
Cotton / Burgundy

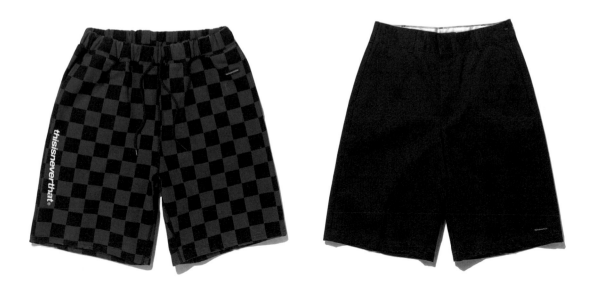

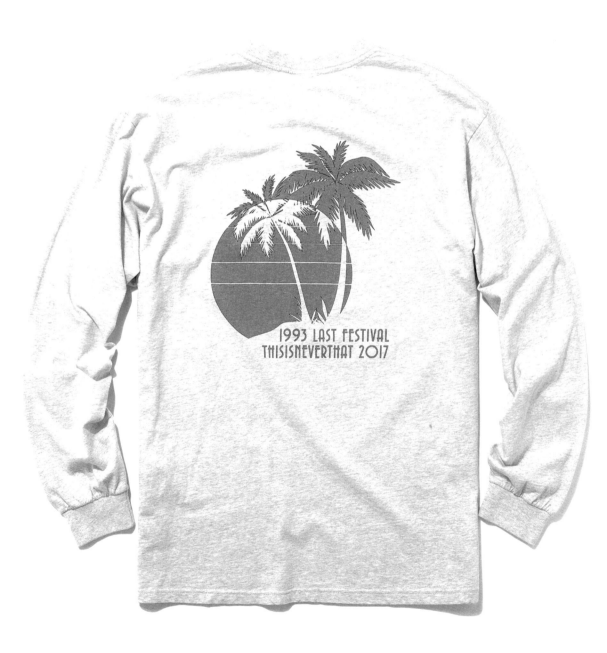

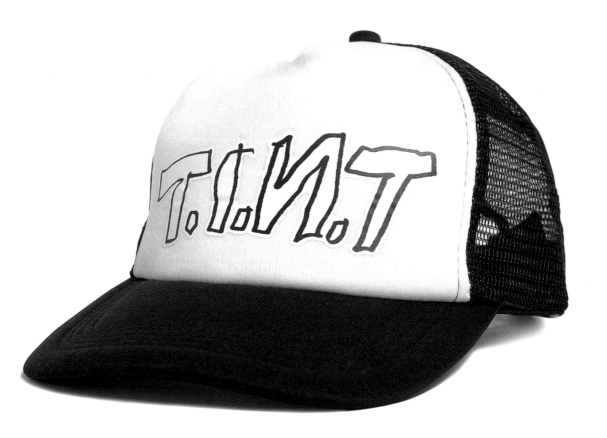

TN17SOW011WH / Jacket
SP Fleece Jacket
Polyester, Nylon / White

TN17SOW009OR / Jacket
Anorak Jacket
Polyester, Nylon / Orange

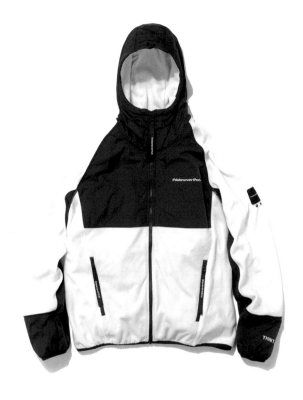

TN17SBT008WH / Pants
SP Fleece Pant
Polyester, Nylon / White

TN17SBT008RD / Pants
SP Fleece Pant
Polyester, Nylon / Red

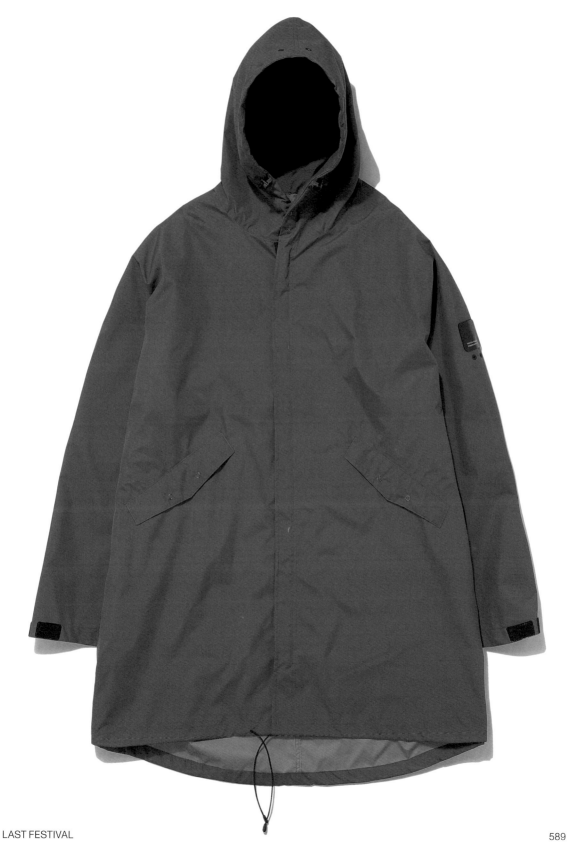

TN17SOW009BL / Jacket
Anorak Jacket
Nylon, Polyester / Blue

TN17STO013BK / Sweatshirt
Tennis Player Hooded Sweatshirt
Cotton / Black

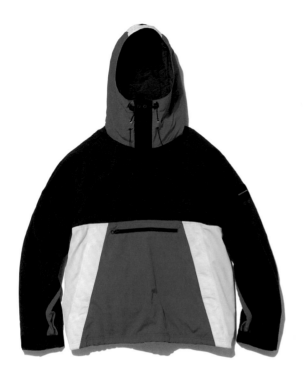

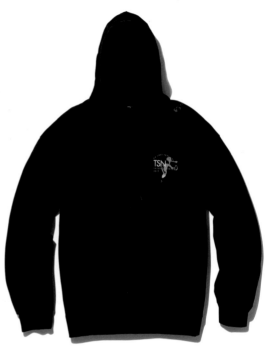

TN17SOW008SR / Jacket
MCR Flight Jacket
Nylon, Polyester / Silver

TN17SOW005WH / Jacket
Fishing Vest
Cotton, Nylon, Polyester / White

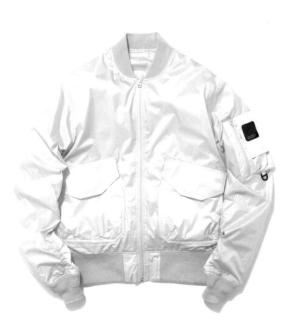

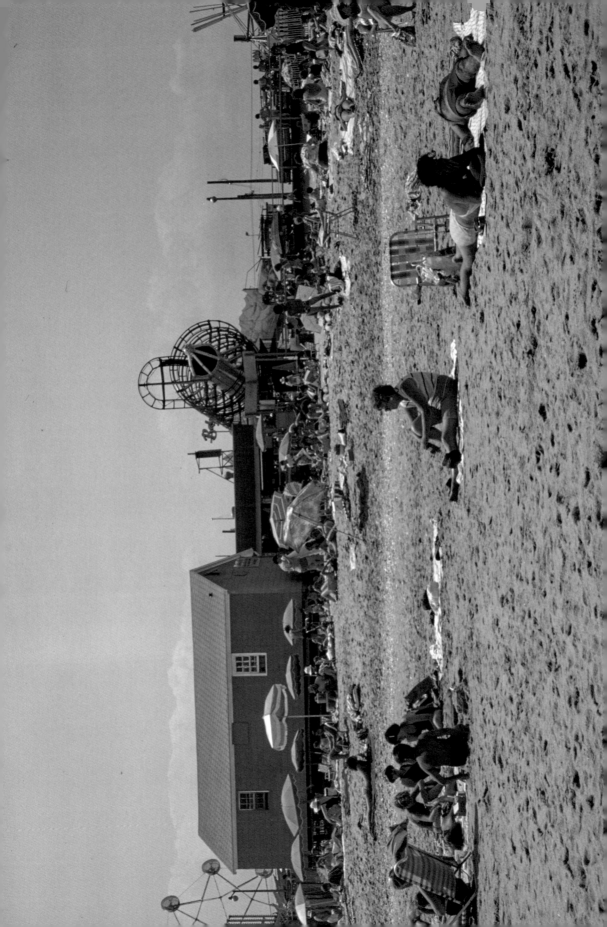

TN17STO026CA / Sweatshirt
TINT ARC Logo Hooded Sweatshirt
Cotton / Camo

TN17STO016CA / Sweatshirt
ARC Logo Crewneck
Cotton / Camo

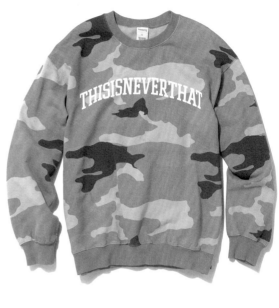

TN17SAC012CA / Hat
SP-Logo Cap
Polyester / Camo

TN17SBT010CA / Pants
SP-Logo Sweat Pant
Cotton / Camo

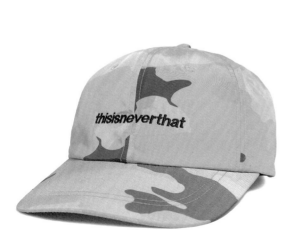

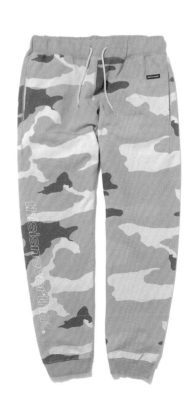

TN17STO061BK TN17SOW001WH

TN17STO051NA TN17STO011PK TN17STO009GN

TN17STO017BK TN17STO017SB TN17STO030ER

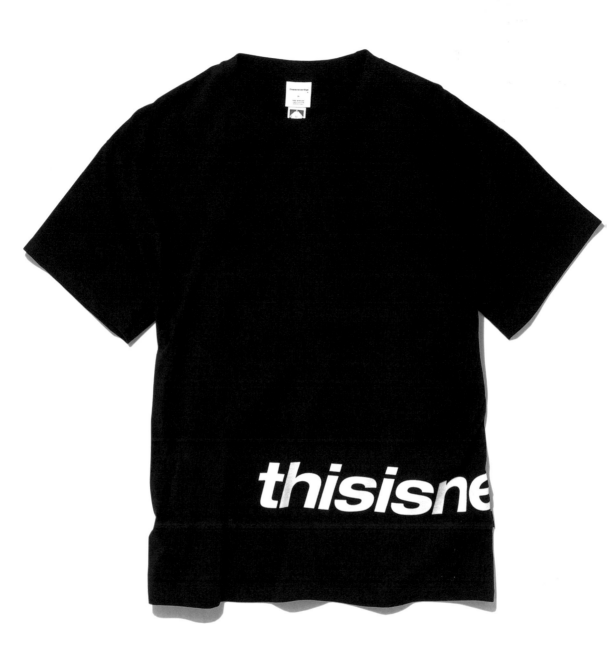

TN17STO061BK	Tee	thisisneverthat × Casestudy Tee	Cotton	Black
TN17SOW001WH	Jacket	M3500 Trucker Jacket	Cotton	White
TN17STO051NA	Tee	Rep-Logo Tee	Cotton	Navy
TN17STO011PK	Shirt	Guayabera Shirt	Cotton	Pink
TN17STO009GN	Shirt	Bandana Shirt	Cotton	Green
TN17STO017BK	Sweatshirt	TINT.INTL. Crewneck	Cotton	Black
TN17STO017SB	Sweatshirt	TINT.INTL. Crewneck	Cotton	Sky Blue
TN17STO030ER	Long Sleeve Tee	Partition SP-Logo L/S	Cotton	Neon Green

TN17SOW012BK

TN17SOW012WH

TN17SOW002BL

TN17STO004BK

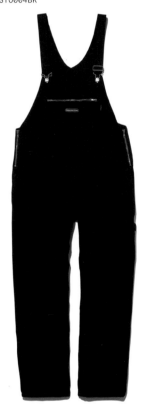

TN17SBT009WH

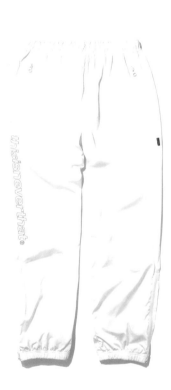

TN17SBT004BR

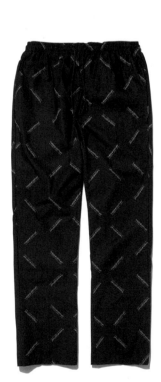

TN17SOW012BK	Jacket	SP Half Zip Windbreaker	Polyester	Black
TN17SOW012WH	Jacket	SP Half Zip Windbreaker	Polyester	White
TN17SOW002BL	Jacket	SP Zip Jacket	Cotton	Blue
TN17STO004BK	Pants	Overalls	Cotton	Black
TN17SBT009WH	Pants	SP Training Jogger	Polyester	White
TN17SBT004BR	Pants	Rep-Logo Relaxed Pant	Cotton	Brown

TN17SAC008BK

TN17SAC008GR

TN17SAC010BK

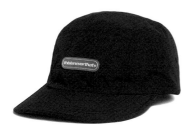
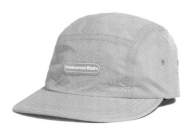
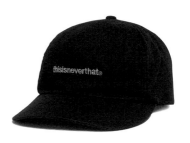

TN17SAC011IA

TN17SAC003BK

TN17SAC005BK

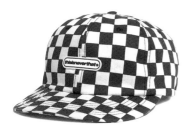
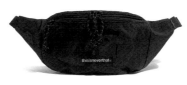
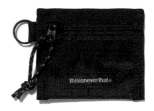

TN17SAC004BL

TN17SAC006BK

TN17SAC034PP

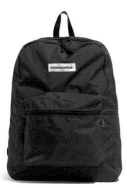
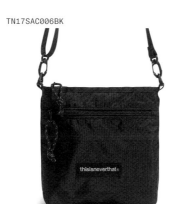
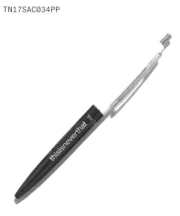

TN17SAC008BK	Hat	Rubber Logo Camp Cap	Nylon	Black
TN17SAC008GR	Hat	Rubber Logo Camp Cap	Nylon	Grey
TN17SAC010BK	Hat	T-Logo 6P Cap	Cotton	Black
TN17SAC011IA	Hat	Checkerboard 6P Cap	Cotton	White, Black
TN17SAC003BK	Bag	RS-Shoulder Bag	Nylon	Black
TN17SAC005BK	Bag	RS-Card Case	Nylon	Black
TN17SAC004BL	Bag	RS-Daypack	Nylon	Blue
TN17SAC006BK	Bag	RS-BOP	Nylon	Black
TN17SAC034PP	Accessory	BIC® Ballpen	Plastic	Purple

Collaborator

Release Date
Mar 17, 2017

Prefix
ST

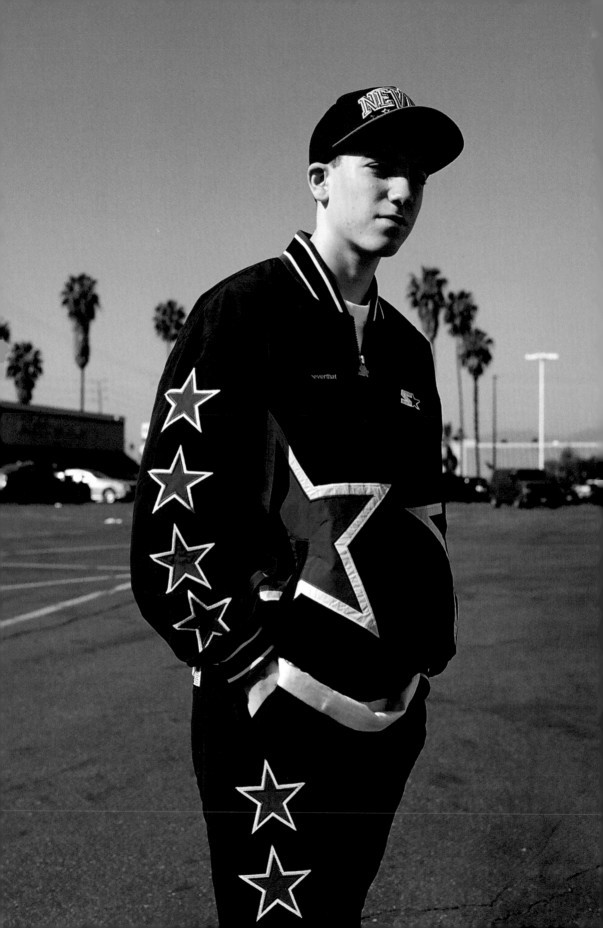

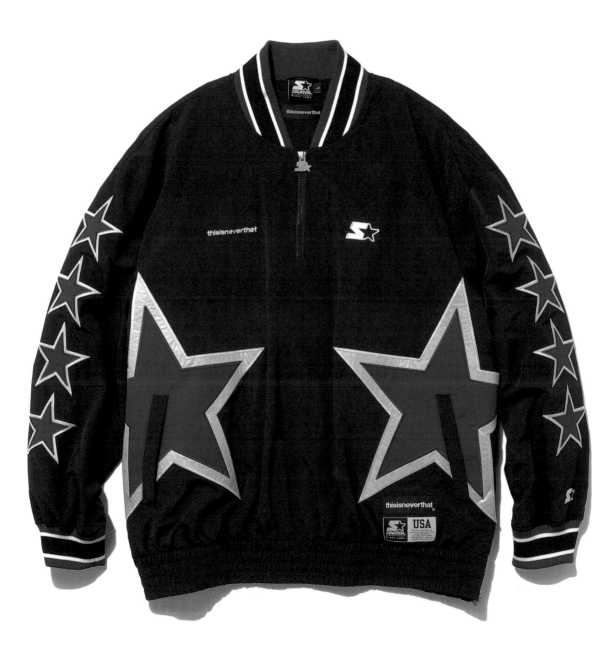

STARTER × thisisneverthat

ST17STO001 / Sweatshirt
TINT® × STARTER® Hooded Sweatshirt
Cotton / Black, Grey

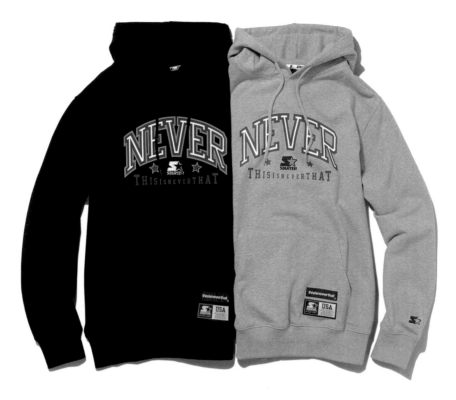

ST17STO002 / Tee
TINT® × STARTER® NEVER Tee
Cotton / Black, Purple, White

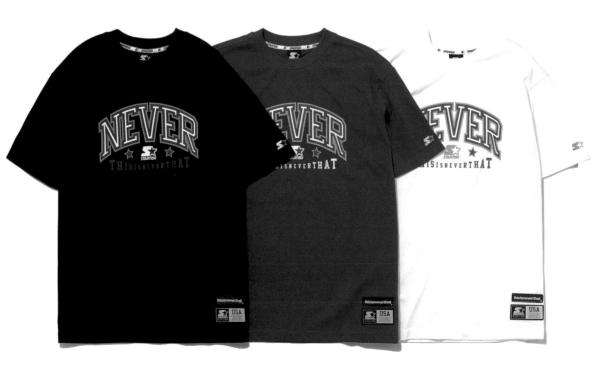

ST17SBT001BK / Pants
TINT® × STARTER® Track Pant
Nylon, Polyester / Black

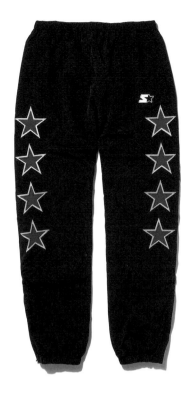

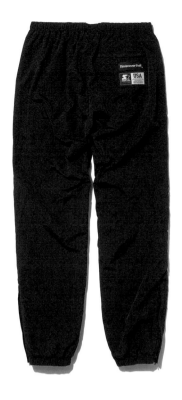

ST17SAC002PP / Hat
TINT® × STARTER® 5P Cap
Acrylic, Wool / Purple

ST17SAC002BK / Hat
TINT® × STARTER® 5P Cap
Acrylic, Wool / Black

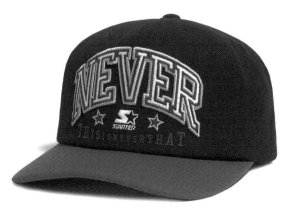

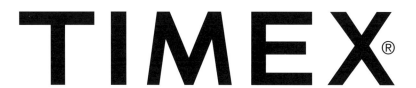

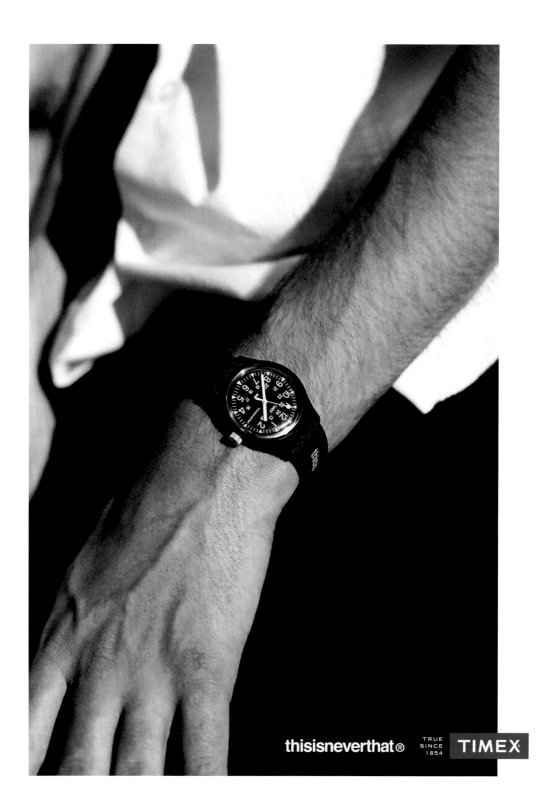

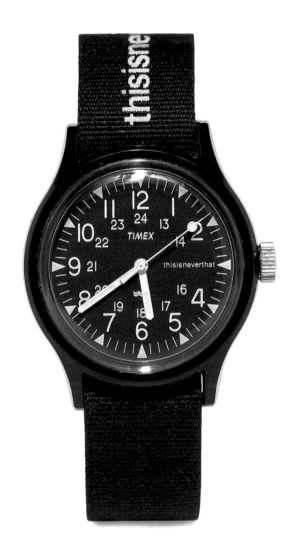

TIMEX x thisisneverthat

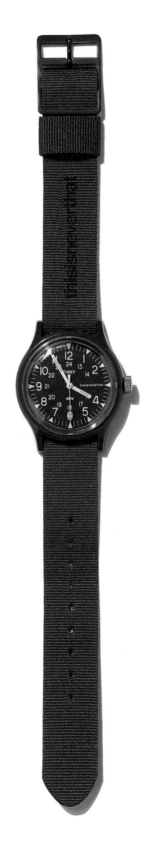

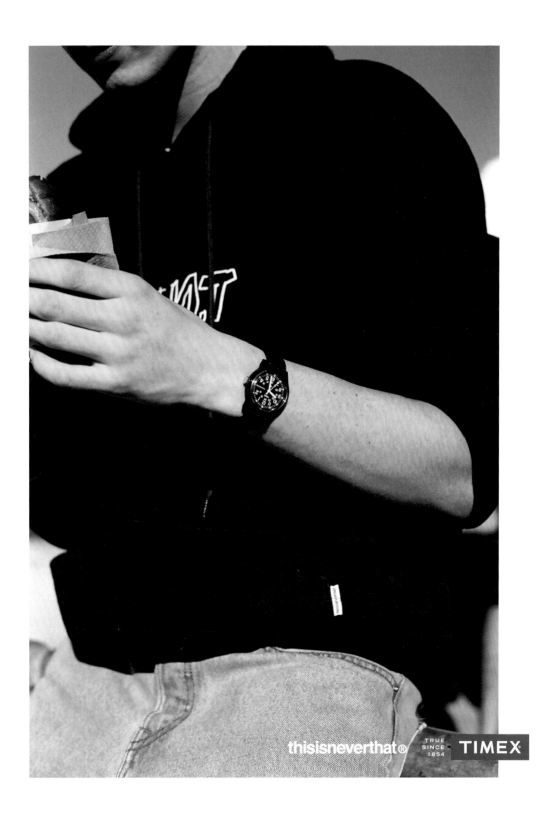

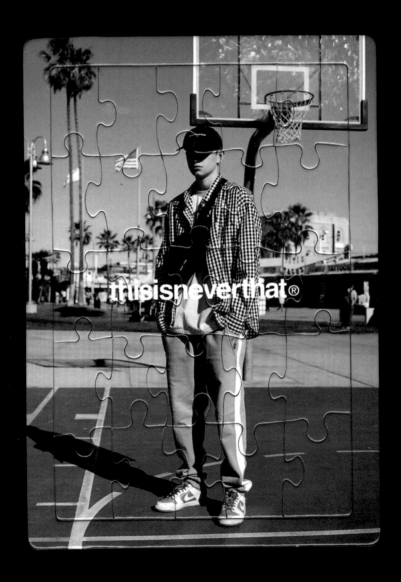

Code	Category	Name	Material(s)	Color(s)

TN16FTO011BK 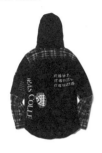 TN16FOW002OV 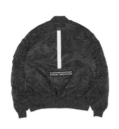 TN16FOW003CA 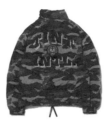 TN16FOW014BL 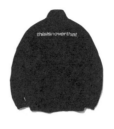 TN16FOW012BK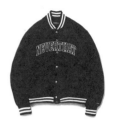

TN16FOW013BE 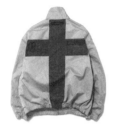 TN16FTO014NA 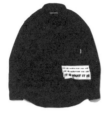 TN16FTO001BK TN16FTO006YZ TN16FOW004IDG

Code	Category	Name	Material(s)	Color(s)
TN16FAC001BE	Hat	T-Logo Camp Cap	Cotton, Nylon	Beige
TN16FAC001BK	Hat	T-Logo Camp Cap	Cotton, Nylon	Black
TN16FAC001CH	Hat	T-Logo Camp Cap	Cotton, Nylon	Charcoal
TN16FAC001OV	Hat	T-Logo Camp Cap	Cotton, Nylon	Olive
TN16FAC002BK	Accessory	Button 5 Set	STS	Black
TN16FAC003BE	Hat	B-Logo 6P Cap	Cotton	Beige
TN16FAC003BK	Hat	B-Logo 6P Cap	Cotton	Black
TN16FAC003NA	Hat	B-Logo 6P Cap	Cotton	Navy
TN16FAC004BE	Hat	Crown 6P Cap	Cotton	Beige
TN16FAC004BK	Hat	Crown 6P Cap	Cotton	Black
TN16FAC004NA	Hat	Crown 6P Cap	Cotton	Navy
TN16FAC005BK	Hat	TISNVRAT Cap	Nylon	Black
TN16FAC005BL	Hat	TISNVRAT Cap	Nylon	Blue
TN16FAC005CH	Hat	TISNVRAT Cap	Nylon	Charcoal
TN16FAC006BK	Hat	Traveller Hat	Cotton, Polyester	Black
TN16FAC007BK	Bag	TD Tote Bag	Cotton	Black
TN16FAC007WH	Bag	TD Tote Bag	Cotton	White
TN16FAC008BK	Bag	C-Emblem Tote bag	Cotton	Black
TN16FAC008WH	Bag	C-Emblem Tote bag	Cotton	White
TN16FAC009BK	Hat	T-Logo Beanie	Acrylic	Black
TN16FAC009GR	Hat	T-Logo Beanie	Acrylic	Grey
TN16FAC009NA	Hat	T-Logo Beanie	Acrylic	Navy
TN16FAC011BK	Hat	Short Beanie	Acrylic	Black
TN16FAC011BL	Hat	Short Beanie	Acrylic	Blue
TN16FAC011GR	Hat	Short Beanie	Acrylic	Grey
TN16FAC011NA	Hat	Short Beanie	Acrylic	Navy
TN16FAC012BK	Hat	Ribbed Beanie	Acrylic	Black
TN16FAC012NA	Hat	Ribbed Beanie	Acrylic	Navy
TN16FAC012OV	Hat	Ribbed Beanie	Acrylic	Olive
TN16FAC012RD	Hat	Ribbed Beanie	Acrylic	Red
TN16FAC013BK	Hat	N-Logo 6P Cap	Cotton	Black
TN16FAC013SB	Hat	N-Logo 6P Cap	Cotton	Sky Blue

Code	Category	Name	Material(s)	Color(s)
TN16FAC013WH	Hat	N-Logo 6P Cap	Cotton	White
TN16FAC014GD	Accessory	SP-Logo Pin	STS	Gold
TN16FAC015WH	Accessory	S&E Pin	STS	White
TN16FAC016BK	Accessory	VA Pin	STS	Black
TN16FAC017GD	Accessory	Eagle Pin	STS	Gold
TN16FAC018GD	Accessory	Insignia Pin	STS	Gold
TN16FBT002BE	Pants	CORD Pant	Cotton	Beige
TN16FBT002BK	Pants	CORD Pant	Cotton	Black
TN16FBT002BU	Pants	CORD Pant	Cotton	Burgundy
TN16FBT003BE	Pants	OG Chino Trousers	Cotton	Beige
TN16FBT003NA	Pants	OG Chino Trousers	Cotton	Navy
TN16FBT004BK	Pants	Flight Pant	Cotton	Black
TN16FBT004OV	Pants	Flight Pant	Cotton	Olive
TN16FBT005BK	Pants	Relaxed Pant	Cotton	Black
TN16FBT005IDG	Pants	Relaxed Pant	Cotton	Indigo
TN16FBT006BK	Jean	SH Denim Pant	Cotton	Black
TN16FBT006IDG	Jean	SH Denim Pant	Cotton	Indigo
TN16FBT007BK	Pants	SP-Logo Sweat Pant	Cotton	Black
TN16FBT007CA	Pants	SP-Logo Sweat Pant	Cotton	Camo
TN16FBT007CH	Pants	SP-Logo Sweat Pant	Cotton	Charcoal
TN16FBT008BK	Pants	Warm Up Pant	Nylon, Polyester	Black
TN16FBT008BL	Pants	Warm Up Pant	Nylon, Polyester	Blue
TN16FMV001NA	Video	TEN	Film	-
TN16FOW001BK	Jacket	WOODSMAN Down Parka	Polyester, Down, Feather, Raccoon Fur	Black
TN16FOW001NA	Jacket	WOODSMAN Down Parka	Polyester, Down, Feather, Raccoon Fur	Navy
TN16FOW001OV	Jacket	WOODSMAN Down Parka	Polyester, Down, Feather, Raccoon Fur	Olive
TN16FOW002BK	Jacket	Flight Jacket	Polyester, 3M Thinsulate	Black
TN16FOW002OV	Jacket	Flight Jacket	Polyester, 3M Thinsulate	Olive
TN16FOW003BK	Jacket	TINT Puffy Jacket	Polyester, Wellon	Black
TN16FOW003CA	Jacket	TINT Puffy Jacket	Polyester, Wellon	Camo
TN16FOW003RD	Jacket	TINT Puffy Jacket	Polyester, Wellon	Red
TN16FOW004BK	Jacket	VA Denim Jacket	Cotton	Black
TN16FOW004IDG	Jacket	VA Denim Jacket	Cotton	Indigo
TN16FOW005BK	Jacket	RF M51 Coat	Cotton, Nylon, Polyester	Black
TN16FOW005OV	Jacket	RF M51 Coat	Cotton, Nylon, Polyester	Olive
TN16FOW006GR	Jacket	Duffle Coat	Wool, Nylon, Polyester	Grey
TN16FOW006NA	Jacket	Duffle Coat	Wool, Nylon, Polyester	Navy
TN16FOW007BK	Jacket	Traveller Coat	Nylon, Polyester, Wool	Black
TN16FOW007NA	Jacket	Traveller Coat	Nylon, Polyester, Wool	Navy
TN16FOW009BK	Jacket	SCHEME Coat	Wool, Nylon, Polyester	Black
TN16FOW010BK	Jacket	TD Coach Jacket	Cotton	Black
TN16FOW010IV	Jacket	TD Coach Jacket	Cotton	Ivory
TN16FOW011BK	Jacket	T-Drivers Jacket	Cotton	Black
TN16FOW012BK	Jacket	Stadium Jacket	Polyester	Black
TN16FOW012BU	Jacket	Stadium Jacket	Polyester	Burgundy
TN16FOW012NA	Jacket	Stadium Jacket	Polyester	Navy
TN16FOW013BE	Jacket	TEN Zip Jacket	Cotton	Beige
TN16FOW013BK	Jacket	TEN Zip Jacket	Cotton	Black
TN16FOW013NA	Jacket	TEN Zip Jacket	Cotton	Navy
TN16FOW014BK	Jacket	Warm Up Jacket	Nylon, Polyester	Black
TN16FOW014BL	Jacket	Warm Up Jacket	Nylon, Polyester	Blue
TN16FOW015MC	Jacket	Reversible Fleece Parka	Polyester, Acrylic	Camo, Black

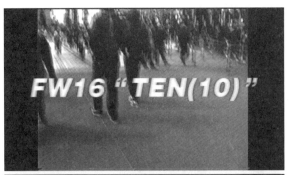

FW16 "TEN(10)"

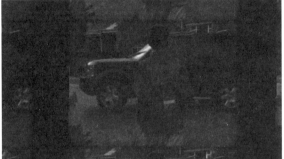

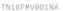

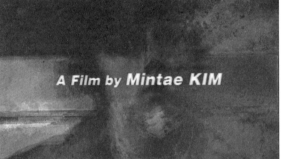

A Film by Mintae KIM

thisisneverthat

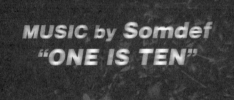

MUSIC by Somdef
"ONE IS TEN"

thisisneverthat

thisisneverthat

thisisneverthat

thisisneverthisisneverthat

Code	Category	Name	Material(s)	Color(s)

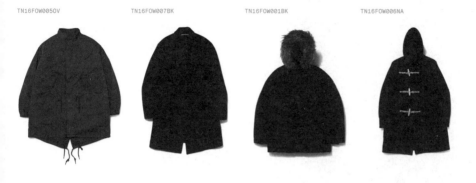

TN16FOW005OV TN16FOW007BK TN16FOW001BK TN16FOW006NA

Code	Category	Name	Material(s)	Color(s)
TN16FOW015MR	Jacket	Reversible Fleece Parka	Polyester, Acrylic	Camo, Ivory
TN16FTO001BK	Shirt	Crown Denim Shirt	Cotton	Black
TN16FTO001IDG	Shirt	Crown Denim Shirt	Cotton	Indigo
TN16FTO002BK	Long Sleeve Tee	T-Drivers L/S	Cotton	Black
TN16FTO002WH	Long Sleeve Tee	T-Drivers L/S	Cotton	White
TN16FTO003BK	Long Sleeve Tee	INTL. Logo L/S	Cotton	Black
TN16FTO003NA	Long Sleeve Tee	INTL. Logo L/S	Cotton	Navy
TN16FTO003OR	Long Sleeve Tee	INTL. Logo L/S	Cotton	Orange
TN16FTO003RD	Long Sleeve Tee	INTL. Logo L/S	Cotton	Red
TN16FTO003WH	Long Sleeve Tee	INTL. Logo L/S	Cotton	White
TN16FTO004BK	Sweatshirt	T-Logo Crewneck	Cotton	Black
TN16FTO004CA	Sweatshirt	T-Logo Crewneck	Cotton	Camo
TN16FTO004GR	Sweatshirt	T-Logo Crewneck	Cotton	Grey
TN16FTO004NA	Sweatshirt	T-Logo Crewneck	Cotton	Navy
TN16FTO004RD	Sweatshirt	T-Logo Crewneck	Cotton	Red
TN16FTO005BK	Sweatshirt	T-Logo Pullover	Cotton	Black
TN16FTO005CA	Sweatshirt	T-Logo Pullover	Cotton	Camo
TN16FTO005CK	Sweatshirt	T-Logo Pullover	Cotton	Check
TN16FTO005GR	Sweatshirt	T-Logo Pullover	Cotton	Grey
TN16FTO005NA	Sweatshirt	T-Logo Pullover	Cotton	Navy
TN16FTO005OR	Sweatshirt	T-Logo Pullover	Cotton	Orange
TN16FTO005RD	Sweatshirt	T-Logo Pullover	Cotton	Red
TN16FTO005WH	Sweatshirt	T-Logo Pullover	Cotton	White
TN16FTO006BZ	Shirt	VA Shirt	Cotton	B.Check
TN16FTO006YZ	Shirt	VA Shirt	Acrylic	Y.Check
TN16FTO007GR	Sweatshirt	TINT Crewneck	Cotton	Grey
TN16FTO007NA	Sweatshirt	TINT Crewneck	Cotton	Navy
TN16FTO008BK	Sweatshirt	TN-CROSS Crewneck	Cotton	Black
TN16FTO008GR	Sweatshirt	TN-CROSS Crewneck	Cotton	Grey
TN16FTO008WH	Sweatshirt	TN-CROSS Crewneck	Cotton	White
TN16FTO009BK	Sweatshirt	S&E Pullover	Cotton	Black
TN16FTO009GR	Sweatshirt	S&E Pullover	Cotton	Grey
TN16FTO010GR	Sweatshirt	Back-VA Pullover	Cotton	Grey
TN16FTO010OR	Sweatshirt	Back-VA Pullover	Cotton	Orange
TN16FTO011BK	Shirt	Hood Shirt	Cotton	Black
TN16FTO011GR	Shirt	Hood Shirt	Cotton	Grey
TN16FTO012BK	Sweatshirt	TD Crewneck	Cotton	Black
TN16FTO012GR	Sweatshirt	TD Crewneck	Cotton	Grey
TN16FTO012WH	Sweatshirt	TD Crewneck	Cotton	White
TN16FTO013BK	Shirt	CUT & PRINT Shirt	Cotton	Black
TN16FTO013CH	Shirt	CUT & PRINT Shirt	Cotton	Charcoal
TN16FTO014CK	Shirt	Oversized Shirt	Rayon, Polyester, Spandex	Check

Code	Category	Name	Material(s)	Color(s)
TN16FTO014NA	Shirt	Oversized Shirt	Cotton	Navy
TN16FTO015BK	Sweatshirt	DANCE Pullover	Cotton	Black
TN16FTO015CK	Sweatshirt	DANCE Pullover	Cotton	Check
TN16FTO015GR	Sweatshirt	DANCE Pullover	Cotton	Grey
TN16FTO016BK	Sweatshirt	INTL. Logo Pullover	Cotton	Black
TN16FTO016GR	Sweatshirt	INTL. Logo Pullover	Cotton	Grey
TN16FTO016NA	Sweatshirt	INTL. Logo Pullover	Cotton	Navy
TN16FTO051BK	Sweatshirt	ARCH Logo Pullover	Cotton	Black
TN16FTO051CA	Sweatshirt	ARCH Logo Pullover	Cotton	Camo
TN16FTO051GR	Sweatshirt	ARCH Logo Pullover	Cotton	Grey
TN16FTO052GN	Sweatshirt	Striped Crewneck	Cotton	Green
TN16FTO052OR	Sweatshirt	Striped Crewneck	Cotton	Orange
TN16FTO052RD	Sweatshirt	Striped Crewneck	Cotton	Red
TN16FTO053BK	Sweatshirt	TISNVRAT Pullover	Cotton	Black
TN16FTO053GR	Sweatshirt	TISNVRAT Pullover	Cotton	Grey
TN16FTO053NA	Sweatshirt	TISNVRAT Pullover	Cotton	Navy
TN16FTO054BK	Sweatshirt	Half Zip Pullover	Cotton	Black
TN16FTO054NA	Sweatshirt	Half Zip Pullover	Cotton	Navy
TN16FTO054WH	Sweatshirt	Half Zip Pullover	Cotton	White
TN16FTO055BK	Sweatshirt	SP-Logo Zipup Sweat	Cotton	Black
TN16FTO055CA	Sweatshirt	SP-Logo Zipup Sweat	Cotton	Camo

TN16FTO053BK

TN16FTO053GR

TN16FTO015BK

TN16FTO056BK

TN16FTO00100R

TN16FTO002WH

TN16FTO002BK

TN16FTO003RD

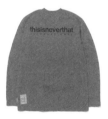

TN16FTO007GR

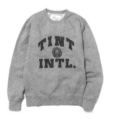

TN16FTO004CA

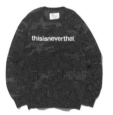

TN16FTO008BK

TN16FTO008WH

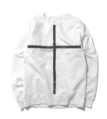

TN16FTO012WH

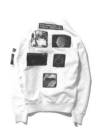

Code	Category	Name	Material(s)	Color(s)
TN16FTO055GR	Sweatshirt	SP-Logo Zipup Sweat	Cotton	Grey
TN16FTO055RD	Sweatshirt	SP-Logo Zipup Sweat	Cotton	Red
TN16FTO056BK	Sweatshirt	SP-Logo Pullover	Cotton	Black
TN16FTO056CA	Sweatshirt	SP-Logo Pullover	Cotton	Camo
TN16FTO056CH	Sweatshirt	SP-Logo Pullover	Cotton	Charcoal
TN16FTO057BK	Sweatshirt	T-Drivers Pullover	Cotton	Black
TN16FTO057GR	Sweatshirt	T-Drivers Pullover	Cotton	Grey

TN16FAC013BK TN16FAC005BL TN16FAC001BE

TN16FBT003NA TN16FBT005IDG TN16FBT002BE TN16FBT006IDG TN16FBT007CA

TN16FAC018GD TN16FAC016BK TN16FAC007BK TN16FAC007WH

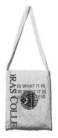

Code	Category	Name	Material(s)	Color(s)

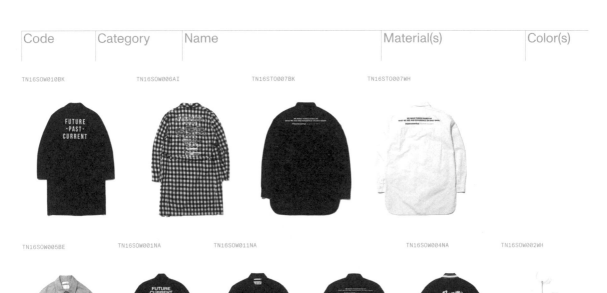

TN16SOW010BK TN16SOW006AI TN16STO007BK TN16STO007WH

TN16SOW005BE TN16SOW001NA TN16SOW011NA TN16SOW004NA TN16SOW002WH

Code	Category	Name	Material(s)	Color(s)
HG16SAC001BE	Hat	have a good time × TINT 6P Cap	Cotton	Beige
HG16SAC001BK	Hat	have a good time × TINT 6P Cap	Cotton	Black
HG16SAC001NA	Hat	have a good time × TINT 6P Cap	Cotton	Navy
HG16SAC001WH	Hat	have a good time × TINT 6P Cap	Cotton	White
HG16STO001BK	Sweatshirt	have a good time × TINT Pullover	Cotton	Black
HG16STO001ER	Sweatshirt	have a good time × TINT Pullover	Cotton	Neon Green
HG16STO001HR	Sweatshirt	have a good time × TINT Pullover	Cotton	Heather Grey
HG16STO002BK	Tee	have a good time × TINT Tee #1	Cotton	Black
HG16STO002WH	Tee	have a good time × TINT Tee #1	Cotton	White
HG16STO003NA	Tee	have a good time × TINT Tee #2	Cotton	Navy
HG16STO003WH	Tee	have a good time × TINT Tee #2	Cotton	White
HG16STO004HR	Sweatshirt	have a good time × TINT Crewneck	Cotton	Heather Grey
HG16STO004NA	Sweatshirt	have a good time × TINT Crewneck	Cotton	Navy
HG16STO004WH	Sweatshirt	have a good time × TINT Crewneck	Cotton	White
HG16STO005BE	Top	have a good time × TINT Cardigan	Wool	Beige
HG16STO005ER	Top	have a good time × TINT Cardigan	Wool	Neon Green
HG16STO005NA	Top	have a good time × TINT Cardigan	Wool	Navy
TN16SAC001BE	Hat	The Past 6P Cap	Cotton	Beige
TN16SAC001BK	Hat	The Past 6P Cap	Cotton	Black
TN16SAC001BU	Hat	The Past 6P Cap	Cotton	Burgundy
TN16SAC001NA	Hat	The Past 6P Cap	Cotton	Navy
TN16SAC002BN	Hat	T-Logo Cap	Cotton	Black
TN16SAC002BU	Hat	T-Logo Cap	Cotton	Burgundy
TN16SAC002WE	Hat	T-Logo Cap	Cotton	White
TN16SAC002YL	Hat	T-Logo Cap	Cotton	Yellow
TN16SAC003BK	Hat	INTL. Logo Cap	Cotton	Black
TN16SAC003WH	Hat	INTL. Logo Cap	Cotton	White
TN16SAC004BE	Hat	INTL. Logo Bucket Hat	Cotton	Beige
TN16SAC004NA	Hat	INTL. Logo Bucket Hat	Cotton	Navy
TN16SAC005BK	Accessory	T-Logo Pin	STS	Black
TN16SAC005GD	Accessory	T-Logo Pin	STS	Gold
TN16SAC006BK	Accessory	Dead Leaves Pin	STS	Black
TN16SAC007GD	Accessory	AF Pin	STS	Gold

S/Summer 2016

thisisneverthat S/Summer 2016 Collection
"tagging"

Art Direction and Design: thisisneverthat
Video: KIM MINTAE
Music: Missy Elliott - Uknowhowwedu (Somdef Rework)
Styling / Coordination: thisisneverthat
Model: ILLIAN FRANEK JULIA DANNY

www.thisisneverthat.com

TN16SMV001NA

Code	Category	Name	Material(s)	Color(s)
TN16SAC007SB	Accessory	AF Pin	STS	Sky Blue
TN16SAC008BK	Accessory	Eagle Pin	STS	Black
TN16SAC009CF	Accessory	iPhone Case	Polycarbonate	CPF
TN16SAC009CG	Accessory	iPhone Case	Polycarbonate	Collage
TN16SAC009DT	Accessory	iPhone Case	Polycarbonate	Delta
TN16SAC010BK	Bag	Collage Tote	Cotton	Black
TN16SAC010IV	Bag	Collage Tote	Cotton	Ivory
TN16SAC011BL	Accessory	Beer Glass	Glass	Blue
TN16SAC012BK	Socks	Sport Socks	Cotton, Rubber	Black
TN16SAC012WH	Socks	Sport Socks	Cotton, Rubber	White
TN16SAC014BK	Underwear	Boxer Briefs	Cotton	Black
TN16SAC014GR	Underwear	Boxer Briefs	Cotton	Grey
TN16SAC014NA	Underwear	Boxer Briefs	Cotton	Navy
TN16SAC016BK	Underwear	Boxer Briefs 3 Pack	Cotton	Black
TN16SAC016WH	Underwear	Boxer Briefs 3 Pack	Cotton	White
TN16SBT001BE	Pants	1Tuck Short	Cotton	Beige
TN16SBT001BK	Pants	1Tuck Short	Cotton	Black
TN16SBT002BE	Pants	Jogging Short	Cotton, Nylon	Beige
TN16SBT002DT	Pants	Jogging Short	Polyester	Delta
TN16SBT002NA	Pants	Jogging Short	Cotton, Nylon	Navy
TN16SBT002PU	Pants	Jogging Short	Polyester	Pull
TN16SBT003BK	Pants	Relaxed Short	Polyester, Rayon	Black
TN16SBT003YG	Pants	Relaxed Short	Polyester, Elastane	Navy, Green
TN16SBT004OO	Jean	Denim Pant	Cotton	#1
TN16SBT004TW	Jean	Denim Pant	Cotton	#2
TN16SBT005OO	Jean	Denim Short	Cotton	#1
TN16SBT005TW	Jean	Denim Short	Cotton	#2
TN16SBT006BT	Pants	Relaxed Pant	Polyester, Rayon	Black, White
TN16SBT006YG	Pants	Relaxed Pant	Polyester, Elastane	Navy, Green
TN16SBT007BK	Pants	PG-28 Short	Cotton	Black
TN16SBT007NA	Pants	PG-28 Short	Cotton	Navy
TN16SBT008SB	Pants	Pajama Pant	Cotton	Sky Blue
TN16SBT009BK	Pants	Sweat Pant	Cotton	Black
TN16SBT009GR	Pants	Sweat Pant	Cotton	Grey
TN16SBT010BK	Skirt	P-Logo Front Button Skirt	Cotton	Black
TN16SBT011OO	Jean	W Denim Short	Cotton	#1
TN16SBT011TW	Jean	W Denim Short	Cotton	#2
TN16SMV001NA	Video	TAGGING	Film	-
TN16SMV002NA	Video	thisisneverthat × have a good time	Film	-
TN16SOW001NA	Jacket	BDU Shirt Jacket	Cotton	Navy
TN16SOW001OV	Jacket	BDU Shirt Jacket	Cotton	Olive
TN16SOW002BK	Jacket	INTL. Training Jacket	Polyester	Black
TN16SOW002WH	Jacket	INTL. Training Jacket	Polyester	White
TN16SOW003DT	Jacket	INTL. Training Jacket	Polyester	Delta
TN16SOW004AP	Jacket	Varsity Jacket	Polyester	Airport
TN16SOW004BE	Jacket	Varsity Jacket	Cotton, Nylon	Beige
TN16SOW004MS	Jacket	Varsity Jacket	Polyester	Museum
TN16SOW004NA	Jacket	Varsity Jacket	Cotton, Nylon	Navy
TN16SOW005BE	Jacket	Coach Jacket	Cotton, Nylon	Beige
TN16SOW005NA	Jacket	Coach Jacket	Cotton, Nylon	Navy
TN16SOW006AI	Jacket	Robe Coat	Cotton	Navy, Ivory
TN16SOW006ID	Jacket	Robe Coat	Cotton	Navy, Ivory Dark
TN16SOW007BE	Jacket	Patched Anorak	Cotton	Beige
TN16SOW007BK	Jacket	Patched Anorak	Cotton	Black

Code	Category	Name	Material(s)	Color(s)
TN16SOW008SL	Jacket	Patched Anorak	Polyester, Cotton	Scotchlite
TN16SOW009BH	Jacket	Trucker Jacket	Cotton	Black, White
TN16SOW009CO	Jacket	Trucker Jacket	Cotton	Black
TN16SOW010BE	Jacket	Double Coat	Cotton	Beige
TN16SOW010BK	Jacket	Double Coat	Cotton	Black
TN16SOW011NA	Jacket	Utility Jacket	Cotton	Navy
TN16SOW011OV	Jacket	Utility Jacket	Cotton	Olive
TN16SOW012BK	Jacket	P-Logo US Jacket	Cotton	Black
TN16STO001AI	Shirt	Zip Shirt	Cotton	Navy, Ivory
TN16STO001RI	Shirt	Zip Shirt	Cotton	Green, Ivory
TN16STO002NO	Tee	Multi Stripe Tee	Cotton	Navy, Orange
TN16STO002YG	Tee	Multi Stripe Tee	Cotton	Navy, Green
TN16STO003NE	Sweatshirt	Striped Crewneck	Cotton	Navy, Grey
TN16STO003YG	Sweatshirt	Striped Crewneck	Cotton	Navy, Green
TN16STO004BK	Sweatshirt	Taped Crewneck	Cotton	Black
TN16STO004GR	Sweatshirt	Taped Crewneck	Cotton	Grey
TN16STO005BK	Sweatshirt	T-Logo Pullover	Cotton	Black
TN16STO005GR	Sweatshirt	T-Logo Pullover	Cotton	Grey
TN16STO006NI	Shirt	CPF Shirt	Cotton	Navy, White
TN16STO006YG	Shirt	CPF Shirt	Cotton	Navy, Green
TN16STO007BK	Shirt	7L Shirt	Cotton	Black
TN16STO007WH	Shirt	7L Shirt	Cotton	White
TN16STO008BL	Shirt	Hooded C-Shirt	Cotton	Blue
TN16STO008GR	Shirt	Hooded C-Shirt	Cotton	Grey
TN16STO009LB	Sweatshirt	Striped Pullover	Cotton	Blue, Black
TN16STO009LR	Sweatshirt	Striped Pullover	Cotton	Blue, Grey
TN16STO010GR	Sweatshirt	NEVER Pullover	Cotton	Grey
TN16STO010NA	Sweatshirt	NEVER Pullover	Cotton	Navy
TN16STO011BK	Sweatshirt	ARC Logo Pullover	Cotton	Black
TN16STO011GR	Sweatshirt	ARC Logo Pullover	Cotton	Grey
TN16STO012BK	Sweatshirt	OLD Car Pullover	Cotton	Black
TN16STO012GR	Sweatshirt	OLD Car Pullover	Cotton	Grey
TN16STO013BK	Sweatshirt	Nothing Pullover	Cotton	Black
TN16STO013GR	Sweatshirt	Nothing Pullover	Cotton	Grey
TN16STO014BK	Shirt	OLD Car Aloha Shirt L/S	Rayon	Black
TN16STO014WH	Shirt	OLD Car Aloha Shirt L/S	Rayon	White
TN16STO015BK	Shirt	OLD Car Aloha Shirt S/S	Rayon	Black
TN16STO015WH	Shirt	OLD Car Aloha Shirt S/S	Rayon	White
TN16STO016SB	Shirt	Pajama Shirt	Cotton	Sky Blue
TN16STO017BK	Sweatshirt	N-Cut Crewneck	Cotton	Black
TN16STO017GR	Sweatshirt	N-Cut Crewneck	Cotton	Grey
TN16STO017NA	Sweatshirt	N-Cut Crewneck	Cotton	Navy
TN16STO018GR	Sweatshirt	EM ARC Logo Crewneck	Cotton	Grey
TN16STO018NA	Sweatshirt	EM ARC Logo Crewneck	Cotton	Navy
TN16STO019BK	Sweatshirt	ARC Logo Crewneck	Cotton	Black
TN16STO019GR	Sweatshirt	ARC Logo Crewneck	Cotton	Grey
TN16STO020BK	Sweatshirt	T-Collar Crewneck	Cotton	Black
TN16STO020NA	Sweatshirt	T-Collar Crewneck	Cotton	Navy
TN16STO021BE	Sweatshirt	N-Logo Terry Crewneck	Cotton	Deige
TN16STO021BL	Sweatshirt	N-Logo Terry Crewneck	Cotton	Blue
TN16STO021NA	Sweatshirt	N-Logo Terry Crewneck	Cotton	Navy
TN16STO022BE	Sweatshirt	Over Dyed Boxer Pullover	Cotton	Beige
TN16STO022NA	Sweatshirt	Over Dyed Boxer Pullover	Cotton	Navy
TN16STO022OV	Sweatshirt	Over Dyed Boxer Pullover	Cotton	Olive
TN16STO023BK	Long Sleeve Tee	Nothing L/S Top	Cotton	Black

Code	Category	Name	Material(s)	Color(s)
TN16STO023SB	Long Sleeve Tee	Nothing L/S Top	Cotton	Sky Blue
TN16STO023WH	Long Sleeve Tee	Nothing L/S Top	Cotton	White
TN16STO024BK	Long Sleeve Tee	B.Court L/S Top	Cotton	Black
TN16STO024WH	Long Sleeve Tee	B.Court L/S Top	Cotton	White
TN16STO025BK	Tee	JN Tee	Cotton	Black
TN16STO025WH	Tee	JN Tee	Cotton	White
TN16STO026BK	Long Sleeve Tee	Baseball Tee	Cotton	Black
TN16STO026WH	Long Sleeve Tee	Baseball Tee	Cotton	White
TN16STO027BK	Long Sleeve Tee	1993 3/4 Top	Cotton	Black
TN16STO027NA	Long Sleeve Tee	1993 3/4 Top	Cotton	Navy
TN16STO027WH	Long Sleeve Tee	1993 3/4 Top	Cotton	White
TN16STO029BK	Tee	N Football Jersey	Polyester	Black
TN16STO030BK	Tee	Two Tone Border Tee	Cotton	Black
TN16STO030BL	Tee	Two Tone Border Tee	Cotton	Blue
TN16STO030NA	Tee	Two Tone Border Tee	Cotton	Navy
TN16STO031BK	Tee	Numbering Tee	Cotton	Black
TN16STO031WH	Tee	Numbering Tee	Cotton	White
TN16STO032BE	Tee	CPF Tee	Cotton	Beige
TN16STO032BK	Tee	CPF Tee	Cotton	Black
TN16STO033BK	Tee	INTL. Logo Tee	Cotton	Black
TN16STO033NA	Tee	INTL. Logo Tee	Cotton	Navy
TN16STO033WH	Tee	INTL. Logo Tee	Cotton	White
TN16STO034BK	Tee	G Logo Tee	Cotton	Black
TN16STO034BL	Tee	G Logo Tee	Cotton	Blue
TN16STO034WH	Tee	G Logo Tee	Cotton	White
TN16STO035GR	Tee	T-Collar Tee	Cotton	Grey
TN16STO035NA	Tee	T-Collar Tee	Cotton	Navy
TN16STO035WH	Tee	T-Collar Tee	Cotton	White
TN16STO036BL	Tee	Terry Leisure Shirt	Cotton	Blue
TN16STO037BK	Tee	N-Cut Tee	Cotton	Black
TN16STO037WH	Tee	N-Cut Tee	Cotton	White
TN16STO038BK	Tee	ARC Logo Tee	Cotton	Black

TN16STO009LR

TN16STO012GR

TN16STO010NA

TN16SOW007BE

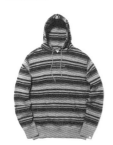 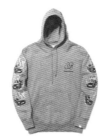 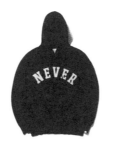

TN16STO006NI

TN16STO014WH

TN16STO001RI

TN16STO018NA

TN16STO016SB

Code	Category	Name	Material(s)	Color(s)
TN16STO038GR	Tee	ARC Logo Tee	Cotton	Grey
TN16STO038WH	Tee	ARC Logo Tee	Cotton	White
TN16STO039BK	Tee	The Future Tee	Cotton	Black
TN16STO039WH	Tee	The Future Tee	Cotton	White
TN16STO040BK	Tee	Rib Tank Top	Cotton	Black
TN16STO040GR	Tee	Rib Tank Top	Cotton	Grey
TN16STO040WH	Tee	Rib Tank Top	Cotton	White
TN16STO041BE	Tee	Back Panel Tee	Cotton	Beige
TN16STO041NA	Tee	Back Panel Tee	Cotton	Navy
TN16STO041WH	Tee	Back Panel Tee	Cotton	White
TN16STO042BK	Tee	Back C-Panel Tee	Cotton	Black
TN16STO042NA	Tee	Back C-Panel Tee	Cotton	Navy
TN16STO043BK	Tee	JN Taped Tee	Cotton	Black
TN16STO043NA	Tee	JN Taped Tee	Cotton	Navy
TN16STO043OV	Tee	JN Taped Tee	Cotton	Olive
TN16STO044BK	Tee	Dead Leaves Tee	Cotton	Black
TN16STO044IV	Tee	Dead Leaves Tee	Cotton	Ivory
TN16STO044OV	Tee	Dead Leaves Tee	Cotton	Olive
TN16STO045BK	Tee	Delta Piz Tee	Cotton	Black
TN16STO045WH	Tee	Delta Piz Tee	Cotton	White
TN16STO046BK	Tee	S-Cut Off Tee	Cotton	Black
TN16STO046NA	Tee	S-Cut Off Tee	Cotton	Navy
TN16STO046WH	Tee	S-Cut Off Tee	Cotton	White
TN16STO047NA	Long Sleeve Tee	The Past Raglan	Cotton	Navy
TN16STO047SB	Long Sleeve Tee	The Past Raglan	Cotton	Sky Blue
TN16STO047WH	Long Sleeve Tee	The Past Raglan	Cotton	White
TN16STO048BL	Sweatshirt	N-Logo Rib Crewneck	Cotton	Blue
TN16STO048BU	Sweatshirt	N-Logo Rib Crewneck	Cotton	Burgundy
TN16STO049BK	Sweatshirt	Dead Leaves Cropped Hood	Cotton	Black
TN16STO049GR	Sweatshirt	Dead Leaves Cropped Hood	Cotton	Grey
TN16STO050BK	Tee	NC-Logo Tee	Cotton	Black
TN16STO050GN	Tee	NC-Logo Tee	Cotton	Green
TN16STO050NA	Tee	NC-Logo Tee	Cotton	Navy
TN16STO050SB	Tee	NC-Logo Tee	Cotton	Sky Blue
TN16STO050WH	Tee	NC-Logo Tee	Cotton	White

Code	Category	Name	Material(s)	Color(s)

TN16STO027BK TN16STO033NA TN16STO030BK TN16STO032BK TN16STO045BK

TN16STO038GR TN16STO038WH TN16STO036BL TN16STO029BK TN16STO042NA

TN16STO050SB TN16STO015WH TN16STO015BK TN16STO040GR

TN16SAC001NA TN16SAC003WH TN16SAC004NA TN16SAC012BK TN16SAC012WH

TN16SAC014GR TN16SAC014BK TN16SBT002DT TN16SBT002BE TN16SBT00500

Code	Category	Name	Material(s)	Color(s)
TN15FAC001AR	Bag	Daypack	Nylon	Navy, Grey
TN15FAC001BE	Bag	Daypack	Nylon	Beige
TN15FAC001KY	Bag	Daypack	Nylon	Black, Navy
TN15FAC002BU	Hat	Six Hours 6P Cap	Cotton	Burgundy
TN15FAC002CH	Hat	Six Hours 6P Cap	Cotton	Charcoal
TN15FAC002GN	Hat	Six Hours 6P Cap	Cotton	Green
TN15FAC002WH	Hat	Six Hours 6P Cap	Cotton	White
TN15FAC003BE	Hat	BCGC 6P Cap	Cotton	Beige
TN15FAC003BK	Hat	BCGC 6P Cap	Cotton	Black
TN15FAC003NA	Hat	BCGC 6P Cap	Cotton	Navy
TN15FAC003OR	Hat	BCGC 6P Cap	Cotton	Orange
TN15FAC004BE	Hat	Wool Felt Hat	Wool	Beige
TN15FAC004BK	Hat	Wool Felt Hat	Wool	Black
TN15FAC004NA	Hat	Wool Felt Hat	Wool	Navy
TN15FAC005MT	Accessory	BIC® Ballpen	Plastic	Multi
TN15FAC006MT	Accessory	Hotel Key Tag	Plastic	Multi
TN15FAC007WH	Accessory	4 Button Set	STS	White
TN15FAC008BE	Hat	Boo Hoo Hoo 6P Cap	Cotton	Beige
TN15FAC008BK	Hat	Boo Hoo Hoo 6P Cap	Cotton	Black
TN15FAC008WH	Hat	Boo Hoo Hoo 6P Cap	Cotton	White
TN15FAC009BE	Hat	D/S 6P Cap	Cotton	Beige
TN15FAC009BK	Hat	D/S 6P Cap	Cotton	Black
TN15FAC009RD	Hat	D/S 6P Cap	Cotton	Red
TN15FAC009WH	Hat	D/S 6P Cap	Cotton	White
TN15FAC010GN	Accessory	Whistle Key Chain	Plastic	Green
TN15FAC011RD	Accessory	YO-YO	Plastic	Red
TN15FAC012BK	Hat	Youth Beanie	Polyester	Black
TN15FAC012WH	Hat	Youth Beanie	Polyester	White
TN15FAC013BK	Hat	OG Beanie	Cotton	Black
TN15FAC013BU	Hat	OG Beanie	Cotton	Burgundy
TN15FAC013NA	Hat	OG Beanie	Cotton	Navy
TN15FAC013NN	Hat	OG Beanie	Cotton	Neon
TN15FAC013WH	Hat	OG Beanie	Cotton	White
TN15FAC014BK	Hat	OG Camp Cap	Nylon	Black
TN15FAC014OV	Hat	OG Camp Cap	Nylon	Olive
TN15FAC015BI	Accessory	Muffler	Acrylic	Blue, Ivory
TN15FAC015RN	Accessory	Muffler	Acrylic	Red, Navy
TN15FAC015UN	Accessory	Muffler	Acrylic	Purple, Navy
TN15FAC016HH	Accessory	Pin	STS	Boo Hoo Hoo
TN15FAC016LG	Accessory	Pin	STS	White
TN15FAC016OM	Accessory	Pin	STS	Old Man
TN15FAC016TT	Accessory	Pin	STS	Black
TN15FAC016WW	Accessory	Pin	STS	White
TN15FAC016WY	Accessory	Pin	STS	Wasted Youth
TN15FAC016YW	Accessory	Pin	STS	White, Yellow
TN15FAC017MV	Accessory	iPhone 5(S) Case	Polycarbonate	Movie
TN15FAC017OM	Accessory	iPhone 5(S) Case	Polycarbonate	Old Man
TN15FAC017PA	Accessory	iPhone 5(S) Case	Polycarbonate	Park
TN15FAC017PL	Accessory	iPhone 5(S) Case	Polycarbonate	Polaroid
TN15FAC018MV	Accessory	iPhone 6 Case	Polycarbonate	Movie
TN15FAC018OM	Accessory	iPhone 6 Case	Polycarbonate	Old Man
TN15FAC018PA	Accessory	iPhone 6 Case	Polycarbonate	Park
TN15FAC018PL	Accessory	iPhone 6 Case	Polycarbonate	Polaroid
TN15FAC019IG	Socks	Sport Socks	Cotton, Rubber	Ivory, Green
TN15FAC019NA	Socks	Sport Socks	Cotton, Rubber	Navy, White

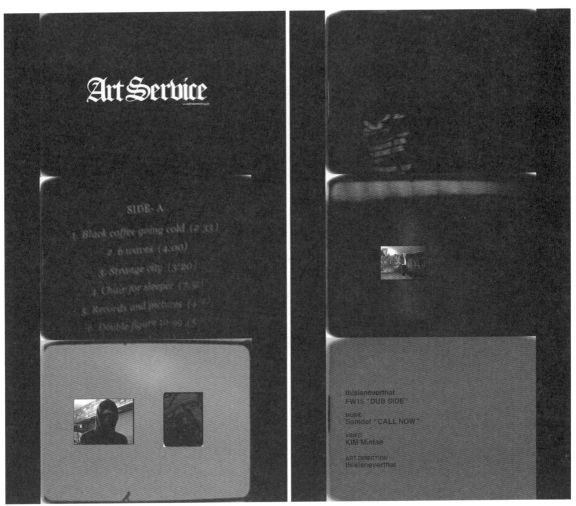

TN15FMV001NA

Code	Category	Name	Material(s)	Color(s)

TN15FOW007NA TN15FOW010BE TN15FOW010BK

TN15FOW011PA TN15FOW006NA TN15FOW002OV TN15FOW006NA TN15FOW006OV

 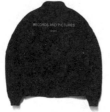 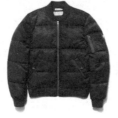 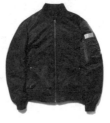 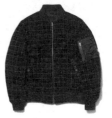

Code	Category	Name	Material(s)	Color(s)
TN15FAC019NG	Socks	Sport Socks	Cotton, Rubber	Navy, Green
TN15FAC020BK	Bag	Art Service Tote	Cotton	Black
TN15FAC020WH	Bag	Art Service Tote	Cotton	White
TN15FAC021BK	Bag	Track List Tote	Cotton	Black
TN15FAC021WH	Bag	Track List Tote	Cotton	White
TN15FAC022NA	Accessory	WY Gloves	Acrylic	Navy
TN15FAC022WH	Accessory	WY Gloves	Acrylic	White
TN15FAC024BL	Accessory	Flexible Key Tag	-	Blue
TN15FAC024WH	Accessory	Flexible Key Tag	-	White
TN15FBT001CN	Pants	Classic Trousers	Wool	Check Black, Check Green
TN15FBT001WP	Pants	Classic Trousers	Wool, Rayon, Spandex	W.P.Check
TN15FBT002BE	Pants	Cord Pant	Cotton	Beige
TN15FBT002BK	Pants	Cord Pant	Cotton	Black
TN15FBT003BE	Pants	Chino Pant	Cotton	Beige
TN15FBT003BK	Pants	Chino Pant	Cotton	Black
TN15FBT003WH	Pants	Chino Pant	Cotton	White
TN15FBT004BK	Pants	City Jogger Pant	Polyester, Rayon, Spandex	Black
TN15FBT004NA	Pants	City Jogger Pant	Polyester, Rayon, Spandex	Navy
TN15FBT005BK	Pants	Two Tone Trousers	Polyester, Rayon	Black
TN15FBT005GR	Pants	Two Tone Trousers	Polyester, Rayon	Grey
TN15FBT006BK	Jean	Denim Pant	Cotton	Black
TN15FBT006BL	Jean	Denim Pant	Cotton	Blue
TN15FBT006WH	Jean	Denim Pant	Cotton	White
TN15FMV001NA	Video	DUB SIDE	Film	-
TN15FMV002NA	Video	VANS × thisisneverthat 'Sunday Tunes Radio'	Film	-
TN15FOW001AK	Jacket	Reversible Coat	Wool, Nylon, Cotton	Charcoal, Black
TN15FOW001KY	Jacket	Reversible Coat	Wool, Polyester, Nylon, Cotton	Black, Navy

Code	Category	Name	Material(s)	Color(s)
TN15FOW002BE	Jacket	MA-1 Down Jacket	Nylon, Polyester, Down, Feather	Beige
TN15FOW002BK	Jacket	MA-1 Down Jacket	Nylon, Polyester, Down, Feather	Black
TN15FOW002OV	Jacket	MA-1 Down Jacket	Nylon, Polyester, Down, Feather	Olive
TN15FOW003CD	Jacket	Zip Shirt	Acrylic	Check Black, Check Red
TN15FOW003WP	Jacket	Zip Shirt	Cotton, Rayon	W.P.Check
TN15FOW004BK	Jacket	Wool Trench Coat	Wool, Polyester	Black
TN15FOW004GR	Jacket	Wool Trench Coat	Wool, Polyester	Grey
TN15FOW004NA	Jacket	Wool Trench Coat	Wool, Nylon, Polyester	Navy
TN15FOW005BK	Jacket	Double Coat	Wool, Nylon, Polyester	Black
TN15FOW005NA	Jacket	Double Coat	Wool, Nylon, Polyester	Navy
TN15FOW005OV	Jacket	Double Coat	Wool, Nylon, Polyester	Olive
TN15FOW006NA	Jacket	RP Reversible MA-1	Nylon, Cotton, Rayon	Navy
TN15FOW006OV	Jacket	RP Reversible MA-1	Nylon, Cotton, Rayon	Olive
TN15FOW007BK	Jacket	Duffle Coat	Wool, Nylon, Polyester	Black
TN15FOW007NA	Jacket	Duffle Coat	Wool, Nylon, Polyester	Navy
TN15FOW008BK	Jacket	Padded Coat	Nylon, Cotton	Black
TN15FOW008NA	Jacket	Padded Coat	Nylon, Cotton	Navy

TN15FTO006WH TN15FTO006BK TN15FTO002GR TN15FTO009KW

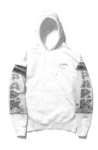
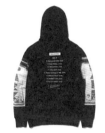
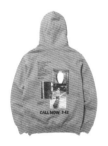
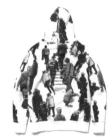

TN15FTO017KY TN15FTO018NK TN15FTO017YH TN15FTO013BK TN15FTO019NA

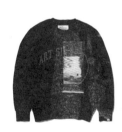
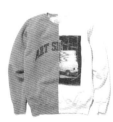
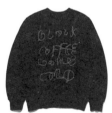
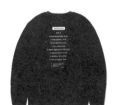

TN15FTO007GC TN15FTO007BC TN15FTO019WH TN15FTO016GV

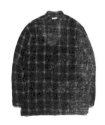
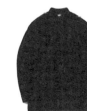
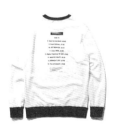
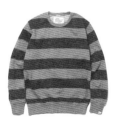

Code	Category	Name		Material(s)	Color(s)

TN15FAC008BK	TN15FAC014OV	TN15FAC003NA	TN15FAC003BE	TN15FAC009WH	TN15FAC009RD

TN15FAC013BK	TN15FAC013WH	TN15FAC019NA	TN15FAC019IG

Code	Category	Name	Material(s)	Color(s)
TN15FOW009BE	Jacket	Hooded Coat	Wool, Nylon, Polyester	Beige
TN15FOW009BK	Jacket	Hooded Coat	Wool, Nylon, Polyester	Black
TN15FOW010BE	Jacket	Cord Trucker Jacket	Cotton	Beige
TN15FOW010BK	Jacket	Cord Trucker Jacket	Cotton	Black
TN15FOW011CS	Jacket	Varsity Jacket	Polyester	Cashed
TN15FOW011HW	Jacket	Varsity Jacket	Polyester	Halloween
TN15FOW011PA	Jacket	Varsity Jacket	Polyester	Park
TN15FOW012BL	Jacket	M-51	Wool, Polyester	Blue
TN15FTO001SB	Shirt	T Oxford Shirt	Cotton	Sky Blue
TN15FTO001WH	Shirt	T Oxford Shirt	Cotton	White
TN15FTO002BK	Sweatshirt	Collage Pullover	Cotton	Black
TN15FTO002GR	Sweatshirt	Collage Pullover	Cotton	Grey
TN15FTO003GR	Sweatshirt	Six Hours Pullover	Cotton	Grey
TN15FTO003NA	Sweatshirt	Six Hours Pullover	Cotton	Navy
TN15FTO004BK	Sweatshirt	T-Logo Pullover	Cotton	Black
TN15FTO004GR	Sweatshirt	T-Logo Pullover	Cotton	Grey
TN15FTO005BK	Sweatshirt	Art Crewneck	Cotton	Black
TN15FTO005GR	Sweatshirt	Art Crewneck	Cotton	Grey
TN15FTO006BK	Sweatshirt	Park Pullover	Cotton	Black
TN15FTO006GR	Sweatshirt	Park Pullover	Cotton	Grey
TN15FTO006WH	Sweatshirt	Park Pullover	Cotton	White
TN15FTO007BC	Shirt	S/C Long Shirt	Cotton	Blue Check
TN15FTO007GC	Shirt	S/C Long Shirt	Cotton	Green Check
TN15FTO008BE	Shirt	Hooded Shirt	Cotton	Beige
TN15FTO008BK	Shirt	Hooded Shirt	Cotton	Black
TN15FTO009KW	Sweatshirt	Back Pullover	Cotton	Black, White Photo
TN15FTO009LP	Sweatshirt	Back Pullover	Cotton	Color Photo
TN15FTO010BK	Sweatshirt	BCGC Pullover	Cotton	Black
TN15FTO010PK	Sweatshirt	BCGC Pullover	Cotton	Pink
TN15FTO011BL	Sweatshirt	Art Service Pullover	Cotton	Blue
TN15FTO011PK	Sweatshirt	Art Service Pullover	Cotton	Pink
TN15FTO012BK	Sweatshirt	Art Service Crewneck	Cotton	Black
TN15FTO012BL	Sweatshirt	Art Service Crewneck	Cotton	Blue
TN15FTO013BK	Sweatshirt	BCGC Crewneck	Cotton	Black

Code	Category	Name	Material(s)	Color(s)
TN15FTO013BL	Sweatshirt	BCGC Crewneck	Cotton	Blue
TN15FTO014NA	Sweatshirt	D/S Crewneck	Cotton	Navy
TN15FTO014WH	Sweatshirt	D/S Crewneck	Cotton	White
TN15FTO015NA	Sweatshirt	T-Logo Crewneck	Cotton	Navy
TN15FTO015WH	Sweatshirt	T-Logo Crewneck	Cotton	White
TN15FTO016GL	Sweatshirt	Striped Crewneck	Cotton	Grey, Light Grey
TN15FTO016GV	Sweatshirt	Striped Crewneck	Cotton	Grey, Navy
TN15FTO017KY	Sweatshirt	Twisted Van Crewneck	Cotton	Black, Navy
TN15FTO017YC	Sweatshirt	Twisted Van Crewneck	Cotton	Grey, Black
TN15FTO017YH	Sweatshirt	Twisted Van Crewneck	Cotton	Grey, White
TN15FTO018GV	Sweatshirt	Cold Coffee Crewneck	Cotton	Grey, Navy
TN15FTO018NK	Sweatshirt	Cold Coffee Crewneck	Cotton	Navy, Black
TN15FTO019NA	Sweatshirt	C/Rib Crewneck	Cotton	Navy
TN15FTO019WH	Sweatshirt	C/Rib Crewneck	Cotton	White
TN15FTO020BK	Top	Six Hours Knit Sweater	Wool, Acrylic	Black
TN15FTO020NA	Top	Six Hours Knit Sweater	Wool, Acrylic	Navy
TN15SAC001BK	Hat	Beanie	Cotton	Black
VA15FAC001BP	Shoes	VANS × TINT Authentic	Cotton	Blue Print
VA15FAC001GG	Shoes	VANS × TINT Authentic	Cotton	Gecko Green
VA15FAC002BP	Shoes	VANS × TINT Classic Slip-On	Cotton	Blue Print
VA15FAC003BP	Hat	VANS × TINT Camp Cap	Nylon	Blue Print
VA15FTO001BP	Long Sleeve Tee	VANS × TINT Baseball Jersey	Cotton	Blue Print
VA15FTO001GG	Long Sleeve Tee	VANS × TINT Baseball Jersey	Cotton	Gecko Green

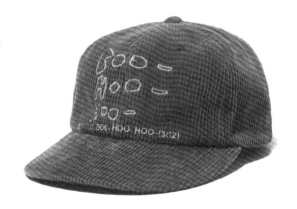

Code	Category	Name	Material(s)	Color(s)
TN15SAC002BK	Hat	O.G Camp Cap	Polyester	Black
TN15SAC003BE	Hat	O.G Ripstop Camp Cap	Cotton	Beige
TN15SAC003WH	Hat	O.G Ripstop Camp Cap	Cotton	White
TN15SAC004BK	Hat	O.G Bucket Hat	Cotton, Nylon	Black
TN15SAC004OV	Hat	O.G Bucket Hat	Cotton, Nylon	Olive
TN15SAC005BK	Hat	New Wave Bucket Hat	Cotton	Black
TN15SAC005WH	Hat	New Wave Bucket Hat	Cotton	White
TN15SAC006BK	Hat	Lake on Fire 6P Cap	Cotton	Black
TN15SAC006RD	Hat	Lake on Fire 6P Cap	Cotton	Red
TN15SAC006WH	Hat	Lake on Fire 6P Cap	Cotton	White
TN15SAC007BE	Hat	New Wave 6P Cap	Cotton	Beige
TN15SAC007BK	Hat	New Wave 6P Cap	Cotton	Black
TN15SAC007BL	Hat	New Wave 6P Cap	Cotton	Blue
TN15SAC007GN	Hat	New Wave 6P Cap	Cotton	Green
TN15SAC007NA	Hat	New Wave 6P Cap	Cotton	Navy
TN15SAC007YL	Hat	New Wave 6P Cap	Cotton	Yellow
TN15SAC008BE	Hat	T-Logo Cap	Cotton	Beige
TN15SAC008BK	Hat	T-Logo Cap	Cotton	Black
TN15SAC008NA	Hat	T-Logo Cap	Cotton	Navy
TN15SAC008OV	Hat	T-Logo Cap	Cotton	Olive
TN15SAC008WH	Hat	T-Logo Cap	Cotton	White
TN15SAC009WH	Bag	New Wave Tote (S)	Cotton	White
TN15SAC010WH	Bag	L.O.F Tote (S)	Cotton	White
TN15SAC011BK	Shoes	PUMA × thisisneverthat TRINOMIC XT2+	-	Black
TN15SAC012CA	Shoes	PUMA × thisisneverthat TRINOMIC XT2+	-	Camo
TN15SAC013BK	Bag	New Wave Tote (L)	Cotton	Black
TN15SAC014WH	Bag	L.O.F Tote (L)	Cotton	White
TN15SAC015BK	Bag	JANSPORT × thisisneverthat Day Pack	Cotton	Black
TN15SAC016WH	Accessory	Paper Clip	-	White
TN15SAC017WH	Accessory	Hotel Key Tag	Plastic	White
TN15SAC018WH	Accessory	Frisbee	-	White
TN15SAC019WH	Accessory	Dog Tag	-	White
TN15SAC020WH	Accessory	Stadium Cup	-	White
TN15SAC021CE	Accessory	iPhone Case	Polycarbonate	Crane
TN15SAC021SI	Accessory	iPhone Case	Polycarbonate	Sign
TN15SAC021US	Accessory	iPhone Case	Polycarbonate	Bus
TN15SAC022SA	Bag	Gym Sack	Polyester	Sauce
TN15SAC022SU	Bag	Gym Sack	Polyester	Subway
TN15SAC023WH	Accessory	Button (6)	-	White
TN15SAC024FI	Accessory	Pin	-	Fire
TN15SAC024LK	Accessory	Pin	-	Lake
TN15SAC024LO	Accessory	Pin	-	Lake on Fire
TN15SAC024PT	Accessory	Pin	-	Path
TN15SAC027BK	Hat	LF O.G Camp Cap	Polyester	Black
TN15SAC028SI	Hat	LF O.G Camp Cap	Polyester	Sign
TN15SAC028US	Hat	LF O.G Camp Cap	Polyester	Bus
TN15SAC030PN	Accessory	LF iPhone Case	Polycarbonate	N.P
TN15SAC031BL	Hat	HEIGHTS. × thisisneverthat 6-Panel	-	Blue
TN15SAC031RD	Hat	HEIGHTS. × thisisneverthat 6-Panel	-	Red
TN15SAC031WH	Hat	HEIGHTS. × thisisneverthat 6-Panel	-	White
TN15SAC033NA	Accessory	Lake on Fire Flag	Cotton	Navy
TN15SBT001BK	Pants	Flight Pant	Cotton	Black
TN15SBT001OV	Pants	Flight Pant	Cotton	Olive
TN15SBT002BK	Pants	Jogger Pant	Cotton, Nylon	Black
TN15SBT002NA	Pants	Jogger Pant	Cotton, Nylon	Navy

Lake on Fire
SS15
thisisneverthat

www.thisisneverthat.com

Directed by
thisisneverthat

Original Sound Track Produced
by
Somdef

TN15SMV001NA

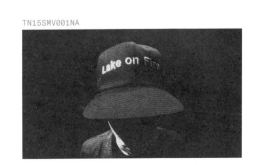

Code	Category	Name	Material(s)	Color(s)
TN15SBT003BE	Pants	Washed Cotton Short	Cotton	Beige
TN15SBT003CK	Pants	Washed Cotton Short	Cotton	Check
TN15SBT003NA	Pants	Washed Cotton Short	Cotton	Navy
TN15SBT003OV	Pants	Washed Cotton Short	Cotton	Olive
TN15SBT004BK	Pants	Relaxed Pant	Linen, Rayon	Black
TN15SBT004CR	Pants	Relaxed Pant	Polyester, Rayon	Cross Stripes
TN15SBT005BK	Pants	Jogging Short	Nylon	Black
TN15SBT005SU	Pants	Jogging Short	Polyester	Subway
TN15SBT005US	Pants	Jogging Short	Polyester	Bus
TN15SBT006BL	Pants	PATH Short	Cotton	Blue
TN15SBT006WH	Pants	PATH Short	Cotton	White
TN15SBT007BK	Pants	Zip Short	Cotton	Black
TN15SBT007OV	Pants	Zip Short	Cotton	Olive
TN15SBT008BE	Pants	1Tuck Short	Cotton	Beige
TN15SBT008BL	Pants	1Tuck Short	Cotton	Blue
TN15SMV001NA	Video	LAKE ON FIRE	Film	-
TN15SMV002NA	Video	thisisneverthat × PUMA Trinomic XT2+	Film	-
TN15SOW001BK	Jacket	Zip Shirt	Cotton	Black
TN15SOW001CL	Jacket	Zip Shirt	Cotton	Check Black
TN15SOW001CY	Jacket	Zip Shirt	Cotton	Check Yellow
TN15SOW002BL	Jacket	PATH Trucker Jacket	Cotton	Blue
TN15SOW002WH	Jacket	PATH Trucker Jacket	Cotton	White
TN15SOW003BK	Jacket	Soutien Collar Coat	Polyester	Black
TN15SOW003NA	Jacket	Soutien Collar Coat	Polyester	Navy
TN15SOW004SI	Jacket	Soutien Collar Coat	Polyester	Sign
TN15SOW004SV	Jacket	Soutien Collar Coat	Polyester	S-Van
TN15SOW005BK	Jacket	Varsity Jacket	Polyester	Black
TN15SOW005NP	Jacket	Varsity Jacket	Polyester	NYPD
TN15SOW005US	Jacket	Varsity Jacket	Polyester	Bus
TN15SOW006BK	Jacket	Coach Jacket	Polyester	Black
TN15SOW007PE	Jacket	Coach Jacket	Polyester	People
TN15SOW007SA	Jacket	Coach Jacket	Polyester	Sauce

TN15SOW002BL TN15SOW001BK TN15SOW007PE

 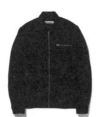 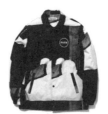

TN15SOW005NP TN15SOW005BK TN15SOW006BK

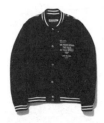 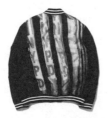 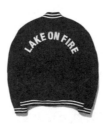 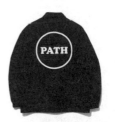

Code	Category	Name	Material(s)	Color(s)
TN15SOW008BK	Jacket	Anorak	Nylon	Black
TN15SOW008NA	Jacket	Anorak	Nylon	Navy
TN15STO001NG	Long Sleeve Tee	Striped Round Neck Tee	Cotton	Navy, Green
TN15STO001NW	Long Sleeve Tee	Striped Round Neck Tee	Cotton	Navy, White
TN15STO002NE	Tee	Two Tone Tee	Cotton	Navy, Beige
TN15STO002NL	Tee	Two Tone Tee	Cotton	Navy, Olive
TN15STO002OG	Tee	Two Tone Tee	Cotton	Olive, Grey
TN15STO002OW	Tee	Two Tone Tee	Cotton	Olive, White
TN15STO003AG	Tee	Baseball Tee	Cotton	Oat, Green
TN15STO003WB	Tee	Baseball Tee	Cotton	White, Blue
TN15STO003YN	Tee	Baseball Tee	Cotton	Grey, Navy
TN15STO004BL	Shirt	Lake S.C Long Shirt	Cotton	Blue
TN15STO004RD	Shirt	Lake S.C Long Shirt	Cotton	Red
TN15STO005BK	Tee	Rode Back Zip Tee	Cotton	Black
TN15STO005WH	Tee	Rode Back Zip Tee	Cotton	White
TN15STO006BK	Tee	JN Long Tee	Cotton	Black
TN15STO006WH	Tee	JN Long Tee	Cotton	White
TN15STO007BL	Tee	Lake on Fire Tee	Cotton	Blue
TN15STO007GN	Tee	Lake on Fire Tee	Cotton	Green
TN15STO008BK	Tee	N Football Tee	Cotton	Black
TN15STO008NA	Tee	N Football Tee	Cotton	Navy
TN15STO008WH	Tee	N Football Tee	Cotton	White
TN15STO009NA	Tee	Striped Rib Tee	Cotton	Navy
TN15STO009WH	Tee	Striped Rib Tee	Cotton	White
TN15STO010BK	Sweatshirt	S/S Crewneck	Cotton	Black
TN15STO010GR	Sweatshirt	S/S Crewneck	Cotton	Grey
TN15STO011BK	Tee	New Wave Tee	Cotton	Black
TN15STO011BL	Tee	New Wave Tee	Cotton	Blue
TN15STO011WH	Tee	New Wave Tee	Cotton	White
TN15STO012BK	Tee	Pique Tennis Shirt	Cotton	Black
TN15STO012NA	Tee	Pique Tennis Shirt	Cotton	Navy
TN15STO012WH	Tee	Pique Tennis Shirt	Cotton	White
TN15STO013BK	Shirt	Rode Long Shirt	Cotton	Black
TN15STO013CK	Shirt	Rode Long Shirt	Cotton	Check
TN15STO013WH	Shirt	Rode Long Shirt	Cotton	White
TN15STO014BK	Shirt	Lake Long Shirt	Cotton	Black
TN15STO014WH	Shirt	Lake Long Shirt	Cotton	White
TN15STO015BK	Tee	Baseball Jersey	Cotton	Black
TN15STO015WH	Tee	Baseball Jersey	Cotton	White
TN15STO016SB	Shirt	Rode Oxford Shirt	Cotton	Sky Blue
TN15STO016WH	Shirt	Rode Oxford Shirt	Cotton	White
TN15STO017CK	Tee	Lake Zip Tee	Cotton	Check
TN15STO018BK	Sweatshirt	MA-1 Crewneck	Cotton	Black
TN15STO018NA	Sweatshirt	MA-1 Crewneck	Cotton	Navy
TN15STO019BK	Sweatshirt	L.O.F Crewneck	Cotton	Black
TN15STO019GR	Sweatshirt	L.O.F Crewneck	Cotton	Grey
TN15STO020BK	Sweatshirt	B.Court Crewneck	Cotton	Black
TN15STO020GR	Sweatshirt	B.Court Crewneck	Cotton	Grey
TN15STO021BK	Sweatshirt	B.Court Pullover	Cotton	Black
TN15STO021GR	Sweatshirt	B.Court Pullover	Cotton	Grey
TN15STO022BK	Tee	G.Loge Tee	Cotton	Black
TN15STO022GR	Tee	G.Logo Tee	Cotton	Grey
TN15STO022WH	Tee	G.Logo Tee	Cotton	White
TN15STO023CH	Tee	Rode Loosefit Tee	Cotton	Charcoal
TN15STO023OV	Tee	Rode Loosefit Tee	Cotton	Olive

Code	Category	Name	Material(s)	Color(s)
TN15STO023WH	Tee	Rode Loosefit Tee	Cotton	White
TN15STO024NA	Tee	Bike/Woods Tee	Cotton	Navy
TN15STO024OV	Tee	Bike/Woods Tee	Cotton	Olive
TN15STO025AB	Tee	PATH Tee	Cotton	Oat, Blue
TN15STO025LL	Tee	PATH Tee	Cotton	Olive, Black
TN15STO025NI	Tee	PATH Tee	Cotton	Navy, White
TN15STO026BT	Tee	Polka Dot Tee	Cotton	Black, White
TN15STO026NV	Tee	Polka Dot Tee	Cotton	Navy, Ivory
TN15STO026WL	Tee	Polka Dot Tee	Cotton	White, Blue
TN15STO027BK	Tee	Home/Boat Tee	Cotton	Black
TN15STO027WH	Tee	Home/Boat Tee	Cotton	White
TN15STO028BK	Tee	L.O.F Scribble Tee	Cotton	Black
TN15STO028WH	Tee	L.O.F Scribble Tee	Cotton	White
TN15STO029BK	Tee	Rode Mesh Tee	Polyester	Black
TN15STO029WH	Tee	Rode Mesh Tee	Polyester	White
TN15STO034NA	Tee	JN Tee	Cotton	Navy
TN15STO034PK	Tee	JN Tee	Cotton	Pink
TN15STO034WH	Tee	JN Tee	Cotton	White
TN15STO035BE	Tee	New Wave Tee (LT)	Cotton	Beige
TN15STO035BL	Tee	New Wave Tee (LT)	Cotton	Blue
TN15STO035WH	Tee	New Wave Tee (LT)	Cotton	White

TN15STO025AB TN15STO022GR TN15STO023OV TN15STO003WB TN15STO010GR

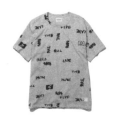

TN15SBT003BE TN15SBT003NA TN15SBT003CK TN15SBT006WH TN15SBT005US

 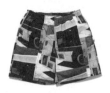

TN15SAC006WH TN15SAC006RD TN15SAC005BK TN15SAC031BL TN15SAC031RD

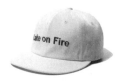 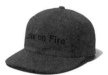 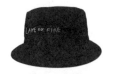

Code	Category	Name	Material(s)	Color(s)
TN14FAC001BK	Hat	O.G Camp Cap	Polyester	Black
TN14FAC002OV	Hat	Ripstop Camp Cap	Cotton	Olive
TN14FAC003OB	Hat	Bucket Hat	Polyester, Cotton	Black, Olive
TN14FAC004BK	Hat	1958 Bucket Hat	Cotton	Black
TN14FAC005GD	Accessory	Whistle	-	Gold
TN14FAC006WH	Accessory	Study Pin	-	White
TN14FAC007WH	Accessory	Emblem Pin	-	White
TN14FAC008BK	Hat	N.S 6P Cap	Acrylic	Black
TN14FAC009KC	Hat	K.C Camp Cap	Polyester	Kurt Cobain
TN14FAC010CU	Hat	Cuba Camp Cap	Polyester	Cuba
TN14FAC011BK	Hat	Wave 5P Cap	Acrylic	Black
TN14FAC012KN	Hat	K.C Bucket Hat	Polyester, Cotton	Kurt Cobain, Navy
TN14FAC013CC	Hat	Cuba Bucket Hat	Polyester, Cotton	Cuba, Black
TN14FAC014BK	Accessory	Navy Pin	-	Black
TN14FAC015BK	Accessory	Rules Pin	-	Black
TN14FAC016BK	Hat	N.S Fedora	Wool	Black
TN14FAC016GR	Hat	N.S Fedora	Wool	Grey
TN14FAC016NA	Hat	N.S Fedora	Wool	Navy
TN14FAC017BK	Accessory	K.C iPhone Case	-	Black
TN14FAC018WH	Accessory	N.S iPhone Case	-	White
TN14FAC019BK	Accessory	Rules iPhone Case	-	Black
TN14FAC020BK	Hat	Beanie	Cotton	Black
TN14FAC020BL	Hat	Beanie	Cotton	Blue
TN14FAC020CH	Hat	Beanie	Cotton	Charcoal
TN14FAC020OV	Hat	Beanie	Cotton	Olive
TN14FAC021NA	Hat	Bucket Hat	Acrylic	Navy
TN14FAC023BK	Accessory	Universe Pin	-	Black
TN14FBT001NA	Pants	Rules Sweat Pant	Cotton	Navy
TN14FBT001OV	Pants	Rules Sweat Pant	Cotton	Olive
TN14FBT002BK	Pants	Chino Pant	Cotton	Black
TN14FBT002OV	Pants	Chino Pant	Cotton	Olive
TN14FBT002WO	Pants	Chino Pant	Cotton	Washed Olive
TN14FBT003CH	Pants	Fatigue Pant	Cotton	Charcoal
TN14FBT003OV	Pants	Fatigue Pant	Cotton	Olive
TN14FBT004BK	Pants	Study Pant	Cotton	Black
TN14FBT004OV	Pants	Study Pant	Cotton	Olive
TN14FBT005NA	Pants	Wool Trousers	Wool, Polyester	Navy
TN14FBT006BK	Pants	Classic Trousers	Wool, Polyester	Black
TN14FBT006BS	Pants	Classic Trousers	Wool, Polyester	Black Stripe
TN14FBT006GT	Pants	Classic Trousers	Wool, Polyester	Grey Stripe
TN14FBT006NA	Pants	Classic Trousers	Wool, Polyester	Navy
TN14FBT007NA	Pants	Work Pant	Cotton	Navy
TN14FBT007OV	Pants	Work Pant	Cotton	Olive
TN14FMV001NA	Video	NAVY/STUDY	Film	-
TN14FOW001BK	Jacket	Padded Coat	Polyester	Black
TN14FOW001NA	Jacket	Padded Coat	Polyester	Navy
TN14FOW001OV	Jacket	Padded Coat	Polyester	Olive
TN14FOW002BL	Jacket	Duffle Coat	Wool, Polyester	Blue
TN14FOW003BK	Jacket	101 Coat	Wool, Polyester, Nylon, Acrylic, Cotton	Black
TN14FOW003CK	Jacket	101 Coat	Wool, Polyester, Cotton	Check
TN14FOW003NA	Jacket	101 Coat	Wool, Polyester, Nylon, Acrylic, Cotton	Navy
TN14FOW004BK	Jacket	Utility Jacket	Cotton	Black

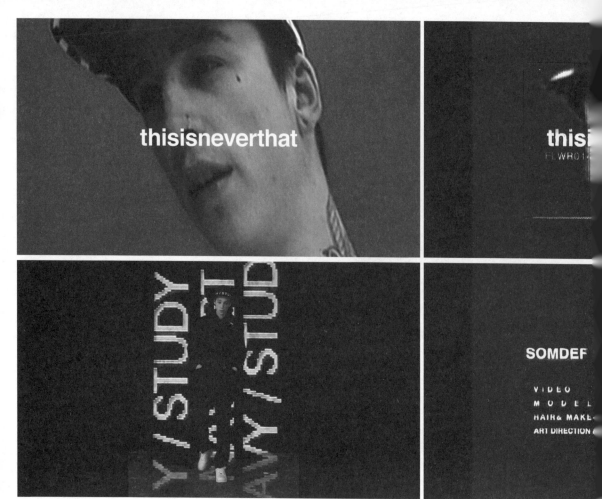

thisisneverthat

thisi
FLWR01

STUDY
/STUDY
AVY/STUD

SOMDEF

VIDEO
MODEL
HAIR& MAKE
ART DIRECTION

TN14FMV001NA

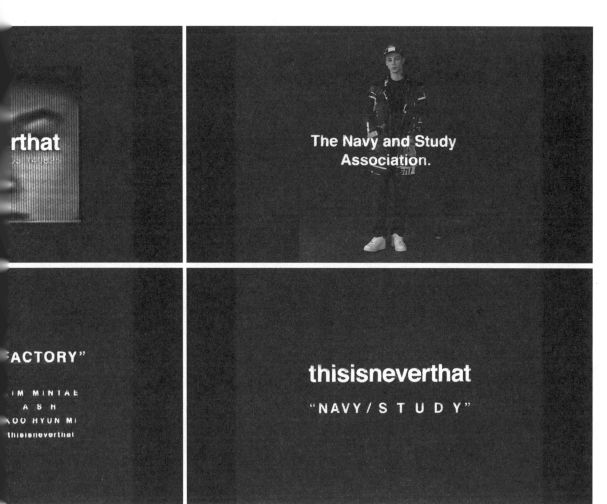

Code	Category	Name	Material(s)	Color(s)

TN14FOW007GR TN14FOW008BK TN14FOW008CH TN14FOW002BL TN14FAC021NA TN14FAC020BK

TN14FOW004NA TN14FTO017NA TN14FOW005BK TN14FTO014IV TN14FTO007NA TN14FTO003OV

TN14FTO001WH TN14FTO008BK TN14FTO008NA TN14FTO005OV

TN14FBT001OV TN14FBT006GT TN14FBT004BK TN14FBT002OV

TN14FOW004NA	Jacket	Utility Jacket	Cotton	Navy
TN14FOW005BK	Jacket	MA-1-R	Cotton	Black
TN14FOW005OV	Jacket	MA-1-R	Cotton	Olive
TN14FOW006NA	Jacket	M-65-Jacket	Cotton	Navy
TN14FOW006OV	Jacket	M-65-Jacket	Cotton	Olive
TN14FOW007GR	Jacket	M.C Coat	Cotton	Grey
TN14FOW007NA	Jacket	M.C Coat	Cotton	Navy
TN14FOW008BK	Jacket	Overcoat	Wool, Nylon, Rayon	Black
TN14FOW008CH	Jacket	Overcoat	Wool, Nylon, Rayon	Charcoal
TN14FOW009CU	Jacket	M-51 Parka	Cotton, Polyester	Cuba
TN14FOW009NA	Jacket	M-51 Parka	Cotton, Polyester	Navy
TN14FOW009OV	Jacket	M-51 Parka	Cotton, Polyester	Olive
TN14FTO001CH	Sweatshirt	Boxer Pullover	Cotton	Charcoal
TN14FTO001GR	Sweatshirt	Boxer Pullover	Cotton	Grey
TN14FTO001WH	Sweatshirt	Boxer Pullover	Cotton	White
TN14FTO002BK	Tee	Baseball Tee	Cotton	Black

Code	Category	Name	Material(s)	Color(s)
TN14FTO002BO	Tee	Baseball Tee	Cotton	Black, Brown
TN14FTO002GR	Tee	Baseball Tee	Cotton	Grey
TN14FTO002NY	Tee	Baseball Tee	Cotton	Navy, Yellow
TN14FTO002ON	Tee	Baseball Tee	Cotton	Olive, Navy
TN14FTO002OV	Tee	Baseball Tee	Cotton	Olive
TN14FTO003BK	Sweatshirt	N.S Crewneck	Cotton	Black
TN14FTO003NA	Sweatshirt	N.S Crewneck	Cotton	Navy
TN14FTO003OV	Sweatshirt	N.S Crewneck	Cotton	Olive
TN14FTO004BK	Sweatshirt	Rules Crewneck	Cotton	Black
TN14FTO004GR	Sweatshirt	Rules Crewneck	Cotton	Grey
TN14FTO005NA	Sweatshirt	Rules Zip Up	Cotton	Navy
TN14FTO005OV	Sweatshirt	Rules Zip Up	Cotton	Olive
TN14FTO006BK	Shirt	Rules Shirt	Cotton	Black
TN14FTO006CK	Shirt	Rules Shirt	Cotton	Check
TN14FTO006WH	Shirt	Rules Shirt	Cotton	White
TN14FTO007GR	Sweatshirt	Patched Crewneck	Cotton	Grey
TN14FTO007NA	Sweatshirt	Patched Crewneck	Cotton	Navy
TN14FTO008BK	Sweatshirt	Crewneck Pullover	Cotton	Black
TN14FTO008NA	Sweatshirt	Crewneck Pullover	Cotton	Navy
TN14FTO009NG	Long Sleeve Tee	Striped Round Neck Tee	Cotton	Navy, Green
TN14FTO009NK	Long Sleeve Tee	Striped Round Neck Tee	Cotton	Navy, Black
TN14FTO009NR	Long Sleeve Tee	Striped Round Neck Crewneck	Cotton	Navy, Red
TN14FTO010BK	Long Sleeve Tee	Waffle LS	Cotton	Black
TN14FTO010SP	Long Sleeve Tee	Waffle LS	Cotton	Stripe
TN14FTO012OV	Shirt	NS Shirt	Cotton	Olive
TN14FTO012WH	Shirt	NS Shirt	Cotton	White
TN14FTO013CH	Top	Heavy Knit Sweater	Lambswool	Charcoal
TN14FTO013NA	Top	Heavy Knit Sweater	Lambswool	Navy
TN14FTO014BK	Top	Brushed Sweater	Lambswool	Black
TN14FTO014CH	Top	Brushed Sweater	Lambswool	Charcoal
TN14FTO014IV	Top	Brushed Sweater	Lambswool	Ivory
TN14FTO017BK	Shirt	Padded Shirt	Cotton, Polyester	Black
TN14FTO017NA	Shirt	Padded Shirt	Cotton, Polyester	Navy
TN14FTO018BK	Tee	Rules Tee	Cotton	Black

Code	Category	Name	Material(s)	Color(s)
TN14SAC001PK	Accessory	BAT iPhone Case	-	Pink
TN14SAC002NO	Accessory	American iPhone Case	-	Navy, Orange
TN14SAC003ST	Hat	Bucket Hat	Polyester	ST, Navy
TN14SAC003VM	Hat	Bucket Hat	Polyester, Cotton	V.M, Black
TN14SAC004EC	Bag	Dolphin Tote S	Cotton	Ecru
TN14SAC005ST	Bag	JN Bag	Polyester	ST
TN14SAC005VM	Bag	JN Bag	Polyester	V.M
TN14SAC006BK	Hat	JN Cap	Cotton	Black
TN14SAC006WH	Hat	JN Cap	Cotton	White
TN14SAC007BK	Hat	PLRDS Cap	Cotton	Black
TN14SAC007NA	Hat	PLRDS Cap	Cotton	Navy
TN14SAC008EC	Bag	PLRDS Tote S	Cotton	Ecru
TN14SAC009BK	Hat	Polaroids Cap	Cotton	Black
TN14SAC009NA	Hat	Polaroids Cap	Cotton	Navy
TN14SAC010EC	Bag	Polaroids Tote L	Cotton	Ecru
TN14SAC011EC	Bag	Polaroids Tote S	Cotton	Ecru
TN14SAC012EC	Bag	Popcorn Tote S	Cotton	Ecru
TN14SAC013GN	Accessory	Shark iPhone Case	-	Green
TN14SAC014DK	Hat	Space Shuttle Cap	Cotton	Dark Camo
TN14SAC014LC	Hat	Space Shuttle Cap	Cotton	Light Camo
TN14SAC015ST	Accessory	ST iPhone Case	-	ST
TN14SAC017BW	Accessory	BIC Clic Gold	-	Black, White
TN14SAC018MT	Accessory	BIC® Slim Lighter	-	Multi
TN14SBT001BL	Jean	5P Repaired Jean	Cotton	Blue
TN14SBT002BL	Jean	5P Washed Jean	Cotton	Blue
TN14SBT003BK	Pants	Basketball Short	Polyester	Black
TN14SBT004BL	Pants	Jogging Short	Nylon	Blue
TN14SBT004NA	Pants	Jogging Short	Nylon	Black
TN14SBT005BK	Pants	Linen Trouser	Linen, Rayon	Black
TN14SBT005NA	Pants	Linen Trouser	Linen, Rayon	Navy
TN14SBT006BL	Pants	OP Short	Cotton	Blue
TN14SBT006NA	Pants	OR Short	Cotton	Navy
TN14SBT007BK	Pants	Sport Chinos	Cotton	Black
TN14SBT007BL	Pants	Sport Chinos	Cotton	Blue
TN14SBT007KH	Pants	Sport Chinos	Cotton	Khaki
TN14SBT007NA	Pants	Sport Chinos	Cotton	Navy
TN14SBT007OV	Pants	Sport Chinos	Cotton	Olive
TN14SBT008BK	Pants	SW Trouser	Wool, Rayon, Polyester	Black
TN14SBT008NA	Pants	SW Trouser	Wool, Rayon, Polyester	Navy
TN14SBT009BK	Pants	Sweat Pant	Cotton	Black
TN14SBT009GR	Pants	Sweat Pant	Cotton	Grey
TN14SBT010BK	Pants	Sweat Short	Cotton	Black
TN14SBT010GR	Pants	Sweat Short	Cotton	Grey
TN14SMV001NA	Video	POLAROIDS	Film	-
TN14SOW001BK	Jacket	Coach Jacket	Polyester	Black
TN14SOW002CA	Jacket	Coach Jacket	Polyester	Camo
TN14SOW002ST	Jacket	Coach Jacket	Polyester	ST
TN14SOW003BK	Jacket	MA-1	Cotton	Black
TN14SOW003EB	Jacket	MA-1	Cotton	Ecru, Black
TN14SOW003EC	Jacket	MA-1	Cotton	Ecru
TN14SOW004BK	Jacket	Mac Coat	Cotton	Black
TN14SOW004GR	Jacket	Mac Coat	Cotton	Grey
TN14SOW005NA	Jacket	SW Blazer	Wool, Rayon, Polyester	Navy
TN14SOW006BL	Jacket	Trucker Jacket	Cotton	Blue
TN14SOW006NA	Jacket	Trucker Jacket	Cotton	Navy

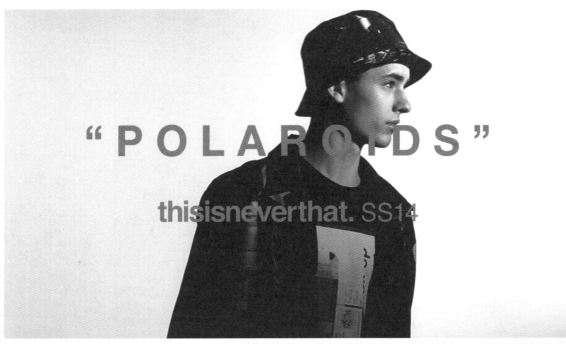

" P O L A R O I D S "

thisisneverthat. SS14

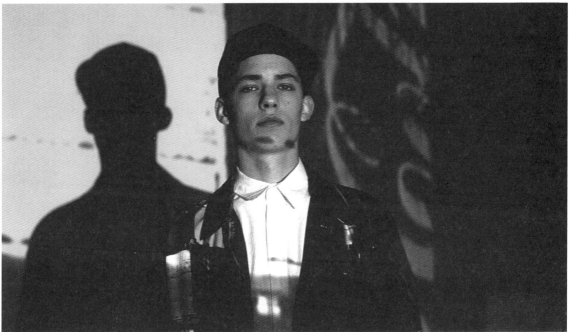

TN14SMV001NA

Code	Category	Name	Material(s)	Color(s)
TN14SOW007KH	Jacket	Two Tone Overcoat	Cotton	Khaki
TN14SOW007NA	Jacket	Two Tone Overcoat	Cotton	Navy
TN14STO001BW	Tee	Baseball Tee	Cotton	Black, White
TN14STO001NG	Tee	Baseball Tee	Cotton	Navy, Green
TN14STO001SN	Tee	Baseball Tee	Cotton	Sky Blue, Navy
TN14STO002BK	Shirt	Baseball Shirt	Cotton	Black
TN14STO002WH	Shirt	Baseball Shirt	Cotton	White
TN14STO003BK	Top	Basketball Jersey	Polyester	Black
TN14STO004BL	Shirt	Bat Shirt	Cotton	Blue
TN14STO004NA	Shirt	Bat Shirt	Cotton	Navy
TN14STO005BW	Shirt	B.D Sport Shirt	Cotton	Black, White
TN14STO005BY	Shirt	B.D Sport Shirt	Cotton	Blue, Yellow
TN14STO005NR	Shirt	B.D Sport Shirt	Cotton	Navy, Red
TN14STO005RY	Shirt	B.D Sport Shirt	Cotton	Red, Yellow
TN14STO006BL	Tee	Border Tee	Cotton	Blue
TN14STO006GR	Tee	Border Tee	Cotton	Grey
TN14STO006RD	Tee	Border Tee	Cotton	Red
TN14STO007GR	Tee	Dolphin Sweat	Cotton	Grey
TN14STO008BB	Tee	Football Tee	Cotton	Blue, Black
TN14STO008NA	Tee	Football Tee	Cotton	Navy
TN14STO008WN	Tee	Football Tee	Cotton	White, Navy
TN14STO009BK	Tee	JN Tee	Cotton	Black

TN14SOW001BK

TN14SOW003EB

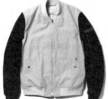

TN14SOW003BK

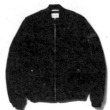

TN14SOW007KH

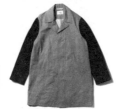

TN14SOW006BL

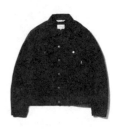

TN14STO007GR

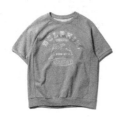

TN14STO020WH

TN14STO018WH

TN14STO022BL

TN14STO015BK

TN14STO005BW

TN14STO005BY

TN14STO005NR

Code	Category	Name	Material(s)	Color(s)

TN14SBT007BL TN14SBT002BL TN14SBT009BK TN14SBT007NA TN14SBT004NA

TN14SAC005ST TN14SAC005VM TN14SAC003ST TN14SAC003VM

Code	Category	Name	Material(s)	Color(s)
TN14STO009WH	Tee	JN Tee	Cotton	White
TN14STO010BK	Shirt	JN Shirt	Cotton	Black
TN14STO010WH	Shirt	JN Shirt	Cotton	White
TN14STO011BK	Tee	Mesh Crewneck	Polyester	Black
TN14STO012BK	Tee	News Tee	Cotton	Black
TN14STO012GR	Tee	News Tee	Cotton	Grey
TN14STO013BK	Sweatshirt	PLRDS Hoodie	Cotton	Black
TN14STO013GR	Sweatshirt	PLRDS Hoodie	Cotton	Grey
TN14STO014BK	Tee	PLRDS Tee	Cotton	Black
TN14STO014WH	Tee	PLRDS Tee	Cotton	White
TN14STO015BK	Tee	Polaroids Tee	Cotton	Black
TN14STO015GR	Tee	Polaroids Tee	Cotton	Grey
TN14STO016BK	Tee	Popcorn Tee	Cotton	Black
TN14STO016GR	Tee	Popcorn Tee	Cotton	Grey
TN14STO016WH	Tee	Popcorn Tee	Cotton	White
TN14STO017BK	Tee	Red State Tee	Cotton	Black
TN14STO017WH	Tee	Red State Tee	Cotton	White
TN14STO018GR	Tee	Shark Tee	Cotton	Grey
TN14STO018NA	Tee	Shark Tee	Cotton	Navy
TN14STO018WH	Tee	Shark Tee	Cotton	White
TN14STO019BK	Tee	Service Tee	Cotton	Black
TN14STO019WH	Tee	Service Tee	Cotton	White
TN14STO020GR	Tee	Stella Tee	Cotton	Grey
TN14STO020WH	Tee	Stella Tee	Cotton	White
TN14STO021BW	Long Sleeve Tee	Striped Round Neck Tee	Cotton	Black, White
TN14STO021NG	Long Sleeve Tee	Striped Round Neck Tee	Cotton	Navy, Green
TN14STO022BL	Tee	Tie-dye Tee	Cotton	Blue
TN14STO022NA	Tee	Tie-dye Tee	Cotton	Navy
TN14STO023BK	Tee	Up Tee	Cotton	Black
TN14STO023GR	Tee	Up Tee	Cotton	Grey
TN14STO024BK	Tee	Yellow Door Tee	Cotton	Black
TN14STO024WH	Tee	Yellow Door Tee	Cotton	White

Code	Category	Name	Material(s)	Color(s)
TN13FAC001BK	Bag	B&B Bag	Cotton	Black
TN13FAC001EC	Bag	B&B Bag	Cotton	Ecru
TN13FAC002BK	Hat	B&B Cap	Cotton	Black
TN13FAC002NA	Hat	B&B Cap	Cotton	Navy
TN13FAC003BK	Hat	Bucket Hat	Polyester	Black
TN13FAC003MT	Hat	Bucket Hat	Polyester	Multi
TN13FAC004BK	Bag	Hawaii Bag	Cotton	Black
TN13FAC004EC	Bag	Hawaii Bag	Cotton	Ecru
TN13FAC005BK	Hat	Hawaii Cap	Cotton	Black
TN13FAC005NA	Hat	Hawaii Cap	Cotton	Navy
TN13FAC006BK	Bag	Hot & Cold Bag	Cotton	Black
TN13FAC006EC	Bag	Hot & Cold Bag	Cotton	Ecru
TN13FAC007BL	Hat	Secret Beanie	Acrylic	Blue
TN13FAC008NA	Hat	Secret Beanie / BOT	Acrylic	Navy
TN13FAC009NA	Hat	Secret Beanie / TOP	Acrylic	Navy
TN13FAC010GR	Hat	Secret Pom Pom Beanie	Acrylic	Grey
TN13FAC010NA	Hat	Secret Pom Pom Beanie	Acrylic	Navy
TN13FAC011BK	Bag	Ski Bag	Cotton	Black
TN13FAC011EC	Bag	Ski Bag	Cotton	Ecru
TN13FAC012BK	Hat	The Cap	Cotton	Black
TN13FAC012NA	Hat	The Cap	Cotton	Navy
TN13FAC013BK	Bag	Waikiki Bag	Cotton	Black
TN13FAC013EC	Bag	Waikiki Bag	Cotton	Ecru
TN13FBT001NA	Pants	Chino Pant	Cotton	Navy
TN13FBT001OV	Pants	Chino Pant	Cotton	Olive
TN13FBT002BK	Pants	Hot & Cold Sweatpant	Cotton	Black
TN13FBT002GR	Pants	Hot & Cold Sweatpant	Cotton	Grey
TN13FBT003BK	Jean	N1 Black Denim	Cotton	Black
TN13FBT004BL	Jean	N1 Indigo Denim	Cotton	Blue
TN13FBT005BL	Jean	N3 Indigo Denim	Cotton	Blue

TN13FMV001NA

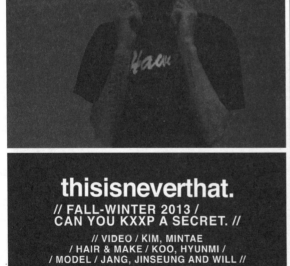

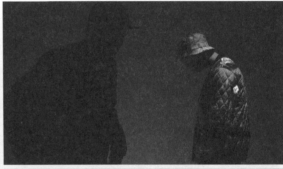

thisisneverthat.
// FALL-WINTER 2013 /
CAN YOU KXXP A SECRET. //

// VIDEO / KIM, MINTAE
/ HAIR & MAKE / KOO, HYUNMI /
/ MODEL / JANG, JINSEUNG AND WILL //

// ART DIRECTION & DESIGN / thisisneverthat
/ www.thisisneverthat.com//

// MUSIC / SOMDEF
/ "thatisneverthis" //

Code	Category	Name	Material(s)	Color(s)

TN13FOW008NA TN13FOW007BL TN13FOW007BK TN13FOW003GR

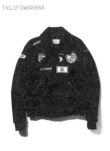 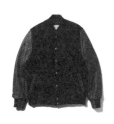 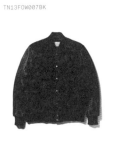 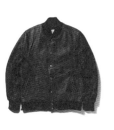

TN13FTO010GR TN13FTO010BL TN13FTO010BK TN13FTO006BK TN13FTO008BK

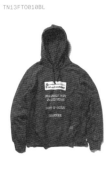 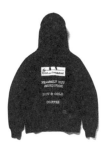 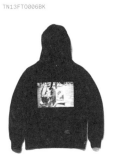 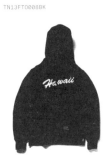

Code	Category	Name	Material(s)	Color(s)
TN13FMV001NA	Video	CAN YOU KEEP A SECRET	Film	-
TN13FOW001GR	Jacket	CKSTIN Chesterfield Coat	Wool, Rayon, Polyester	Grey
TN13FOW001NA	Jacket	CKSTIN Chesterfield Coat	Wool, Rayon, Polyester	Navy
TN13FOW002BK	Jacket	Garret Coat	Wool, Nylon, Rayon, Polyester	Black
TN13FOW002NA	Jacket	Garret Coat	Wool, Nylon, Rayon, Polyester	Navy
TN13FOW003BK	Jacket	Leather Varsity Jacket	Genuine Leather, Polyester	Black
TN13FOW003GR	Jacket	Leather Varsity Jacket	Genuine Leather, Polyester	Grey
TN13FOW004BK	Jacket	MA-1	Nylon, Polyester	Black
TN13FOW004BL	Jacket	MA-1	Nylon, Polyester	Blue
TN13FOW005BK	Jacket	Quilted Bomber	Polyester	Black
TN13FOW005MT	Jacket	Quilted Bomber	Polyester	Multi
TN13FOW006GR	Jacket	Quilted Hunting Jacket	Wool, Nylon, Rayon, Polyester	Grey
TN13FOW006OV	Jacket	Quilted Hunting Jacket	Wool, Nylon, Rayon, Polyester	Olive
TN13FOW007BK	Jacket	Varsity Jacket	Cotton, Genuine Leather, Polyester	Black
TN13FOW007BL	Jacket	Varsity Jacket	Cotton, Genuine Leather, Polyester	Blue
TN13FOW008NA	Jacket	Wool Aviator Jacket	Wool, Nylon, Rayon, Polyester	Navy
TN13FOW008OV	Jacket	Wool Aviator Jacket	Wool, Nylon, Rayon, Polyester	Olive
TN13FTO001GR	Tee	134 Football Tee	Cotton	Grey
TN13FTO001NA	Tee	134 Football Tee	Cotton	Navy
TN13FTO001RD	Tee	134 Football Tee	Cotton	Red
TN13FTO002BK	Tee	B&B Football Tee	Cotton	Black
TN13FTO002GR	Tee	B&B Football Tee	Cotton	Grey
TN13FTO002RD	Tee	B&B Football Tee	Cotton	Red

Code	Category	Name	Material(s)	Color(s)
TN13FT0003BK	Tee	B&B Tee	Cotton	Black
TN13FT0003BL	Tee	B&B Tee	Cotton	Blue
TN13FT0004BL	Shirt	Paisley Chambray Shirt	Cotton	Blue
TN13FT0005GR	Top	Cable Knit	Lambswool	Grey
TN13FT0005NA	Top	Cable Knit	Lambswool	Navy
TN13FT0005RD	Top	Cable Knit	Lambswool	Red
TN13FT0006BK	Sweatshirt	Domino Pullover	Cotton	Black
TN13FT0006GR	Sweatshirt	Domino Pullover	Cotton	Grey
TN13FT0007BL	Shirt	Dot Chambray Shirt	Cotton	Blue
TN13FT0008BK	Sweatshirt	Hawaii Pullover	Cotton	Black
TN13FT0008NA	Sweatshirt	Hawaii Pullover	Cotton	Navy
TN13FT0009BK	Tee	Hawaii Tee	Cotton	Black
TN13FT0009BL	Tee	Hawaii Tee	Cotton	Blue
TN13FT0010BK	Sweatshirt	Hot & Cold Pullover	Cotton	Black
TN13FT0010BL	Sweatshirt	Hot & Cold Pullover	Cotton	Blue
TN13FT0010GR	Sweatshirt	Hot & Cold Pullover	Cotton	Grey
TN13FT0011BK	Sweatshirt	JANE Crewneck	Cotton	Black
TN13FT0011GR	Sweatshirt	JANE Crewneck	Cotton	Grey
TN13FT0012GR	Top	KXXP Crewneck Knit	Lambswool	Grey
TN13FT0012NA	Top	KXXP Crewneck Knit	Lambswool	Navy
TN13FT0013BK	Long Sleeve Tee	KXXP Long Sleeve Tee	Cotton	Black
TN13FT0013GR	Long Sleeve Tee	KXXP Long Sleeve Tee	Cotton	Grey
TN13FT0013NA	Long Sleeve Tee	KXXP Long Sleeve Tee	Cotton	Navy
TN13FT0014NA	Top	SECRET Crewneck Knit	Lambswool	Navy
TN13FT0014RD	Top	SECRET Crewneck Knit	Lambswool	Red
TN13FT0015BL	Shirt	Secret Oxford Shirt	Cotton	Blue
TN13FT0015WH	Shirt	Secret Oxford Shirt	Cotton	White

TN13FT0002RD TN13FT0002BK TN13FT0001RD TN13FT0016IV TN13FT0016NA TN13FT0018GR

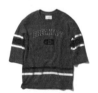 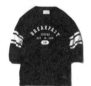 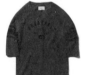 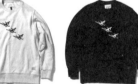 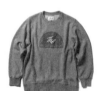

TN13FT0017CB TN13FT0017NM TN13FT0017IG TN13FT0017NB

 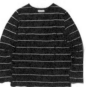 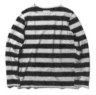

TN13FT0005RD TN13FT0005GR TN13FT0014RD TN13FT0014NA TN13FT0013NA

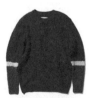 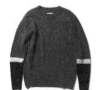 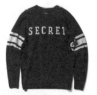 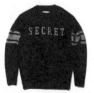

Code	Category	Name	Material(s)	Color(s)
TN13FTO016IV	Sweatshirt	Ski Crewneck	Cotton	Ivory
TN13FTO016NA	Sweatshirt	Ski Crewneck	Cotton	Navy
TN13FTO017CB	Long Sleeve Tee	Striped Round Neck Tee	Cotton	Charcoal, Blue
TN13FTO017IG	Long Sleeve Tee	Striped Round Neck Tee	Cotton	Ivory, Green
TN13FTO017NB	Long Sleeve Tee	Striped Round Neck Tee	Cotton	Navy, Blue
TN13FTO017NM	Long Sleeve Tee	Striped Round Neck Tee	Cotton	Navy, Mint
TN13FTO018BL	Sweatshirt	The Crewenck	Cotton	Blue
TN13FTO018GR	Sweatshirt	The Crewenck	Cotton	Grey
TN13FTO018RD	Sweatshirt	The Crewenck	Cotton	Red
TN13FTO019BK	Sweatshirt	Waikiki Crewneck	Cotton	Black
TN13FTO019RD	Sweatshirt	Waikiki Crewneck	Cotton	Red

Code	Category	Name	Material(s)	Color(s)
TN13SAC001NA	Hat	"ace" Cap	Wool	Navy
TN13SAC002PP	Hat	"ee" P Cap	Wool	Purple
TN13SAC003RD	Hat	"ee" R Cap	Wool	Red
TN13SAC004GN	Bag	"N.I.G" Daypack	Cotton	Green
TN13SAC004NA	Bag	"N.I.G" Daypack	Cotton	Navy
TN13SAC004OV	Bag	"N.I.G" Daypack	Cotton	Olive
TN13SAC005BE	Bag	"N.I.G" iPad Pouch	Cotton	Beige
TN13SAC005NA	Bag	"N.I.G" iPad Pouch	Cotton	Navy
TN13SAC006BE	Bag	L-Tote Bag	Cotton	Beige
TN13SAC006NA	Bag	L-Tote Bag	Cotton	Navy
TN13SAC007BE	Bag	S-Tote Bag	Cotton	Beige
TN13SAC007OV	Bag	S-Tote Bag	Cotton	Olive
TN13SAR001WH	Accessory	A Printing	Paper	White
TN13SAR002WH	Accessory	J Printing	Paper	White
TN13SAR003SB	Accessory	13 Printing-1	Paper	Sky Blue
TN13SAR004WH	Accessory	13 Printing-2	Paper	White
TN13SAR005SB	Accessory	Gardener Printing-1	Paper	Sky Blue
TN13SAR006WH	Accessory	Gardener Printing-2	Paper	White
TN13SBT001BE	Pants	"N.I.G" 5L Carpenter Pant	Cotton	Beige
TN13SBT001BL	Pants	"N.I.G" 5L Carpenter Pant	Cotton	Blue
TN13SBT002BE	Pants	"N.I.G" 5L Pant	Cotton	Beige
TN13SBT002NA	Pants	"N.I.G" 5L Pant	Cotton	Navy
TN13SBT002OV	Pants	"N.I.G" 5L Pant	Cotton	Olive
TN13SBT003BE	Pants	"N.I.G" 5P Pant	Cotton	Beige
TN13SBT003BL	Pants	"N.I.G" 5P Pant	Cotton	Blue
TN13SBT004BL	Pants	"N.I.G" Carpenter Pant	Cotton	Blue
TN13SBT004OV	Pants	"N.I.G" Carpenter Pant	Cotton	Olive
TN13SBT005BL	Jean	5/L Denim Pant	Cotton	Blue
TN13SBT006NA	Pants	Army 5/L Pant	Cotton	Navy
TN13SBT006OV	Pants	Army 5/L Pant	Cotton	Olive
TN13SBT006PP	Pants	Army 5/L Pant	Cotton	Purple
TN13SBT007NA	Pants	Army Pant	Cotton	Navy
TN13SBT007OV	Pants	Army Pant	Cotton	Olive
TN13SBT008GR	Pants	Midweight Twillterry Pant	Cotton	Grey
TN13SBT008NA	Pants	Midweight Twillterry Pant	Cotton	Navy
TN13SBT008YL	Pants	Midweight Twillterry Pant	Cotton	Yellow
TN13SBT009OR	Pants	"N.I.G" 5/L Pant	Cotton	Orange
TN13SMV001NA	Video	A NOOK IN THE GARDEN	Film	-

TN13SMV001NA

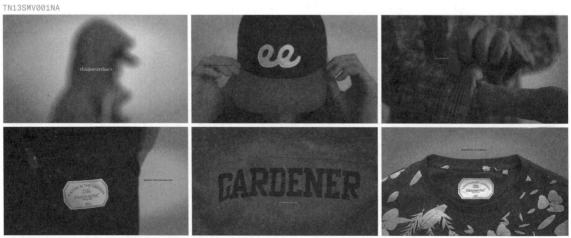

Code	Category	Name	Material(s)	Color(s)

TN13SOW008GN TN13SOW005OV TN13STO002OV TN13STO002BL TN13STO004YL

TN13STO012YL TN13STO007NA TN13SBT008YL TN13SBT009OR TN13SAC005BE

TN13STO001GR TN13STO001RD TN13STO001BK

TN13SBT004OV TN13SBT002OV TN13SBT005BL TN13SAC004GN TN13SAC007OV

Code	Category	Name	Material(s)	Color(s)
TN13SOW001KH	Jacket	"N.I.G" Pattern Duffle Coat	Cotton	Khaki
TN13SOW002NA	Jacket	3Layer Coat	Cotton	Navy
TN13SOW003GN	Jacket	French Army Jacket	Cotton	Green
TN13SOW003NA	Jacket	French Army Jacket	Cotton	Navy
TN13SOW004BL	Jacket	G Field Parka	Nylon, Cotton	Blue
TN13SOW004GS	Jacket	G Field Parka	Nylon, Cotton	Greyish
TN13SOW004KH	Jacket	G Field Parka	Nylon, Cotton	Khaki
TN13SOW004YL	Jacket	G Field Parka	Nylon, Cotton	Yellow
TN13SOW005BL	Jacket	GN 4B Jacket	Cotton	Blue
TN13SOW005NA	Jacket	GN 4B Jacket	Cotton	Navy
TN13SOW005OV	Jacket	GN 4B Jacket	Cotton	Olive
TN13SOW006KH	Jacket	Hunting Jacket	Cotton	Khaki
TN13SOW006OV	Jacket	Hunting Jacket	Cotton	Olive
TN13SOW007BK	Jacket	Mac Coat	Cotton	Black
TN13SOW007KH	Jacket	Mac Coat	Cotton	Khaki
TN13SOW007NA	Jacket	Mac Coat	Cotton	Navy

Code	Category	Name	Material(s)	Color(s)
TN13SOW008GN	Jacket	Varsity Jacket	Wool, Cow Leather, Polyester	Green
TN13SOW008NA	Jacket	Varsity Jacket	Wool, Cow Leather, Polyester	Navy
TN13STO001BK	Tee	"13" Football Tee	Cotton	Black
TN13STO001GR	Tee	"13" Football Tee	Cotton	Grey
TN13STO001NA	Tee	"13" Football Tee	Cotton	Navy
TN13STO001RD	Tee	"13" Football Tee	Cotton	Red
TN13STO002BL	Shirt	"GARDENER" L/S	Cotton	Blue
TN13STO002KH	Shirt	"GARDENER" L/S	Cotton	Khaki
TN13STO002OV	Shirt	"GARDENER" L/S	Cotton	Olive
TN13STO003GR	Sweatshirt	"GN" Crew Sweatshirt	Cotton	Grey
TN13STO003NA	Sweatshirt	"GN" Crew Sweatshirt	Cotton	Navy
TN13STO003YL	Sweatshirt	"GN" Crew Sweatshirt	Cotton	Yellow
TN13STO004NA	Shirt	"N.I.G" Pattern Shirt	Cotton	Navy
TN13STO004YL	Shirt	"N.I.G" Pattern Shirt	Cotton	Yellow
TN13STO005CH	Tee	"N.I.G" Pattern Tee	Cotton	Charcoal
TN13STO005GR	Tee	"N.I.G" Pattern Tee	Cotton	Grey
TN13STO005YL	Tee	"N.I.G" Pattern Tee	Cotton	Yellow
TN13STO006GR	Tee	6 Stripe Tee	Cotton	Grey
TN13STO006NA	Tee	6 Stripe Tee	Cotton	Navy
TN13STO007GR	Tee	Baseball Tee	Cotton	Grey
TN13STO007NA	Tee	Baseball Tee	Cotton	Navy
TN13STO007WH	Tee	Baseball Tee	Cotton	White
TN13STO008BK	Tee	JAN10 A Tee	Cotton	Black
TN13STO008WH	Tee	JAN10 A Tee	Cotton	White
TN13STO009BK	Tee	JAN10 J Tee	Cotton	Black
TN13STO009WH	Tee	JAN10 J Tee	Cotton	White
TN13STO011RD	Shirt	Madras Shirt	Cotton	Red
TN13STO011WH	Shirt	Madras Shirt	Cotton	White
TN13STO012GR	Sweatshirt	Midweight Twillterry Pullover Hoodie	Cotton	Grey
TN13STO012NA	Sweatshirt	Midweight Twillterry Pullover Hoodie	Cotton	Navy
TN13STO012YL	Sweatshirt	Midweight Twillterry Pullover Hoodie	Cotton	Yellow
TN13STO013GN	Long Sleeve Tee	Striped Round Neck Tee	Cotton	Green
TN13STO013NB	Long Sleeve Tee	Striped Round Neck Tee	Cotton	Navy, Blue
TN13STO013NG	Long Sleeve Tee	Striped Round Neck Tee	Cotton	Navy, Green
TN13STO013NR	Long Sleeve Tee	Striped Round Neck Tee	Cotton	Navy, Red
TN13STO013OR	Long Sleeve Tee	Striped Round Neck Tee	Cotton	Orange
TN13STO014GR	Tee	Thunder Tee	Cotton	Grey
TN13STO014WH	Tee	Thunder Tee	Cotton	White
TN13STO015GR	Tee	Dot Tee	Cotton	Grey
TN13STO015NY	Tee	Dot Tee	Cotton	Navy
TN13STO015OV	Tee	Dot Tee	Cotton	Olive

스트리트 패션과 유스 컬처: 옷은 손에 쥔 사람이 운용하기에 달렸다

박세진, 패션 칼럼니스트

1. 어느 날 등산복은 힙합의 옷이 된다

'마운틴 파카' 또는 '마운틴 재킷'이라는 옷이 있다. '파카'와 '재킷'이라는
말을 혼용하기도 하지만, 거칠게 후드가 있으면 파카, 없으면 재킷으로
구분하는 편이다. 물론 말은 나라와 언어에 따라 복잡해지기 때문에 단지
이 사실만으로는 모든 것을 깔끔하게 아우를 수는 없다. 어쨌든 마운틴 파카
또는 마운틴 재킷이다.

 마운틴 파카는 말 그대로 등산을 할 때 입는 옷이다. 방수와 방풍
기능을 갖춘, 살짝 단단한 겉감에 길이는 엉덩이를 덮는 정도다. 일반적으로
보온재는 들어 있지 않다. 산에서 입기 위해 만든 옷이고, 인간이 옷에서
감당할 수 있는 무게에는 절대적인 한계가 있다. 따라서 무엇보다 최소의
무게로 최대의 효과를 얻어야 한다. 보온용 아우터웨어와 우의의 구조에서는
일반적으로 겉감이 겹치기 마련이다. 이런 비효율성은 겉감과 보온재를 따로
착용할 수 있을 뿐 아니라 서로 결합할 수 있도록 고안하면 간단히 해결된다.
여기서 겉감에 해당하는 것이 마운틴 파카다.

 마운틴 파카 이전에 파카는 에스키모가 입는 두꺼운 겨울 외투를
모방한 결과다. 세계대전 시기에 군대에서는 이를 바탕으로 용도에 맞고,
활동성이 우수한 보온 의류를 만들었다. 그 뒤에 등장한 여러 방한 외투는
오늘날 일상복은 물론이고, 패션 아우터웨어 분야에서 널리 사용된다.

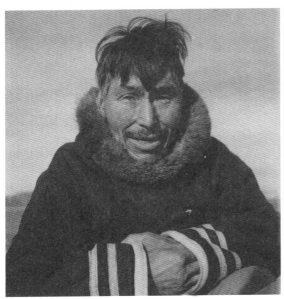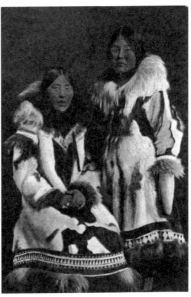

오늘날 우리가 입는 파카는 본디 에스키모가 입는 두꺼운 겨울용 외투를 모방한 결과다. 에스키모에게
옷, 특히 외투는 생존을 위한 도구였다. 일반적으로 사냥감의 모피를 벗겨 만들었고, 경우에 따라 마른
풀을 덮기도 했다. 여름에는 방수를 위해 물개 가죽을 이용했다.

여기서 주목해야 할 옷은 베트남전쟁 시기에 등장한 M-65다. 정식
명칭은 'M-1965 필드 재킷'으로, 모델명에서 알아차릴 수 있듯 1965년에
생산되었다. 이전 모델로는 M-43과 M-51이 있다. 이름에 붙은 숫자를
따라가보면 미군이 세계대전, 한국전쟁, 베트남전쟁 등 대규모 전쟁에
참전할 때마다 현지의 상황에 맞게 수정되고 보완된 점을 알 수 있다.
M-65는 전면에 커다란 주머니 네 개, 붙였다 뗄 수 있는 내피, 면
50퍼센트와 나일론 50퍼센트의 혼방으로 살짝 두꺼우면서 발수가 되는
겉감을 갖췄다. 칼라 속에 간이 후드가 있지만, 붙였다 뗄 수 있는 본격적인
후드는 따로 있다. 그 뒤 M-65는 생김새, 기능성, 유래 등이 각각 분리되고
결합되며 히피와 서바이벌 마니아, 밀리터리 패션과 하이 패션, 일상복과
작업복까지 여러 범위에서 사용된다.

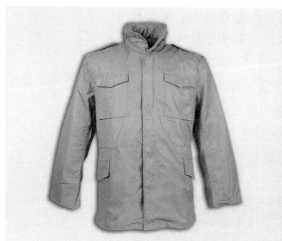

전쟁은 많은 것을 파괴하지만 동시에 어떤 것을
잉태한다. 1965년 베트남전쟁 시기에 등장한 미군
재킷 M-65는 아웃도어 의류의 교본이 되고, 이후
사회, 계층, 문화에 따라 여러 모습으로 분화한다.
알파 인더스트리(Alpha Industries)는 당시 미군에
M-65를 납품한 대표적인 업체 가운데 하나였다. 1976년
영화 「택시 드라이버(Taxi Driver)」에서 로버트 드
니로(Robert De Niro)가 입어 유명해지기도 했다.

그리고 이제는 누구나 입는 옷이 된다.

시에라 디자인 SIERRA DESIGNS에서 초창기에 선보인 마운틴 파카 또한
M-65와 마찬가지로 1965년에 등장했다. 마운틴 파카의 유래에 관해서는
이견이 있지만, 홀루바 Holubar가 먼저고, 시에라 디자인에서 뒤를
이었다는 것이 대체적이다. 시에라 디자인의 공동 창립자인 밥 스완슨(Bob
Swanson)이 홀루바에서 일하는 동안 마운틴 파카에 친숙해졌다는
이야기가 전해진다. 1978년 미국에서 개봉한 반전 영화 「디어 헌터(Deer

Hunter)」에서 로버트 드 니로(Robert De Niro)가 입은 오렌지색 마운틴
파카는 홀루바의 제품이었다.

M-65나 마운틴 파카의 바탕에는 M-51 같은 제품이 있을 테다.
따라서 시에라 디자인의 마운틴 파카는 M-65와 비슷한 점이 적지 않다.
특히 커다란 주머니 네 개가 붙은 앞면은 비슷하다. 하지만 마운틴 파카는 등
쪽에 헌터 재킷에서 유래한 듯한 게임(game, 사냥감) 포켓이 있다. 과거에는
겨울에 게임 포켓에 신문지 등을 넣어 보온성을 끌어올렸다는 이야기도
있다. 이렇게 겉면에만 다섯 개나 있는 주머니는 확장성이 커 완전히 채우면
웬만한 백팩 하나쯤은 채울 분량을 넣을 수 있다.

한편, 팔은 래글런 방식으로 붙어 있고 소매는 M-65와 비슷하게
벨크로를 이용해 조절할 수 있다. 약간 고풍스러운 주름이 붙어 있는데,
여기서 고풍스럽다는 판단은 오늘날의 관점이기 때문에 당시에는 다른
느낌이었을지 모른다. 여기에 커다란 후드가 붙어 있고, 면 60퍼센트,
나일론 40퍼센트의 크로스 패브릭으로 만들었다. 이 옷감의 원리는 다소
원시적이지만 방풍과 방수 기능을 갖췄다. 이 옷감은 뻣뻣한 나일론 텐트
같은 분위기를 풍긴다. 옷에 사용하기에 적절한 소재는 아닌 듯한 느낌이
들고, 그런 점에서 직물의 촉감에서는 M-65가 더 '옷'에 가깝다. 하지만
그 덕에 마운틴 파카가 조금 더 '기능적'으로 보인다.

마운틴 파카는 후드 부분에 옷을 말아 넣어 작게 접을 수 있다.
등산을 할 때 그렇게 말아 배낭에 넣었다가 갑자기 바람이 불거나 가는
비가 내리면 꺼내 입으면 된다. 안에 셔츠를 입어도 되고, 약간 더 추워지면
스웨터를 입는다. 아주 추우면 다운 조끼나 재킷을 입을 수도 있다. 쉽게
접어 휴대할 수 있다는 점은 마운틴 파카를 비롯한 아웃도어용 셸의
특징이다. 도심에서만 입는 터라 후드에 접어 넣을 일이 없어도 적어도
그런 기능을 갖춰야만 하는 분위기가 있다. 이는 고기능성을 표방한 패션의
특징이기도 하다.

그렇게 도심의 반전 시위형 히피들은 M-65를, 상업화한 문명에
반감을 품고 자연과 함께하려는 운동형 히피들은 시에라 디자인의 마운틴
파카를 입었다. 히피 문화가 세계로 퍼져 나가며 그들이 입은 옷 또한
퍼져나갔다. 그리고 홀루바나 시에라 디자인을 시작으로 당대의 여러
아웃도어 브랜드에서 형태가 거의 비슷한 마운틴 재킷을 내놓기 시작했다.
1970~80년대 미국에서 등장한 아웃도어 의류를 살펴보면 같은 공장에서
만들어 로고만 달리 붙인듯 거의 유사하다. 마운틴 재킷뿐 아니라 다운 조끼,
플리스 재킷 또한 마찬가지다.

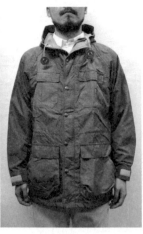
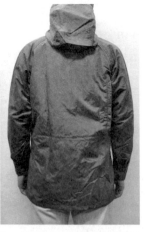

면 60퍼센트, 나일론 40퍼센트를 혼방한 옷감 '60/40 클로스'는 시에라 디자인의 마운틴 파카에 사용된다. 나일론 사이의 면이 부풀어 올라 방수 기능을 실현한다. 살짝 광택이 도는 옷감 자체는 일반 면에 비해 단단하고, 일반 나일론에 비해 마찰에 강하기 때문에 등산을 할 때 주로 입는 마운틴 파카에 사용된 것은 어떻게 보면 자연스러운 결과다. 디자인은 조금 다르지만 의외로 정통성을 추구하는 유니클로(Uniqlo)에서는 마운틴 파카에 60/40 클로스를 고집한다. 60/40 클로스에는 적당한 정교함과 호쾌함이 있고, 이는 65/35 클로스에서는 느낄 수 없는 또 다른 매력이다.

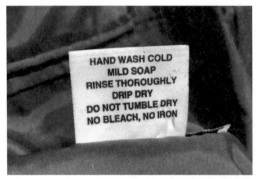

오늘날에는 라벨에 물 세탁을 지양하라는 문구가 적혀 있다. 이는 60/40 클로스의 특성상 염색이 잘 빠지기 때문인데, 본디 곱게 입을 필요가 없는 마운틴 파카가 얼룩덜룩해지는 것 또한 재미다.

1980년대부터는 노스페이스 **THE NORTH FACE** 를 비롯한 다양한 브랜드에서 새로운 소재와 디자인을 적용한 '현대적인' 마운틴 재킷을 선보인다. 노스페이스의 경우 최근의 리이슈 제품 리스트를 보면, 브랜드가 언제를 기점으로 삼는지 대강 파악할 수 있다. 마운틴 재킷 GTX(GTX는 고어텍스 **GORE·TEX**를 뜻한다.)는 1985년과 1990년 모델이 다시 출시된다. 1985년 모델은 아주 흐릿하지만 커다란 아래 주머니에서 구시대 마운틴 파카의 흔적을 찾을 수 있다. 하지만 1990년 모델은 그 이후 등장한 현대적인 마운틴 재킷과 흡사하다.

새로운 형태의 마운틴 파카는 고어텍스나 그와 비슷한 소재로 만든 제품이 많다. 구시대의 방수 직물보다 성능 면에서 훨씬 뛰어나 비를

막고 동시에 몸의 열기를 효과적으로 밖으로 내보낸다. 이제는 촌스러워
보이는 커다란 주머니가 사라진 대신 지퍼가 달린, 긴 대각선의 주머니가
붙은 경우가 많다. 겨드랑이 부분에 여닫을 수 있는 환기 구멍이 붙어
있는 경우도 많은데, 이 또한 여러 상황에서 쾌적한 신체 상태를 유지하기
위해서다.

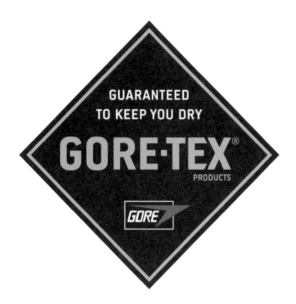

바야흐로 고어텍스의 시대다. 미국의 화학 회사 듀폰(Dupon)에서 엔지니어로 일하던 W. L. 고어(W. L.
Gore)는 테플론을 가열해 늘이면 미세한 구멍이 무수하게 생겨난다는 사실을 발견한다. 이는 발명으로
이어져 고어텍스는 그렇게 방수와 투습이라는 상반된 기능을 겸비한 섬유로서 오늘날 아웃도어 의류를
비롯한 각종 기능성 의류는 물론이고 가방, 신발 등에까지 사용된다. 그 이전에 고어텍스 역할을
담당한 소재는 가죽이었다.

커다란 주머니는 사라졌지만 가지고 다닐 짐은 여전히 많다. 가볍고 튼튼한
백팩을 쉽게 구할 수 있게 된 덕이면서 옷의 무게 부담을 줄이는 데 초점을
맞춘 결과다. 가볍고 편안한 옷을 한번 경험한 뒤에는 이전의 답답한 옷으로
되돌아가기 어렵다. 손목은 여전히 벨크로로 조절한다. 대체재가 많지
않다는 뜻일 테다. 크기를 조절할 수 있는 제법 커다란 후드 또한 붙어 있다.
헬멧을 착용했을 때 그 위를 덮을 수 있도록 커다랗게 만드는데, 이 또한
전문가를 위한 배려다. 기본적인 옷을 차려 입은 뒤 그 위에 입는 용도기
때문에 일반적인 옷에 비해 품이 큰 편이다.
　　　　신소재를 사용한 마운틴 재킷은 아웃도어 브랜드의 최상급
제품이고, 극한 상황을 대비한 전문가용인 경우가 대부분이었다. 브랜드마다
조금씩 다르지만 미군의 의류 보온 시스템처럼 속옷부터 겉옷까지 아우르며
체계화된 경우가 많다.

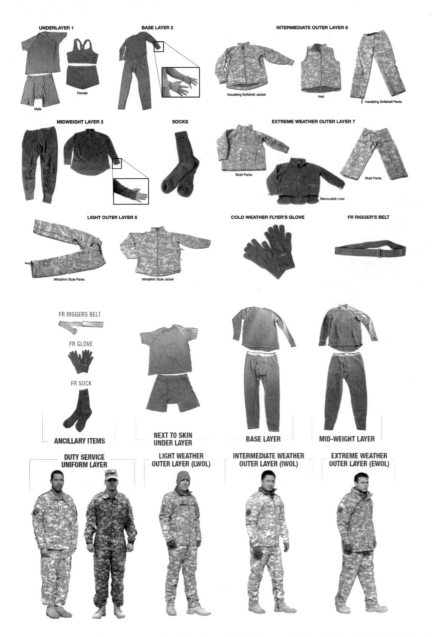

미군의 의류 보온 시스템. 벨트, 장갑, 양말, 군화를 포함한 일반적인 복장에 기온에 따른 다른 재질의 속옷과 겉옷이 마련돼 있다.

1980년대에 들어서며 노스페이스를 비롯한 아웃도어 브랜드의 사용처는 제법 넓어지기 시작해 미국 동부, 특히 뉴욕을 기반으로 활동하는 힙합 뮤지션 사이에서 자리 잡았다. 날씨가 아주 추울 때는 다운 재킷이나 헤비 플리스 등과 함께 입을 수 있는 다용도의 특징과 함께 급변하는 날씨에 쉽고 빠르게 대응할 수 있는 기능성과 가벼움, 착용감은 좋지 않은 날씨에 도심을 돌아다니기에도 나쁠 리가 없다.

그리고 메서드 맨(The Method Man), LL 쿨 J(LL Cool J), 노토리어스 B.I.G.(Notorious B.I.G.) 등의 1990년대 뮤직 비디오에 등장한다. 힙합 뮤지션이 입은 옷이 화면 속에만 존재하는 의도된 무대 의상이 아닌, 일상에서 흔하게 보고 입을 수 있다는 사실은 팬들에게 큰 설득력을 지닌다. 등산인과 히피, 패션에 무관심한 일상인의 옷이었던 마운틴 파카는 힙합을 들으며 유행에 민감한 도시 아이들의 스타일이 된다.

1980년 이후 아웃도어 의류는 뉴욕을 기반으로 활동하는 힙합 뮤지션의 유니폼으로 기능한다. 그뿐 아니라 헬리 핸슨(Helly Hanen)의 다운 파카, 캉골(Kangol)의 털 모자, 팀버랜드(Timberland)의 부츠, 타미 힐피거(Tommy Hilfiger), 노티카(Nautica), 폴로 스포츠(Polo Sport) 등의 스포츠 의류 등까지 흡수했다.

그 외에도 파타고니아 **patagonia**, 팀버랜드 **Timberland**, 마모트 **Marmot** 등 훌륭한 의류를 만드는 많은 아웃도어 브랜드가 산 아래에서 서브 컬처의 패션이나 기능적 일상복으로 각자의 위치를 확보했다. 그런가 하면 시에라 디자인의 마운틴 파카도 1980~90년대에 일본에서 시부카지(渋カジ, 시부야 캐주얼), 아메카지(アメカジ, 아메리칸 캐주얼)의 일부로 자리 잡은 한편, 과거의 제조 방식을 재현한 복각 브랜드들을 통해 다시 출시되었다. 모두 마운틴 파카라는 울타리 안에 있지만, 심지어 같은 마운틴 파카도 국면에 따라 용도, 맥락, 스타일링이 달라진다.

후드와 스웨트셔츠에 관한 이야기에도 파카가 등장한다. 앞에서 말했듯
파카는 후드가 달린 아우터를 뜻하기 때문이다. 그렇다고 후드를 파카라고
부르는 경우가 흔하지는 않지만 그렇게 소개하는 제품 또한 볼 수 있다.
조금 더 많이 사용되는 명칭은 후디(hoody)다. 후드가 붙은 스웨트셔츠, 즉
후디드 스웨트셔츠를 가리킨다. 한편, 스웨트셔츠는 한국에서 '맨투맨'으로
부르기도 하지만, 여기서는 각각 스웨트셔츠와 후드라고 적는다.

대표적인 형태의 스웨트셔츠. 형태나 옷감이 크게 다르지 않으니 수많은 브랜드를 가르는 차이는
로고뿐일지 모르지만, 그 차이가 만드는 틈은 생각보다 넓고 깊다. 즉, 생김새가 같더라도 패션의 어떤
세계에서는 어떤 브랜드의 제품을 선택하는지가 관건이 된다.

운동복이나 그에 준하는 일상복으로 많이 사용되는 두 가지 옷은 공통점이
많지만 유래에는 조금 차이가 있다. 스웨트셔츠에 모자가 달리면 더
유용하겠다는 이유로 후드가 등장하거나, 후드에 모자가 없으면 더
편하겠다는 이유로 스웨트셔츠가 등장한 것은 아니다. 이런 오래된 옷의
유래는 역사를 강조하는 브랜드를 거쳐 정리되는 경우가 많기 때문에
흘려들을 필요는 있다.
　　　　1920년대 미식축구 선수들은 울로 만들어진 유니폼을 주로
입었는데, 따갑고 불편했다고 한다. 당시 쿼터백이었던 벤자민 러셀
주니어(Benjamin Russell Jr.)는 여성과 어린 아이용 셔츠와 속옷을 만드는
공장을 운영하던 아버지와 함께 풀오버(pullover)를 개발했다. 이 옷은

두꺼운 코튼 저지로 땀을 잘 흡수하는 한편, 따뜻하고 헐렁해 편하게 입을 수 있었다. 이 옷이 바로 스웨트셔츠고, 벤자민 러셀 주니어의 아버지는 회사 이름을 '러셀 어슬레틱 컴퍼니(Russell Athletic Company)'로 바꿨다. 1919년 미식축구 유니폼 등을 만들던 니커보커 니팅 컴퍼니(Knickerbocker Knitting Company)는 1930년대에 '챔피언 니팅 밀스(Champion Knitting Mills)'로 이름을 바꾸고 스웨트셔츠를 내놓기 시작했다. 이 옷은 곧 미국 육군사관학교에서 훈련이나 신체 교육 등에 사용되었다. 스웨트셔츠는 등장과 함께 체육과 밀리터리의 세계에서 자리 잡는다.

후드는 1930년대 뉴욕의 물류 창고에서 일하던 노동자의 작업복에서 유래했다고 알려져 있다. 챔피언 Champion 은 지금 우리에게 익숙한 모습으로 현대화해 업스테이트 뉴욕의 추운 환경에서 작업하는 노동자를 대상으로 판매했다. 스웨트셔츠에 후드가 붙어 있다는 점 외에도 배 부분에 '머프(muff)'로 부르는 주머니가 달린 제품이 많은데, 이 또한 작업복의 흔적이다. 후드에는 끈이 달려 있어서 추운 날씨에 조일 수 있다. 방풍 기능이 우수한 마운틴 파카보다 효과는 확실히 떨어지지만, 스웨트셔츠와 견주면 후드의 위력을 느낄 수 있다.

스웨트셔츠와 후드 외에 티셔츠도 있다. 세 가지 옷은 모두 1920년대 미국에서 등장한 옷이다. 용도는 거의 비슷하다. 티셔츠, 스웨트셔츠, 후드 순으로 더 따뜻하고 생김새가 복잡해진다. 티셔츠는 19세기까지 입던 위아래가 연결된 속옷이 출발점이다. 1898년 미국과 스페인 사이의 전쟁 가운데 어느 시점에 분리되고, 미국 해군이 보급했다. 면으로 만든 크루넥이나 반팔로, 생김새에서는 지금의 티셔츠, 또는 상의 속옷과 다른 점은 거의 없다. 이를 군인, 선원, 노동자, 농부 등이 속옷으로 셔츠 안에 입다가 몸에 열이 나면 셔츠를 벗었고, 그러다 보니 바깥에도 입는 식으로 독립된 옷이 된다. 특히 제2차 세계대전이 끝난 뒤 전역한 군인들이 티셔츠를 입으면서 널리 퍼지기 시작했다.

프린트를 새겨 넣은 티셔츠는 1930~40년대부터 영화나 선거를 홍보하거나 소속 군부대를 표시하기 위해 사용된다. 무늬가 없는 단색의 옷이니 알리고 싶은 메시지를 새기는 것은 필연적인 전개다. 티셔츠를 비롯해 스웨트셔츠와 후드 모두 색상과 생김새가 단순해 새겨진 글자나 그림, 브랜드 로고를 더 선명하게 보이는 힘이 있다. 이는 블레이저나 코트 위에 새겨진 글자와는 분명히 다르며 이런 측면은 오늘날 패션에 큰 영향을 끼친다.

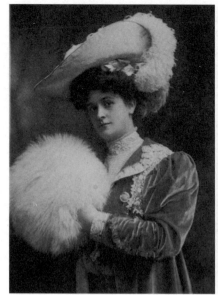

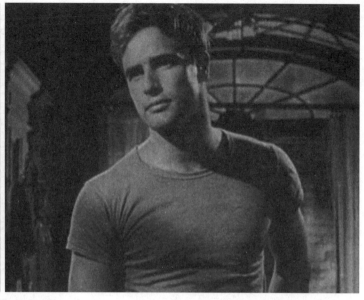

후드에 달린 머프는 본디 양손을 따뜻하게
유지하기 위해 양쪽 끝이 열린, 모피로 만들어진
액세서리였다. 16세기에 여성 패션 아이템이
된 이래 17~8세기에는 남녀를 불문하고 인기를
끌었다. 후드에 달린 머프는 용도에 적합하기만
하면 무엇이든 취할 수 있다는 오늘날의 태도를
일찍이 드러낸다.

일찍이 영화, 음악 등의 대중매체는 패션을
대중화하는 데 공헌해왔다. 「욕망이라는
이름의 전차」에서 말론 브란도는 미 해군의
속옷(그것도 본디 위아래가 붙어 있던)에
불과하던 티셔츠를 패션으로 끌어올렸다.
한편, 당시 영화에서 말론 브란도가 입은
티셔츠는 그의 몸에 맞게 세탁과 바느질을
거쳐 특별히 제작되었다.

대중화의 측면에서 티셔츠나 후드도 마운틴 파카와 마찬가지로 영화의
힘이 지대했다. 티셔츠의 경우 1951년 영화 「욕망이라는 이름의 전차
(A Streetcar Named Desire)」에서 말론 브란도(Marlon Brando)가
화이트 티셔츠를 입은 뒤 대중적인 아이템으로 널리 퍼지고, 동시에
본격적으로 패션 아이템이 되었다. 이는 말론 브란도가 반항적 청년의
패션으로 끌어올린 청바지, 가죽 모터사이클 재킷 등과 동일한 선상에 있다.
　　　후드가 대중화한 것은 조금 더 뒤의 일이다. 1976년 영화
「록키(Rocky)」에서 실베스터 스탤론(Sylvester Stallone)은 훈련으로
땀에 흠뻑 젖은 회색 후드에 회색 트레이닝 팬츠를 입고 필라델피아 거리를
뛰어다녔다. 「록키」 이후 후드는 대중적인 아이템으로 전 세계에 퍼졌다.
사실 후드는 약간 더 앞서 서브 컬처에 자리 잡았는데, 이번에도 뉴욕의
힙합 뮤지션들이 등장한다. 뉴욕 노동자들의 작업복과 운동복에 바탕을 둔
편안하고 따뜻한 옷이기 때문에 자연스럽게 힙합 문화에 스며들어 패션이
되었다. 그런가 하면 IT 전문가, 해커 같은 사람들이 즐겨 입기 시작해
긱(geek) 또는 너드(nerd) 문화의 일부가 되고, 캘리포니아에서는 서퍼,

등산인, 스케이트보더 등이 입으면서 이와 관련한 스트리트 패션 문화와
함께 크게 성장한다.

　　　　1990년대 이후 이 옷들은 폭발적으로 다양한 곳에서 다양한
용도로 사용된다. 예컨대 랠프 로런RALPH LAUREN이나 타미
힐피거TOMMY ▦ HILFIGER 같은 미국 디자이너뿐 아니라 파리와
밀라노의 여러 디자이너 컬렉션에도 등장하며 하이 패션 스타일에서
사용되고, 2010년이 지나며 고프코어(Gorpcore) 등으로 스트리트 패션이
하이 패션의 주류로 자리 잡으며 이전과는 다른 새로운 패션이 대세가 되고,
일상복은 수많은 형태로 재생되었다.

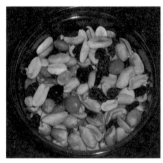

고프코어에서 '고프'는 트레일(trail), 즉 가벼운 산행에서 꺼내 먹는 그래놀라(Granola), 귀리(Oat),
건포도(Raisin), 땅콩(Peanut)을 가리킨다. 고프코어의 울타리 안에 있는 옷과 문화의 특징(가벼움,
실용성, 재미)을 드러내는 명칭이다.

구형 마운틴 파카와 마찬가지로 티셔츠, 스웨트셔츠, 후드 또한 레플리카
전문 브랜드의 복각 대상이 되었다. 신소재가 사용된 뒤 마운틴 파카는
생김새가 크게 변화했지만, 스웨트셔츠나 후드는 구분 지점을 특정할 만한
변화는 없었다. 하지만 예전의 제품들은 분명히 분위기가 다르고, 낮은
게이지의 편물 직기, 루프 휠, 튜블라 니트 등 다양한 형태로 제조 방식을
재현했다. 이와 함께 경년변화를 강조하는 식으로 제품의 특성을 만들었다.
오래 입다 보면 빈티지 매장에서 파는 것과 비슷해질지 모른다. 구시대
분위기가 나는 조악하고 낡은 프린트는 구찌GUCCI 같은 하이 패션
브랜드에서 자신의 과거를 모사하는 패션으로 재탄생하기도 했다.

　　　　대량생산에서 출발한 이 옷들은 결국 하이 패션과 크래프트맨십
등으로 패셔너블함과 제조 측면의 높은 퀄리티까지 확보했다. 패셔너블한
측면과 함께 하이 패션의 고유한 특징으로 여겨지던 고품질과 희소성
등은 평범한 일상복도 지닐 있을 수 있는 요소가 되었다. 베이비 부머가
일군 시대에 형성된 하이 패션의 질서는 이렇게 서서히 역사의 뒷 자리로
물러나기 시작했다.

세상 어디에나 있고 누구나 입는 옷이지만 모두 다른 역할로 다른 맥락 위에 놓인다. 오히려 단순한 생김새 때문에 로고나 프린트 슬로건은 선명하게 인식된다. 따라서 그것만으로도 다양한 직업이나 분야를 표현하는 데 이용할 수 있다. 자유롭고 비격식적인 옷이지만 군복이나 운동복처럼 유니폼으로 자못 엄격한 면모를 지니고 사용되기도 한다. 이 옷들은 이렇게 일상복이자 패션, 작업복이자 운동복, 특정 서브 컬처나 패션 등으로 다양하게 활용되었다. 만드는 브랜드 또한 따라가거나 개척하는 분야에 따라 이들 옷의 특징 가운데 어떤 부분은 제외하고, 어떤 부분은 특별히 강조했다.

3. 그리고 오랜 시간에 걸쳐 이곳으로 들어온다

기능성을 염두에 두고 만들어진 일상복은 소비되는 지역에 깊이 뿌리 박고 있다. 라이프스타일과 문화의 사이에서 자연스럽게 등장해 사용되었기 때문이다. 그리고 그 자리를 떠난 뒤 새로운 장소에서 새로운 역할을 찾는다. 사실 기능성이 패션이나 일상복으로 자리 잡는 일은 제법 흔하다. 일찍이 루이 비통 LOUIS VUITTON 은 방수 기능을 갖춘 여행 가방으로 유명했고, 에르메스 HERMÈS 는 마구(馬具)를 제조하는 회사였다. 버버리 **BURBERRY**의 개버딘(Gabardine)은 오늘날의 고어텍스 같은 기능성 직물로, 극지를 탐험하거나 에베레스트를 오르는 모험가들이 입는 옷에 사용되곤 했다. 그뿐 아니라 청바지가 세상에 자리 잡는 과정만 살펴도 알 수 있다. 패션에 가장 민감한 사람도 청바지를 입고, 가장 둔감한 사람도 청바지를 입는다.

일상적 작업복과 기능복이 세상을 도는 사이에 한편에서는 다른 일이 일어난다. 인터넷과 월드 와이드 웹, 그리고 소셜 미디어는 사고의 일부가 되고, 세상의 흐름을 이전보다 훨씬 빠르게 만든다. 힙합은 주류 문화가 된다. 마운틴 파카와 스웨트셔츠, 후드를 비롯해 패커블 윈드브레이커, 플리스 등 대량생산을 전제로 만들어지는 옷이 주인공의 자리에 등극하면서 러프함은 하이 패션에서도 주요한 덕목이 된다.
 아웃도어와 작업용으로 사용되던 옷의 오버사이즈 핏은 안락함과 편안함뿐 아니라 젠더리스, 유니섹스, 자기 몸 긍정주의 등 사람들이 오늘날의 패션에 요구하는 덕목을 제공하는 바탕이 된다. '어글리 프리티(ugly pretty)' 같은 이름으로 패션의 새로운 미감이 되기도 한다. 세월이 만들어낸 지워지지 않는 얼룩과 수선을 거친 자국은 '낡은 옷을 입는

창피함'이 아니라 물건에 삶의 흔적을 부여하며 오랫동안 사용하는 명예가 된다.

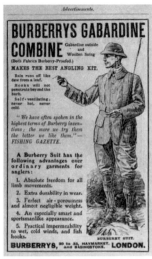

19세기 중반 영국인들은 고무로 만든 무거운 레인코트를 주로 입었다. 하지만 버버리에서 가볍고 방수성이 뛰어난 개버딘을 발명한 이후 최첨단 기능성이 필요한 군인, 탐험가, 비행사 등이 입는 옷에까지 사용된다. 개버딘은 '넉넉하고 긴 윗도리'란 뜻으로, 본디 종교인의 순례용 망토를 가리킨다.

못나면서 아름다운 어글리 프리티는 오늘날 패션에서, 나아가 생활에서 낯설거나 이율배반적인 개념이 아니다. 이제 아름다움은 오히려 못남 덕에 배가된다. 엄밀히 말하면 못남이 아름다움에 포섭된 것이 아니다. 못남은 사라졌다.

이는 한국에서도 자리를 잡는다. 아웃도어웨어, 워크웨어, 스포츠웨어 등 기능성 옷은 각자의 시간에 각자의 자리로 이 나라에 들어왔다. 해외 아웃도어 브랜드의 옷은 등산복으로 종로5가나 남대문시장, 도봉산 아래에 모여 있었다. 이 옷은 어느새 백화점으로 진출하고, '아저씨 패션' 같은 이름으로, 특히 마운틴 파카는 어디서나 입고 다니는 옷이 되었다. 등산가의 세계에서 '멋진' 옷으로 부러움을 받는 동시에 패션 문외한이라는 놀림거리가 되기도 했다. 하지만 이들은 이미 고프코어를 실천했다.

이 옷은 2000년대 이후 힙합 그룹, 케이팝 그룹, 아메카지나 레플리카 패션, 캠핑 유행, 고프코어 패션 등 여러 방향에서 각자의 맥락을 품었다. 한국발 스트리트 패션 브랜드가 등장하는 한편, 무신사 같은 플랫폼도 크게 성장한다. 밖에서 가져온 것과 여기서 만들어진 것은 한데 섞여 새로운 관점을 만들고 오늘날의 패션을 구성한다.

패션화한 아웃도어 의류에는 기능성보다 생김새가 더욱 중요할지 모른다. 하지만 이는 기능성이 없어도 괜찮다는 의미는 아니다. 고어텍스 로고,

멀리서도 식별할 수 있는 리플렉티브 띠, 안전을 위한 클립 고리 등은 패션을 위한 장식이 된다. 한쪽에서는 패션과 상관없이 따뜻하려고 플리스를 입고, 다른 한쪽에서는 최신 레트로 유행의 하나로 플리스를 입는다. 아메카지에 심취한 사람들은 전통의 방식이 깃든 티셔츠를 입고, 어디에서는 1980년대 뉴욕의 힙합 뮤지션처럼 후드를 입는다. 비슷한 옷이 많을수록 색상과 로고는 무엇보다 눈에 띄는 방식이 된다. 이 브랜드의 옷을 입었다는 표시는 자신의 패션 스타일과 삶에 대한 태도뿐 아니라 심지어 사회적·정치적 성향까지 드러낼 수 있다. 색상과 로고 외에도 다른 브랜드와의 협업은 기능성이나 디자인을 보충하거나 상징성을 배가하는 역할을 한다.

　　티셔츠나 스웨트셔츠, 후드 같은 단순한 옷은 분해하면 면 섬유와 함께 염색약 잔여물이 나오는 정도로 서로 크게 다를 바가 없을지 모른다. 따라서 이런 작은 특징은 옷이 의미하는 거의 모든 것이지만 어떤 사람들에게는 달리 인식된다. 즉, 누군가에게는 하나같이 똑같이 보이겠지만, 누군가에게는 눈에 잘 띄지도 않는 구석에 찍힌 작은 로고가 지갑을 여는 결정적인 이유가 된다. 결국 차이는 특정 문화에 대한 이해와 참여도에 따라 갈린다. 이렇듯 작은 로고는 자신이 현재 어떤 좌표에 위치하고, 무엇을 하는지 알려주는 신호가 된다.

별 생각 없이 지나치는 남대문시장은 종로5가, 도봉산 아래와 함께 고프코어의 성지로 추앙받을 만하다. 2018년 한국을 방문한 영국에서 활동하는 불가리아의 패션 디자이너 키코 코스타디노브(Kiko Kostadinov)는 동묘를 세계 최고의 거리로 극찬했다. 자유주의에서 비롯한 기능성, 활동성, 실용성이 만들어낸 다층적인 풍경은 외부인에게는 자못 달리 보인 셈이다.

상황이 이렇게 흘러가면서 실제로 산을 오르는 사람, 즉 등산인들은 산 아래에서 패셔너블하게 받아들여지는 노스페이스 대신 '비(非)패션'을 표방하면서 더욱 전문적인 분위기를 풍기는 '진짜' 아웃도어 브랜드의 아웃도어 제품을 입는다. 하지만 패션이 전문성을 다시 빨아들이고, 패션에서 아직 두드러지지 않는 희소성과 고기능성은 패셔너블하면서 독특한 특징이 된다. 그 뒤에는 숫자가 도표가 서로 얽힌 복잡한 기능성 비교 프레젠테이션과 함께 도심의 젊은이들이 입는 옷이 아니라 혹독한 아웃도어에서 자연을 상대하면서 입는 옷이라는 배경이 깔린다.

근미래에 백두산 화산이 폭발한다. 한국을 비롯해 전 세계에 대재앙이 닥친다. 어딘가로 대피하더라도 옷은 필요하다. 집 밖으로 나가기 전에 옷걸이에 걸린 옷 가운데 무엇을 챙겨야 할까?

2020년 가을·겨울 루이 비통 남성복 패션쇼가 끝난 뒤 인사를 하러 나온 아트 디렉터 버질 아블로(Virgil Abloh)는 아크테릭스 ARC'TERYX 의 알파 SV 고어텍스 하드셸을 입고 있었다. 이 옷은 이어진 오프화이트 **Off-White™**의 컬렉션에서 여성용 드레스와 '결합한' 모습으로 등장했다. 반대편에서 실행되는 몽클레르 MONCLER 다운 파카의 패션화와 함께 아크테릭스를 비롯한 스위스의 마무트 **MAMMUT**, 오스프리 O^{SPREY}, 클라터뮤젠 *Klättermusen®* 같은 전문 브랜드도 서서히 패션과 일상복의 자리로 스민다.

한편, 기능성 자체가 이미지화하는 경우도 있다. 이는 오늘날 발렌시아가 **BALENCIAGA** 나 오프화이트처럼 스트리트 패션의 직접적인

이제는 사용자에 따라 무엇이든 패션이 되는 시대다. 오늘날 패션은 건강하게 소용돌이친다.

그늘 아래 머문 브랜드만의 상황은 아니다. 지방시 **GIVENCHY**의 2020년 봄·여름 남성복 컬렉션에는 나일론 재질의 다양한 윈드브레이커와 파카가 등장했다. 리플렉티브 재질, 지퍼, 후드와 드로스트링 등 아웃도어풍 외향은 우아하면서 정교하게 주조된 지방시의 클래식 로고 단추와 제법 잘 어울린다.

상황이 이렇다고 얼핏 평범해 보이는 옷에 숨은 다양하고 복잡한 맥락을 하나하나 따져야 하는지 심각하게 고민할 필요는 없다. 일상과 동떨어져 홀로 고고하게 빛나는 패션의 시대는 이미 저물고 있다. 주위에서 유행하기 때문에, 왠지 멋져 보이기 때문에, 유명인이 입었기 때문에 이것저것 대책 없이 사들인 결과는 빈약한 통장 잔고와 자신의 생활과 아무런 관련 없이 쌓여가는 옷 뭉치뿐이다. 자신이 원하는 즐거운 삶을 살아가면서 주변을 둘러보면 그에 맞는 라이프스타일과 패션, 브랜드와 문화를 찾을 수 있다. 브랜드 또한 사회 문화적 맥락 속에서 점점 정교하게 자신의 자리를 점유한다. 자신에게 필요한 것을 자신의 방식으로 운용하는 것, 이제 패션은 바로 그런 것이다.

Street Fashion and Youth Culture: Clothes Depend on How People Wear Them

Park Sehjin, Fashion Columnist

1. Mountaineering Clothes Become Hip-Hop Fashion
One Day

There is a piece of clothing called "Mountain Parka" or "Mountain Jacket." The words "parka" and "jacket" may be used interchangeably, but broadly speaking, if it has a hood, it's a parka and if it doesn't, it's a jacket. Of course, words are complicated by country and language so this fact alone can't cover everything neatly. Anyway, the clothing is called a Mountain Parka or Mountain Jacket.

A Mountain Parka is, as the name suggests, what people wear when they climb a mountain. It's waterproof and windproof with a somewhat sturdy exterior and comes down to the hips. The Mountain Parka usually doesn't have insulation. It's made for mountain wear, and there is an absolute limit to the weight people can bear in their clothes. Maximum effect has to be achieved from minimum weight. In thermal outerwear and rainwear, the outer layers usually overlap. This inefficiency can be easily resolved by wearing the outerwear and the thermal wear separately and also by a design that combines the two. The Mountain Parka corresponds to the outerwear here.

The parka we wear today is a result of imitating the thick winter coat originally worn by the Inuit. For the Inuit, clothes, especially coats, were a tool for survival. They lined their coats with fur from game animals and, in some cases, covered it with dry grass too. In summer, they used sealskin for waterproofing.

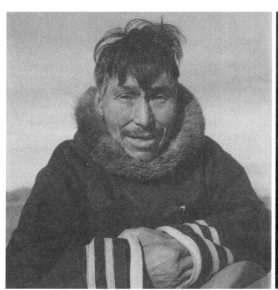 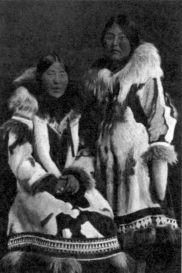

The parka we wear today is a result of imitating the thick winter coat originally worn by the Inuit. For the Inuit, clothes, especially coats, were a tool for survival. They lined their coats with fur from game animals and, in some cases, covered it with dry grass too. In summer, they used sealskin for waterproofing.

The piece of clothing to note here is the M-65 that appeared during the Vietnam War. The official name is "M-1965 Field Jacket" and as is evident from the model name, it was produced in 1965. Previous models included the M-43 and M-51. The number appended to the model names tells us that every time the US military participated in a large-scale war, such as World War II, the Korean War, or the Vietnam War, it modified and supplemented the jacket to suit local conditions. The M-65 had four large pockets on the front, detachable lining, and a slightly thick water-repellent exterior made of a blend of 50 percent cotton and 50 percent nylon. There was a simple hood inside the collar, but there was also a separate detachable hood. Later, the M-65 split and merged into different styles depending on appearance, functionality, and origin, ranging from hippie and survival clothing and military and high fashion to everyday wear and work wear.

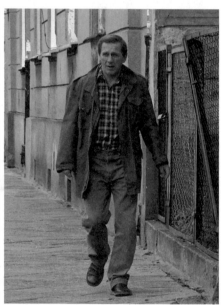

War destroys many things but at the same time it conceives some others. The US M-65 military jacket that appeared during the Vietnam War in 1965 became an archetype for outdoor clothing and later diverged into various forms according to society, class, and culture. Alpha Industries was one of the leading suppliers of the M-65 to the US military at the time. Robert De Niro made the M-65 famous when he wore it in *Taxi Driver* (1976).

And now everybody wears it.

The Mountain Parka was first introduced by SIERRA DESIGNS in 1965, the same year the M-65 appeared. There is some disagreement about the origin of the Mountain Parka but there is a general consensus that Holubar was the first to come out with it, followed by Sierra Designs. Bob Swanson, co-founder of Sierra Designs, is said to have become acquainted with the Mountain Parka while working at Hol-

ubar. The orange Mountain Parka that Robert De Niro wore in the anti-war movie *The Deer Hunter* was a Holubar product.

There will be products like the M-51 in the background of the M-65 or the Mountain Parka. Thus, Sierra Designs' Mountain Parka shares many similarities with the M-65. In particular, both have a similar front with four large pockets. But the Mountain Parka has a game pocket on the back that seems to originate from the hunter jacket. There are stories about newspapers being put in the game pocket in the past to improve insulation. The five pockets on the outside are highly expandable so that they can carry the entire contents of a backpack.

Meanwhile, the raglan sleeves can be adjusted using Velcro, similar to the M-65. The crease is a bit old-fashioned, but that's a judgement call from today's point of view and it must've been seen differently back then. The Mountain Parka also has a large hood that is made of 60 percent cotton and 40 percent nylon cross fabric. The principle of this fabric is somewhat primitive but it is wind and waterproof. It gives off the atmosphere of a stiff nylon tent. It feels unsuitable for clothes and in that sense the texture of the M-65's fabric makes it more "cloth"-like. But that makes the Mountain Parka a bit more "functional."

The Mountain Parka can be reduced in size by rolling it into the hood. You can roll it up and put it in your backpack when you go hiking, and if the weather suddenly turns windy or rainy you can take it out and wear it. You can wear a shirt inside, or you can wear a sweater when it's cold. If it's chilly you can wear a down vest or jacket underneath. Being easy to fold and carry is a characteristic of all outdoor clothing, including the Mountain Parka. Since it is mainly worn only in the city, there are not many occasions where the Mountain Parka needs to be rolled up into the hood, but it is still expected to have that function. This is also a characteristic of fashion that advocates high functionality.

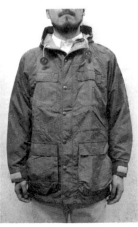
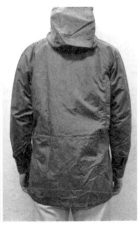

Sierra Designs' Mountain Parka uses the "60/40 cloth" fabric, a blend of 60 percent cotton and 40 percent nylon. The cotton between the nylon swells up to achieve waterproofing. This slightly glossy fabric is sturdier than ordinary cotton and more resistant to friction than regular nylon, so it is only natural for it to be used in the Mountain Parka which is usually worn during mountain treks. Uniqlo which seeks legitimacy through trust, insists on using this 60/40 cloth in its Mountain Parkas though the design might be a bit different. The 60/40 cloth has adequate sophistication and exhilaration which is yet another attraction that the 65/35 cloth lacks.

Today, the label says to refrain from washing the parka in water. This is because the 60/40 cloth loses color easily. Another attraction of the Mountain Parka is that it doesn't have to be worn with care and can be allowed to get smudged.

The anti-war hippie protesters in the city wore the M-65 and the pro-nature athletic hippies who were hostile to commercialized civilization wore Sierra Designs' Mountain Parka. Hippie culture spread throughout the world and so did the clothes they wore. Starting with Holubar and Sierra Designs, several outdoor clothing brands of the time began offering similar looking mountain jackets. If we look at the outdoor apparel that appeared in the US in the 1970s–1980s, they look almost the same, as if they were produced at the same facility and only had different brand logos attached. The same was true of down vests and fleece jackets as well.

From the 1980s onward, various brands, including THE NORTH FACE, showcased "modern" mountain jackets with new materials and designs. In the case of North Face, we can surmise when the brand considers its starting point if we look at their recent reissue list. North Face relaunched its Mountain Jacket GTX (GTX stands for GORE-TEX) in 1985 and 1990. Faint traces of the old Mountain Parka could be found in the large lower pocket of the 1985 model. But the 1990 model was similar to the modern mountain jacket that came after.

Many newer models of the modern mountain jacket were made of materials like Gore-tex. Gore-tex performed much better than older waterproof fabrics in simultaneously resisting water and effectively dispersing body heat. The large rustic-looking pocket was often replaced with long diagonal pockets with zippers. In many cases, the armpit areas had openings for ventilation that could be opened and closed and this too was for maintaining optimal body temperature in different situations.

This is the era of Gore-tex. W. L. Gore, an engineer at the US chemical company Dupon, discovered that heating and stretching Teflon created numerous microscopic pores in it. This led to the invention of Gore-tex, a fabric that with its combination of contrary functions of waterproofing and permeability is now being used not only in outdoor and other functional clothing but also in bags and shoes. Leather was the material widely used prior to Gore-tex.

The large pockets were gone but there still was a lot of baggage to carry. This was the result of light and strong backpacks becoming easily available and the focus on reducing the weight burden of clothes. After experiencing light and comfortable clothes, it was difficult to return to the old stuffy clothes. The wrist was still controlled by Velcro. This could mean that there were not many substitutes. There was also a fairly large adjustable hood. It could be expanded to cover a helmet, which was a consideration for professionals. The Mountain Parka was worn on top of basic clothes so it was larger than ordinary clothes.

Mountain jackets made of new materials were the top products of outdoor brands and most of them were meant to be used by professionals in extreme situations. Although it varied slightly from brand to brand, the apparel was often systematized and offered

everything from underwear to outerwear, like the US military's Extended Cold Weather Clothing System.

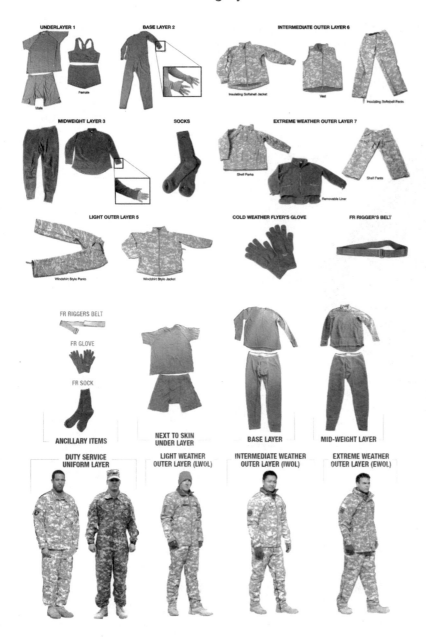

The US military's Extended Cold Weather Clothing System. It provides general clothing, including belts, gloves, socks, and military boots, along with underwear and outerwear of different materials according to temperature.

Entering the 1980s, North Face and other outdoor brands expanded their user base considerably and established themselves among hip-hop musicians active in the eastern United States, especially New York. Along with the Mountain Parka's versatility and func-

tionality which allowed one to easily and quickly respond to rapidly changing weather conditions by wearing a down or heavy fleece jacket when the weather was very cold, its lightness and comfort made it suitable for walking around the city in bad weather.

The Mountain Parka appeared in music videos of the 1990s of artists like The Method Man, LL Cool J, and Notorious B.I.G. The fans found the fact that hip-hop artists' clothes weren't stage costumes that existed only on the screen but could be seen and worn in everyday life very persuasive. The Mountain Parka, which used to be the cloth of mountaineers, hippies, and everyday people uninterested in fashion, became the style of fashion-conscious city youth who listened to hip-hop.

After 1980, outdoor clothing served as a uniform for hip-hop musicians based in New York. Hip-hop fashion also absorbed the Helly Hansen down parka, Kangol fur hat, Timberland boots, and Tommy Hilfiger, Nautica, and Polo Sport sportswear.

In addition, outdoor brands like **patagonia**, **Timberland**, and **Marmot** that made excellent clothing secured their respective positions in subculture fashion or functional everyday wear. On the other hand, Sierra Designs' Mountain Parka became part of Japan's Shibukaji (Shibuya casual) and Amekaji (American casual) styles in the 1980s to 1990s and was relaunched through retro brands that recreated the way it was manufactured in the past. These all fell under the label of Mountain Parka but even the same Mountain Parka differed in its use, context, and styling depending on the situation.

2. Warehouse Workers' Work Clothes Become the Clothes of Surfers One Day

The parka also appears in stories about hoodies and sweatshirts. This is because, as I mentioned earlier, parka implies an outer with a hood, and while it's uncommon, we can also see parkas being advertised as hoodies. A hoodie is a sweatshirt with a hood. Sweatshirts are called "Man-to-Man" in Korea, but here I will refer to sweatshirts and hoodies by their original names.

A typical sweatshirt. The shapes and fabrics used are similar, so the only difference that separates the many brands may be their logos, but the gap that this difference creates is wider and deeper than one would expect. In other words, even if they look the same, the key in the world of fashion is which brand's product you choose.

Sweatshirts and hoodies, which are widely used as sportswear or equivalent everyday wear, share many similarities, but they have some differences in their origin. Hoodies didn't come into being because having a hood would make sweatshirts more useful, and sweatshirts weren't created because hoodies would be more comfortable without a hood. The origin of these old clothes is often created by brands that emphasize history, so we should listen to them with only one ear.

In the 1920s, soccer players wore uniforms made of wool which they found to be itchy and uncomfortable. A quarterback called Benjamin Russell Jr. worked with his father who owned a manufacturing company that made women's and children's knit shirts and undergarments to create a pullover jersey. This thick cotton jersey soaked up sweat and was warm and comfortably baggy. Thus was born the sweatshirt. Benjamin's father changed the name of his

company to Russell Athletic Company. Knickerbocker Knitting Company, which used to make soccer uniforms in 1919, changed its name to Champion Knitting Mills in the 1930s and began producing sweatshirts. The US Military Academy soon adopted these sweatshirts for their training exercises and physical education classes. Soon after, sweatshirts were established in the physical education and military worlds.

The hoodie is known to have originated from the clothes of workers in New York's warehouses in the 1930s. Champion modernized the hoodie to the look we are familiar with today and sold it to laborers working in freezing temperatures in upstate New York. In addition to the hood, a pocket called "muff" was also attached to the lower front which also was a remnant of work clothes. The hood had a drawstring that allowed it to be tightened in cold weather. Although inferior to the Mountain Parka, which had excellent wind-proofing, the effectiveness of the hoodie's wind protection was evident when compared to the sweatshirt.

The muff attached to the hoodie was originally an accessory made of fur with both ends open to keep hands warm. It became a women's fashion time in the sixteenth century and gained popularity among all sexes in the seventeenth and eighteenth centuries. The muff attached to the hoodie reflects the modern attitude that anything can be adapted as long it's suitable for the purpose.

Mass media such as movies and music have contributed to popularizing fashion since early on. In *A Streetcar Named Desire*, Marlon Brando raised something that was only a US Navy issue undergarment (which was originally a one-piece) to the level of a fashion item. As an aside, the T-shirt worn by Marlon Brando in the film was specially sewn and washed to fit him.

Just as was the case with Mountain Parkas, movies were central to the popularization of T-shirts and hoodies. The T-shirt became a popular item after Marlon Brando wore it in the 1951 film *A Streetcar Named Desire* and at the same time it became a fashion item. This was on the same lines as how Marlon Brando made jeans and leather motorcycle jackets the fashion of rebellious young men.

The hoodie became popular a little later. In the 1976 film *Rocky*, Sylvester Stallone ran through the streets of Philadelphia wearing a sweat-soaked gray hoodie and gray training pants. After *Rocky*, the hoodie became popular around the world. Actually, the hoodie had already gained a foothold in subculture a little earlier, and this time, too, it had to do with hip-hop musicians from New York. The hoodie was a comfortable and warm piece of clothing based on the work clothes and sportswear of New York laborers, so it naturally permeated hip-hop culture and fashion. Again, IT professionals and hackers began wearing the hoodie and it became part of geek or nerd culture, while in California, surfers, trekkers, and skateboarders wore it and it became a major part of their respective street fashion cultures.

Since the 1990s, these clothes have been used for various purposes in an explosive variety of places. For example, they were used in high fashion styles, appearing in collections of not just American designers like RALPH LAUREN and TOMMY ☐ HILFIGER but also designers in Paris and Milan and, and after 2010, street fashion became the mainstream of high fashion with developments like Gorpcore and so on, and new fashion that was different from the past took centre stage and everyday clothes were produced in numerous forms.

Like the old Mountain Parka, T-shirts, sweatshirts, and hoodies were also subject to reproduction by replica specialist

"Gorp" in Gorpcore refers to a mixture of granola, oat, raisin, and peanuts to be eaten on the trail while hiking. It is a name that reveals the characteristics of clothing and culture (light, practical, fun) that come under the label of Gorpcore.

brands. The Mountain Parka's appearance changed significantly with the adoption of new materials, but there was no distinctive outward change in sweatshirts or hoodies. However, the earlier products clearly had a different vibe, and their manufacturing methods were reproduced in various ways such as by using low-gauge knitting looms, loopwheel machines, and tubular knitwear. At the same time, the products were given character by emphasizing their worn-in appearance. If worn for a long time, they could look similar to the clothes sold in vintage stores. High fashion brands such as GUCCI recreated coarse, old prints that gave off an old-fashioned vibe to replicate their pasts.

These clothes that started off as mass-produced items eventually secured fashionability and high manufacturing quality through high fashion and craftsmanship. High-quality and rarity, which were regarded as unique characteristics of high fashion, along with the aspect of fashionability became something that even ordinary everyday wear could achieve. The high fashion order formed in the baby boomer era began gradually retreating to the back of history.

They can be found everywhere in the world and are worn by everybody but they all are placed in different contexts with different roles. Rather, because of their simple appearance, logos or printed slogans can be clearly recognized. And thus with that alone they can be used to express various occupations or fields. They're free and informal clothes, but they can also take on an austere aspect when used in military uniforms or sportswear. These clothes were used in various ways, such as everyday wear and fashion, work clothes and sportswear, and in specific subcultures and fashions. The brands making them also push certain characteristics while leaving out some others depending on the areas they're following or pioneering.

3. And after a Long Time They Return Here

Everyday wear made with functionality in mind is deeply rooted
in the region where it is worn. This is because it naturally
appears and is used within lifestyle and culture. And then it
leaves that place and finds a new role in a new place. In fact, it
is quite common for functionality to become a fashion item or
everyday wear. LOUIS VUITTON made a name for itself with
its waterproof travel bag while HERMÈS was a maker of horse
harnesses. **BURBERRY**'s Gabardine fabric was a functional textile
like today's Gore-tex and was worn by adventurers exploring the
Arctic or climbing Everest. Not only that, we can see this in the
process by which jeans have become popular all over the world:
Both acutely fashion sensitive people and fashion-blind people
wear them.

In the mid-nineteenth century, the English wore heavy raincoats made of rubber. After Burb-
erry invented the light, waterproof Gabardine for its raincoats, it started being used in clothes
worn by soldiers, explorers, and aviators who required cutting-edge functionality. The word
Gabardine means "long, comfortable cloak" and originally referred to a pilgrim's cloak.

While everyday work clothes and functional clothes spread around
the world something else happened at the same time. The internet,
world wide web, and social media became part of our thinking and
made the world revolve much faster than before. Hip-hop became a
mainstream culture. As clothes created for mass-production, such

as Mountain Parkas, sweatshirts, hoodies, packable windbreakers, fleece, and so on, took center stage, ruggedness became a major virtue in high fashion.

Ugly pretty which is unattractive yet beautiful is not an unfamiliar or paradoxical concept in today's fashion or even life. Now beauty is doubled thanks to ugliness. Strictly speaking, ugliness hasn't been embraced by beauty. Rather, ugliness has disappeared.

The oversized fit of clothes used for the outdoors and for work offers not just ease and comfort but also virtues demanded from today's fashion such as genderless, unisex, and body positivity. It also has become the new fashion aesthetic under labels like "ugly pretty." Unwashable stains left by the years and mending stitches and patches don't cause one to feel the "embarrassment of wearing old clothes" but rather the honor of using objects for a long time by granting the object the traces of life.

This has been established in South Korea as well. Functional clothes like outdoor wear, work wear, and sportswear each entered South Korea in their respective time and place. Overseas outdoor mountaineering brands were first concentrated around the Jongno 5-ga, Namdaemun Market, and Mount Dobong areas. They suddenly entered department stores and with labels like "older male fashion," particularly the Mountain Parka, became a clothing item that was worn everywhere. The people who wore it became the object of envy in the mountaineering world for wearing "cool" clothes, and at the same time they became the butt of jokes for being fashion blind. However, they were already practitioners of Gorpcore.

Since the 2000s, these clothes have had their own context in various ways, including hip-hop groups, K-pop groups, Amerikaji or replica fashion, camping fashion, Gorpcore fashion, and so on. While Korean-origin street fashions brands have appeared on the one

hand, online fashion platforms like Musinsa have also grown significantly. Things brought in from the outside and things made here mix together to create a new perspective that constitutes today's fashion.

Namdaemun Market, which we pass by without much thought, deserves to be admired as Gorpcore's holy land, along with Jongno-5 and Mount Dobong. Bulgarian fashion designer Kiko Kostadinov who visited South Korea in 2018 praised Dongmyo as the best street in the world. The multi-layered landscape created by the functionality, activity, and practicality wrought by liberalism looks quite different to outsiders.

Appearance may be more important than functionality in fashionable outdoor clothing. But this doesn't mean that it's okay to have zero functionality. The Gore-tex logo, the reflective strip that can be identified from a distance, the safety clip rings, and so on, are embellishments for fashion. One side wears a fleece jacket for warmth regardless of fashion, and the other side wears a fleece as the latest retro trend. People immersed in Amekaji wear T-shirts in the traditional way, while somewhere people wear hoodies like New York hip-hop musicians from the 1980s. The more similar clothes there are, the more colors and logos stand out above all else. Wearing a brand's clothing reveals not only one's fashion style and attitude toward life but even socio-political disposition. In addition to the color and logo,

collaboration with other brands serves to complement the brand's functionality or design and reinforces its symbolism.

Simple clothing like T-shirts, sweatshirts, and hoodies may be so similar to one another that when they disintegrate they leave behind only cotton fibres and dye residues. So these little features are almost everything they have but these features may be perceived differently by different people. Though it may all look the same to someone, to someone else an easy-to-miss tiny logo printed in a corner can be the decisive reason that makes them open their wallet. In the end, the difference depends on the understanding of and participation in a particular culture. In this way, a small logo becomes a sign of where one is located and what one is doing.

As the situation progresses in this way, people who actually climb mountains, that is, mountaineering experts, advocate "non-fashion" and wear "real" outdoor brand clothing that has a more professional vibe to it, instead of North Face which is considered fashionable by people at the base of the mountain. However, fashion absorbs expertise again, and rarity and high functionality not yet noticeable in the fashion world again become something fashionable and distinctive. Behind this is a complex presentation comparing features with intertwined digits and charts and the background that it is not clothing worn by young people in the city but by people facing nature in the harsh outdoors.

When Artistic Director Virgil Abloh came out to the runway at the end of the Louis Vuitton FW20 menswear fashion show, he was wearing ΛRC'TERYX's Alpha SV Gore-tex hard shell jacket. This same jacket appeared in the **Off-White**™ collection in "combination" with women's dresses. Along with the "fashionization" of MONCLER's down parka, professional brands like Switzerland's **MAMMUT**, OSPREY, and *Klättermusen* are gradually entering the world of fashion and everyday wear.

On the other hand, functionality itself may become the image. This is not the situation only for brands like **BALENCIAGA** or Off-White that have stayed under the direct shadow of street fashion. **GIVENCHY**'s SS20 menswear collection featured a variety of nylon windbreakers and parkas. The outdoorsy look with the reflective materials, zippers, hoods, and drawstrings looked elegant and went well with the exquisitely molded classic Givenchy logo buttons.

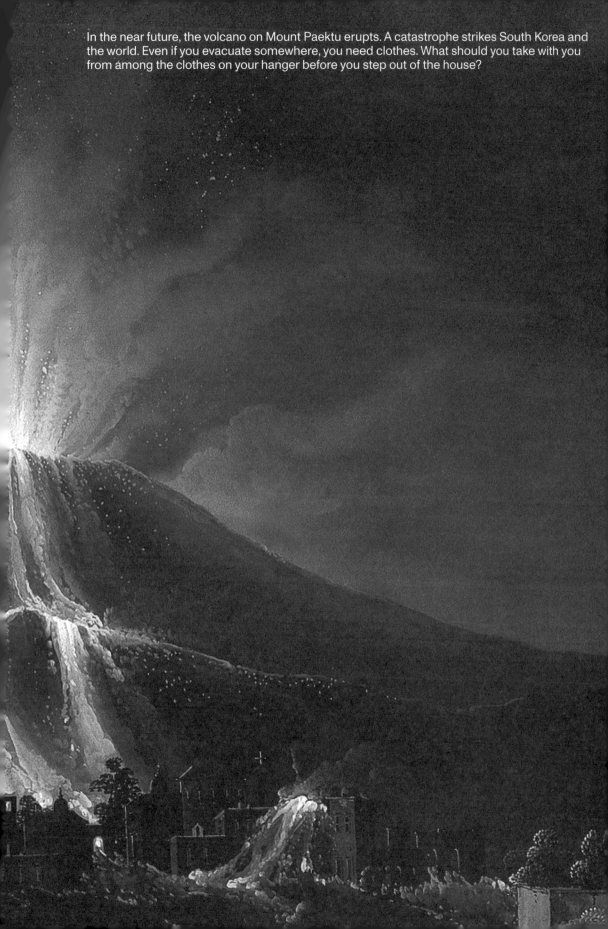

In the near future, the volcano on Mount Paektu erupts. A catastrophe strikes South Korea and the world. Even if you evacuate somewhere, you need clothes. What should you take with you from among the clothes on your hanger before you step out of the house?

It's an age now when anything can become fashion depending on the user. Fashion today swirls healthily.

Just because the situation is like this, there's no need to pick over each of the various and complex contexts hidden in clothes that look ordinary at first glance. The era of fashion that shines by itself detached from everyday life is already coming to an end. Buying clothes just because they're trendy, look cool somehow, or because a celebrity wore them only results in a pile of clothes that keeps growing regardless of one's scanty bank balance and one's life. If you look around while living the pleasant life that you want, you can find a lifestyle, fashion, brand, and culture that suits you. Brands are also subtly occupying their positions within socio-cultural contexts. Managing what you need in your own way. That's what fashion is now.

Translation
Agnel Joseph

FALL/WINTER
2016

TEN

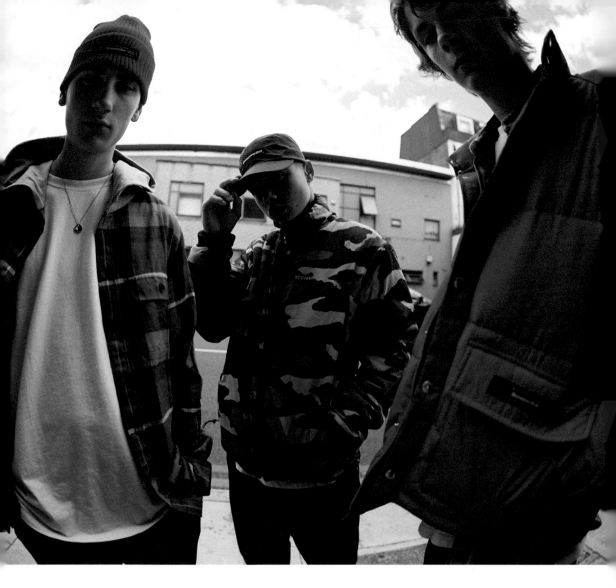

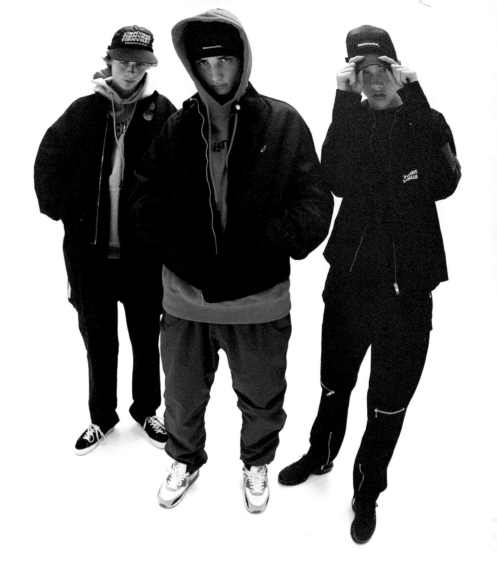

TN16FOW005OV, Jacket, RF M51 Coat ● TN16FTO015CK, Sweatshirt, DANCE Pullover ● TN16FBT004BK, Pants, Flight Pant

TN16FOW001NA, Jacket, WOODSMAN Down Parka ● TN16FTO006BZ, Shirt, VA Shirt ● TN16FTO003WH, Long Sleeve Tee, INTL. Logo L/S ● TN16FBT006IDG, Pants, SH Denim Pant ● TN16FAC009NA, Hat, T-Logo Beanie

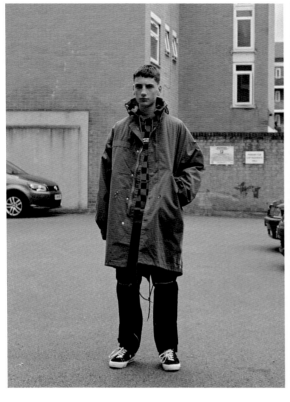

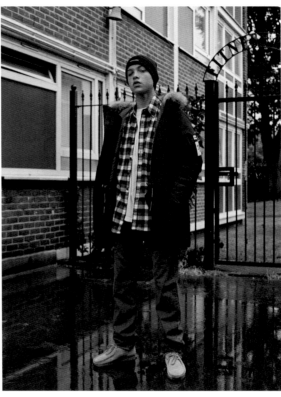

TN16FOW011BK, Jacket, T-Drivers Jacket ● TN16FTO003BK, Long Sleeve Tee, INTL. Logo L/S ● TN16FBT004BK, Pants, Flight Pant ● TN16FAC001BK, Hat, T-Logo Camp Cap

TN16FOW015MC, Jacket, Reversible Fleece Parka ● TN16FTO003WH, Long Sleeve Tee, INTL. Logo L/S ● TN16FBT007BK, Pants, SP-Logo Sweatpant

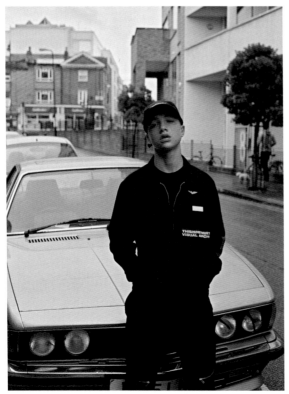

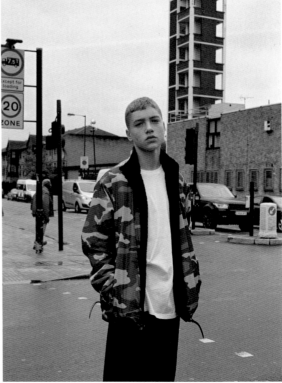

TN16FOW001OV, Jacket, WOODSMAN Down Parka ● TN16FTO013CH, Shirt, CUT & PRINT Shirt ● TN16FBT007BK, Pants, SP-Logo Sweat Pant ● TN16FAC001CH, Hat, T-Logo Camp Cap

TN16FOW006GR, Jacket, Duffle Coat ● TN16FTO014CK, Shirt, Oversized Shirt ● TN16FTO002WH, Long Sleeve Tee, T-Drivers L/S ● TN16FBT002BK, Pants, CORD Pant ● TN16FAC009NA, Hat, T-Logo Beanie

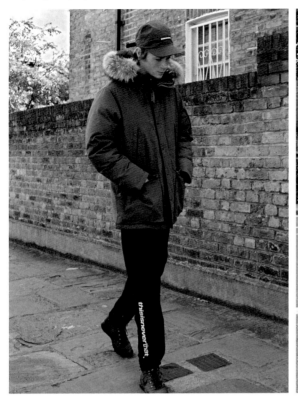

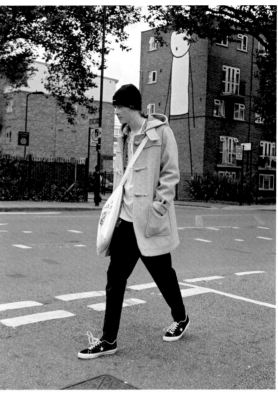

[R] TN16FOW010IV, Jacket, TD Coach Jacket ● TN16FTO005CK, Sweatshirt, T-Logo Pullover ● TN16FBT002BK, Pants, CORD Pant

TN16FOW013NA, Jacket, TEN Zip Jacket ● TN16FTO005OR, Sweatshirt, T-Logo Pullover ● TN16FBT008BL, Pants, Warm Up Pant ● TN16FAC009GR, Hat, T-Logo Beanie

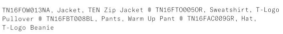

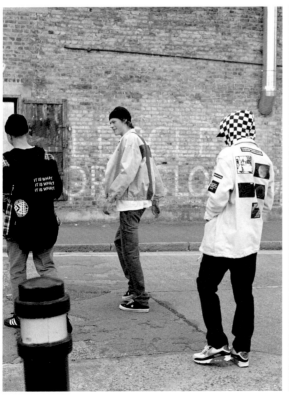

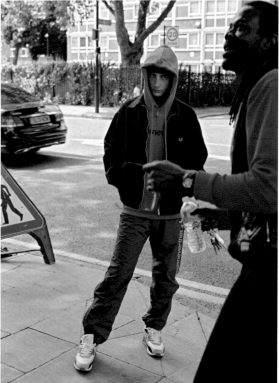

TN16FOW012BU, Jacket, Stadium Jacket ❚ TN16FTO002WH, Long Sleeve Tee, TN16FTO054WH, Top, Half Zip Pullover
T-Drivers L/S ❚ TN16FBT007CH, Pants, SP-Logo Sweat Pant

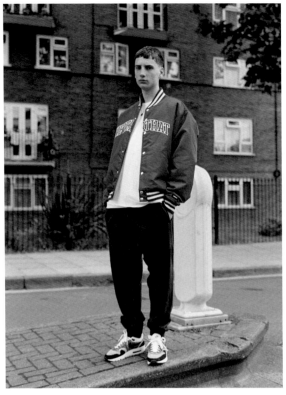 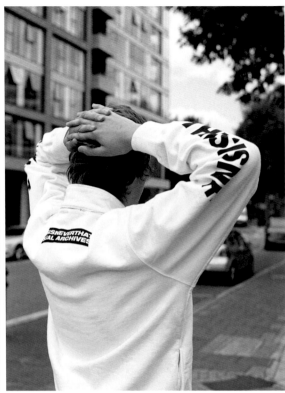

TN16FOW007BK, Jacket, Traveller Coat ❚ TN16FOW014BL, Jacket, Warm Up TN16FOW004BK, Jacket, VA Denim Jacket ❚ TN16FTO002WH, Long Sleeve Tee,
Jacket ❚ TN16FBT007BK, Pants, SP-Logo Sweat Pant ❚ TN16FAC007BK, Bag, T-Drivers L/S ❚ TN16FBT002BU, Pants, CORD Pant
TD Tote Bag ❚ TN16FAC011BK, Hat, Short Beanie

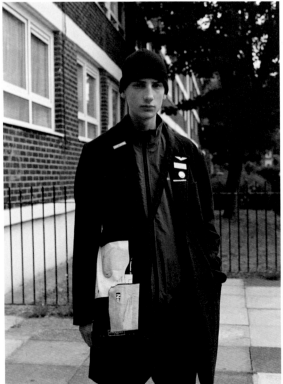 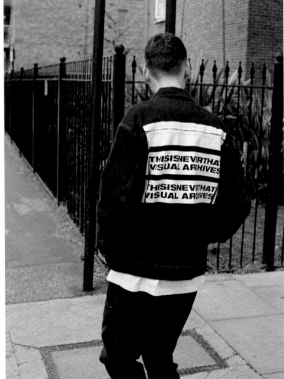

TN16FTO055CA, Jacket, SP-Logo Zipup Sweat ▊ TN16FTO004CA, Sweatshirt, T-Logo Crewneck ▊ TN16FBT008BL, Pants, Warm Up Pant ▊ TN16FAC012OV, Hat, Ribbed Beanie

TN16FOW002BK, Jacket, Flight Jacket ▊ TN16FTO003WH, Long Sleeve Tee, INTL.Logo L/S ▊ TN16FBT008BK, Pants, Warm Up Pant ▊ TN16FAC012BK, Hat, Ribbed Beanie

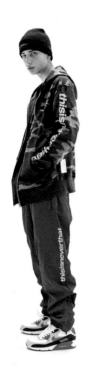

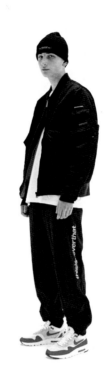

TN16FTO011GR, Shirt, Hood Shirt ▊ TN16FBT005IDG, Pants, Relaxed Pant ▊ TN16FAC012RD, Hat, Ribbed Beanie

TN16FTO013BK, Shirt, CUT & PRINT Shirt ▊ TN16FTO002BK, Long Sleeve Tee, T-Drivers L/S ▊ TN16FBT005BK, Pants, Relaxed Pant ▊ TN16FAC006BK, Hat, Traveller Hat

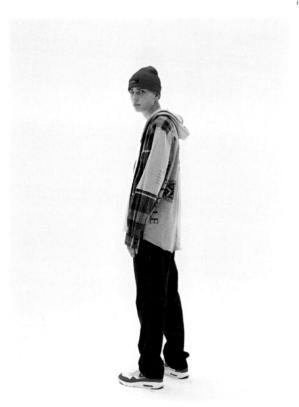

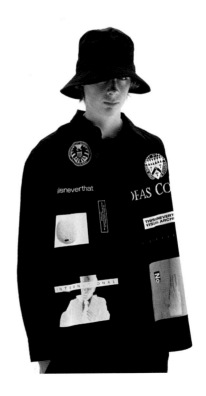

TEN

TN16FOW005BK, Jacket, RF M51 Coat ⏺ TN16FTO051GR, Sweatshirt, ARCH
Logo Pullover ⏺ TN16FBT005BK, Pants, Relaxed Pant ⏺ TN16FAC005BK, Hat,
TISNVRAT Cap ⏺ TN16FAC007WH, Bag, TD Tote Bag

TN16FOW003BK, Jacket, TINT Puffy Jacket ⏺ TN16FTO005CK, Sweatshirt,
T-Logo Pullover ⏺ TN16FBT002BK, Pants, CORD Pant

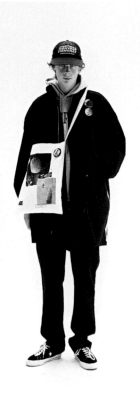

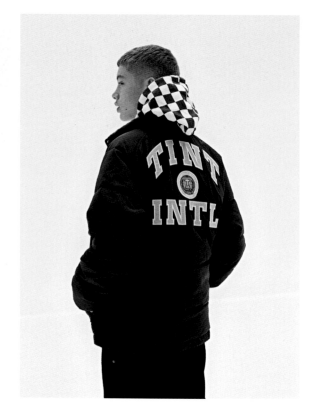

TN16FOW015MC, Jacket, Reversible Fleece Parka ⏺ TN16FTO003WH, Long
Sleeve Tee, INTL.Logo L/S ⏺ TN16FBT007CA, Pants, SP-Logo Sweat Pant ⏺
TN16FAC009GR, Hat, T-Logo Beanie

TN16FTO052RD, Sweatshirt, Striped Crewneck ⏺ TN16FBT002BK, Pants, CORD
Pant ⏺ TN16FAC009BK, Hat, T-Logo Beanie

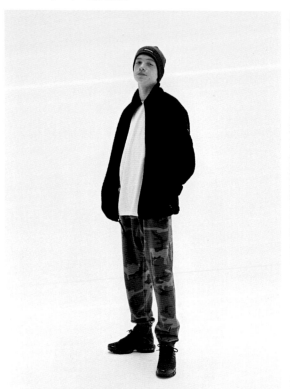

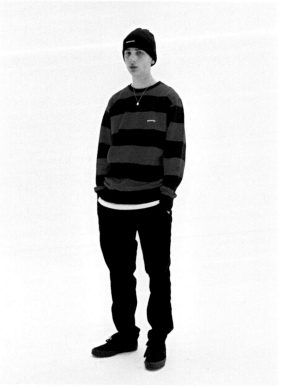

TN16FOW002OV, Jacket, Flight Jacket ▌ TN16FTO010OR, Sweatshirt, Back-VA Pullover ▌ TN16FBT002BU, Pants, CORD Pant

TN16FOW013BE, Jacket, TEN Zip Jacket ▌ TN16FTO003WH, Long Sleeve Tee, INTL.Logo L/S ▌ TN16FBT006IDG, Pants, SH Denim Pant ▌ TN16FAC011NA, Hat, Short Beanie

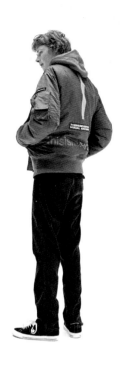
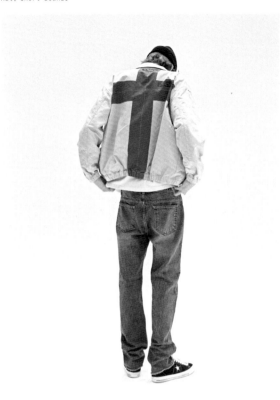

TN16FTO001IDG, Shirt, Crown Denim Shirt ▌ TN16FTO002WH, Long Sleeve Tee, T-Drivers L/S ▌ TN16FBT003BE, Pants, OG Chino Trousers ▌ TN16FAC004BE, Hat, Crown 6P Cap

TN16FTO010OR, Sweatshirt, Back-VA Pullover ▌ TN16FBT005IDG, Pants, Relaxed Pant ▌ TN16FAC013BK, Hat, N-Logo 6P Cap

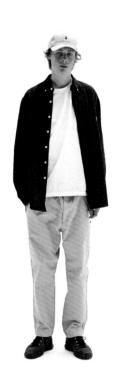
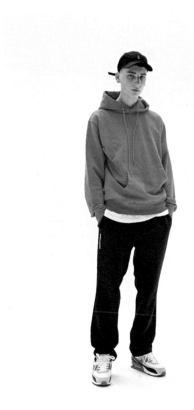

Directed by Kim Mintae
Music "ONE IS TEN" by Somdef

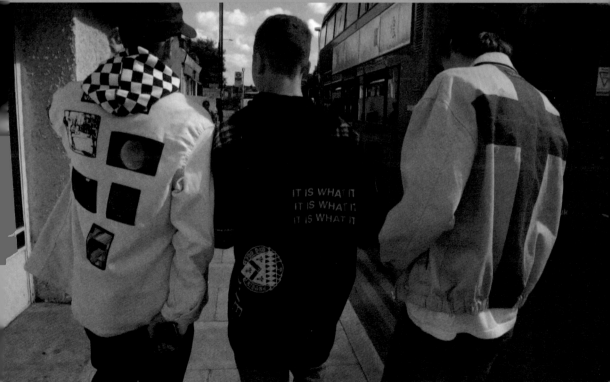

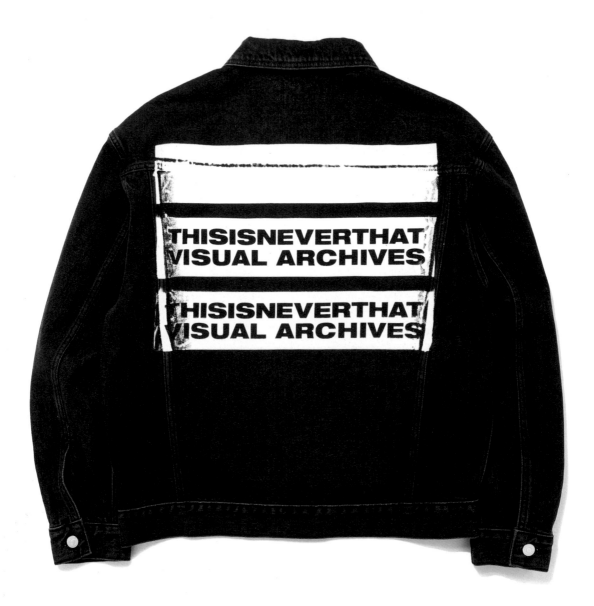

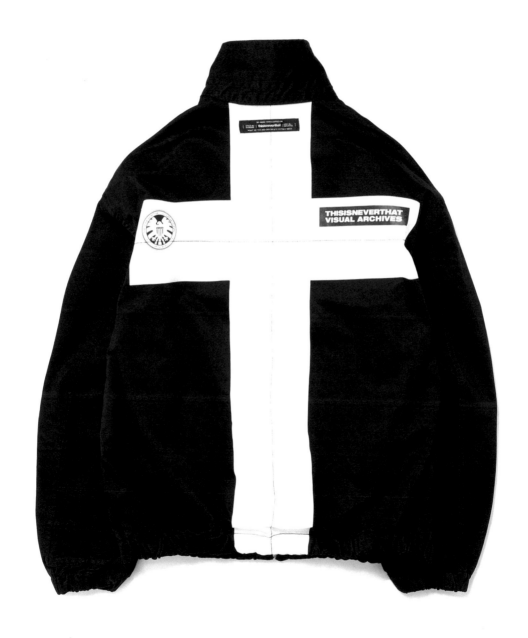

TN16FOW011CH / Jacket
T-Drivers Jacket
Cotton / Charcoal

TN16FOW012NA / Jacket
Stadium Jacket
Polyester / Navy

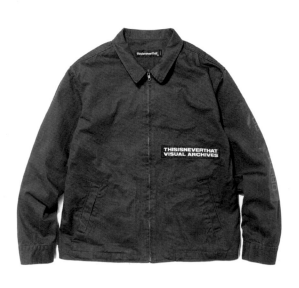

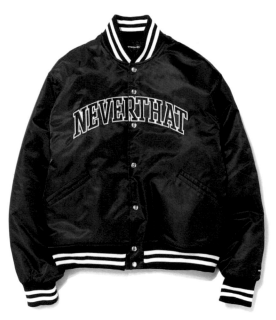

TN16FTO013CH / Shirt
CUT & PRINT Shirt
Cotton / Charcoal

TN16FOW010IV / Jacket
TD Coach Jacket
Cotton / Ivory

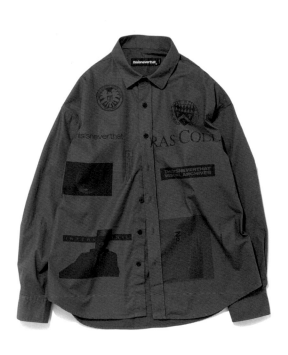

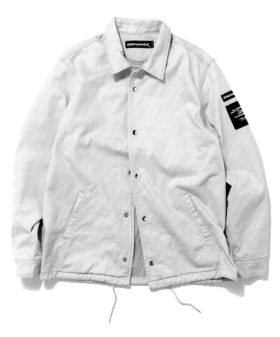

TN16FOW002BK / Jacket
Flight Jacket
Polyester, 3M Thinsulate / Black

TN16FTO006BZ / Shirt
VA Shirt
Cotton / B.Check

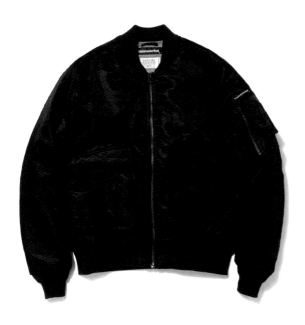

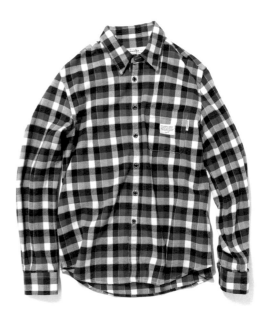

TN16FOW004IDG / Jacket
VA Denim Jacket
Cotton / Indigo

TN16FTO013BK / Shirt
CUT & PRINT Shirt
Cotton / Black

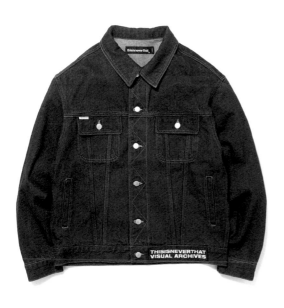

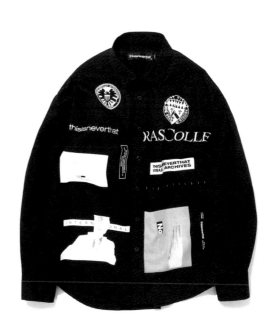

TN16FT0006BZ / Shirt
VA Shirt
Cotton / B.Check

TN16FOW002BK / Jacket
Flight Jacket
Polyester, 3M Thinsulate / Black

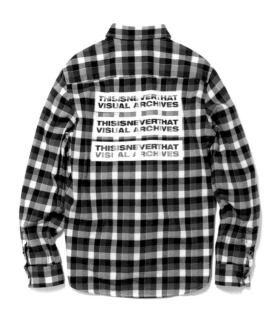

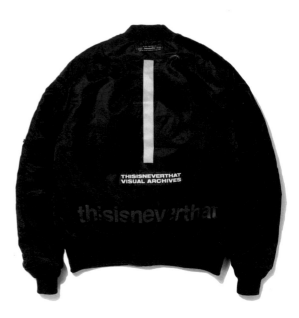

TN16FT0013BK / Shirt
CUT & PRINT Shirt
Cotton / Black

TN16FOW004IDG / Jacket
VA Denim Jacket
Cotton / Indigo

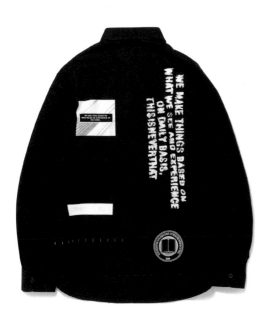

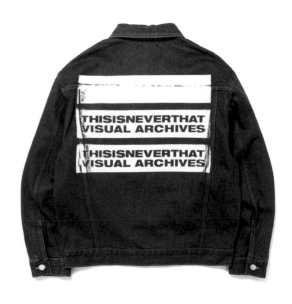

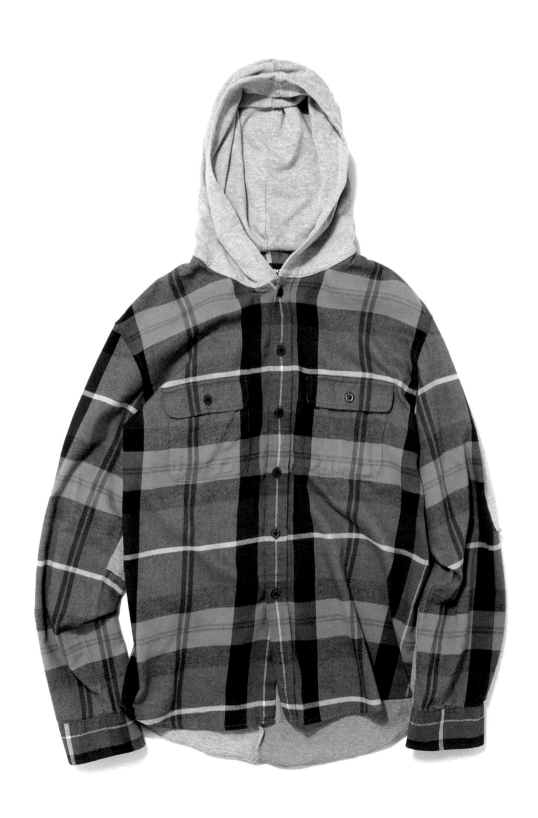

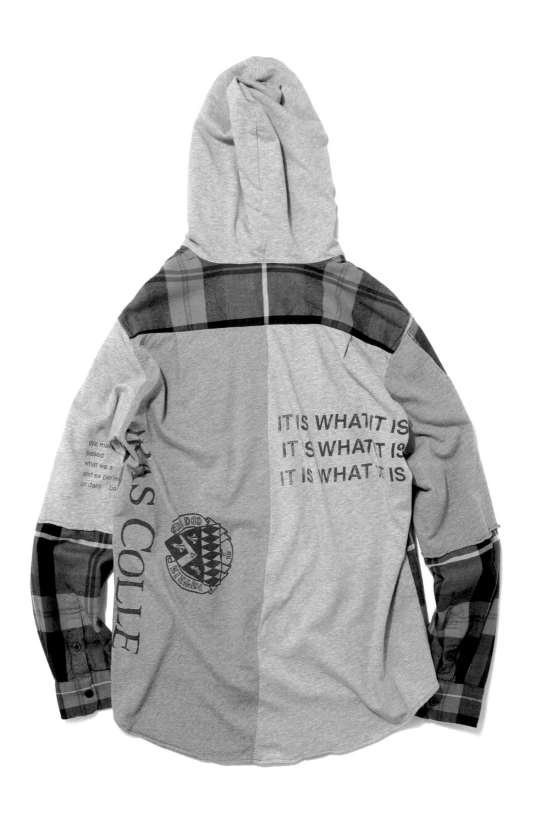

TN16FAC005CH / Hat
TISNVRAT Cap
Nylon / Charcoal

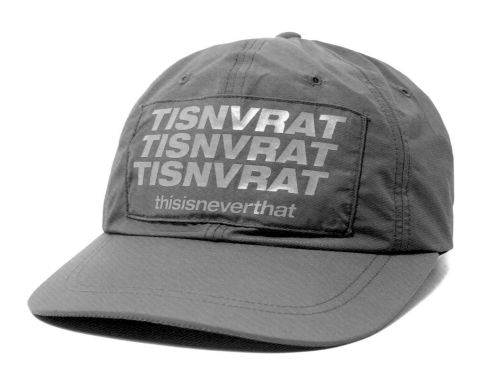

TN16FAC012BK / Hat
Ribbed Beanie
Acrylic / Black

TN16FTO051CA / Sweatshirt
ARCH Logo Pullover
Cotton / Camo

TN16FOW001OV / Jacket
WOODSMAN Down Parka
Polyester, Down, Feather, Raccoon Fur / Olive

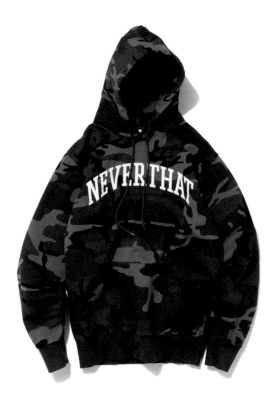

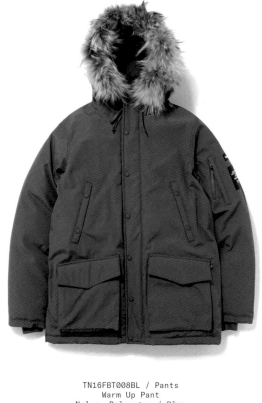

TN16FBT004OV / Pants
Flight Pant
Cotton / Olive

TN16FBT008BL / Pants
Warm Up Pant
Nylon, Polyester / Blue

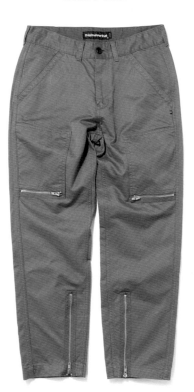

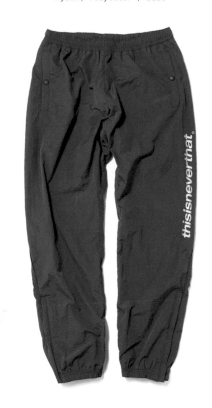

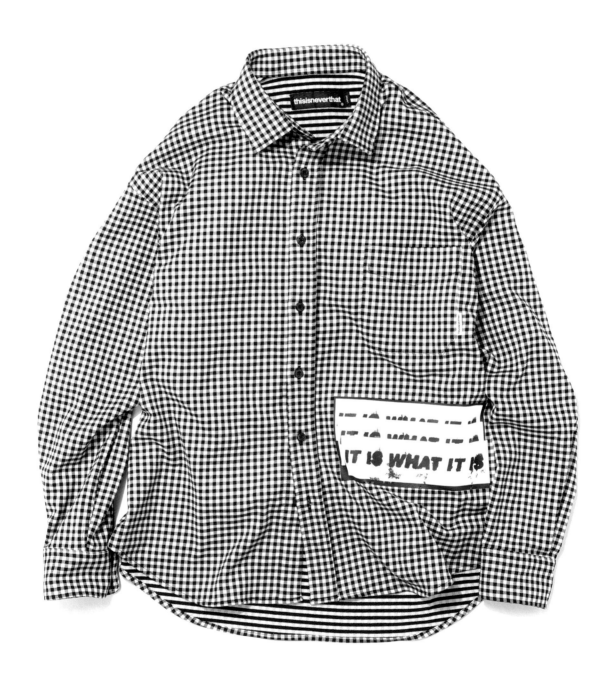

TN16FOW007BK / Jacket
Traveller Coat
Nylon, Polyester, Wool / Black

TN16FAC007WH / Bag
TD Tote Bag
Cotton / White

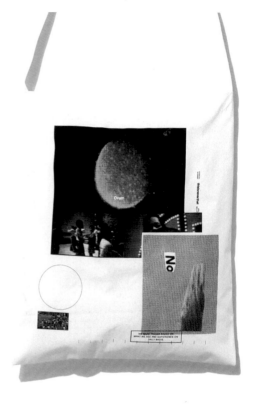

TN16FTO008GR / Sweatshirt
TN-CROSS Crewneck
Cotton / Grey

TN16FTO012GR / Sweatshirt
TD Crewneck
Cotton / Grey

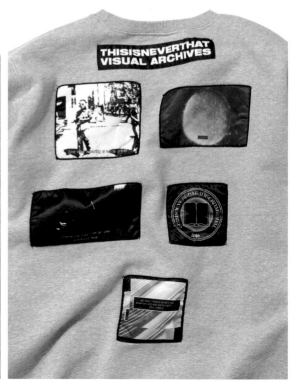

WE MAKE
IT THINGS BASED
ON WHAT

THIS IS

THISISNEVERTHAT
VISUAL ARCHIVES

TN16FOW001NA TN16FTO053NA

TN16FOW015MC TN16FOW015MR

TN16FOW001NA	Jacket	WOODSMAN Down Parka	Polyester, Down, Feather, Raccoon Fur	Navy
TN16FTO053NA	Sweatshirt	TISNVRAT Pullover	Cotton	Navy
TN16FOW015MC	Jacket	Reversible Fleece Parka	Polyester, Acrylic	Camo, Black
TN16FOW015MR	Jacket	Reversible Fleece Parka	Polyester, Acrylic	Camo, Ivory

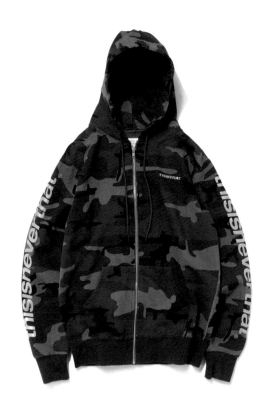

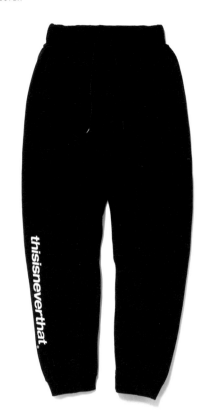

TN16FAC017GD

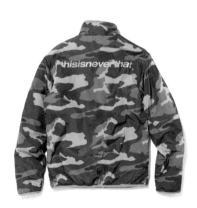

TN16FAC014GD

TN16FTO055CA	Sweatshirt	SP-Logo Zipup Sweat	Cotton	Camo
TN16FBT007BK	Pants	SP-Logo Sweat Pant	Cotton	Black
TN16FAC017GD	Accessory	Eagle Pin	STS	Gold
TN16FAC014GD	Accessory	SP-Logo Pin	STS	Gold

TN16FT0015GR TN16FT0015CK TN16FT0005CK

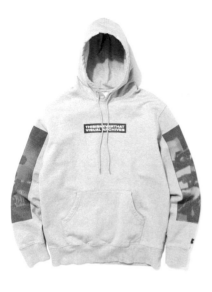 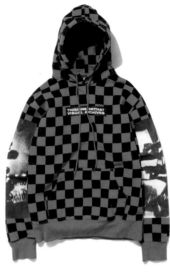 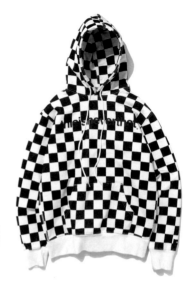

TN16FT0052OR TN16FT0054NA TN16FT0054WH

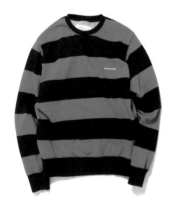 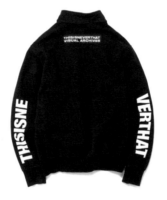 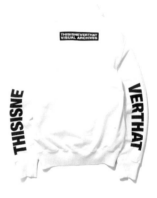

TN16FT0015GR	Sweatshirt	DANCE Pullover	Cotton	Grey
TN16FT0015CK	Sweatshirt	DANCE Pullover	Cotton	Check
TN16FT0005CK	Sweatshirt	T-Logo Pullover	Cotton	Check
TN16FT0057BK	Sweatshirt	T-Drivers Pullover	Cotton	Black
TN16FT0009BK	Sweatshirt	S&E Pullover	Cotton	Black
TN16FT0056CH	Sweatshirt	SP-Logo Pullover	Cotton	Charcoal
TN16FT0052OR	Sweatshirt	Striped Crewneck	Cotton	Orange
TN16FT0054NA	Sweatshirt	Half Zip Pullover	Cotton	Navy
TN16FT0054WH	Sweatshirt	Half Zip Pullover	Cotton	White
TN16FOW011BK	Jacket	T-Drivers Jacket	Cotton	Black
TN16FOW010BK	Jacket	TD Coach Jacket	Cotton	Black
TN16FT0001IDG	Shirt	Crown Denim Shirt	Cotton	Indigo
TN16FT0003BK	Long Sleeve Tee	INTL. Logo L/S	Cotton	Black
TN16FT0008GR	Sweatshirt	TN-CROSS Crewneck	Cotton	Grey

TN16FTO057BK

TN16FTO009BK

TN16FTO056CH

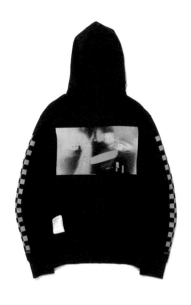

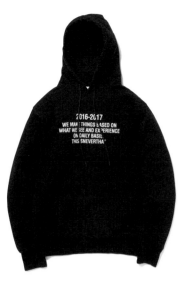

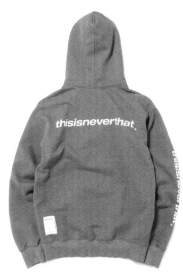

TN16FOW011CH

TN16FOW010BK

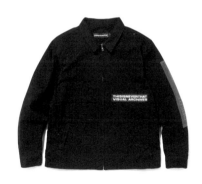

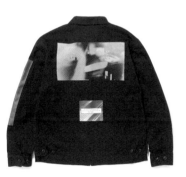

TN16FTO001IDG

TN16FTO003BK

TN16FTO008GR

WE MAKE THINGS BASED ON
WHAT WE SEE AND EXPERIENCE
ON DAILY BASIS
THISISNEVERTHAT

BUTTON 5 SET
BLACK F
TN16FAC002BKF
₩9,000

SPRING/SUMMER 2016

TAGGING

TN16STO015BK, Shirt, OLD Car Aloha Shirt S/S ⬤ TN16STO023WH, Long Sleeve Tee, Nothing L/S Top ⬤ TN16SBT006YG, Pants, Relaxed Pant

TN16STO003NE, Sweatshirt, Striped Crewneck ⬤ TN16SBT006YG, Pants, Relaxed Pant

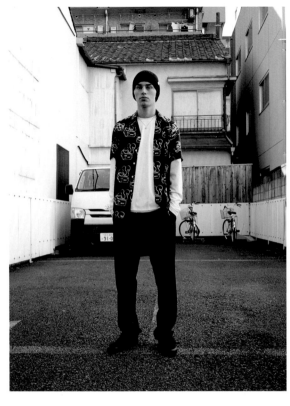

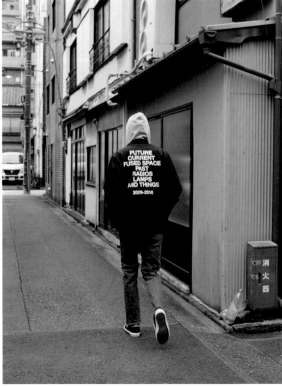

TN16SOW001OV, Jacket, BDU Shirt Jacket ⬤ TN16STO035WH, Tee, T-Collar Tee ⬤ TN16SBT007BK, Pants, PG-28 Short

TN16SOW001NA, Jacket, BDU Shirt Jacket ⬤ TN16STO005GR, Sweatshirt, T-Logo Pullover ⬤ TN16SBT004TW, Jean, Denim Pant

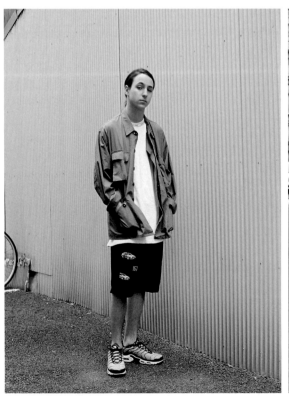

TN16SOW004NA, Jacket, Varsity Jacket ▮ TN16STO017GR, Sweatshirt, N-Cut
Crewneck ▮ TN16SBT004OO, Jean, Denim Pant

TN16STO006YG, Shirt, CPF Shirt ▮ TN16STO045WH, Tee, Delta Piz Tee ▮
TN16SBT008SB, Pants, Pajama Pant

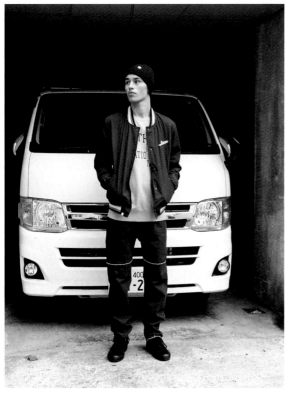

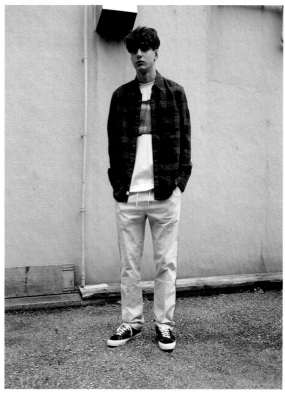

TN16STO018NA, Sweatshirt, EM ARC Logo Crewneck ▮ TN16SBT001BE, Pants,
1Tuck Short

TN16STO048BU, Sweatshirt, N-Logo Rib Crewneck ▮ TN16SBT010BK, Skirt,
P-Logo Front Button Skirt ▮ TN16SAC002BN, Hat, T-Logo Cap

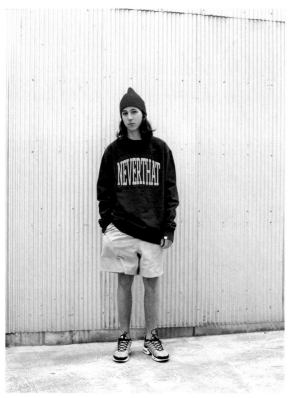

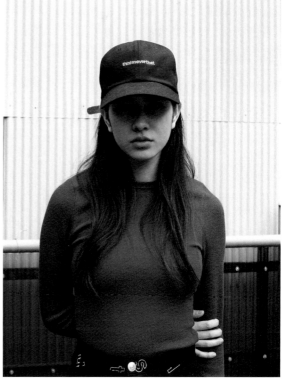

TAGGING

TN16SOW009CO, Jacket, Trucker Jacket ◉ TN16STO023WH, Long Sleeve Tee, Nothing L/S Top ◉ TN16STO040GR, Tee, Rib Tank Top ◉ TN16SBT001BK, Pants, 1Tuck Short

TN16STO019BK, Sweatshirt, ARC Logo Crewneck ◉ TN16STO034WH, Tee, G Logo Tee ◉ TN16SAC003BK, Hat, INTL. Logo Cap

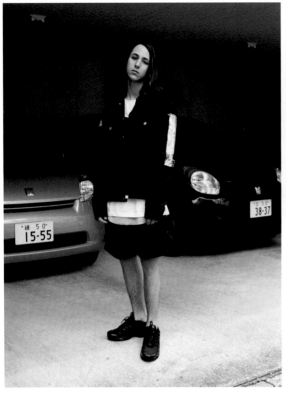

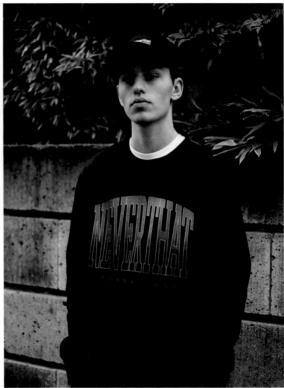

TN16SOW006AI, Jacket, Robe Coat ◉ TN16STO046NA, Tee, S-Cut Off Tee ◉ TN16SBT002BE, Pants, Jogging Short

TN16SOW010BE, Jacket, Double Coat

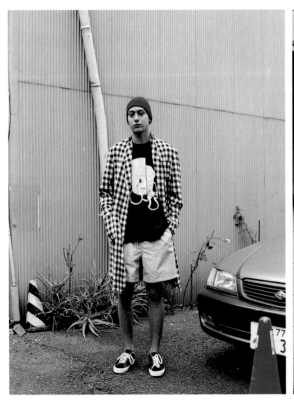

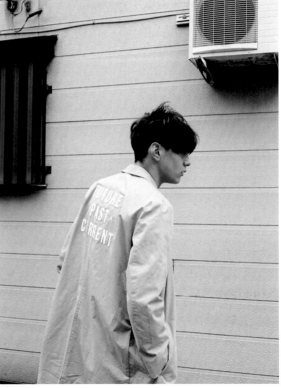

TN16STO006NI, Shirt, CPF Shirt ▌ TN16STO011GR, Sweatshirt, ARC Logo Pullover ▌ TN16SBT005OO, Jean, Denim Short

TN16STO008GR, Shirt, Hooded C-Shirt ▌ TN16SOW007BK, Jacket, Patched Anorak ▌ TN16SBT001BK, Pants, 1Tuck Short ▌ TN16SAC001BK, Hat, The Past 6P Cap

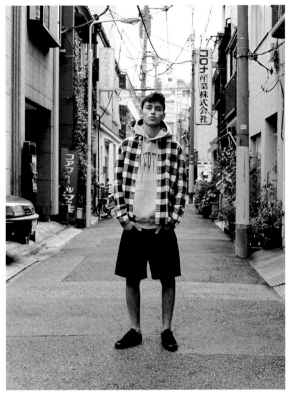

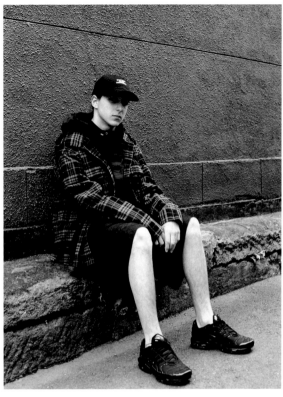

TN16SOW012BK, Jacket, P-Logo Us Jacket ▌ TN16SBT010BK, Skirt, P-Logo Front Button Skirt

TN16SOW003DT, Jacket, INTL. Training Jacket ▌ TN16SBT004TW, Jean, Denim Pant

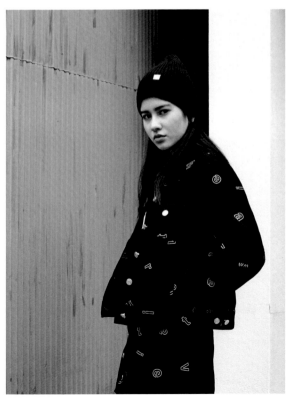

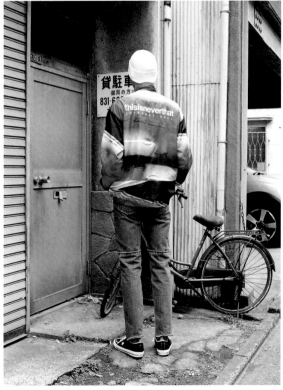

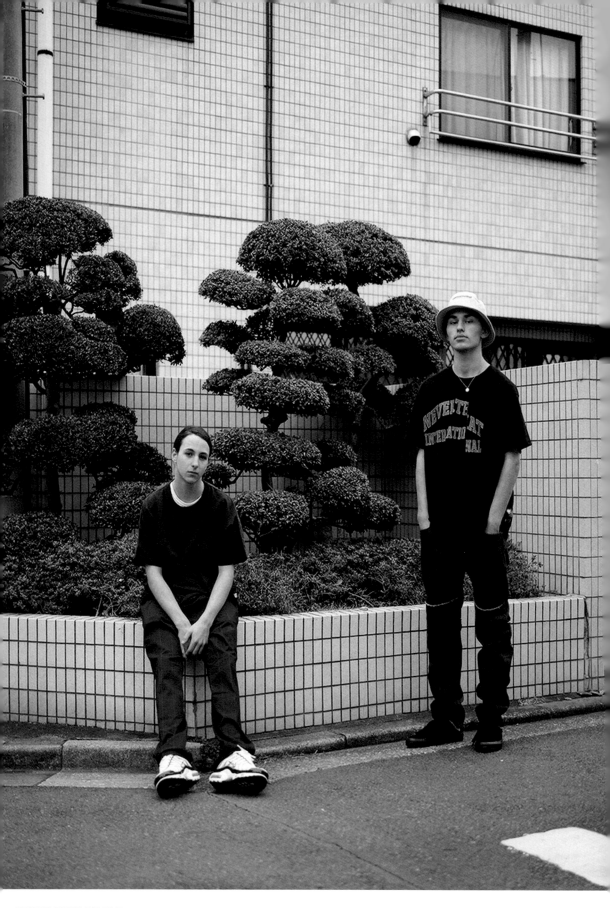

TN16STO017NA, Sweatshirt, N-Cut Crewneck ❚ TN16SBT009GR, Pants, Sweat
Pant

TN16STO007WH, Shirt, 7L Shirt ❚ TN16STO033WH, Tee, INTL. Logo Tee ❚
TN16SBT003BK, Pants, Relaxed Short

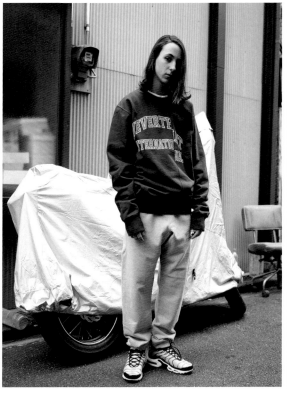

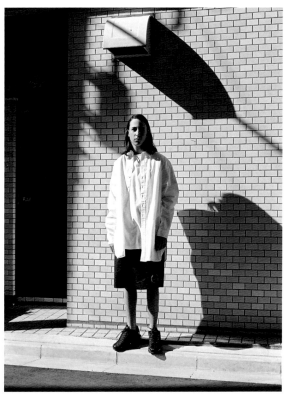

TN16SOW011OV, Jacket, Utility Jacket ❚ TN16STO045WH, Tee, Delta Piz Tee
❚ TN16SBT005OO, Jean, Denim Short ❚ TN16SAC001BE, Hat, The Past 6P Cap

TN16SOW007BK, Jacket, Patched Anorak ❚ TN16STO035GR, Tee, T-Collar Tee
❚ TN16STO040WH, Tee, Rib Tank Top ❚ TN16SBT003BK, Pants, Relaxed Short

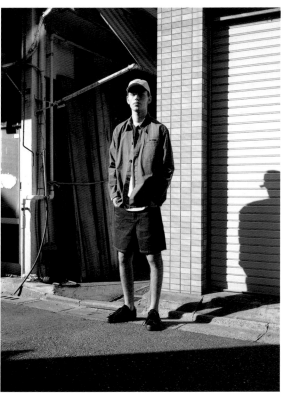

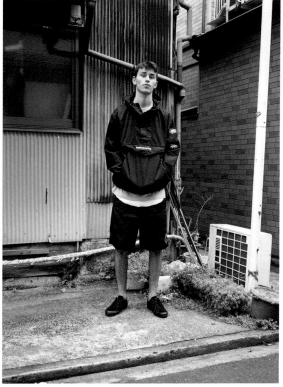

TN16STO042NA, Tee, Back C-Panel Tee ◉ TN16STO040WH, Tee, Rib Tank Top ◉ TN16STO023SB, Long Sleeve Tee, Nothing L/S Top ◉ TN16SBT001BK, Pants,
TN16SBT006BT, Pants, Relaxed Pant 1Tuck Short

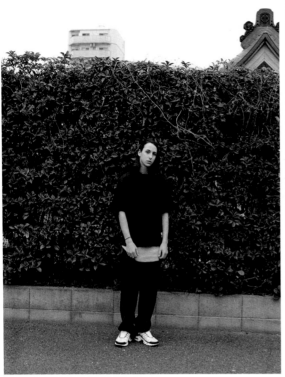
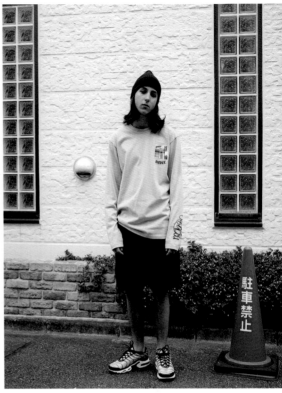

TN16SOW004MS, Jacket, Varsity Jacket ◉ TN16STO033BK, Tee, INTL. Logo TN16SOW006ID, Jacket, Robe Coat ◉ TN16STO044BK, Tee, Dead Leaves Tee ◉
Tee ◉ TN16SBT003YG, Pants, Relaxed Short TN16SBT006YG, Pants, Relaxed Pant

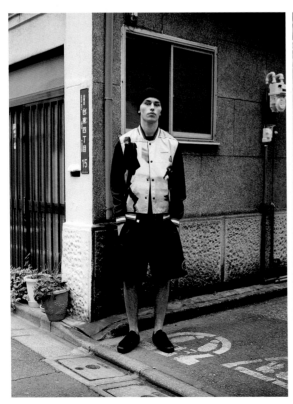
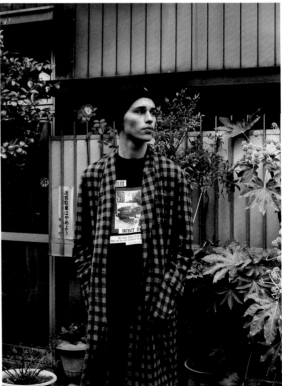

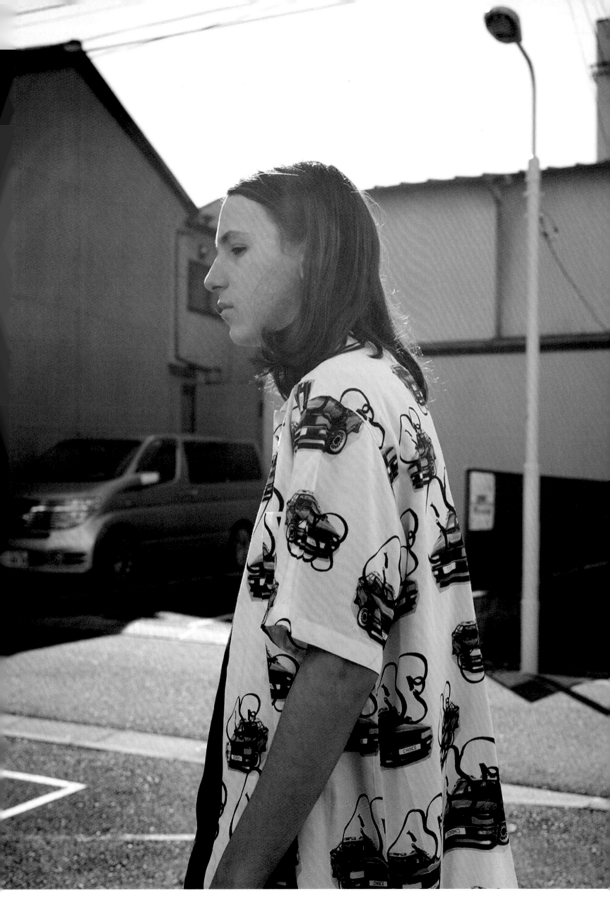

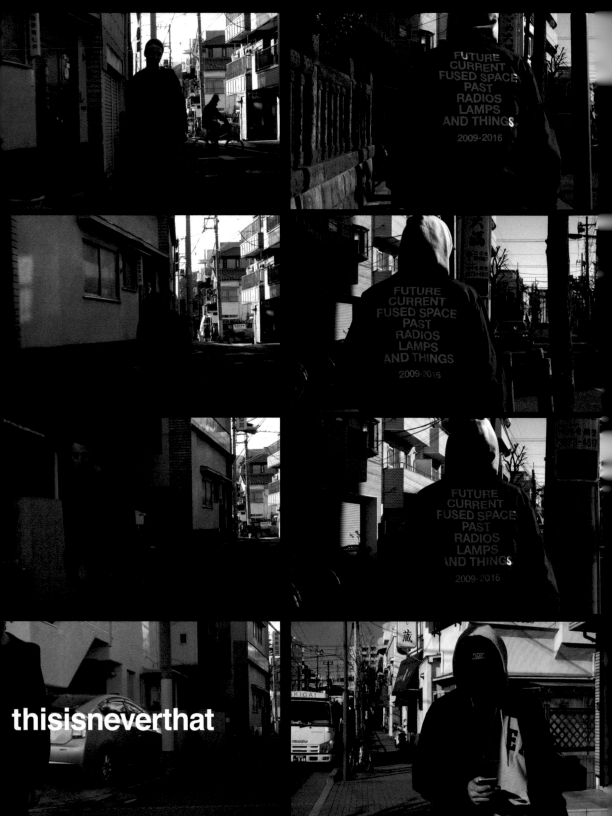

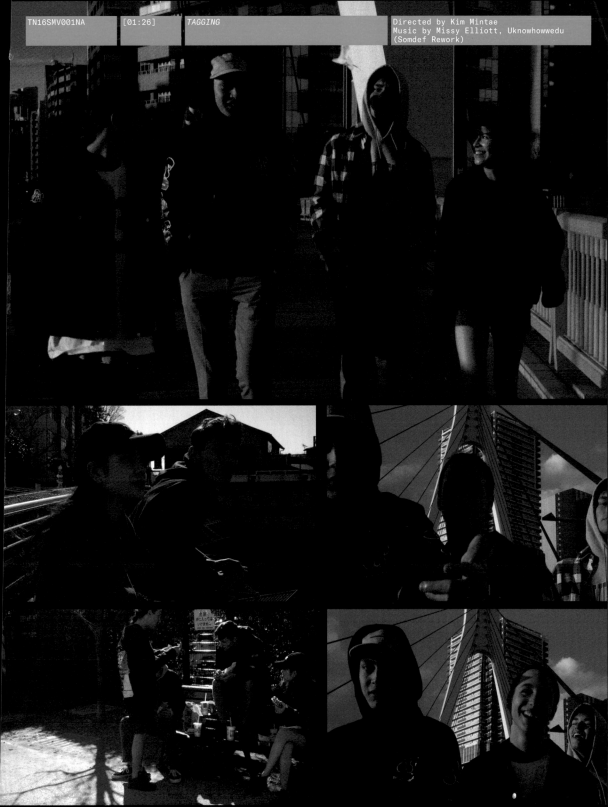

TN16SMV001NA [01:26] *TAGGING* Directed by Kim Mintae
 Music by Missy Elliott, Uknowhowwedu
 (Somdef Rework)

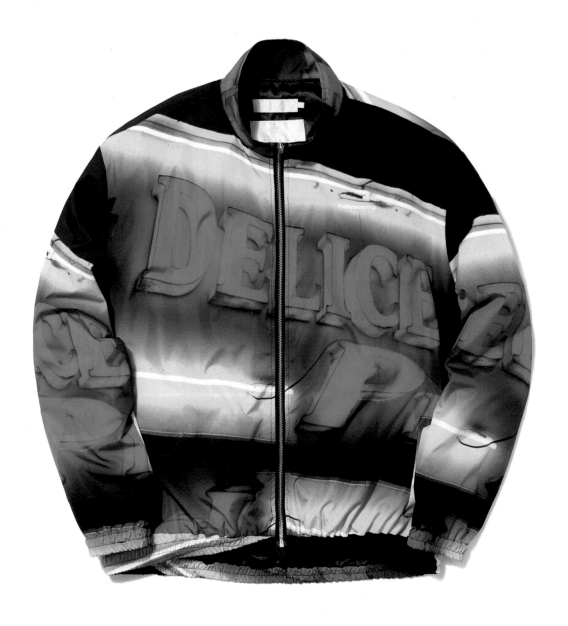

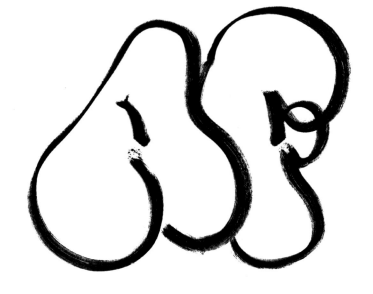

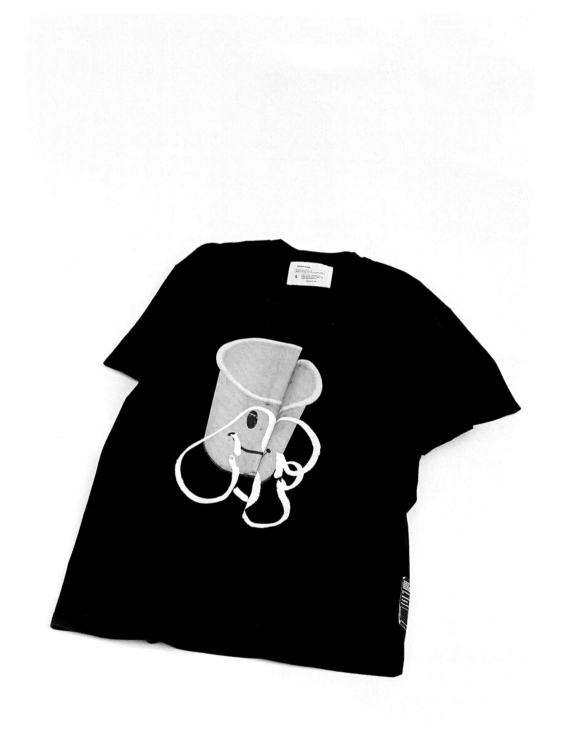

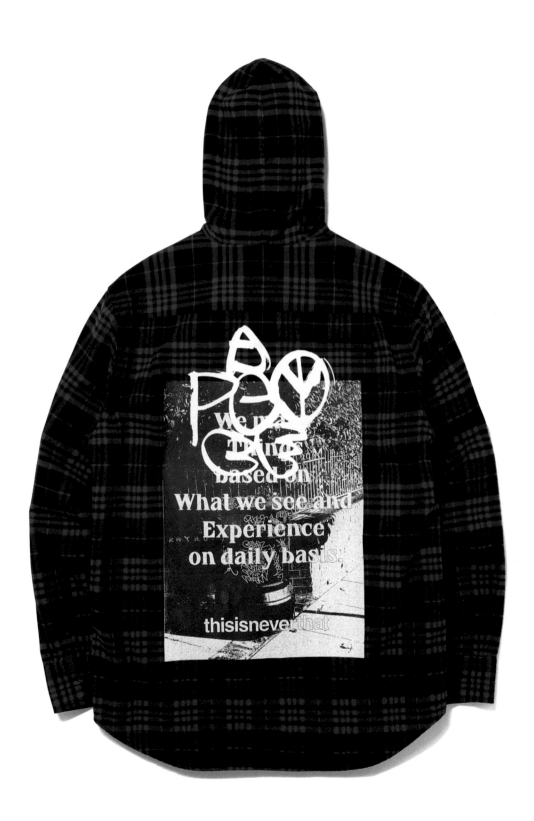

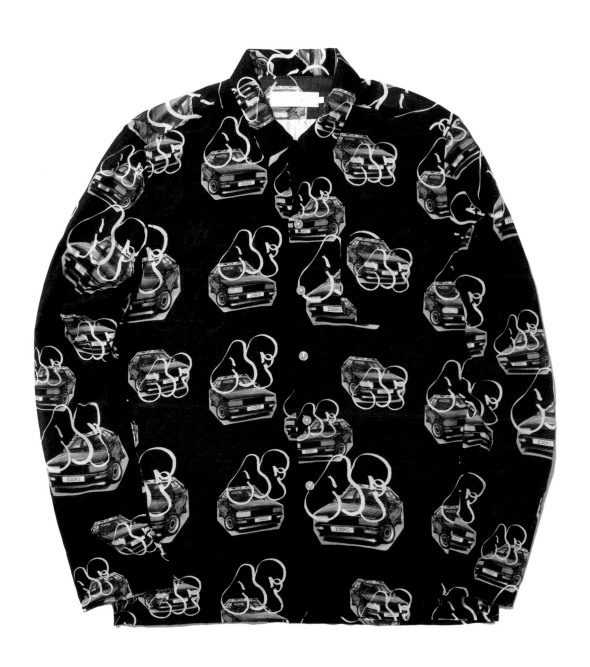

TN16SOW004AP / Jacket
Varsity Jacket
Polyester / Airport

TN16SOW009CO / Jacket
Trucker Jacket
Cotton / Black

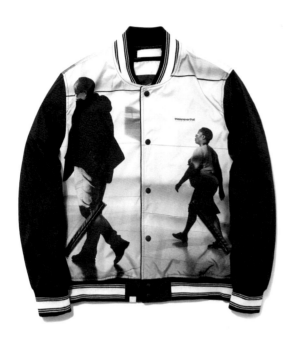

TN16STO004BK / Sweatshirt
Taped Crewneck
Cotton / Black

TN16STO012BK / Sweatshirt
OLD Car Pullover
Cotton / Black

TN16STO044OV / Tee
Dead Leaves Tee
Cotton / Olive

TN16STO023SB / Long Sleeve Tee
Nothing L/S Top
Cotton / Sky Blue

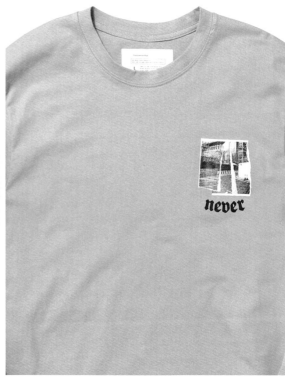

TN16STO034WH / Tee
G Logo Tee
Cotton / White

TN16STO024WH / Long Sleeve Tee
B.Court L/S Top
Cotton / White

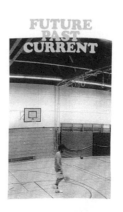

TN16STO018GR / Sweatshirt
EM ARC Logo Crewneck
Cotton / Grey

TN16STO011BK / Sweatshirt
ARC Logo Pullover
Cotton / Black

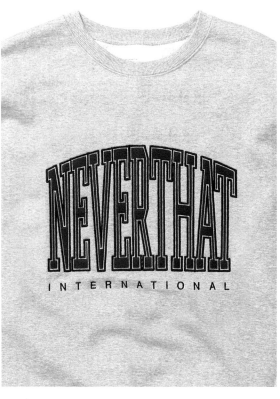

TN16STO013GR / Sweatshirt
Nothing Pullover
Cotton / Grey

TN16STO010GR / Sweatshirt
NEVER Pullover
Cotton / Grey

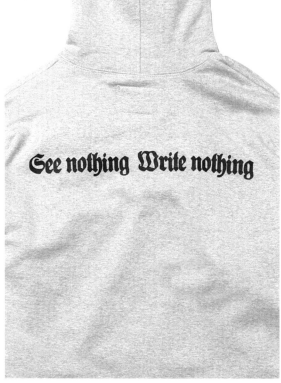

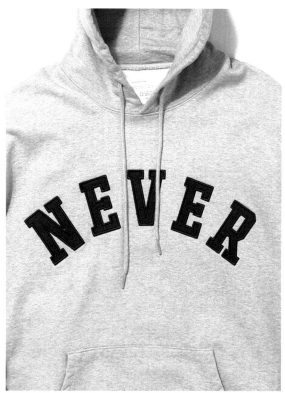

TN16SAC007GD / Accessory
AF Pin
STS / Gold

TN16SAC008BK / Accessory
Eagle Pin
STS / Black

TN16SAC007SB / Accessory
AF Pin
STS / Sky Blue

TN16SAC006BK / Accessory
Dead Leaves Pin
STS / Black

TN16SAC005GD / Accessory
T-Logo Pin
STS / Gold

TN16SAC005BK / Accessory
T-Logo Pin
STS / Black

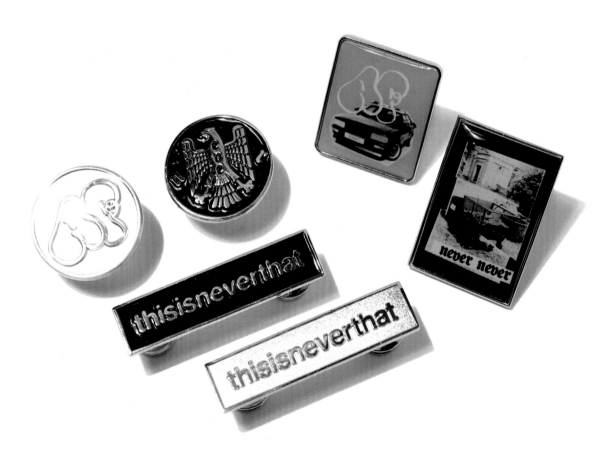

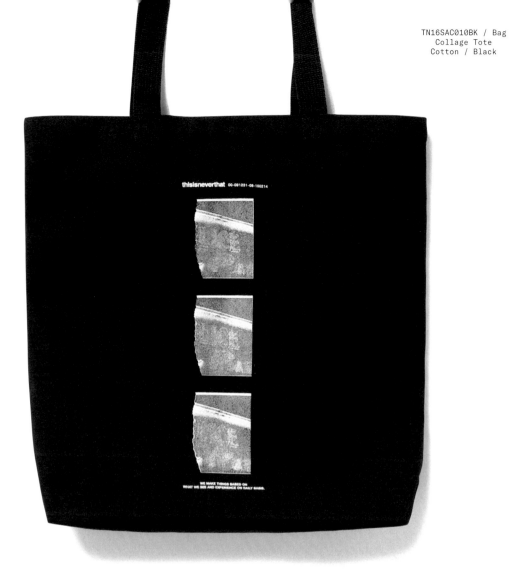

TN16SAC009CG / Accessory
iPhone Case
Polycarbonate / Collage

TN16SOW009BH

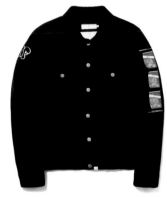

TN16SOW0110V

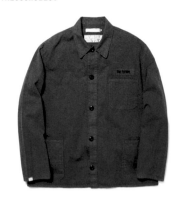

TN16SOW004BE

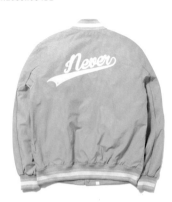

TN16SBT009BK

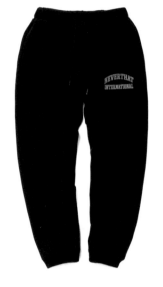

TN16SBT004TW

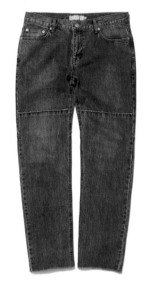

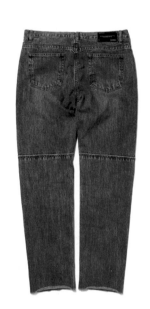

TN16STO009LB

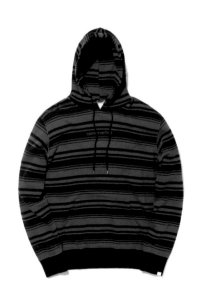

TN16STO013BK

TN16SOW006ID

TN16STO001AI

TN16STO003YG

TN16STO027BK

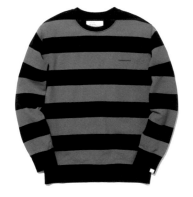
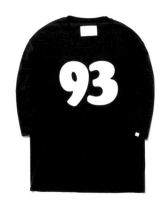

TN16SBT004OO

TN16SBT008SB

TN16SBT006YG

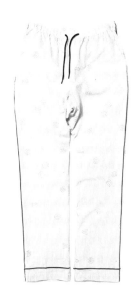
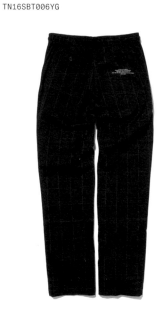

TN16SOW009BH	Jacket	Trucker Jacket	Cotton	Black
TN16SOW011OV	Jacket	Utility Jacket	Cotton	Olive
TN16SOW004BE	Jacket	Varsity Jacket	Cotton, Nylon	Beige
TN16STO001AI	Shirt	Zip Shirt	Cotton	Navy, Ivory
TN16STO003YG	Sweatshirt	Striped Crewneck	Cotton	Navy, Green
TN16STO027BK	Long Sleeve Tee	1993 3/4 Top	Cotton	Black
TN16SBT009BK	Pants	Sweat Pant	Cotton	Black
TN16SBT004TW	Jean	Denim Pant	Cotton	#2
TN16SBT004OO	Jean	Denim Pant	Cotton	#1
TN16SBT008SB	Pants	Pajama Pant	Cotton	Sky Blue
TN16SBT006YG	Pants	Relaxed Pant	Polyester, Elastane	Navy, Green
TN16STO009LB	Sweatshirt	Striped Pullover	Cotton	Blue, Black
TN16STO013BK	Sweatshirt	Nothing Pullover	Cotton	Black
TN16SOW006ID	Jacket	Robe Coat	Cotton	Navy, Ivory Dark

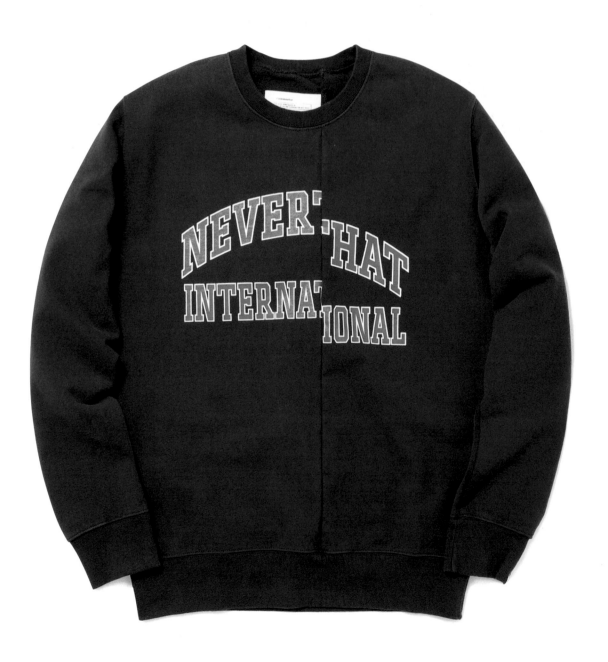

Collaborator

Release Date
Apr 8, 2016
Apr 15, 2016

Prefix
HG

have a good time × thisisneverthat

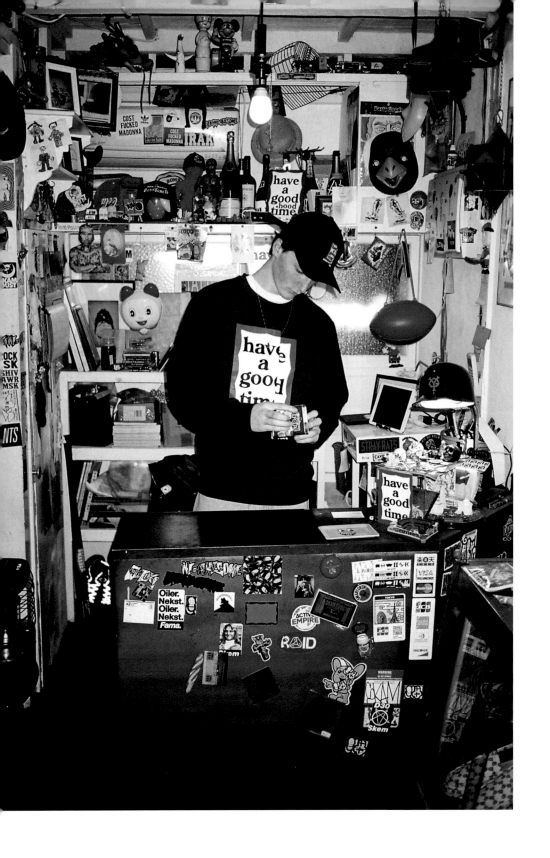

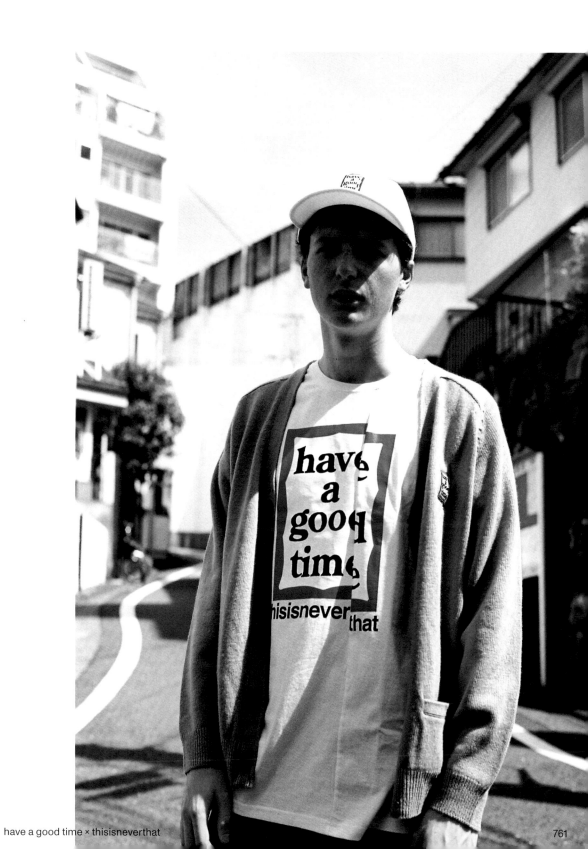

have a good time × thisisneverthat

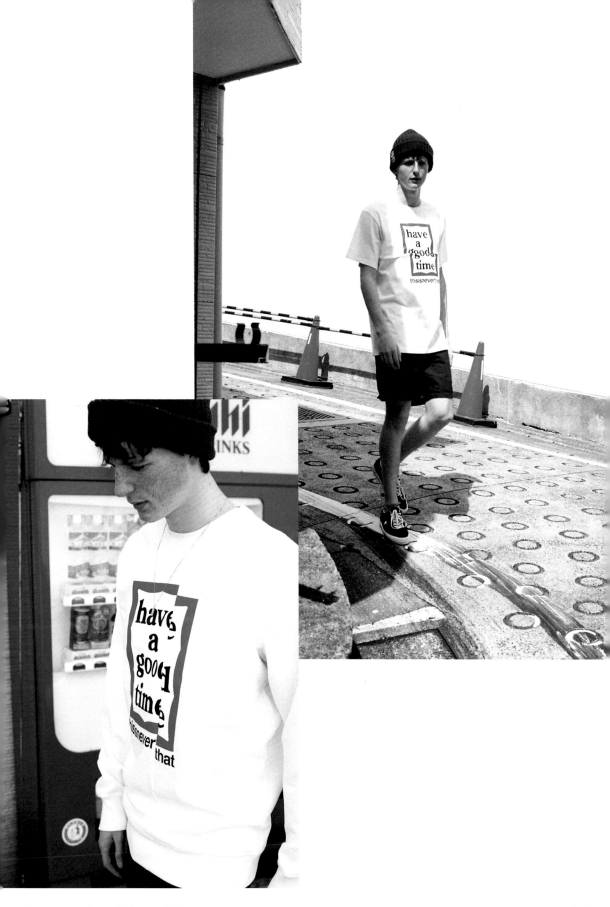

have a good time × thisisneverthat

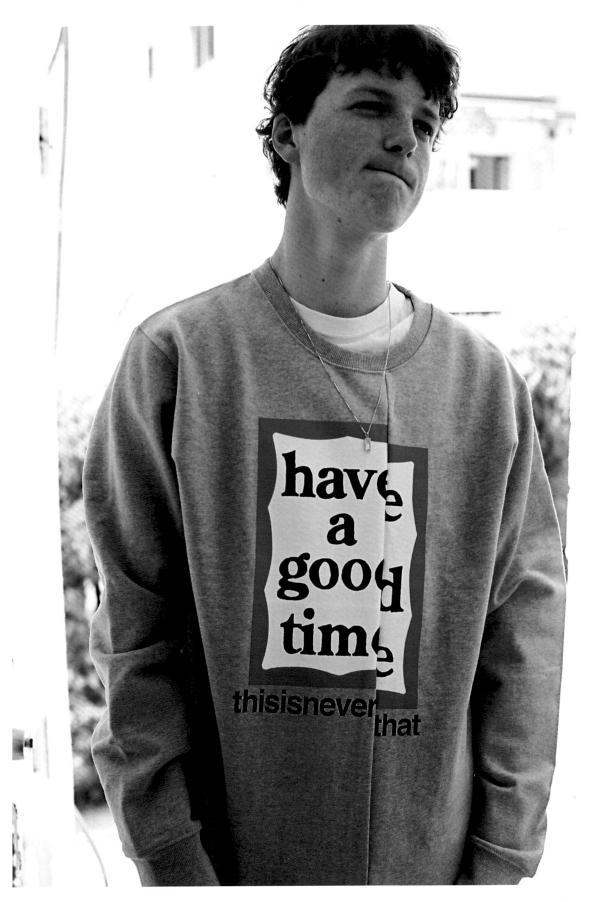

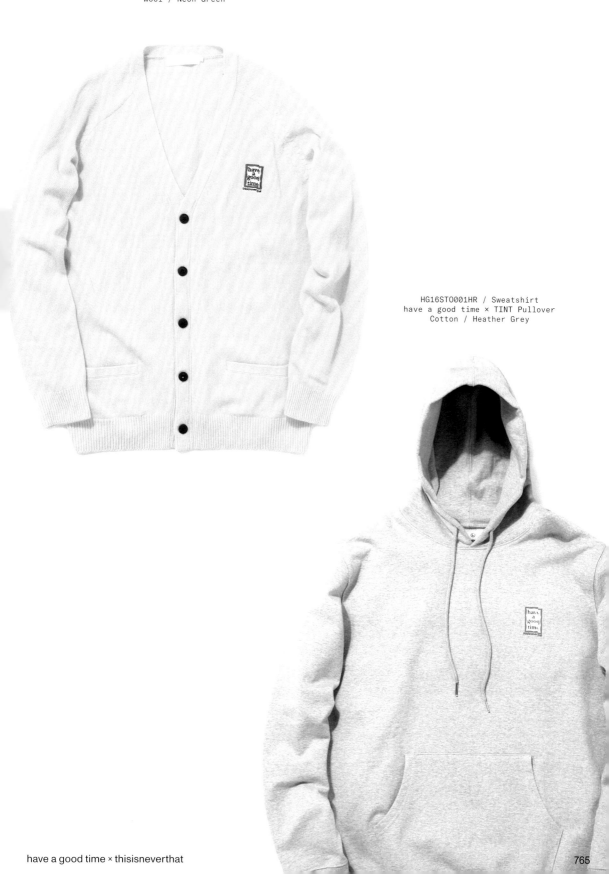

HG16STO005ER / Top
have a good time × TINT Cardigan
Wool / Neon Green

HG16STO001HR / Sweatshirt
have a good time × TINT Pullover
Cotton / Heather Grey

have a good time × thisisneverthat

HG16SAC001BE

HG16SAC001BK

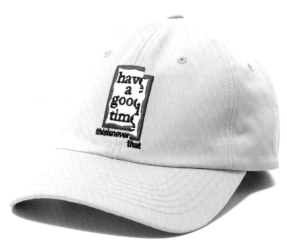

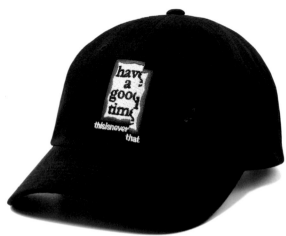

HG16SAC001NA

HG16SAC001WH

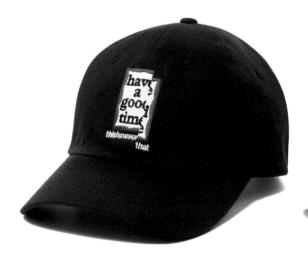

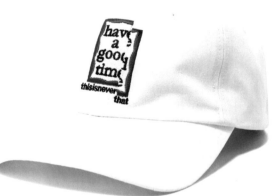

HG16SAC001BE	Hat	have a good time × TINT 6P Cap	Cotton	Beige
HG16SAC001BK	Hat	have a good time × TINT 6P Cap	Cotton	Black
HG16SAC001NA	Hat	have a good time × TINT 6P Cap	Cotton	Navy
HG16SAC001WH	Hat	have a good time × TINT 6P Cap	Cotton	White

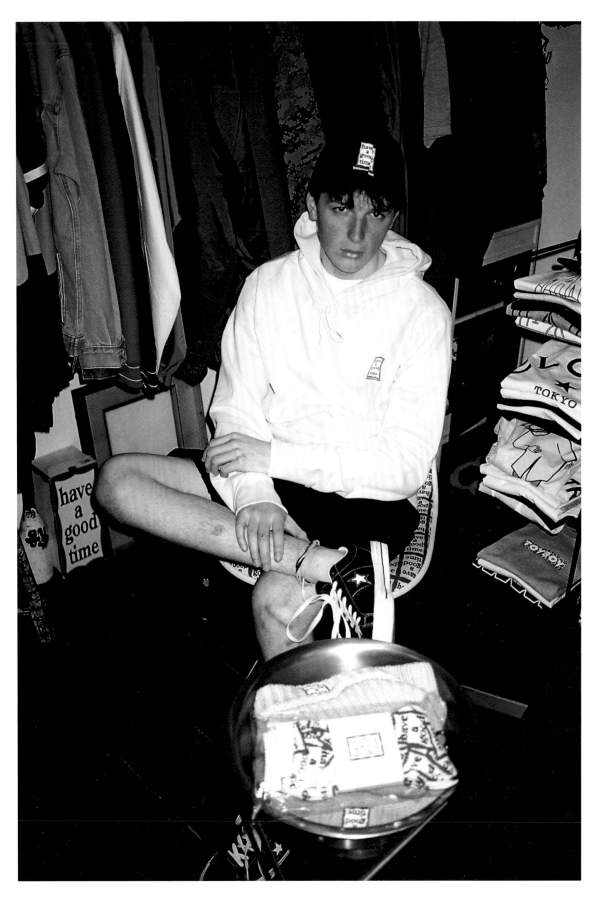

have a good time × thisisneverthat

S/Summer 2016

thisisneverthat

FALL/WINTER 2015

DUB SIDE

TN15FOW006OV, Jacket, RP Reversible MA-1 ◍ TN15FTO006WH, Sweatshirt, PARK Pullover ◍ TN15FBT003BK, Pants, Chino Pant ◍ TN15FAC013WH, Hat, OG Beanie

TN15FOW011HW, Jacket, Varsity Jacket ◍ TN15FBT003WH, Pants, Chino Pant ◍ TN15FAC013BK, Hat, OG Beanie

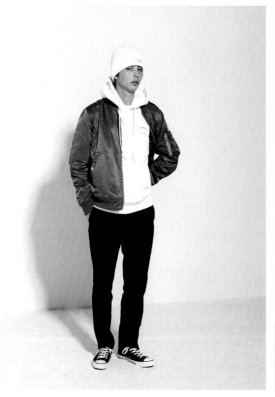

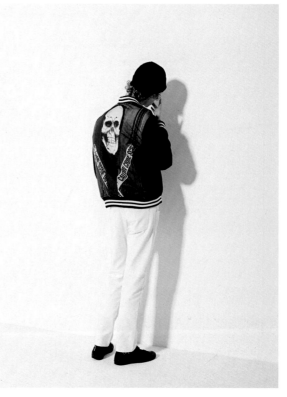

TN15FOW001KY, Jacket, Reversible Coat ◍ TN15FTO019NA, Sweatshirt, C/Rib Crewneck ◍ TN15FBT001CN, Pants, Classic Trousers ◍ TN15FAC013BK, Hat, OG Beanie ◍ VA15FAC001GG, Shoes, VANS × TINT Authentic

TN15FTO006WH, Sweatshirt, PARK Pullover ◍ TN15FBT003BK, Pants, Chino Pant ◍ TN15FAC009WH, Hat, D/S 6P-Cap

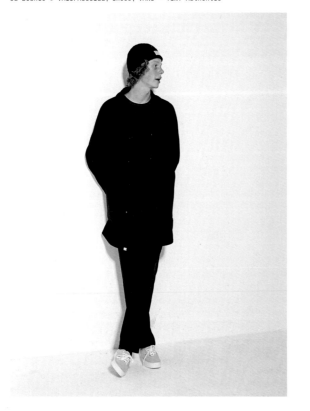

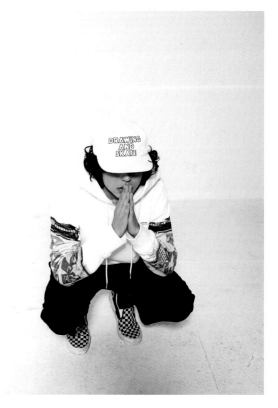

TN15FTO008BE, Shirt, Hooded Shirt ▧ TN15FBT002BE, Pants, Cord Pant ▧
TN15FAC009RD, Hat, D/S 6P-Cap

TN15FOW008NA, Jacket, Padded Coat ▧ TN15FTO009LP, Sweatshirt, Back
Pullover ▧ TN15FBT005BK, Pants, Two Tone Trousers

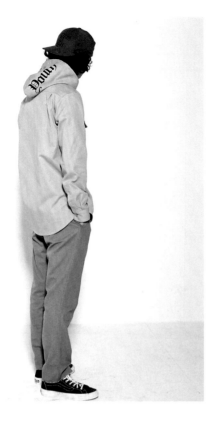

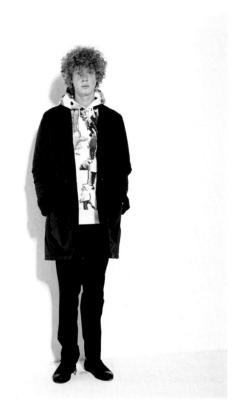

TN15FOW006OV, Jacket, RP Reversible MA-1 ▧ TN15FTO012BK, Sweatshirt,
Art Service Crewneck ▧ TN15FBT005GR, Pants, Two Tone Trousers

TN15FTO016GV, Sweatshirt, Striped Crewneck ▧ TN15FBT004NA, Pants, City
Jogger Pant ▧ TN15FAC008WH, Hat, Boo Hoo Hoo 6P-Cap

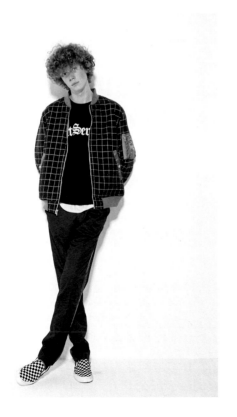

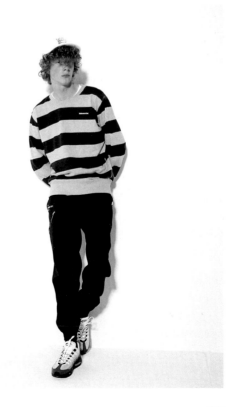

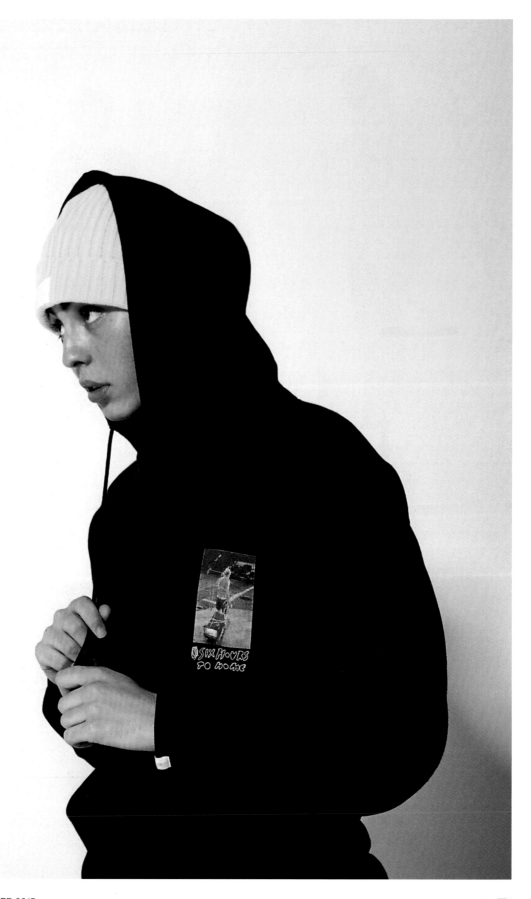

TN15FTO014WH, Sweatshirt, D/S Crewneck ▮ TN15FBT001WP, Pants, Classic Trousers ▮ LF15FAC001BK, Bag, Daypack

TN15FOW007NA, Jacket. Duffle Coat ▮ TN15FTO015WH, Sweatshirt, T-Logo Crewneck ▮ TN15FBT003BE, Pants, Chino Pant ▮ TN15FAC013NN, Hat, OG Beanie

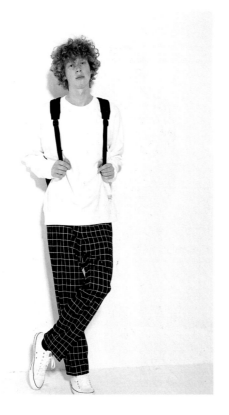

TN15FOW009BK, Jacket, Hooded Coat ▮ TN15FBT006BK, Pants, Denim Pant ▮ TN15FAC004BK, Hat, Wool Felt Hat

TN15FOW002OV, Jacket, MA-1 Down Jacket ▮ TN15FBT003BK, Pants, Chino Pant

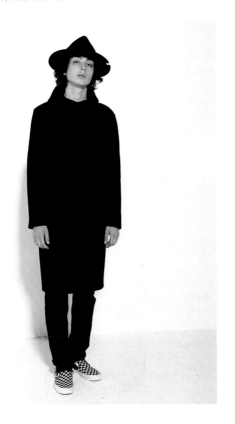

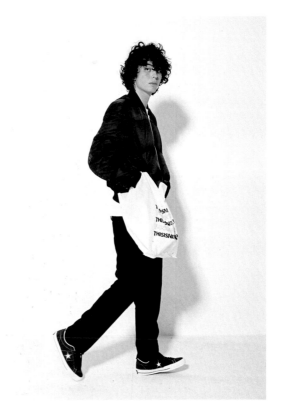

[L] TN15FOW010BE, Jacket, Cord Trucker Jacket ● TN15FTO015WH, Sweat-
shirt, T-Logo Crewneck ● TN15FBT002BE, Pants, Cord Pant ● VA15FAC002BP,
Shoes, VANS × TINT Classic Slip-On ● TN15FAC004BE, Hat, Wool Felt Hat
● [R] TN15FTO005GR, Sweatshirt, Art Crewneck ● TN15FBT001WP, Pants,
Classic Trousers ● TN15FAC002BU, Hat, Six Hours 6P-Cap

[L] TN15FTO008BK, Shirt, Hooded Shirt ● TN15FBT003BK, Pants, Chino
Pant ● TN15FAC008WH, Hat, Boo Hoo Hoo 6P-Cap ● [R] TN15FOW0020V,
Jacket, MA-1 Down Jacket ● TN15FTO016GL, Sweatshirt, Striped Crewneck
● TN15FBT005BK, Pants, Two Tone Trousers

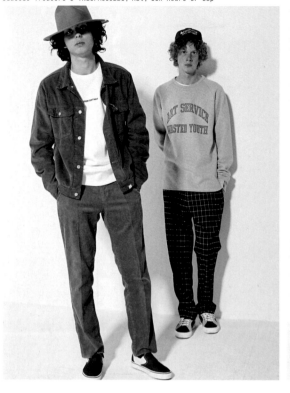

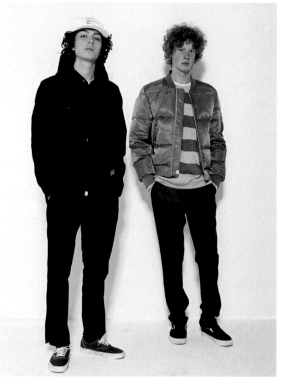

[L] TN15FOW002BE, Jacket, MA-1 Down Jacket ● TN15FTO011BL, Sweatshirt,
Art Service Pullover ● TN15FBT003BE, Pants, Chino Pant ● TN15FAC002GN,
Hat, Six Hours 6P-Cap ● VA15FAC001GG, Shoes, VANS × TINT Authentic ● [R]
TN15FTO003GR, Sweatshirt, Six Hours Pullover ● TN15FBT004NA, Pants,
City Jogger Pant ● TN15FAC013BK, Hat, OG Beanie

[L] TN15FOW011CS, Jacket, Varsity Jacket ● TN15FBT006BL, Pants, Denim
Pant ● TN15FAC013BU, Hat, OG Beanie ● VA15FAC002BP, Shoes, VANS ×
TINT Classic Slip-On ● [R] TN15FOW004GR, Jacket, Wool Trench Coat ●
TN15FTO010PK, Sweatshirt, BCGC Pullover ● TN15FBT002BE, Pants, Cord
Pant

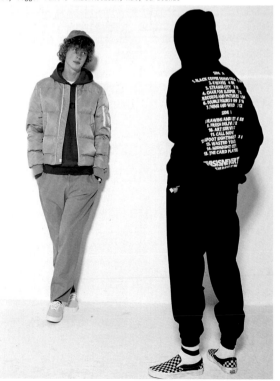

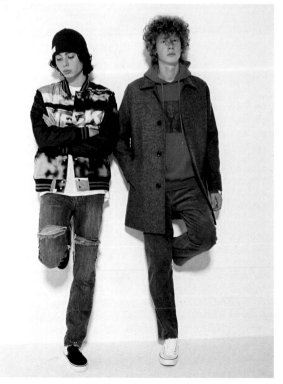

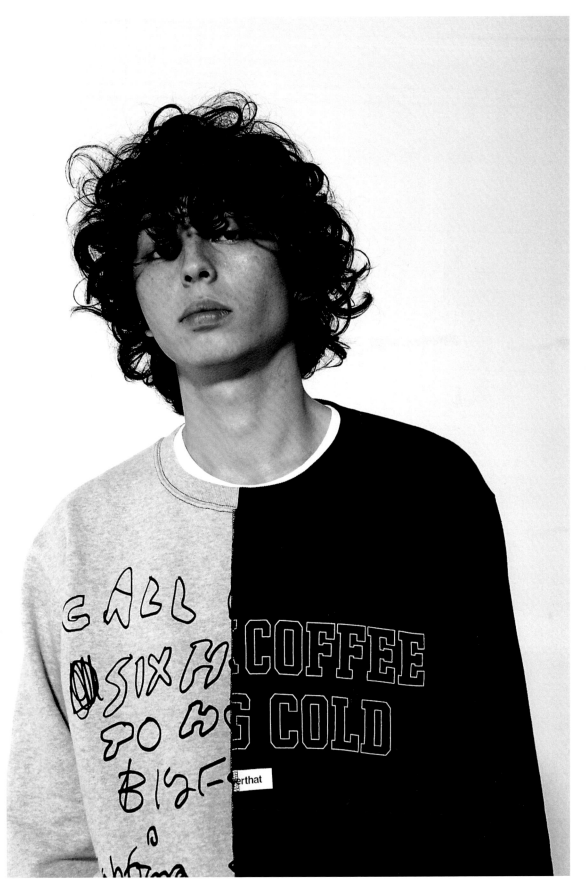

[L] TN15FOW007BK, Jacket, Duffle Coat ◉ TN15FTO005BK, Sweatshirt, Art Crewneck ◉ TN15FBT004NA, Pants, City Jogger Pant ◉ [R] TN15FOW006NA, Jacket, RP Reversible MA-1 ◉ TN15FTO015NA, Sweatshirt, T-Logo Crewneck ◉ TN15FBT005BK, Pants, Two Tone Trousers ◉ TN15FAC004BK, Hat, Wool Felt Hat

[L] TN15FOW003WP, Jacket, Zip Shirt ◉ TN15FTO004GR, Sweatshirt, T-Logo Pullover ◉ TN15FBT003BK, Pants, Chino Pant ◉ TN15FAC008BK, Hat, Boo Hoo Hoo 6P-Cap ◉ [R] TN15FOW009BE, Jacket, Hooded Coat ◉ TN15FTO020NA, Top, Six Hours Knit Sweater ◉ TN15FBT003WH, Pants, Chino Pant ◉ VA15FAC001BP, Shoes, VANS × TINT Authentic

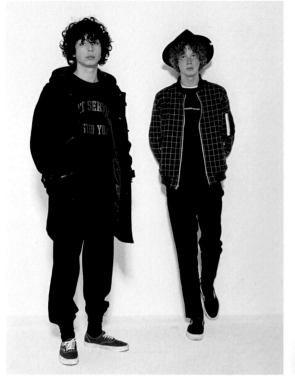

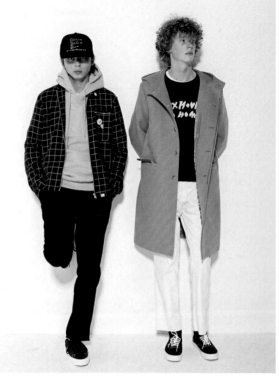

[L] TN15FOW003CD, Jacket, Zip Shirt ◉ TN15FBT006BK, Pants, Denim Pant ◉ TN15FAC015RN, Accessory, Muffler ◉ [R] TN15FOW004NA, Jacket, Wool Trench Coat ◉ TN15FTO013BL, Sweatshirt, BCGC Crewneck ◉ TN15FBT003BK, Pants, Chino Pant ◉ TN15FAC012WH, Hat, Youth Beanie ◉ VA15FAC002BP, Shoes, VANS × TINT Classic Slip-On

[L] TN15FTO007GC, Shirt, S/C Long Shirt ◉ TN15FBT006BK, Pants, Denim Pant ◉ TN15FAC009WH, Hat, D/S 6P-Cap ◉ [R] TN15FOW006NA, Jacket, RP Reversible MA-1 ◉ TN15FTO001SB, Shirt, T-Oxford Shirt ◉ TN15FBT003WH, Pants, Chino Pant ◉ TN15FAC002BU, Hat, Six Hours 6P-Cap ◉ VA15FAC002BP, Shoes, VANS × TINT Classic Slip-On

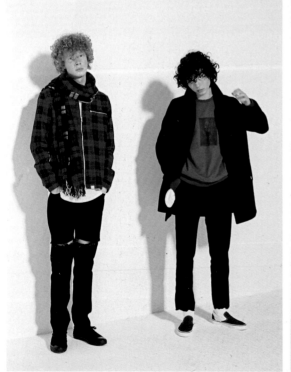

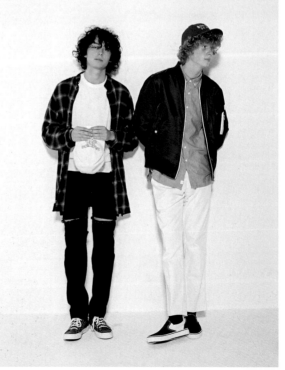

[L] TN15FOW001AK, Jacket, Reversible Coat ◉ TN15FTO002GR, Sweatshirt, Collage Pullover ◉ TN15FBT003BE, Pants, Chino Pant ◉ TN15FAC002CH, Hat, Six Hours 6P-Cap ◉ [R] TN15FOW010BK, Jacket, Cord Trucker Jacket ◉ TN15FTO006WH, Sweatshirt, PARK Pullover ◉ TN15FBT002BK, Pants, Cord Pant ◉ TN15FAC013WH, Hat, OG Beanie

[L] TN15FTO015WH, Sweatshirt, T-Logo Crewneck ◉ TN15FBT003BE, Pants, Chino Pant ◉ TN15FAC013NN, Hat, OG Beanie ◉ [R] TN15FTO017KY, Sweatshirt, Twisted Van Crewneck ◉ TN15FBT003BK, Pants, Chino Pant ◉ TN15FAC009RD, Hat, D/S 6P-Cap

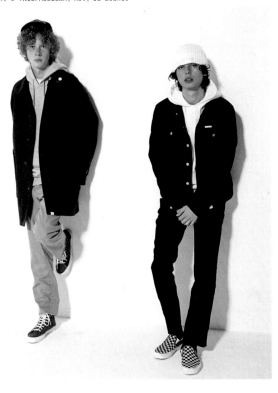

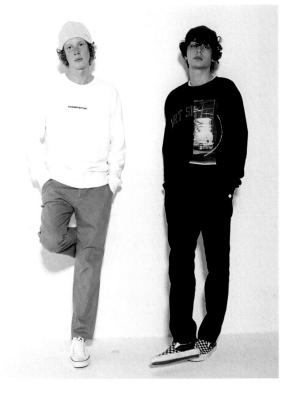

[L] TN15FTO017YH, Sweatshirt, Twisted Van Crewneck ◉ TN15FBT003WH, Pants, Chino Pant ◉ TN15FAC013WH, Hat, OG Beanie ◉ [R] TN15FOW011PA, Jacket, Varsity Jacket ◉ TN15FTO012BK, Sweatshirt, Art Service Crewneck ◉ TN15FBT006BK, Pants, Denim Pant ◉ TN15FAC003BK, Hat, BCGC 6P-Cap ◉ VA15FAC001GG, Shoes, VANS × TINT Authentic

TN15FOW012BL, Jacket, M-51 ◉ TN15FTO017YH, Sweatshirt, Twisted Van Crewneck ◉ TN15FBT003WH, Pants, Chino Pant ◉ TN15FAC013WH, Hat, OG Beanie

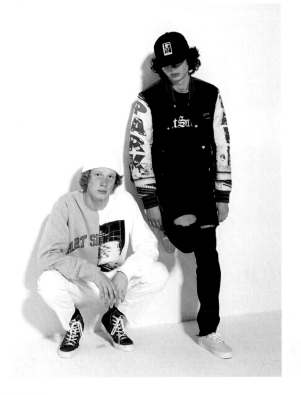

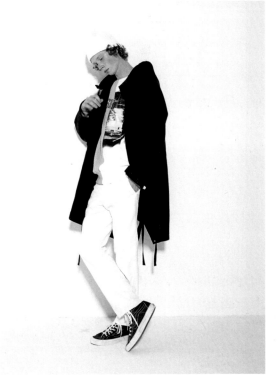

SIX HOARS
TO HOME

DRAWING
AND
(6:55)
SKATE

CALL NOW 342

BLACK COFFEE
Going COLD

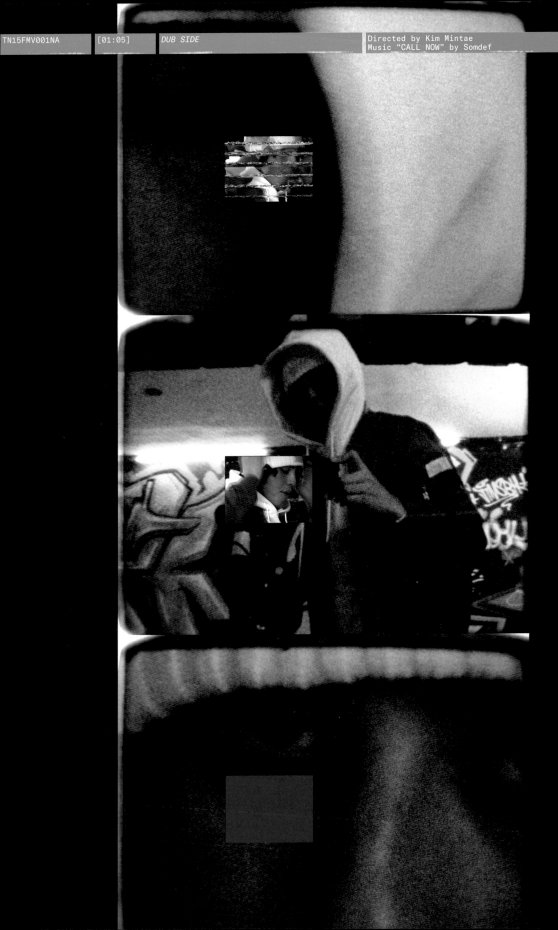

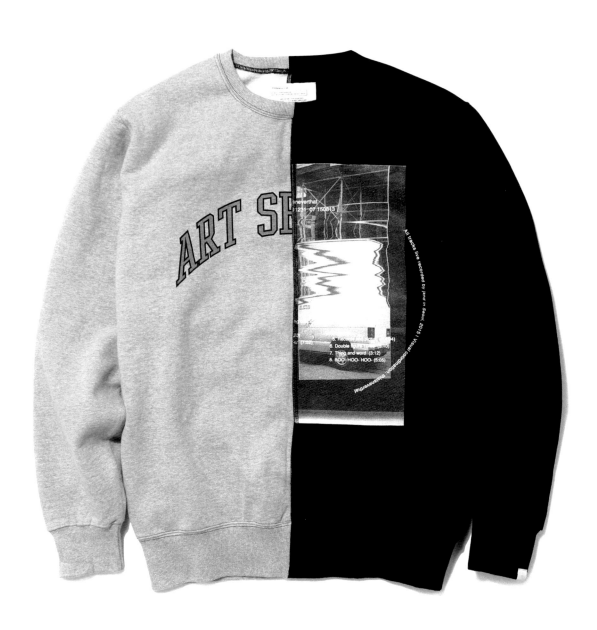

TN15FOW006NA / Jacket
RP Reversible MA-1
Nylon, Cotton, Rayon / Navy

TN15FOW002BE / Jacket
MA-1 Down Jacket
Nylon, Polyester, Down, Feather / Beige

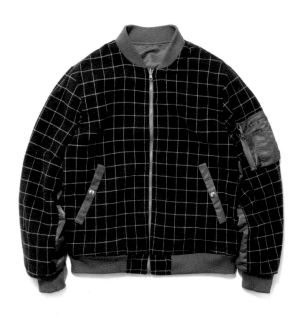

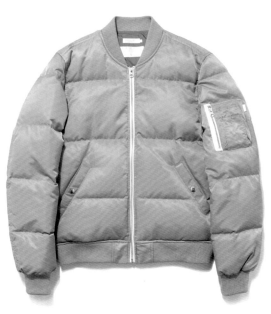

TN15FTO009LP / Sweatshirt
Back Pullover
Cotton / Color Photo

TN15FTO003GR / Sweatshirt
Six Hours Pullover
Cotton / Grey

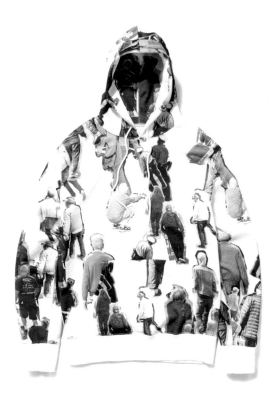

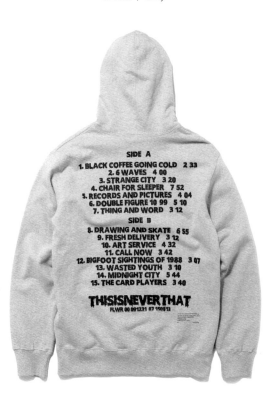

TN15FOW004GR / Jacket
Wool Trench Coat
Wool, Polyester / Grey

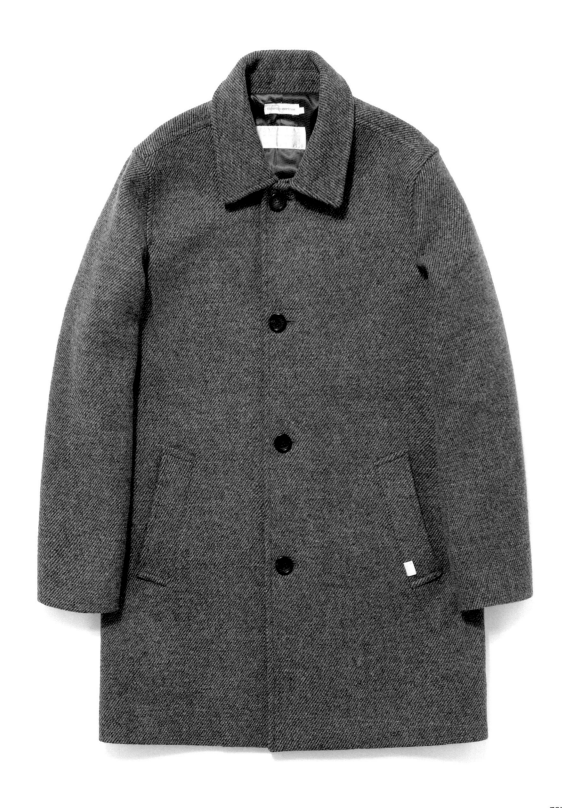

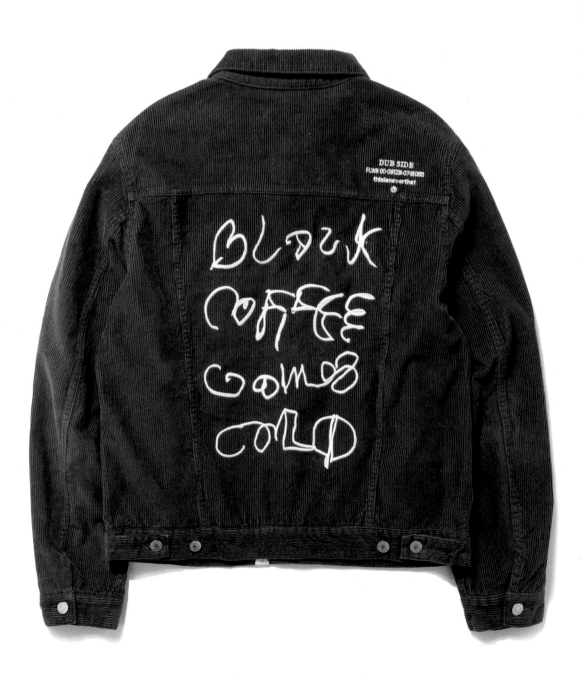

SIDE- A

1. Black coffee going cold (2:33)

2. 6 waves (4:00)

3. Strange city (3:20)

4. Chair for sleeper (7:52)

5. Records and pictures (4:04)

6. Double figure 10-99 (5:10)

7. Thing and word (3:12)

DUB SIDE

(P) & © 2015 thisisneverthat RECORDS Ltd.

All tracks live recorded by jknd in Seoul, 2015 I Visual coodination: thisisneverthat

thisisneverthat

FLWR 00-091231-07-150813

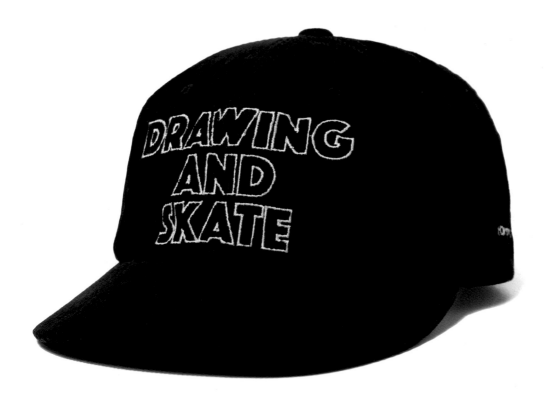

TN15FOW005BK / Jacket
Double Coat
Wool, Nylon, Polyester / Black

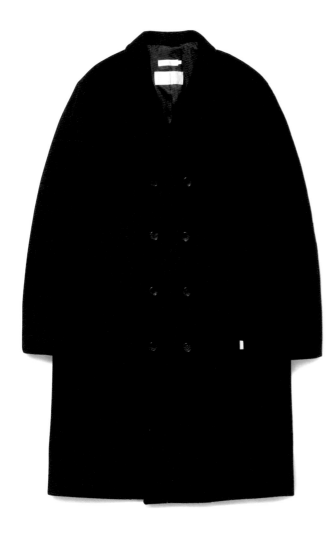

TN15FBT006BL / Jean
Denim Pant
Cotton / Blue

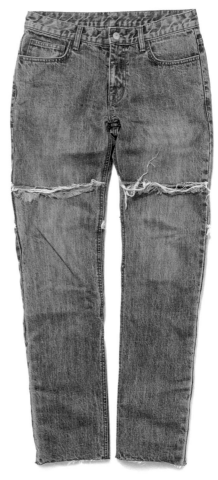

TN15FAC003BK / Hat
BCGC 6P Cap
Cotton / Black

TN15FAC012WH / Hat
Youth Beanie
Polyester / White

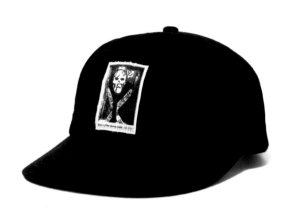

TN15FAC018OM / Accessory
iPhone 6 Case
Polycarbonate / Old Man

TN15FAC015RN / Accessory
Muffler
Acrylic / Red/Navy

TN15FOW011HW

TN15FOW011PA

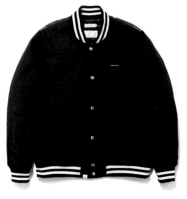 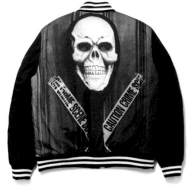 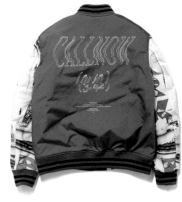

TN15FTO018GV

TN15FTO012BK

TN15FTO005GR

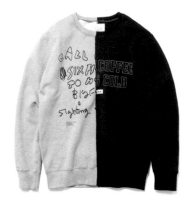

TN15FOW003CD

TN15FTO001SB

TN15FTO007BC

 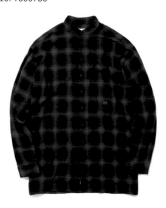

TN15FOW011HW	Jacket	Varsity Jacket	Polyester	Halloween
TN15FOW011PA	Jacket	Varsity Jacket	Polyester	Park
TN15FTO018GV	Sweatshirt	Cold Coffee Crewneck	Cotton	Grey, Navy
TN15FTO012BK	Sweatshirt	Art Service Crewneck	Cotton	Black
TN15FTO005GR	Sweatshirt	Art Crewneck	Cotton	Grey
TN15FOW003CD	Jacket	Zip Shirt	Acrylic	Check Black, Check Red
TN15FTO001SB	Shirt	T Oxford Shirt	Cotton	Sky Blue
TN15FTO007BC	Shirt	S/C Long Shirt	Cotton	Blue Check
TN15FTO003NA	Sweatshirt	Six Hours Pullover	Cotton	Navy
TN15FBT004BK	Pants	City Jogger Pant	Polyester, Rayon, Spandex	Black
TN15FOW007BK	Jacket	Duffle Coat	Wool, Nylon, Polyester	Black
TN15FTO008BE	Shirt	Hooded Shirt	Cotton	Beige

TN15FTO003NA

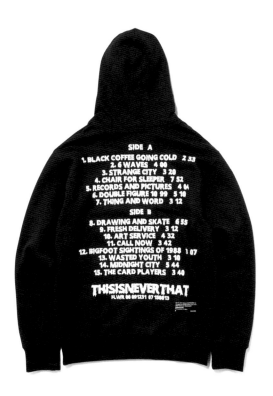

TN15FBT004BK

TN15FOW007BK

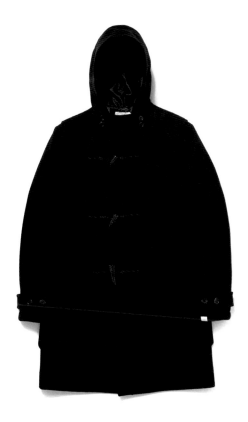

TN15FTO008BE

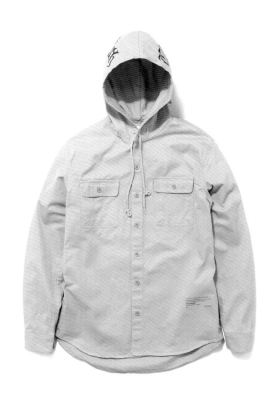

DUB SIDE

TN15FAC020BK

TN15FAC021BK

TN15FAC001BE

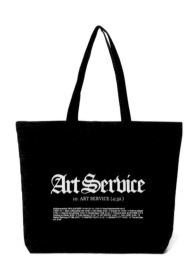 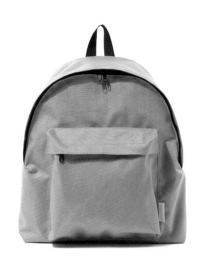

TN15FAC019NG

TN15FAC022NA

TN15FAC005MT

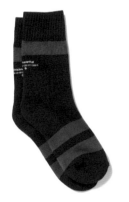 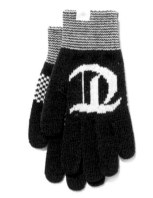 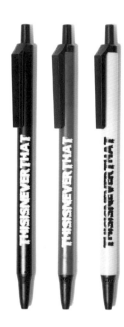

TN15FAC004NA

TN15FAC002GN

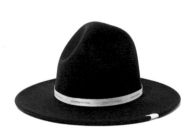 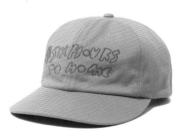

TN15FAC020BK	Bag	Art Service Tote	Cotton	Black
TN15FAC021BK	Bag	Track List Tote	Cotton	Black
TN15FAC001BE	Bag	Daypack	Nylon	Beige
TN15FAC019NG	Socks	Sport Socks	Cotton, Rubber	Navy, Green
TN15FAC022NA	Accessory	WY Gloves	Acrylic	Navy
TN15FAC005MT	Accessory	BIC® Ballpen	Plastic	Multi
TN15FAC004NA	Hat	Wool Felt Hat	Wool	Navy
TN15FAC002GN	Hat	Six Hours 6P Cap	Cotton	Green

TN15FAC016LG

TN15FAC016WY

TN15FAC016YW

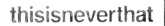

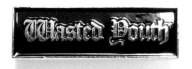

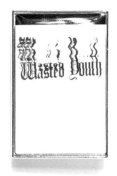

TN15FAC016HH

TN15FAC016WW

TN15FAC016TT

TN15FAC016OM

TN15FAC006MT

TN15FAC016LG	Accessory	Pin		STS	White
TN15FAC016WY	Accessory	Pin		STS	Wasted Youth
TN15FAC016YW	Accessory	Pin		STS	White
TN15FAC016HH	Accessory	Pin		STS	Boo Hoo Hoo
TN15FAC016WW	Accessory	Pin		STS	White
TN15FAC016TT	Accessory	Pin		STS	Black
TN15FAC016OM	Accessory	Pin		STS	Old Man
TN15FAC006MT	Accessory	Hotel Key Tag		Plastic	Multi

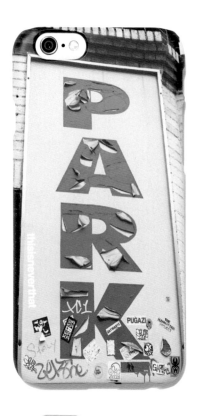

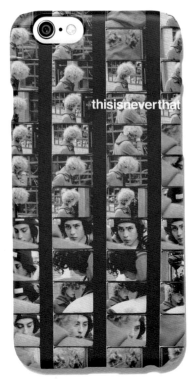

thisisneverthat

FW15 DUB SIDE 00-091231-07-150813

// SIDE- A /
/ 1. Black coffee going cold (2:33)
/ 2. 6 waves (4:00)
/ 3. Strange city (3:20)
/ 4. Chair for sleeper (7:52)
/ 5. Records and pictures (4:04)
/ 6. Double figure 10-99 (5:10)
/ 7. Thing and word (3:12)

// SIDE- B /
/ 8. Drawing and Skate (6:55)
/ 9. Fresh Delivery (3:12)
/ 10. ART SERVICE (4:32)
/ 11. CALL NOW (3:42)
/ 12. Bigfoot Sightings Of 1988 (3:07)
/ 13. WASTED YOUTH (3:10)
/ 14. MIDNIGHT CITY (5:44)
/ 15. The card players (3:40)

Collaborator

Release Date
Sep 25, 2015

Prefix
VA

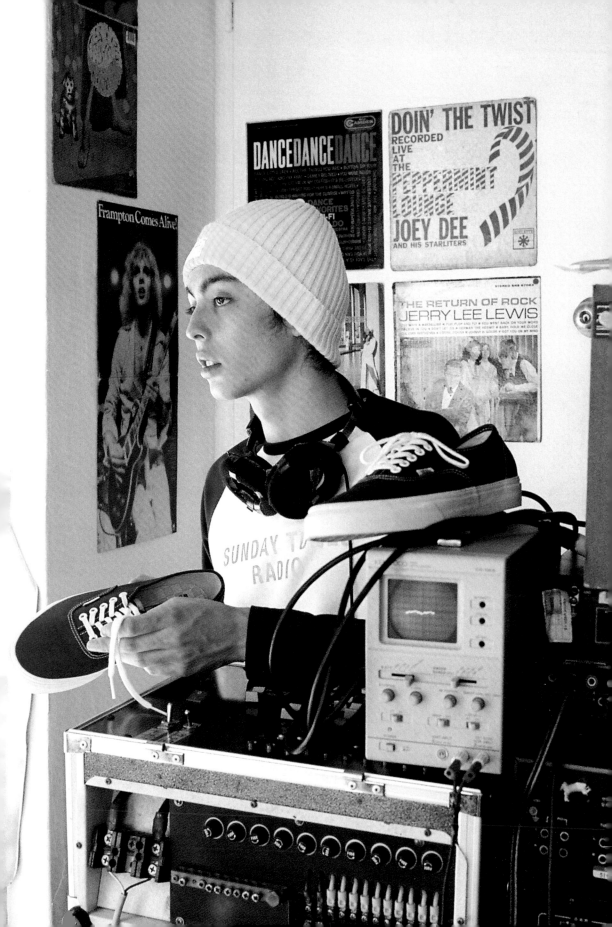

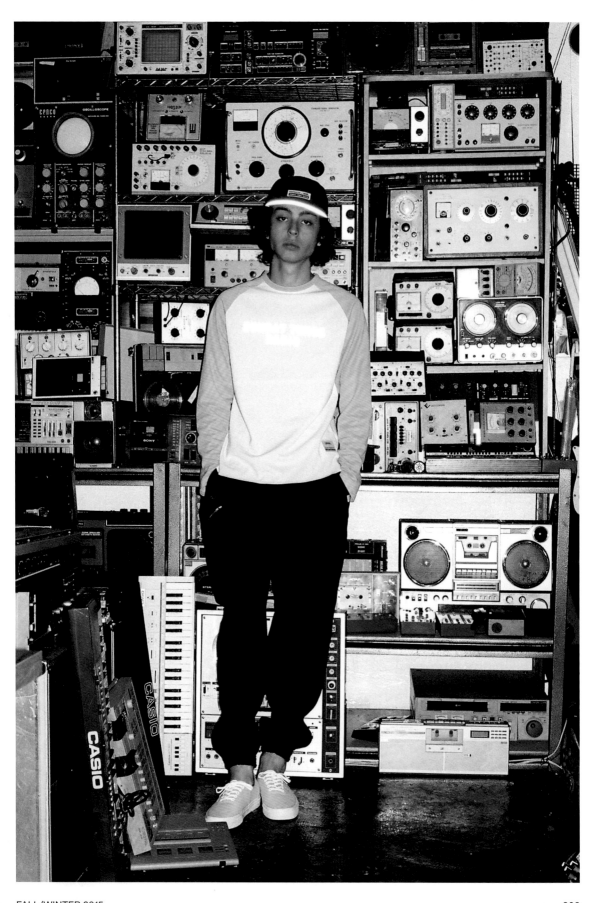

TN15FAC013NN / Hat
OG Beanie
Cotton / Neon

VA15FAC003BP / Hat
VANS × TINT Camp Cap
Nylon / Blue Print

VA15FTO001GG / Long Sleeve Tee
VANS × TINT Baseball Jersey
Cotton / Gecko Green

VA15FAC001BP / Shoes
VANS × TINT Authentic
Cotton / Blue Print

VA15FAC002BP / Shoes
VANS × TINT Classic Slip-On
Cotton / Blue Print

VANS × thisisneverthat

VANS × thisisneverthat

#thisisneverthat FW15 DUB SIDE / 00-091231-07-150813 // www.thisisneverthat.com //
// SIDE- A // 1. Black coffee going cold (2:33) / 2. SIX waves (4:00) / 3. Strange city (3:20) / 4. Chair for sleeper (7:52) / 5. Records and pictures (4:04) / 6. Double figure 10-99 (5:10) / 7. Thing and word (3:12) // SIDE- B // 8. Drawing and Skate (6:55) / 9. Fresh Delivery (3:12) / 10. ART SERVICE (4:32) / 11. CALL NOW (3:42) / 12. Bigfoot Sightings Of 1988 (3:07) / 13. WASTED YOUTH (3:10) / 14. MIDNIGHT CITY (5:44) / 15. The card players (3:40)

thisisneverthat

SPRING/SUMMER 2015

LAKE ON FIRE

TN15STO024NA, Tee, Bike/Woods Tee ◙ TN15SBT005US, Pants, Jogging Short ◙ TN15SAC003BE, Hat, O.G Ripstop Camp Cap ◙ TN15SAC012CA, Shoes, PUMA × thisisneverthat TRINOMIC XT2+

TN15STO005WH, Tee, Rode Back Zip Tee ◙ TN15SBT004BK, Pants, Relaxed Pant ◙ TN15SAC005WH, Hat, New Wave Bucket Hat

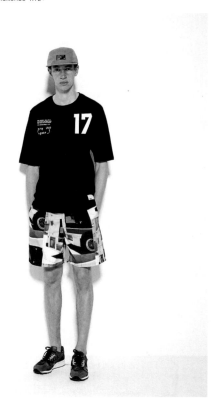

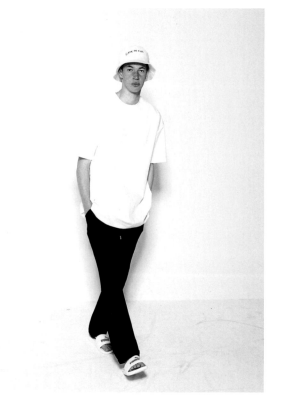

TN15SOW002WH, Jacket, PATH Trucker Jacket ◙ TN15STO008WH, Tee, N FOOTBALL Tee ◙ TN15SBT001OV, Pants, Flight Pant ◙ TN15SAC007BE, Hat, New Wave 6P Cap

TN15STO004RD, Shirt, Lake S/C Long Shirt ◙ TN15STO021GR, Sweatshirt, B.Court Pullover ◙ TN15SBT001OV, Pants, Flight Pant ◙ TN15SAC006RD, Hat, Lake on Fire 6P Cap

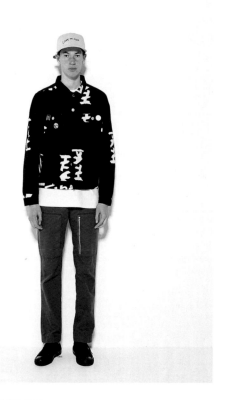

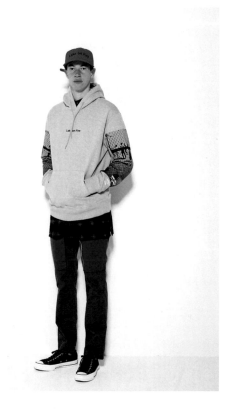

TN15SOW008NA, Jacket, Anorak ◉ TN15STO004BL, Shirt, Lake S/C Long Shirt
◉ TN15SBT002NA, Pants, Jogger Pant ◉ TN15SAC007NA, Hat, New Wave 6P Cap

TN15SOW007SA, Jacket, Coach Jacket ◉ TN15STO029WH, Tee, Rode Mesh Tee ◉
TN15SBT003BE, Pants, Washed Cotton Short ◉ TN15SAC005WH, Hat, New Wave
Bucket Hat

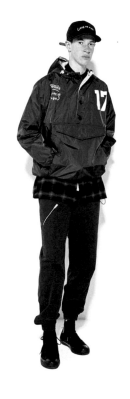 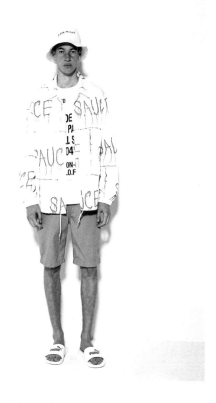

TN15STO014BK, Shirt, Lake Long Shirt ◉ TN15STO009WH, Tee, Striped Rib
Tee ◉ TN15SBT002BK, Pants, Jogger Pant ◉ TN15SAC004BK, Hat, O.G Bucket
Hat ◉ TN15SAC022PE, Bag, Gym Sack

TN15STO013CK, Shirt, Rode Long Shirt ◉ TN15STO017CK, Tee, Lake Zip Tee
◉ TN15SBT003CK, Pants, Washed Cotton Short

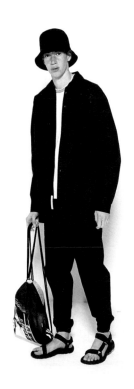 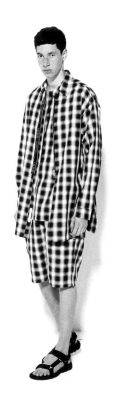

TN15STO015WH, Top, Baseball Jersey ❚ TN15STO032WH, Tee, N Football Tee ❚ TN15SBT002BK, Pants, Jogger Pant ❚ TN15SAC006BK, Hat, Lake on Fire 6P Cap

TN15STO018BK, Sweatshirt, MA-1 Crewneck ❚ TN15SBT002BK, Pants, Jogger Pant ❚ TN15SAC011BK, Shoes, PUMA × thisisneverthat TRINOMIC XT2+ ❚ TN15SAC005WH, Hat, New Wave Bucket Hat

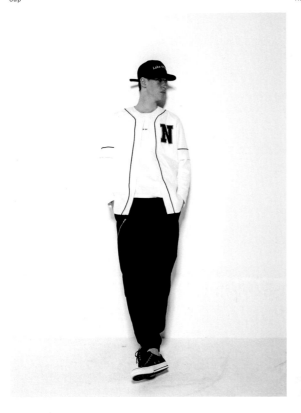

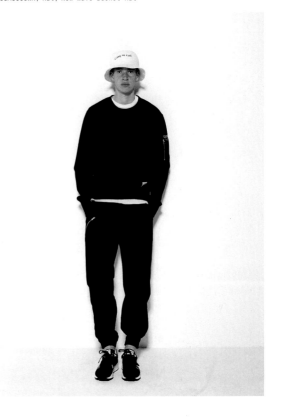

TN15SOW001CL, Jacket, Zip Shirt ❚ TN15STO026BT, Tee, Polka Dot Tee ❚ TN15SBT003OV, Pants, Washed Cotton Short ❚ TN15SAC006BK, Hat, Lake on Fire 6P Cap ❚ TN15SAC011BK, Shoes, PUMA × thisisneverthat TRINOMIC XT2+

TN15STO021BK, Sweatshirt, B.Court Pullover ❚ TN15SBT001BK, Pants, Flight Pant ❚ TN15SAC006WH, Hat, Lake on Fire 6P Cap

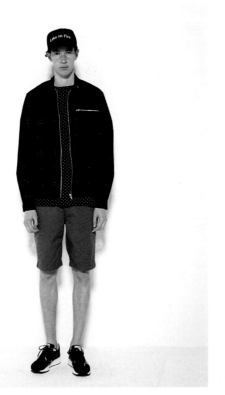

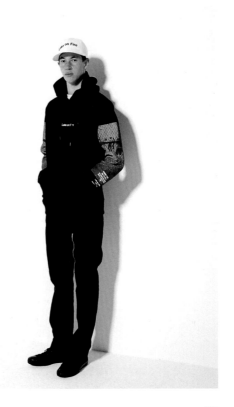

TN15SOW004SI, Jacket, Soutien Collar Coat ◉ TN15STO011BK, Tee, New Wave Tee ◉ TN15SBT001BK, Pants, Flight Pant ◉ TN15SAC006BK, Hat, Lake on Fire 6P Cap

TN15STO006WH, Tee, JN Long Tee ◉ TN15SBT002BK, Pants, Jogger Pant ◉ TN15SAC008BK, Hat, T-Logo Cap

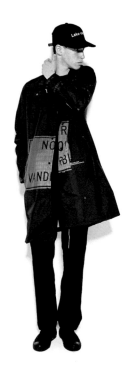

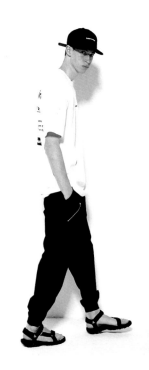

TN15SOW002WH, Jacket, PATH Trucker Jacket ◉ TN15STO008WH, Tee, N Football Tee ◉ TN15SBT001OV, Pants, Flight Pant ◉ TN15SAC007BE, Hat, New Wave 6P Cap

TN15SOW001CY, Jacket, Zip Shirt ◉ TN15STO024OV, Tee, Bike/Woods Tee ◉ TN15SBT008BE, Pants, 1Tuck Short ◉ TN15SAC012CA, Shoes, PUMA × thisisneverthat TRINOMIC XT2+ ◉ TN15SAC007BE, Hat, New Wave 6P Cap

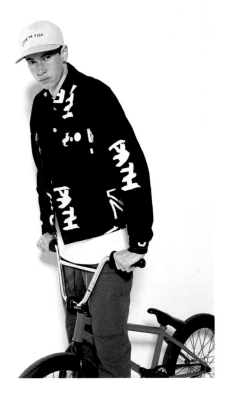

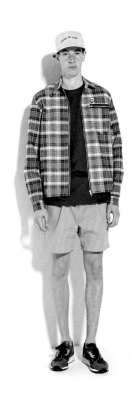

TN15SOW008BK, Jacket, Anorak ▌ TN15STO010BK, Sweatshirt, S/S Crewneck ▌ TN15SBT005SU, Pants, Jogging Short ▌ TN15SAC007BE, Hat, New Wave 6P Cap

TN15SOW001BK, Jacket, Zip Shirt ▌ TN15STO021BK, Sweatshirt, B.Court Pullover ▌ TN15SBT001BK, Pants, Flight Pant ▌ TN15SAC006WH, Hat, Lake on Fire 6P Cap

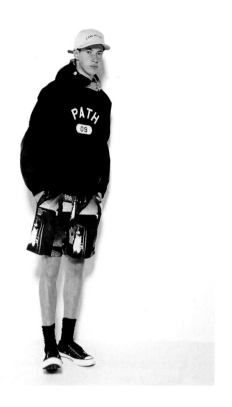

TN15STO005BK, Tee, Rode Back Zip Tee ▌ TN15SBT004CR, Pants, Relaxed Pant ▌ TN15SAC004BK, Hat, O.G Bucket Hat

TN15STO025NI, Tee, PATH Tee ▌ TN15SBT002NA, Pants, Jogger Pant ▌ TN15SAC007BK, Hat, New Wave 6P Cap ▌ TN15SAC011BK, Shoes, PUMA × thisisneverthat TRINOMIC XT2+

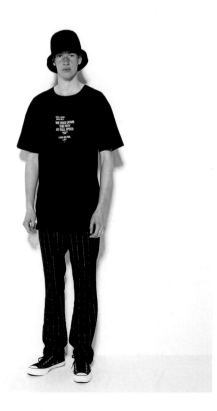

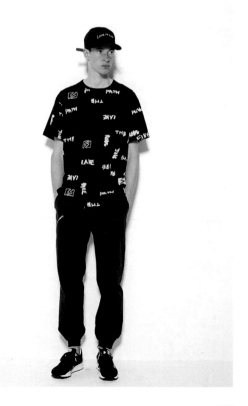

TN15STO011BL, Tee, New Wave Tee ❚ TN15SBT006BL, Pants, PATH Short ❚
TN15SAC006BK, Hat, Lake on Fire 6p Cap

TN15SOW007PE, Jacket, Coach Jacket ❚ TN15STO022BK, Tee, G.Logo Tee
❚ TN15SBT007BK, Pants, Zip Short ❚ TN15SAC011BK, Shoes, PUMA ×
thisisneverthat TRINOMIC XT2+ ❚ TN15SAC008BK, Hat, T-Logo Cap

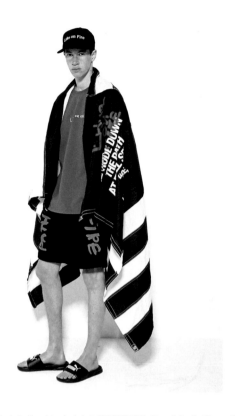

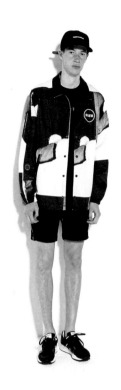

TN15SOW005NP, Jacket, Varsity Jacket ❚ TN15STO008WH, Tee, N Football
Tee ❚ TN15SBT005BK, Pants, Jogging Short ❚ TN15SAC006WH, Hat, Lake on
Fire 6P Cap

TN15STO002NE, Tee, Two Tone Tee ❚ TN15SBT007BK, Pants, Zip Short ❚
TN15SAC004BK, Hat, O.G Bucket Hat

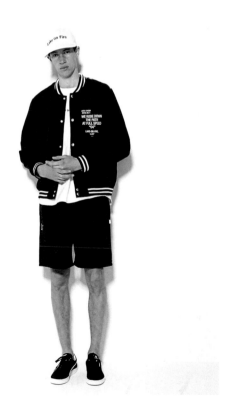

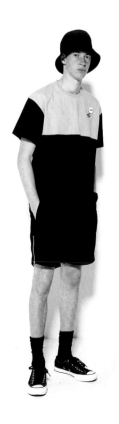

LAKE ON FIRE

"So, have you seen him?

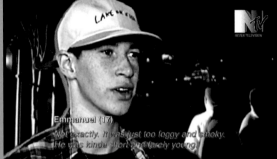

Emmanuel (17)
Not exactly. It was just too foggy and smoky.
He was kinda short and fairly young.

"Did you get to see him set it on fire?

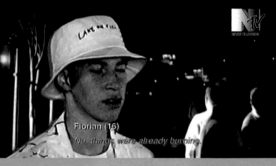

Florian (16)
No, things were already burning.

"Can you describe him?

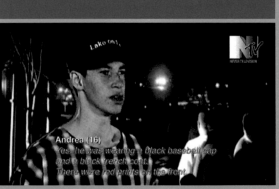

Andrea (16)
Yes, he was wearing a black baseball cap
and a black trenchcoat.
There were red prints on the front.

Andrea (16)
*Yes, he was wearing a black baseball cap
and a black trench coat.
There were red prints on the front.*

*Please tell us more about what you saw that day

1. At the break of dawn, I stumbled upon the lake on fire.

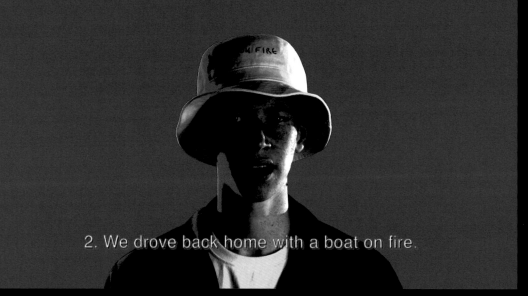

2. We drove back home with a boat on fire.

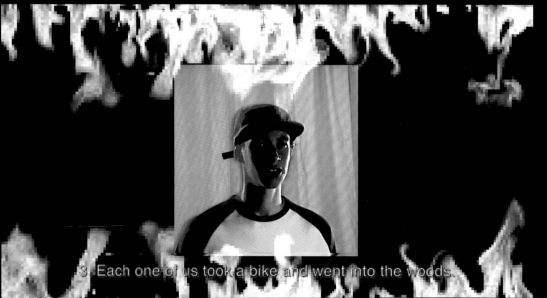

3. Each one of us took a bike and went into the woods.

4. We rode down the path at full speed.

5. When looking back.

There we saw the lake on fire.

Lake on FIRE

We drove back home with a boat on FIRE. At Breakdown, I stumbled upon the lake ON FIRE. Each one of us took a bike and went into the woods. we rode down the path at full speed

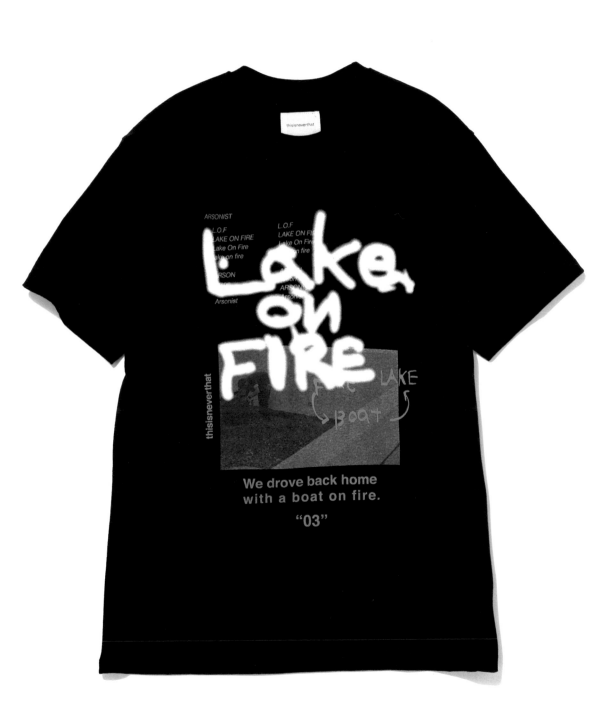

LAKE ON FIRE

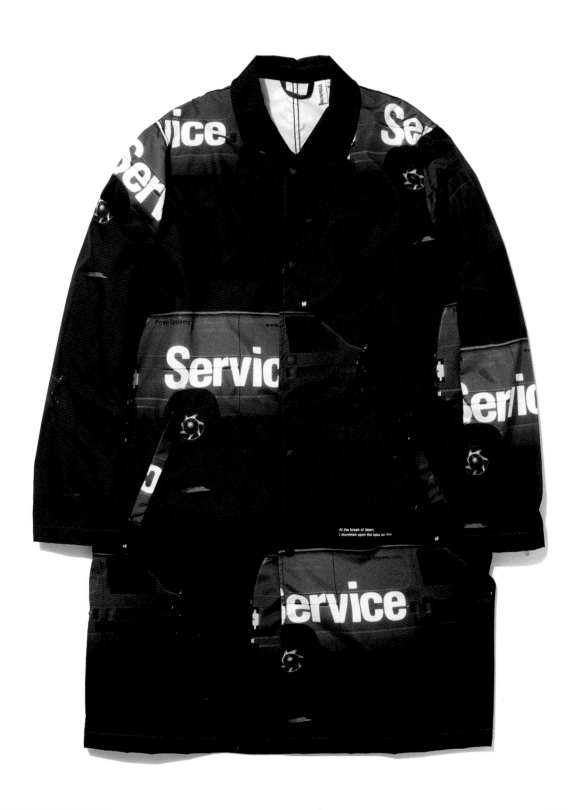

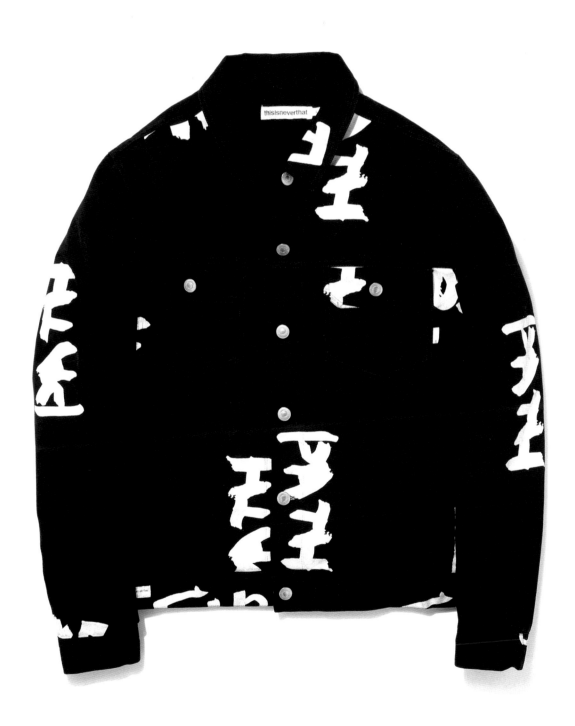

LAKE ON FIRE

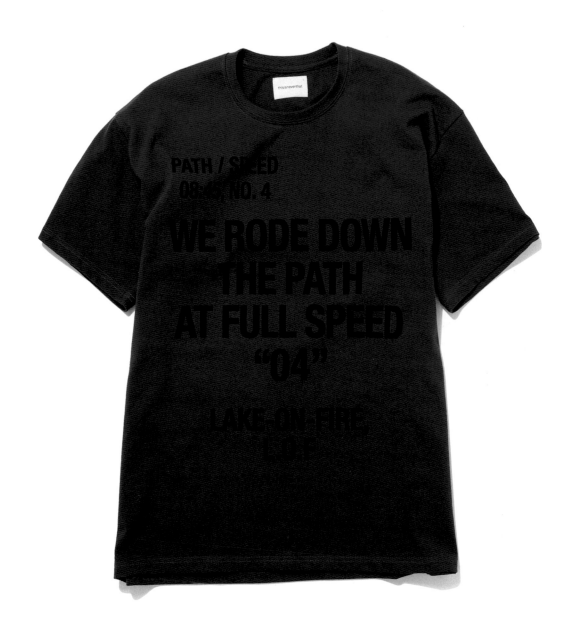

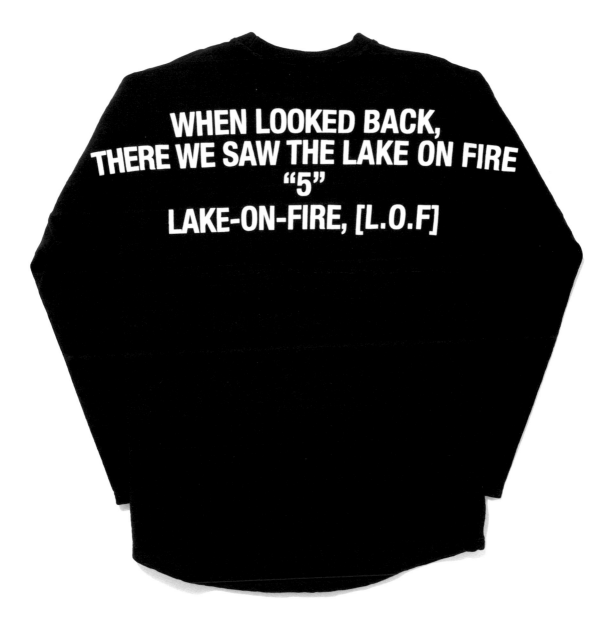

TN15SOW006BK

TN15SOW001CL

TN15SOW007PE

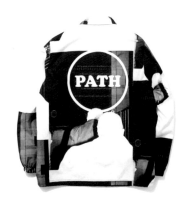

TN15SBT002BK

TN15STO004BL

TN15STO016WH

TN15STO019BK

TN15STO020GR

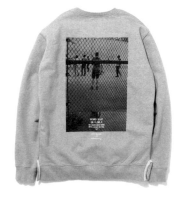

TN15SOW006BK	Jacket	Coach Jacket	Polyester	Black
TN15SOW001CL	Jacket	Zip Shirt	Cotton	Check Black
TN15SOW007PE	Jacket	Coach Jacket	Polyester	People
TN15SBT002BK	Pants	Jogger Pant	Cotton, Nylon	Black
TN15STO004BL	Shirt	Lake S.C Long Shirt	Cotton	Blue
TN15STO016WH	Shirt	Rode Oxford Shirt	Cotton	White
TN15STO019BK	Sweatshirt	L.O.F Crewneck	Cotton	Black
TN15STO020GR	Sweatshirt	B.Court Crewneck	Cotton	Grey

TN15SOW008NA / Jacket
Anorak
Nylon / Navy

TN15STO024OV / Tee
Bike/Woods Tee
Cotton / Olive

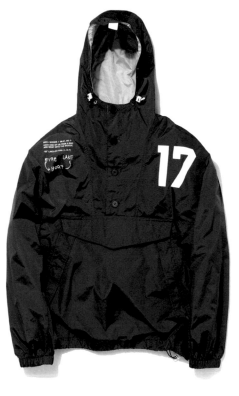

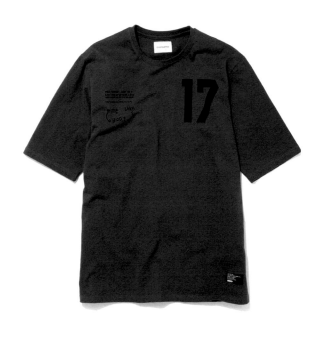

TN15SOW005US / Jacket
Varsity Jacket
Polyester / Bus

TN15STO022WH / Tee
G.Logo Tee
Cotton / White

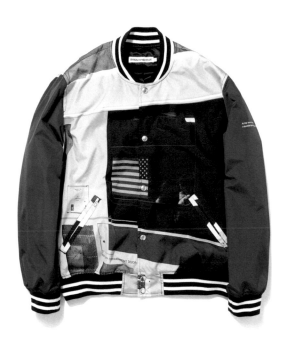

thisisneverthat

TN15STO021BK / Sweatshirt
B.Court Pullover
Cotton / Black

TN15STO013CK / Shirt
Rode Long Shirt
Cotton / Check

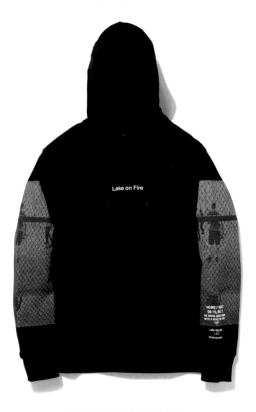

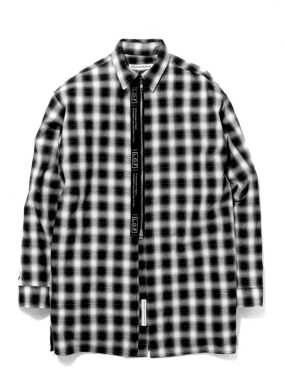

TN15STO010BK / Sweatshirt
S/S Crewneck
Cotton / Black

TN15SBT001OV / Pants
Flight Pant
Cotton / Olive

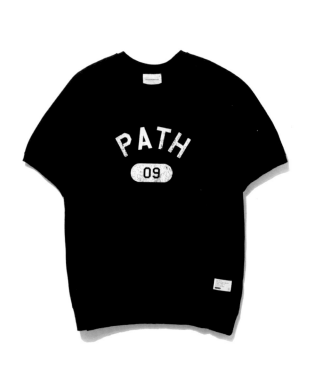

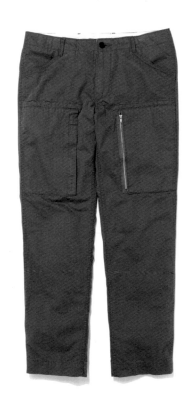

TN15STO015BK

TN15STO025NI

TN15STO001NW

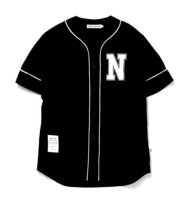

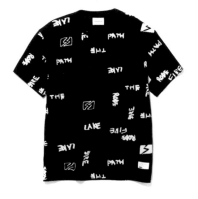

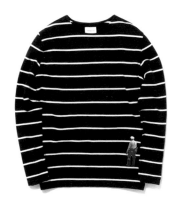

TN15STO007GN

TN15STO017CK

TN15STO006WH

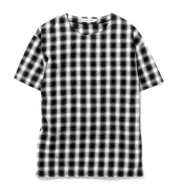

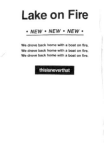

TN15SBT007OV

TN15SBT005BK

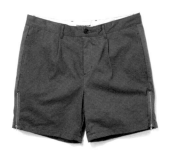

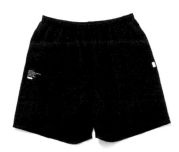

TN15STO015BK	Top	Baseball Jersey	Cotton	Black
TN15STO025NI	Tee	PATH Tee	Cotton	Navy, White
TN15STO001NW	Long Sleeve Tee	Striped Round Neck Tee	Cotton	Navy, White
TN15STO007GN	Tee	Lake on Fire Tee	Cotton	Green
TN15STO017CK	Tee	Lake Zip Tee	Cotton	Check
TN15STO006WH	Tee	JN Long Tee	Cotton	White
TN15SBT007OV	Pants	Zip Short	Cotton	Olive
TN15SBT005BK	Pants	Jogging Short	Nylon	Black

LAKE ON FIRE

TN15SAC007BE

TN15SAC007BK

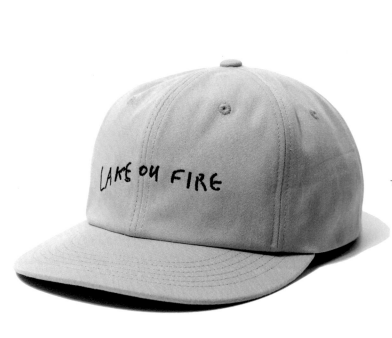

TN15SAC003WH

TN15SAC028SI

TN15SAC028US

TN15SAC033NA

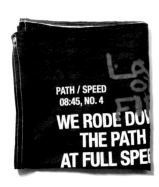

TN15SAC024FI, TN15SAC024LK, TN15SAC024LO, TN15SAC024PT

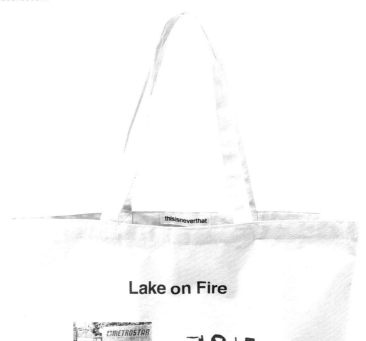

TN15SAC030PN

TN15SAC007BE	Hat	New Wave 6P Cap	Cotton	Beige
TN15SAC006BK	Hat	Lake on Fire 6P Cap	Cotton	Black
TN15SAC003WH	Hat	O.G Ripstop Camp Cap	Cotton	White
TN15SAC028SI	Hat	LF O.G Camp Cap	Polyester	Sign
TN15SAC028US	Hat	LF O.G Camp Cap	Polyester	Rus
TN15SAC033NA	Accessory	Lake on Fire Flag	Cotton	Navy
TN15SAC024FI	Accessory	Pin	STS	Fire
TN15SAC024LK	Accessory	Pin	STS	Lake
TN15SAC024LO	Accessory	Pin	STS	Lake on Fire
TN15SAC024PT	Accessory	Pin	STS	Path
TN15SAC009WH	Bag	New Wave Tote (S)	Cotton	White
TN15SAC017WH	Accessory	Hotel Key Tag	Plastic	White
TN15SAC030PN	Accessory	LF iPhone Case	Polycarbonate	N.P

Collaborator

Release Date
Feb 28, 2015

Prefix
TN

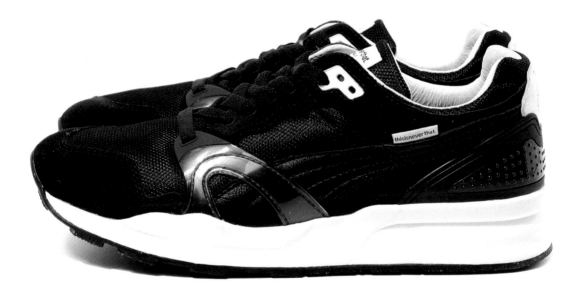

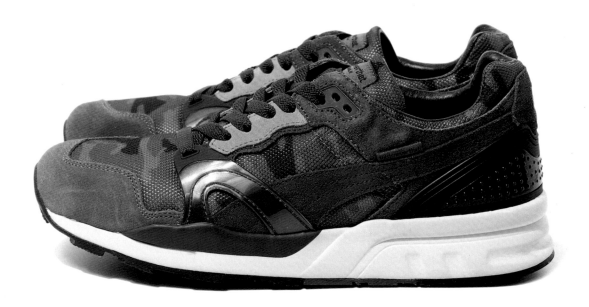

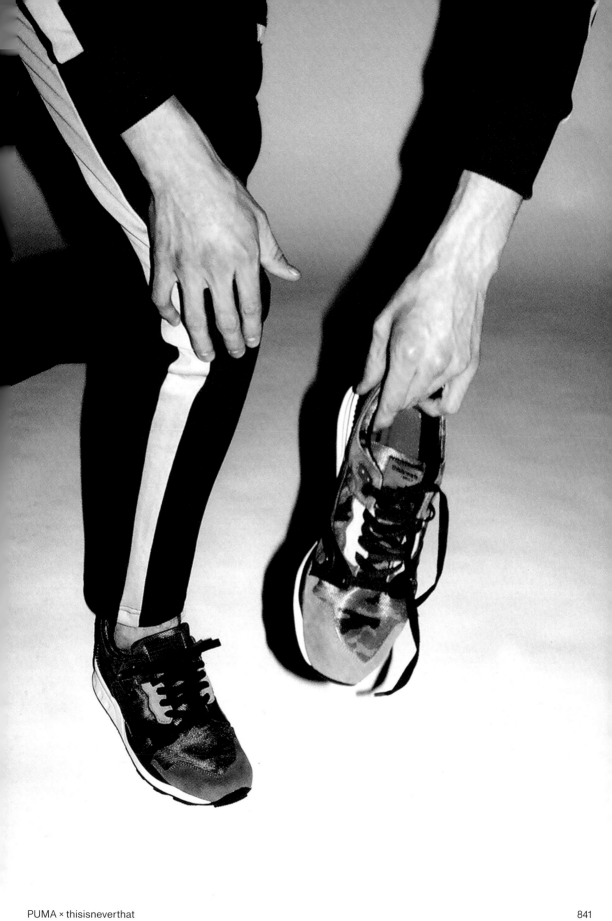

PUMA × thisisneverthat

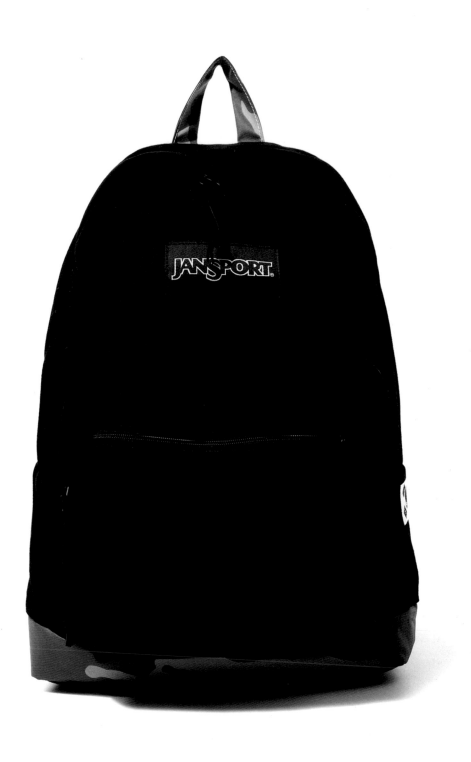

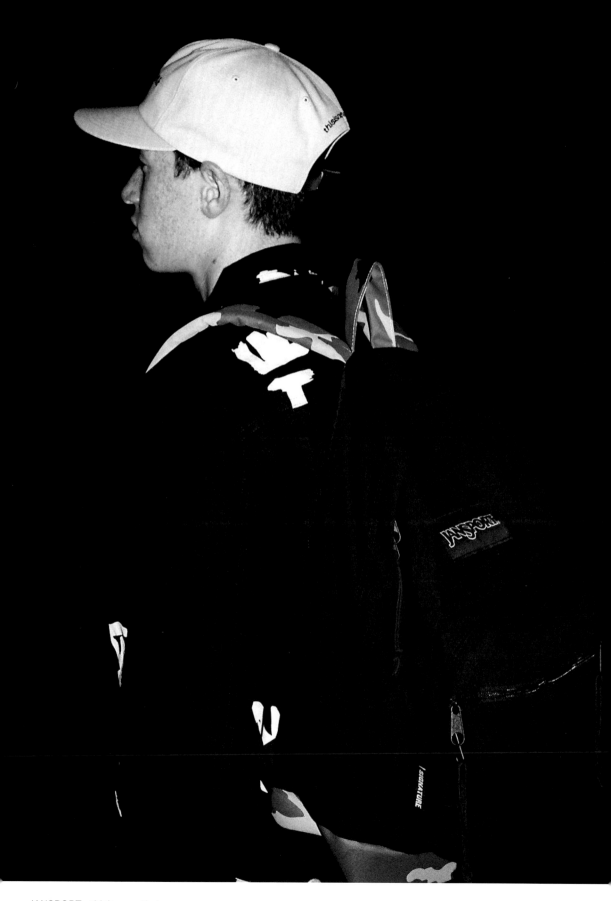

JANSPORT × thisisneverthat

thisisneverthat
SS15
Lake on Fire

Title: thisisneverthat SS15 - Lake on Fire /
Our Spring-Summer 2015 collection is based on 5 phrases that tells a story.
Those phrases were then taken down into smaller pieces, mostly words,
to describe imaginary characters of our own. The full collection was built and
expanded by designing looks of 3 main characters from the story.

thisisneverthat

thisisneverthat
SS15
Lake on Fire

Title; thisisneverthat SS15 - Lake on Fire /
Our Spring-Summer 2015 collection is based on 5 phrases that tells a story.
Those phrases were then taken down into smaller pieces, mostly words,
to describe *imaginary characters* of our own. The full collection was built and
expanded by designing looks of *3 main characters* from the story.

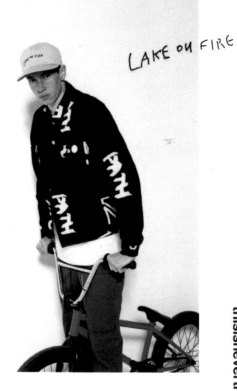

thisisneverthat

FALL/WINTER
2014

NAVY/STUDY

TN14FOW004NA, Jacket, Utility Jacket ◾ TN14FTO005NA, Sweatshirt, Rules Zip Up ◾ TN14FBT001NA, Pants, Rules Sweat Pant ◾ TN14FAC021NA, Hat, Bucket Hat

TN14FTO003BK, Sweatshirt, N.S Crewneck ◾ TN14FAC001BK, Hat, O.G Camp Cap

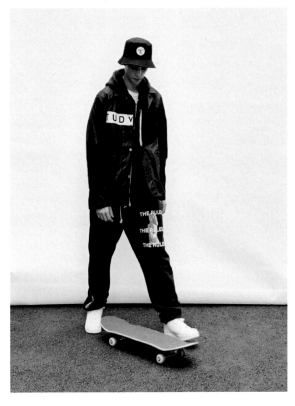

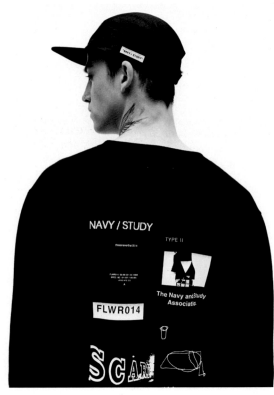

TN14FOW008BK, Jacket, Overcoat ◾ TN14FTO003BK, Sweatshirt, N.S Crewneck ◾ TN14FBT006BK, Pants, Classic Trousers

TN14FTO001GR, Sweatshirt, Boxer Pullover ◾ TN14FBT003OV, Pants, Fatigue Pant ◾ TN14FAC012KN, Hat, K.C Bucket Hat

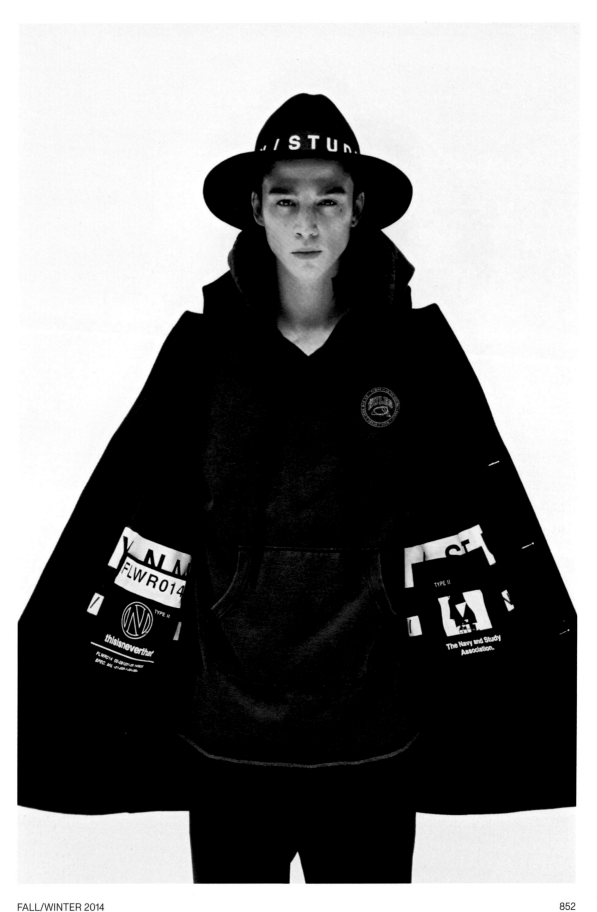

TN14FOW003NA, Jacket, 101 Coat ∥ TN14FTO001WH, Sweatshirt, Boxer
Pullover ∥ TN14FBT007WH, Pants, Work Pant ∥ TN14FAC020BK, Hat, Beanie

TN14FOW005BK, Jacket, MA-1-R ∥ TN14FTO002BK, Tee, Baseball Tee ∥
TN14FBT006BK, Pants, Classic Trousers ∥ TN14FAC001BK, Hat, O.G Camp Cap

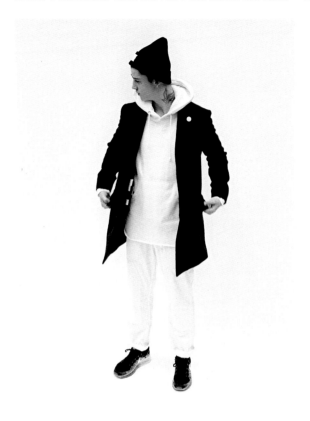

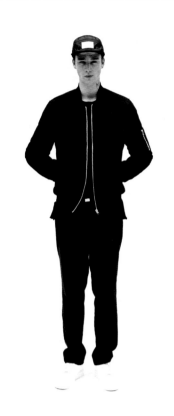

TN14FTO014CH, Top, Brushed Sweater ∥ TN14FAC020BK, Hat, Beanie

TN14FOW009OV, Jacket, M-51 Parka ∥ TN14FTO006WH, Shirt, Rules Shirt ∥
TN14FAC003OB, Hat, Bucket Hat

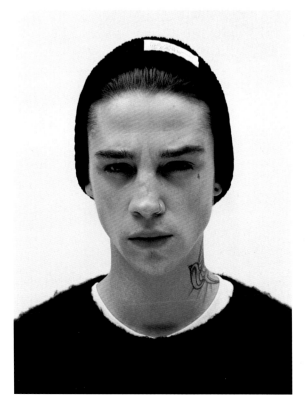

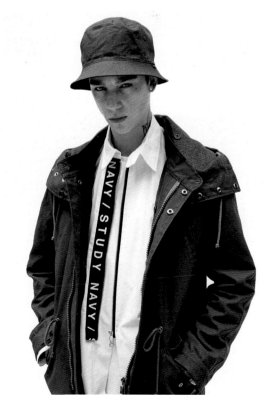

NAVY/STUDY

TN14FOW003CK, Jacket, 101 Coat ● TN14FT0008BK, Sweatshirt, Crewneck Pullover ● TN14FBT006BK, Pants, Classic Trousers ● TN14FAC020BK, Hat, Beanie

TN14FTO004GR, Sweatshirt, Rules Crewneck ● TN14FBT006BK, Pants, Classic Trousers

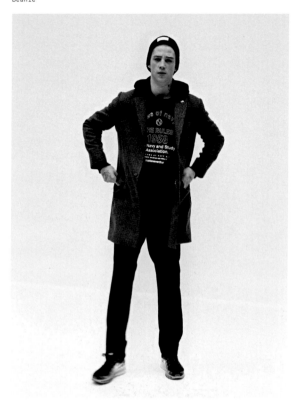

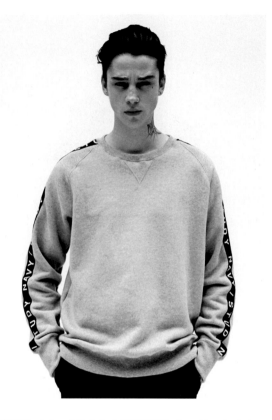

TN14FTO007NA, Sweatshirt, Patched Crewneck ● TN14FAC010CU, Hat, Cuba Camp Cap

TN14FOW009NA, Jacket, M-51 Parka ● TN14FTO007GR, Sweatshirt, Patched Crewneck ● TN14FBT006BK, Pants, Classic Trousers ● TN14FAC001BK, Hat, O.G Camp Cap

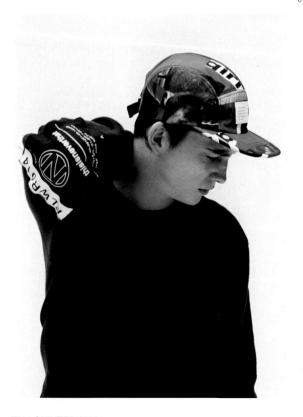

TN14FOW009NA, Jacket, M-51 Parka ▯ TN14FTO007GR, Sweatshirt, Patched Crewneck ▯ TN14FBT006BK, Pants, Classic Trousers ▯ TN14FAC001BK, Hat, O.G Camp Cap

TN14FTO006CK, Shirt, Rules Shirt ▯ TN14FBT006BK, Pants, Classic Trousers ▯ TN14FAC016BK, Hat, N.S Fedora

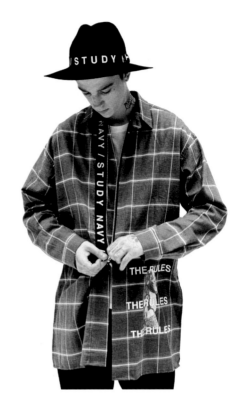

TN14FOW009CU, Jacket, M-51 Parka ▯ TN14FTO004BK, Sweatshirt, Rules Crewneck ▯ TN14FBT006GR, Pants, Classic Trousers ▯ TN14FAC010CU, Hat, Cuba Camp Cap

TN14FOW006NA, Jacket, M-65 Jacket ▯ TN14FTO008NA, Sweatshirt, Crewneck Pullover ▯ TN14FBT006GR, Pants, Classic Trousers ▯ TN14FAC020BL, Hat, Beanie

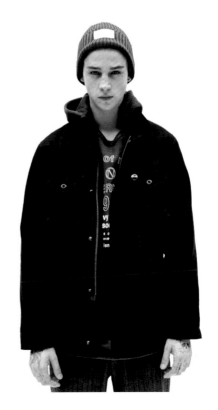

THE NAVY
THE STUDY

combust...
bianchi poveri; 5...
dunque, gli scritto...
bbero essere quegli scritt...
pame o bubbole, o di gente s...
eri, se sono americani), nut...
glie di canna da zucchero), al f...
ovrebbe essere quello di ques...
a Céline mostrava la parte nera del...
uno stile trash, o non è invece uno...
simo? Nella letteratura italiana conte...
medesima importanza che in un salotto...
co. Può accadere che in un salotto eleg...
cuno abbia dimenticato di togliere un...
la padrona o il padrone di casa se ne...
fanno sparire. Altrimenti, sta lì: co...
e, stantio. Ma poi gli ospiti, di bu...
ro le cicche delle loro sigarette,...
posacenere usato qualunque. Irso...
o, a far scomparire il trash. ...
rugge da solo. Ma certo, int...
ette consumate dentro, è is...
crutarne il fondo. In...
stessa parola. Il...
tero. E una p...

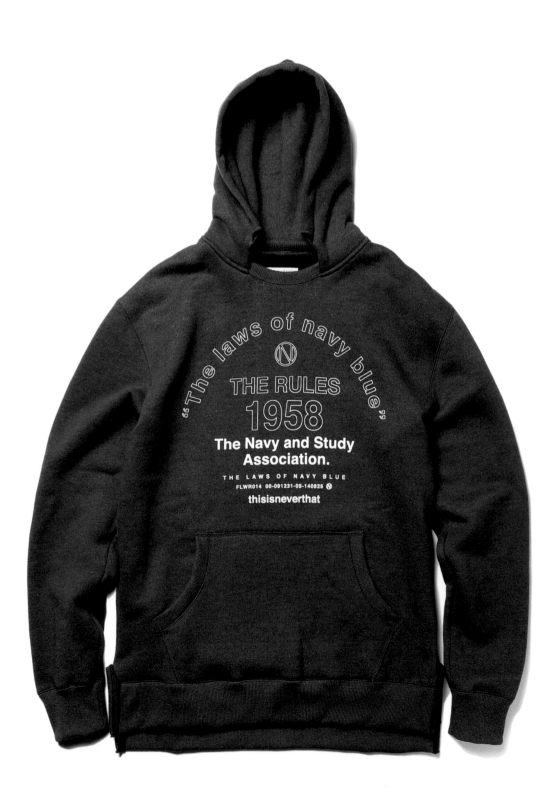

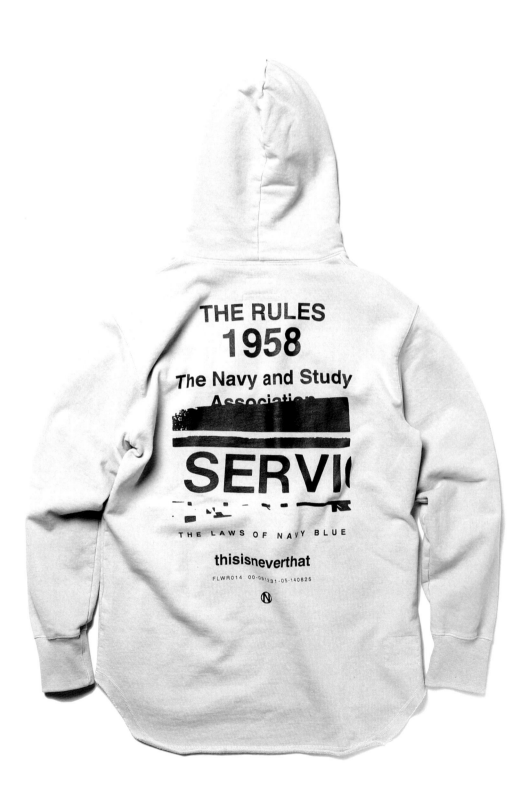

TN14FT0004GR / Sweatshirt
Rules Crewneck
Cotton / Grey

TN14FT0004BK / Sweatshirt
Rules Crewneck
Cotton / Black

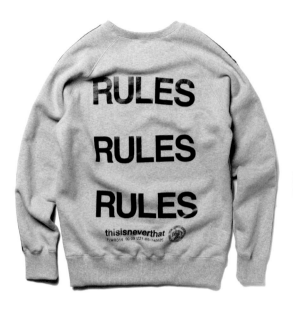

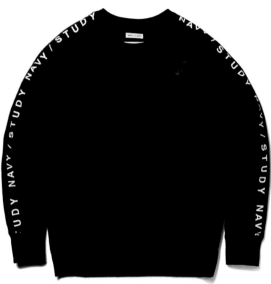

TN14FT0007NA / Sweatshirt
Patched Crewneck
Cotton / Navy

TN14FT0003OV / Sweatshirt
N.S Crewneck
Cotton / Olive

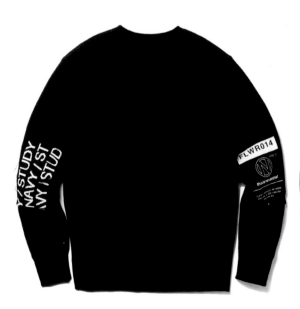

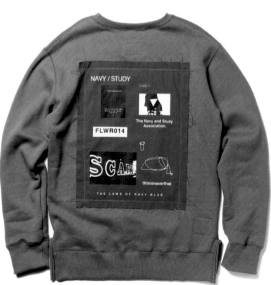

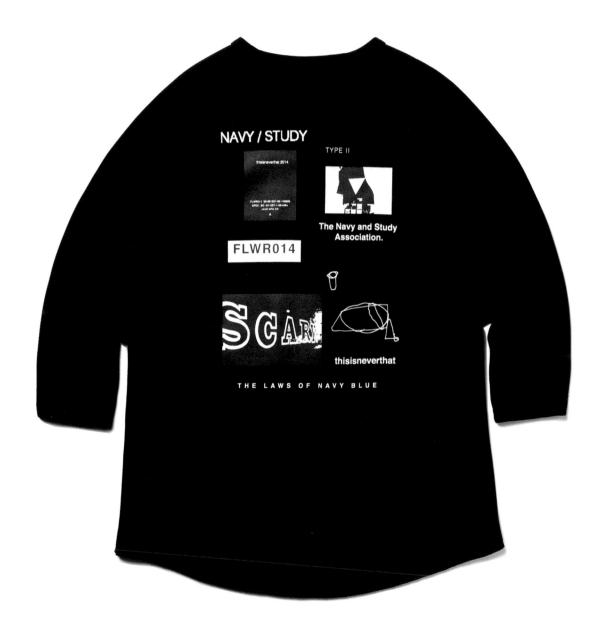

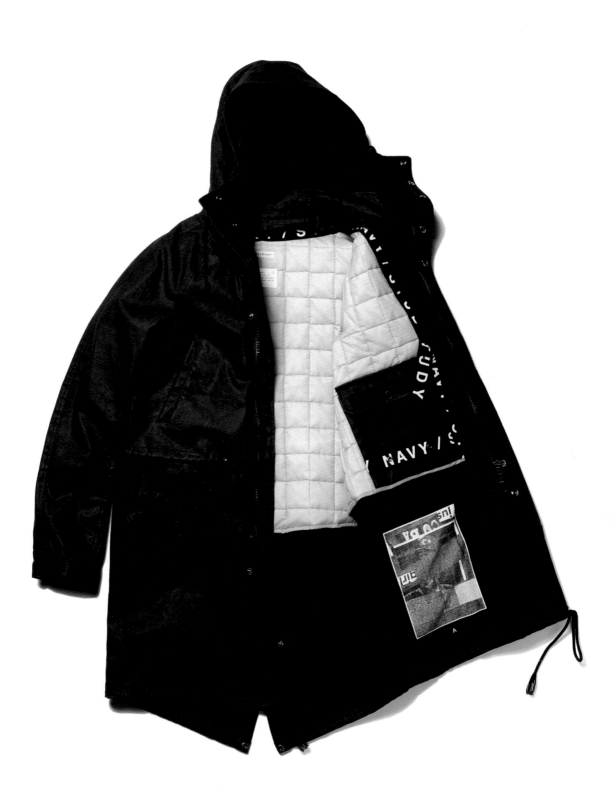

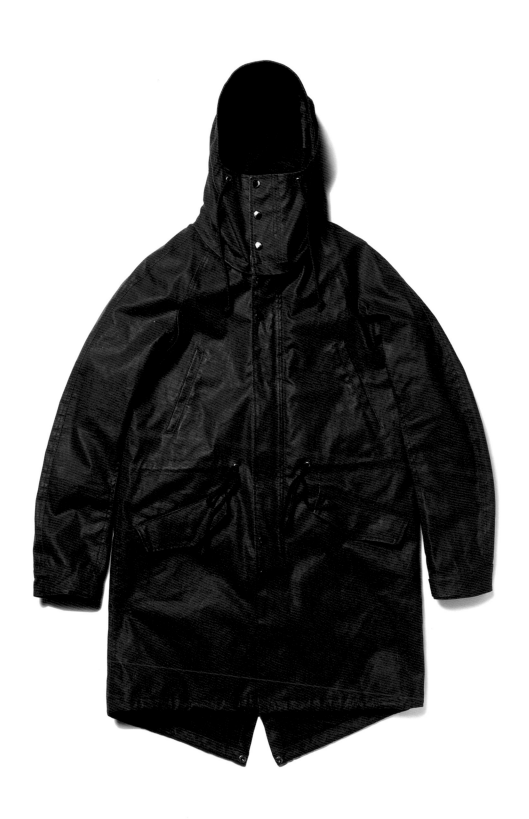

TN14FTO006CK / Shirt
Rules Shirt
Cotton / Check

TN14FOW008CH / Jacket
Overcoat
Wool, Nylon, Rayon / Charcoal

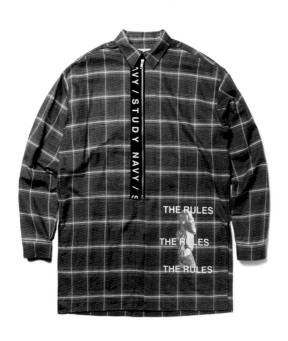

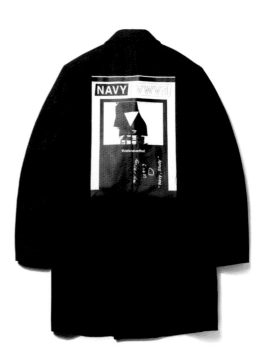

TN14FTO017BK / Shirt
Padded Shirt
Polyester / Black

TN14FOW001NA / Jacket
Padded Coat
Polyester / Navy

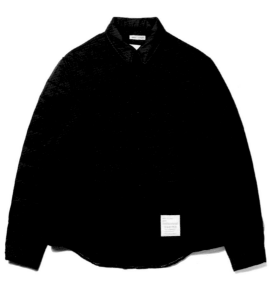

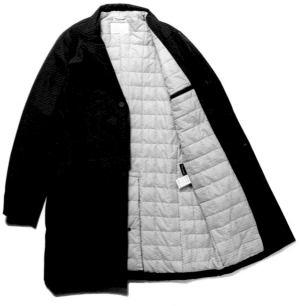

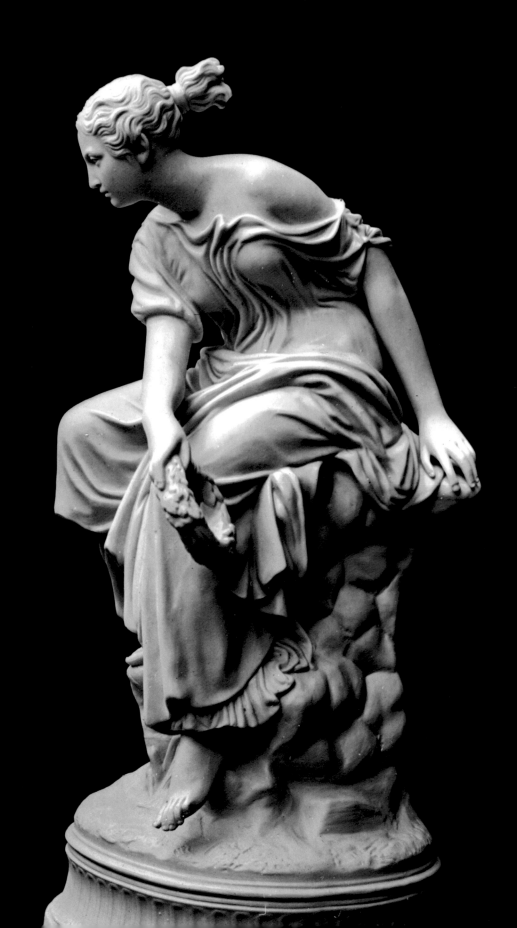

TN14FOW003CK / Jacket
101 Coat
Wool, Polyester, Cotton / Check

TN14FOW006NA / Jacket
M-65 Jacket
Cotton / Navy

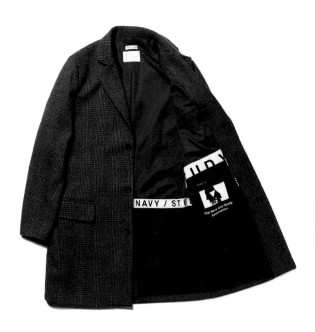

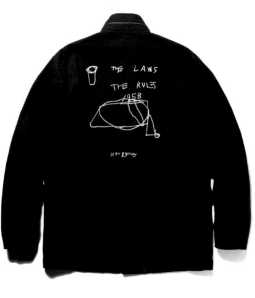

TN14FTO005NA / Sweatshirt
Rules Zip Up
Cotton / Navy

TN14FTO001GR / Sweatshirt
Boxer Pullover
Cotton / Grey

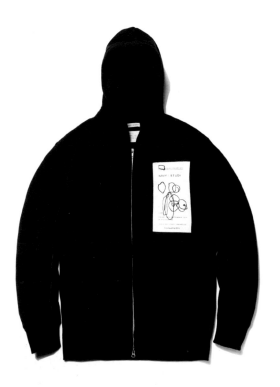

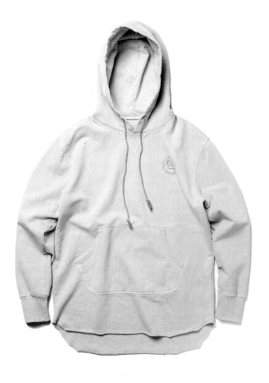

TN14FBT001NA / Pants
Rules Sweat Pant
Cotton / Navy

TN14FBT006NA / Pants
Classic Trousers
Wool, Polyester / Navy

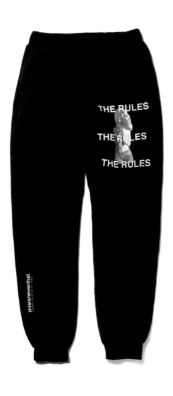

TN14FBT006BS / Pants
Classic Trousers
Wool, Polyester / Black Stripe

TN14FBT007OV / Pants
Work Pant
Cotton / Olive

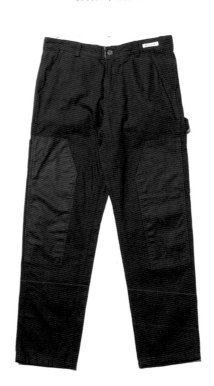

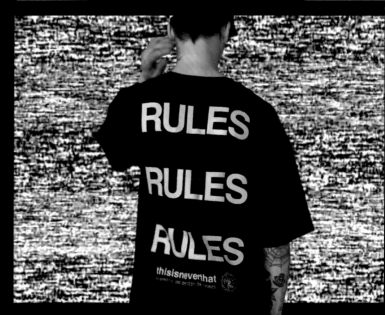

TN14FOW004BK

TN14FTO012OV

TN14FTO018BK

TN14FTO013CH

TN14FTO013NA

TN14FTO014CH

TN14FTO002ON

TN14FTO002NY

TN14FTO009NK

TN14FOW004BK	Jacket	Utility Jacket	Cotton	Black
TN14FTO012OV	Shirt	NS Shirt	Cotton	Olive
TN14FTO018BK	Tee	Rules Tee	Cotton	Black
TN14FTO013CH	Top	Heavy Knit Sweater	Lambswool	Charcoal
TN14FTO013NA	Top	Heavy Knit Sweater	Lambswool	Navy
TN14FTO014CH	Top	Brushed Sweater	Lambswool	Charcoal
TN14FTO002NW	Tee	Baseball Tee	Cotton	Navy, White
TN14FTO002NY	Tee	Baseball Tee	Cotton	Navy, Yellow
TN14FTO009NK	Long Sleeve Tee	Striped Round Neck Tee	Cotton	Navy, Black

TN14FTO006BK

TN14FTO006WH

TN14FTO006CK

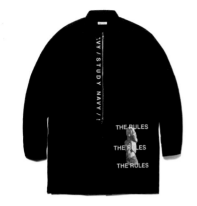

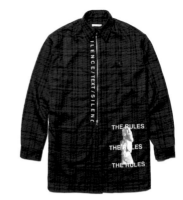

TN14FBT006BK

TN14FBT003OV

TN14FBT007NA

TN14FTO006BK	Shirt	Rules Shirt	Cotton	Black
TN14FTO006WH	Shirt	Rules Shirt	Cotton	White
TN14FTO006CK	Shirt	Rules Shirt	Cotton	Check
TN14FBT006BK	Pants	Classic Trousers	Wool, Polyester	Black
TN14FBT003OV	Pants	Fatigue Pant	Cotton	Olive
TN14FBT007NA	Pants	Work Pant	Cotton	Navy

TN14FAC016BK TN14FAC016NA TN14FAC020OV

TN14FAC002OV TN14FAC011BK TN14FAC004BK

TN14FAC012KN TN14FAC009KC TN14FAC013CC

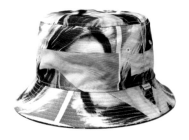 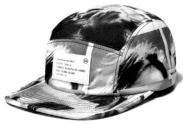 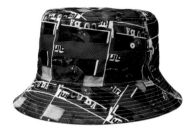

TN14FAC016BK	Hat	N.S Fedora	Wool	Black
TN14FAC016NA	Hat	N.S Fedora	Wool	Navy
TN14FAC020OV	Hat	Beanie	Cotton	Olive
IN14FAC002OV	Hat	Ripstop Camp Cap	Cotton	Olive
TN14FAC011BK	Hat	Wave 5P Cap	Acrylic	Black
TN14FAC004BK	Hat	1958 Bucket Hat	Cotton	Black
TN14FAC012KN	Hat	K.C Bucket Hat	Polyester, Cotton	Kurt Cobain, Navy
TN14FAC009KC	Hat	K.C Camp Cap	Polyester	Kurt Cobain
TN14FAC013CC	Hat	Cuba Bucket Hat	Polyester, Cotton	Cuba, Black

TN14FAC010CU / Hat
Cuba Camp Cap
Polyester / Cuba

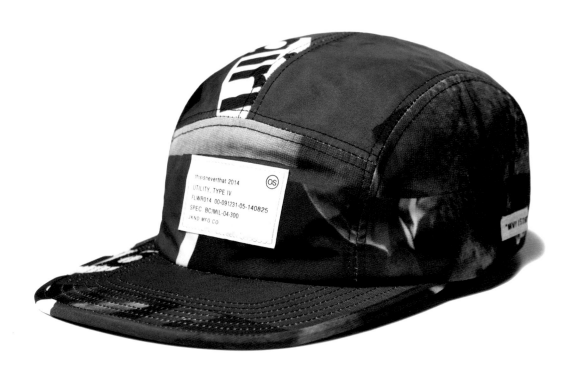

TN14FAC008BK / Hat
N.S 6P Cap
Acrylic / Black

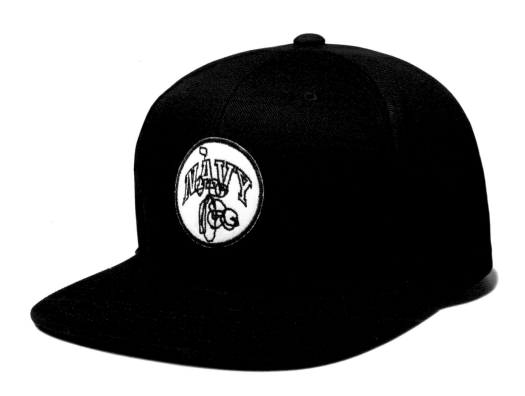

TN14FAC006WH

TN14FAC023BK TN14FAC015BK

TN14FAC007WH	Accessory	Emblem Pin	-	White
TN14FAC014BK	Accessory	Navy Pin	-	Black
TN14FAC006WH	Accessory	Study Pin	-	White
TN14FAC023BK	Accessory	Universe Pin	-	Black
TN14FAC015BK	Accessory	Rules Pin	-	Black
TN14FAC018WH	Accessory	N.S iPhone Case	-	White
TN14FAC017BK	Accessory	K.C iPhone Case	-	Black
TN14FAC005GD	Accessory	Whistle	-	Gold

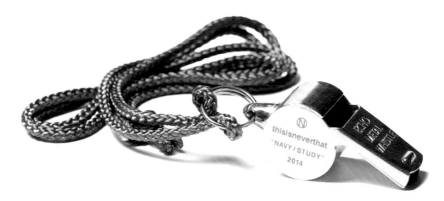

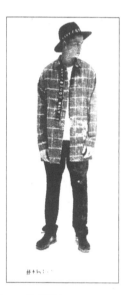

thisisneverthat 2014

FW14

thisisneverthat

thisisneverthat : FW14 EXHIBITION - NAVY S T U D Y
WHEN : FRIDAY SATURDAY | 29 30 AUGUST 2014 | 13:00 - 21:00
WHERE : thisisneverthat STORE | 326-23, SEOKYO, MAPO, SEOUL
INFO :+82(0)70-4015-0014 / www.thisisneverthat.com
FOR BUYER & PRESS, FRIENDS

NAVY / STUDY

SPRING/SUMMER 2014

POLAROIDS

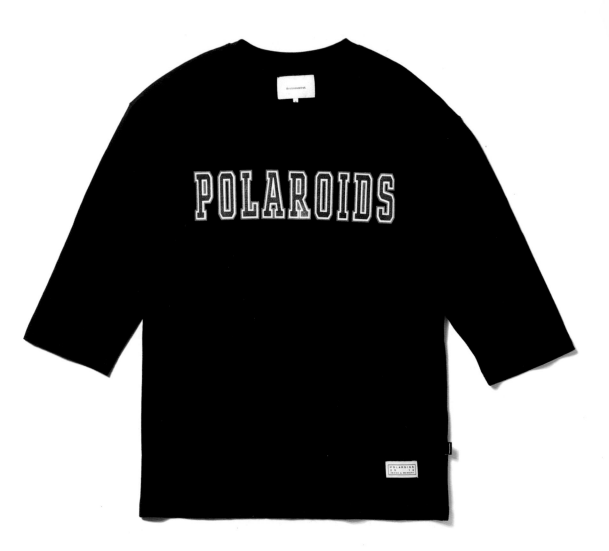

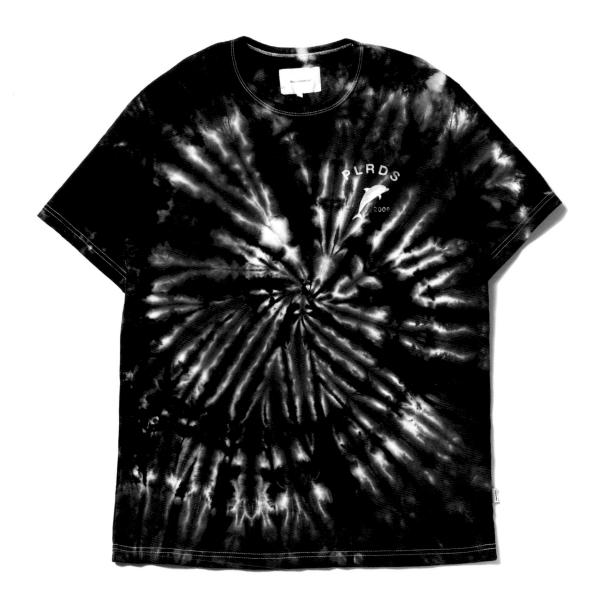

...gathered an enthusi-astic response in Venice. It is an enthralling work. In one room, six distressed mothers were seen on plasma screens; six troubled fathers were likewise shown in an adjacent room. The twist here is that all of these parents in extre-mis were culled from Hollywood blockbusters. Breitz took short clips, some a few seconds long and some just a split second, from several recognizable films dealing with parental mayhem, like *Kramer vs. Kramer*, *Mommie Dearest*, and *Postcards From the Edge*. Because of Breitz's expert editing and the fact that everything occurs against a neutral backdrop, iconic figures from the big screen seem to have been extracted from their original movies to be placed in some frantic, herky-jerky, end-lessly shifting group discussion having to do with the upheavals and anxieties of parenthood.

Self-doubt, self-loathing, pal-pable anger and occasional hopefulness course through the mothers. Much the same hap-pens with the fathers, along with shrill declarations of their own validity as parents. As hard-hitting

...gical ...ut, larger-...n movie stars get their comeuppance; Breitz manipulates the manipulators, and just about everyone else in the world who goes to the movies. Still, as savvy as Breitz is, and as technically brilliant, what takes the work to another level are the intimations that she might also be dealing with raw personal matters, perhaps a wish for and fear of motherhood, perhaps memories of family conflicts. This ultra-medi-ated work is humanly explorative and surprisingly touching.

The exhibition also featured two excellent new multichannel videos involving a novel exploration of the relationship between pop-culture stars and their anonymous fans. For *King (A Portrait of Michael Jackson)*, 2005, Breitz located 16 German fans of Jackson and invited them to individually record a cappella versions of his 1982 album *Thriller* in a profes-sional recording studio in Berlin. Displayed in a row at the gallery, these 16 singing-and-dancing enthusiasts form a fascinating choir. Some (always the men) have Jackson's shoulder-shifting, hand-flashing, crotch-clutching moves down cold. Others, nota-bly a belly dancer and a pensive

comes together ...harmonies and breaks ... as non-choreographed ...ves are performed, one ... by these impassioned ...s. They've got their own ...uality, creativity, flamboy-... and they're basically won-...ul. Breitz's interventions in ...rdom and fandom were a high point in the new exhibition season.
—*Gregory Volk*

Omer Fast
at Postmasters

Colonial Williamsburg is a re-creation of the town as it flourished in the 18th century, from period build-ings to actors playing historical characters. In his recent show at Postmasters (concurrently on view at London's Institute of International Visual Arts), Israeli-born, Berlin-based Omer Fast

character as 18th-century towns-people and partly out; the artist then confused this distinction by aggressively reconfiguring the interviews. He cut, rearranged and spliced the tape back togeth-er, building individual sounds or longer passages into dialogues the actors never actually spoke. At times there's a startling visual staccato as the characters' pos-tures and gestures change jerk-ily from one video fragment to the next. They mix discussions of the Revolutionary War and the Gulf War, and jumble terror-ist attacks with guerrilla actions against the British. According to Colonial Williamsburg's Web site, its mission is to interpret "the ori-gins of the idea of America." As Fast's interviewees slip between past and present, they sug-gest that the idea of America is very much still in formation.

View of Omer Fast's *Godville*, 2005, two-channel video installation, 50 minutes; at Postmasters.

Excuse

de you

IPCNY

A Non-Profit Organ...
Celebrating the F...
Presenting Print Exhib...

IMAGINED WORLDS
Willful Invention and the
Printed Image 1470-2005
November 2, 2005 -
January 28, 2006
AXA Gallery
787 7th Avenue (at 51st Street)
New York City, 212-554-4818

Support for Imagined Worlds has been provided by the International Fine Print Dealers Association, the Samuel H. Kress Foundation, and the Arthur Ross Foundation. The AXA Gallery is sponsored by AXA Financial. Additional support is provided by AXA Art Insurance Corporation.

NEW PRINTS
2005/AUTUMN
A group show of selected artists' prints
November 3, 2005-
December 23, 2005
IPCNY
526 West 26th Street, F
New York City, 212-
Support for the New P
for the Visual Arts.
New York State

5TH ANNIVERSARY SEASON

"Printmaking is a lost art that is found again and again...."

— Lesley D...

Your

u
p

brilliance

TN14STO012BK / Tee
News Tee
Cotton / Black

TN14STO017BK / Tee
Red State Tee
Cotton / Black

TN14STO023BK / Tee
Up Tee
Cotton / Black

TN14STO024BK / Tee
Yellow Door Tee
Cotton / Black

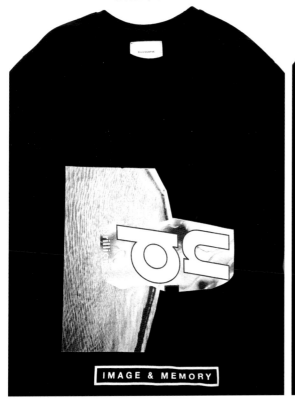

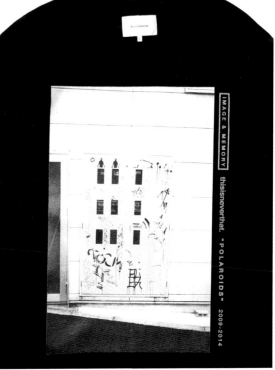

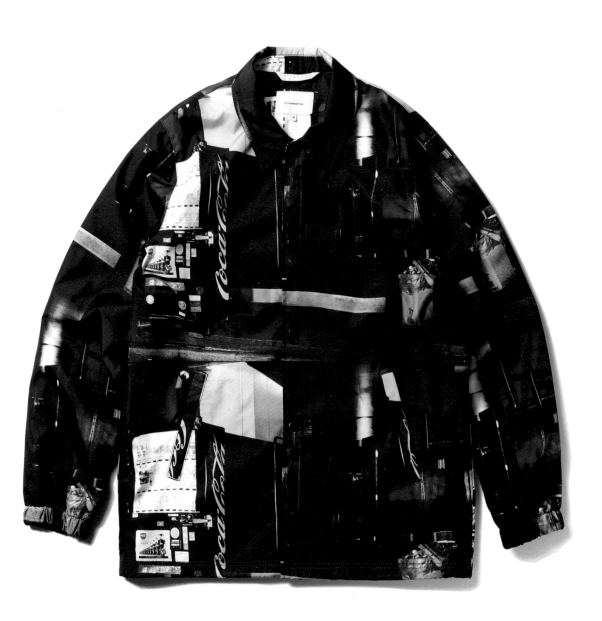

TN14SOW002CA / Jacket
Coach Jacket
Polyester / Camo

TN14SOW002ST / Jacket
Coach Jacket
Polyester / ST

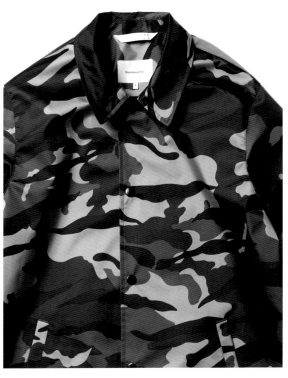

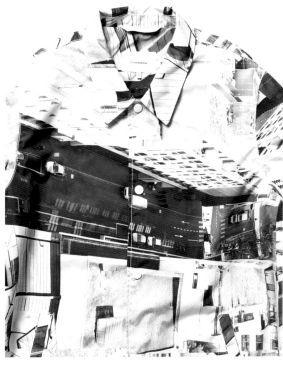

TN14STO013BK / Sweatshirt
PLRDS Hoodie
Cotton / Black

TN14STO013GR / Sweatshirt
PLRDS Hoodie
Cotton / Grey

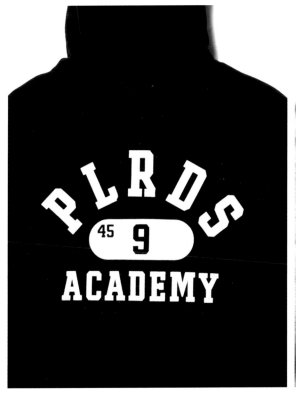

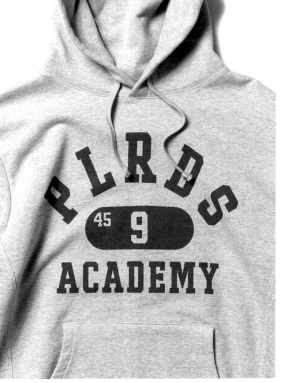

POLAROIDS

TN14SOW003EC / Jacket
MA-1
Cotton / Ecru

TN14STO005RY / Shirt
B.D Sport Shirt
Cotton / Red, Yellow

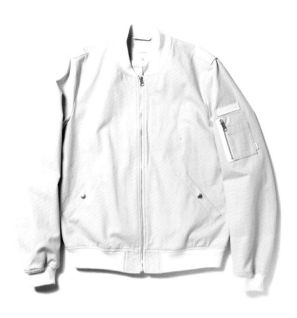

TN14STO018NA / Tee
Shark Tee
Cotton / Navy

TN14STO021NG / Long Sleeve Tee
Striped Round Neck Tee
Cotton / Navy, Green

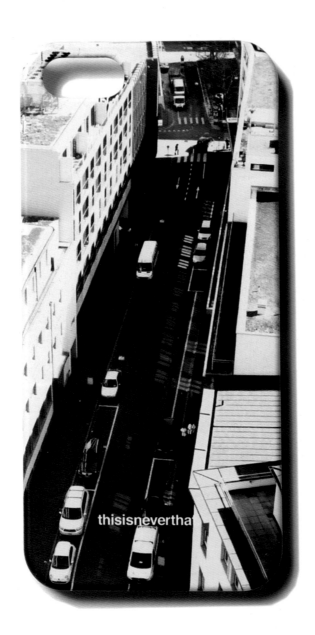

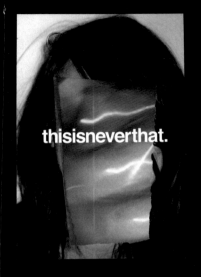
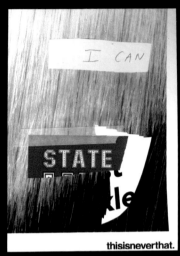
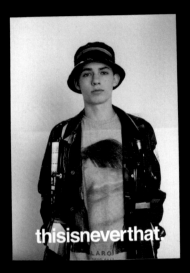

FALL/WINTER 2013

CAN YOU KEEP A SECRET

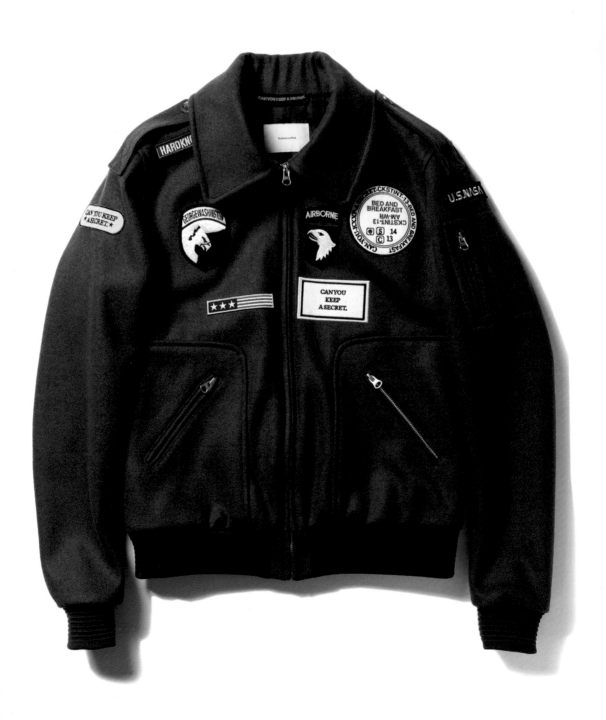

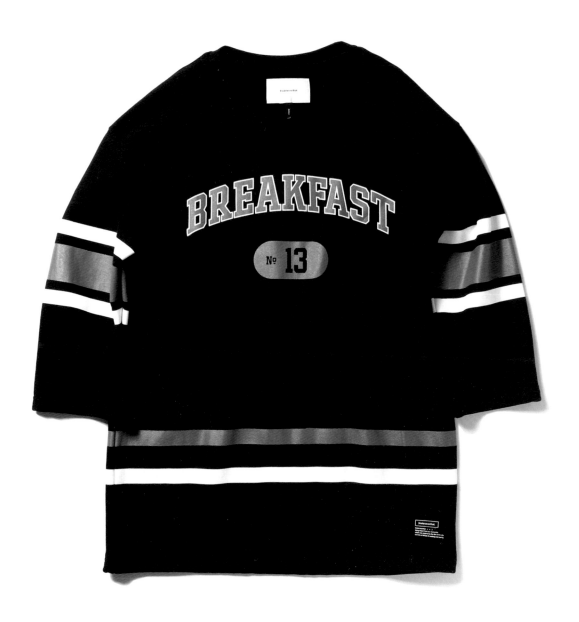

CAN YOU KEEP A SECRET

TN13FOW006GR / Jacket
Quilted Hunting Jacket
Wool, Nylon, Rayon, Polyester / Grey

TN13FOW003BK / Jacket
Leather Varsity Jacket
Genuine Leather, Polyester / Black

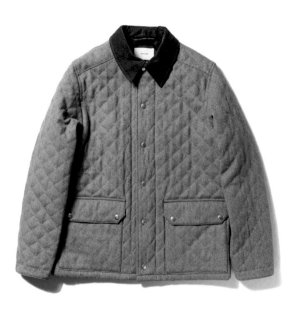

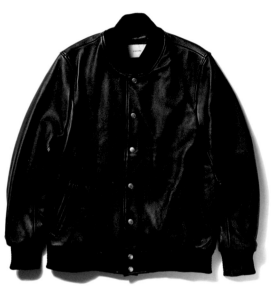

TN13FTO005NA / Top
Cable Knit
Lambswool / Navy

TN13FTO012NA / Top
KXXP Crewneck Knit
Lambswool / Navy

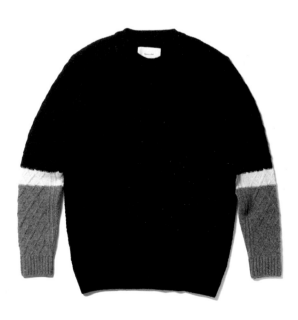

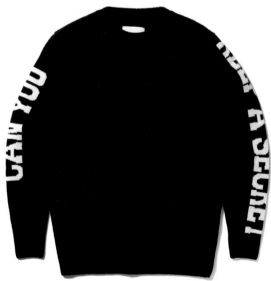

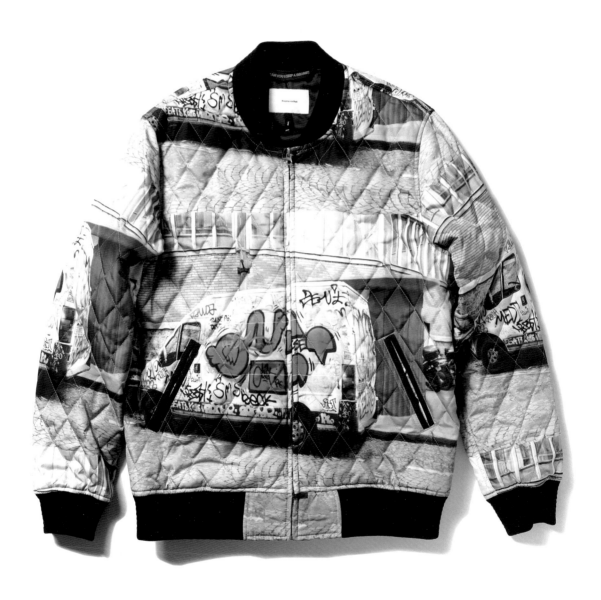

CAN YOU KEEP A SECRET

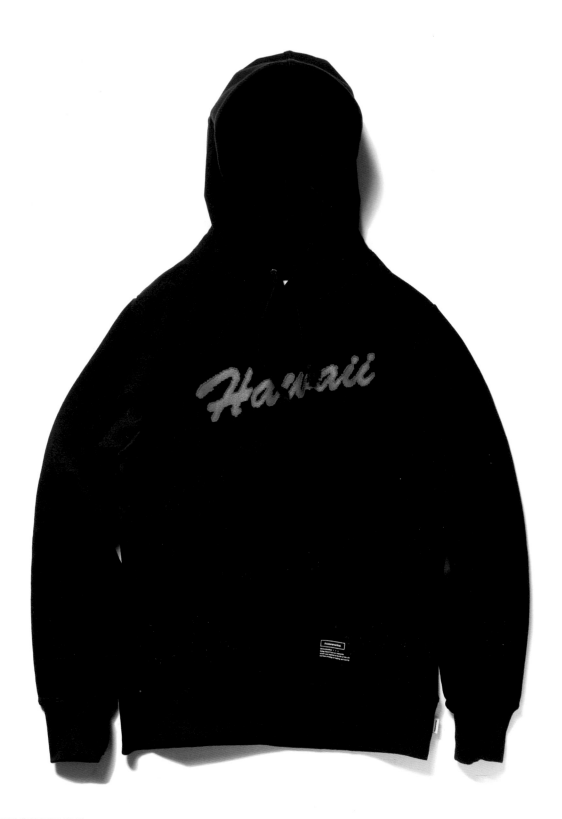

TN13FTO006GR / Sweatshirt
Domino Pullover
Cotton / Grey

TN13FTO009BK / Tee
Hawaii Tee
Cotton / Black

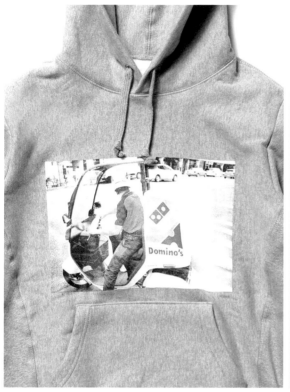

TN13FTO019RD / Sweatshirt
Waikiki Crewneck
Cotton / Red

TN13FTO018BL / Sweatshirt
The Crewenck
Cotton / Blue

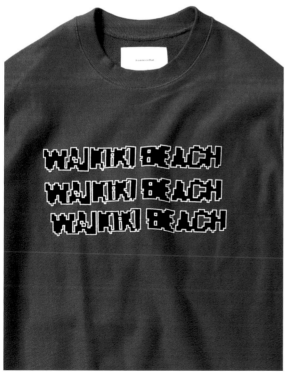

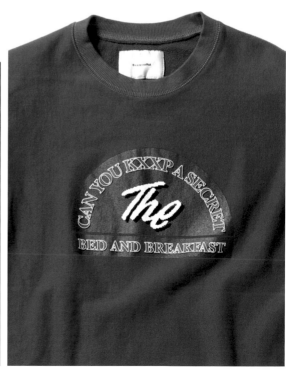

TN13FTO003BL

TN13FTO015BL

TN13FTO002GR

TN13FAC007BL

TN13FAC008NA

TN13FAC010NA

TN13FTO003BL	Tee	B&B Tee	Cotton	Blue
TN13FTO015BL	Shirt	Secret Oxford Shirt	Cotton	Blue
TN13FTO002GR	Tee	B&B Football Tee	Cotton	Grey
TN13FAC007BL	Hat	Secret Beanie	Acrylic	Blue
TN13FAC008NA	Hat	Secret Beanie / BOT	Acrylic	Navy
TN13FAC010NA	Hat	Secret Pom Pom Beanie	Acrylic	Navy

TN13FOW002BK / Jacket
Garret Coat
Wool, Nylon, Rayon, Polyester / Black

TN13FOW004BL / Jacket
MA-1
Nylon, Polyester / Blue

TN13FTO001GR / Tee
134 Football Tee
Cotton / Grey

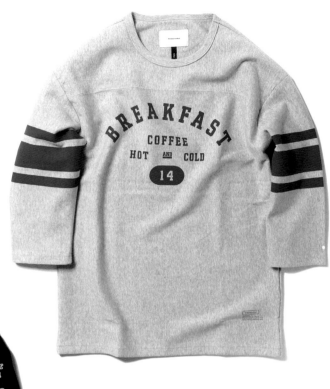

TN13FBT002BK / Pants
Hot & Cold Sweatpant
Cotton / Black

CAN YOU KEEP A SECRET

SPRING/SUMMER 2013

A NOOK
IN THE GARDEN

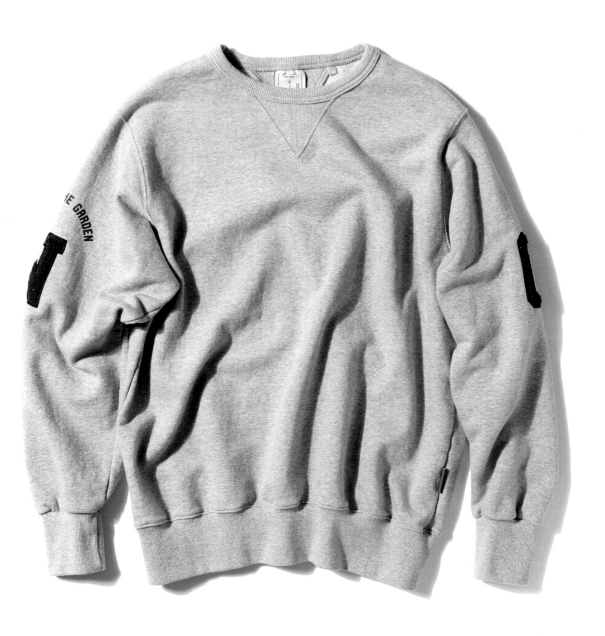

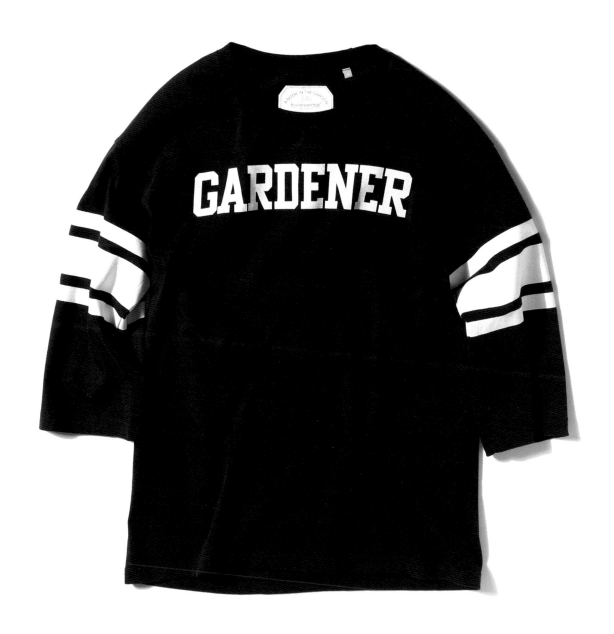

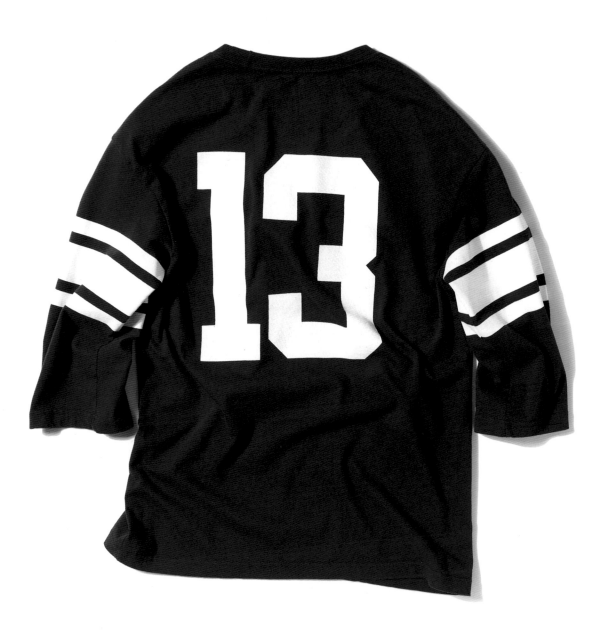

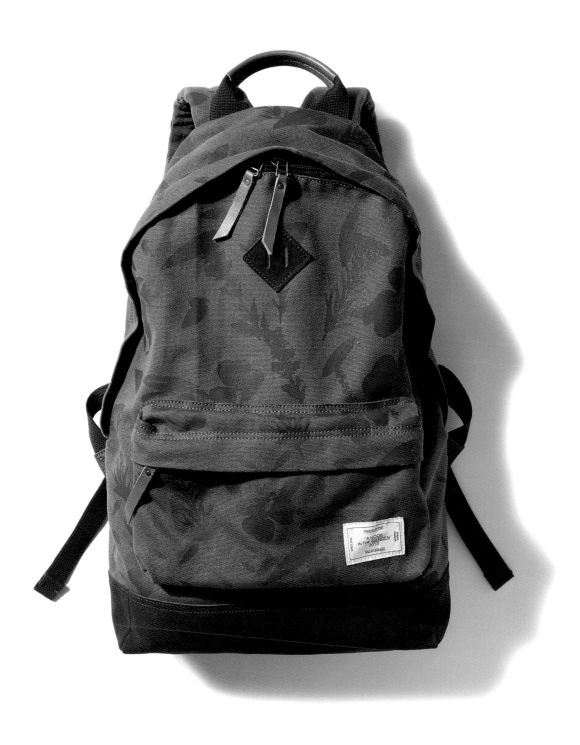

A NOOK IN THE GARDEN

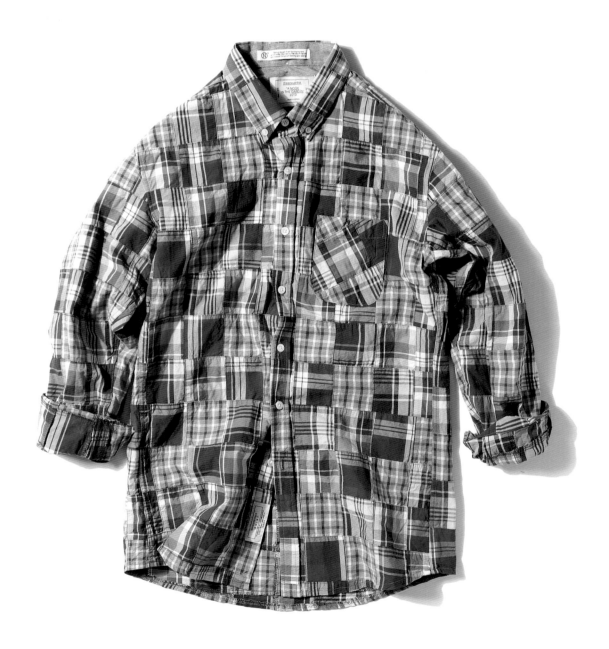

TN13SOW006OV / Jacket
Hunting Jacket
Cotton / Olive

TN13SOW006KH / Jacket
Hunting Jacket
Cotton / Khaki

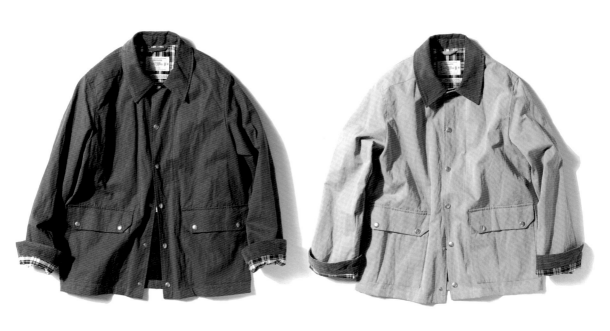

TN13SOW007KH / Jacket
Mac Coat
Cotton / Khaki

TN13STO011WH / Shirt
Madras Shirt
Cotton / White

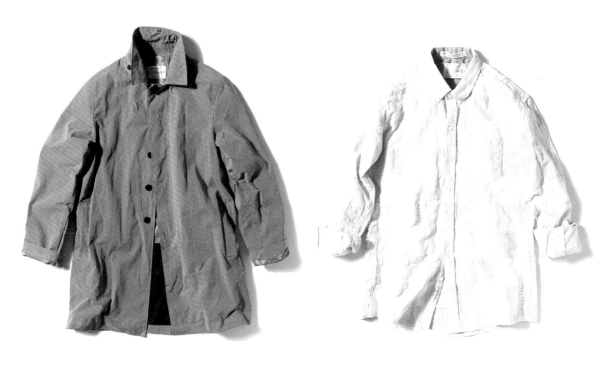

A NOOK IN THE GARDEN

TN13SOW004BL / Jacket
G Field Parka
Nylon, Cotton / Blue

TN13SOW004YL / Jacket
G Field Parka
Nylon, Cotton / Yellow

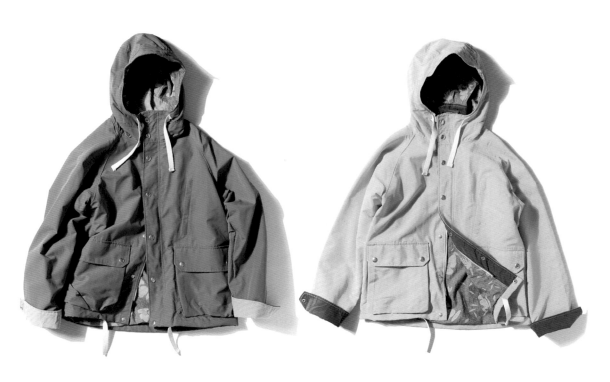

TN13SOW004KH / Jacket
G Field Parka
Nylon, Cotton / Khaki

TN13SOW004GS / Jacket
G Field Parka
Nylon, Cotton / Greyish

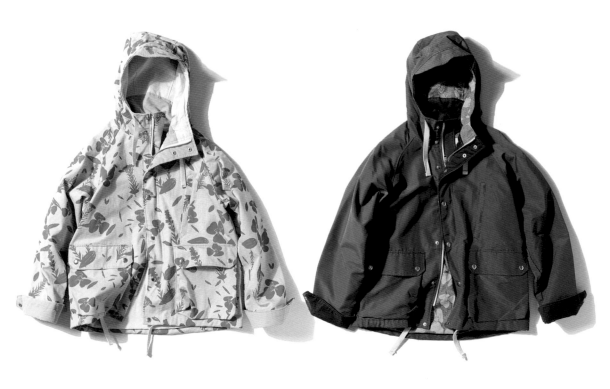

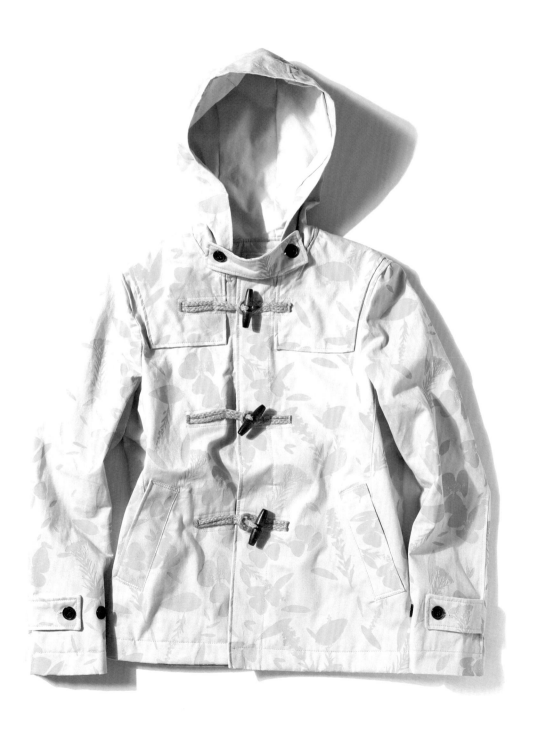

A NOOK IN THE GARDEN

TN13STO005CH / Tee
"N.I.G" Pattern Tee
Cotton / Charcoal

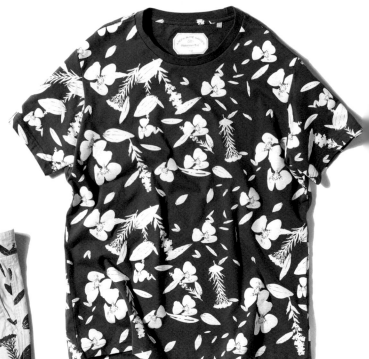

TN13SBT003BE / Pants
"N.I.G" 5P Pant
Cotton / Beige

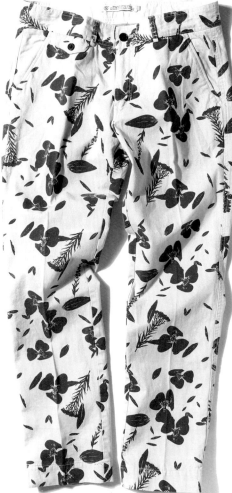

TN13SBT004BL / Pants
"N.I.G" Carpenter Pant
Cotton / Blue

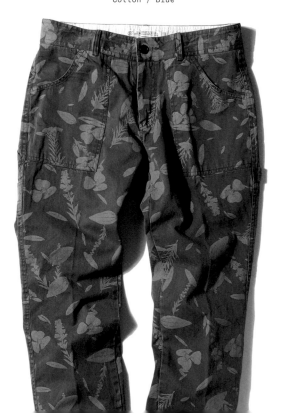

TN13SOW005BL

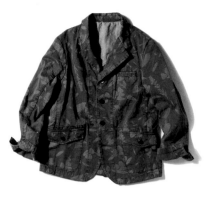

TN13STO004NA

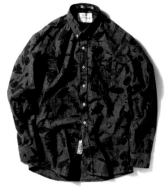

TN13SBT001BL

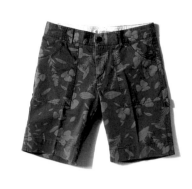

TN13STO013GN

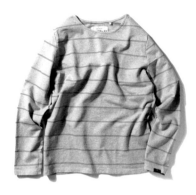

TN13STO013NG

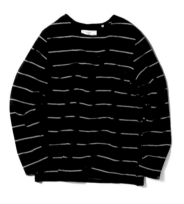

TN13SBT002OV

TN13STO003YL

TN13STO005YL

TN13SBT002BE

TN13SOW005BL	Jacket	GN 4B Jacket	Cotton	Blue
TN13STO004NA	Shirt	"N.I.G" Pattern Shirt	Cotton	Navy
TN13SBT001BL	Pants	"N.I.G" 5L Carpenter Pant	Cotton	Blue
TN13STO013GN	Long Sleeve Tee	Striped Round Neck Tee	Cotton	Green
TN13STO013NG	Long Sleeve Tee	Striped Round Neck Tee	Cotton	Navy, Green
TN13SBT002OV	Pants	"N.I.G" 5L Pant	Cotton	Olive
TN13STO003YL	Sweatshirt	"GN" Crew Sweatshirt	Cotton	Yellow
TN13STO005YL	Tee	"N.I.G" Pattern Tee	Cotton	Yellow
TN13SBT002BE	Pants	"N.I.G" 5L Pant	Cotton	Beige

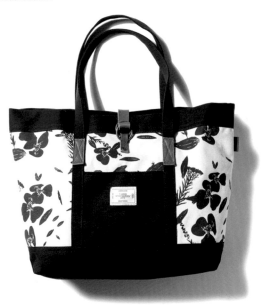

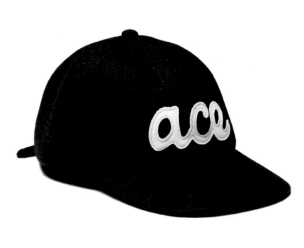

TN13SAC006NA TN13SAC004NA TN13SAC005NA

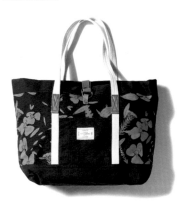

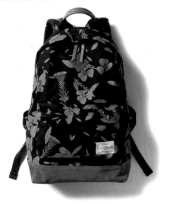

TN13SAC006BE	Bag	L-Tote Bag	Cotton	Beige
TN13SAC001NA	Hat	"ace" Cap	Wool	Navy
TN13SAC006NA	Bag	L-Tote Bag	Cotton	Navy
TN13SAC004NA	Bag	"N.I.G" Daypack	Cotton	Navy
TN13SAC005NA	Bag	"N.I.G" iPad Pouch	Cotton	Navy

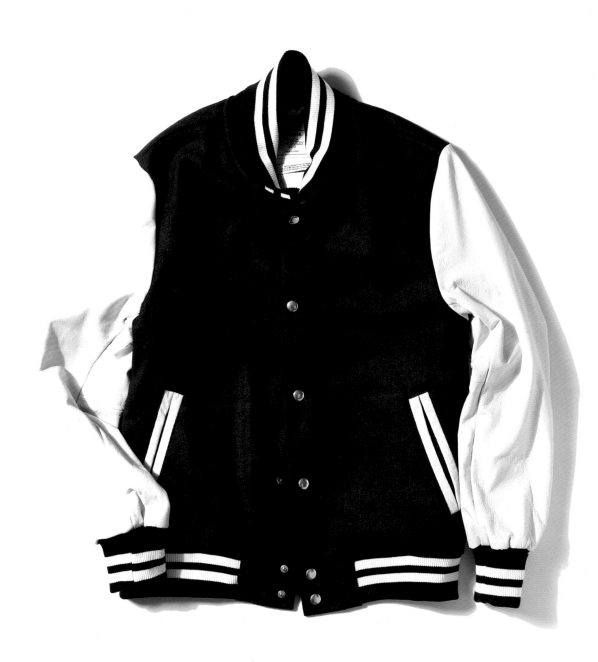

A NOOK IN THE GARDEN

A NOOK IN THE GARDEN - 2013 SPRING/SUMMER
T H I S I S N E V E R T H A T

1.
MAC COAT_BLACK [WAXED COTTON]
JAN10 JR TEE_BLACK
5/L DENIM PANTS

2.
MAC COAT_KHAKI [WAXED COTTON]
JAN10 JR TEE_WHITE
5/L DENIM PANTS

3.
FRENCH ARMY JACKET_NAVY [COTTON RIPSTOP]
"N.I.G" PATTERN TEE_CHARCOAL
ARMY PANTS_OLIVE [COTTON RIPSTOP]
"N.I.G" DAYPACK_NAVY

4.
"N.I.G" PATTERN TEE_CHARCOAL
ARMY PANTS_OLIVE [COTTON RIPSTOP]

5.
"GARDENER" L/S SHIRT_OLIVE
"N.I.G" PATTERN TEE_YELLOW
ARMY PANTS_OLIVE [COTTON RIPSTOP]
S-TOTE BAG_OLIVE

6.
"GARDENER" L/S SHIRT_BLUE
"N.I.G" PATTERN TEE_GREY
ARMY PANTS_NAVY [COTTON RIPSTOP]

7.
GN 4B JACKET_OLIVE
R MADRAS SHIRT
ARMY PANTS_OLIVE [COTTON RIPSTOP]

8.
W MADRAS SHIRT
ARMY PANTS_NAVY [COTTON RIPSTOP]
"ace" CAP

9.
G FIELD PARKA_BLUE [NYLON TASLAN]
"N.I.G" PATTERN TEE_GREY
ARMY PANTS_NAVY [COTTON RIPSTOP]
"ace" CAP

10.
G FIELD PARKA_KHAKI [COTTON TWILL]
JAN10 A TEE_WHITE
5/L DENIM PANTS

11.
VARSITY JACKET_GREEN
JAN10 A TEE_WHITE
"N.I.G" 5/L PANTS_OLIVE

12.
VARSITY JACKET_NAVY
JAN10 A TEE_WHITE
5/L ARMY PANTS_NAVY [COTTON RIPSTOP]
"ace" CAP

13.
JAN10 A TEE_BLACK
"N.I.G" 5/L PANTS_OLIVE
"N.I.G" DAYPACK_OLIVE
"ee" R CAP

14.
"GN" CREW SWEATSHIRT_NAVY
MIDWEIGHT TWILLTERRY PANTS_NAVY
"ace" CAP

15.
HUNTING JACKET_OLIVE [MMT]
"GARDENER" L/S SHIRT_KHAKI
"N.I.G" CARPENTER PANTS_OLIVE
"ace" CAP

16.
HUNTING JACKET_KHAKI [MMT]
"GARDENER" L/S SHIRT_BLUE
"N.I.G" 5P PANTS_BEIGE
"ee" P CAP

17.
"N.I.G" 4B JACKET_BLUE
"N.I.G" i-PAD POUCH

18.
"N.I.G" DUFFLE COAT
"GARDENER" L/S SHIRT_KHAKI
"N.I.G" 5/L PANTS_BEIGE
"ace" CAP

19.
FRENCH ARMY JACKET_OLIVE [COTTON RIPSTOP]
MID-W TWILLTERRY PULLOVER HOODIE_YELLOW
MID-W TWILLTERRY PANTS_NAVY
"13" FOOTBALL TEE_GREY
"ace" CAP

20.
G FIELD PARKA_GRAYISH BLUE [NYLON TASLAN]
BASEBALL TEE_IV/BD
"N.I.G" CARPENTER PANTS_OLIVE

21.
G FIELD PARKA_YELLOW [NYLON TASLAN]
"13" FOOTBALL TEE_NAVY
MID-W TWILLTERRY PANTS_GREY
"ace" CAP

22.
"13" FOOTBALL TEE_GREY
5/L COTTON PANTS_NAVY

23.
"13" FOOTBALL TEE_RED
5/L ARMY PANTS_OLIVE [COTTON RIPSTOP]
"ee" R CAP

24.
"N.I.G" PATTREN CHAMBRAY SHIRT
5/L ARMY PANTS_NAVY [COTTON RIPSTOP]
"ee" R CAP

25.
"GN" CREW SWEATSHIRT_YELLOW
"N.I.G" 5/L PANTS_OLIVE
"ee" R CAP

26.
"GN" CREW SWEATSHIRT_GREY
"N.I.G" 5/L CARPENTER PANTS_BLUE

27.
JAN10 A TEE_BLACK
"N.I.G" 5/L CARPENTER PANTS_BEIGE
"ee" CAP

28.
"GN" CREW SWEATSHIRT_GREY
"N.I.G" 5/L CARPENTER PANTS_BLUE
"ace" CAP

29.
MID-W TWILLTERRY PULL OVER HOODIE_GREY
"GARDENER" L/S SHIRT_BLUE
5/L ARMY PANTS_LEOPARD [COTTON RIPSTOP]
"ee" CAP

30.
MID-W TWILLTERRY PULL OVER HOODIE_NAVY
"GARDENER" L/S SHIRT_OLIVE
"N.I.G" 5/L PANTS_ BEIGE
"ace" CAP

EXHIBITIONS

SS20
SOFT WORK

Date
Feb 7, 2020

Venue
18, Seojeon-ro 37beon-gil,
Busanjin-gu, Busan

Music
360sounds (Soulscape, Maalib,
Someone, Andow, Make-1)

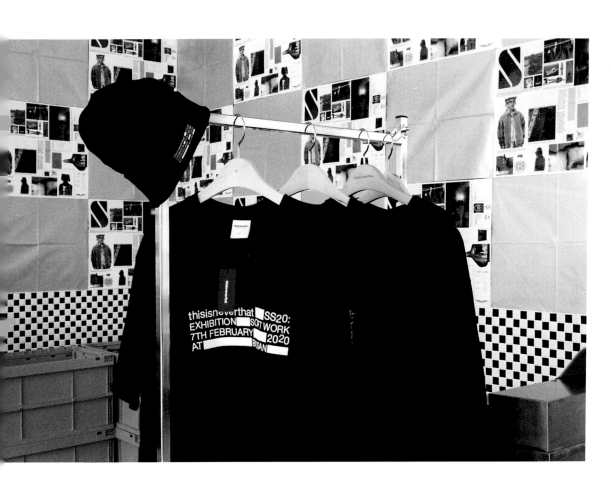

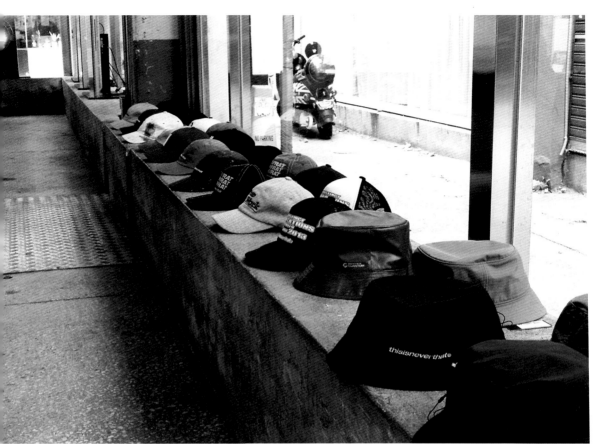

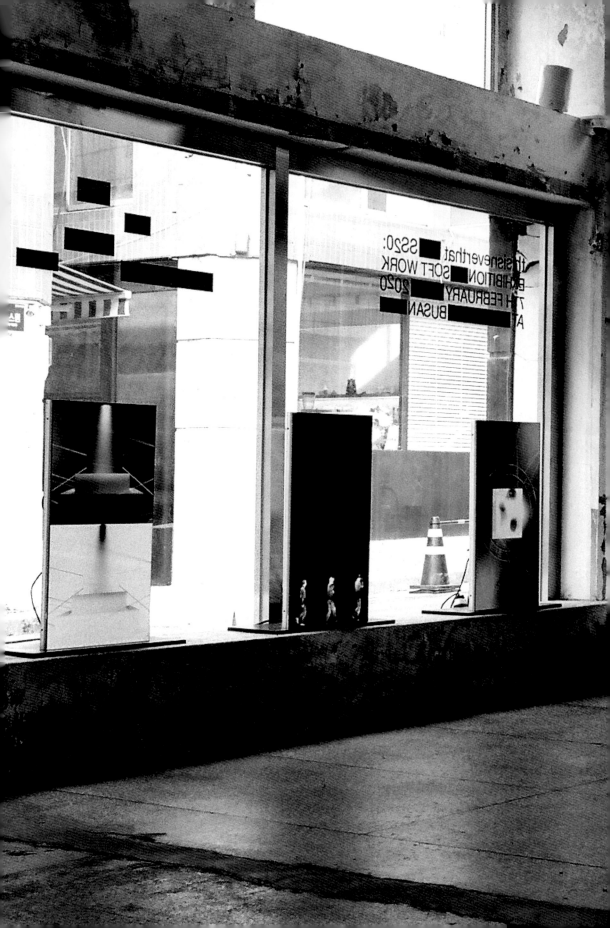

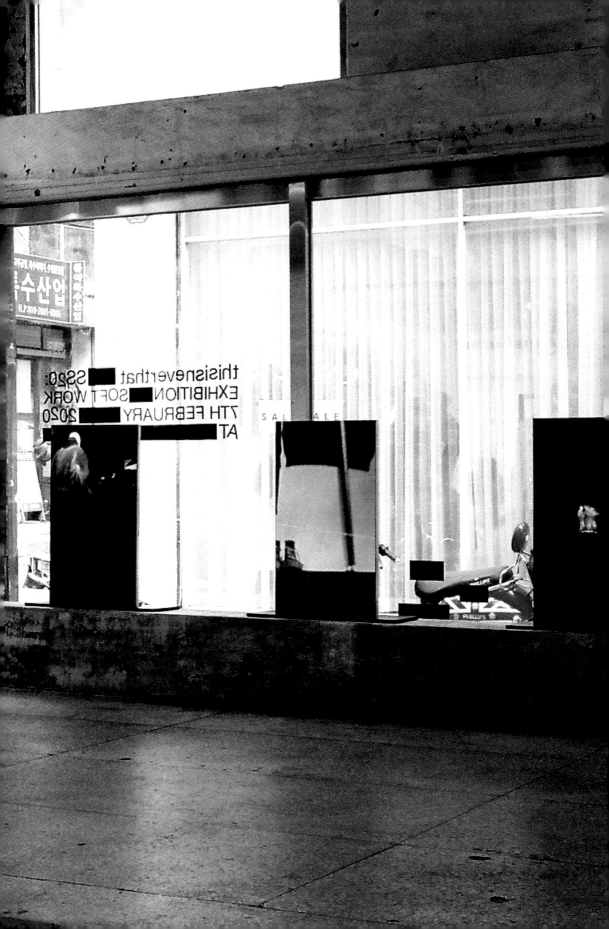

FW19
PREP-SCHOOL GANGSTERS

Date
Aug 8, 2019

Venue
Musinsa Terrace, 17F, 188,
Yanghwa-ro, Mapo-gu, Seoul

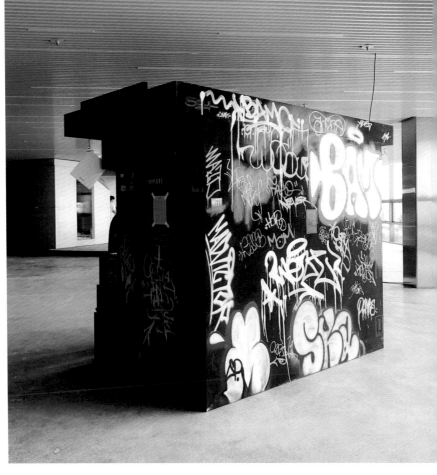

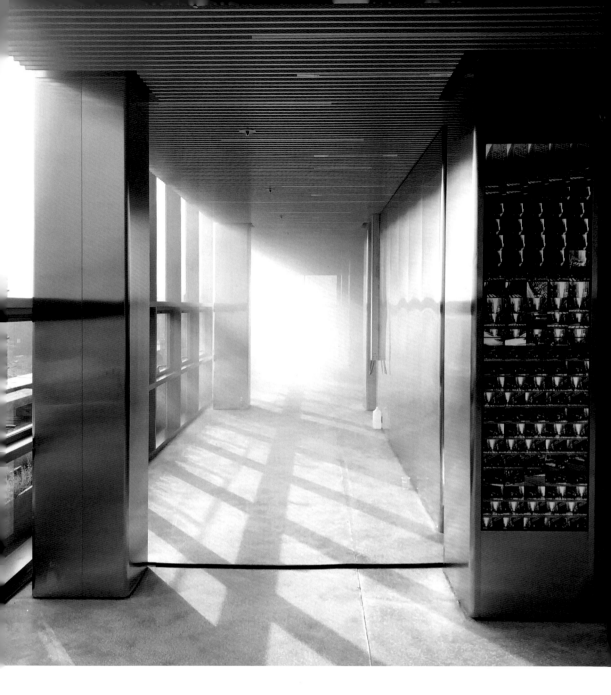

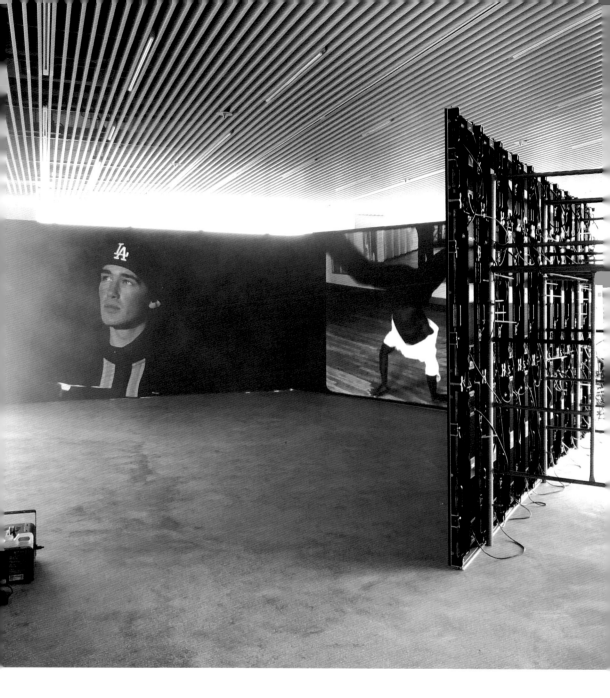

FW18
ADVENTURER II

Date
Aug 11, 2018

Venue
WORKSOUT RYSE, 130, Yanghwa-ro,
Mapo-gu, Seoul, Republic of Korea

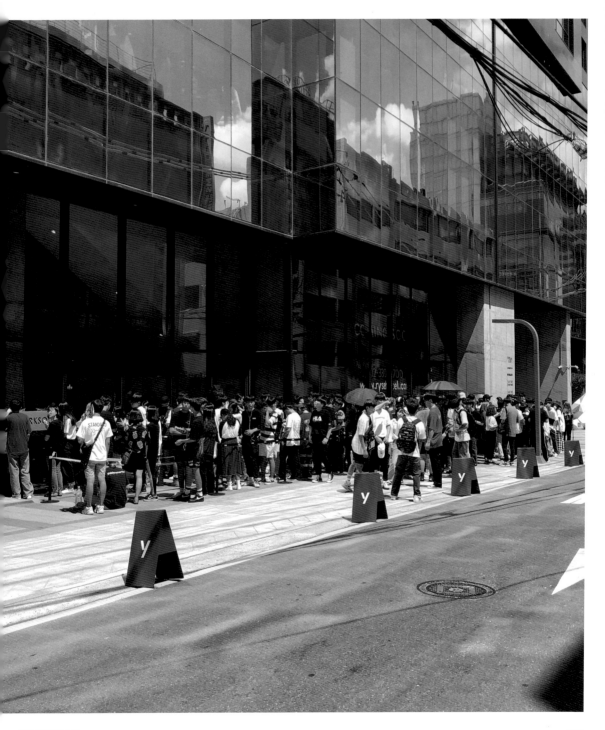

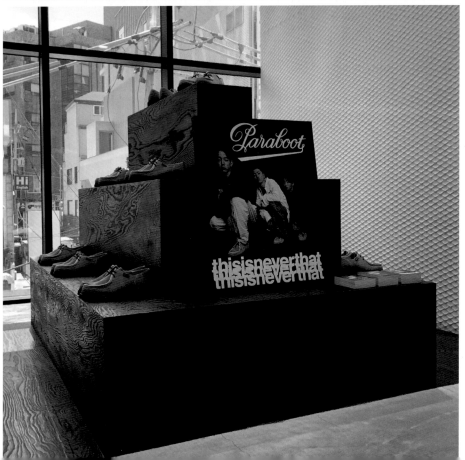

FW17
SPECIAL GUEST

Dates
Aug 25 – 31, 2017

Venue
WORKSOUT, 20-4, Seolleung-ro
157-gil, Gangnam-gu, Seoul

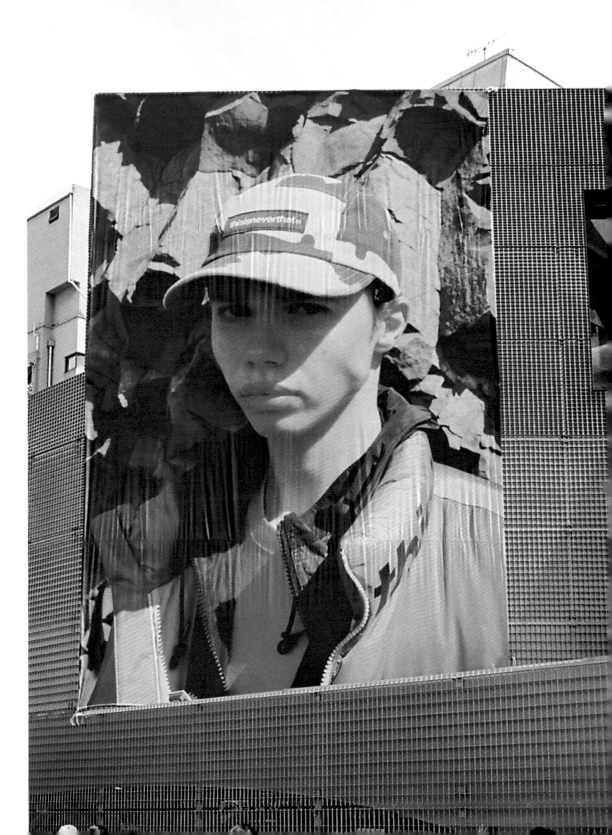

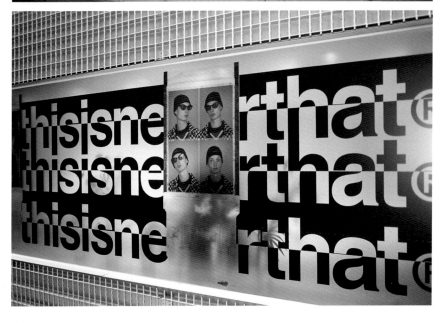

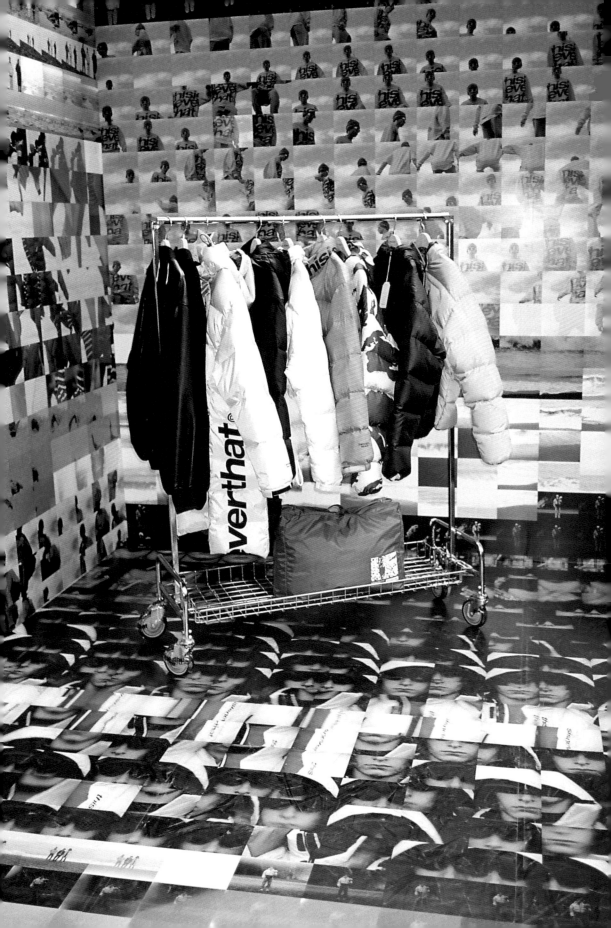

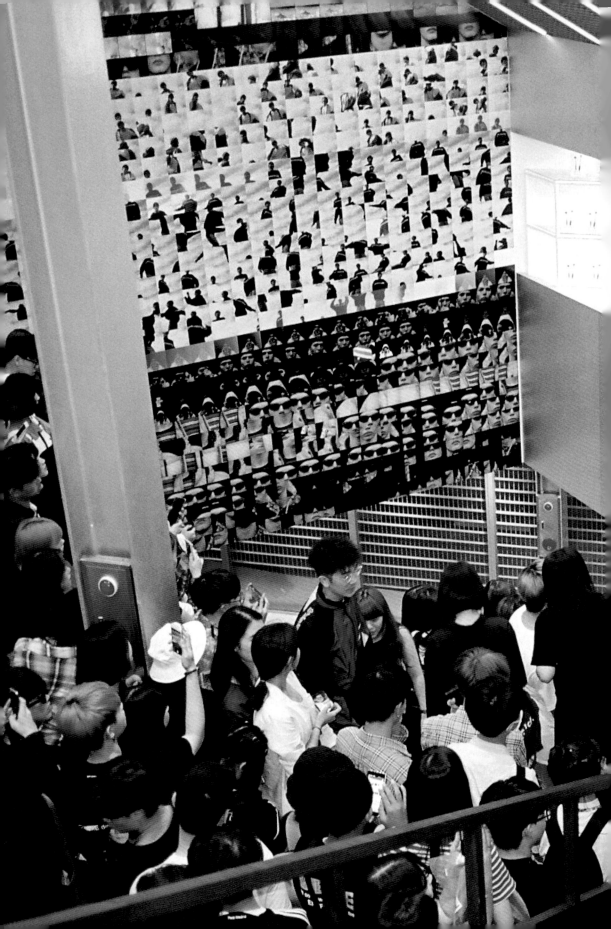

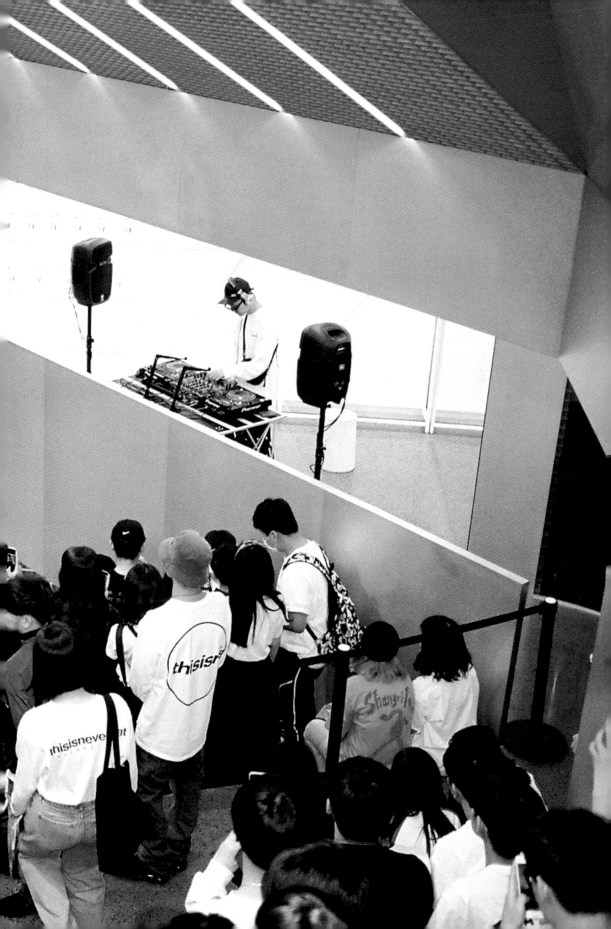

SS17
LAST FESTIVAL

Date
Mar 2, 2017

Venue
WORKSOUT, 20-4, Seolleung-ro
157-gil, Gangnam-gu, Seoul

thisisneverthat

FW16
TEN

Dates
Aug 26–7, 2016

Venue
29cm Center, 45, Yanghwa-ro 10-gil,
Mapo-gu, Seoul

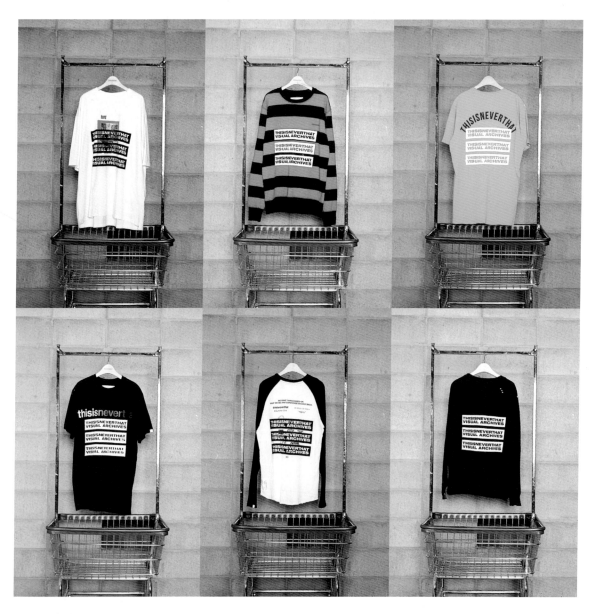

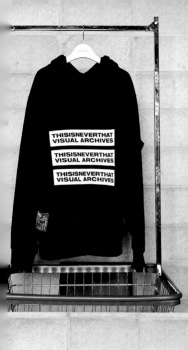
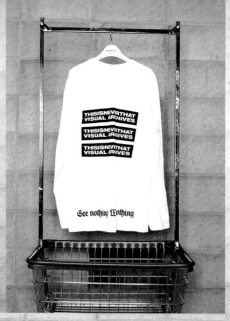
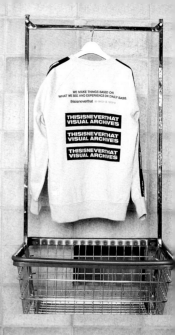
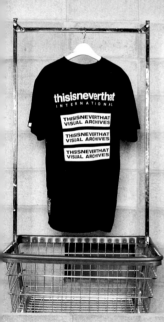
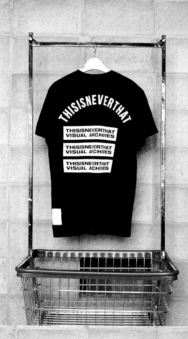
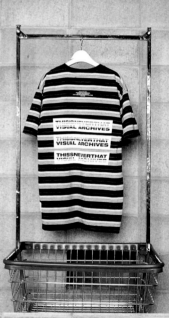
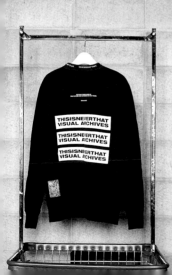
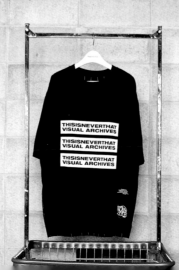
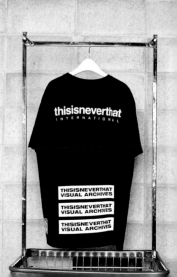

SS16
TAGGING

Date
Feb 19, 2016

Venue
MUDAERUK, 12, Tojeong-ro 5-gil,
Mapo-gu, Seoul

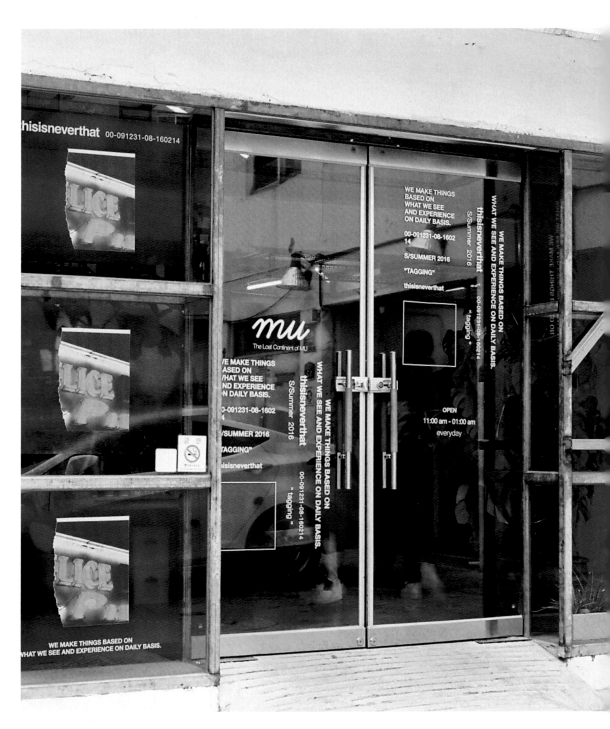

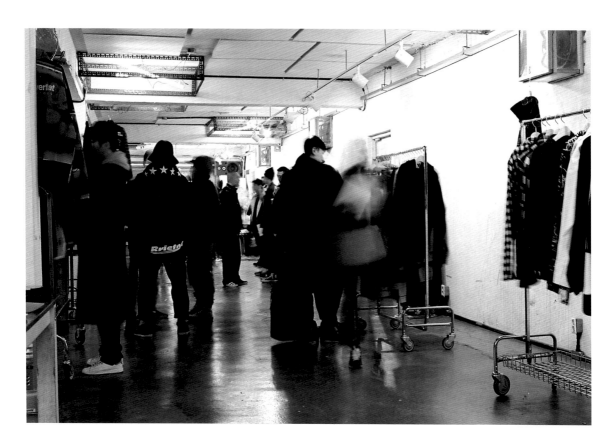

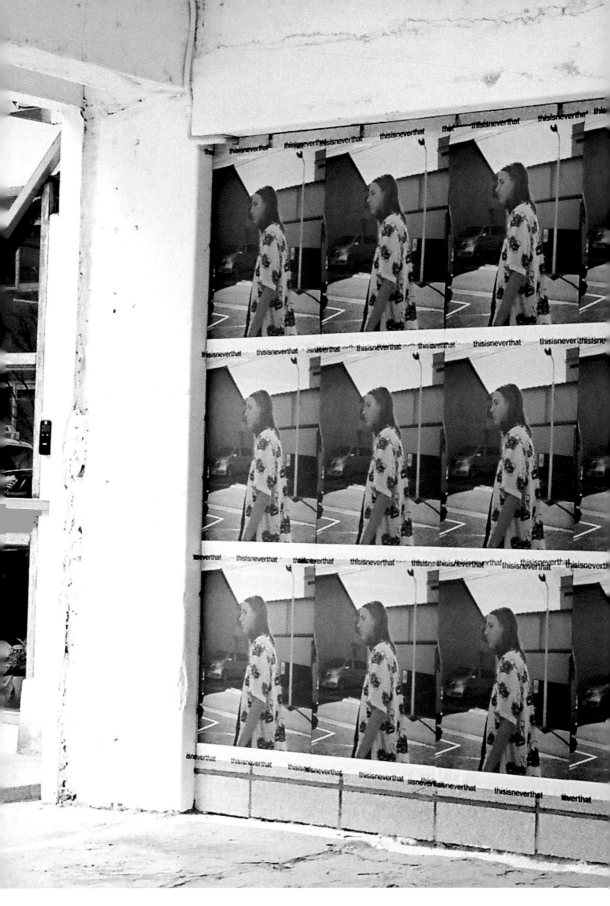

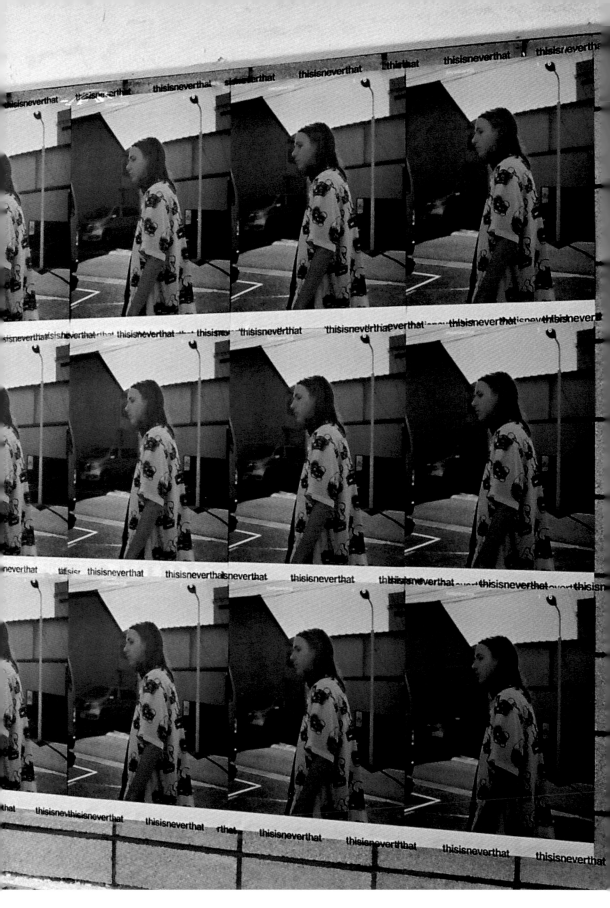

thisisneverthat

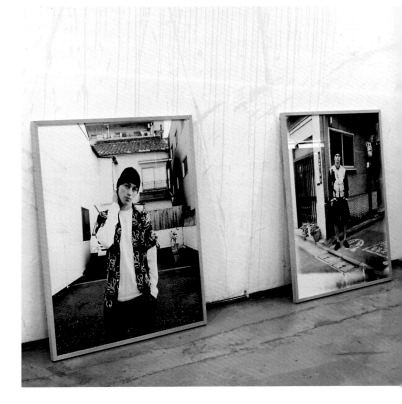

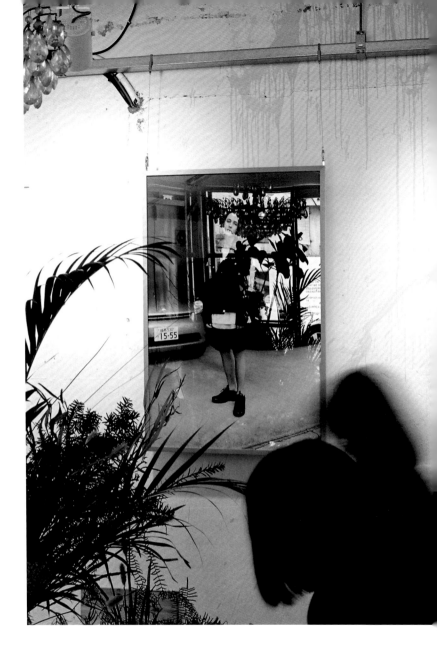

SS13
A NOOK IN THE GARDEN

Dates
Mar 1–2, 2013

Venue
1984, 194, Donggyo-ro, Mapo-gu,
Seoul, Republic of Korea

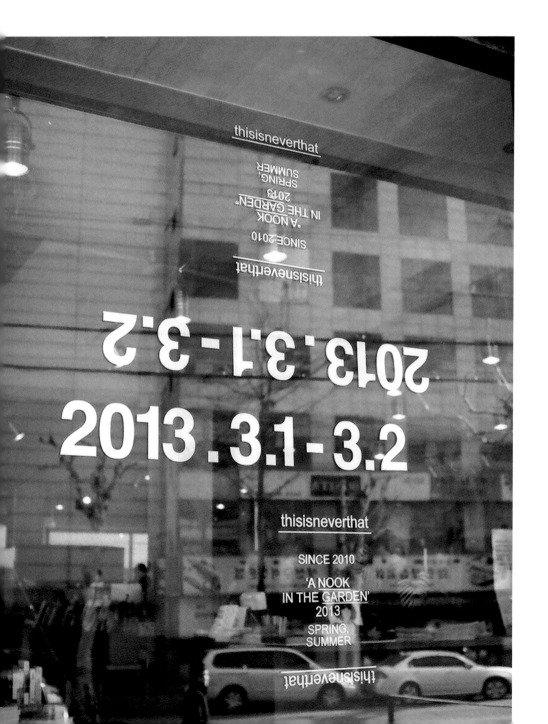

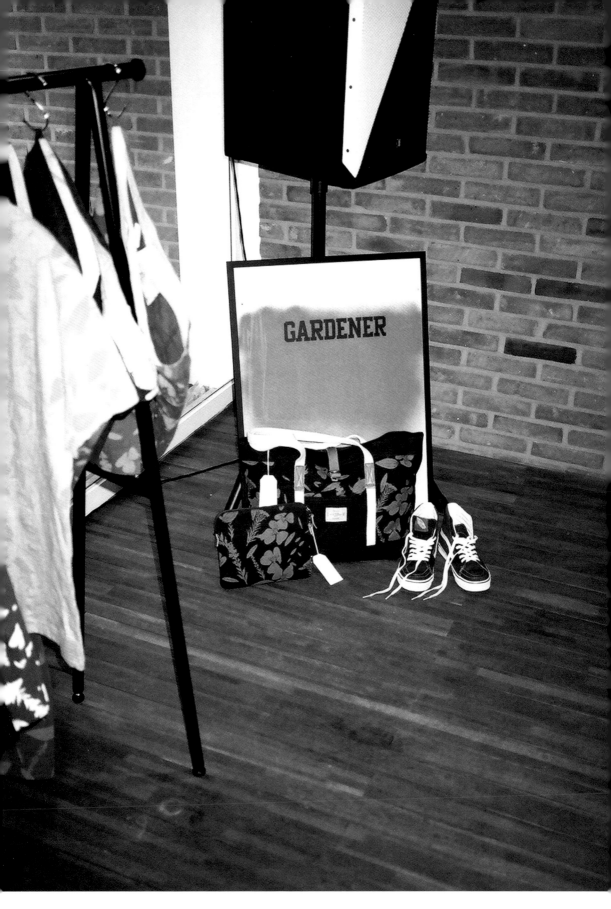

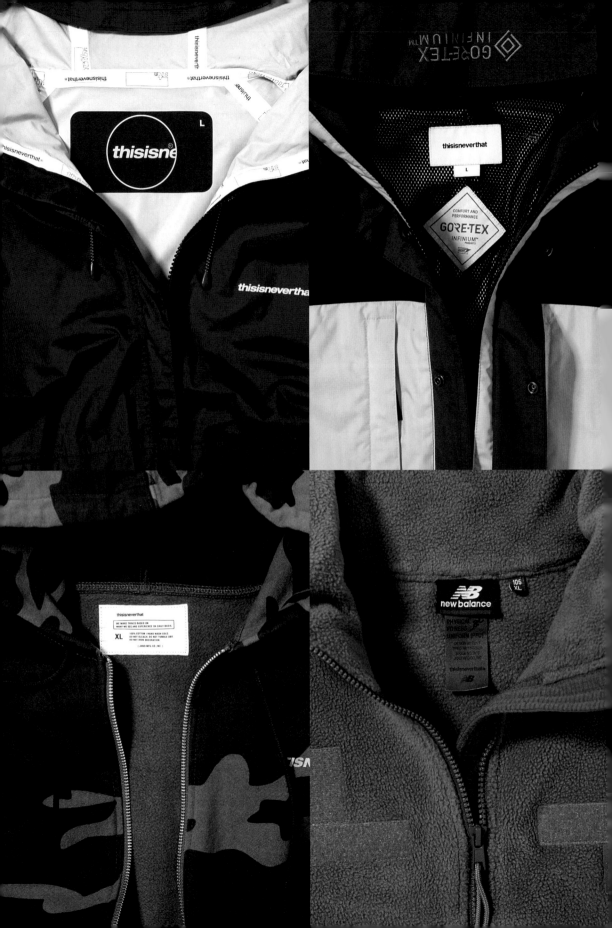

"NAVY / STUDY"

PARKA, SHELL, TYPE I - A(1/2) ☆

1. Wear as outer garment or as under layer
 in cold wet climate.

2. Adjust closures and drawcords to ventilate,
 avoid overheating of body.

3. Brush snow or frost from garments before
 entering heated shelters.

4. Do not expose to hight temperature a stove.

A(1/2)

JACKET, THISISNEVERTHAT INTERNATIONAL
TYPE MA-1 SPEC. No.(M)IL-NT-GT-EQ
CONTRACT. NT-017-08-16Q
STOCK NO. 0091231-12-17081G
TINT CLOTHING CO.,INC
PROPERTY TINT (SUPPLIES)

LARGE

CAN YOU KEEP A SECRET.

thisisneverthat® S

"I'M ON YOUR SIDE"

Concept by
thisisneverthat®

CARE INSTRUCTIONS

DOWN Jackets & Vests:
HAND WASH IN LUKE-WARM
WATER WITH MILD SOAP, GENTLY
KNEADING SUDS THROUGH GARMENT.
RINSE THOROUGHLY TO AVOID LUMPING
OF DOWN. TUMBLE DRY AT LOW HEAT.
DRY CLEAN ONLY WITH DRY CLEANER
EXPERIENCED IN CLEANING DOWN PRODUCTS.

JACKETS & COATS
HAND WASH IN LUKE-WARM
WATER WITH MILD SOAP, GENTLY
KNEADING SUDS THROUGH GARMENT.
TUMBLE DRY AT LOW HEAT.
DRY CLEAN ONLY WITH DRY CLE

thisisneverthat.

thisisneverthat

WE WEAR THINGS BASED ON
WHAT WE SEE AND EXPERIENCE ON DAILY BASIS.

M 100% COTTON / HAND WASH COLD.
DO NOT BLEACH. DO NOT TUMBLE DRY.
DO NOT IRON DECORATION.

[JKNS MFG CO.,INC.]

A NOOK IN THE GARDEN.
SPRING.
SUMMER
thisisneverthat®
SINCE 2010
2013

EVER?HAT

GARDENE

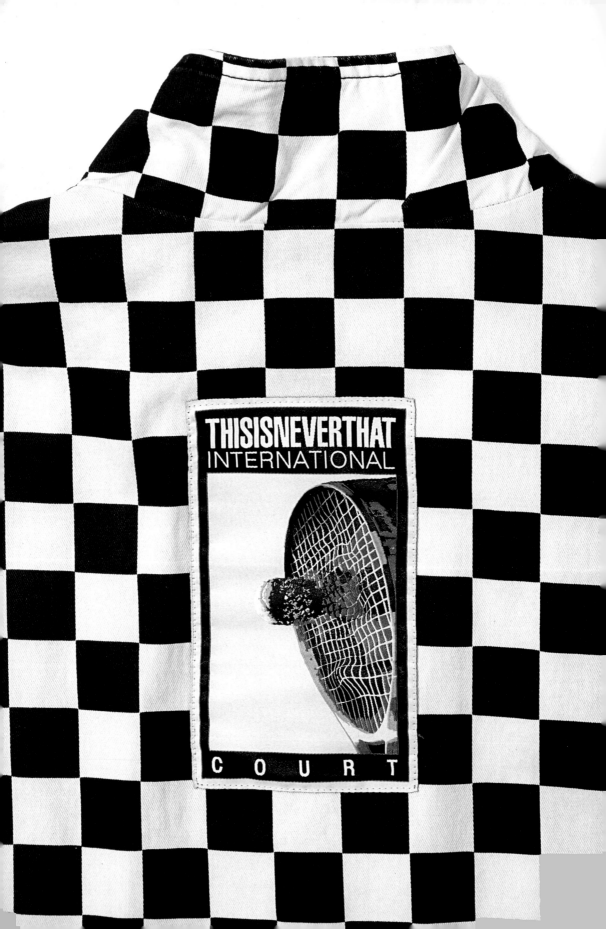

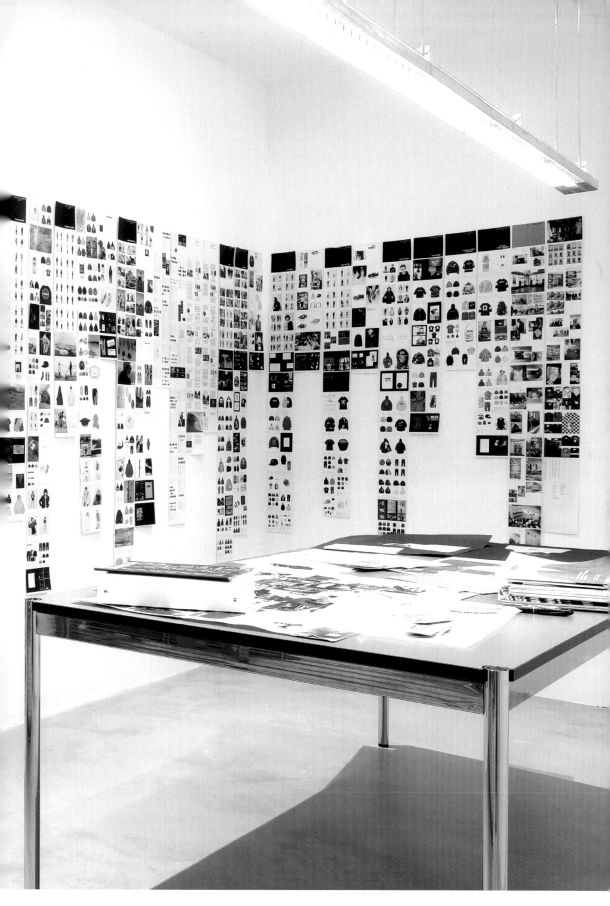

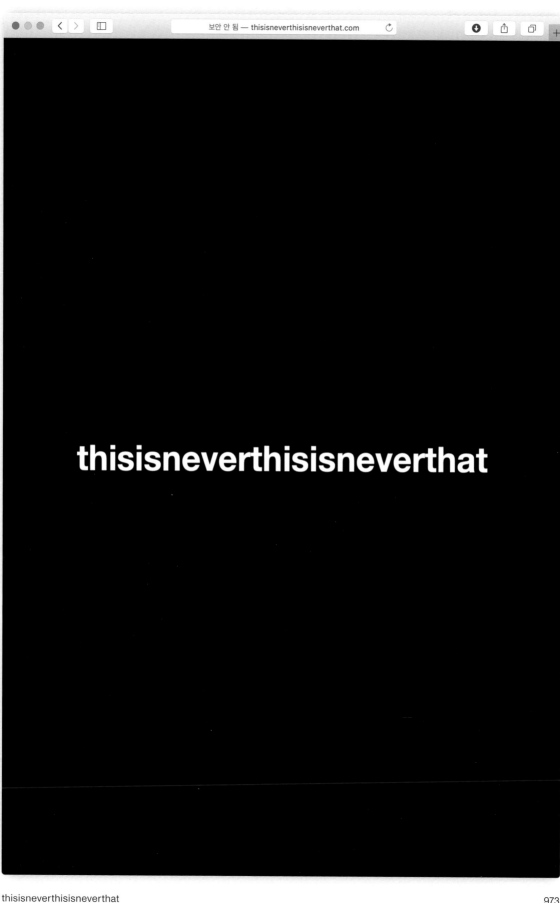

보안 안 됨 — thisisneverthisisneverthat.com

thisisneverthisisneverthat

Seasons	Categories	Materials	Colors	Collaborators	Search

✓ Seasons
- SS20
- FW19
- SS19
- FW18
- SS18
- FW17
- SS17
- FW16
- SS16
- FW15
- SS15
- FW14
- SS14
- FW13
- SS13

✓ Categories
- Accessory
- Bag
- Hat
- Jacket
- Jean
- Long Sleeve Tee
- Pants
- Printed Matter
- Shirt
- Shoes
- Skirt
- Socks
- Sweatshirt
- Tee
- Text
- Top
- Underwear
- Video
- Website

✓ Materials
- 3M Thinsulate
- 925 Silver
- Acetate
- Acetate Frame
- Acrylic
- Amber
- Angora
- Brass
- Ceramic
- Cotton
- Cow Leather
- Crystal
- Down
- Elastane
- Ethanol
- Feather
- Fiberglass
- Film
- Fragrance
- Ginger
- Glass
- Image
- Lambswool
- Leather
- Letter
- Linen
- Metal
- Nylon
- Other
- Paper
- Plastic
- Plastic Buckle
- Polycarbonate
- Polyester
- Polyester Strap
- Polypropylene
- Polyurethane
- Raccoon Fur
- Rayon
- Rubber
- STS
- Sage
- Silicon
- Silver
- Spandex
- Stainless Steel
- Suede
- Surfactant
- TPU
- Tritan
- Vent Nouveau
- Vetiver
- Water
- Waxed Cotton
- Wellon
- Woody Leather
- Wool

✓ Colors
- #1
- #2
- Airport
- Anthracite
- Apricot
- BK&WH Photo
- BOO HOO HOO
- Beige
- Black
- Black Stripe
- Blue
- Blue Check
- Blue Green
- Blue Print
- Brick Red
- Brown
- Burgundy
- Bus
- Camo
- Cashed
- Charcoal
- Check
- Check Black
- Check Blue
- Check Green
- Check Red
- Check Yellow
- Checkerboard
- Clear
- Collage
- Color Photo
- Cool Grey
- Coral
- Coyote
- Crane
- Crazy
- Cream
- Cross Stripes
- Cuba
- Dark
- Dark Blue
- Dark Bluegreen
- Dark Bluegrey
- Dark Camo
- Dark Forest
- Dark Green
- Dark Navy
- Dark Olive
- Deep Blue
- Deep Coral
- Deep Grey
- Delta
- Desert
- Desert Camo
- Dusty Blue
- Dusty Rose
- Ecru
- Ecru Black
- Fire
- Flower
- For 6
- For 7
- Forest
- Forest Green
- Gecko Green
- Gold
- Graphite
- Green
- Green Check

✓ Collaborators
- APFR
- Alpha Industries
- DJ Soulscape
- G-SHOCK
- GORE-TEX
- GRAMiCCi
- HEIGHTS.
- Hyungajo
- JanSport
- Jin Sil
- LEATHERMAN
- Manhattan Portage
- New Balance
- New Era
- PUMA
- Paraboot
- Plastic Kid
- Pokémon
- Quandol
- Reebok
- STARTER
- SUPERGA
- Somdef
- TAION
- TIMEX
- VANS
- Workroom
- Yang Junghoon
- have a good time

SS20	TN20SOW01			Navy	-
SS20	TN20SOW01			Flow...	-
SS20	TN20SOW015NA	Track Jac			
SS20	TN20SPA002BK	Paneled		Paint	-
SS20	TN20SPA002BL	Paneled		Char...	-
SS20	TN20SPA003BK	Zip Flig			
SS20	TN20SPA003TB	Zip Flig		Olive	-
SS20	TN20SPA004BE	Work Pani			
SS20	TN20SPA004NA	Work Pani		Green	-
SS20	TN20SPA005FL			Black	-
SS20	TN20SPA005PNT	Crazy Wor			
SS20	TN20SPA006CH	Overdyed		Sage	-
SS20	TN20SPA003OV	Zip Flig		Black	-
SS20	TN20SPA006GN	Overdyed			
SS20	TN20SPA007BK	Zip Cargo		Mint	-
SS20	TN20SPA007ES	Zip Cargo		Navy	-
SS20	TN20SPA008BK	S.W. Carp			
SS20	TN20SPA008MI	S.W. Car		Black	-
SS20	TN20SPA008NA	S.W. Car		Blue	-
SS20	TN20SPA009BK	Sportsman			
SS20	TN20SPA009BL	Sportsman		Black	-
SS20	TN20SPA010BK	DSN Warm		Stone	-
SS20	TN20SPA009SO	Sportsman		Lemon	-
SS20	TN20SPA010LM	DSN Warm		Navy	-
SS20	TN20SPA010NA	DSN Warm		Dark...	-
SS20	TN20SPA013DNY	SP-Logo Sweatpant		Fore...	-
SS20	TN20SPA013FR	SP-Logo Sweatpant			
SS20	TN20SPA013LBG	SP-Logo Sweatpant		Ligh...	-
SS20	TN20SPA014BK	Damaged Sweatpant		Black	-
SS20	TN20SPA014FR	Damaged Sweatpant		Fore...	-

LOCATIONS

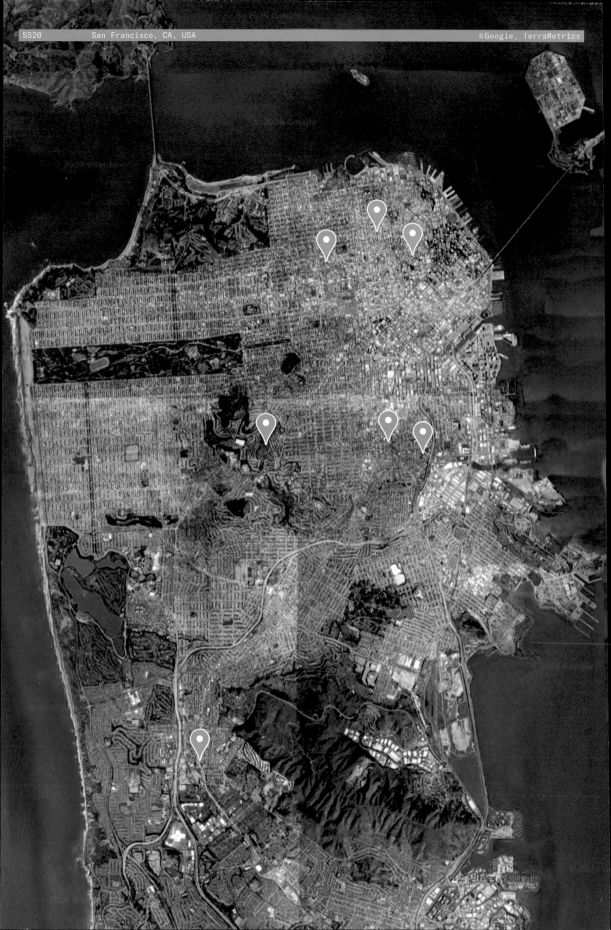

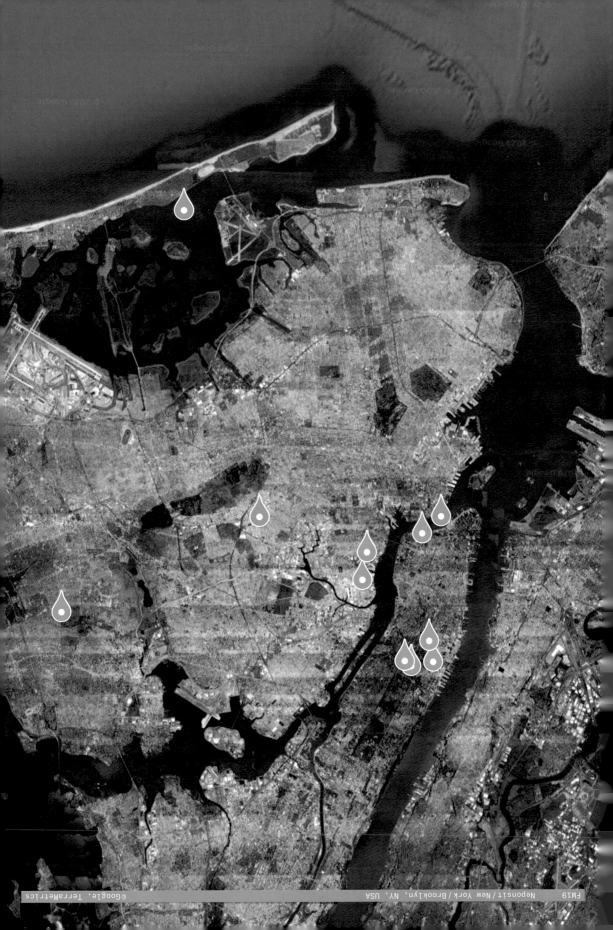

2266 California St, San Francisco, CA 94115

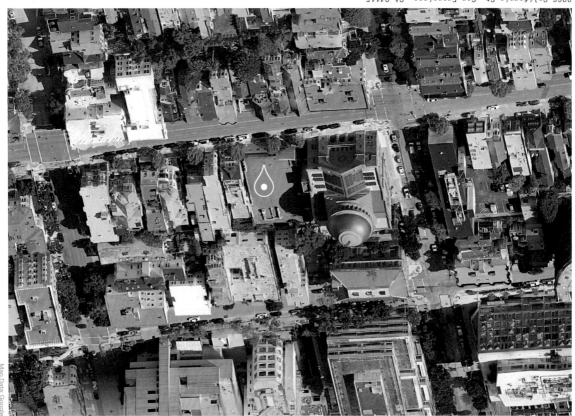

3130 24th St, San Francisco, CA 94110

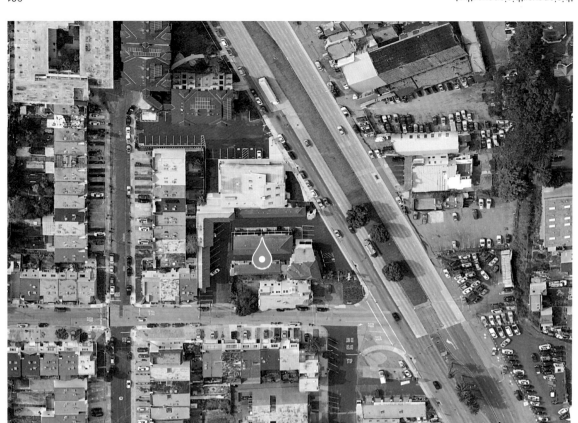

7525 Mission Street, Daly City, CA 94014

1443 Potrero Ave, San Francisco, CA 94110

W 42nd St & 5th Ave ● 89 E 42nd St, New York, NY 10017

37 W 26th St 9th floor, New York, NY 10010

68 Jay Street, Brooklyn, NY 11201

141-24 Cronston Ave, Neponsit, NY 11695

Lausitzer Str. 10, 10999 Berlin

Tempelhofer Damm 23 ● Platz der Luftbrücke 2, 12101 Berlin

©Google

FW18 Berlin, Germany

69 ◉ 247-1 Sunabe, Chatan, Nakagami District, Okinawa 904-0111

1411-91 Nakadomari ◉ 885 Nakadomari, Onna, Kunigami District, Okinawa 904-0415 ◉
3259 Ishikawa, Uruma, Okinawa 904-1106

CX35+77 Vík

9CP52RW6+3C Austfirðir

2P8H+6W Hveragerði

PRXX+89 Kirkjubæjarklaustur

976 Elkland Pl ● 1057 Palms Blvd, Venice, CA 90291

1708-1798 Ocean Front Walk, Venice, CA 90291

SS16 Tokyo, Japan ©Google

4 Chome-5-10 Higashinippori, Arakawa City, Tōkyō-to 116-0014
3-chome-13 Taito City, Tōkyō-to 110-0003 ⬤

Tram Depot, 38-40 Upper Clapton Rd, London E5 8BQ ⬤
184 Queensbridge Rd, London E8 4QE

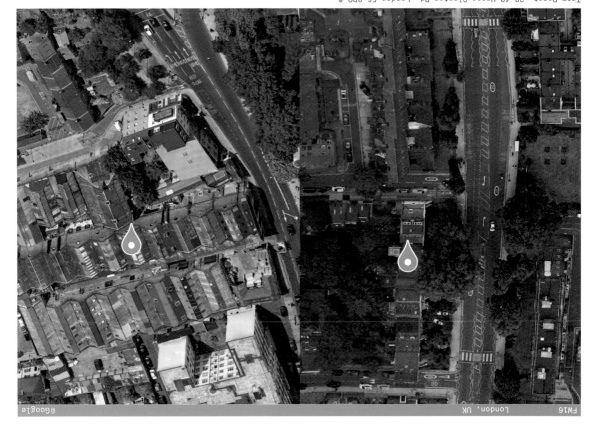

FW16 London, UK ©Google

SS20		SOFT WORK	
Dec 5	09:00	37°34'04.1"N 126°55'49.3"E	31, Yeonhuimat-ro, Seodaemun-gu, Seoul, Republic of Korea
Dec 6	09:00	37°33'04.8"N 126°56'26.6"E	35, Baekbeom-ro, Mapo-gu, Seoul, Republic of Korea
Dec 13	09:30	37°45'10.1"N 122°24'52.8"W	3130 24th St, San Francisco, CA 94110, USA
Dec 13	11:00	37°45'01.9"N 122°24'19.5"W	1443 Potrero Ave, San Francisco, CA 94110, USA
Dec 13	12:30	37°45'08.3"N 122°26'50.5"W	501 Twin Peaks Blvd, San Francisco, CA 94114, USA
Dec 13	15:00	37°47'26.5"N 122°24'30.9"W	634 Powell St, San Francisco, CA 94108, USA
Dec 13	16:30	37°47'45.0"N 122°25'04.6"W	1600 Hyde St, San Francisco, CA 94109, USA
Dec 14	09:00	37°41'15.7"N 122°27'49.6"W	7525 Mission Street, Daly City, CA 94014, USA
Dec 14	11:00	37°47'45.0"N 122°25'04.6"W	1600 Hyde St, San Francisco, CA 94109, USA
Dec 14	13:30	37°47'22.8"N 122°25'52.6"W	2266 California St, San Francisco, CA 94115, USA

FW19		PREP-SCHOOL GANGSTERS	
Jun 23	06:30	40°42'31.0"N 73°57'28.2"W	160-176 Marcy Ave, Brooklyn, NY 11211, USA
Jun 23	08:00	40°45'11.5"N 73°59'33.2"W	500 8th Ave, New York, NY 10018, USA
Jun 23	10:00	40°45'13.4"N 73°58'51.0"W	W 42nd St & 5th Ave, New York, NY 10017, USA
Jun 23	12:00	40°34'35.5"N 73°51'39.7"W	141-24 Cronston Ave, Neponsit, NY 11695, USA
Jun 24	07:00	40°45'10.8"N 73°58'38.0"W	89 E 42nd St, New York, NY 10017, USA
Jun 24	08:00	40°41'47.2"N 73°59'51.0"W	Montague St & Pierrepont Pl, Brooklyn, NY 11201, USA
Jun 24	10:00	40°43'59.8"N 73°47'39.5"W	6825 Fresh Meadow Ln, Flushing, NY 11365, USA
Jun 24	12:00	40°41'42.9"N 73°54'00.9"W	1659 Cody Avenue Suite C, Ridgewood, NY 11385, USA
Jun 25	12:00	40°43'15.3"N 73°57'17.5"W	N 12 St & Bedford Ave, Brooklyn, NY 11249, USA
Jun 25	14:30	40°44'41.3"N 73°59'25.6"W	37 W 26th St 9th floor, New York, NY 10010, USA
Jun 25	17:00	40°42'11.0"N 73°59'12.6"W	68 Jay Street, Brooklyn, NY 11201, USA
Jul 11	09:00	37°34'04.1"N 126°55'49.3"E	31, Yeonhuimat-ro, Seodaemun-gu, Seoul, Republic of Korea
Jul 30	10:00	37°33'06.9"N 126°56'20.5"E	35, Baekbeom-ro, Mapo-gu, Seoul, Republic of Korea
Sep 10	09:00	37°34'06.4"N 126°55'48.3"E	10-2, Yeonhui-ro 11ra-gil, Seodaemun-gu, Seoul, Republic of Korea

SS19		TEENAGE FISHING CLUB	
Dec 13	09:00	37°31'25.9"N 127°02'20.3"E	803, Seolleung-ro, Gangnam-gu, Seoul, Republic of Korea
Feb 12	10:00	37°33'06.9"N 126°56'20.5"E	35, Baekbeom-ro, Mapo-gu, Seoul, Republic of Korea
Mar 6	10:00	35°18'14.9"N 139°30'51.6"E	2 Chome-1-12 Shichirigahamahigashi, Kamakura, Kanagawa 248-0025, Japan

FW18		ADVENTURER II	
Jun 11	09:00	37°31'25.9"N 127°02'20.3"E	803, Seolleung-ro, Gangnam-gu, Seoul, Republic of Korea
Jun 20	10:00	52°28'50.5"N 13°23'14.1"E	Tempelhofer Damm 23, 12101 Berlin, Germany
Jun 20	13:00	52°29'00.1"N 13°23'16.0"E	Platz der Luftbrücke 2, 12101 Berlin, Germany
Jun 20	15:00	52°33'46.7"N 13°24'08.1"E	Heynstudios Berlin, Heynstraße 15, 13187 Berlin, Germany
Jun 20	21:00	52°29'50.9"N 13°25'42.3"E	Lausitzer Str. 10, 10999 Berlin, Germany
Sep 20	10:00	37°44'53.0"N 126°43'55.0"E	127, Jangmyeongsan-gil, Paju-si, Gyeonggi-do, Republic of Korea

SS18		ADVENTURER	
Jan 8	09:00	37°31'25.9"N 127°02'20.3"E	803, Seolleung-ro, Gangnam-gu, Seoul, Republic of Korea
Jan 15	08:00	26°26'06.7"N 127°48'05.0"E	1411-91 Nakadomari, Onna, Kunigami District, Okinawa 904-0415, Japan
Jan 15	10:00	26°26'52.2"N 127°49'56.2"E	3259 Ishikawa, Uruma, Okinawa 904-1106, Japan
Jan 15	12:00	26°20'06.2"N 127°44'43.5"E	247-1 Sunabe, Chatan, Nakagami District, Okinawa 904-0111, Japan
Jan 15	14:00	26°20'01.6"N 127°44'42.1"E	69 Sunabe, Chatan, Nakagami District, Okinawa 904-0111, Japan
Jan 15	17:30	26°26'33.8"N 127°48'12.8"E	885 Nakadomari, Onna, Kunigami District, Okinawa 904-0415, Japan
Jan 16	09:00	26°26'33.8"N 127°48'12.8"E	3259 Ishikawa, Uruma, Okinawa 904-1106, Japan
Jan 16	12:00	26°26'06.7"N 127°48'05.0"E	1411-91 Nakadomari, Onna, Kunigami District, Okinawa 904-0415, Japan
Jan 16	15:00	26°20'01.6"N 127°44'42.1"E	69 Sunabe, Chatan, Nakagami District, Okinawa 904-0111, Japan

FW17		SPECIAL GUEST	
Jul 17	09:00	37°31'25.9"N 127°02'20.3"E	803, Seolleung-ro, Gangnam-gu, Seoul, Republic of Korea
Jul 23	09:00	64°00'56.1"N 21°16'12.6"W	2P8H+6W Hveragerði, Ísland
Jul 23	11:50	63°24'11.3"N 19°02'30.4"W	CX35+77 Vík, Ísland
Jul 23	18:00	64°02'42.7"N 16°11'20.3"W	9CP52RW6+3C Austfirðir, Ísland
Jul 23	22:50	63°44'53.8"N 18°09'05.8"W	PRXX+89 Kirkjubæjarklaustur, Ísland
Jul 24	18:00	63°28'00.5"N 19°21'40.4"W	9CM2FJ8Q+PG Suðurland, Ísland
Jul 24	21:00	63°24'11.3"N 19°02'30.4"W	CX35+77 Vík, Ísland

SS17		LAST FESTIVAL	
Jan 29	15:30	34°04'33.9"N 118°18'37.1"W	4650 Beverly Blvd, Los Angeles, CA 90004, USA
Jan 29	18:00	34°04'44.0"N 118°14'55.6"W	1199 Scott Ave, Los Angeles, CA 90012, USA
Jan 30	09:00	33°59'09.8"N 118°28'24.1"W	1708-1798 Ocean Front Walk, Venice, CA 90291, USA
Jan 30	12:00	33°59'55.5"N 118°27'29.3"W	1057 Palms Blvd, Venice, CA 90291, USA
Jan 30	14:00	33°59'56.5"N 118°27'31.1"W	976 Elkland Pl, Venice, CA 90291, USA
Feb 1	10:30	34°02'41.0"N 118°14'11.2"W	801 E Fourth place, Los Angeles, CA 90013, USA

FW16		TEN	
Aug 3	09:30	51°33'35.4"N 0°03'20.8"W	Tram Depot, 38-40 Upper Clapton Rd, London E5 8BQ, UK
Aug 4	10:30	51°32'17.4"N 0°04'11.7"W	184 Queensbridge Rd, London E8 4QE, UK

SS16		TAGGING	
Feb 10	09:00	35°43'17.9"N 139°46'52.7"E	3-chōme-1 Negishi Taito City, Tōkyō-to 110-0003, Japan
Feb 10	12:00	35°43'26.2"N 139°46'55.0"E	3-chōme-13 Taito City, Tōkyō-to 110-0003, Japan
Feb 10	15:30	35°43'31.9"N 139°46'54.7"E	4 Chome-5-10 Higashinippori, Arakawa City, Tokyo 116-0014, Japan

2009–	박인욱	대표/크리에이티브 디렉터		2009–	Cho Nadan	CEO
	조나단	대표			Choi Jongkyu	CEO
	최종규	대표			Park Inwook	CEO / Creative Director
2012–	김민태	포토그래퍼/비디오그래퍼		2012–	Kim Mintae	Photographer / Videographer
2014–	김재성	디자이너		2014–	Kim Jaesung	Designer
	박진우	디자이너			Lee Inseop	Sales & Merchandise Manager
	서준형	디자이너			Park Jinwoo	Designer
	이인섭	기획 MD			Seo Junhyung	Designer
2015–	김범균	고객 관리		2015–	Bae Bumyeol	Production Developer
	배범열	생산 MD			Kim Beomgyun	Customer Service
2016–	구희경	매장 매니저		2016–	Gu Heekyung	Store Manager
	나현철	생산 MD			Na Hyunchul	Production Manager
2017–	김효진	고객 관리		2017–	Han Chanhee	Sales & Merchandise Specialist
	박선식	기획 MD			Jung Yongjun	Logistics
	임성욱	매장 스태프			Kim Hyojin	Customer Service
	정용준	물류 관리			Lim Sungwook	Store Staff
	한찬희	기획 MD			Park Sunsik	Sales & Merchandise Specialist
2018–	김범식	물류 관리		2018–	Choi Seho	Logistics Manager
	김상현	매장 스태프			Jung Sujin	Finance & Accounting
	남상영	생산 MD			Kim Bumsic	Logistics
	박상연	물류 관리			Kim Sanghyun	Store Staff
	박세진	해외 영업 MD			Lee Gyeuk	Production Developer
	송다영	고객 관리			Lee Minhyeok	Logistics
	양준혁	고객 관리			Lee Seokhun	Designer
	윤상혁	해외 영업 MD			Nam Sangyoung	Production Developer
	이계욱	생산 MD			Park Sangyeon	Logistics
	이민혁	물류 관리			Park Sejin	International Sales Manager
	이석훈	디자이너			Song Dayoung	Customer Service
	정수진	회계			Yang Junhyuck	Customer Service
	최세호	물류 관리			Yoon Sanghyuk	International Sales Specialist
2019–	곽민영	그래픽 디자이너		2019–	Gwak Minyeong	Graphic Designer
	김수호	매장 스태프			Ham Songhak	Logistics
	김혜인	매장 스태프			Hwang Haein	Store Staff
	박성찬	물류 관리			Jeon Hyounggoo	Production Developer
	박제욱	물류 관리			Kim Hyein	Store Staff
	선지민	매장 스태프			Kim Suho	Store Staff
	심우빈	물류 관리			Lee Taemin	Logistics
	엄건웅	디자이너			Park Jeuk	Logistics
	우승민	고객 관리			Park Sungchan	Logistics
	이태민	물류 관리			Seon Jimin	Store Staff
	전형구	생산 MD			Shim Woovin	Logistics
	함송학	물류 관리			Um Gunwoong	Designer
	황해인	매장 스태프			Woo Seungmin	Customer Service
2020–	김근호	포토그래퍼		2020–	Cho Youngjune	Designer
	김진수	매장 스태프			Jeong Wonsik	Designer
	이도훈	포토 어시스턴트			Kim Geunho	Photographer
	이민형	인터랙션 디자이너			Kim Jinsu	Store Staff
	정원식	디자이너			Lee Dohoon	Photo Assistant
	조영준	디자이너			Lee Minhyung	Interaction Designer

별도로 표기되지 않은 사진과 이미지는 모두 thisisneverthat이 제공했다.
All the unmarked images were provided from thisisneverthat.

소설가 정지돈은 2013년 『문학과 사회』 신인문학상에 단편소설 「눈먼 부엉이」가 당선되면서 등단했다. 「건축이냐 혁명이냐」로 2015년 젊은작가상 대상과 「창백한 말」로 2016년 문지문학상을 수상했다. 『내가 싸우듯이』, 『문학의 기쁨』, 『작은 겁쟁이 겁쟁이 새로운 파티』, 『팬텀 이미지』, 『우리는 다른 사람들의 기억에서 살 것이다』 등을 썼다.

패션 칼럼니스트 박세진은 패션붑(fashionboop.com)을 운영하며 패션에 관한 글을 쓰고 번역을 한다. 지은 책으로 『패션 vs. 패션』, 『레플리카』, 『일상복 탐구: 새로운 패션』이, 옮긴 책으로 『빈티지 맨즈웨어』, 『아빠는 오리지널 힙스터』, 『아메토라』가 있다.

번역가 아그넬 조셉은 영국 국립문예창작센터 멘토십, 대산문화재단 한국문학번역지원, GKL 한국문학번역상 대상, 코리아 타임즈 현대한국문학번역상 등 여러 번역상, 지원금 및 멘토십 수상자다. 번역한 책으로 박민규의 『더블』, 정지돈의 『내가 싸우듯이』 등이 있다.

WRITERS, TRANSLATOR

Jung Jidon debuted in 2013 when his story "The Blind Owl" won *Literature and Society*'s New Writers' Award. He went on to win the Munhakdongne Young Writers' Award in 2015 for "Architecture or Revolution?" and the Moonji Literary Award in 2016 for "The Pale Horse." His works include *Like I Fight; The Joy of Literature; Little Cowards, New Party of Cowards; Phantom Image;* and *We Shall Survive in the Memories of Others*.

Fashion columnist Park Sehjin writes about fashion on his website Fashion Boob (fashionboop.com). His publications include the books *Fashion vs. Fashion, Replica,* and *Exploring Everyday Wear: The New Fashion,* and the translations *Vintage Menswear, Dads are the Original Hipsters,* and Ametora: How Japan Saved American Style.

Agnel Joseph is a recipient of multiple awards, grants, and mentorships, including the UK National Centre for Writing Mentorship, Daesan Foundation Translation Grant, Grand Korea Leisure Translation Award, and the Korea Times' Modern Korean Literature Translation Award among others. His book-length translations include *Double* by Park Mingyu and *Like I Fight* by Jung Jidon.

thisisneverthisisneverthat
thisisneverthisisneverthat.com

초판 1쇄 발행
2020년 8월 15일

기획
thisisneverthat, 워크룸

글
thisisneverthat, 워크룸,
박세진, 정지돈

번역
아그넬 조셉

사진·이미지
thisisneverthat, COM,
스튜디오 텍스처 온 텍스처,
신경섭, 푸하하하 프렌즈

편집·디자인
워크룸(김형진, 민구홍, 황석원)

지원
민구홍 매뉴팩처링(김민지)

인쇄
세걸음(정호영)

워크룸 프레스
03043, 서울시 종로구 자하문로16길 4, 2층
전화. 02-6013-3246
팩스. 02-725-3248
wpress@wkrm.kr
workroompress.kr

ISBN 979-11-89356-37-8 03600
50,000원

이 도서의 국립중앙도서관 출판예정도서
목록(CIP)은 서지정보유통지원 시스템
(seoji.nl.go.kr)과 국가자료공동목록시스템
(nl.go.kr/kolisnet)에서 이용하실 수 있습니다.
CIP제어번호: CIP2020029708

thisisneverthisisneverthat
thisisneverthisisneverthat.com

FIRST PUBLISHED ON
August 15, 2020

CONCEPT
thisisneverthat, Workroom

WRITING
thisisneverthat, Workroom,
Jung Jidon, Park Sehjin

TRANSLATION
Agnel Joseph

IMAGES
thisisneverthat,
COM, FHHH Friends,
Shin Kyungsub,
Studio Texture on Texture

EDITING & DESIGN
Workroom (Hwang Seogwon,
Kim Hyungjin, Min Guhong)

SUPPORT
Min Guhong Mfg. (Kim Minji)

PRINTING
Seguleum (Jung Hoyoung)

Workroom Press
03043, 2F, 4, Jahamun-ro 16-gil,
Jongno-gu, Seoul, Republic of Korea
Tel. 02-6013-3246
Fax. 02-725-3248
wpress@wkrm.kr
workroompress.kr

ISBN 979-11-89356-37-8 03600
50,000 KRW

2012년 황학동 사무실.

Office at Hwanghakdong, 2012.